The Subjects of Art History

Historical Objects in Contemporary Perspectives

The Subjects of Art History provides an introduction to the historiography and theory of the history of art. Examining a variety of theoretical approaches, the editors and contributors to this volume provide interpretations of the history and contemporary relevance of such important methodologies as semiotics, phenomenology, feminism, gay and lesbian studies, museology, and computer applications, among other topics. Each chapter, specially commissioned for this volume, gives a fresh perspective on the topic by demonstrating how a particular approach can be applied to the understanding and interpretation of specific works of art. This volume will be a timely contribution to the current debate on the theory and practice of art history.

Mark A. Cheetham is Professor of the Theory and History of Art at the University of Western Ontario. He is the author of *The Rhetoric of Purity: Essentialist Theory and the Advent of Abstract Painting*.

Michael Ann Holly is Chair of Art and Art History and Professor of Visual and Cultural Studies at the University of Rochester. She is the author of *Past Looking: Historical Imagination and the Rhetoric of the Image*.

Keith Moxey is Ann Whitney Olin Professor of Art History at Barnard College and Columbia University. He is the author of *The Practice of Theory: Poststructuralism, Cultural Politics, and Art History*.

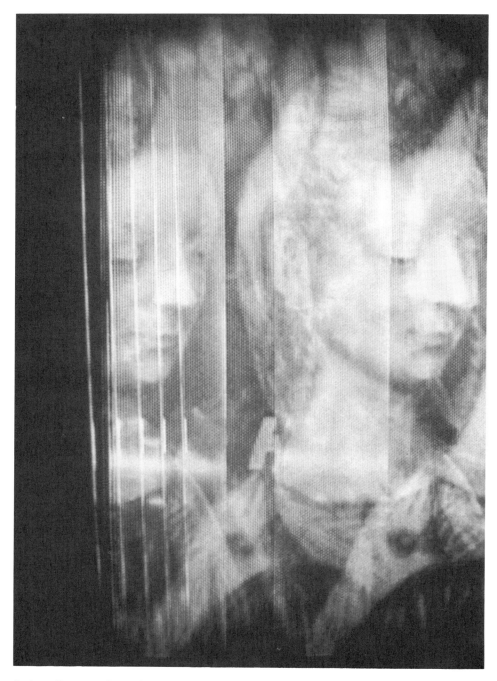

Barbara Steinman, Icon, 1990. Video Installation. Collection: The Art Gallery of Ontario, Toronto. Photo courtesy of Barbara Steinman.

The Subjects of Art History

Historical Objects in Contemporary Perspectives

Edited by

Mark A. Cheetham **Michael Ann Holly** **Keith Moxey**

CAMBRIDGE
UNIVERSITY PRESS

PUBLISHED BY THE PRESS SYNDICATE OF THE UNIVERSITY OF CAMBRIDGE
The Pitt Building, Trumpington Street, Cambridge, United Kingdom

CAMBRIDGE UNIVERSITY PRESS
The Edinburgh Building, Cambridge CB2 2RU, UK http://www.cup.cam.ac.uk
40 West 20th Street, New York, NY 10011–4211, USA http://www.cup.org
10 Stamford Road, Oakleigh, Melbourne 3166, Australia

First published 1998

Printed in the United States of America

Typefaces Gill Sans and Sabon 10.5/13 pt. *System* QuarkXPress™ [GR]

*A catalog record for this book is available from
the British Library.*

Library of Congress Cataloging-in-Publication Data

The subject of art history / edited by Mark A. Cheetham, Michael Ann
Holly, Keith Moxey.
p. cm.
Includes index.
ISBN 0–521–45490–5 (hardbound)
1. Art – Historiography. I. Cheetham, Mark A. (Mark Arthur),
1954– . II. Holly, Michael Ann, 1944– . III. Moxey, Keith P. F., 1943– .
N7480.S83 1998
701′.18 – dc21 97–38628
 CIP

ISBN 0 521 45490 5 hardback
 0 521 45572 3 paperback

Contents

Contents

Illustrations

Contributors

Mieke Bal is Professor of the Theory of Literature at the University of Amsterdam, and Founding Director of the Amsterdam School of Cultural Analysis (ASCA). She is also Andrew D. White Professor at Cornell University. Her interest in an interdisciplinary study of visual art is reflected in her books *Reading "Rembrandt": Beyond the Word–Image Opposition* (1991) and *Double Exposures: The Subject of Cultural Analysis* (1996).

Stephen Bann is Professor and Director of the Centre for Modern Cultural Studies at the University of Kent. His work on the history and culture of the museum has been published most recently in *Under the Sign: John Bargrave as Collector, Traveler and Witness* (1994) and in *Romanticism and the Rise of History* (1995). He has been working on the career of the historical genre painter Paul Delaroche, marking his bicentury with the publication of a book (*Paul Delaroche: History Painted* [1997]) and the organization of an international conference in 1997.

Bruce Barber is an internationally known artist, writer, and curator and is Professor at the Nova Scotia College of Art & Design, Halifax. His interdisciplinary studio work was included in the Paris Biennale (1977), the Sydney Biennial (1979), and such exhibits as The Art of Memory: The Loss of History (New Museum, New York, 1985) and A Different War: Vietnam in Art (1989–92). He is the author of *Popular Modernisms: Art, Cartoons, Comics and Cultural In/Subordination* (forthcoming) and coeditor of *Voices of Fire: Art, Rage, Power, and the State* (Toronto, 1996).

Mark A. Cheetham is Professor in the Department of Visual Arts at the University of Western Ontario, where he teaches art theory and art history. He is the author of three books, *Alex Colville: The Observer Observed* (ECW Press, 1994), *The Rhetoric of Purity: Essentialist Theory and the Advent of Abstract Painting* (Cambridge University Press, 1991), and *Remembering Postmodernism: Trends in Recent Canadian Art* (Oxford University Press, 1991). He is also coeditor of *Theory between the Disciplines: Authority/Vision/Politics* (University of Michigan Press, 1990), as well as author of articles in the fields of Canadian

and European art and art theory of the eighteenth, nineteenth, and twentieth centuries. His current work includes a book on the influence of Immanuel Kant in art history and the visual arts – supported by a 1994 Guggenheim Fellowship – and the touring exhibition and catalog *Disturbing Abstraction: Christian Eckart.*

Whitney Davis is John Evans Professor of Art History and Director of the Alice Berline Kaplan Center for the Humanities at Northwestern University. He is the author of *The Canonical Tradition in Ancient Egyptian Art* (1989), *Masking the Blow: The Scene of Representation in Late Prehistoric Egyptian Art* (1992), *Drawing the Dream of the Wolves: Homosexuality, Interpretation, and Freud's "Wolf Man"* (1995), *Replications: Archaeology, Art History, Psychoanalysis* (1996), and *Pacing the World: Construction in the Sculpture of David Rabinowitch* (1996) and editor of *Gay and Lesbian Studies in Art History* (1994). He has been a J. Paul Getty Fellow in the History of Art and the Humanities, a fellow of the John Simon Guggenheim Memorial Foundation, and a resident fellow at the Stanford Humanities Center. In 1993, he gave the Tomas Harris Lectures in the History of Art at University College London.

James D. Herbert is Associate Professor of Art History at the University of California, Irvine. His book *Fauve Painting: The Making of Cultural Politics*, published by Yale University Press in 1992, received the Hans Rosenhaupt Memorial Book Award from the Woodrow Wilson National Fellowship Foundation. He is currently completing a book entitled *Global Speculations: Exhibitions of Commerce, Ethnography, and Art in Paris, 1937–38.*

Michael Ann Holly is Chair of Art and Art History and Professor of Visual and Cultural Studies at the University of Rochester. She is the author of *Panofsky and the Foundations of Art History* (Ithaca, 1984) and *Past Looking: Historical Imagination and the Rhetoric of the Image* (Ithaca, 1996). She is also coeditor with Norman Bryson and Keith Moxey of *Visual Theory: Painting and Interpretation* (Cambridge, 1991) and *Visual Culture: Images and Interpretation* (Hanover, N.H., 1994). She has been a 1992 Guggenheim Fellow and the Ailsa Mellon Bruce Senior Fellow at the Center for Advanced Study in the Visual Arts at the National Gallery during 1996–8.

Wolfgang Kemp is Professor of Art History at the University of Hamburg. His recent publications include *Christliche Kunst: Ihre Anfänge, ihre Struktur* (1994); *Die Räume der Maler: Zur Bilderzählung seit Giotto* (1996).

Steven Z. Levine, Leslie Clark Professor in the Humanities, has been teaching in the Department of History of Art at Bryn Mawr College since 1975. His book *Monet, Narcissus, and Self-Reflection: The Modernist Myth of the Self* was published by the University of Chicago Press in 1994; in the same year a

précis of the text with color plates was published by Rizzoli; and a psychoanalytical postscript was published in 1996 in *American Imago* ("Virtual Narcissus: On the Mirror Stage with Monet, Lacan, and Me").

Patricia Mathews is Associate Professor of Art History at Oberlin College. She writes on gender issues in late nineteenth-century Symbolist art (*Passionate Discontent: Creativity and Gender in the French Symbolist Period*, University of Chicago, 1998) and on women artists ("The Nudes of Suzanne Valadon," ms.; "The Art of May Stevens," in progress). Her publications on feminist methodologies include "The Feminist Critique of Art History," written with Thalia Gouma-Peterson, *Art Bulletin*, 1987, and *Feminism and the Discipline of Art History*, 1998, for the series "The Impact of Feminism on the Arts and Sciences." She has also published in *Oxford Art Journal, Art Journal*, and *Art in America*, among others.

Gerald McMaster, a Plains Cree, was born in 1953 in Saskatchewan and grew up near North Battleford on the Red Pheasant Reserve. He studied fine art at the Institute of American Indian Art, Santa Fe, N. Mex., from 1973 to 1975. He completed a Bachelor of Fine Arts degree at the Minneapolis College of Art and Design in Minnesota and a Master of Arts (Anthropology) degree at Carleton University, Ottawa, Ont. He was Head of the Indian Art program at the Saskatchewan Indian Federated College at the University of Regina from 1977 to 1981 and has been the Curator of Contemporary Indian Art for the Canadian Museum of Civilization, Hull, Que., since 1981. Exhibitions he curated include: *Challenges*, de Meervaart Cultural Center (Amsterdam, 1985); In the Shadow of the Sun (Canadian Museum of Civilization, Hull, 1988); Public Private Gatherings (Canadian Museum of Civilization, Hull, 1991); *Indigena* (Canadian Museum of Civilization, Hull, 1992). In 1985 he was selected as Chief Curator for the Canadian Pavilion exhibit *Edward Poitras Canada XLVI Biennale di Venezia*. McMaster is an active visual artist whose one-person exhibitions include: The Sun Series (Ottawa, 1981), Riel Remembered (Thunder Bay Art Gallery, 1985), TP Series (Saskatchewan Arts Board Touring Exhibition, 1988–9), Ancients Singing (1988) and Eclectic Baseball (1990) (Ufundi Gallery, Ottawa), The Cowboy/Indian Show (McMichael Gallery, Kleinburg, 1991), and Savage Graces (UBC Museum of Anthropology, Vancouver, 1992). He has published numerous essays and catalogs; in addition, there are many publications of his work as an artist.

Stephen Melville is Associate Professor of the History of Art at Ohio State University. He is the author of *Philosophy beside Itself: On Deconstruction and Modernism* (University of Minnesota Press, 1986) and *Seams: Art as a Philosophic Context* (Gordon & Breach, 1996) and editor with Bill Readings of *Vision and Textuality* (Macmillan, 1995).

Keith Moxey is Ann Whitney Olin Professor of Art History at Barnard College/Columbia University. He is the author of *Peasants, Warriors, and*

Wives: Popular Imagery in the Reformation (Chicago: University of Chicago Press, 1989) and *The Practice of Theory: Postructuralism, Cultural Politics and Art History* (Ithaca: Cornell University Press, 1994). He is also coeditor with Michael Ann Holly and Norman Bryson of *Visual Theory: Painting and Interpretation* (Cambridge: Polity Press, 1991) and *Visual Culture: Images and Interpretation* (Hanover, N.H.: University Press of New England, 1994).

David Phillips teaches in the School of Humanities at the University of Western Sydney, Hawkesbury. He has published articles on the history and theory of photography and on contemporary art and gay studies. He is currently working on two books, one on social documentary photography and the other on photography and urban modernity.

William Vaughan is Professor of the History of Art at Birkbeck College, University of London. His publications include *Romanticism and Art* (1978/1995) and *German Romantic Painting* (1980). He is currently working on a study entitled "The Image of the Artist." William Vaughan is also Editor in Chief of the journal *Computers and the History of Art*. He has developed a number of computer projects and is at present involved in providing a visual matching system for the European Commission libraries project VAN EYCK.

Anthony Vidler is Professor of Architectural Theory at UCLA. His most recent book, *The Architectural Uncanny: Essays in the Modern Unhomely*, was published by MIT Press. He is presently working on a book entitled *The Anxiety of Space*.

Introduction

Mark A. Cheetham, Michael Ann Holly, and Keith Moxey

S URPRISING as it may seem in the midst of the creative chaos constituting art-historical studies at the end of the twentieth century, it was not even a decade and a half ago that Norman Bryson chastised the field for operating at an "increasingly remote margin of the humanities," at the site which he would memorably dub "the leisure sector of intellectual life" (*Vision and Painting: The Logic of the Gaze*, 1983). So much has happened to the discipline: so many controversies, conflicts, even crises. Far from remaining in a state of scholarly torpor, the history of art today promises its students neither a unified field of study nor a time-tested methodology for analyzing visual images. And that lack is precisely where its intellectual excitement comes from. The essays collected here offer a celebration of the diversity of mind, method, and material that has come to define the supple and shifting parameters of the history of art at the end of this millennium.

Evidence for this change of heart is to be found in many of the discipline's institutions. In the United States, for example, each issue of the *Art Bulletin* now publishes a variety of different perspectives on theoretical topics that are crucial to historical interpretation, and the College Art Association's annual conferences currently provide a forum for interpretive debates rather than ignoring them. Many universities and colleges support highly successful curricular initiatives in cultural and visual studies, and grants and book contracts are often awarded to theoretically sustained interdisciplinary projects. Museums and galleries as well have increasingly framed their exhibitions in terms other than those of universal aesthetic value, and practicing artists have become as informed as critics when it comes to situating their work inside larger cultural and political debates. It is no longer necessary to argue either that stylistic analysis and iconography should be the only forms of interpretation recognized by the profession or that there is only one canon of art-historical masterpieces on which scholars should go to work. The theoretical inspiration of art-historical practitioners is both diverse and eclectic. A whole range of heuristic procedures has now been recognized as valid in the making of art-historical meaning.

It might be said that art history, like many other fields in the humanities, has entered a postepistemological age. In many quarters it is now acknowledged that history is not about the truth, that there is no way in which contemporary understanding can come to grips with the events of the past with any degree of finality or closure. The importance of the historian's subjectivity is recognized as an essential ingredient in any historical or critical narrative. Far from resulting in the facile pluralism that these changes, according to their critics, are supposed to have brought about, they have encouraged more self-reflexive forms of historical interpretation in which the choice of theoretical perspectives and methodological strategies is foregounded and thematized in such a way as to articulate the author's commitment to his or her chosen narrative. The essays brought together in this volume cannot hope to suggest the complete panorama of theoretical traditions that now inform art-historical writing. Instead, they address and exemplify a few of the leading forms of interpretation, as well as issues that have assumed new importance in the new circumstances.

The array of subjects, objects, and interpretive positions offered here, however, does not come without a cost. Once the idea of universal aesthetic value and the validity of historical research are opened to question, the confident center of the field dissipates, and art-history students, no matter how advanced, might legitimately feel bewildered about how to proceed. That is why the editors conceive of this anthology as a kind of theoretical primer. Each essayist has been asked to contribute an example of his or her particular interpretive point of view by making it "go to work" on a particular historical object. By paying attention to this multiplicity of perspectives (which are often in indirect conflict with one another), a student may be emboldened to find his or her own theoretical voice. Obviously, no serious scholar of art history can hope to master all of the interpretive viewpoints now on offer, but a passing familiarity with some of the most visible can only help to encourage the engendering of others as yet unheard.

This collection is intended primarily for an audience of graduate students, and certainly for advanced undergraduates as well: that audience, in other words, that is currently confronted by a bewildering array of methodological alternatives. By putting theory into practice and providing a working bibliography, all of the essays anthologized here attempt to convert the unconverted. But this new intellectual fervor is hardly the result of a revolution "from above" or "from without"; for the most part it has been a revolution "from below." Graduate students, intrigued by interpretive complexity and diversity, have clamored for courses and texts that address the plethora of interpretive issues up front instead of burying them under the auspices of disinterested scholarship. Because they have so often prized the value of intellectual excitement over the scholarly lassitude of teaching and doing business as usual, this collection is dedicated to them.

A word on the cover illustration. *Icon* (1990), an installation by Montreal artist Barbara Steinman, announces some of the themes and concerns of the anthology before a reader turns to the introduction, or even the table of contents, for it visually questions the status of art history as a science, the discipline that traditionally probed the secrets of mute works of art. On the front

cover, we see her photograph of a restorer's camera taking a close-up of a sixteenth-century Madonna from the school of della Robbia. Out of sight initially (both in the installation and on our cover) is another photo (our frontispiece) that appears to be the result of the conservation lab's analysis. What looks at first like a pentimento revealed by X-ray or infrared photography – and in which the Madonna appears twice – is actually Steinman's electronic manipulation of the first picture. Screened from our view by these two large photos in her installation is *Icon*'s third element (our back cover), comprising two video monitors that show test tubes, one empty, the other being filled with a bloodlike liquid. A voice says, "Take a deep breath."

These aspects of *Icon* might make us contemplate several themes crucial to the study of art history today. What are we to make of the field's dream of scientific objectivity captured here, a dream that places an observer – or a technological surrogate – over against a passive object that awaits scrutiny? This dream also operates under the assumption that works of art have meanings that are hidden and in need of revelation. Steinman's installation confounds other art-historical assumptions as well: Painting is often valued over photography, but of course her work is photography, presented now as an art form that is no longer confined to the role of technological helpmate or documentary supplement to art history. Old-master art is often held in higher esteem than that produced by contemporary artists, yet Steinman accesses the old through her work in the present and leaves conspicuous traces of her temporal and ideological positioning. And while many art historians might continue to insist on the autonomy of their subject and its objects, Steinman shrewdly and instructively imbricates the theme of scientific experimentation on art with the wider and more culturally significant phenomenon of medical testing on human subjects. Were it not for the audio "Take a deep breath," we might tend to think that the analysis in the "back room" of the installation still involved the relief painting. Perhaps we are witnessing a pigment analysis. But the voice makes the testing very personal: We take a deep breath as our blood is drawn; we move from the art world to the "real" world and from the objectivity of disinterested scientific analysis to a personal experience. The point is that the distinctions among these areas are fragile (though revealing) in the extreme.

Looking at this work, then, we can think about how art history cannot remain isolated or innocent in its operations. It forms and performs cultural norms and assumptions. It acts upon and responds to its neighbors in cultural space, whether medical science, as in this case, or other disciplinary structures. The field has contours, borderlines that inscribe sanctioned practices for subjects and about objects but that are also there to be crossed, redefined, reshaped. As a discipline, art history's shape will necessarily change because of pressure from both inside and outside, above and below. Because the subjects and objects of the discipline are in constant flux, the contributors to this collection cannot completely describe the present shape of the field, its historiography, or its future. Least of all do we wish to prescribe its affinities or activities. We believe that it is also the case that the discipline has entered a moment of self-consciousness

that is substantially different from the heady reinvigoration of the theoretical matrices it has witnessed since about 1980. "Theory" in art history, as in art, now needs no apology. Approaches are adopted and affinities exercised with increasing ease: None is clearly ascendant, which is why the notion of a "representative" set of approaches or methodologies seems destined to be outdated. If collectively we can demonstrate that the field does have shape(s) that are formed historically and that constitute everyday practice as well as influence future patterns of inquiry, we will have accomplished our principal pedagogical objective.

Part One

Philosophy of History and Historiography

Immanuel Kant and the Bo(a)rders of Art History

Mark A. Cheetham

O NE of the working titles for this volume – "The Contours of Art History" – incorporated the notion that a discipline or institution can be conceived spatially, that it has a *shape* defined by insides and outsides, borders and limits. If we believe that the field art historians create, inhabit with their various activities, and call their own does indeed have a shape that separates it – however provisionally and without any claim to internal unity or homogeneity, and necessarily depending upon the anamorphic angle from which it is conceived (Preziosi 1989) – from other disciplines and concerns, how are we to characterize these disciplinary limits, and in what ways might such descriptions be important historically, theoretically, and in the practice of art history today? Michel Foucault has argued that disciplines have developed historically as expressions and conduits of power/knowledge; it follows that the particular "shape" of a discipline at a given time will both reflect and fashion its policies of inclusion and exclusion regarding its legitimized objects of study, its methodologies, and its practitioners. As Timothy Lenoir argues, "disciplines are *political institutions* that demarcate areas of academic territory, allocate privileges and responsibilities of expertise, and structure claims on resources" (1993: 82). My first aim is to have us think about art history as a spatial entity in order to refine and answer questions about the field. Perceiving its shape (or shapes), how it came to be contoured this way, and how it changes can help us to understand where we are in a disciplinary sense and how this placement might affect our beliefs, claims, and behavior.

Rather than discuss a particular methodology, I will offer an apology – a defense in the Platonic sense – for the historiography of the discipline itself by focusing on Immanuel Kant's remarkable yet underestimated role in shaping art history and indeed art practice. I will concentrate on his reception as opposed to that of other more obviously influential thinkers such as Hegel.[1] Kant and Hegel have arguably had the greatest influence of any philosophers on the discipline of art history and on artists, and their effects are perhaps equal in scope and significance. As Stephan Nachtsheim claims, "The development of the relationship between art history and the philosophy of art stands from the beginning

as evidence of the two authoritative, classic authors of German aesthetics, as Kant's and Hegel's mark" (1984: 10).[2] I do not want to assign one a greater importance than the other, but we nonetheless need to ask why so much more has been written about Hegel's roles in these areas than about Kant's.[3] Kant's influence, though pervasive, is less overt than Hegel's, and it frequently stems from his writings in areas other than art and aesthetics. Kant is, in addition, a quintessentially spatial, architectonic thinker[4] whose specific doctrines and terminology, as well as larger patterns of thought and assumptions about philosophy, have thoroughly infected art history and the practicing visual arts in part because of the persuasive, even seductive, form in which they are presented, a form that I believe is crucial in shaping disciplinary behavior. The use of "Kant" in art history can be thought of as paradigmatic of – if certainly not unique in – the relationship between this relatively new, nineteenth-century, field and philosophy, with its ancient traditions. If this claim can answer the question "Why study Kant in relation to art history?," it does so in ways that are not completely in concert with the recent resurgence of interest in his aesthetics. To generalize, negative readings see him as a paradigmatic Enlightenment figure, whose obsession with reason leads to abuses, to a Eurocentric absolutism in aesthetic judgment, for example, and to misogyny (Battersby, Eagleton, Mattick). More affirmative interest in Kant today often focuses on his theory of the sublime, to which I will return below. While my own contribution in no way denies the troubling implications of Kant's ideas, it does seek to recover some of the ways in which he has been influential historically in the visual arts and art history – an influence that can be seen as largely positive. His presence has been constant and can remain useful if we understand its history more fully.

Kant and the History of Art

What we witness in the employment of the name Kant in art history and cognate fields is a practice that might best – if awkwardly – be deemed "Kantism."[5] The name becomes a synecdoche for his doctrines (or those attributed to him), which in turn, through their reception in the visual arts and its surrounding discourses, come to stand for philosophy, the discipline of which he is a part and whose supremacy he asserts.[6] "Kantism" exercises Kant's thinking in at least a minimal way. For Christopher Norris, Kant's philosophy "raises certain questions – of agency, autonomy, ethical conduct, reflective self-knowledge – which were also some of Kant's most important concerns throughout the three *Critique*s" (1993: 71). Frequently, as we will see, "Kantism" invokes "the broadly Kantian notion that consciousness constitutes its world" (Summers 1989: 373). Another formulation of Kant's basic contribution comes from Thomas McEvilley: "The foundation of the Kantian doctrine is the notion of a [disinterested] sense of taste through which we respond to art . . . this quality is

noncognitive, nonconceptual; it is a *sensus communis*, innate and identical in everyone; it is a higher faculty, above worldly concerns; it is governed by its own inner necessity" (1988: 125).

Kant remains an outsider, despite important work on several areas in which he has been instrumental to art history and to artists. Some examples of his reception are so obvious that they tend to slip from our consciousness. As Albert Boime has noted, many of the earliest responses to Kant were to the first *Critique*, to its apparent claims that we do not have access to the noumenal and that our knowledge of the world rests on our own faculties (1990: 329). Kant's first *Critique* is also the source for the famous analytic/synthetic distinction used early in discussions of Cubism to distinguish both working methods and chronological developments (Green). In both cases, Kant's terminology entered non-philosophical discourse, with artists, critics, and historians referring to the "thing-in-itself" or to "analytic" procedures in Cubist composition. The use of his terminology is neither innocent nor superficial. Thus for Daniel-Henry Kahnweiler, the art dealer and critic, Cubism's

> new language has given painting an unprecedented freedom . . . colored planes, through their direction and relative position, can bring together the formal scheme without uniting in closed forms . . . Instead of an analytical description, the painter can . . . also create in this way a synthesis of the object, or in the words of Kant, "put together the various conceptions and comprehend their variety in our perception." (1949: 12)

Kahnweiler read Kant and neo-Kantian texts by Wilhelm Wundt, Heinrich Rickert, and others in Bern during World War I (Bois 1990, Gehlen 1966). For him, the analytic/synthetic distinction, the notions of the thing-in-itself and disinterestedness, and the formal autonomy of the work of art provided nothing less than a way of conceptualizing Cubism.

Perhaps the two best-known uses of Kant's name were by Clement Greenberg in his apologies for the European avant-garde and for post–World War II abstract painting (Crowther 1985, Curtin 1982, Stadler 1982, Summers 1994) and by the central founders of academic art history – Wölfflin and Panofsky especially – who used Kant to demarcate and ground the new discipline. These relations within art history have been expertly examined by Hart, Holly (1984), Podro (1982), Preziosi, and others, but it is worth emphasizing here that the *need* for grounding is itself a philosophical imperative and that the view that philosophy is the only secure place *for* grounding is a Kantian legacy, one that has done much to shape and place the discipline. This grounding can be metaphysical and epistemological, as in Panofsky's famous and distinctly Kantian search for a stable Archimedean point *outside* the flux of empirical reality from which to judge individual works of art. Kant has also been used more recently to buttress what we might call an ethics of art-historical behavior: In the final paragraph of his essay on Hegel, Ernst Gombrich surprisingly invokes Kant's "stern and frightening doctrine that nobody and nothing can relieve us of

the burden of moral responsibility for our judgement" as an antidote to the "theophany" that Hegel purportedly saw in history (1984: 69).[7] L. D. Ettlinger similarly looked to Kant as the defender of individual, humanist priorities in art history. In a lecture delivered in 1961 titled "Art History Today," he mentions Kant only in his final remarks, relying on him as the ultimate defender of a renewed humanism, the focus on "those central problems which concern man and his works" (1961: 21).[8]

Largely forgotten today are examples of specific Kantian ideas that have been employed, with varying consequences, by artists. This partial amnesia is, I think, highly selective along the contours established between disciplines and says much about the typically hierarchical relationship between art history and artists as well as about the relationship of philosophy to both these areas. Yet recently artists as different but important as Joseph Kosuth and Barnett Newman in the United States and Anselm Kiefer in Germany have used Kant in various ways. While I certainly do not want to argue for a "pure" Kant or a pure reception of his work in any of these cases – philosophical ideas tend to blend when put into practice, as in Greenberg's teleological and no doubt Hegelian invocation of what he saw as a Kantian insistence on auto-criticism and "formalism" (McEvilley 1991: 160) – I maintain that attention to specific artists' uses of Kant demonstrates both the complexity and potency of his reception and its role in shaping disciplines. I will return to Kiefer, but let me first detail a fascinating use of Kant among artists and critics of his own time. My hope is to add concreteness to the excellent studies of Kant mentioned above and to adumbrate a new conceptual mapping of his importance to disciplinarity.

In 1796, the later eminent Danish sculptor Bertel Thorvaldsen (1770–1844) was commissioned to bring with him on his way from Northern Europe to Rome Kant's recently published essay "Perpetual Peace" (*Zum ewigen Frieden* [1795]). His interest in Kant was made concrete by this text and gave him an entry into a vibrant German-speaking art community that based its sense of personal, artistic, and political autonomy largely on Kant's *political* views (Schoch 1992), precisely and not coincidentally at the time when Napoleon declared Rome a republic and artistic freedom seemed to be guaranteed, however briefly, by political change. The leader of this artist colony in Rome ca. 1800, Asmus Jakob Carstens (1754–98), was sufficiently earnest about Kantian ideas to produce a drawing titled *Raum und Zeit* (1794). His rather literal yet allegorical rendition of the fundamental categories of space and time from the first *Critique* was the topic of correspondence between Goethe and Schiller in which the two dramatists criticized the artist's flat-footed response to Kant. But Carstens employed the philosopher's political thinking to greater effect. As Busch confirms, he adopted Kant's distinction between public and private duty to justify his bold refusal to return from Rome to his position at the Prussian Academy in Berlin. "I belong to humanity, not to the Academy of Berlin," he wrote in 1796, and "I am ready . . . to assert it in public, to justify myself to the world, as I feel justified in my own conscience" (Carstens 1970: 109). "By the public use of one's reason I mean that use which anyone may make of it *as a man of learning* addressing the entire

reading public," Kant stated in "What Is Enlightenment?" (Beantwortung der Frage: was ist Aufklärung?). Like Kant, Carstens asserts the "public" primacy of his conscience over the strictures of what Kant labeled any "private" "*civil post or office*" (Kant 1991: 55).

Another member of the circle Thorvaldsen sought to join, the Tyrolean landscape painter Joseph Anton Koch (1768–1839), evolved a particularist style of depicting nature's phenomena which, in its emphases on amassing detail and on inclusive visibility, is very close to Kant's innovative notion of the "mathematical" sublime in the third *Critique* (Cheetham 1987). But the most profound and sustained interaction between Kant's philosophy and the Carstens circle was realized by the critic and historian Carl Ludwig Fernow, for whom Thorvaldsen's copy of Kant's new book was destined. Fernow knew Schiller (the main disseminator of Kantian ideas at this time) and had studied in Jena with the Kantian Karl Leonhard Reinhold from 1791 to 1793 before arriving in Rome in 1794. Fernow demonstrated that Kant's philosophy was important to more than specialists and that in its reception, his thinking bore directly on the contemporary visual arts: In the winter of 1795–6, in Rome, he gave a series of lectures on Kant's aesthetics to an audience of thirty-six artists, intellectuals, and art lovers, two of whom were Koch and Carstens. Fernow claimed that Kant "made palpable the full dignity and significance of art" (Schoch 1992: 21), and that his philosophy was helpful to the judgments of an active critic and historian (Einem 1935: 82). Though more concrete than Kant, Fernow largely agreed with the philosopher on the need to ground our knowledge of beauty and reality itself in the subject. His letters also reveal his interest in other aspects of Kant's ideas. He notes favorably the formation of the contemporary Roman Republic while praising Kant's "Perpetual Peace" (1944: 231); indeed, Fernow and his compatriots styled their "Künstlerrepublik" on Kant's ideals and thus skillfully and effectively combined the political and aesthetic sides of his doctrine of autonomy, both his belief in personal freedom (under rules) and the necessary independence of artistic judgment from morality on the one hand and nature on the other. Through Fernow, Kant's ideas on politics, ethics, and aesthetics went a long way in structuring the self-image and artistic goals of these important artists.

Students of the humanities know Kant as an important figure in the European Enlightenment and as central to this day in philosophical aesthetics, a field he consolidated with the publication of the *Critique of Judgment* in 1790. In his own time as today, his thoughts on aesthetics were held to be difficult, technical, and best adapted to a strictly philosophical setting. Yet as we have seen, Kant's contemporaries and those in later times were not deterred from absorbing his theories directly or in some mediated form. In 1796, for example, Friedrich Grillo published "Ueber Kunst nach Herrn Kant," written specifically "für denkende Künstler, die die Critik der Urteilskraft nicht lesen" (p. 721)![9] Many recent commentators, on the other hand, minimize the importance of Kant's work with art in the third *Critique*. Cohen and Guyer, two of his most distinguished interpreters, refer to "mere digressions on some specific

issues raised by judgments about works of art" (1982: 4).[10] It is in some respects true that Kant's writings have little to do explicitly with the historical or current arts, as he makes clear in the preface to the third *Critique*, where he apologizes – not without irony – for his book's "deficiency" in empirical matters (1987: 7). Kant was seeking the transcendental conditions of the faculty of judgment, so, as D. N. Rodowick puts it, "the object of [his] *Critique* is not art per se" (1994: 100). For Kant, the transcendentally grounded possibility of judgment is secure *because* it precedes all manifestations of art, both metaphysically and temporally. But is it also true, as Rodowick asserts, and as we are frequently told, that "art or the making of art has no place in Kant's philosophy" (p. 100)? Given the interest in Kant on the part of the artists and critics discussed here, it is more accurate and productive to see this issue of disciplinary place as crucial to Kant himself and in his reception, both early and recent. He habitually strove in the *Critique of Judgment* to legislate the "domain" of philosophy within the power of judgment precisely by excluding art and its history (and of course much else). Art isn't properly "in" the corpus or purview of philosophy. Yet art visits the third *Critique* in the form of examples that are the occasions for Kant's reflections on aesthetic judgments of the beautiful and the sublime. Art defines an edge, a limit for philosophy in one direction (the empirical), expressly by being outside, different, separate. As the examples from the Carstens circle have shown, Kant's political, ethical, and metaphysical writings were at least as influential for artists and the development of art history as were his ideas on aesthetics. Kant established borders by being expert in so many different areas. His penchant for disciplinary and methodological delineation was itself what most influenced one of his most famous contemporaries. Goethe found Kant's ability to *shape* and bring together seemingly disparate materials in the third *Critique* its most powerful aspect. "Here I saw my most diverse thoughts brought together," the poet wrote, "artistic and natural production handled in the same way; the powers of aesthetic and teleological judgment mutually illuminating each other" (cited in Cassirer 1981: 273).

Kant's Place

Cassirer was himself an important neo-Kantian whose writings were effectual in the discipline of art history through his influence on Erwin Panofsky. Cassirer wrote that Kant "regarded philosophical reason itself as nothing else than an original and radical faculty for the determination of limits" (1951: 276), stating abstractly Goethe's insight about Kant's genius for structure. Even before his critical turn in the 1770s, Kant called metaphysics "a science of the limits of human reason" (Goetschel 1994: 77); the first *Critique* is fundamentally about limiting our knowledge and metaphysical speculations to realms in which we can be secure. Thus Kant also wanted to keep each discipline pure, to assign it a proper jurisdiction and keep it within these bounds. Referring to the relations between theology and philosophy, for example, he claimed that "as soon as we

allow two different callings to combine and run together, we can form no clear notion of the characteristic that distinguishes each by itself" (1979: 37).

Discussions of disciplinarity in general are increasingly present in art history, as they are across the humanities.[11] Though the determinants of the profile of any field arise from many sources, in art history a recurrent interest has been its relation to other disciplinary structures. Perhaps because of its relative newness as a discipline, it could not avoid shaping itself in response to extant disciplinary structures. Recently, art history has been portrayed as remiss in its belated acceptance of new methodologies pioneered in adjacent domains. Significant change in art history, this argument asserts in typically spatial terms that I have thematized here, is usually initiated from "outside" the discipline. As Norman Bryson – who, along with another self-styled "outsider" from literary studies, Mieke Bal,[12] has changed art history profoundly – wrote in 1988: "There can be little doubt: the discipline of Art History, having for so long lagged behind, having been among the humanities perhaps the slowest to develop and the last to hear of changes as these took place among even its closest neighbours, is now unmistakably beginning to alter." He goes on to describe the innovations brought to the field by a number of art historians, each of whom, "to varying degrees, . . . brings art history into relation with another field of inquiry" (1988: xiii). Serge Guilbaut is more blunt:

> At a time when literary criticism went through an exciting autoanalysis, producing serious theoretical discussion about its goals and tools of analysis (from New Criticism and Barthes in the 1950s to the new texts by Edward Said, Terry Eagleton and Frank Lentricchia) liberating, shaking a field of study always on the verge of academicism, Art History was superbly purring along in the moistness of salons and museums. [It] did not produce a similar array of critical texts, of serious debates about the purpose of the profession, or of its tools of analysis. (1985: 44)

Art history has its own theoretical traditions, and there are what might be called disciplinary reasons for its sometimes reluctant associations with other areas of inquiry (Holly 1984). Increasingly, too, discussions of the discipline revolve around what is done in its name, rather than around what might be imported into an impoverished area (Bal 1996a, Bois 1996). Nonetheless, since the early 1980s, art history's connections with literary studies have often been claimed to be its most vital. Literary methodologies from semiotics to psychoanalysis are seen to have reinvigorated art history. But disciplinary interactions change, and they are launched from particular ideological angles. There are many contenders for the role of model discipline, the mantle of preexisting mentor for nascent art history: Anthony Vidler claims that "Art History is and always has been a discourse based on that of history" (1994: 408), and Joan Hart has noted that "philology was the most valued and privileged discipline in Germany" when art history was forming as an academic field (1993: 559). If we look at the

early mapping of art history's place among its disciplinary neighbors found in Hans Tietze's *Die Methode der Kunstgeschichte: Ein Versuch* (1913), we find confirmation of art history's propinquity to both history and philology but also an emphasis on associations with "Naturwissenschaft," "Aesthetik," and "Kunst." As Goethe recognized, Kant's philosophy deftly mediated all three areas.

Kant's use of art and his ideas' various effects on art and art history can lead us to reconceive the spatiality of disciplinary relationships among art, art history, and philosophy. Instead of imagining a geometrical grid of lines, boundaries, and borders, or the stable architecture of a well-constructed edifice, we can better envision a multidimensional and radically pliable space that could conceptualize the "places" of art history, those locales where it is defined and practiced.[13] Kant clearly did imagine the relations among fields in the former very structured way, but this led him to posit clear and rigid distinctions between fields. More important, his vision could not do justice to the complex dynamism of spatial relationships at work in the definition of disciplines and their interests, whether in his own work or in his reception. Thinking instead of the specificity of place – as opposed to the abstractness of space/time – incorporates limits and boundaries, but is also as a model more dynamic and precise. What Edward S. Casey calls "emplacement" can apply to a disciplinary locale in the terms specified by Plato's contemporary Archytas, whom he quotes: "Place, by virtue of its unencompassability by anything other than itself, is at once the limit and the condition of all that exists" (Casey 1993: 15). Because Kant had to write "about" art – in the thematic and spatial senses explored by Derrida in *The Truth in Painting* – to establish the irrefragable borders of his own discipline, philosophy, in (superior) relation to its neighbors, he was in fact a *boarder* in, not just a neighbor to, discourses about art. He behaved as a temporary lodger who himself moved and who was subsequently injected by others, rather like an antidote (or infection), into and around the developing contours of these areas, and who shaped these areas because of his personal fame and the recognized leadership of the field he personified, philosophy.[14] What we might ironically call his "patronage" of the visual arts and art history can be understood as an example of the spatial procedures of the *parergon* – the mutual definition and reciprocal dependency of the work (*ergon*) and what lies outside it (*parergon*) – again delineated in *The Truth in Painting* and exemplified in recent research on disciplinarity. Using Derrida's term, we could say that for Kant art and art history are merely "ornamental" to philosophy.[15] The same is true of the inverse relation: Philosophy is ornamental for art and art history too, or, in a closely allied Derridean term, it is a "supplement." But just as a vitamin "supplement" is advertised as and perhaps can be essential despite the literal connotations of the term, so too philosophy as conceived by Kant proves to be central – both theoretically and historically – to the definition of both art history and art. The third *Critique* cannot function without art. What is more, philosophy has been and continues to be an essential bo(a)rder in and for art history in ways that mirror and in convoluted ways stem from the relations between art and philosophy in Kant's work. Michael Ann Holly's arguments

about how thinkers replicate the patterns of thought of their forebears is telling here (Holly 1996).

In general, "statements require the positioning of adjacent fields for their meaning" (Lenoir 1993: 74). Critic Thomas McEvilley – who makes reference to Kant frequently and to great effect – thinks (or hopes?) that we have witnessed "the overthrow of the Kantian theory" (1991: 171) in art history and philosophy, especially their emphasis on disinterestedness and the claims of auto-criticism. I claim that, on the contrary, "Kantian theory" as a structuring set of paradigms continues to define the disciplinary senses of inside and outside that maintain mutually constitutive distinctions between philosophy and art history. Except in the most literal sense of everyday awareness, then, neither is the "immense philosophical tradition of speculation" on art to which art history is "heir" – a tradition exemplified, even personified, by Kant – "remote from modern disciplinary practice and institutional organization" (Preziosi 1992: 374). While the "silent majority" of contemporary art historians in the West may not discuss or acknowledge the immediate relevance to their work of the philosophical tradition, or "theory" more generally (Elkins), it is also true that Kant especially is a central concern for theorists who work on the margins of philosophy, art history, and the visual arts: Crowther, Derrida, Lyotard, Nancy, Lacoue-Labarthe, and many others. Kant's theories of the sublime – the limit discourse par excellence – are the prime interest of these contemporary writers (see Librett 1993). These authors see Kant's struggle with the sublime as central to his aesthetics and indeed his entire critical project, not least because the sublime is by definition *beyond* reason, past the reach of Kant's passion for control and disciplinary order. In this sense it is a "limit" discourse, that which stands just beyond us but which thereby defines who and what we are. Significantly, the sublime and its Kantian associations is also an active concern for many practicing visual artists (Cheetham 1995, Crowther 1995), sometimes as they variously envision the incomprehensible spectre of AIDS – Ross Bleckner and General Idea – or, more traditionally, as they image the overwhelming forces of nature (Paterson Ewen).

Kant's Forehead

I have claimed that Kant's name has been used repeatedly in and around the visual arts from the 1790s until the present. It is impossible to isolate a "pure" philosophical strain, Kantian or otherwise, but his name and the names of other philosophers are cited and their ideas or patterns of thought employed. Yet "Kant" more than anyone is invoked to ground art-historical and artistic practices in the territory that he actively made the necessary reference point: philosophy. His name – and even his image, in an example I want to turn to now – continues to live in and form these places. The German artist Anselm Kiefer (b. 1945) produced three versions of the *Wege der Weltweisheit* (Ways of worldly wisdom) between 1976 and 1980. These evocative works contain miniature (and

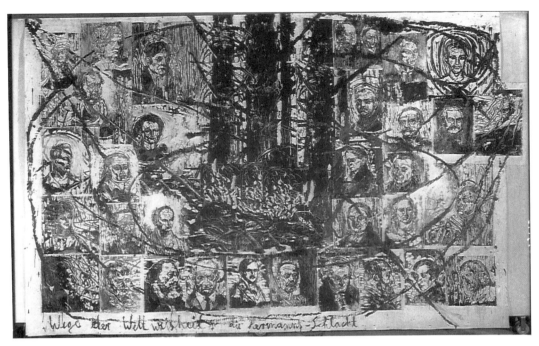

Figure 1. *Anselm Kiefer (German, b. 1945),* Paths of the Wisdom of the World: Herman's Battle, *1980. Woodcut, additions in acrylic and shellac. 11'4¹/₂" × 17'2" (344.8 × 528.3 cm). Art Institute of Chicago; restricted gift of Mr. and Mrs. Noel Rothman, Mr. and Mrs. Douglas Cohen, Mr. and Mrs. Thomas Dittmer, Mr. and Mrs. Ralph Goldenberg, Mr. and Mrs. Lewis Manilow, and Mr. and Mrs. Joseph Shapiro; Wirt D. Walker Fund, 1986. Photo courtesy of the artist and the Art Institute of Chicago. [Kant appears on the bottom row, fourth from the right.]*

sometimes labeled) portraits of important figures from German history. Kiefer's preoccupation is with the roles these figures play in the formation of a contemporary sense of German identity. Significantly, all are involved – both pictorially and thematically – in "die Hermanns-Schlacht," Arminius's Battle, a reference to a "German" victory over the Roman invader Varus in the Teutoburger Wald (Schama 1995: 128). In this work, Kiefer boldly conflates this early defining moment and myth with characters from the more recent past. Some are poets, some are Nazis, and one is Immanuel Kant, whose oddly hunched form appears in two of the three pieces from this series (Fig. 1). Kant is not the only philosopher brought by Kiefer to this meeting in the forest, the forest of and as history and the symbol, as Schama argues brilliantly, of Germanness, a fact that Kiefer reinforces with the woodcut technique used in this example. Kant is no more important to Kiefer than the other figures gathered here.[16] Given the contexts of his reception that I've examined thus far, however, what are we to make of his surprising simultaneous migration from philosophy into art and ancient history, as well as into the eternal present of reception? We have already seen how Kant's "Perpetual Peace" was carried across national and generic

borders by Thorvaldsen, how it operated as a shibboleth in a developing artistic community as well as being a political proclamation. Nationalism and national self-identity link the eighteenth-century example and the places established for Kant by Kiefer, a point reinforced by Kiefer's inclusion of another philosopher's portrait, that of Johann Gottlieb Fichte (1762–1814), one of Kant's inheritors, who clearly identified philosophy as a uniquely German trait and whose outspoken views on German nationalism were twisted to gruesome effect by the Nazis.

Kant was not portrayed often during his lifetime, but the one image for which he is said to have sat (in 1791, the year after he published his *Critique of Judgment*) is redeployed here by Kiefer. The original is by Döbler. It shows a three-quarter-length view of a rather intense Kant. His face is distinguished by large eyes, a prominent straight nose, and especially its high, receding forehead. The forehead and eyes come across strongly in Kiefer's cropped version of this famous picture. I want to speculate that Döbler's portrait conveyed in the late eighteenth century as it does today the rational intelligence and integrity of *the* German philosopher. Kant's forehead is, like his name but now literally in art, a synecdoche for philosophy as the "master" discipline that crosses borders into other contexts, as it necessarily does in a generic sense by becoming a picture. The contours of the head were the focus of the highly influential eighteenth-century preoccupation with "physiognomy," that "science" pioneered by Johann Caspar Lavater (1741–1801). Lavater's book of the same name was first published in Germany in 1775; by 1810, there were fifty-five editions, with no fewer than twenty available in England (Stafford 1991: 91; Stemmler 1993). On the frontispiece of one of these English editions is Lavater's pithy definition of his obsession: "Physiognomy is reading the handwriting of nature upon the human countenance" (Lavater 1869), reading it in the visual, in the visage. Lavater identifies the "peculiar delineation of the outline and position of the forehead . . . [as] the most important of all the things presented to physiognomical observation" (1869: 47). In specific remarks about this feature, he claims that "the longer the forehead, the more comprehension and less activity. . . . Above it must retreat, project beneath" (pp. 48, 50). In Döbler's portrait and in Kiefer's faithful if expressionistic reproduction of it – as well as in many of the other late eighteenth- and early nineteenth-century portraits of Kant – the forehead is remarkably large and decidedly retreating. Was Kant's forehead shaped this way in these images because he was a philosopher, or, to follow the implications of Lavater's system, was he a philosopher because of the intellectual acuity manifested by his forehead? Kant and Lavater were correspondents on theological matters, and Lavater cites Kant in the *Physiognomy*. It would be hard to imagine that contemporary German painters didn't know of Lavater's theories, though that is not to say that any applied them in creating portraits in the same way that we can in seeing them today. While there is no evidence that Lavater himself depicted Kant in one of his famous "shades" or silhouettes, I suggest that Döbler's image of the brainy Kant incorporates the late eighteenth-century ideal of philosophy as powerful rational intellection.

Kant's skull was remarked on by his early nineteenth-century biographers and was the object of a detailed phrenological analysis in 1880. The remarkable monograph titled *Der Schaedel Immanuel Kants* (The skull of Immanuel Kant), by C. Kupffer and F. Bessel Hagen, was made possible by the exhumation of Kant's body in that year. Among pages of measurements and statistics, we learn for example that Kant's skull outscored the median statistics for a hundred "Preussische Maenner" by several millimeters (p. 30). Phrenology was closely related to Lavater's physiognomy and was born at about the same time. More than Lavater, though, its many proponents sought to predict and thus control human behavior through phrenological study. Kant was clearly the paradigmatic philosophical type. Lest we are tempted to ignore the possible contemporary impact of this sort of "science," we should remember the current controversy over the ownership and alleged dissection of Albert Einstein's brain.

If Kant appears in Kiefer's *Wege der Weltweisheit* as the personification of philosophy, then he is working again in art and amidst the "battle" of forces represented by figures as diverse in the formation of German identity as the poet Hölderlin and Wiprecht von Groitzsh, an "eleventh-century German prince who colonized Eastern Europe and was later celebrated by the Nazis" (Rosenthal 1987: 157). Kant's stature as a thinker does indeed play a role in German nationalism. Two examples from the time of Prussia's military and political adventures ca. 1866–70 are significant in the context developed here, because they tie Kant's Germanness, even philosophy's Germanness, to Jakob Asmus Carstens. Carstens' reputation was recuperated at this time of German national pride. Thus Friedrich Eggers wrote in his 1867 book on Carstens: "The Kantian philosophy, the intelligence of the great poets, the ideas of liberal culture, that is what the German people have now accomplished more than anyone else" (p. 22).[17] In *Carstens Werke* of 1869, Herman Riegel expressed a similar pride in German artistic and philosophical accomplishments: "It was stipulated by inner necessity that with the rise of German poetry, as in music and philosophy, so too the visual arts prepared themselves for a rebirth."[18] Eggers shows that Kant's name was associated with this rebirth. No longer, it seems, was philosophy to be represented allegorically as in Ripa's *Iconologia*, which in Hertel's famous illustrated German edition of 1758–60 was subtitled *Die Welt Weisheit*, and which found wide currency in Germany. As a German, "Kant" could represent the national identification with this field much better than the person Hertel actually used in his edition of Ripa, Pythagoras. Given the Germans' penchant for Greek culture, perhaps we can even see Kant as the new Pythagoras. In Kiefer's image of *Weltweisheit*, Kant's forehead does the same referential work in the context of nationalism and identity. The *line* of the forehead betokens rationalism, a force of good in historical and current nationalistic self-definition.

Kant's preoccupation with drawing conceptual lines is found throughout his copious writings. In his 1764 *Observations on the Feeling of the Beautiful and Sublime*, he tries to keep morality and aesthetics apart in ways that will become crucial to his position in the third *Critique*. More generally, the architecture of the three *Critique*s was designed to maintain autonomy and thus proper

relations among scientific inquiry, ethics, and aesthetics respectively. But of course the *Critique of Judgment* was also Kant's self-consciously constructed bridge between what we can know of the world and how we ought to behave in it. As he makes clear in his late *Conflict of the Faculties*, independence and proper relationships guarantee fruitful interactions among equals; they assure the sorts of comparisons that Goethe found wonderful in the third *Critique*. This habit and method of delineation is maintained on the most minute level in Kant's texts. In §17 of the third *Critique*, for example, "On the Ideal of Beauty," Kant presents a difficult discussion of how the mind arrives at the notion of the "average" or "common standard" (Kant 1987: 234).[19] He begins with an example of how we judge the average size of a man by looking at a thousand examples but moves immediately to a (not immediately helpful) "analogy from optics: in the space where most of the images are united, and within the *outline* where the area is illuminated by the color applied most heavily, there the *average size* emerges . . . and that is the stature for a beautiful man" (p. 234; first emphasis mine). In trying to explain how it is that we compare sizes by perceiving their overlapping extremities, Kant typically underscores outline (*Umriss*) rather than color. More than simply a neoclassical preference for linear simplicity, Kant's insistence on the supreme value of line is epistemological. In contour he can accurately *measure* the average or standard, the perfect line between too much and too little. Applying the result of this seeming digression in a comment that is reminiscent of Winckelmann's interest in bodies' outlines, he then adds that it is in each case "this shape which underlines the standard idea of a beautiful man" (p. 234). To this statement he adds a qualification that takes us back to Lavater's interest in national and racial physiognomy (on which he cites Kant from another text): the "standard" operates "in the country where this comparison is made. That is why, given these empirical conditions, a Negro's standard idea of the beauty of the [human] figure necessarily differs from that of a white man, that of a Chinese from a European." "Rules for judging," he concludes, become possible not because of experience, but vice versa (p. 234): in effect, we discover the standard, the perfect contour that divides inside from outside, in ourselves, never in empirical experience. This is part of the reason for Kant's belief in a universally applicable faculty of judgment, a notion that has been widely accepted in art history and often applied in ways that suggest the hegemony of a Western perspective on art (Moxey 1994: 37, 67). It can be said that for Kant, judgment works with form, and "form came to be regarded as the universal common denominator of human things. . . . It was largely under such auspices that the history of art came into existence and currency as an intellectual discipline" (Summers 1989: 375). The precision allowed by measurement, by perceiving the contour here or the line of a forehead in physiognomy, is, perhaps, also related in a causal way to what Donald Preziosi has identified as art history's habit of "siting" works of art and their authors, what he specifies as the obsessive "assignment of an 'address' to the work within a nexus of synchronic and diachronic relationships" (1993b: 220).

In another "exotic" reference, Kant follows the same procedure in his discussion of the estimation of the overwhelming size of the pyramids as an example of the mathematically sublime (§56, p. 252). Again it is the line (literally in the sand), placed by the observer who is in the right place, neither too close to nor too far from the monuments, that allows the feeling of the sublime to occur. The sublime is in us; it is not a response to external art or nature. It is typical of Kant to invent a species of sublimity that relies upon – instead of dismissing, as in Burke's model – the specificity and legibility of line and position within a "field." The sublime marks the outer limit of what we can know. In a disciplinary sense too, Kant is the master of emplacement. By placing art, philosophy, and the history of art in relation to one another, he established a pattern of disciplinary contouring that remains potent today. As we see in Kiefer's image and the other migrations I have examined, however, "Kant" could not draw the outlines he envisions by staying strictly within the bounds of his own field. Neither could he control the repercussions of his work. Nonetheless, being a boarder – voluntary or otherwise – and creating borders are neither random nor exclusive activities. Kant was a notorious stay-at-home, a voracious reader of travel literature who rarely left his home town. Perhaps he was solely concerned with the structure or "form" of national boundaries as well as those between disciplines, not with their empirical realities. Recently, creation and patrolling of borders typified by Kant has come under broad suspicion in Postmodernism, as Kiefer's image shows us. "The boundaries that traditional reason draws between the integral, non-contradictory thing and its others are now seen as a process of excluding contents that were included in a more complete, if also more chaotic, whole before reason began its divisive work" (McGowan 1991: 19). As the epitome of reason's claims to autonomy through the establishment of domains, Kant is also now under suspicion in art history especially, as it tries to understand and revise its inclusions, exclusions, and relations with other fields. But Kant is not to be forgotten. While it is the structuring, emplacing quality of his thought that has allowed his name to travel so far in art history, he turns out not to be the absolute protector of disciplinary borders that he might appear to be. As Kant's multifarious writings and reception show, border zones are necessarily fluid and even vague, and there must be outsides and outsiders (such as Kant) to define the separated territories. Even for those who oppose his ideas, then, Kant is a necessary and worthy interlocutor.

Notes

I wish to thank the John Simon Guggenheim Memorial Foundation and the Social Sciences and Humanities Research Council of Canada for their support of my research. I am also grateful to Jennifer Cottrill for her work on the entire manuscript of this volume and to Mitchell Frank, Elizabeth D. Harvey, Michael Ann Holly, Michael Kelly, Keith Moxey, and the students in my 1996–7 graduate art theory class for their many helpful comments on this article.

 1 On Hegel and art history, see Keith Moxey's article in this volume, as well as Cheetham 1991, Gombrich 1984, Hart 1982, Melville 1990, and Podro 1977.

2 "Die Entwicklung der Beziehungen zwischen Kunstgeschichte und Kunstphilosophie . . . standen von Anfang an im Zeichen der beider massgebenden Klassiker der deutscher Aesthetik, im Zeichen Kants und Hegels."

3 There are major exceptions to this pattern of overlooking Kant's influence in the discipline: See for example Karen Lang 1997, Thomas McEvilley 1991, Michael Podro 1982, and David Summers 1989, 1993, 1994. Stephen Melville (1990) has made the suggestive comment (regarding Panofsky's choice, as it were, of Kant over Hegel) that "the explicit problematic of historicality recedes" (p. 10) when Kant is used as an inspiration in art-historical writing.

My belief is that these excellent studies prove the rule that Kant's ideas are usually seen as remote from the discipline of art history and from artistic practice. Julius von Schlosser's groundbreaking 1924 *Die Kunstliteratur* ignores Kant, as does his pupil Ernst Gombrich in a 1952 piece published in 1992 and Evert van der Grinten (1952). Heinrich Dilly (1979) says much about Hegel's influence but little about Kant's. As we have seen, Stephen Melville (1990) also claims Hegel's as the greater influence, as do Elkins (1988) and Gombrich (1984), even though the latter tellingly focuses on Kant as a corrective at the end of his article. To find Kant's influence acknowledged, we need to look to overtly "philosophical" work by Panofsky, of course, and to now largely forgotten writers such as Krystal (1910) and Passarge (1930). The extent to which the employment of Kant (and by implication Hegel) in art history can be seen as paradigmatic of a general relationship between philosophy and art history is one of the issues I address in my book *Moments of Discipline: Immanuel Kant in the Visual Arts*, now in progress.

4 In *The Architecture of Deconstruction: Derrida's Haunt*, Mark Wigley has examined brilliantly the spatial relationships among philosophy, art, and architecture that proceed from Kant's "architectonic." On this theme, see also Sallis 1987. My own claim is that some of Kant's specific arguments and insistence on a disciplinary logic of inside/outside helped to shape the discipline of art history as well as individual artistic practice.

5 I coin this term to suggest an ongoing impact from Kant's ideas that can be seen as more eclectic than the nineteenth-century philosophical movement known as neo-Kantianism.

6 Kant's name is "dropped" in art history both in that it is often mentioned as an authority and in the contradictory sense that it is omitted from most official histories of the field (see following note). On the use of names in contemporary theory, see Jay 1990.

7 Gombrich's use of Kant in an article on Hegel shows a philosophical disposition well known to his readers, as Mitchell has shown (1986: 152). Rhetorically, however, it is odd to have Kant's name "dropped" in the essay's finale.

8 On Kant and humanism, see Moxey 1995: 397.

9 I thank Dr. Anne-Marie Link for bringing this article to my attention.

10 For a lucid discussion of "analytic" vs. "Continental" readings of the third *Critique*, see McCormick 1990.

11 On art history as a discipline, see *Art Bulletin* 77, 4 (December 1995); Bal 1996a, b; Bryson, Holly, and Moxey 1991, 1994; Cheetham 1992; Holly 1996; Mitchell 1995; Moxey 1994; Preziosi 1989, 1992, 1993a, b. Regarding the humanities generally, see Chamberlin and Hutcheon 1992; Greenblatt and Gunn 1992; Kreiswirth and Cheetham 1990; Messer-Davidow, Shumway, and Sylvan 1993.

12 See Bal's thought-provoking reflections on the difference between a "paradigm" and a "discipline" – and her own relations with both – in Bal 1996a, b.

13 On space and place, see Casey 1993. Pierre Bourdieu's sociology of aesthetic judgment, *Distinction*, is also relevant in this context.

14 Christie McDonald writes that "Kant codified a certain consensus emerging from eighteenth-century thinkers which put philosophy at the center of the disciplines" (1992: 38). See also Derrida 1992 on Kant's own assertion of reason – and philosophy as the domain which alone can deploy it fully – as superior within the university. In his essay "Tympan," Derrida argued that philosophy "has always insisted upon assuring itself

mastery over the limit" (1982: x). I would modify Derrida's "always" and insist on the primacy of this activity during the Enlightenment and especially in Kant's work, which in its aim to master art through aesthetics was the direct heir of Baumgarten. Art history is not alone in its relationship with the "master discipline" philosophy. John S. Nelson writes: "Philosophy, history, law, literature, economics, anthropology, sociology, and psychology . . . each thinks that its rules or procedures of inquiry come fundamentally from philosophy" (1993: 165).

15 Wigley holds that art/architecture is foundational for philosophy, not ornamental, but also – in a reading of Derrida that I agree with – that architecture "derives its force precisely from its ornamental role" (1993: 64, 93).

16 For a list of the people included in the three works, see Rosenthal (1987: 157).

17 "Die kantische Philosophie, das Verständniss der grossen Dichter, die Gedanken der Humanität, das war es, das deutsche Volk jetze mehr alles Andere mit Interesse erfüllte."

18 "Von innere Notwendigkeit bedingt war es, dass mit dem Aufschwung deutscher Dichtung, wie der Musik und Philosophie, auch die bildenden Künste sich ebenfalls zu einer Widergeburt anschickten" (p. 1).

19 References are to the pagination of the German edition; Pluhar's translation.

Works Cited

Bal, Mieke. 1996a. "Art History and Its Theories." *Art Bulletin* 78, 1 (March): 6–9.
 1996b. "Semiotic Elements in Academic Practices." *Critical Inquiry* 22 (Spring): 573–89.
Battersby, Christine. 1995. "Stages on Kant's Way: Aesthetics, Morality, and the Gendered Sublime." In *Feminism and Tradition in Aesthetics*, ed. Peggy Zeglin Brand and Carolyn Korsmeyer. University Park: Pennsylvania State University Press, pp. 88–116.
Boime, Albert. 1990. *Art in an Age of Bonapartism, 1800–1815*. The Social History of Modern Art, Vol. 2. Chicago: University of Chicago Press.
Bois, Yve-Alain. 1990. "Kahnweiler's Lesson." *Painting as Model*. Cambridge: MIT Press, pp. 65–97.
 1996. "Whose Formalism?" *Art Bulletin* 78, 1 (March): 9–12.
Bourdieu, Pierre. 1984. *Distinction: A Social Critique of the Judgement of Taste*. Trans. Richard Nice. Cambridge: Harvard University Press.
Bryson, Norman (ed.). 1988. *Calligram: Essays in New Art History from France*. Cambridge: Cambridge University Press.
Bryson, Norman, Michael Ann Holly, and Keith Moxey (eds.). 1991. *Visual Theory: Painting and Interpretation*. New York: HarperCollins.
 1994. *Visual Culture: Images and Interpretations*. Hanover, N.H.: Wesleyan University Press/University Press of New England.
Busch, Werner. 1982. "Kunsttheorie und Malerei." In *Kunsttheorie und Kunstgeschichte des 19. Jahrhunderts in Deutschland: Texte und Dokumente*, vol. 1, ed. W. Beyrodt, U. Bischoff, W. Busch, and H. Hammer-Schenk. Stuttgart: Philipp Reclam.
Carstens, Jakob Asmus. 1970. Letter to Baron von Heinitz, February 20, 1796. In *Neoclassicism and Romanticism 1750–1850: Sources and Documents*, vol. 1, ed. Lorenz Eitner. Englewood Cliffs, N.J.: Prentice-Hall, p. 109.
Casey, Edward S. 1993. *Getting Back into Place: Toward a Renewed Understanding of the Place-World*. Indiana University Press.
Cassirer, Ernst. 1951. *The Philosophy of the Enlightenment*. Trans. Fritz C. A. Koelln and James P. Pettegrove. Princeton: Princeton University Press.
 1981. *Kant's Life and Thought*. Trans. James Haden. New Haven: Yale University Press.
Chamberlin, J. E., and Linda Hutcheon (eds.). 1992. *The Discovery/Invention of Knowledge*. Special issue of *University of Toronto Quarterly* 61, 4.
Cheetham, Mark A. 1987. "The Nationality of Sublimity: Kant and Burke on the Intuition and Representation of Infinity." *Journal of Comparative Literature and Aesthetics* 10, 1–2: 71–88.

1991. *The Rhetoric of Purity: Essentialist Theory and the Advent of Abstract Painting.* Cambridge: Cambridge University Press.

1992. "Disciplining Art's History." *University of Toronto Quarterly* 61, 4: 437–42.

1995. "The Sublime Is Now (Again)." *C Magazine* 44, 5 (Winter): 27–39.

Cohen, Ted, and Paul Guyer (eds.). 1982. *Essays in Kant's Aesthetics.* Chicago: University of Chicago Press.

Crowther, Paul. 1985. "Greenberg's Kant and the Problem of Modernist Painting." *British Journal of Aesthetics* 25, 4: 317–25.

1995. *The Contemporary Sublime: Sensibilities of Transcendence and Shock.* London: Academy Group.

Curtin, Deane W. 1982. "Varieties of Aesthetic Formalism." *Journal of Aesthetics and Art Criticism* 40, 3: 315–32.

Derrida, Jacques. 1982. "Tympan." *Margins of Philosophy.* Trans. Alan Bass. Chicago: University of Chicago Press, pp. ix–xxix.

1987. *The Truth in Painting.* Trans. Geoff Bennington and Ian McLeod. Chicago: University of Chicago Press.

1992. "Mochlos; or, The Conflict of the Faculties." In *Logomachia: The Conflict of the Faculties*, ed. Richard Rand. Lincoln: University of Nebraska Press, pp. 1–34.

Dilly, Heinrich. 1979. *Kunstgeschichte als Institution: Studien zur Geschichte einer Disziplin.* Frankfurt am Main: Suhrkamp.

Eagleton, Terry. 1990. *The Ideology of the Aesthetic.* Oxford: Blackwell.

Eggers, Friedrich. 1867. *Jakob Asmus Carstens.* Potsdam: Literarische Gesellschaft.

Einem, Herbert von. 1935. *Carl Ludwig Fernow: Eine Studie zum deutschen Klassizismus.* Berlin: Deutsche Verein für Kunstwissenschaft.

Elkins, James. 1988. "Art History without Theory." *Critical Inquiry* 14, 2: 354–78.

Ettlinger, L. D. 1961. "Art History Today." London: H. K. Lewis.

Fernow, Carl Ludwig. 1944. *Römische Briefe an Johann Pohrt, 1793–1798*, ed. Herbert von Einem and Rudolf Pohrt. Berlin: Walter de Gruyter.

Gehlen, Arnold. 1966. "D.-H. Kahnweilers Kunstphilosophie." In *Pour Daniel-Henry Kahnweiler*, ed. Werner Spies. London: Thames and Hudson, pp. 92–103.

Goetschel, Willi. 1994. *Constituting Critique: Kant's Writing as Critical Praxis*, trans. Eric Schwab. Durham, N.C.: Duke University Press.

Gombrich, Ernst. 1984. " 'The Father of Art History': A Reading of the *Lectures on Aesthetics* of G. W. F. Hegel (1770–1831)," *Tributes: Interpreters of Our Cultural Tradition.* Ithaca: Cornell University Press, pp. 51–69.

1992 (1952). "The Literature of Art." Trans. Max Marmor. *Art Documentation* 11, 1: 3–8.

Green, Christopher. 1987. *Cubism and Its Enemies.* New Haven: Yale University Press.

Greenblatt, Stephen, and Giles Gunn (eds.). 1992. *Redrawing the Boundaries: The Transformation of English and American Literary Studies.* New York: Modern Language Association of America.

Grillo, Friedrich. 1796. "Ueber Kunst nach Herrn Kant." In *Neue Miscellaneen artistischen Inhalts für Künstler und Kunstliebhaber*, ed. Johann Georg Meusel. Leipzig: Gerhard Fleischer.

Grinten, Evert van der. 1952. *Enquiries into the History of Art-Historical Writing: Studies of Art-Historical Functions and Terms up to 1850.* Venlo.

Guilbaut, Serge. 1985. "Art History after Revisionism: Poverty and Hopes." *Art Criticism* 2, 1: 39–50.

Hart, Joan. 1982. "Reinterpreting Wölfflin: Neo-Kantianism and Hermeneutics." *Art Journal* 42: 292–7.

1993. "Erwin Panofsky and Karl Mannheim: A Dialogue on Interpretation." *Critical Inquiry* 19: 534–66.

Holly, Michael Ann. 1984. *Panofsky and the Foundations of Art History*. Ithaca: Cornell University Press.

1994. "Art Theory." In *The Johns Hopkins Guide to Literary Theory & Criticism*, ed. M. Groden and M. Kreiswirth. Baltimore: Johns Hopkins University Press, pp. 48–53.

1996. *Past Looking: Historical Imagination and the Rhetoric of the Image*. Ithaca: Cornell University Press.

Jay, Martin. 1990. "Name-Dropping or Dropping Names? Modes of Legitimation in the Humanities." In *Theory between the Disciplines: Authority/Vision/Politics*, ed. Martin Kreiswirth and Mark A. Cheetham. Ann Arbor: University of Michigan Press, pp. 19–34.

Kahnweiler, Daniel-Henry. 1949. *The Rise of Cubism* (1920). Trans. Henry Aronson. New York: Wittenborn, Schultz.

Kant, Immanuel. 1972 (1795). "Perpetual Peace, a Philosophical Essay." Trans. M. Campbell Smith. New York: Garland.

1979 (1798). *The Conflict of the Faculties*. Trans. Mary J. Gregor. Lincoln: University of Nebraska Press.

1987 (1790). *Critique of Judgment*. Trans. Werner S. Pluhar. Indianapolis: Hackett.

1991 (1784). "An Answer to the Question: 'What Is Enlightenment?'" In *Kant: Political Writings*, 2nd ed., ed. Hans Reiss, trans. H. B. Nisbet. Cambridge: Cambridge University Press, pp. 54–60.

Kreiswirth, Martin, and Mark A. Cheetham (eds.). 1990. *Theory between the Disciplines: Authority/Vision/Politics*. Ann Arbor: University of Michigan Press.

Krystal, B. 1910. *Wie ist Kunstgeschichte als Wissenschaft möglich? Ein kritischer Versuch*. Halle: Niemeyer.

Kupffer, C., and F. Bessel Hagen. 1880. *Der Schaedel Immanuel Kants*. Braunschweig.

Lang, Karen. 1997. "The Dialectics of Decay: Rereading the Kantian Subject." *Art Bulletin* 79, 3, pp. 413–39.

Lavater, Johann Caspar. 1869 (1775). *Physiognomy . . .* London: William Tegg.

Lenoir, Timothy. 1993. "The Discipline of Nature and the Nature of Discipline." In *Knowledges: Historical and Critical Studies in Disciplinarity*, ed. Ellen Messer-Davidow, David R. Shumway, and David J. Sylvan. Charlottesville: University Press of Virginia, pp. 70–102.

Librett, Jeffrey S. 1993. *Of the Sublime: Presence in Question*. Albany: State University of New York Press.

Mattick, Paul, Jr. 1990. "Beautiful and Sublime: Gender Totemism in the Constitution of Art." *Journal of Aesthetics and Art Criticism* 48, 4: 293–303.

McCormick, Peter. 1990. *Modernity, Aesthetics, and the Bounds of Art*. Ithaca: Cornell University Press.

McDonald, Christie. 1992. "Institutions of Change: Notes on Education in the Late Eighteenth Century." In *Logomachia: The Conflict of the Faculties*, ed. Richard Rand. Lincoln: University of Nebraska Press, pp. 35–55.

McEvilley, Thomas. 1988. "empyrrhical thinking (and why kant can't)." *Art Forum* 27 (October): 120–7.

1991. *Art and Its Discontents: Theory at the Millennium*. Kingston, N.Y.: McPherson.

McGowan, John. 1991. *Postmodernism and Its Critics*. Ithaca: Cornell University Press.

Melville, Stephen. 1990. "The Temptation of New Perspectives." *October* 52 (Spring): 3–15.

Messer-Davidow, Ellen, David R. Shumway, and David J. Sylvan (eds.). 1993. *Knowledges: Historical and Critical Studies in Disciplinarity*. Charlottesville: University Press of Virginia.

Mitchell, W. J. T. 1986. *Iconology: Image, Text, Ideology*. Chicago: University of Chicago Press.

1995. "Interdisciplinarity and Visual Culture." *Art Bulletin* 77, 4: 540–4.

Moxey, Keith. 1994. *The Practice of Theory: Poststructuralism, Cultural Politics, and Art History.* Ithaca: Cornell University Press.

 1995. "Motivating History." *Art Bulletin* 77, 3: 392–401.

Nachtsheim, Stephan. 1984. *Kunstphilosophie und empirische Kunstforschung 1870–1920.* Berlin: Mann.

Nelson, John S. 1993. "Approaches, Opportunities and Priorities in the Rhetoric of Political Inquiry: A Critical Synthesis." In *The Recovery of Rhetoric: Persuasive Discourse and Disciplinarity in the Human Sciences,* ed. R. H. Roberts and J. M. M. Good. Charlottesville: University of Virginia Press, pp. 164–89.

Norris, Christopher. 1993. *The Truth about Postmodernism.* Oxford: Blackwell.

Passarge, Walter. 1930. *Die Philosophie der Kunstgeschichte in der Gegenwart.* Berlin: Junker u. Dünnhaupt.

Podro, Michael. 1977. "Hegel's Dinner Guest and the History of Art." *New Lugano Review* 1–2: 19–25.

 1982. *The Critical Historians of Art.* New Haven: Yale University Press.

Preziosi, Donald. 1989. *Rethinking Art History: Meditations on a Coy Science.* New Haven: Yale University Press.

 1992. "The Question of Art History." *Critical Inquiry* 18: 363–86.

 1993a. Introduction to Part III of *The Early Years of Art History in the United States: Notes and Essays on Departments, Teaching, and Scholars,* ed. Craig Hugh Smyth and Peter M. Lukehart. Princeton: Princeton University Press, pp. 147–50.

 1993b. "Seeing through Art History." In Messer-Davidow, Shumway, and Sylvan (eds.) (q.v.), pp. 215–31.

Riegel, Herman. 1869. *Carstens Werke.* Leipzig: Alphons Dürr.

Rodowick, D. N. 1994. "Impure Mimesis, or the Ends of the Aesthetic." In *Deconstruction and the Visual Arts: Art, Media, Architecture,* ed. Peter Brunette and David Wills. Cambridge: Cambridge University Press.

Rosenthal, Mark. 1987. *Anselm Kiefer.* Exhibition catalog. Chicago: Prestel.

Sallis, John. 1987. *Spacings – Of Reason and Imagination in Texts of Kant, Fichte, Hegel.* Chicago: University of Chicago Press.

Schama, Simon. 1995. *Landscape and Memory.* New York: Random House.

Schoch, Rainer. 1992. "Rom 1797 – Fluchtpunkt der Freiheit." In *Künstlerleben in Rom. Bertel Thorvaldsen (1770–1844): Der dänische Bildhauer und seine deutsche Freunde.* Exhibition catalog. Nuremberg: Germanischen Nationalmuseums, pp. 17–23.

Schlosser, Julius von. 1924. *Die Kunstliteratur: Ein Handbuch zur Quellenkunde der neueren Kunstgeschichte.* Vienna: Anton Schroll.

Stadler, Ingrid. 1982. "The Idea of Art and of Its Criticism: A Rational Reconstruction of a Kantian Doctrine." In *Essays in Kant's Aesthetics,* ed. Ted Cohen and Paul Guyer. Chicago: University of Chicago Press, pp. 195–218.

Stafford, Barbara Maria. 1991. *Body Criticism: Imaging the Unseen in Enlightenment Art and Medicine.* Cambridge: MIT Press.

Stemmler, Joan K. 1993. "The Physiognomical Portraits of Johann Caspar Lavater." *Art Bulletin* 75, 1 (March): 151–68.

Summers, David. 1989. " 'Form,' Nineteenth-Century Metaphysics, and the Problem of Art Historical Description." *Critical Inquiry* 15, 2: 372–406.

 1993. "Why Did Kant Call Taste a 'Common Sense'?" In *Eighteenth-Century Aesthetics and the Reconstruction of Art,* ed. Paul Mattick, Jr. Cambridge: Cambridge University Press, pp. 120–51.

 1994. "Form and Gender." In Bryson, Holly, and Moxey (eds.) (q.v.), pp. 384–411.

Vidler, Anthony. 1994. "Art History's *Posthistoire.*" *Art Bulletin* 76, 3: 407–10.

Wigley, Mark. 1993. *The Architecture of Deconstruction: Derrida's Haunt.* Cambridge: MIT Press.

2

Art History's Hegelian Unconscious

Naturalism as Nationalism in the Study of Early Netherlandish Painting

Keith Moxey

Historicism contents itself with establishing a causal connection between various moments in history. But no fact that is a cause is for that reason historical. It became historical posthumously, as it were, through events that may be separated from it by thousands of years. A historian who takes this as his point of departure stops telling the sequence of events like the beads of a rosary. Instead, he grasps the constellation which his own era has formed with a definite earlier one. Thus he establishes a conception of the present as the "time of the now" which is shot through with chips of Messianic time.

<div style="text-align: right">

Walter Benjamin, "Theses on the Philosophy of History, XVIII A," in *Illuminations*, ed. Hannah Arendt, trans. Harry Zohn (New York: Schocken, 1968), p. 263

</div>

The history of art, through its continuous mediation of past and present art, can become a paradigm for a history that is to show the "development of this present." . . . But art history can take on this function only if it itself overcomes the organon-type principle of the history of style, and thus liberates itself from traditionalism and its metaphysics of supratemporal beauty.

<div style="text-align: right">

Hans Robert Jauss, "Art History and Pragmatic History," *Towards an Aesthetics of Reception*, trans. Timothy Bahti, intro. Paul de Man (Minneapolis: University of Minnesota Press, 1982), pp. 46–75 (p. 62)

</div>

IN the context of notions of history marked by what has come to be known as the "linguistic turn," it is possible to look at the historiography of the history of art with different eyes.[1] Once the idea that written histories correspond with events that may have taken place in the past is abandoned so that the concept of truth is necessarily irrelevant to the historian's project, the status of history as text acquires new significance. Just as poststructuralism has altered our views about history, so it has transformed our attitudes toward historiography. Instead of being viewed as the record of past attempts to do justice to the past, attempts that need to be corrected and superseded as subsequent generations of historians discover new and more pertinent "facts" among the "documents" or "archives" relating to the period under scrutiny, the textual history of the discipline can now be examined from a different perspective. If the importance of the subjectivity of the author is taken into consideration, if the writer's location in the present is acknowledged as an integral part of his or her account of the past, then it becomes possible to analyze the written record, the literature on the history of art, with an eye to its cultural values and the ideological commitments with which the authors have invested their texts, in order to determine their social function at the time of their composition. Such an approach to historiography serves to enrich its traditional status as part of the cultural history of ideas by associating it with the notion of ideological criticism or discourse analysis.

It is with this new situation in mind, with the new centrality ascribed to the text of history in poststructuralist theory, that I have become fascinated with the notion of teleological direction or progress that informs much of the historiography on early Netherlandish painting. The insistence with which scholars in this field have invoked the notion of progress prompted me to ask two related questions. First, what was the ideological purpose of the concept of a teleologically directed concept of history? That is, why had so many scholars subscribed to the idea of development or progress in history? Second, what happens to the concept of history once the idea of development is foresaken? How do we conceive of history once the teleological imperative has been abandoned? If, as Jean-François Lyotard suggests, the age of "grand narratives" is over, then what might be a philosophy of history appropriate to our poststructural or postmodern condition?[2]

In thinking about the prevalence of teleological narratives in accounts of early Netherlandish painting, I concluded that the greatest debt was to the philosophy of Hegel. Art history, like history itself, has tended to assume that the events of the past make sense; that there is an immanent logic in the succession of artistic styles; that it is the task of the historian to describe it. In calling this assumption "Hegelian," I am clearly using the term in its broadest etymological sense. If the historiography of art history is "Hegelian," it is because the basic strategies of its approach to history, the idea of purposive or teleological development, the notion that the sequence of styles that characterizes different periods embodies an inherent principle of historical change, and the conviction that there are certain artists that transcend their historical circumstances in order

to enable great artistic transformations, all figure prominently in its historical narratives.[3] While such strategies are so generally invoked as to appear to be the very conditions of possibility for art history as a practice, I will argue that they have histories of their own. The assumption that these clichés of art-historical interpretation actually coincide with the structure of events – that such concepts reflect the "order of things" – is what this essay seeks to contest.

As we shall see, the impulse to tell purposive narratives, a tendency promoted by Hegel's philosophy of history, effectively coincided with the nationalist politics of nineteenth- and twentieth-century Europe. Hegel's view of history must thus be considered only one aspect of a dense set of ideas that constitute the discursive practice of art history. In referring to the discipline's "Hegelian unconscious," I intend social as well as psychoanalytic associations. The values that characterize the signifying systems that constitute art history's professional existence may in all fairness be described as ideological. They are, in other words, ideas that betray attitudes and prejudices associated with the time in which they are manifested, and which eventuated in practices that defy rational explanation. Art-historical ideology carries the raced, classed, and gendered convictions of those responsible for its production, as well as its reception. Needless to say, the full complexity of art history's unconscious freight cannot be unpacked in this study of the epistemological underpinnings of the history of Northern Renaissance art. I will be principally concerned here to articulate the ways in which Hegel's ideas have intersected with some of the other less explicit agendas of its professional discourse.

In criticizing the Hegelian assumptions that have determined the nature of the stories that have been told about the past, I do not mean to repudiate the desire to find meaning in it. This is neither a call for history that eschews the ambition of strong interpretation, nor a call for history based on allegedly neutral descriptions of empirical "fact." Some of the finest pages of art history, those produced by the founders of the discipline, Alois Riegl, Max Dvořák, Heinrich Wölfflin, Wilhelm Worringer, and Erwin Panofsky, who all found in the principle of style a way of tracking the progress of the spirit in history, or those written by art history's Marxist wing, such as Frederick Antal, Max Raphael, Arnold Hauser, and T. J. Clark, who secularized and materialized the spirit as the class struggle, are products of the Hegelian tradition. Whereas the Hegelian historian naturalizes the authorial perspective by claiming insight into the implicit "history" of history, an interpretive gesture that suggests that there is a correspondence between a sequence of events and the narrative that recites them, poststructuralist historians can make no claim as to whether or not their narratives intersect with anything beyond themselves (except perhaps for their relation to other texts dealing with similar issues). In order to make explicit the distinction between these two perspectives, I will use the term "teleological historicism" to refer to the view that events themselves contain an inherent narrative, and "historicism" to refer to the view that whatever narrative we discern in events has been placed there by the historian.[4] While it is clear on both the Hegelian and the non-Hegelian models that history can only be told

from a position in the present, this essay calls for an explicit acknowledgment of the historian's personal agenda in the creation of historical meaning.

Naturalism as Nationalism

To exemplify the workings of the Hegelian unconscious within the context of Northern Renaissance art on which I would like to focus, I will concentrate in this chapter on the historiography of Hans Memling.[5] I am interested not only in the forces that brought him to scholarly light, but also in those that led to the eclipse of his reputation. What sorts of narrative have been told about this artist, and what are the cultural values that inform them? What follows is by no means intended to be a complete review of the Memling literature. Instead, I have selectively chosen certain authors whose texts seemed to me to be emblematic of both the attitudes that supported the esteem in which he was once held and those that have led to his fall from favor. In discussing Memling, it will be necessary to refer to the historiography of two other artists, Jan van Eyck and Hugo van der Goes, on whom his status can be seen to depend. The second of the pair is particularly relevant to this project, for it could be said that Memling's prestige is structurally related to Hugo's – as one rises in scholarly estimation, the other falls. The mechanics of this historiographic hydraulics are generated by changing attitudes toward the philosophy of history.

This account of the Memling historiography must also pay attention to the operation of what Ernst Gombrich has called "Hegel's wheel."[6] Historians often imply that different aspects of a particular culture are related to one another by historical developments characteristic of the culture as a whole, in the same way as the spokes of a wheel are related to its hub. According to this view, all facets of a culture, which is to say all of the spokes (such as art, literature, politics, etc.), may be "explained" by means of a broader historical movement, the hub (the spirit of the age) from which each individual aspect is presumed to radiate outwards. I will argue that the assumption that cultural relationships are by definition meaningful fails to recognize the active role of the historian in the construction of historical narratives. In the light of poststructuralist theory, historians must acknowledge that the hub that accounts for the significance of the spokes is not found in the past, but placed there in the present by the activity of the pattern-making historian.

Before Memling became caught up in the wheels of a teleologically oriented historiography, he first attracted the imagination of early nineteenth-century critics. With its incipient nationalism and conception of the artist as genius, it was the Romantic movement that found in the artistic culture of Northern Europe an artist who seemed to embody the virtues of the Germanic race, but who at the same time displayed an extraordinary capacity to express the piety that was part of the culture of the Middle Ages. The German literary figure Friedrich Schlegel, for example, was living in Paris when works of art confiscated by the victorious armies of Napoleon were put on display in the Louvre. Amidst this

booty, the objects that excited his most profound admiration were those that exemplified the spirit of selfless devotion he identified with the medieval imagination. Departing from the prevailing preference for the art of the Italian Renaissance, he saw in the Middle Ages a period whose exceptional qualities had been unjustly neglected. More important for my purposes, his appreciation for medieval art enabled him to sing the praises of German art. Making no distinction between the artistic production of Germany and that of the Netherlands, he articulates his reasons for revering the northern virtues of van Eyck and Memling in the following terms:

> We must not however forget that in the heyday of the older Netherlandish School both the general and the particular existed harmoniously side by side; as in the work of van Eyck and Hemmelink [Memling], the deeply symbolic quality of devotion and sacred beauty and the emotional German strain are united. . . . In addition there is an evocation of that merry German life very clearly depicted according to the contemporary manner and custom, in the varied expressions of the other faces and secondary figures as well as in the fantastic splendor and daintiness of the colorful costumes.[7]

Memling's *Moreel Altarpiece* (Fig. 2) is among the paintings Schlegel selects for special scrutiny. After comparing the earlier artist with Dürer, in his eyes the acme of old German painting, Schlegel commends Memling for his gentler, more peaceful spirit:

> The faces are remarkably more genuinely German than is usually the case among the oldest Netherlandish painters. Here, in this admirable and relatively little known painter, one is offered a view into the as yet unknown world of old German art history. This painting could be a model for the way in which the solitary and rural circumstances of the lives of the saints should be handled. It exhales a moving expression of his deepest devotion and piety.[8]

What is remarkable about Schlegel's criticism is the way in which Christian piety and nationalism interlock so as to mutually implicate and sustain one another. The pious spirit of the Middle Ages is identified as German, and what is German is identified with the spirituality of a bygone age.

The Romantic view of Memling as an exemplary Christian artist informed much of the literature on him throughout the nineteenth century and often granted him a higher status even than that of Jan van Eyck, the historiographic hero of the twentieth century. A late example of this Romantic tendency is found in James Weale's monograph published in 1901, almost exactly a century after Schlegel's writings had eventuated in the development of a historical interest in early Netherlandish painting. Weale, a convert to Catholicism, spent much of his life in Bruges, searching for archival evidence to document the lives of early

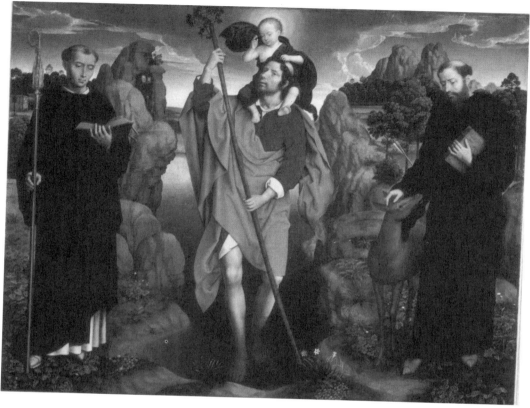

Figure 2. *Hans Memling,* St. Christopher Carrying the Christ Child, *central panel of the* Moreel Altarpiece, *1484. Oil on wood. 3'11³/₁₆" × 4'11¹³/₁₆₆" (121.1 × 153.4 cm). Groeningemuseum, Bruges. Photo courtesy of Erich Lessing/Art Resource, New York.*

Flemish painters. According to him, Memling was the leading Flemish artist of the fifteenth century:

> John van Eyck saw with his eyes, Memlinc with his soul. John studied, copied and reproduced with marvellous accuracy the models he had before him. Memlinc, doubtless, studied and copied, but he did more; he meditated and reflected; his whole soul went into his work, and he idealised and glorified, and, so to say, transfigured the models which he had before him. . . . As compared with the other masters of the Flemish school, he is the most poetical and the most musical; many of his pictures are perfect little gems.[9]

Why is there an opposition enunciated here between copying and studying the model and meditating and reflecting on it? Why is Memling's soul opposed to van Eyck's eyes? How did the imitation of nature become associated with

the secular and the worldly, and idealism identified with the spiritual and the transcendent?

The answers to these questions are to be found in the revolutionary paradigm of historical consciousness that was developed in the first half of the nineteenth century in the philosophy of Hegel. While some aspects of his philosophy of history coincided with and further developed tendencies already present in Romanticism – for example, the importance ascribed to nationalism – other features represented a radical break with the Romantic sensibility. One of the most important of these differences lies in Hegel's conception of movement or progress in history. Romantic philosophers, such as J. G. Herder, had embraced a relativistic notion of history, in which an emphasis was placed on the individuality and autonomy of cultures and nations at different moments in time.[10] Believing that the divine plan which lies behind the particularity of historical moments is by definition inscrutable, Herder did not try to detect a discernible pattern in the past. Hegel, on the other hand, conceived of history as a process in which it was possible to trace the workings of the "spirit" through time. In the Hegelian dialectic, history possessed an immanent logic with a teleological purpose, namely the fulfillment of the spirit.

The nationalism of the Romantics, which had depended largely on a sense of the relative worth of different cultures, as well as of different moments in time, was transformed in Hegel's thought by being awarded historical purpose and drive. Hegel conceived of history as a history of nations rather than of individuals or groups, for it was through nations that the spirit, or *Volksgeist*, of different peoples found its historical manifestation. The political appeal of such a philosophical doctrine for nineteenth-century Europe, which saw the attainment of nation status by a whole host of countries, including major political powers on the scale of Germany and Italy, cannot be overestimated.[11] New nations could claim a place for themselves in the momentous tale of the realization of the spirit, a tale whose teleological structure gave free rein to hindsight. Several generations of art historians followed Hegel in seeing art as a manifestation of transcendent values. Not surprisingly, it was in those qualities of works of art with which Kant had most closely identified aesthetic response, namely the formal properties of line, shape, color, and so on, that art historians believed they could discern the material embodiment and operation of the spirit.[12] These formal properties, gathered together under the rubric of style, became the focus of art-historical attention.[13] The equation of style with the passage of the spirit made it possible to give color and form to the immanent forces at work in history. In an age in which knowledge was often metaphorized as vision, it is not surprising that art history should have sought disciplinary status as the history of the visible, as opposed to history proper, which was to remain the history of the textual.

Art historians inevitably look at the art of their own time in order to assess the visual history of the past. The importance of Realism as a European style in the middle of the nineteenth century, for example, affected the way in which they read the stylistic record of previous ages. If Realism was to be viewed as

the culmination of a transhistorical process, then the task of the Hegelian scholar was to explain how this result came about. Because of the dialectical nature of Hegel's own understanding of the past, his system afforded a means of interpreting both those periods that seemed to progress toward the ideal of nineteenth-century Realism and those that seemed to counter such directionality. As Gombrich points out, even if it proved difficult to argue that the art of, say, Byzantium might be considered a prelude to Realism, its value could be located in the way it constituted a dialectical antithesis to a development that ultimately represented an advance toward the present (that is, out of the conflation or reconciliation of the opposites contained in the thesis and the antithesis, a new synthesis will emerge). Hegelianism could thus be said to have licensed the practice of an ecumenical history of art.[14]

The dialectical tension between the Renaissance and the Middle Ages in Hegel's account of the liberation of the spirit, a tension that reiterated the difference which the Renaissance itself had discerned between its own culture and that of preceding ages (a contrast most forcefully articulated for art historians in Vasari's *Lives of the Artists*), proved immensely influential in privileging realism, or naturalism, as the leading style of the history of art. According to Hegel, the Renaissance was a period in which human beings rejected the spiritual and psychological constraints of religion in order to immerse themselves in the secular study of the natural world.[15] Jacob Burckhardt, the first art historian to put Hegel's ideas to work in historical interpretation, used the notion of the spirit's turn toward nature as a means of understanding the realistic quality of Italian art of the fifteenth century.[16] In Burckhardt's eyes, the new naturalism, which was antithetical to the traditional content of the devotional art of the Middle Ages, was more important than the revival of antiquity with which the Renaissance had previously been identified:

> The work of art gives progressively more than the Church demands; in addition to religious matters, it now furnishes an impression of the real world; the artist dedicates himself to the research and representation of the outer appearance of things and gradually grasps the human figure as well as the spatial environment in all its manifestations.[17]

Burckhardt's interpretation of Italian Renaissance art underscores two Hegelian points. First and foremost, it establishes a form/content distinction that empowers the history of art to become a history of style. Secondly, it defines the artist's interest in the world of appearances as something which is at odds with the representation of spiritual truths.

The contrast with Schlegel's Romantic criticism of early Flemish painting could not be more striking. For Schlegel, spirituality and nationalism are indistinguishable from one another. The work of art does not admit a separation of form from content, so that the history of art cannot be identified with only one aspect of the equation. Schlegel's respect for the unity of the work, its indivisible wholeness, could be read as a metaphor of its autonomy, a claim that the work is

not part of some larger scheme of things. The work must be appreciated for qualities that distinguish it from others, rather than for those that connect it to them. In light of this contrast between Burckhardt and Schlegel, it is easier to understand Weale's opposition of Memling and van Eyck. Weale was a belated Romantic who preferred Memling's spiritualism to van Eyck's naturalism. Writing in the context of Hegelian art history, however, he uses the methodological tools of his opponents to defend his hero. Accepting the distinction between form and content, Weale identifies van Eyck's naturalism with the material and the secular. Because naturalism is worldly, idealism must be spiritual. Where one artist merely studied and copied nature, the other idealized and glorified it. Where van Eyck is the eye, Memling is the soul.

Weale's defense of Memling's reputation, however, could not long withstand the identification of naturalism with the secular spirit of the Renaissance. It is ironic that it should have been in the eyes rather than in the soul that the march of the spirit was discerned. Not only was it possible for the age of Realism to identify with the age of naturalism, but Burckhardt's translation of Hegel's notion of the liberation of human consciousness into the age of individualism meant that the nineteenth century had another reason to view the Renaissance as a mirror image of itself.[18] The consequences of the value ascribed to naturalism for Memling's reputation were exacerbated by the nationalism of nineteenth- and twentieth-century art-historical writing. Art historians sought to claim that naturalism, the most prestigious of the styles of the past, had its origins in their own national traditions. Burckhardt, who had praised the art of Renaissance Italy on the ground of its naturalism, did so out of the sympathy he felt for Italian patriots who were calling for the unification of Italy.[19] His attitude was soon replaced by that of other scholars who sought to identify naturalism with their own national traditions.

Subsequent art historians contested Burckhardt's thesis concerning the Italian origins of Renaissance naturalism. In Belgium, for example, it was Hippolyte Fierens-Gevaert, writing at the beginning of the twentieth century, who first insisted that the origins of naturalism be traced back to Flemish artists of the fourteenth and fifteenth centuries.[20] Ironically, the claim that naturalism was a Flemish invention proved the downfall of Memling's exalted position in the canon. In the eyes of Fierens-Gevaert, it was the style of the Flemish primitives, not the content of their art, that had lent them their historical power. In an interpretive scheme governed by teleology, it was predictable that the innovative naturalism of the van Eycks should come to be regarded as more important than the spiritual sentiments of Memling. According to Fierens-Gevaert, the van Eyck brothers were the architects of early Netherlandish painting. The *Adam* and *Eve* panels from the *Ghent Altarpiece* (Figs. 3, 4) became valued for their remarkable fidelity to nature rather than for their role within the theological program of the whole work.[21] In the context of the world-historical importance ascribed to van Eyck, Memling's star began to fade. Fierens-Gevaert's evaluation of Memling's paintings included in the famous Flemish Primitives exhibition held in Bruges in 1902 was devastating:

Ecstasy is demanded in the presence of the paintings of this charming master, and on this occasion it has become frenzied. Alas, I have not been able to share this premeditated enthusiasm. The great artist appeared affected next to van Eyck, artificial next to van der Weyden, without precision next to Thierry Bouts, without sobriety next to Gérard David.[22]

Fierens-Gevaert's remarkable self-reflexivity in formulating these judgments offers us an interesting insight into a transitional moment in the history of taste:

Nevertheless, I confess that for the past few years I have not felt as keenly the religious passion which is usually attributed to the illustrious master Hans. I scarcely have acknowledged this change to myself; I fought against that which I regarded as a weakness in my taste. Today, I admit that Memling no longer has, in my eyes, the exceptional importance or the creative grandeur not only of a van Eyck, but even of a Roger van der Weyden, a Gérard David or a Quentin Metsys.[23]

The triumph of the history of art as a history of style, as well as the triumph of the Renaissance at the expense of the period that preceded it, meant that Memling's spirituality could not now be identified with the progressive workings of the spirit.

The forward march of history replaced the nostalgia of the Romantics for the lost piety of a bygone age. History no longer simply looks back, but looks back in order to see the future. Religious devotion has no place in a scheme that is leading to the unfettering of human consciousness and its return to the natural world. Historians no longer daydream about the past as a way of validating the present, but about the utopian ambitions of the moment – ambitions that are inextricably identified with the emerging nation states.

Predictably, Max Friedländer, director of the Kaiser Friedrich Museum in Berlin and architect of the canon of early Netherlandish painting still observed by scholarship today, did not support Fierens-Gevaert's claim that naturalism was a Flemish invention. Far from viewing its origins as a historical phenomenon in which Flemish artists just happened to play a major role, Friedländer believed that naturalism was a characteristic of the German people. In this conviction, he shared widely held views that can be traced back at least as far as Gustav Friedrich Waagen's influential monograph of 1822 on the van Eyck brothers.[24] Writing in the context of World War I, Friedländer emphasized that the naturalism of early Flemish artists was indebted to their Germanic background: "Apart from personal genius that triumphantly transcends place and time, we may regard as Germanic heritage the impulse to observe nature that bears such fruit throughout Eyck's work and confers universally acknowledged superiority on Netherlandish panel painting."[25] Friedländer's stress on the German character of Netherlandish naturalism echoes Schlegel's failure to differentiate between German and Netherlandish national identity. The physical contiguity between German and Netherlandish territory and the similarity between the German and Dutch or Flemish

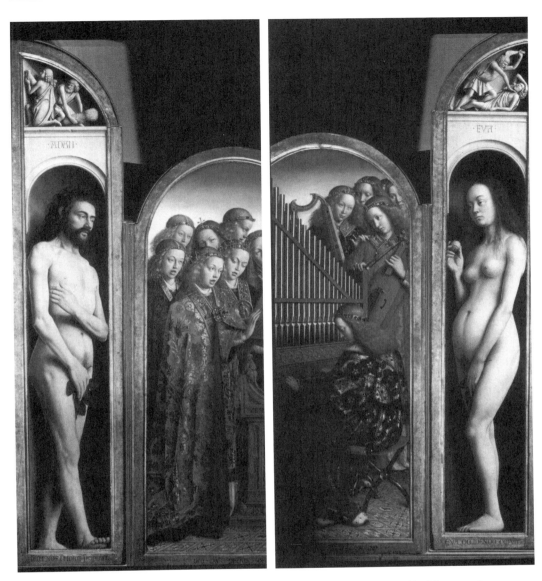

Figure 3 (left). *Jan van Eyck,* Adam *(detail from the* Ghent Altarpiece*), 1432. Oil on wood. Cathedral of St. Bavo, Ghent. Photo courtesy of Scala/Art Resource, New York.* **Figure 4 (right).** *Jan van Eyck,* Eve *(detail from the* Ghent Altarpiece*), 1432. Oil on wood. Cathedral of St. Bavo, Ghent. Photo courtesy of Scala/Art Resource, New York.*

languages, together with a history of shared religious and political institutions, allowed German scholars of Friedländer's generation to include Netherlandish culture within the parameters of what was considered the broader concept of German identity.

In subscribing to a view of naturalism as an essentially Germanic charac-teristic, Friedländer echoed a long tradition in German writing about the history

of art. Wilhelm Worringer, for example, had argued that it was the fusion of the abstract, linear quality of the spiritual art of the German Middle Ages, together with the mimetic tradition of Italian art in the work of German artists of the Renaissance, that produced the greatest achievements of naturalistic art in the Western tradition.[26] Friedländer's Austrian contemporary Max Dvořák also argued that naturalism was a special characteristic of the German people. In an ingenious argument that turned the tables on the Hegelian association of the observation of nature with the Italian Renaissance, Dvořák insisted that far from their standing in a dialectical relationship with one another, the Renaissance represented the fruition of Gothic naturalism that was the supreme quality of the art of the Middle Ages. Not only did naturalism find its origins in the art of the Middle Ages rather than in the Renaissance, but it was the product of the Northern European peoples rather than those of the Mediterranean.[27] While Dvořák's argument takes issue with Burckhardt's identification of realism with the Renaissance, thus breaking with Hegel's assessment of the age's historical significance, his own interpretation substitutes another transcendental narrative for the one with which he takes issue. While escaping the Hegelian tradition in one regard, his own story has a developmental structure, one that privileges the notion of the evolution of style and therefore belongs to a pattern made popular by teleological historicism.

Regardless of whether it was nation or race that prompted Friedländer to reclaim Flemish painting for the Germanic people (or, as seems more likely, some combination of the two), the assertion is once again motivated by the prestige of naturalism's identification with the Renaissance as an age that saw the rise of individualism: "The naturalism of the new pictures is closely related to the growth of individualism. Tradition has begun to lose its hold, eyes were trained on the world's infinite diversity – and rigid contemporary patterns lost their power."[28]

The emphasis on style is structurally related to the neglect of content. Where stylistic innovation is absent, devotional subject matter is regarded as hackneyed and conventional. According to Friedländer, Memling does not participate in the naturalistic observation that characterizes the school to which he belongs. His art is said to depend on that of his predecessor Roger van der Weyden, whose compositional formulas he repeated without alteration. Memling failed, in other words, to behave like an exemplary "Renaissance man": "Whether or not Memlinc had a personal relationship with Roger, whether or not he spent any time in the Brussels Workshop as an assistant or journeyman, his was an almost womanly receptivity in respect of the actively creative Netherlander. Memlinc was conquered and he never quite liberated himself."[29] Friedländer's gendering of Memling as female is meant to signal his failings as an artist. Both the Kantian notion of the genius, as an extraordinarily gifted individual, and Hegel's concept of the world-historical "hero" (such as Napoleon), as a figure who transcends the culture of his time in order to bring about the next chapter in the history of the spirit, had been gendered male. By identifying Memling as female, Friedländer consigned him to the ranks of minor masters. As such, he was clearly regarded as an unworthy vehicle for a nationalist history of art.

His alleged passivity also affects Friedländer's understanding of Memling's spirituality, so that his piety is now regarded as naively sentimental:

> In Memlinc's devout vision, acceptance knew no struggle, dedication no doubts, no ecstatic crises. He saw the world of God in a state of paradise, as an assemblage of pure beings, their bliss best exemplified by pleasing forms. His creatures are accessible – there is no arrogance about them. Shy and coy at first, they later relax into smiling security and animated trust, bringing more and more brightness into the gloomy churches of Flemish towns.[30]

Friedländer's evaluation of Memling's oeuvre was closely followed by the most authoritative twentieth-century historian of the Northern Renaissance, Erwin Panofsky. In his work, Memling is accused of failing to exercise his powers of observation in the representation of nature (a quality which Panofsky also identified with the Northern races and with the Flemish people in particular),[31] he is faulted for his dependence on Roger van der Weyden, and he is dismissed as a *retardataire* rather than a progressive figure in a historical narrative that is marked by the inexorable march of history toward the glorious dawn of the Renaissance.[32] As we have seen, the fact that Memling's work is so closely related to that of Roger van der Weyden was an important reason for ascribing to him a minor role in the history of early Netherlandish painting. Both Friedländer and Panofsky, for example, suggest that his incapacity to develop a distinctive style of his own is an index of his lack of artistic talent. It was also interpreted as an indication that Memling should not be associated with the new age of the Renaissance, which, since Burckhardt, had been identified as the age of "man and the rediscovery of the world."

Transcendental Genius

The ignominy of Memling's failure to live up to the expectations of Renaissance individualism was exacerbated by his being compared with his contemporary Hugo van der Goes. At first sight, the importance ascribed to Hugo's work seems paradoxical, for his work is also marked by symbolic and mystical qualities that openly compromise the reality effects produced in his paintings. The key to Hugo's location in the canon has less to do with whether or not he participated in the stylistic development that led to the Renaissance than with his identification as an artist who personifies the quality of freedom that is characteristic of the new age. Whereas the Hegelian narrative usually equates naturalism with artistic genius, in Hugo's case these concepts are contrasted to one another. It is Hugo's capacity to transcend the principles of the art of the Renaissance – reminiscent of the struggle of the Hegelian dialectic – that establishes him as a personality who is bound neither by place nor by time; he becomes, in other words, the personification of the active human spirit in the age of the

Renaissance. The identification of Hugo as a Renaissance man simultaneously suggests a desire to show that during this period the appearance of artistic genius was not limited to the Italian peninsula.

Hugo's extraordinary life history, the exceptional nature of his personal experience, was crucial to the Hegelian project of identifying him as a Northern manifestation of Renaissance genius. The Romantic myth of Memling's having been a soldier who sought shelter in the Bruges hospital of St. John in order to be cured of his wounds by the nuns who ran it – and who had subsequently painted the altarpieces that still grace this institution out of gratitude to the sisters who tended him[33] – was soon dispelled with the advent of positivistic scholarship. This was not the case with the lurid tale associated with the biography of Hugo. The story of Hugo's mental illness and of his retreat into a monastery at the height of his career could be substantiated in the archives, and the record of his troubles kept by one of the brothers of the cloister was published in the earliest monograph on the artist, published by Alphonse Wauters in 1875.[34]

Wauters developed the Romantic potential of the story, speculating that Hugo's despair was caused by the contrast between the ascetic aspirations that had led him to the monastic life and his longing for the sensuality and dissipation of an earlier existence.[35] Early twentieth-century art historians, however, under the spell of a teleological approach to history, found it easy to identify his malady as an outbreak of melancholy, the mental condition of Renaissance genius. Friedländer, for example, writes: "Van der Goes, Grünewald and Michelangelo – three artists of melancholic temperament. Aside from the works that testify to the somber moods of their authors, there is no dearth of confirmatory evidence to show that in these men blackness of soul transcended the normal limits of the healthy mind."[36]

The state of Hugo's mind accounts for the nature of his art. Hugo's individualism is woven into the fabric of the Hegelian dialectic of the Renaissance and the Middle Ages. He is claimed to belong to a transitional moment, one in which the medieval guild system was breaking down. Though the regulations and requirements of the guilds still determined artistic production, Hugo proves the exception to the rule. He is the artist who breaks the bonds of convention. He is, in other words, ahead of his time:

> The virtues compatible with the guild system were virtues anyone could acquire – hard work, honest craftsmanship. They did not include genius, the kind of extraordinary skill that sets its owner apart, exalts him, marks him as someone special. It was fame that burst the confines of craft society. A master who grew aware of his superiority, who perceived the difference between his work and that of his colleagues as a gulf that could not be bridged, became an enemy of society, felt like an intruder in the community.[37]

The condition Wauters had described as a personal struggle between two sides of Hugo's personality, an allegory of the battle between the spiritual and the

sensual, is heroized by being ascribed social and transhistorical significance. In Friedländer's vivid account, Hugo becomes a personification of the Hegelian spirit, torn between the ambition to express his genius on the one hand and a desire for a self-effacing piety on the other:

> Pride, ambition, the joy of creating were at war with his religious qualms, his need to humble himself. His visions, his spiritual experiences, were at odds with pictorial tradition. The art that was born of these inner struggles attained grandeur and pathos. . . . He was a stranger in Ghent, a stranger in the monastery, a stranger to his age. Striding forward in solitude, he lost his way. No wonder we associated him with Grünewald and Michelangelo – two who came later than he.[38]

Friedländer's prose suggests the aesthetic rewards to be obtained from subscribing to the Hegelian paradigm. His poetic evocation of Hugo's inner conflict, the struggle between the piety of the dying Middle Ages and the self-assertiveness of the pagan Renaissance, clothe Hugo's mental distress in a striking series of metaphors that serve to make his art memorable to us. In a figure such as Hugo, the history of art as a history of style reaches its fruition. The meaning of history is suddenly exposed as transhistorical forces clash and struggle with one another in a dialectic that gives rise to the future.

Panofsky, author of the definitive study on Renaissance melancholy,[39] once again followed Friedländer in his account of this artist's work. He attempted to add historical texture to this art-historical tale of the rise of Renaissance individualism by indicating that the Renaissance doctrine of the melancholic genius was first laid out by Marsilio Ficino in a book published in 1482 – the year of Hugo's death.[40] This coincidence, however, possesses more power on the metaphoric level than on the historical. Panofsky admits, for example, that there was little interaction between the cultures of Italy and the Netherlands during the fifteenth century and that the humanist ideology on which Ficino's thesis depends was wholly foreign to Hugo's Ghent. Panofsky's argument indicates the strain placed on his narrative by the desire to find a manifestation of Renaissance genius in a culture to which such an idea was manifestly alien. The insertion of irrelevant and extraneous evidence into his argument betrays the urgency of the need to identify Hugo as a Northern equivalent to personalities such as those of Leonardo, Raphael, and Michelangelo. If the claims to artistic autonomy and power on which such artists based their claims lay in the psychological theories of Ficino, then so could Hugo's.

Like Friedländer, Panofsky reads Hugo's works as manifestations of genius. The scale of the figures in the *Portinari Altarpiece* (Fig. 5), a work that is said to be more at home in Florence, where it is now located, than in Ghent, where it was produced, is interpreted as a metaphor of Hugo's status as a *totus homo* – the fully realized "Renaissance man." Because of Hugo's transitional position – the fact that he appeared in a culture that had no way of recognizing

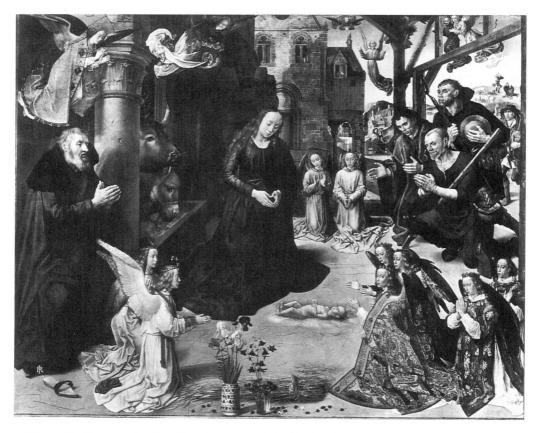

Figure 5. *Hugo van der Goes,* The Adoration of the Shepherds, *center panel of the* Portinari Altarpiece, *ca. 1476. Oil on wood. 8′3 ¹/₂″ × 10′ (255.1 × 307.7 cm). Galleria degli Uffizi, Florence. Photo courtesy of Alinari-Scala/Art Resource, New York.*

the world-historical importance of his talent – he was necessarily conflicted, torn between ". . . the humanistic glorification and idealization of man and the non-humanist principle of total particularization – between 'great form' and the minutiae of optical appearance."[41]

In an argument that moves from the works to the artists and back again, Panofsky claims that Hugo's paintings are riven by contradiction. Of his last work, *The Death of the Virgin* (Fig. 6), Panofsky eloquently writes:

In the "Death of the Virgin," . . . the indistinct light that comes from the left foreground is shattered by the glare of the miraculous apparition while the desaturated blues, reds, mauves, pinks and browns, some of them as dissonant as unresolved seconds, weirdly contrast with the chalk-white of the Virgin's kerchief and St. Peter's alb and with the green-fringed yellow of the big glory. And the intensity of simple-hearted devotion, prophetic ecstasy and muted sorrow have reached a point at which emotion blots

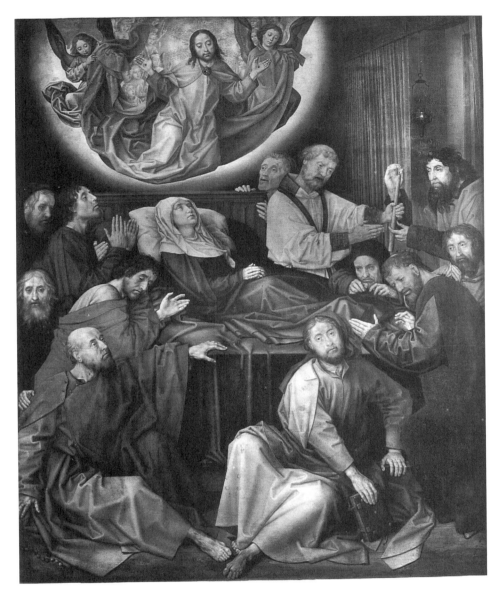

Figure 6. *Hugo van der Goes, The Death of the Virgin, ca. 1481. Oil on wood. Municipal Museum, Bruges. Photo courtesy of Alinari-Scala/Art Resource, New York.*

out consciousness and threatens to break down the barrier that protects reason both from the subhuman and the superhuman.[42]

In the figure of Hugo van der Goes, we thus see the birth pangs of a new age. The artist's struggle to give expression to a new conception of human consciousness, one that depends on the capacity to realize his potential regardless of the limitations imposed on human conduct by historical (or national)

circumstances, is responsible for his descent into insanity.[43] Memling, the copyist and follower of Roger van der Weyden, could clearly be no match for this eruption of Renaissance genius into the placid stream of early Netherlandish painting, a tradition which had until this point allegedly concerned itself with the rather pedestrian task of imitating nature.

The superimposition of Hegelian teleology onto the Romantic conception of the artist-as-genius adds status not only to the artist, the object of interpretation, but to the historian. Identifying the life of Hugo van der Goes as a site where it is possible to discern the workings of the spirit, the historian becomes a seer, someone whose function it is to explain the present in terms of the past. Not only does the spirit animate Hugo van der Goes, but it also animates the narrative of the historian. Historical authority is enhanced as the historian becomes the temporary embodiment of a world-historical process. The distance that distinguishes two historical horizons is erased in the voice of History itself.

The first objection to this teleological evaluation of Memling's artistic status and historical significance is found in Ludwig von Baldass's book of 1942.[44] Baldass describes the prominent location ascribed to Memling in the canon of Netherlandish painting by the popular imagination, contrasting it to the low esteem in which the artist is held by contemporary art historians. He claims that historians have preferred complex, difficult, and changeable artists over those whose work is simple, unproblematic, and peaceful. More important, they should not have been so willing to sacrifice the reputation of an artist who does not fit some preconceived notion of historical development:

> . . . the historiography should not have as its only goal to move as fast as possible from Dirk Bouts and Hugo van der Goes in order to attain Geertgen and Quentin Metsys by placing the resolution of the problem of passionate expressivity and enhanced naturalism in the forefront of attention. In such circumstances any prolonged engagement with Memling's art appears like an unnecessary halting place.[45]

Writing in 1971, the British scholar K. B. McFarlane pursued Baldass's attack on the transcendental narrative that had condemned Memling to second-rate status, even obscurity.[46] He defends the pacific quality of Memling's art, suggesting that there is no necessity for art to disturb or unsettle in order to be deemed great. He mocks Panofsky's language, which had, for example, called van Eyck an "explorer" and van der Weyden an "inventor," by saying that such terms are an expression of the "Agonistic Ascendancy" in the historiography of this period.[47] In other words, he satirizes the assumption that it is only the artists who can be characterized as heroes, those involved in a dramatic struggle, who deserve the attention of the historian. McFarlane is particularly concerned with the role that the notion of "progress" has played in Memling scholarship. Although he is prepared to grant that fifteenth-century Flemish painting sees progress as manifested in technical achievement, he denies the type of "progress" that is implied by a more teleological and therefore more Hegelian interpretation:

This whole-hearted reliance upon what to others may seem a coarse identification of "progress" with "innovation," and preferably dramatic innovation, allows Memling's claims upon our attention to be quickly disposed of. He was retarded when he should have been advancing; he ought more obviously to have gone one better than his predecessors. . . . To equate novelty with life is to adopt a needlessly philistine solution to every historian's inescapable problem: how to distinguish the significant from the trivial. No mere rule of thumb can relieve him from the need to exercise his own judgement and consider pictures, like other historical "facts," on their merits.[48]

In conclusion, then, and in contrast to the nationalistic conflicts that raged about the origins of pictorial naturalism, conflicts that depended on Hegel's notion of the state as the embodiment of the spirit, the opposition of Hugo van der Goes and Hans Memling refers to another aspect of Hegel's thought. In Hugo van der Goes, Friedländer and Panofsky discerned a world-historical figure responsible for preparing another stage in the history of the spirit. In doing so, they found a means by which the status of genius might be bestowed upon a "Germanic" artist, thus dignifying the Northern tradition with the type of prestige that had hitherto been reserved for the Italian Renaissance. This strategy also allowed both to account for the historical changes that distinguish sixteenth- from fifteenth-century Flemish painting. Hugo becomes the hinge on which the door of the new century swings open.

"Hegel's Wheel"

Many aspects of the contemporary approach to the work of Hans Memling have been prefigured by the imaginative contributions of the early twentieth-century writer Johan Huizinga. The rejection of the idea that naturalism is somehow associated with national identity and that it has something to do with the rise of the Renaissance is forcefully argued in his influential book *The Waning of the Middle Ages*, which first appeared in 1924.[49] In his compelling account of Franco-Burgundian culture of the fourteenth and fifteenth centuries, Huizinga proposed that, far from being a harbinger of things to come, the naturalism of the art of this period is a symptom of a civilization in decline. Religious ideas had become ossified and meaningless, so that as a consequence it became possible to render them in material terms. The sparkling sensuality of the natural record in the art of Jan van Eyck, an art meant to please the opulent lifestyles of his aristocratic patrons, was at odds with the intellectual and emotional significance of the religious subjects he represented:

> Instead of heralding the advent of the Renaissance, as is generally assumed, this naturalism is rather one of the ultimate forms of development of the medieval mind. The craving to turn every sacred idea into precise images, to give it a distinct and clearly outlined form, . . . controlled art, as it

controlled popular beliefs and theology. The art of the brothers van Eyck closes a period.[50]

More important, in arguing that there is nothing exclusive about the naturalism of the Renaissance, pointing out that the observation of nature is a characteristic of the art of widely different periods, as well as a stylistic feature that often occurs in conjunction with styles characterized by idealization and abstraction, Huizinga suggested that this style could not be associated with the artistic production of any single race or nation.[51] Furthermore, if we are to judge a style by its most developed manifestations, then it can be argued that naturalism is a feature of fifteenth-century Italian art rather than that of the sixteenth, say the art of Raphael and Michelangelo, where the movement is commonly said to have reached its apogee: "The essence of the Renaissance lies in its triumph over naive naturalism, and it is the failure to understand this that has led to the mistaken incorporation of Jan van Eyck in the Renaissance."[52]

In a remarkable reflection on the nature of visual mimesis, Huizinga suggests that the terms "naturalism" and "realism" (he uses the terms indistinguishably) are often used to refer to works which, while not actually corresponding optically to any particular set of natural circumstances, are designed, nevertheless, to give the impression that they duplicate the real world. The essay "Renaissance and Realism" thus raises the prospect that in naturalism we may often have what Roland Barthes was later to call a "reality effect."[53] Huizinga's analysis allows for the possibility that the style which contemporary art historians were calling "Renaissance naturalism," a metaphor for the turn of the spirit toward nature, is actually nothing but the effect of a cultural value whose goals may well transcend the principle of imitation.

If Huizinga and those who have followed him can be said to have broken the identification of naturalism with the Renaissance and with national identity, his understanding of the cultural significance of style is nevertheless still indebted to the teleological tradition. In likening artistic production to rhetorical figures and social rituals, Huizinga, like Hegel, implies that each aspect of a particular culture is related to every other aspect of that culture, and that there is a process or development that unites them all. Huizinga's interpretation, in short, can still be regarded as an illustration of "Hegel's wheel." Poetry, music, court etiquette, and visual art are all said to share certain qualities which are related to an explanatory thesis that accounts for the period as a whole, as the spokes of a wheel are related to its hub. While Huizinga's abandonment of the identification of style as the vehicle for the unfolding of the "spirit" in history represents a remarkable critique of the Hegelian tradition in art history, in subscribing to "Hegel's wheel" his work is nevertheless indebted to a teleological historicism on a deeper and ultimately more problematic level. In other words, Huizinga is confident that the Hegelian notion of the *Zeitgeist*, or "spirit of the times" that is thought to pervade all aspects of each synchronic slice of a teleologically conceived historical time, is sufficient to explain the relation of every individual manifestation of a culture to every other.

Conclusion

The effectiveness of the concept "spirit of the age" as an interpretive gesture continues to be demonstrated in the Memling literature to this day. Working in 1990, Paul Philippot, for example, makes use of Sixten Ringbom's thesis that Flemish painting of the fifteenth century represents a transition from iconic or devotional art to one that is concerned with the narrative aspects of the Christian story.[54] Memling's figures are said to lose their specificity as they share their ontological status with the depicted nature that surrounds them. Instead of freezing time for devotional purposes, instead of reducing, say, the landscape setting to a backdrop for the motionless, eternal figures that were the objects of worship, Memling is said to forfeit some of that emotional intensity in an effort to endow the figures with an animated engagement with the circumstances in which they are represented. As the figures become less iconic, their relation to their surroundings becomes more active, and a devotional art is replaced by a narrative one. The viewer is encouraged to look and recognize, rather than to worship.

Philippot attempts to rescue Memling from his devaluation at the hands of a narrative that exalted the rise of the Renaissance by inscribing him in one about the emergence of narrative art. Effective as this resuscitation is as a means of insuring that critical attention does not dismiss Memling out of hand, Philippot's account is teleological in nature. Philippot's Memling, riven between a devotional and a narrative art, is recuperated as the link that insured the development of one into the other. It is the tension resulting from Memling's heroic intervention, from his attempt to mediate mutually antagonistic principles, that is said to mark his art as exceptional.

Similarly, in the literature of Hugo van der Goes, Bernhard Ridderbos has recently sought to interpret the artist's changing style in terms of the historical culture of which he was a part, rather than as a manifestation of the passage of the spirit.[55] Ridderbos returns to a Romantic reading of the artist's style as an allegory of his personal struggle between a desire for worldly recognition and a desire for spiritual redemption. Style, in other words, is not regarded as a transhistorical process in which the artist is the means by which the spirit manifests itself in history; it is an integral part of the work's social function. Like Huizinga, Ridderbos looks around the edges of Flemish naturalism to determine its cultural significance. While not denying that the naturalism of van Eyck served a religious purpose, that it served to make transcendental truths materially accessible, Ridderbos believes that, like Roger van der Weyden, Hugo sought to develop a style that was related to the spiritual agenda of the leading form of lay spirituality of his time, the *devotio moderna*. In doing so, he connects two different aspects of Netherlandish culture, suggesting that their participation in a common *Zeitgeist* constitutes a historical interpretation. According to Ridderbos, Hugo's spiritual concerns prompted him to abandon the Eyckian idiom on which his reputation was established in favor of a more direct and passionate style that was calculated to appeal to the emotions of the beholder.

Instead of illustrating the conflict between the Middle Ages and the Renaissance, as Panofsky suggested, Hugo's art is said to manifest the artist's internal turmoil resulting from his aspirations to social prominence and a need to prepare for his life after death.

As in the older literature, both Philippot and Ridderbos purport to "find" their interpretations in the historical context they study, and both of them make use of "Hegel's wheel" in one form or another. In the case of Philippot it is found in the vertical axis of the developmental narrative that traces the change from a devotional to a narrative art form; in the case of Ridderbos it is located in the synchronic movement that links Hugo's art to the devotional culture of his time. Such a conclusion would appear to have devastating implications for the future of historical writing. If every attempt to interpret the past is to be questioned if it assumes a developmental narrative or challenged on the ground that it accounts for one aspect of a culture in terms of another; if both the vertical and horizontal axes inherent in the Hegelian philosophy of history are regarded as illegitimate, what happens to history writing as a form of cultural production? Does a poststructuralist critique of Hegel's philosophy of history serve to fulfill his prediction that history has an end?

This analysis of a segment of the art-historical canon, the historiographic reception of the work of Hans Memling, has allowed us to meditate upon the way in which the history of art has been "framed" by a teleological historicism. While the individual subjectivities of historians insure that history continues to provide us with ever changing accounts of the past, our study has shown that these contributions inevitably share certain philosophical assumptions. In the case of Memling, these assumptions dictated that his work should be evaluated in terms of a historical narrative that depended on the notion of style as a developmental process, one that achieved its apogee in the Renaissance. As a consequence, Hegel's account of the unfolding of the "spirit" in history, appropriated by nineteenth- and twentieth-century discourses of nationalism, enabled art historians to wrangle about the national origins of naturalism. The power attributed to individual artists as agents of historical change is another Hegelian conviction with a tenacious afterlife. From this point of view, history has become an allegory for the freedom of the humanist subject to determine his or her fate. The irony of these claims lies in the fact that "genius" only becomes so by realizing a thesis or bringing closure to a narrative that was projected back into the past by the historian. The exceptional power of the artist's "genius" as a tool in the unfolding of the spirit lies in playing a historical role that has been retroactively assigned to him (less often to her) by the present.

And most important, perhaps, this discussion has allowed us to reflect upon what could be considered one of the "deep structures" of narrative history, namely "Hegel's wheel." The difficulty presented by Hegelian histories lies not so much with the diachronic and synchronic axes of interpretation on which they depend as on the historical horizon in which they are situated. If we assume the poststructuralist conclusion that history is a text whose narrative cannot

coincide with the "order of things," then it is no longer possible to situate the axes of interpretation on the historical horizon that is the object of study. The historian must acknowledge that the developments and correspondences he or she discerns are not only the product of the scholar's imagination, but that they serve a particular cultural function in the historical horizon in which they are created.

Notes

I thank Michael Holly for reading this text in various incarnations. I am also indebted to Mark Cheetham, Eduardo Neiva, Peter Parshall, and Mieke Bal for close readings and helpful suggestions. Michael Levine gave me an opportunity to present these ideas for the German Studies Department of Columbia University, and Renja Suominen-Kokkonen and Riita Nikula invited me to discuss them in a seminar, "Art History and Its Paradigms," sponsored by the Department of Art History of the University of Helsinki. As a member of the Society for the Humanities at Cornell University during the academic year 1996–7, I was also able to discuss this paper with my colleagues and with its director, Dominick LaCapra.

1 The adoption by several disciplines in the humanities of a conception of language as something opaque rather than transparent was first brought home to historians by Michel Foucault. Foucault used the term "discursive practices" to cover all aspects of the production of cultural meaning, thus claiming the capacity to read social formations as texts. Some of his most influential historical readings are *The Order of Things*, trans. Alan Sheridan (London: Tavistock, 1970); *Madness and Civilization*, trans. Richard Howard (London: Tavistock, 1971); *The Archaeology of Knowledge*, trans. Alan Sheridan (London: Tavistock, 1972); and *Discipline and Punish*, trans. Alan Sheridan (London: Allen Lane, 1979). In the English-speaking world, it was Hayden White who, in a series of powerfully argued books and essays, insisted on a textual understanding of the past and a rhetorical conception of the text. See his *Metahistory: The Historical Imagination in Nineteenth-Century Europe* (Baltimore: Johns Hopkins University Press, 1973); *Tropics of Discourse: Essays in Cultural Criticism* (Baltimore: Johns Hopkins University Press, 1978); and *The Content of the Form: Narrative Discourse and Historical Representation* (Baltimore: Johns Hopkins University Press, 1987). Much the same approach has been applied to intellectual history by Dominick LaCapra, *Rethinking Intellectual History: Texts, Contexts, Language* (Ithaca: Cornell University Press, 1983); *History and Criticism* (Ithaca: Cornell University Press, 1985); *Soundings in Critical Theory* (Ithaca: Cornell University Press, 1989). More recently the implications of the concept of history as text have been explored by Robert Berkhofer, Jr., *Beyond the Great Story: History as Text and Discourse* (Cambridge: Harvard University Press, 1995), and Phillipe Carrard, *Poetics of the New History: French Historical Discourse from Braudel to Chartier* (Baltimore: Johns Hopkins University Press, 1992). The "linguistic turn" has also had important implications for our understanding of historical knowledge, particularly the notion of historical objectivity. See Peter Novick, *That Noble Dream: The "Objectivity Question" and the American Historical Profession* (New York: Cambridge University Press, 1988), and Robert D'Amico, *Historicism and Knowledge* (London: Routledge, 1989). The influence of Foucault can be discerned in the movement known as the "new historicism." In the work of Stephen Greenblatt, Louis Montrose, and others, a recognition of the textuality of history, of the opacity of the past, has resulted in the production of texts that often call attention to the authors' involvement with contemporary cultural issues as part of their accounts of the past. See Stephen Greenblatt, *Renaissance Self-Fashioning: From More to Shakespeare* (Chicago: University of Chicago Press, 1980); *Shakespearean Negotiations: The Circulation of Social Energy in Renaissance England* (Oxford: Clarendon Press, 1988); *Marvelous Possessions: The Wonder of the New World* (Chicago: University of Chicago Press, 1991). For an account of the British counterpart

of this movement, known as "cultural materialism," see Scott Wilson, *Cultural Materialism: Theory and Practice* (Oxford: Blackwell, 1995).

2 Jean-François Lyotard, *The Postmodern Condition: A Report on Knowledge*, trans. Geoff Bennington and Brian Massumi (Minneapolis: University of Minnesota Press, 1984 [1st ed. Paris, 1979]).

3 Art history's dependence on Hegelian ideas has always been recognized; see, for example, Ernst Gombrich, *In Search of Cultural History* (Oxford: Clarendon Press, 1969), and his article "The Father of Art History: A Reading of the Lectures on Aesthetics of G. W. F. Hegel (1770–1831)," *Tributes: Interpreters of Our Cultural Tradition* (Ithaca: Cornell University Press, 1984), 51–69. For a discussion of the relevance of the Hegelian tradition for contemporary art history, see Hans Belting, *The End of Art History*, trans. Christopher Wood (Chicago: University of Chicago Press, 1987). The Hegelian tradition has been viewed favorably by James Elkins, "Art History without Theory," *Critical Inquiry* 4 (1988), 354–78, and unfavorably by Stephen Melville, "The Temptation of New Perspectives," *October* 52 (1990), 3–15.

4 The literature on the concept of historicism is enormous. The term has been used quite variously and indeed contradictorily. Some authors have used it to insist on the importance of historical location for the interpretation of human culture, whereas others have used it to describe a teleological view of the past. See, for example, Friedrich Meinecke, *Historicism: The Rise of a New Historical Outlook*, trans. J. Anderson (New York: Herder and Herder, 1972 [1st ed. 1936]); Maurice Mandelbaum, *The Problem of Historical Knowledge: An Answer to Relativism* (New York: Liveright, 1938); George Iggers, *The German Conception of History: The National Tradition of Historical Thought from Herder to the Present* (Middletown, Conn.: Wesleyan University Press, 1968); D'Amico, *Historicism and Knowledge*; Paul Hamilton, *Historicism* (London: Routledge, 1996). The importance of the concept in art history has been described by Catherine Sousloff, "Historicism," *Encyclopedia of Aesthetics* (Oxford University Press, forthcoming). For attacks on the concept of historicism when understood as a teleology, see Karl Popper, *The Poverty of Historicism* (London: Routledge, 1994 [1st ed. 1957]), and *The Open Society and Its Enemies*, 2 vols. (Princeton: Princeton University Press, 1962).

5 For useful introductions to the historiography of early Netherlandish painting, see Suzanne Sulzberger, *La réhabilitation des primitifs flamands, 1802–1867* (Brussels: Palais des Académies, 1961); Francis Haskell, "Huizinga and the 'Flemish Renaissance,'" *History and Its Images: Art and the Interpretation of the Past* (New Haven: Yale University Press, 1993), 431–95; and Bernhard Ridderbos and Henk van Veen (eds.), "*Om iets te weten van de oude meesters.*" *De vlaamse primitieven – herontdekking, waardering en onderzoek* (Nijmegen: SUN, 1995). W. E. Krul's contribution to this last book, "Realisme, Renaissance en nationalisme: cultuurhistorische opvattingen over de Oud-nederlandse schilderkunst tussen 1860 en 1920," was especially useful in the preparation of this essay. I am grateful to Maryan Ainsworth for this reference. For a review of the Memling literature, see Vida Joyce Hull, *Hans Memlinc's Paintings for the Hospital of Saint John in Bruges* (New York: Garland, 1981), chap. 7 and Lori van Biervliet, "De roem van Memling," in *Hans Memling: Essays*, ed. Dirk de Vos (Bruges: Ludion, 1994), 109–24.

6 Gombrich, *In Search of Cultural History*, 10.

7 Gert Schiff (ed.), "Friedrich Schlegel. From *Descriptions of Paintings from Paris and the Netherlands in the Years 1802 to 1804*. From Second Supplement of Old Paintings, Spring, 1804," trans. Peter Wortsman and Gert Schiff, *German Essays on Art History* (New York: Continuum, 1988), 59–72 (pp. 71–2).

8 Friedrich Schlegel, *Kritische Friedrich Schlegel. Ausgabe IV, Ansichten und Ideen von der christlichen Kunst*, ed. Hans Eichner (Munich: Ferdinand Schoningen, 1959), 44–5. "Die Gesichter sind auffallend mehr eigentlich deutsch, als sie sonst bei den ältesten niederländischen Malern zu sein pflegen. Hier in diesem vortrefflichen und verhältnismässig nicht so berühmten Maler öffnet sich der Blick in eine noch unbekannte Weltgegend der

altdeutschen Kunstgeschichte. Dieses Gemälde könnte ein Vorbild sein, wie man land-schaftliche und einsiedlerische Gegenstände der Heiligengeschichte zu behandeln hat. Es atmet durchaus in ihm ein rührende Ausdruck der innigsten Andacht und Frömmigkeit." This and the following translations are my own.

9 James Weale, *Hans Memlinc* (London: George Bell, 1901), 80. This passage paraphrases Eugène Fromentin's comparison of the two artists in *Les maitres d'autrefois*, ed. Pierre Moisy (Paris: Garnier Frères, 1972 [1st ed. 1876]), 279. Both passages are quoted by Hull, *Memlinc's Paintings*, 210–11. For Weale, see Lori van Biervliet, *Leven en werk van W. H. James Weale: Een engels kunsthistoricus in Vlaanderen in de 19e eeuw* (Brussels: Paleis der Academien, 1991 [Verhandelingen van de Koninglijke Academie voor Wetens-chappen, Letteren en Schone Kunsten. Klasse der Schone Kunsten, vol. 53, no. 55]).

10 Iggers, *The German Conception of History*, 35. The correspondence between Romantic and poststructuralist attitudes toward history, according to which the local and specific is more important than the general and the universal, and the past is defined as something essentially inaccessible and incomprehensible, has been pointed out by Hans Kellner, "Introduction: Describing Redescriptions," in *A New Philosophy of History*, ed. Frank Ankersmit and Hans Kellner (Chicago: University of Chicago Press, 1995), 1–18 (p. 15).

11 For a discussion of the creation of the nation states of Europe in the nineteenth century, see Eric Hobsbawm and Thomas Ranger (eds.), *The Invention of Tradition* (Cambridge: Cambridge University Press, 1983), and Benedict Anderson, *Imagined Communities: Reflections on the Origin and Spread of Nationalism* (New York: Verso, 1991).

12 Immanuel Kant, *Critique of Aesthetic Judgment*, trans. James Meredith (Oxford: Oxford University Press, 1952 [1st ed. 1790]), "The Analytic of the Beautiful," 41–89.

13 For the importance of the concept of style for art-historical practice, see Meyer Schapiro, "Style," in *Anthropology Today*, ed. A. L. Kroeber (Chicago: University of Chicago Press, 1953), 287–312; Ernst Gombrich, "Norm and Form: The Stylistic Categories of Art History and Their Origins in Renaissance Ideals" (1961), *Norm and Form: Studies in the Art of the Renaissance* (London: Phaidon, 1971), 81–98; Gombrich, "Style," in *International Encyclopedia of the Social Sciences*, ed. David Sills, 18 vols. (New York: Macmillan, 1968–79), vol. 15, 352–61; Willibald Sauerlander, "From Stylus to Style: Reflections on the Fate of a Notion," *Art History* 6 (1983): 253–70; George Kubler, "Towards a Reductive Theory of Visual Style," in *The Concept of Style*, ed. Berel Lang (Ithaca: Cornell University Press, 1987 [1st ed. 1979]), 163–73; Svetlana Alpers, "Style Is What You Make It: The Visual Arts Once Again," in ibid., 137–62.

14 Gombrich, "The Father of Art History," 65: "Today it is considered scientific to eradicate the concept of decline from the art historian's vocabulary wherever possible, so as to allot every era that was once condemned, its rightful place in the chain of development. The vindication of Gothic art in the eighteenth century was accepted even by Hegel. Later, following in the tracks of Burckhardt, Wölfflin reinstated Baroque art, Wickhoff defended Roman art, Riegl the art of late antiquity, and Max Dvořák the catacomb paint-ings and El Greco. Walter Friedländer completely freed Mannerist art from the stigma of decline, and Millard Meiss undertook a positive evaluation of the painting of the late Trecento. At the moment we are even witnessing a revival of respect for French nineteenth-century Salon painting, which until recently was still considered to be the ulti-mate in kitsch."

15 Wallace Ferguson, *The Renaissance in Historical Thought: Five Centuries of Interpreta-tion* (Cambridge: Riverside Press, 1948), 171–2.

16 For a discussion of the ambivalence of Burckhardt's attitude toward Hegel, see Michael Ann Holly, *Panofsky and the Foundations of Art History* (Ithaca: Cornell University Press, 1984), 30–3.

17 Jacob Burckhardt, *Der Cicerone: Eine Einleitung zum Genuss der Kunstwerke italiens*, 2 parts, ed. Wilhelm Bode (Leipzig: Seeman, 1879), 524. "Das Kunstwerk gibt zunächst mehr als die Kirche verlangt; ausser den religiosen Beziehungen gewährt es jetzt ein Ausbild

der wirklichen Welt; der Künstler vertieft sich in die Erforschung und Darstellung des äussern Scheines der Dinge und gewinnt der menschlichen Gestalt sowohl als räumlichen Umgebung allmählich alle ihre Erscheinungsweisen ab."

18 Jacob Burckhardt, *The Civilization of the Renaissance in Italy*, trans. S. G. C. Middlemore (London: Penguin, 1990 [1st German ed. 1860]).

19 For Burckhardt's receptiveness to the political aspirations of Italian nationalists, see the review of *Civilization* by Wilhelm Dilthey, *Selected Works*, 6 vols., vol. 4, ed. Rudolf Makkreel and Frithjof Rodi (Princeton: Princeton University Press, 1996), 271–7, cited by Catherine Sousloff, *The Absolute Artist: The Historiography of a Concept* (Minneapolis: University of Minnesota Press, 1997), 88. For Burckhardt's political alienation following the failed revolutions of 1848 and his disenchantment with the liberal nationalist convictions of his youth, see Michael Ann Holly, "Burckhardt and the Ideology of the Past," *History of Human Sciences* I (1988), 47–73.

20 Hippolyte Fierens-Gevaert, *La renaissance septentrionale et les premiers maîtres de Flandres* (Brussels: van Oest, 1905). Fierens-Gevaert followed the lead of the French art historian Louis Courajod, who had argued that the origins of artistic naturalism should be traced to France because it was in the French courts of the dukes of Berry and Burgundy that Flemish artists had initiated their naturalistic experiments (see Haskell, "Huizinga and the 'Flemish Renaissance,'" 444). For a much fuller account of the relation between naturalism and nationalism in art-historical scholarship on early Flemish painting of the nineteenth century, see Krul, "Realisme, Renaissance en nationalisme."

21 Fierens-Gevaert, "L'exposition des primitifs flamandes à Bruges," *Revue de l'Art Ancien et Moderne* (1902), 105–15, 173–82, 435–44 (p. 110).

22 Ibid., 177. "L'extase est de rigueur devant les tableaux de ce maître charmant et, cette fois, elle est devenue de la frénésie. Hélas! je n'ai pu partager cet enthousiasme prémédité. Le grand artiste m'a paru mièvre à côté de van Eyck, artificiel à côté de van der Weyden, sans rigueur à côté de Thierry Bouts, sans sobriété à côté de Gérard David."

23 Ibid., 177–8. "Toutefois, j'avoue que depuis quelques années je sentais s'amoindrir la passion religieuse qu'il est convenu de vouer à l'illustre maître Hans. J'osais à peine m'avouer à moi-même ce changement; je luttais contre ce que je croyais une faiblesse de mon goût. Aujourd'hui, je confesse que Memlinc n'a plus à mes yeux l'importance exceptionelle et la grandeur féconde, non seulement d'un van Eyck, mais même d'un Roger van der Weyden, d'un Gérard David, d'un Quentin Metsys."

24 Gustav Friedrich Waagen, *Ueber Hubert und Johann van Eyck* (Breslau: Josef Max, 1822), 145. See also Wilhelm Waetzoldt, *Deutsche Kunsthistoriker* (Berlin: Hessling, 1965 [1st ed. 1921–4]), 38–45, and Gabriele Bickendorf, *Der Beginn der Kunstgeschichtsschreibung unter dem Paradigma "Geschichte": Gustav Friedrich Waagens Frühschrift "Ueber Hubert und Johann van Eyck"* (Worms: Wernersche Verlagsgesellschaft, 1985 [Heidelberger Kunstgeschichtliche Abhandlungen, n.s., vol. 18]). For a critique of the nationalism of German art-historical scholarship in the period between the world wars, see Pierre Francastel, *L'histoire de l'art: instrument de la propagande germanique* (Paris: Librairie de Medicis, 1945).

25 Max Friedländer, *From van Eyck to Bruegel* (London: Phaidon, 1969 [1st German ed. 1916]), 5.

26 Wilhelm Worringer, *Form in Gothic*, trans. Herbert Read (New York: Schocken, 1957 [1st ed. 1912]), 59–67.

27 Max Dvořák, "Die geschichtliche Stellung Huberts und Jans und das Geheimnis der neuen Kunst," *Das Rätsel der Kunst der Brüder van Eyck* (Munich: Piper, 1925), 141–242.

28 Friedländer, *Early Netherlandish Painting, vol. 1, The van Eycks–Petrus Christus*, comments and notes by Nicole Veronee Verhaegen, trans. Heinz Norden (New York: Praeger, 1967 [1st German ed. 1924]), 20.

29 Friedländer, *Early Netherlandish Painting, vol. 4, Hans Memlinc and Gérard David*, comments and notes by Nicole Veronee Verhaegen, trans. Heinz Norden (New York: Praeger, 1967), 32.

30 Ibid., 34.

31 Erwin Panofsky, *Early Netherlandish Painting*, 2 vols. (Cambridge: Harvard University Press, 1953). For an example of his identification of naturalism with the Flemish people, see p. 53.

32 Ibid., 347–50.

33 Biervliet, "De roem van Memling," 112. Biervliet traces the story to Jean Baptiste Descamps's *La vie des peintres flamands, allemands et hollandais* (Paris, 1753). It colors the rather dissolute characterization of Memling in the popular nineteenth-century English historical novel by Charles Reade, *The Cloister and the Hearth: A Tale of the Middle Ages* (New York: Grosset and Dunlap, 1922 [1st ed. 1859]).

34 Alphonse Wauters, *Hugo van der Goes: sa vie et ses oeuvres* (Brussels: Hayez, 1872).

35 Ibid., 22.

36 Friedländer, *Early Netherlandish Painting*, vol. 4, 48.

37 Ibid., 50.

38 Ibid.

39 Panofsky and Raymond Klibansky, *Saturn and Melancholy: Studies in the History of Natural Philosophy* (London: Nelson, 1964).

40 Panofsky, *Early Netherlandish Painting*, vol. 1, 330.

41 Ibid., 332.

42 Ibid., 338.

43 For a critique of the equation of genius and insanity in art history, see Griselda Pollock, "Artists' Mythologies and Media Genius, Madness and Art History," *Screen* 21 (1980): 57–96.

44 Ludwig von Baldass, *Hans Memling* (Vienna: Schroll, 1942).

45 Ibid., 7. "Zweitens darf die Geschichtsschreibung nicht nur das Ziel im Auge haben, so schnell wie möglich von Dirk Bouts und Hugo van der Goes zu Geertgen und Quentin Metsys zugelangen und die Verfolgung der Probleme leidenschaftlichen Ausdrucks und gesteigerter Naturwiedergabe in die vordergrund des Interesses zu stellen. Dann erschient nämlich jede eingehende Beshafftigung mit Memlings Kunst leicht wie ein unnützer Aufenthalt."

46 K. B. McFarlane, *Hans Memling*, ed. Edgar Wind and G. L. Harris (Oxford: Clarendon Press, 1971), esp. 38–45.

47 Ibid., 39.

48 Ibid., 44. McFarlane's criticism of the teleological bias of the Memling literature was noted by Hull, *Memlinc's Paintings*, 217.

49 Johan Huizinga, *The Waning of the Middle Ages: A Study in the Forms of Life, Thought, and Art in France and the Netherlands in the XIV & XV Centuries* (Garden City, N.Y.: Doubleday, 1954 [1st Dutch ed. 1924]).

50 Ibid., 264.

51 Huizinga, "Renaissance and Realism" (1929), *Men and Ideas: History, the Middle Ages, and the Renaissance*, trans. James Holmes and Hans van Marle (New York: Meridian, 1959), 288–309.

52 Ibid., 303.

53 Roland Barthes, "The Reality Effect" (1968), in *French Literary Theory Today*, ed. Tzvetan Todorov, trans. K. Carter (Cambridge: Cambridge University Press, 1982), 11–17.

54 Paul Philippot, "Icône et narration chez Memling," in *Pénétrer l'art. Restaurer l'oeuvre* (Kortrijk: Gooeninghe, 1990), 77–84. Philippot's interpretation has proven influential. It is followed, for example, by Dirk de Vos, *Hans Memling: The Complete Works* (Ghent: Ludion, 1994). See also Sixten Ringbom, *Icon to Narrative: The Rise of the Dramatic Close-Up in Fifteenth-Century Devotional Painting* (Abo: Abo Akademi, 1965).

55 Bernhard Ridderbos, *De melancolie van de kunstenaar. Hugo van der Goes en de oudnederlandse schilderkunst* (The Hague: SDU, 1991).

3

Spirits and Ghosts in the Historiography of Art

Michael Ann Holly

Suddenly, out of the becalmed mentality of the nineteenth century's last two decades, an invigorating fever rose all over Europe. No one knew exactly what was in the making; nobody could have said whether it was to be a new art, a new humanity, a new morality, or perhaps a reshuffling of society. . . . Something went through the thicket of beliefs in those days like a single wind bending many trees – a spirit of heresy and reform, the blessed sense of an arising and going forth . . . ; whoever entered the world then felt, at the first corner, the breath of this spirit on his cheek.

Robert Musil, *The Man without Qualities*

NEAR the beginning of *Civilization and Its Discontents*, Freud muses upon the complexities of the past's enduring connectedness to the present, what he calls the problem of "preservation in the sphere of the mind": "nothing which has once been formed can perish. . . . all the earlier phases of development continue to exist alongside the latest one." To picture this state of metaphysical atemporality he invokes the image of historic Rome, the eternal city not of "human habitation but a psychical entity with a similarly long and copious past," a site where an ancient temple could be imaged as evocatively emerging from the very same geographical spot as a long-demolished Baroque church, itself now replaced by some nondescript busy urban thoroughfare. Ghost-like, the structures of the past interpenetrate and silently resonate with the pedestrian who passes through them, the fellow who "would perhaps only have to change the direction of his glance or his position in order to call up the one view or the other."[1]

Freud's architectural fantasy possesses considerable metaphorical power for any historiography that attempts to write the intellectual history of a discipline by focusing on the way in which past concerns evolve into present methodologies. Major thinkers, schools of thought, influential studies, institutional histories,

historical causes and effects, and so forth are without a doubt the manifest content of sound historiographic analyses. Telling the story of the history of the history of art is an accepted practice in these self-reflexive poststructuralist days: how the discipline originated, how it changed, who its leading practitioners were, how it intersected with other scholarly developments in the humanities, and so on. But such "who, what, where, when" inquiries sometimes neglect what lies latent beneath the surface of historical narrative: the unsaid, the unspoken, the unseen. In that sense, historiography can also function as the analytic angle that attempts to penetrate into the methodological unconscious of the discipline. And Freud's image of buried Rome is particularly apt for a focus on the subterranean life of the field. To invoke his metaphor, a slight change in the direction of a glance, for example, might reveal not only the persistence of the past in the present, but also the subjective struggles and psychic conflicts that gave rise to the presumed objectivity of *Kunstwissenschaft* in all of its twentieth-century metamorphoses.

An interest in historiography (the ways in which historians have written history) rather than an interest in history itself (what happened) might at first appear to be a mere "pondering on . . . one of those strange flowers from the philosopher's garden."[2] The intrigue of historiography for me, however, is that it unequivocally reveals that history writing is never a univocal affair. Sometimes, when persuasive ideas get articulated, bound up into books, and accepted by a professional community, they tend to possess the weight of authority: "This is the way it was." A good historiographic tale, however, like effective psychoanalysis, has the capacity to stir things up by showing that schemes of historical interpretation are subject to all sorts of extrinsic and intrinsic complexities, whether they originate in politics, practical exigencies, intellectual or personal or psychological conflicts, or whatever. In short, ideas about the past are constructed out of the polysemous panoply of their contemporary existence, not just in the spirit of pure inquiry. Consequently, they cannot constitute the last word, the "truth." Historiography is in the position of being able to offer compelling comparisons and critiques of the master narratives of the past by highlighting the inextricable situatedness, the inescapable motivatedness of its historians.

The temptation, and the one to which I effortlessly succumb here, is to "contextualize" a past school or genre of historical works by mapping its surround, literally its geographic place, but by mapping it figuratively as well by locating its genesis in a particular ideological milieu – what might have once upon a time been called the "spirit of the age." That procedure is probably legitimate as long as the historiographer recognizes that that context, as Dominick La Capra has stressed, is always just another text and ultimately is deserving of its own "reading."[3] The challenge is to write a narrative "thick" enough, in Clifford Geertz's phrase,[4] "to deal not only with the sequence of events and the conscious intentions of the actors in these events, but also with structures – institutions, modes of thought, and so on – whether these structures act as a brake on events or as an accelerator."[5] And, then, as a final caveat, the historiographer must try, however impossible it may be, to remember that her or his

present concerns as an intellectual historian are implicated in the telling of the historiographic tale. If it is the case, as the work of Hayden White has convincingly emphasized, that no historical narrative ever straightforwardly reproduces the events it purports to describe but instead merely informs us of a way to think about them, then the historiographer must apply that insight into a self-consciousness about her or his own scholarly project as well.[6] In what follows, I want to invoke a particular historical situation to suggest, by way of example, how the spirits of ephemeral forces and the ghosts of darkened contexts haunt the enterprise of writing the history of the history of art.

IN fin-de-siècle Vienna, Freud often sat in his antiquity-filled study in the Berggasse yearning for a sight of the architectural marvels of ancient Rome. On occasion, he recruited the services of a well-known art historian of antiquity, Emanuel Loewy, to abet his daydreaming.[7] By Freud's account, the two of them would linger late into the night, scanning the most recent archaeological excavation reports and trading myths about the mysteries of the ancient world.[8] In many fundamental ways, Freud's nostalgia for a time that had come and gone is consonant with the historicist impulses of late nineteenth-century Viennese culture in general, the melancholic sentiment, according to his contemporary Felix Salten, the art critic, that "everything has already been undertaken and done and achieved and now there is nothing left more to do other than to understand and enjoy what is here already, like a costly possession."[9]

This ethical commitment to the merits of the past was nowhere more physically evident than in the buildings of late nineteenth-century Vienna, which collectively constituted "not just a city, but the symbol of a way of life,"[10] the grand urban surround of an imperial residence crafted "to look like what it was: a concentration of wealth and power, learning and taste." An imposing eclectic parade of historical styles, the architectural monuments in the center of the city still visibly project today a distinctive nineteenth-century sensitivity toward the past:

> The mistake [however] is to confuse history with antiquarianism, to define it as "the study of the past" rather than as a way of perceiving past, present, and future; art and science; man and nature; church and state; the good, the true, and the beautiful. History for the nineteenth century was no mere field of research, still less a way of escaping from the present, but a pervasive mode of thinking, a world view, a means of coping with and mastering the multitudinous facts, images, and ideas with which the contemporary consciousness was being bombarded.[11]

Freud's own urban environment, in fact, actually offered as much material evidence for rumination about the past's grip on the present as did ancient Rome. Taking a walk of about a half-mile from his offices, the Viennese doctor would have entered the circuit of traffic in the famed Ringstrasse, that broad and busy avenue (laid over the boundaries of the old city fortifications) which itself became

the symbol of the bourgeois (un)certainties of the waning years of Franz Joseph's Austro-Hungarian empire, the elliptical boulevard where the individual structures "float unorganized in a spatial medium whose only stabilizing element is an artery of men in motion."[12] As the pedestrian observer of his own city, rather than that of the Rome to which he never found his way, Freud would have passed many imposing art-historical monuments in which the high-cultural pursuit of securely mapping art's history was conducted daily under the auspices of a benevolent Hapsburg state: the Naturhistorisches Museum and the Kunsthistorisches Museum facing each other across a grand imperial square (the city designers once planned a link to the Hofburg Palace by way of a triumphal arcade over the roadway),[13] the university classrooms dedicated to the philosophical and scientific study of art and its history, and several smaller professional institutes, such as the Oesterreichische Museum für Kunst und Industrie (Austrian museum of art and industry), with its allied school of applied arts, the Kunstgewerbeschule (modeled on the South Kensington Museum of Arts and Crafts in London), in which the major art historians of Vienna – Franz Wickhoff, Alois Riegl, Julius von Schlosser, Max Dvořák, Josef Strzygowski, Hans Sedlmayr, and Otto Pächt, among many others – all seemed to play an administrative or pedagogical role at one time or another. "In an aesthetic culture dominated by history," as James Sheehan has pointed out, the institution of the museum had a "special claim to significance."[14]

In 1900, Viennese art history was in the ascendancy. The first International Congress of Art had been held in Vienna in 1873. In the last quarter of the century, the discipline had emerged as a respectable academic field of study, with the publication of several specialized journals, in addition to a number of monographs and handbooks that effectively canonized the accepted story of art.[15] Inspired by the historicist mood of the 1880s and 90s, as well as by the nineteenth-century passion for science, various institutes, and the historians and curators who worked in them, created, in effect, a specific kind of scholarship, which has long been identified by historiographers as the Vienna school of art history.

That "school," despite the often hostile interaction of its members (not coincidentally corresponding to its war years), bore a very distinctive stamp throughout its existence, which endured until the Anschluss, Hitler's annexation of Austria in 1938. Managing to combine an appreciation for the specificities of individual works of art with an impulse to theorize principles operative throughout the history of stylistic change, the historians of art associated with it were all formidable scholars indeed. Perhaps the best-known today to the English-speaking art-historical community are Alois Riegl and Max Dvořák. In several works written around the turn of the century, Riegl rescued several styles and genres of art from the oblivion to which they had been consigned by the repressive combination of nineteenth-century historicism and aesthetics. By abstracting from the history of art formative "laws" (such as his well-known *Kunstwollen*, or his Hegelian-derived dialectics of "haptic" and "optic") to explain the autonomous, immanent impulses behind the artistic productions of different

periods (especially that of ornament), Riegl in effect posited a "historical grammar" of evolutionary change.[16] Dvořák, who had an enormous impact on the study of "Kunstgeschichte als Geistesgeschichte" (art history as cultural history), an approach which still seems to be the major kind of art history practiced in Central Europe today, was both a well-known connoisseur and, later in his career, a theorist of social and stylistic metamorphoses.[17] His academic adversary Josef Strzygowski was one of the first historians of art in Europe to focus attention on the art of the Near East, and – in this being like his colleagues with whom he was so frequently in dispute – his concentration on evolutionary methods of cultural analysis (as opposed to philological) had a lasting influence.[18] Julius von Schlosser, the historiographer of the school who inherited Dvořák's position, also revived the positivist interest in source and document studies and became the teacher of Ernst Gombrich.[19] But that is already jumping too far ahead in this historiographic story of Viennese art history.

While it might be interesting to chart critically the interests, influences, and interactions of the many established scholars from this school over the course of time,[20] what I would prefer to do here is to enlist a specific issue in Viennese art history in its early "Renaissance phase" (to borrow Julius von Schlosser's revealing phrase)[21] to make a couple of larger points about the challenges of doing historiography in general. For the purposes of this essay, in other words, I want to take a synchronic (a look into one moment in time, circa 1900) as opposed to a diachronic approach (that might, say, chart the development of Viennese art history across four decades).

Writing the history of the "history of art" from either perspective involves more than a recitation of historical developments. First of all, if we are dealing with historians, we need to understand what their attitude to history (not to mention art) was. And in Vienna, this perspective was one fraught with public controversy as well as extreme ambiguity. Secondly, the societal constraints and intellectual repressions (someone once said that Vienna was the city in which psychoanalysis needed to be invented)[22] that made the field of study what it was must also be investigated. Despite the claims of scholarly objectivism, no historian of art ever wrote in an empiricist vacuum. Despite appearances, intellectual self-assurance is very often a defense against psychic and societal turmoil, both conscious and unconscious. Supremely self-confident about the nature of its objects and what constitutes the telling of the progressivist view of the history of art, the Vienna school was nonetheless prey to the vicissitudes of change and the spirit (as Musil says) of heresy and reform, as much as were the city's poets, painters, and politicians. And that brings me to my third, perhaps more subtle, Freudian point about writing historiography. The story of this one geographical branch of art history in one particular moment in time would not be especially interesting in and of itself if its concerns did not, ghost-like, continue to haunt the practice of the discipline today. What constituted the history of art was as much up for grabs at the beginning of the twentieth century as it is at its end. Attention to the cultural, artistic, and political ambience of one particular event in early Viennese art history tells us that it is so.

In 1900, the Secessionist movement was three years old. In March, when the president of the association and its leading painter, Gustav Klimt, exhibited the first of three paintings, *Philosophy*, commissioned for the ceiling of the Great Hall, or Aula, of the university (itself another eclectic Renaissance building complex on the Ring), a public furor arose.[23] His earlier work as a "decorator," in studio collaboration with a fellow graduate of the Kunstgewerbeschule, Ernst Matsch, had hardly prepared the conservative bourgeois public for what amounted to a drastic change of taste, not to mention ideology. Murals painted for the last two imposing buildings of the Ringstrasse, the Kunsthistorisches Museum and the Burgtheater (designed by Gottfried Semper and built by Carl Hasenauer), had been conceived in imitation of the "Old Masters," especially Raphael, and both painters had appropriately drawn their subjects from antiquity. The painters' success in the public arena is what landed them the university commission. To culminate the university building project (it had opened only a decade before, in 1883), the university governance (in the manner of all Renaissance princes) requested that the ceilings of its central hall (in the manner of all Renaissance palaces) be decorated with lofty allegories, in this case emblems of the four faculties, Theology, Philosophy, Medicine, and Jurisprudence. Matsch, who was to remain a successful society painter all his life, was awarded the central panel of Theology. The three secular faculties more fittingly went to Klimt.[24]

He began with *Philosophy* (Fig. 7). Intended by its patrons to represent the triumph of enlightenment over pagan darkness, Klimt turned that stolid academic vision on its head (in a painting which is now destroyed).[25] Alongside the impassive, amorphous, and androgynous figure of Wisdom, he portrayed a pillar of writhing naked forms cavorting in witless abandon, as mindless in their intertwining as the biting beasts on the trumeau at the Romanesque church at Souillac. The painted allegory was criticized in the popular press for many reasons, not the least of which were its overt female sexuality, its dismissal of classic canons of female beauty, its "colouristic nervosity," and its unabashed pessimism: "The picture shows how humanity, regarded merely as a part of the cosmos, is nothing more than a dull, unwilling mass, which in the eternal service of procreation is driven hither and thither as if in a dream, from joy to sorrow, from the first stirrings of life to powerless collapse into the grave."[26] Wilhelm von Neumann, the university chancellor, attacked it on the academic ground of Klimt's ignorance of higher learning: "In an age when philosophy [seeks] truth in the exact sciences, it [does] not deserve to be represented as a nebulous, fantastic construct."[27] This elitist sentiment was underhandedly echoed by the literary satirist Karl Krauss in the March 1900 issue of his journal, *Die Fackel*: "An artist who is not a philosopher has every right to paint Philosophy, but his allegory should portray what is painted in the minds of the philosophers of his time."[28] Were the latter to be the principal criterion for the choice of themes, the subject would have been a sober one indeed. At the time, Viennese philosophy was practically synonymous with the positivistic approach of the sciences, whereas Klimt's Schopenhauerian vision of the futility

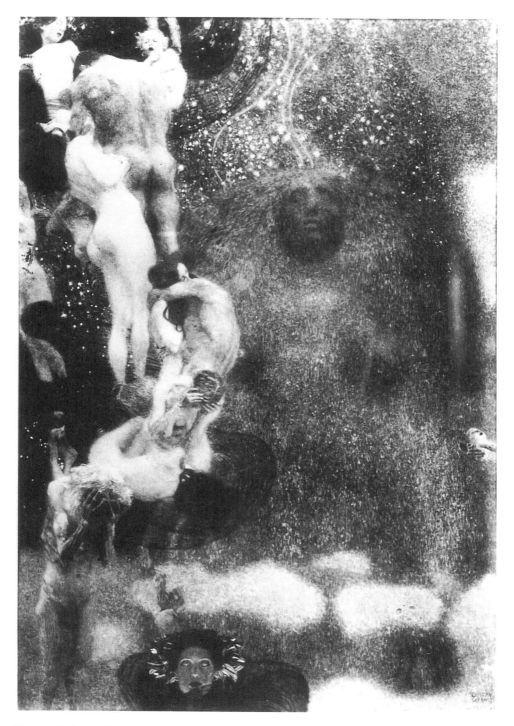

Figure 7. *Gustav Klimt*, Philosophy, *1899–1907. Oil on canvas. 13′11³/₄″ × 9′9″ (430 × 300 cm). Destroyed by fire 1945. Photo courtesy of Austrian National Library.*

of a commitment to either science or learning resulted in an image of archetypal mystery and misery.

Undaunted by his critics, among whom were some of the most powerful journalists and prominent academicians of the day, Klimt went on a year later to exhibit the second panel planned for the Aula ceiling, *Medicine* (Fig. 8).[29] Once again, all the accepted canons of taste were presumptuously violated, as an even more densely packed mass of naked humanity, some with decaying flesh, ascends upwards in his painting, away from the Byzantine figure of Hygeia, daughter of the god of healing, Asclepius. High priestess of the ambiguity of nature, Hygeia offers a crystal cup of water from Lethe (the river of the dead, of forgetfulness) to the thirsty snake encircling her arm. Above her and to the side, a self-absorbed naked woman thrusts her pelvis outwards, her cascading hair providing the cloud upon which the entangled masses take their suffering flight. Needless to say, a year had not softened the Viennese popular reaction: "The figures represented in these pictures might be suitable for an anatomical museum, not, however, for one of the public rooms of the university . . . where they must, on account of their crudeness of conception and aesthetic deficiency, offend the general public."[30]

Exasperated by this double pictorial blow to their professions, the vast majority of the faculty at the university, eighty-seven of them, went so far as to sign and publish a petition, the "protest of the professors," demanding that these brazen depictions ("unclear ideas [expressed] through unclear forms")[31] never appear in their hallowed halls. With the weight of academic conservatism behind it, this time the outcry reached the parliamentary chambers, leaving the liberal minister of culture, Wilhelm von Hartel, to defend the original commission on the ground of artistic license.[32]

Klimt's work, indeed the whole Secessionist aesthetic, however, was not without its politicized supporters. On one occasion a few laid a wreath in front of *Philosophy*, pompously inscribed with the motto of the movement (which was also inscribed in gold over the doorway of Olbrich's 1899 experimental Secessionist building), "Der Zeit ihre Kunst, der Kunst ihre Freiheit" (To the age its art, to the art its freedom).[33] And a few (though certainly not many) bold faculty members from the university, who also were associated with the imperial museums and art schools, came to Klimt's defense. It is at this juncture, in fact, that the story of the political reaction to the emerging modernist aesthetic intersects with the historiographic tale of the development of Viennese art history, which was in its origins quietly concerned with late antique art.

Before recounting that part of the tale, however, I want to make another historiographic point by combating outright a common assumption about what art history does or should do: the belief that it should stick with art. No less formidable a figure than Carl Schorske, the preeminent cultural historian of Vienna, is guilty of that charge. In his *Fin-de-siècle Vienna*, he offers an indirect caveat about the territory within which the discipline should confine itself. Speaking of the Klimt affair, he says:

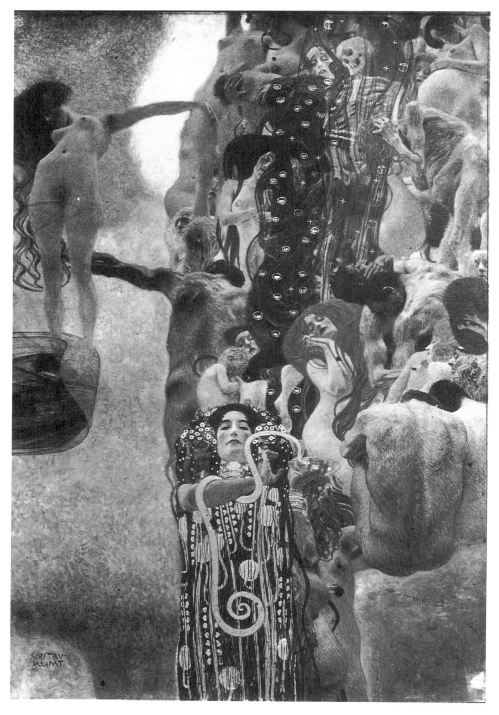

Figure 8. *Gustav Klimt, Medicine, 1900–7. Oil on canvas. 13'11³/₄" × 9'9" (430 × 300 cm). Destroyed by fire 1945. Photo courtesy of Austrian National Library.*

The crisis over the University paintings has its importance for art history in its impact on the development of Klimt's work. For the general historian, however, the artistic *cause célèbre* opens a window on a wider problem, the intricate relationship between culture and politics as the new century dawned. The strength of the reaction to "Philosophy" and the positions taken by Klimt's opponents and defenders reveals how deep was the crisis of rationalism within the Austrian élite. . . . When political issues became cultural, cultural issues became political.[34]

It is precisely this attitude toward the history of art as a discipline – that it should be concerned only with artistic development and not the "wider problem" of "culture and politics" – that has restricted the field to ancillary status. It is therefore incumbent on a subtle historiography to demonstrate to the contrary that the spirits and issues, both seen and unseen, that animated the rest of the ideological world in a particular time and place also somehow crept inside the framed work of art, or in some cases even originated at that pictorial site and worked outwards toward the culture at large.

Both directions of cause and effect played a role in the intellectual commitments of the Vienna school of art history. One of Klimt's most vociferous defenders was Franz Wickhoff, the esteemed chair of art history at the University of Vienna and, consequently, a member of the philosophy faculty. Away on a research trip to Rome when the controversy arose, Wickhoff returned to the fray and delivered a lecture at nine o'clock on the morning of May 15, 1900, to a packed audience in the Philosophical Society. While the address itself, entitled "What Is Ugly?," was never published, Hermann Bahr, a Secessionist partisan, provided a lengthy summary of its contents in his book of 1903 (actually excerpts from press releases) about the Klimt affair, entitled *Gegen Klimt* (Against Klimt), along with some chilling anti-Semitic reaction to both Wickhoff's lecture and Klimt's art.[35]

What surprised Wickhoff most about the accusations leveled against Klimt, he said in his opening remarks, was that the artist's university murals were "ugly." A strange mixture of nineteenth-century evolutionary theory and homage to Impressionist art, the lecture made the point that to use the beauty of the antique as a value against which to judge Klimt's iconography would be to use a criterion that had never been employed against Rembrandt, Velazquez, or Rubens. To equate beauty with the past was to ignore the visionary progressivism of contemporary art. With no frame of reference by which to judge the merits of this avant-garde work, popular opinion had condemned Klimt for exceeding common understanding, thus betraying the public's own limited view of the world. Wickhoff's sentiments echoed Bahr's own 1895 attack on the hegemony of naturalism in bourgeois Viennese art, in which he had argued, in a favorable review of Secessionist art, that to "paint red trees" was "neither against the laws nor against the customs of art" (using the examples of Leonardo and Raphael, who also painted things that "don't exist"), and, furthermore, that the visionary artists who did so were only serving "the most recent evolutionary

impulses and at last [satisfying] zealously and long-guarded desires."[36] In the
same vein, Wickhoff regarded, for example, the conservative condemnation of
the nebulous sphinxlike figure of Philosophy as simply benighted, for the rep-
resentation to his modernist eyes was apparently "full of consolation, and as
gleaming as the evening star."[37] Arguing for the primacy of authentic "natural"
expression in different historical eras, Wickhoff's lecture was above all about
cultural difference and consequently advocated a time-bound cultural aesthetics
which could be justifiably summarized by the Secessionist battle cry, "To each
age its art, to each art its freedom."

 Had the learned doctor himself not been engaged in breaking ground in icono-
graphic studies of Renaissance, and especially antique, illustrative cycles,[38] he
might not have been so prepared to recognize the value of Klimt's challenge to
inherited modes of representation. "A scholar of universal orientation and a
partisan of modern art," Wickhoff used the "authority of his office as holder
of the chair in art history" to opt against the classicizing impulses of his day.[39]
On several occasions, he had publicly championed the functionalist, engineered
architectural aesthetic of iron and steel over the eclectic historicism of the
Ringstrasse's rusticated palaces.[40] As an art historian rather than an architec-
tural critic, he was intrigued, actually, not so much by the *Jugendstil* of his con-
temporaries as by French Impressionism, and in 1895 he had borrowed the
concept of illusionism to revalidate the study of Roman art.[41] A concentration
on the late Roman representational world was in itself a revolutionary move,
with the antique in almost all other contemporary art-historical studies being
a serious study reserved only for the high classical art and architecture of Greece.
In putting forth a scholarly program that looked at period styles in terms of
their own artistic and cultural needs, rather than judging them against some
canon of classical perfection, Wickhoff was one of the first relativists of the
art-historical profession as well.

 One hundred years ago, he was commissioned to write a scholarly essay
for a facsimile edition of the *Vienna Genesis*, an early Christian manuscript
dating from the fourth century (see Fig. 9). His colleague Wilhelm von Hartel,
a philologist and professor of classics, who was to become minister of culture
during the Klimt affair (and who was indirectly responsible as well for Freud's
long-overdue promotion to a professorship in the medical faculty at the Uni-
versity of Vienna), had edited the biblical text in Greek.[42] Wickhoff's task was
to provide an introductory analysis of its accompanying Roman illustrations:
a presumably standard, and safe enough, task for any historian of ancient art,
especially one so effectively trained in Morellian principles of connoisseurship.[43]

 The way Wickhoff handled the assignment, however, was eventually to send
intellectual shock waves throughout twentieth-century art history. His claims
about this manuscript were not spectacular, but the conceptual route through
which he framed his argument about an art that was usually considered deriva-
tive, even decadent, was indeed unusual for the time. Openly borrowing some
conceptual categories from contemporary art, such as "illusionism" ("Granting
that the purpose of all art is to produce . . . the illusionist copy of reality, never-

Figure 9. *The expulsion from Paradise, from the Book of Genesis in Vienna, 4th century. Early Christian manuscript page, ink on vellum. Photo courtesy of Austrian National Library.*

theless the way in which this illusion is contrived at different times denotes a generic difference in the arts")[44] and the "demands of narration," Wickhoff argued that the late Roman manuscript illuminator's "remarkable" pictorial cycles ("as the text flows on the heroes of the narrative accompany it in a continuous series of related circumstances passing, smoothly and unbroken, one into another, just as during a river voyage the landscape of the banks seems to glide

before our eyes")[45] were responsive in their own stylistic way to a long-standing problem of how to illustrate the biblical text in a religious culture suspicious of the deceits of imagery. Viewed from the perspective of different, that is to say, nonclassical needs, this art necessarily violated classical norms of representation in its struggle to embody the "fantasy of the poetic situation":[46] "There was in the antique art of the Roman Empire a development along the ascending line, and not merely a decadence as is universally believed."[47]

Different times create different art. Wickhoff's fundamental thesis is straightforward enough, but to the historicizing Viennese world obsessed with the classical glories of Greece and the classicism of Renaissance humanism, the idea that all periods, indeed all cultures, should be valued for their own artistic merit was revolutionary. His fascination for the Japanese influence on Impressionist art led him into even more chronologically and geographically "removed" areas of study, and his 1898 study "The Historical Unity in the Universal Evolution of Art" actually investigated styles of ornament in Chinese bronzes and ceramics in order to prove the ultimately dubious (and, one might say, thoroughly inescapable historicist conviction) that "it truly is a single tradition that came full circle, and all art of the modern civilized nations can be traced back directly to the Greeks, whose influence spread in all directions."[48]

Wickhoff's commitment to the art of all peoples, his championing of contemporary art, his refusal (most times) to accept a standard of beauty against which to judge all the world's artistic productions, his scholarly investigation of arts usually considered minor (that is to say, manuscripts and the decorative arts), and his efforts to deduce "principles" of artistic change from the visual evidence all found a fuller expression in his more scholarly (and less political) successor, Alois Riegl. Riegl's work, of course, has received much more attention of late (with several books and translations recently appearing), so we need not dwell here on the meaning and considerable impact of his scholarship.[49] And to continue the story at this point would lead us into the diachronic narrative which I earlier promised we would avoid – one of the reasons for doing so being that tracing a dominant intellectual history across time is a more familiar historiographic protocol than plotting a particular (perhaps even less significant) historiographic moment back into its own "unconscious" context. There is no doubt, however, that synchronic and diachronic axes of historical investigation need cross each other at every historiographic moment.[50]

So where does that leave us? What kind of historiographic tale have I told? The answer, of course, is a preliminary story at most. What I would like to do by way of conclusion is to speculate on some other or deeper kinds of questions we might ask of this material. Just how far can historiography go? Everywhere, I would argue, from an exploration of the most physical or institutional explanations to the most metaphysical, or even psychoanalytic.

Much more time, for example, could be spent looking into the geographic locale and physical setting of this historical moment. Turn-of-the-century Vienna

was a very specific place at a very specific time. Its architecture, its urban spaces, its delineation through stone of what did or did not count as significant would be a most important consideration: "The Ringstrasse . . . is 'about' monarchy, empire, law, science, music, painting, sculpture, scholarship, order, joy, movement, commerce, war, industry, horticulture, thrift – not necessarily in that order."[51] And spaces, without a doubt, are envelopes of time and circumstance. The political situation of Austria in the waning days of the Hapsburg empire (as a social historian might look at it, on the one hand; or, on the other, as the days leading up to World War I) has much to do, for example, with which scholars held the major appointments, what they could or could not say in the public or academic arena, who directed the temples of high culture (the museums), and what kinds of art and artifacts were collected in them.

Whatever political or cultural or intellectual cause-and-effect narrative is constructed must then be sensitive to the complexity of the context, which is another way of saying that issues of conflict and contradiction have to be addressed. Looking into the university curriculum, for example, to see what kinds of subjects were taught and from what perspective would probably yield a complex array of difference. If the empirical sciences held the day, where do we locate Freud, and what do we have to say about the philosophy of history's indebtedness to the positivist paradigm? Who were the dissenters, what traditions of inquiry were coming to dead ends, what ones were opening up? What was the impact of female students, who were first admitted to the University in 1900, and why did the humanities and natural sciences draw increasing numbers of lower-middle-class students?[52]

The nineteenth century has been called the great age of historical science. If that is the case, how do we explain the poetic fascination with mysteries, the evocative archaeology of the past? And if the sacrosanct tenets of science and history were in strife and undergoing metamorphosis, how much more relevant for the historiography of art history is what was happening in all of the arts – with the invention of photography, the impact of the arts of the East, the genesis of nonrepresentational painting, the advent of a modernist aesthetic in functionalist architecture, the writing of satiric novels and essays of cultural malaise, the discovery of psychoanalysis, the popularity of coffeehouses for the dissemination of revolutionary ideas, the beginnings of atonal music, the practice of legal and logical positivism, the allied movements of Arts and Crafts, Art Nouveau, Secessionism, all going on at the same place at the same time.[53] The litany gains momentum. Where are the checks, the stopping-off points? In effect, just where the historiographer chooses to put them to construct his or her tale.

The list of possible areas of exploration can be inventoried, researched, analyzed, and then arrayed along a continuum of historical explanation. The topics' juxtaposition and ordering, in short (no matter how revealing it might be of the predispositions of the historian behind the history), would in all likelihood result in a responsible cultural history of fin-de-siècle Vienna, in which the Vienna school of art history would assume, like a small piece of a jigsaw

puzzle, its fitting place. But I prefer to think that there is still something more to the historiographic enterprise than artfully arranging that sort of surface array.

What I have in mind is the search for some underlying theme(s), something that beckons all the random bits and pieces of historical evidence to cohere around its ordering principle (whether they easily accept or not is another matter). For Carl Schorske, this Viennese unconscious was manifested in the "collective Oedipal revolt" of the sons over the historical outlook central to the late nineteenth-century attitudes of their fathers – "in music and philosophy, in economics and architecture, and, of course, in psychoanalysis."[54] The cultural historian can find evidence of this reaction everywhere, but one of the more sensitive registers of the psychic turbulence is located in the art of the period. In the novelist Musil's words,

> the just-buried century had painted like the Old Masters, written like Goethe and Schiller, and built its houses in the style of the Gothic and the Renaissance. The demands of the ideal ruled like a police headquarters over all expressions of life. . . . This illusion, embodied in the magical date of the turn of the century, was so powerful that it made some people hurl themselves with zeal at the new, still-unused century, while others chose one last quick fling in the old one, as one runs riot in a house one absolutely has to move out of, without anyone feeling much of a difference between these two attitudes.[55]

In one way or another, attitudes to the legacy of the nineteenth century seem to hold the key for unlocking both innovative expression in the arts and societal repression of changing behavioral values. Were I to explore the situation further, I think my metaphorical guide to the spirit of turn-of-the-century Vienna would be the psychoanalytic concept of melancholia. For Freud, the complex of melancholy (a state of unresolved mourning) behaves like an open wound, the consequence of a loss of an object that never heals.[56] For Musil (and, perhaps, Klimt, Wickhoff, the emperor Franz-Joseph, Freud, et al.), that ghostly object was the past, and the certainties it once upon a time brought with it. In the aftermath of loss, the typical Viennese citizen, "the man without qualities" as Musil calls him in the title of his novel, has been cast adrift:

> What he thinks of anything will always depend on some possible context – nothing is, to him, what it is; everything is subject to change, in flux, part of a whole, of an infinite number of wholes presumably adding up to a superwhole that, however, he knows nothing about. So every answer he gives is only a partial answer, evey feeling only an opinion, and he never cares *what* something is, only "how" it is – some extraneous seasoning that somehow goes along with it, that's what interests him . . . [standing] for nothing but this state of dissolution that all present-day phenomena have.[57]

The "coating of waltzes and whipped cream was the surface covering to a despair-ridden society,"[58] masking a nostalgia that one recent reviewer has called the

result "of a defunct empire, of a closed conditional: what was to happen did not."[59] The struggle against moral and aesthetic corruption was part of a much larger culture-critique of language, society, laws, norms, and so on, perhaps most fully embodied in the analytic philosophy of the Viennese thinker Ludwig Wittgenstein.[60] Consequently, the changes that took place in the Viennese school of art history have had a tendency in other cultural histories of the period to be overshadowed by the enormity of recognition granted other achievements in music, architecture, psychology, literature, urban planning, and so on. Yet the need to explore the limits and nature of language clearly did not originate with the publication of Wittgenstein's *Tractatus Logico-Philosophicus* just after World War I. The heated debates in art-historical circles about what constitutes both the science and the art of art-history writing provide complementary (and sometimes contradictory) insights into the psychic toll exacted when a culture (or a scholarly discipline) tries to forsake the past without acknowledging how present it always remains. The historiographic rebellion initiated by Wickhoff and Riegl needs to be plotted not only against the background of nineteenth-century historical understanding, but also against the crisis of representation animating the cultural and political universe at large.

To set either the Klimt affair (turmoil caused, after all, by the issue of how best to picture "philosophy") or the Viennese school of art history's preoccupation with deducing epistemological principles to explain stylistic change in the context of such an unconscious philosophical and cultural milieu promises to be an immensely interesting undertaking. And one, I also believe, well worthwhile. Why? Because historiographic study always reveals to us that writing the history of the history of art is never an uncomplicated, straightforward narrative event. And in reminding us of this, it sharpens our critical sensibilities when it comes to grappling with issues that visit us, like Freud's ghosts, from our own historiographic past.

At the end of this century, thinkers in a variety of fields worry anew over the status of memory, the power of oblivion, the return of the repressed. One symptom of this anxiety is the proliferation of models for rewriting history, literally telling time differently. The awareness that the metamorphosing meanings of culture, the past, art, even the ideological rationale for historical scholarship, are necessarily constructed and compromised through the practice of writing history has animated our field in recent years nearly to the extent that it once energized Viennese art history. At the other end of the twentieth century, we find ourselves in an intellectual and political predicament similar to the one in which the committed art historians of Vienna were once writing. There may yet be something to be learned from this one historiographic moment in the Viennese past.

Notes

1 Sigmund Freud, *Civilization and Its Discontents*, trans. James Strachey (New York: Norton, 1961), pp. 16–17.
2 Ernst Breisach, *Historiography: Ancient, Medieval, and Modern*, 2nd ed. (Chicago: University of Chicago Press, 1994), p. 2.

3 Dominick LaCapra, "Rethinking Intellectual History and Reading Texts," *Modern European Intellectual History: Reappraisals and New Perspectives*, ed. D. LaCapra and Steven L. Kaplan (Ithaca: Cornell University Press, 1982), pp. 56–78.

4 Clifford Geertz, "Thick Description: Towards an Interpretative Theory of Culture," *The Interpretation of Cultures* (New York: Basic, 1973).

5 Peter Burke, *New Perspectives on Historical Writing* (Cambridge: Polity Press, 1991), p. 240.

6 Among Hayden White's many essays and books on the topic, see *Metahistory: The Historical Imagination in Nineteenth-Century Europe* (Baltimore: Johns Hopkins University Press, 1973); *Tropics of Discourse: Essays in Cultural Criticism* (Baltimore: Johns Hopkins University Press, 1978); *The Content of the Form: Narrative Discourse and Historical Representation* (Baltimore: Johns Hopkins University Press, 1987).

7 Loewy was one of Sir Ernst Gombrich's early Viennese teachers, possessed of a "bold mind" that resulted in the publication in 1900 of *Die Naturwiedergabe in der älteren griechischen Kunst*, a book, according to Gombrich, that "contains most of what is worth preserving in evolutionism." In Gombrich's *Art and Illusion: A Study in the Psychology of Pictorial Representation* (Princeton: Princeton University Press, 1960), p. 22.

8 See *The Complete Letters of Sigmund Freud to Wilhelm Fliess, 1887–1904*, trans. and ed. Jeffrey Moussaieff Masson (Cambridge: Harvard University Press, 1985), letter of November 5, 1897. For Freud's continuing fascination with all things antique, see letters, for example, of January 30, February 6, and May 28, 1899.

9 Felix Salten, "The Vienna Route," in *The Vienna Coffeehouse Wits, 1890–1938*, trans. and ed. Harold B. Segel (West Lafayette, Ind.: Purdue University Press, 1993), p. 182.

10 Allan Janik and Stephen Toulmin, *Wittgenstein's Vienna* (New York: Simon and Schuster, 1973), p. 42.

11 Donald J. Olsen, *The City as a Work of Art: London, Paris, Vienna* (New Haven: Yale University Press, 1986), pp. 269, 296.

12 Carl E. Schorske, *Fin-de-siècle Vienna: Politics and Culture* (New York: Knopf, 1980), p. 36.

13 Olsen, *The City as a Work of Art*, p. 79.

14 James J. Sheehan, "From Princely Collections to Public Museums," in *Rediscovering History: Culture, Politics, and the Psyche*, ed. Michael S. Roth (Stanford: Stanford University Press, 1994), p. 177.

15 Ibid.

16 Alois Riegl, *Stilfragen: Grundlegungen zu einer Geschichte der Ornamentik* (1893), 2nd ed. (Berlin: Schmidt, 1923), recently translated by Evelyn Kain as *Problems of Style: Foundations for a History of Ornament* (Princeton: Princeton University Press, 1992), and *Spätrömische Kunstindustrie* (Vienna: K. K. Hof- und Staatsdruckerei, 1901).

17 Max Dvořák, *Das Rätsel der Kunst der Brüder van Eyck, mit einem Anhang über die Anfänge der hollandischen Malerei* (Munich: Piper, 1925); *Idealism and Naturalism in Gothic Art* (1918), trans. R. J. Klawiter (Notre Dame, Ind.: Notre Dame University Press, 1967); *Kunstgeschichte als Geistesgeschichte: Studien zur abendländischen Kunstentwicklung* (Munich: Piper, 1924). Also see his *Gesammelte Aufsätze zur Kunstgeschichte* (Munich: Piper, 1929).

18 Josef Strzygowski, *Orient oder Rom: Beiträge zur Geschichte der spätantiken und frühchristlichen Kunst* (Leipzig: J. C. Hinrichs'sche Buchhandlung, 1901).

19 Julius von Schlosser, *Die Kunstliteratur: Ein Handbuch zur Quellenkunde der neueren Kunstgeschichte* (Vienna: Schroll, 1924).

20 A very good initiation into this comparative study in English would be W. Eugene Kleinbauer's lengthy introduction to his *Modern Perspectives in Western Art History: An Anthology of 20th-Century Writings on the Visual Arts* (New York: Holt, Rinehart and Winston, 1971). This introductory essay also provides a valuable bibliographic and analytic survey of the historiography of art in general. See also *Kunstgeschichte: Eine*

Einführung, ed. Hans Belting, Heinrich Dilly, Wolfgang Kemp, Willibald Sauerländer, and Martin Warnke, 3rd ed. (Berlin: Reimer, 1988); Michael Podro, *The Critical Historians of Art* (New Haven: Yale University Press, 1982); and Michael Ann Holly, *Panofsky and the Foundations of Art History* (Ithaca: Cornell University Press, 1984).

21 Julius von Schlosser, in his "Die wiener Schule der Kunstgeschichte: Rückblick auf ein Sakulum deutscher Gelehrtenarbeit in Oesterreich," *Mitteilungen des Oesterreichischen Instituts für Geschichtsforschung* 13 (1934): 145–228, divides Viennese art history into phases, beginning its prehistory with the early nineteenth-century historian Rudolf von Eitelberger (founder of the Austrian Museum for Art and Industry) and ending with as-yet-unnamed heirs. Its "Renaissance" is represented by the work of his teacher Franz Wickhoff and Wickhoff's successor, Alois Riegl.

22 Peter Vergo, *Art in Vienna, 1898–1918: Klimt, Kokoschka, Schiele, and Their Contemporaries*, 3rd ed. (London: Phaidon, 1993), p. 15.

23 For a good summary of the controversy, see ibid., pp. 49–62. For a fuller account of the decade-long commission, see Alice Strobl, "Zu den Fakultätsbildern von Gustav Klimt," *Albertina Studien* 2 (1964), 138–69.

24 The story of the controversial commission, as well as Klimt's deteriorating relationship with Matsch, is recounted in many sources. See, for example, several recent monographs on Klimt: Gabriella Belli, *Gustav Klimt: Masterpieces* (Boston: Little, Brown, 1990); Gerbert Frodl, *Klimt*, trans. Alexandra Campbell (New York: Holt, 1992); Susanna Partsch, *Klimt: Life and Work*, trans. Charity Scott Stokes (Munich: International Publishing, 1993).

25 Along with the third painting, *Jurisprudence* (executed 1903–7), *Philosophy* and *Medicine* were reportedly destroyed in 1945, when retreating SS troops burned the Schloss Immendorf, where they had been stored for safekeeping (Vergo, *Art in Vienna*, pp. 61–2).

26 The anonymous reviewer for the periodical *Die Kunst für Alle*, 15 (1900), p. 500, is cited by Vergo, *Art in Vienna*, pp. 53–4.

27 Paraphrased in Schorske, *Fin-de-siècle Vienna*, p. 232.

28 Frodl, *Klimt*, p. 46.

29 Klimt even won an award for the painting once it had left the Secession exhibition in Vienna. In Paris that spring it was awarded the Grand Prix at the Exposition Universelle. See Vergo, *Art in Vienna*, p. 57.

30 Accounts of the reception are to be found in Hermann Bahr, *Gegen Klimt* (Vienna: Eisenstein, 1903). Some are quoted by Vergo on p. 58.

31 "Verschwommene Gedanken durch verschwommene Formen." Schorske, *Fin-de-siècle Vienna*, p. 232. Parts of the petition are reprinted in Strobl, "Zu den Fakultäts bildern von Gustav Klimt," pp. 152–4.

32 Hartel, as Schorske points out in a footnote, was an "exemplary" member of the "cultivated liberal bureaucracy." Before he became minister of culture, in the last five years of the century he had been "section chief in charge of university and secondary schools. He played a key role in opening university study to women, and in dealing patiently with nationalist student unrest. Like many other progressive liberals, Hartel was a fanatical Wagnerite but had no patience with anti-Semitism. In the face of anti-Semitic attacks in Parliament he defended the award of a literary prize to Arthur Schnitzler" (*Fin-de-siècle Vienna*, p. 238). Also see A. Engelbrecht, "Wilhelm Ritter von Hartel," *Biographisches Jahrbuch für Altertumswissenschaft* 31 (1908), 75–107.

33 Vergo, *Art in Vienna*, p. 57. All of the older museums had been modeled on Renaissance palaces; the model here was a pagan temple.

34 Schorske, pp. 231–2.

35 See, for example, an essay from the *Deutsches Volksblatt* (*Gegen Klimt*, pp. 34–6). The undercurrent of Viennese anti-Semitism is one that certainly deserves study. The charges against Gustav Mahler, the well-known composer and director of the Imperial Opera, which resulted in his ignominious exile, would be an apt place to start. "Perhaps the strangest paradox of Viennese life," according to Janik and Toulmin, "is the fact that

the politics of both the Nazis' Final Solution and the Zionists' Jewish state . . . sprang up there" (*Wittgenstein's Vienna*, p. 58).

36 Bahr's "Rothe Bäume" originally appeared in *Die Zeit* on January 5, 1895. For an evaluation of Bahr as literary, drama, and art critic, see Donald G. Daviau, *Hermann Bahr* (Boston: Twayne, 1985). Excerpts, from which this quotation is taken, appear in *The Vienna Coffeehouse Wits*, pp. 52–3.

37 Bahr, paraphrasing Wickhoff, in *Gegen Klimt*, p. 34.

38 In his "Bibliothek Julius II," Wickhoff actually compares the allegorical program of Raphael's decoration of the Segnatura to the ongoing university commission. *Jahrbuch der Königlich Preussischen Kunstsammlungen* 14 (1893): 49–64.

39 Gert Schiff, in his introduction to *German Essays on Art History*, ed. Schiff (New York: Continuum, 1988), pp. xlii–xliii.

40 Cited in Udo Kultermann, *The History of Art History* (New York: Abaris Books, 1993), from an unnamed source: "Many of the despised products of modern industry – train stations, large bridges, huge iron constructions – are far more impressive than most actual works of architecture. The new style that architecture is forever in search of has already been created, and we would do better to have engineers build our buildings these days than architects" (p. 160).

41 Franz Wickhoff, *Die Wiener Genesis, Jahrbuch der Kunsthistorischen Sammlungen des Allerhöchsten Kaiserhauses*, with Wilhelm Ritter von Hartel (suppl. to vols. 15–16, 1895), trans. and ed. Mrs. S. Arthur Strong as *Roman Art: Some of Its Principles and Their Application to Early Christian Painting* (New York: Macmillan, 1900). In his paean to the Viennese school, *Die wiener Schule der Kunstgeschichte*, Julius von Schlosser argues that Wickhoff, his teacher, used the concept of Impressionism to combat the positivism of his day, in the same way that "illusionism" became a resource for cracking open the hold that Greek idealism had had on aesthetic understanding (p. 177).

42 Wickhoff and von Hartel, pp. 1–13. An English translation appears in the Strong book, *Roman Art*, cited in n. 41. For part of the story, see Schorske, *Fin-de-siècle Vienna*, pp. 237–8, 244–5.

43 Von Schlosser, in his *Die wiener Schule der Kunstgeschichte*, points out that despite being very astute in Morellian observation, Wickhoff possessed an almost contrary will against the purely formal consideration of works of art (p. 178). This did not stop the Italian art historian Giovanni Morelli from claiming that Wickhoff was his best disciple, probably because he was responsible for disseminating ideas about connoisseurship to the German-speaking world. See Kultermann, *The History of Art History*, p. 160. Also see Dvořák's synopsis of Wickhoff's and Riegl's contributions to art history in his *Gesammelte Aufsätze zur Kunstgeschichte*. For Freud's admiration for Morelli and his principles of detection, see Carlo Ginzburg, "Morelli, Freud, and Sherlock Holmes: Clues and Scientific Method," trans. Anna Davin, *History Workshop* 9 (1980): 5–36.

44 Wickhoff, *Roman Art*, p. 18.

45 Ibid., p. 8.

46 Wickhoff, *Wiener Genesis*, p. 4.

47 Wickhoff, *Roman Art*, p. 17.

48 An excerpt, translated by Peter Wortsman, is anthologized in Schiff, *German Essays on Art History*, pp. 165–72. What is interesting to the historiographer, I would argue, are precisely the contradictions and inconsistencies in historical arguments, for it is there that one can locate a perspective in the process of formation. In Wickhoff's case, we have to try and reconcile his 1898 claims about universality with his 1900 assertions about the merits of different traditions.

49 See Alois Riegl, *Problems of Style*; Margaret Olin, *Forms of Representation in Alois Riegl's Theory of Art* (University Park: Pennsylvania State University Press, 1992); Margaret Iversen, *Alois Riegl: Art History and Theory* (Cambridge: MIT Press, 1993). Also see Podro, *The Critical Historians of Art*, and Holly, *Panofsky and the Foundations of Art*

History, for chapters on Riegl. For Riegl's more subdued reaction and activity on behalf of the "Klimt affair," see Olin, p. 219 n. 40. For Riegl's assessment of Wickhoff's contribution (before him "the latest phase of ancient art [was] a dark continent on the map of art historical research"), see his *Late Roman Art Industry* (1901), trans. Rolf Winkes (Rome: Bretschneider, 1985), p. 6.

50 Suffice it to say that the Vienna school maintained its grip on the art-historical imagination for several decades: for example in the work of the Baroque art historian Hans Sedlmayr, who posited two "sciences" of art history, one concerned with the physical object per se, and one with the conceptualization of its significance (Sedlmayr, *Verlust der Mitte: Die bildende Kunst des 19. und 20. Jahrhunderts als Symptom und Symbol der Zeit* [Salzburg: Müller, 1948]; for a translation, see *Art in Crisis: The Lost Center*, trans. Brian Battershaw [Ann Arbor: University Microfilms International, 1980]). By the 1930s, however, the community of thinkers was enmeshed in considerably different political circumstances. By that time it (or, rather, a couple of its practitioners) had come in for serious criticism for what was perceived to be an undercurrent of racism, and the legacy of its first generation of scholars was lauded at the expense of its later exponents. Meyer Schapiro, who, in a 1936 review essay for *Art Bulletin* entitled "The New Viennese School," praised the contemporary Viennese historians for being much more theoretically sophisticated than his American colleagues, returned to the earlier generation of Viennese scholars to remind his readers of the historical strength of the school, which lay "in the intensity and intelligence with which they examine[d] formal arrangements and invent[ed] new terms for describing them." Schapiro, "The New Viennese School," review of *Kunstwissenschaftliche Forschungen*, vol. 2, ed. Otto Pächt (Berlin: Frankfurter, 1933), in *Art Bulletin* 18 (1936): 258.

51 Olsen, *The City as a Work of Art*, p. 285.

52 See Gary B. Cohen, "Ideals and Reality in the Austrian Universities, 1850–1914," in *Rediscovering History*, ed. Roth, pp. 86–9.

53 In Olsen's eulogistic characterization, "The Ringstrasse provided the stage for the intellectual and artistic achievements that made Vienna, in the years just before 1914, our century's nearest approach to the Athens of Pericles, or the Florence of the Medici" (*The City as a Work of Art*, p. 239).

54 Schorske, *Fin-de-siècle Vienna*, p. xviii.

55 Robert Musil, *The Man without Qualities*, trans. Sophie Wilkins (New York: Knopf, 1995), pp. 52–3.

56 Freud, "Mourning and Melancholia" (1915; publ. 1917), trans. and excerpted in Peter Gay, *The Freud Reader* (New York: Norton, 1989), pp. 584–9.

57 Musil, *The Man without Qualities*, p. 64.

58 Janik and Toulmin, paraphrasing Musil, *Wittgenstein's Vienna*, p. 64.

59 Michael Hofmann, review of *The Man without Qualities*, *New York Times Book Review*, May 14, 1995, p. 27.

60 This is, of course, precisely the point of the study of Wittgenstein's cultural history by Janik and Toulmin: " 'The limits of reason' " argument "was the starting point of the whole debate about language and values, which came to a head in the Vienna of 1890–1914" (*Wittgenstein's Vienna*, p. 148).

Part Two

The Subjects and Objects of Art History

4

Seeing Signs

The Use of Semiotics for the Understanding of Visual Art

Mieke Bal

SEMIOTICS is the theory of signs and sign use, including *seeing* signs. It is not a historical but rather a hermeneutic discipline, but it can be usefully integrated within historical inquiries. Semiotics focuses on construction and representation, considering "texts" as specific combinations of signs yielding meaning. This is a limited perspective without imperialistic claims; I propose it here as a helpful additional instrument, not as the one theory that should replace all others.

Trying to understand how images affect viewers in today's image-saturated culture, I have found semiotics helpful as a perspective, a set of conceptual tools, and a caution. As a perspective, it helps to consider a work of visual art as an object whose relevance derives from the processes in which it functions. Thus it takes art out of a formalist and autonomist idealization and takes the work as dynamic. Simultaneously semiotics also privileges meaning and the ways in which meaning is produced, considering aspects and details as signs rather than forms or material elements only.

As a set of tools, semiotics offers concepts that I find useful for the detailed analysis of works. While these concepts might originate in psychoanalytic, narrative, and rhetorical theory, they yield insights that are not in contradiction with traditional art history. In fact, they often enable the student to be more precise, and to formulate interpretations in intersubjectively accessible ways. In this chapter I can give only a few examples of such concepts semiotically employed.[1] As a caution, finally, it helps avoid fallacies such as excessive realism, intentionalism, and nonreflexive projection of anachronistic preoccupations authorized as "historical."

A Semiotic Perspective: Peirce

According to Charles S. Peirce, the process of semiosis works through three positions: a perceptible or virtually perceptible item – the sign, or *representamen* – that stands in for something else; the mental image, called the *interpretant*, that the recipient forms of the sign; and the thing for which the sign stands – the *object*, or *referent*.[2] When one sees a painting, say a still life of a fruit bowl, the image is, among other things, a sign, or representamen, of something else. The viewer shapes in her or his mind an image of that something with which she or he associates this image. That mental image, *not the person shaping it*, is the interpretant. This interpretant points to an object. The object is different for each viewer: it can be real fruit for one, other still-life paintings for another, a huge amount of money for a third, "seventeenth-century Dutch" for a fourth, and so on. The object for which the painting stands is therefore fundamentally subjective and reception-determined.

Peirce's famous definition of the sign runs as follows:

> A sign, or *representamen*, is something which stands to somebody for something in some respect or capacity. It addresses somebody, that is, creates in the mind of that person an equivalent sign, or perhaps a more developed sign. That sign which it creates I call the *interpretant* of the first sign. The sign stands for something, its *object*. It stands for that object, not in all respects, but in reference to a sort of idea, which I have sometimes called the *ground* of the representamen. ("Logic as Semiotic," in Innis 1984: 9)

The structure of address of the sign has been taken up by speech-act theory;[3] the "more developed sign" points at the complex acts of interpretation, e.g., in scholarly work; the "ground" can be seen as the basis on which the interpretation takes place, and comes closest to the more common concept of *code*.

As for the process, the interpretant is constantly shifting. As soon as the mental image takes shape, it becomes a new sign, which will yield a new interpretant, and we are in the middle of the process of *semiosis*. None of the aspects of this process can be isolated from the others, which is the reason why this theory is incompatible with any dichotomistic theory of the sign, such as Saussure's pair signifier/signified. Peirce insists that the thing that becomes a sign only does so when it begins to evoke its interpretant: "A *Sign* is a Representamen with a mental interpretant." Peirce's interpretant, although presented as a mental image and therefore carrying the burden of mentalism, can be redefined as radically social in origin. For the Peircean *ground* without which no interpretant can occur, is, precisely, a *common ground*.[4]

A primary division of the field of semiotic inquiry is based on the relations between the elements of semiosis. The relation between the sign and the ground leads to grammar, whose most commonly studied aspect is syntax. The relation between sign and object leads to questions of meaning, or semantics. The relation between sign and interpretant can be linked to questions of rhetoric

as part of pragmatics by virtue of the idea that one thought brings forth another. This division into three fields of inquiry is more common in linguistics than in art criticism. Pragmatics would be the dimension where the affective efficacy of a work is examined; semantics includes any hypothesis about the meaning of a work; syntactics studies the relations between elements of the work to codes or ways of producing meaning.

Although many of Peirce's elaborate typologies of signs derived from this basic theory have not been commonly taken up by art critics, the most famous of these – *icon*, *index*, *symbol* – is popular. Peirce's own definitions matter, because this typology is frequently misunderstood.

> An *icon* is a sign which would possess the character which renders it significant, even though its object had no existence; such as a lead-pencil streak as representing a geometric line. An *index* is a sign which would, at once, lose the character which makes it a sign if its object were removed, but would not lose that character if there were no interpretant. Such, for example, is a piece of mould with a bullet-hole in it as a sign of a shot; for without the shot there would have been no hole; but there is a hole there, whether anybody has the sense to attribute it to a shot or not. A *symbol* is a sign which would lose the character which renders it a sign if there were no interpretant. Such is any utterance of speech which signifies what it does only by virtue of its being understood to have that signification. (Innis 1984: 9–10)

First of all, any identification of icon and the entire domain of the visual is mistaken. As Peirce clearly states, the iconic is a quality of the sign in relation to its object; it is best seen as a sign capable of evoking nonexistent objects because it proposes to imagine – as an *interpretant* – an object similar to the sign itself. Iconicity is in the first place a mode of reading, based on a hypothetical similarity between sign and object. Thus, when we see a portrait by Frans Hals, we imagine a person looking like the image, and we do not doubt the existence, in the time of Hals, of such a person; we do not demand substantiation of that existence by other sources, because we adopt the iconic way of reading when we look at portraits.

But the example of portraits might wrongly suggest that the icon is predicated upon the degree of "realism" of the image. An abstract element like a triangular composition can become an iconic sign whenever we take it as a ground to interpret the image in relation to it, dividing the represented space into three interrelated areas (Leo Steinberg, for example, makes this division in his paper on *Las Meninas* [1981]). A red field in a painting by Elsworth Kelly *is* not only so red it shimmers before your eyes, but also *means* "the color red" as well as "what red does or means to you." Instead of visuality in general, or realism for that matter, the decision to suppose that the image refers to something on the basis of likeness is the iconic act, and a sense of specularity is its result. A romantic sound of violins accompanying a love scene in a film is as iconic as the graphic representation of Apollinaire's poem about rain in the shape of rain.

The concept of index is implicated in analyses of subjectivity.[5] Peirce's description of the index emphasizes its symmetrical opposition to the icon: while the icon does not need the object to exist, the index functions precisely on the ground of that existence. His example suggests that real, existential contiguity between indexical sign and object (or meaning) is indispensable. But that existence need not be confined to "reality"; the indexical sign and its meaning can entertain such a contiguous relationship within the image itself.

The many recent publications on the gaze and the look which take the represented look of the figures in the painting as their starting point, for example, implicitly state that there is an indexical relationship between the look and what is looked at. The represented voyeur looking at the nude body of a woman is an effective figure precisely because he stands for a real, objectifying contiguity between look and object defined by looking as a real act. The index functions here in conjunction with the icon: the figure directing his eyes somewhere is taken to stand for a similar figure: a man looking at a woman. In the same way, the open mouths, iconically suggesting screams, of the popes in Francis Bacon's early portraits after Velazquez function iconically because they also function indexically; the contiguity between screaming and the pain that induces it enhances the effectiveness of the works.[6]

The most obvious use of the concept of index is the pointer. Pointing elements in an image are the most convincing case against the notion that the image is still and can be "read" in a momentary, punctual act. Pointers make us aware of the way our eyes move about the surface in different directions, some of which are suggested by indexical signs. When a figure points a finger in a certain direction, our look will follow the figure's directions. In language, elements of *deixis* that have no meaning outside the discourse are indexical (I and you, here and there, yesterday, tomorrow, etc.).

Precisely as an antidote to an unwarranted conflation of icon and visuality, the third of Peirce's signs, the symbol, can be very useful. The symbolic sign produces meaning, not through an existential (index) or analogous (icon) relation to its objects, but on the basis of convention. Language is primarily a symbolic system. But Panofsky already argued that even such a "naturalizing" device as linear perspective is fundamentally symbolic. Symbolicity works by means of recognition. It is useful to realize how much of a visual image we can process because we have seen elements, structures, poses, colors, compositional elements of it before, in other works making use of the same stock of elements the history of art has produced, and then reusing them, made conventional. But recognition of forms is not what makes viewers interpret the images; it is assigning meaning to them, "reading" them, that we make them work as signs.

Semiotic Tools: Narrative

Accounts of narrative in visual art tend to focus on the question of how images are able to narrate stories.[7] Although such accounts have great usefulness, the

underlying presupposition seems to be that images are a priori handicapped in this competition; narrating is primarily a matter of discourse, not of visuality. But from a semiotic perspective, various theories of narrative have been developed which can be brought to bear on visual art, without presupposing that narrative is somehow a foreign mode in visual art. Perhaps the best-known example of such a theory is the one implied in Barthes's famous book *S/Z*.[8] Barthes develops an interpretation of Balzac's short story "Sarrasine" through an analysis of five codes which the reader allegedly activates when reading this story. The essay is attractive because it is reader-oriented while placing the act of reading within cultural constraints.

The *prorairetic* code is a "series of models of action that help readers place details in plot sequences: because we have stereotyped models of 'falling in love,' or 'kidnapping,' or 'undertaking a perilous mission,' we can tentatively place and organize the details we encounter as we read."[9] In a way this is a narrative version of an iconographic code.[10] The *hermeneutic* code presupposes an enigma and induces us to seek out details that can contribute to its solution. There is a hermeneutic code at work for the viewer precisely when an image's subject is hard to make out. The *semic* code inserts cultural stereotypes, "background information" that the viewer brings in to make sense of figures in the image in terms of class, gender, ethnicity, age, and the like. With the help of the *symbolic* code the viewer brings in symbolic interpretation to read certain details, for instance "love," "hostility," "loneliness," or, for that matter, "theatricality," "vanitas," or "self-referentiality." Finally, the *referential* code brings in cultural knowledge, such as the identity of the sitter for a portrait, the program of an artistic movement, or the social status of the figures represented. Together, these (and other) codes produce a "narrative," as a satisfying interpretation of the image in which every detail receives a place. This narrative is emphatically produced by the reader to deal with the image; it produces the story through the processing of a strange image into a familiar mindset.

The intertwining of codes produced by earlier discourses of a culture makes Barthes's approach congenial with Bakhtin's theory of narrative.[11] Barthes starts from the receiver, the reader (or viewer) of the work. Bakhtin's concept of polyphony, the intertwining of different voices in the novel, resulting in *heteroglossia*, or the cacophony of incongruous strands of cultural discourses, takes the same issue up from the other side, the side of the sender or writer, in our case the maker of the image. The major gain this view of semiotics yields for our purposes is the awareness that the image is not unified. Indeed, classical art criticism and history have tended, just like literary studies, to seek the interpretation that accounts for each and every detail of the work within the same framework. Thus details that do not fit are ignored or set aside as unimportant or as "mistakes," evidence of a foreign hand, of studio practice, ultimately discounting the work as nonautographic rather than contributing to a heteroglossic view of the work. Bakhtin helps us to accept that even when the image is made by one artist, the inherent heterodiscursive nature of the culture of which this artist is a product necessarily brings in elements of alterity, if only to be repressed

to the margins. Thus an image that overtly represents the intervention of women in a fight between men, such as David's *Sabine Women* (Paris: Louvre), cannot help inserting indexes of homosexual interest.[12]

In spite of the importance of Barthes's and Bakhtin's insights into the various factors that collaborate or compete to produce narrative, the one factor that keeps slipping away is the traffic of meaning from source to destination and back. In traditional narrative theory, the concept of the narrator as the source of information or the utterer of the speech act of narrating has favored a model of a unified voice: one narrator determines what the reader is going to get. Replacing the author by the narrator, or the artist by an implied orchestrator of the image, does not really help in understanding the various signs at work in an image.

Attempts to atomize the informational sources of narrative in view of a semiotic conception of texts may be more useful. One such attempt distinguishes among three narrative agents: the *narrator* or speaker, source of the utterance, the *focalizer* or source of the vision presented in the utterance, and the *actor* or agent acting out the fabula (the sequence of events presented).[13] This model allows for integration of two important views: the idea that signs are organized, and the possibility of "the difference within."[14] Precisely because the narrators of a text hold discursive power, they are also able to embed the vision of somebody else, as in the sentence "She saw that he noticed that the lipstick on his collar had not escaped her." Here one narrator conveys three views, embedded like Russian dolls, and each based on signs positioned on different levels: in the fabula, two actors are confronted, one of whom, the woman, constructs on the basis of a sign of facial expression that the other, the man, has in turn constructed, on the basis of the sign of her own facial expression, a third construction, the sign of lipstick on his collar, which he may up till then have been unaware of himself.

In this structure of embedding, one voice conveys in a single discourse a visual dialogue that seems typical of language. In fact, something like Free Indirect Discourse, where not just the vision but even aspects of the voice of another figure are embedded in the narrator's monological voice, might seem impossible in visual images, where this hierarchical ordering is replaced with the presence of all elements of the configuration of subjects on the one surface. Yet this is a deceptive unification of the status of the various elements.

What this view of narrative suggests, then, is that the act of looking at a narrative painting is a dynamic process. The viewer moves about the surface to anchor his or her look at a variety of positions. These positions are not just alternatives, as a pluralistic view would have it, but are interrelated and embedded.[15] The semiotic nature of this model emphasizes the sign status of the elements involved in this kind of reading. The atomization of narrative within a discursive order – the integration of pluralization with embeddedness – allows for an account of ideology that breaks away from monolithic readings without falling back into an "innocent" relativism. Thus those paintings by Anselm Kiefer which have disturbed some viewers because of their allusions to Nazism, while being

hailed by others as a critique of fascism, can be seen as a visual debate *with* Nazism. This dialogic approach refuses to silence, ignore, repress, and thereby conserve fascism today. By integrating another partner in this debate, the tradition of linear perspective, that emblem of realism and objectivity, Kiefer's works also signify the complicity of art with politics. The suggestion is that perspective and the scientific pursuit it stands for collaborate with the fascist tendencies that an obliteration of the Nazi past facilitates. The resulting narrative presents a highly complex account of both fascism and painting, within which the various possible focalizers take their share in the production of meaning. The narrative of the paintings is constituted by the tensions between these focalizers.[16]

Narrative semiotics does not merely identify subjects within the image and their relations of embedding; it also allows us to specify the nature, place, and effectiveness of each subject's agency. It provides a possibility for reading images against the grain of the alleged opposition between discourse and image by interpreting elements as signs of negation, as signs of syntactical connection, as signs of causality. Most important, narrative semiotics provides insight into visual narrative, as distinct from visual allusions to verbal narratives.

It is crucial to keep in mind that narrative is not a one-sided structure. Address, the ways in which a viewer is invited to participate in the representation, is perhaps the most relevant aspect of a semiotics of subjectivity. According to the linguist Emile Benveniste (1971), language inscribes the subject of discourse as the implicit "I" who speaks. Certain linguistic categories, like, precisely, "I" and its correlate, "you," but also other elements such as pronouns and adverbs like "here' or "yesterday," have no referential value but only mean in terms of the discourse itself. Thus the subject of discourse is defined by these *deictic* words, whether or not she or he is the same person as the speaker who conveys the speech, say, the narrator. The noncoincidence between the speaker and the subject of the discourse is precisely the condition of possibility of narrative. The equivalent of "I" in a painting is often the figure whose act of looking is represented, thereby suggesting participation in a story: "I" takes the shape of an "eye." But that story involves the onlooker as well. If Manet's *Olympia* scandalized its contemporary viewers, we now say it was because, precisely, the woman participated too fully in her own display; rather than contenting herself with being the "third person" whose body was objectified in an impersonal narration for the sake of the onlooker, this woman looks actively at the viewer, so much so that her objectification is scandalously annihilated, and the viewer, who is now no longer the "I" who can take possession of the woman, is offered the position of the "you" hailed by the woman and held accountable for the act of looking.[17] For any "I" implies a "you" whom it addresses. The French philosopher Louis Althusser claimed that this address, this "hailing," constitutes the subject in ideology: It forms the subject as what the "ideological state apparatuses" wish the subject to identify with. However much autonomy a particular viewer may have (or assume to have) in front of a painting, according to this theory subjectivity is always produced at least by the interaction between the "I" of the work and the "you" this "I" addresses (Althusser 1971, 1977).

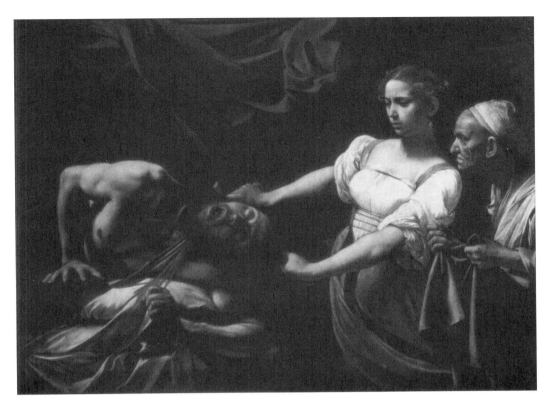

Figure 10. *Michelangelo da Caravaggio,* Judith Beheading Holofernes, *1598–9. Oil on canvas. Galleria Nazionale d'Arte Antica, Palazzo Barberini, Rome. Photo courtesy of Nimatallah/Art Resource, New York.*

Semiotics as Caution: Reading Images

How can a semiotic perspective and semiotic tools help to *read* images: to see them as sets of signs carrying meaning, not as realistic representations or deterministically fixed products of outside elements? How can semiotics serve to estrange us from what we already (think we) know, in order to see something new? I will use the case not of one image or artist but of a cultural topos that travels through history, yet is always historically anchored. I have chosen the story of Judith, projection screen for our culture's gynophobia and (for that reason?) occasion for endless numbers of images throughout Western art. Caravaggio and Gentileschi painted some that are rightly famous. I will not go into all the obvious, and obviously important, historical data and visual elements that have been brought to bear on our understanding these images; I will just limit the discussion to a couple of *signs*.[18]

First, the Caravaggio (Fig. 10). The image is clearly not unified; it is unequal

in its treatment of the protagonists. Between the women, the contrast in age is emphasized. Between Judith and Holofernes, the contrast is more complicated. Garrard mentions the tendency, at the time, to turn Holofernes into a tragic hero (1988: 291) as well as the incapacity on the part of the painter to identify strongly enough with a woman character to flesh her out with the same level of human interest; as a result, she alleges, Judith is not dramatically involved in the scene. So far so good; this is a reasonable art-historical interpretation. But then a problem occurs: "Caravaggio's rendering of such aesthetically imbalanced types – the female conventional, the male real – is less likely to be explained by Renaissance art theory or Jesuit theology than by the influence of gender on the practice of an artist who happened to be male" (ibid.). This seems an implausible dualism between male and female, verging on essentialism, especially in the case of an artist who represented male figures as explicitly androgynous or inscribed them with the signs of femininity. It is hard to maintain, without further exploration of nuances, that Caravaggio as an artist just "happened to be male," as if there were just one kind of masculine identity, and to ignore the possibility of artistic results of homosexual subjectivity.[19] It is, moreover, essentialist and simplistic to explain his representations of men and women figures through his biological sex. More important for my little demonstration, this statement projects this essentialist view on artistic subjectivity through a realist argument: although the phrase used is "aesthetically imbalanced types," the measure of this imbalance is realism: "the female conventional, the male real." Semiotics can help overcome this realism-cum-essentialism.

To that effect, I propose we make more of a pictorial detail that the Judith image insists on in several ways; a detail I consider as a sign in order to see how that helps me read the image. Then another interpretation becomes possible. The sign I am alluding to consists of the blood spurting out of the victim's neck. It is a powerful sign, because it is a conjunction of icon, index, and symbol. The red color is iconic, imposing the similitude between paint and blood. The direction is indexical: It comes out of the victim's body, is part of him. The symbolic nature of the association red/blood increases the effect and strengthens the realistic illusion. Yet this realism is immediately undermined. This blood draws realistically implausibly straight stripes of red set off emphatically on the flesh of the body, then on the white pillow and sheet. The blood is so emphatically detached from the body it could be expected to soil that the spurts leave a shadow on the neck. This sign (the shadow, sign of distance) works by means of perspective: the severing of image from picture plane, and the distinction between planes, suggesting, in turn as a sign, that there is a route to be traveled from foreground to background, from the eye of the viewer to the depth of the image.

Whereas the shiny white of the bed-linen rhymes with the immaculate bodice of the heroine, the red gush that crosses out Holofernes' whiteness echoes the curtain behind him. But most important, the red spurts alliterate with the sword that is slightly behind them. And this order of things matters. The insistent

Figure 11. *Dottie Attie,* A Violent Child *(detail), 1988. Oil on canvas. Photo courtesy of Gallery PPOW.*

layering – blood first, sword next – becomes indexical of the act of looking as a route, a voyage; it turns looking at this image into a narrative.

"Logically," realistically, that is, the blood *follows* the sword as its consequence; this is so obvious one tends to take it as the natural and inevitable meaning. Visually, however, according to the eye's itinerary into the representation, the blood, being closer to the picture plane, precedes the sword, as its visual "cause": *Because* we see the blood, we subsequently see the sword. This seems an irresistible reminder of the deconstruction of pin and pain, rendered classical by Jonathan Culler's use of it as primary example (1983: 86–7). In both cases, the relation between violence and suffering is questioned.

What has happened by the doing of the sign status of the blood-followed-by-sword in terms of Barthes's *S/Z* is that the *semic* code carrying cultural stereotypes had to recede, and the *symbolic* code was ambiguously suspended: "Blood" remained between hostility and suffering on the one hand, and passion on the other. The *prorairetic* code, bringing in known models of action, was equally brought to a standstill. These suspensions explain the odd stillness of the figure of Judith. Instead, the code that comes to the fore is the *hermeneutic* code, which presupposes an enigma and induces us to seek out details that can contribute to its solution. As I said before, there is a hermeneutic code at work for the viewer precisely when an image's subject is hard to make out.

The difference between Judith's statuesque quality and Holofernes' dramatic one, striking indeed, is not caused by stereotypical gender positions, but questions these. Each character is objectified, but which objectification precedes, or causes, the other is now an open, disturbing question. The difference matters, but in view of Bakhtin's concept of heteroglossia it seems wise to resist the double temptation of hierarchization and coherence. Challenging causality, the sign thus questions the stories of origin through which we culturally construct responsibility and guilt.

This sign helps to read the image, then, and the image thus read helps to deal with the topos, and unfix it. Instead of taking Judith as a female figure whose heroism is opposed to her wickedly seductive act in a binary struggle for gendered allegiances, therefore, I would like to take her as a figure who represents a challenge, not so much to faith and chastity, nationality and group

solidarity, but to our assumptions, the certainties that reign in our academic work, about what it is and how it is we can *know*. Of course, I am not suggesting that the traditional Judith themes are irrelevant or misplaced; but if these were crucial at one time in history, the very attempt to base our current dealings with Judith on this archaeology is caught up in the very confusion of causality the painting sets out to demonstrate. Using ancient readings of Judith and folding these into today's projections of essentialist identity, then, is a way of denying Caravaggio the use of his art; a way of refusing to look; a way of ignoring what strikes the eye.

Contemporary artist Dottie Attie challenges stereotypical responses to the figure of Judith and to Caravaggio's representation of the topos.[20] In her work *A Violent Child* (1988), she has fragmented, copied, and rearranged that famous work, and added a narrative to it through which, in art critic Max Kozloff's words, "instead of casting the visual narrative in words, she whispers a counternarrative" (1991: 106; see Fig. 11). For my purpose here, the most relevant feature of Attie's reworking of the painting is her positioning of Judith as reclining. Thus she becomes the victim of violence. The statuesque quality of Caravaggio's figure suddenly lights up as a sculpture on an ancient tombstone, and becomes an index, a memorial to innumerable victims of violence.

More specifically, the same figure "Judith," the topos of the heroic/wicked woman, signifier of nationalism in the one interpretation and of male dread of women in the other, is here represented as a sign of her very sign status. The statuesque quality that Caravaggio gave her here comes to mean that she is always-already dead. She is a monument to her own reification as a focus or token of "woman," either sanctified or vilified, but never allowed to "live." Attie takes this element from Caravaggio's painting and turns it into the ultimate sign, a sign of signness, as radically different from an object or person. There is no Judith in this painting, only a "Judith," as sign, according to Peirce's definition, that stands in for the absent referent.

There is no better lesson in semiotics than the one this work by Attie offers, but neither is there a better lesson in art history. Her work proclaims that Caravaggio was able to overcome the compulsive unification of representation that would refute elements that do not appear to "fit," and offers instead a "text" composed of a variety of signs that on only one level can be unified into a story, while also moving in different directions: self-portraiture, sculpture, and, yes, cultural critique. Attie's art-history lesson also proclaims the aftereffect of painting, something that Michael Holly (1996) would call prefiguration: that Caravaggio's work already inscribed, in this differentiating semiotic, the attempts to reunify his works and how these would fail – a failure whose symptom is the criticism of his female figure. Finally, Attie proclaims her own status as a superior art critic and art historian: She demonstrates that it is crucial to understand contemporary art in order to understand the art of the past. And she does all that by way of a sign, which in this latter interpretation becomes a typical Saussurian sign, one that signifies by differentiation. Just turning the head forty-five degrees has changed its meaning forever.

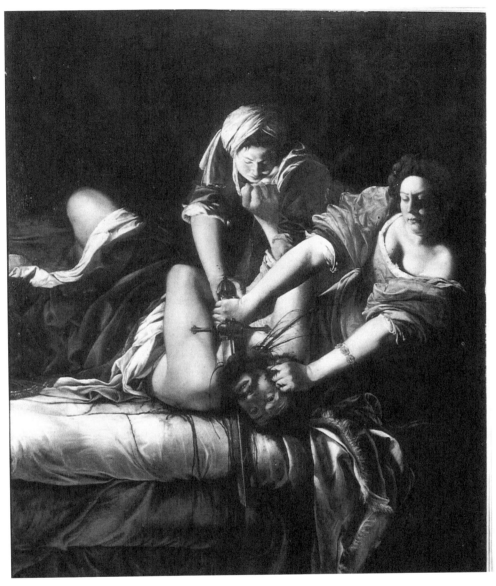

Figure 12. *Artemesia Gentileschi,* Judith Slaying Holofernes, *1620. Oil on canvas. Ufizzi (Bardazzi), Florence. Photo and permission courtesy of Scala/Art Resource, New York.*

My second instance of the Judith topos is Artemesia Gentileschi's *Judith Slaying Holofernes* (Fig. 12). More relevant for my purpose is a sign, not a detail this time but a problem: the visual difficulty the image poses, discussed by Germaine Greer (1979). Changing the direction of Caravaggio's spurts of blood, Gentileschi makes the image confusing, not in the detail that works as a sign, but in its overall structure, as if to insist on what was too easily

overlooked in the Caravaggio. The spouting blood turns in the other direction, threatening to stain Judith, but this contamination is only a pointer, an index synecdochically signifying the confusion of arms and of jobs being done. Needless to insist on the resemblance between Holofernes' arms and thighs, even stronger in the earlier version, where the end of the thigh has been omitted or cropped. The confusion emphasizes the resemblance among the three major jobs in women's lives according to the tradition to which Judith belongs: life giving, life taking, and, in between, hard work. That the baroque whirling of arms circles around the man's head, the still center, only emphasizes that the confusion is a meaningful organizational principle, not a compositional flaw or simply a baroque *folie*: a sign before all else.

The head is central, still in the middle of movement, and thereby doubly detached, from the body and from the surrounding drama. And the confused arms radiating out of the central head signify that confusion with something like concentration; they relate, after all, to a center. The arms express strength and determination; the faces, commitment to the task at hand. There is something passionate about the figures that has nothing in common with the traditionally applied qualifications like triumph, cruelty, or horror, something passionate that Caravaggio's *Judith* completely lacks, not because his female figure is less accomplished but because the system of signs in this work is structured differently, so that, also, its *meaning* is different.

Gentileschi's work radiates a contained and serious, almost organized, passion that enhances the sense of efficacy of the work being done. This is the feature that for me underlies the confusion, which can then be spelled out as: a serious and passionate commitment to confusion, to complexity over clarity, to mobility over fixity, to collusion over collision, to intersubjectivity over objectivity. This gives the struggle an epistemological slant. It puts knowledge, as it is traditionally construed, at risk. The sign carries a proposition, even a philosophical statement.

The epistemological proposition implied here involves two modes of representation that both have a controversial epistemological status. There are aspects in the Judith topos that make it particularly suitable for *visual* representation, and those aspects also address specific problems of the possibility to know. Vision is connected to such issues as "the mind's eye," empirical evidence, the possibilities and limits of observation, and the separation of object from subject which the sense of sight alone appears to guarantee. There are also aspects which encourage the use of *narrative*, aspects that are partly obvious, like the centrality of suspense and action.

Attention to what happens outside the preestablished frame is the theme in a later *Judith* (Fig. 13). As Garrard noticed, the element of seduction in the story is here not represented; in semiotic terms, it is not at all signified iconically, only through a symbolic reference to the Venus Pudica pose, the sword replacing Venus's hand that covers her genitals. Garrard makes much of the telling detail of Judith's exposed heavy shoe, which indexically signals her involvement in heavy-duty work of a military nature. An antifetish, so to speak. She

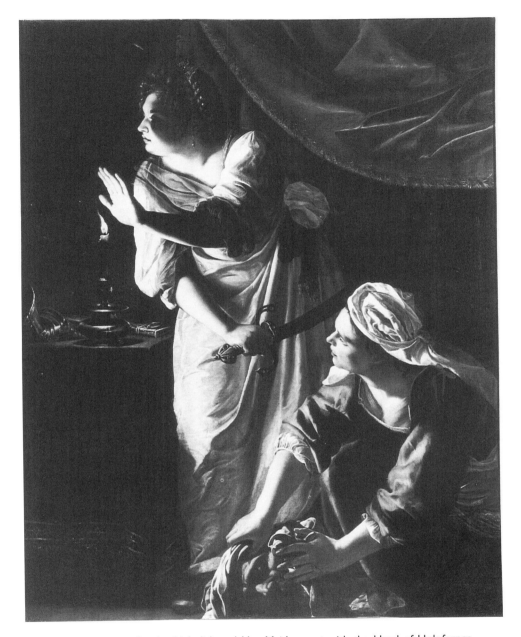

Figure 13. *Artemesia Gentileschi,* Judith and Her Maidservant with the Head of Holofernes, *ca. 1625. Oil on canvas. 72 ¹/₂″ × 55 ³/₄″ (184.15 × 141.61 cm). Detroit Institute of Arts; gift of Mr. Leslie H. Green. Photo courtesy of Detroit Institute of Arts.*

also cleverly places an allusion to the painter's name in the half-moon-like shape of the section of Judith's face that is illuminated, which she alleges to be an allusion to Diana and hence to Artemis. Thus it functions as a veiled signature.

But the Caravaggesque lighting emphasizes another element as well. The new addition to what I am construing as a Gentileschian epistemology is the hand. In this painting, the hand is the sign that cautions.

This hand does many things at once. It warns and directs, signals the leader as it signals attention. Attention becomes the equivalent of action; to see is to do; just as mis-seeing is helping along undoing. Here visuality is signified. And thus the cognitive link between narrative and visuality can be read as the epistemological theme of this work. It is signified as such in many different ways. First of all, the candle, instrument of Caravaggesque chiaroscuro but also the bearer of the light that enables one to see. It enables Judith to see, within the story that is implied, and it enables us to see Judith, to see her face and her active way of looking; her looking as an act. Her being-looked-atness becomes a lesson in looking.

The flame also illuminates her hand, emphatically so, and stressing that emphasis once more by form, by the rhyming shapes of flame and hand. Like a hand offered to a fortuneteller, this hand foretells the cautious actions to follow, which will bring complete success to Judith's self-assigned mission. But in a visual image, there is more to a hand than meets the eye. As in Rembrandt's *Danae*[21] here, too, visual accessibility of what there is to see is organized by the female figure whose power it is to turn events around. Events within the story about her, as well as the event her story yields: a story of visual access.

Against this background, Gentileschi's hand functions as a similar pointer. It sets up a story of looking, through a line of focalization that entices us to follow it. It directs our gaze outside, to the source of light; it illuminates the directing function of illumination, suggesting the importance of a mode of looking that is not obvious. The clarity so desired must be sacrificed, or delayed, in favor of something more messy that takes more time, more effort, and more complexity. A new, more effective kind of clarity is the result. Not surprisingly, Gentileschi depicted herself, in her work, in her status as a visual artist, in a pose that echoes this Judith's hand (Fig. 14).[22] The hand that signaled fine-tuned attention yielding autonomy over fate here signals cultural productivity. The connection matters; it implies a proposition to the effect that representing, making images, is always also a form of responding to the world, of looking, listening, *reading*.

This self-portrait does nothing to prettify the depicted woman. Slightly falling forward to the picture plane, she looks plumper than strictly necessary; the pose and position almost dwarf her. What is clearly the major focus of this portrait is the arm. Realistically, this is a rather fleshy arm, full of muscle. A raised arm – or should we say "elevated"? The arm says: This woman is physically strong, has to be, for the job she is doing is hard work. We recognize the arm from *Judith Slaying Holofernes*, if not the face, because of the tension "work" necessitates.

From confinement to the transgression of the picture frame, from confusion to a different kind of clarity: Such is the epistemological itinerary that Gentileschi's *Judith*s propose. Instead of the immediate clarity of binary opposition that the tradition of Judith is so often taken to embody in its dichotomy

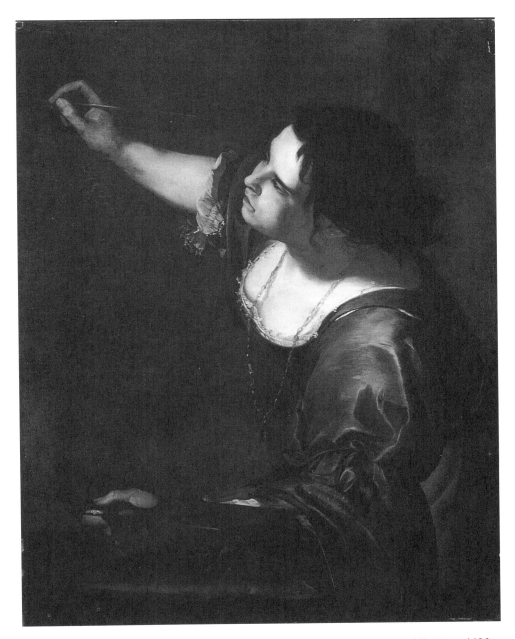

Figure 14. *Artemesia Gentileschi (1593–1652/3),* Self-Portrait as the Allegory of Painting, *1630. Oil on canvas. Collection of Her Majesty Queen Elizabeth II, Kensington Palace, London. Photo courtesy of Rodney Todd-White & Son.*

between heroism and sexual depravity, loyalty to the nation versus betrayal of an entire gender, these works offer a theory of knowledge that is more congenial to what philosophy today is trying to elaborate. But they do so in connection

to other cultural expressions, for alternatives, too, come about as a form of reading.

In order to drive my point home, let me carry on reading. The signs I have been pointing out in these paintings ultimately stage the nature of the gaze as Lacan has theorized it. Like a discourse, it is ready for you to step in and work with, but whatever you make of it, whatever you *see*, is structured and to a certain extent semantically filled for you. If this aspect of Lacanian theory turns out to be represented in these *Judith*s, then it is doubtless not a coincidence that another flash of insight is enabled by these paintings. Seeing, in a glance, thighs in Holofernes' arms imposes a choice of two fictions: Either the head is a head, but of a baby, or the head is a penis, and being cut off. These arms/thighs work like the skull in Holbein's *Ambassadors* as discussed by Lacan: Invisible yet highly visible, they draw attention to what Freud's story of sexual difference declares unseeable, and thus they offer a theory of seeing as insight.

There is a paradox to this topos of Judith, then: How can a topos that has invariably been connected with severing and cutting serve to relate, to link? But this paradox is dissolved as soon as one realizes that in Gentileschi's cutting scene the biblical text is being contradicted. There it says, "Look! Holofernes is lying on the ground! And his head is missing!" The phrase is a direct representation of character speech, yelled by Bagoas to his people (Judith 14: 16).[23] In Gentileschi's painting, in contrast, the head is not missing but absolutely central. And although it is narratively in the process of being cut off, it is visually a knot, firmly attaching arms, legs, and other members to itself. It is all in the mind, after all.

L ET me stop my reading here and step back to see what I have done. The paintings, traditional narratives in that they represent a (literary) narrative, tend to become invisible, overpainted as it were, if we let the doxic narrative inform our visual reading. Putting the visual image first, suspending both coherence and realism, I have focused on a few elements – a detail here, a problem there, a motif in the third case – that I have declared *signs*, appointed, so to speak, to do the job for me that needed to be done: revisualize the paintings, and take seriously what they, visually, had to *say*.

The semiotic perspective helped me to assign meaning to these elements instead of ignoring, discounting, or explaining them away. It also enticed me to suspend the paintings' unity as narrative, in order to let these elements form knots, or intertexts, with other elements, outside these images alone. The semiotic toolbox gave me a handle on *how* they signified: through which codes, through which modes. The index established a continuity between the viewing subject and the represented subject. Of Barthes's codes, some were suspended to leave room for others. Of the concepts of narratology, focalization became crucial, so that the story of Judith the dangerous woman could become a story of risky looking. And the combination of perspective and tools helped me construe a

propositional content for the images that is based on their visual surface, not some established verbal precedent.

In order to demonstrate the seriousness, the relevance, the "depth" of what the images had to say, I pursued my reading of them far beyond what is historically plausible. What matters, in a semiotic analysis of images, is not to reconstruct a historical context of meaning, but readability, *including* historical readability, but not only that. If I have made Gentileschi respond to Lacan, it is not in order to suggest the nonsensical claim that this painter was a prophet, nor the inane claim that historicality is irrelevant. I wanted to demonstrate that reading is, by definition, something the reading subject does; and that also holds for historical interpretation. But if I have transgressed some disciplinary boundaries in doing so, I have also suggested, I hope, that disciplinary boundaries can be confining, and thus fail to let the subject of the discipline, the visual image, speak.

Notes

1 I have to refer the reader interested in a fuller survey to the article "Semiotics and Art History" (Bal & Bryson 1991), from which some of the following remarks have been taken.

2 The most elaborate – and critical – contemporary Peircean semiotician is Umberto Eco (1976, 1979, 1984).

3 See Austin 1975, and esp. Felman 1980.

4 See De Lauretis 1983.

5 Rosalind Krauss has introduced the concept of the index as a tool for art-*historical* analysis (1976–7).

6 On this aspect of Bacon's work, see Ernst van Alphen 1992.

7 Recent examples are A. Kibédi Varga 1989; Wendy Steiner 1988 (also 1982).

8 *S/Z* (1975). Barthes's initial, structuralist, theory of narrative is 1972. His essays on visual images not bound up with his narrative theory are mostly in *Image – Music – Text* (1977). On photography he published *Camera Lucida: Reflections on Photography* (1980, tr. 1981). His *Empire of Signs* (1970, tr. 1982) offers a semiotic interpretation of Japanese culture, which can be seen as an implicit semiotic of ethnocentrism. Two of Barthes's older texts deal with visual material, albeit in a linguocentric way: *Mythologies* (1973); and *The Fashion System* (1967, tr. 1983). A most accessible introduction to Barthes's work is Jonathan Culler 1983b.

9 Culler 1983b: 84.

10 In *Travels in Hyperreality*, Eco analyzes *Casablanca* as a "cultfilm" because of the predominance and intertextual play of the stories projected by what Barthes calls the prorairetic code. A comparison between iconography in visual art and literature is undertaken in Bal 1991: ch. 5.

11 Mikhail Bakhtin, *The Dialogic Imagination*, edited by Michael Holquist, translated by Caryl Emerson and Michael Holquist (Austin, Tex., 1981). Hirshkop and Shepherd 1989 offer a wonderful collection of critical essays on the usefulness of Bakhtin in a perspective of cultural studies. A good introduction is Tzvetan Todorov, *Bakhtin: The Dialogic Principle*, translated by Wlad Godzich (Minneapolis 1984).

12 See Bryson 1984.

13 The following is drawn from Bal 1985, further elaborated in Bal 1988. This theory is used for visual analysis in Bal 1991.

14 This phrase is explained and applied by Barbara Johnson (1987).

15 Bakthin's radical view of heteroglossia, as well as Derrida's account of polysemy in the concept of dissemination, are often followed up as liberal pluralism. This is a mistaken

interpretation of both theorists' positions. On Bakhtin's critical edge, see Hirschkop and Shepherd 1989; on Derrida's disavowal of the pluralistic position, see his 1988.

16 On the question of Kiefer's position on recent German history, see Andreas Huyssen 1995, esp. "Anselm Kiefer: The Terror of History, the Temptation of Myth."

17 The expression "reading as a man" is the equivalent of "reading as a woman," put into currency by Jonathan Culler in his famous section of this title in *On Deconstruction* (1983a). Culler distinguishes three moments in feminist criticism which may have their parallel in art history: identification with the roles of women, reevaluation of the traditionally female roles, and deconstructing the oppositions on which these value systems are based. In a mitigated manner, all three approaches can be seen in Saunders 1989.

18 The following is based on elements of my book *Double Exposures* (1996).

19 Gay studies has provided ample evidence to the contrary. The most spectacular analyses of homosexual subjectivity in visual art (e.g., Fassbinder's films) to my mind are those carried out by Silverman (1992).

20 Attie's work was brought to my attention by Lisa Corrin's superb show Going for Baroque held in Fall 1995 at the Walters Art Gollery, Baltimore. See Corrin 1995.

21 See Bal 1991: 339–46 for the meaning of the hand in this painting.

22 For an analysis of this painting, see Garrard 1980; see also her book on Gentileschi (1988).

23 The term "character speech" and other narratological terms are from my book *Narratology* (1985).

References

Alphen, Ernst van. 1992. *Francis Bacon and the Loss of Self*. London: Reaktion Books/ Cambridge: Harvard University Press.

Althusser, Louis. 1971. *Lenin and Philosophy and Other Essays*, tr. Ben Brewster. London: New Left Books.

 1977. *For Marx*, tr. Ben Brewster. London: New Left Books.

Austin, J. L. 1975. *How to Do Things with Words*. Cambridge: Harvard University Press.

Bal, Mieke. 1997. *Narratology: Introduction to the Theory of Narrative*, Toronto: University of Toronto Press (second, expanded edition).

 1988. *Death and Dissymmetry: The Politics of Coherence in the Book of Judges*. Chicago: University of Chicago Press.

 1991. *Reading "Rembrandt": Beyond the Word–Image Opposition*. Cambridge: Cambridge University Press.

 1996. *Double Exposures: The Subject of Cultural Analysis*. London: Routledge.

Bal, Mieke, and Norman Bryson. 1991. "Semiotics and Art History." *Art Bulletin* 73, 2: 174–208.

Barthes, Roland. 1967. *Elements of Semiology*, tr. Annette Lavers and Colin Smith. New York: Hill and Wang.

 1968. "L'effet de réel." *Communications*, pp. 84–9. In English: "The Reality Effect," tr. Richard Howard, in Barthes, *The Rustle of Language*, pp. 141–54. New York: Hill and Wang.

 1972. *Critical Essays*, tr. Richard Howard. Evanston, Ill.: Northwestern University Press.

 1973. *Mythologies*, tr. Annette Lavers. New York: Hill and Wang. Originally published 1957.

 1975. *S/Z*, tr. Richard Miller. New York: Hill and Wang.

 1977. *Image – Music – Text*. Essays selected and tr. Stephen Heath. New York: Hill and Wang.

 1981. *Camera Lucida: Reflections on Photography*, tr. Richard Howard. New York: Hill and Wang.

 1982. *Empire of Signs*, tr. Richard Howard. New York: Hill and Wang.

1983. *The Fashion System*, tr. Matthew Ward and Richard Howard. New York: Hill and Wang.

Benveniste, Emile. 1971. *Problems in General Linguistics*, tr. Mary Elizabeth Meek. Coral Gables, Fla.: University of Miami Press.

Bryson, Norman. 1984. *Tradition and Desire: From David to Delacroix*. New York: Cambridge University Press.

Corrin, Lisa G. 1995. "Contemporary Artists Go for Baroque," in *Going for Baroque: 18 Contemporary Artists Fascinated with the Baroque and Rococo*, ed. Lisa G. Corrin and Joaneath Spicer, pp. 17–33. Baltimore: The Contemporary and The Walters.

Culler, Jonathan. 1983a. *On Deconstruction: Theory and Criticism after Structuralism*. Ithaca: Cornell University Press.

1983b. *Roland Barthes*. New York: Oxford University Press.

De Lauretis, Teresa. 1983. *Alice Doesn't: Feminism, Semiotics, Cinema*. London: Macmillan.

Derrida, Jacques. 1988. *Limited Inc.*, tr. Samuel Weber. Evanston, Ill.: Northwestern University Press.

Eco, Umberto. 1976. *A Theory of Semiotics*. Bloomington: Indiana University Press.

1979. "Peirce and the Semiotic Foundations of Openness: Signs as Texts and Texts as Signs," in *The Role of the Reader: Explorations in the Semiotics of Texts*. Bloomington: Indiana University Press.

1984. *Semiotics and the Philosophy of Language*. Bloomington: Indiana University Press.

1986. *Travels in Hyperreality*, tr. William Weaver. New York: Harcourt Brace Jovanovitch.

Felman, Shoshana. 1980. *Le scandale du corps parlant: Don Juan avec Austin ou la séduction en deux langages*. Paris: Editions du Seuil. In English: *Literary Speech Acts*, Ithaca: Cornell University Press, 1983.

Garrard, Mary. 1980. "Artemesia Gentileschi's Self-Portrait as the Allegory of Painting." *Art Bulletin* 62: 97–112.

1988. *Artemesia Gentileschi: The Image of the Female Hero in Italian Baroque Art*. Princeton: Princeton University Press.

Greer, Germaine. 1979. *The Obstacle Race: The Fortunes of Women Painters and Their Work*. London: Secker and Warburg.

Hirschkop, Ken, and David Shepherd (eds). 1989. *Bakhtin and Cultural Theory*. Manchester: Manchester University Press.

Holly, Michael Ann. 1996. *Past Looking*. Ithaca: Cornell University Press.

Huyssen, Andreas. 1995. *Twilight Memories: Marking Time in a Culture of Amnesia*. New York: Routledge.

Innis, Robert E. (ed.). 1984. *Semiotics: An Introductory Anthology*. Bloomington: Indiana University Press.

Johnson, Barbara. 1987. *A World of Difference*. Baltimore: Johns Hopkins University Press.

Kozloff, Max. 1991. "The Discreet Voyeur." *Art in America*, pp. 100–6, 137.

Krauss, Rosalind. 1976–7. "Notes on the Index." In *October: The First Decade, 1976–1986*, pp. 2–15. Cambridge: MIT Press.

Saunders, Gill. 1989. *The Nude: A New Perspective*. New York: Harper and Row.

Silverman, Kaja. 1992. *Male Subjectivity at the Margin*. London: Routledge.

Steinberg, Leo. 1981. "Velasquez' *Las Meninas*." *October* 19: 45–54.

Steiner, Wendy. 1982. *The Colors of Rhetoric: Problems in the Relation between Modern Literature and Art*. Chicago: University of Chicago Press.

1988. *Pictures of Romance: Form against Context in Painting and Literature*. Chicago: University of Chicago Press.

Varga, A(ron) Kibédi. 1989. *Discours, récit, image*. Liège: Pierre Amanda.

5

The Politics of Feminist Art History

Patricia Mathews

I T has been ten years since Thalia Gouma-Peterson and I published "The Feminist Critique of Art History" (September 1987) for the "State of Research" series in the *Art Bulletin*.[1] Feminist issues and feminist art historians today are much more visible in the discourse of art history than a decade ago and appear with some regularity in art and women's studies journals. I will be referring throughout to those particular feminist art-historical practices that have emerged and become most influential in North America and Britain.

Feminist criticisms, often in league with critical theory and its methodological revisions, have deeply undercut the naturalized principles of conventional art history. Modernist art history's confinement of content to the visual and aesthetic realms, its peremptory and linear art histories based on the continual killing of the father by the son through some innovation or "gambit,"[2] and its confident assumption that Western art and its topoi are universal no longer enjoy the cachet they once garnered. Both radical theorists as well as "juste milieu" practitioners who pepper the conventional with the radical have come to endorse a less insular and exclusive view of art practice and its history. More specifically, feminists have sustained a challenge to art history's assumptions of gender difference and its exclusions of women artists, artists of color of both sexes, alternative sexualities, and issues of class. These breaches in the structural politics of traditional art histories have had the effect of transforming art's histories into more flexible, fissured, interdependent, interactive, and inclusive narratives. Few feminists see their work as definitively redefining and replacing traditional art-historical modes. On the contrary, most feminist perspectives call for a process of continual revision based not on some final telos of the discipline, but on the fluid contingencies of contemporary narratives and the never-ending potential for perceiving overlooked sites and voices between, among, or within discourses. Such processes depend on interdisciplinarity – to a large degree a product of the crossover among feminisms, strategies to represent a cultural politics (of race, class, nationalities, and other categories including gender), and the importance of visual images in the ongoing elaboration of the discourses

of representation. These concerns manifested themselves most boldly in contemporary art and art criticism, but have now migrated into art history as well.

Despite the strong impact of feminisms on the making of new art histories, many art historians, including a number of those immersed in critical theories, do not acknowledge feminist politics and issues either in their teaching or in their scholarship. They act as though the feminist dismantlings of power hierarchies did not disturb "art history as usual." Token feminists, a commonplace in art departments and art journals, are expected to "do" feminism, as though it were only another "method." However, for the majority of feminists, including art historians, feminism is much more than a methodology; it is a world view, a politics which informs all inquiry.[3] As a result, feminists in North America and Britain, at least, generally agree that it is not enough merely to establish a feminist niche in the halls of academia. The productive contribution of these feminisms are premised on activism – in its many manifestations – against cultural oppressions and inequalities at all levels of institutionalization.

Feminism as a world view and a committed politics has many facets, each of which embraces a variety of strategic methodologies. In art history, these strategies range from those which operate strictly within the normative discipline in hopes of transforming it, to those which aim for an interdisciplinary and complete restructuring (or renunciation) of the field. All however share the vision of dismantling the sociocultural hierarchies of distinction and difference that had rigidified by the end of the nineteenth century and that remain central to the constitution of values and meaning in Western cultures today.

The following synopsis of feminisms currently practiced in art history is by no means comprehensive. Instead, I broadly outline a few representative practices of feminist art-historical politics still relevant to or emerging since the 1987 article: (1) a feminist politics that focuses on recuperating the experience of women and women artists; (2) practices that critique and deconstruct authority, institutions, and ideologies and/or examine resistances to them; (3) and strategies concerned to rethink the cultural and psychological spaces traditionally assigned to women and consequently to reenvision the subject/self, particularly from psychoanalytic perspectives. These three areas constitute mobile, unregulated, unprescribed performative sites in continual flux rather than boundaried, authoritative categories. They encompass wide-ranging positions and are characterized by their fluid interaction. By now, these approaches have proven sufficiently effective and compelling to attract large numbers of adherents, including men.[4]

Experience and Recuperation

In a recent spate of texts, relatively small but lively and outspoken groups of feminist art historians, often in collaboration with feminist artists, have moved to recuperate and revise the reputation and ideas of feminist art, criticism, and art history of the 1970s. These groups are in varying degrees antagonistic to

postmodern theories.[5] Many of these women were involved in or closely ally themselves with the dynamic beginnings of feminist art and art history in the 1970s, and they consider the more overtly theory-oriented politics of other feminists to be a defection from an earlier conception of the feminist agenda – to resurrect and reposition women artists as well as the experience of women within a more or less normative model of art history.

This strand of feminism has had perhaps its strongest impact on the debate over the position and status of the individual "subject." Many feminists of this political persuasion argue that poststructuralist and psychoanalytic theories of the decentered subject – even in the hands of feminists – are no more than another form of masculinist silencing of women's experiences and histories at the very moment when they are finally beginning to be heard. Essays such as Linda Klinger's "Where's the Artist? Feminist Practice and Poststructural Theories of Authorship,"[6] express this threat of renewed obscurity. As Broude and Garrard put it, "the death of the author as subjective agent as posited by postmodernism may lead only to the death of feminism as an agent for positive political – or, indeed, art-historical – change."[7] Along the same lines, artist and writer Mira Schor argues that the "injunction against essentialism seems a continuation of the repression by Western civilization of woman's experience (of which sexuality is only a part), and it should be defied, no matter what the risk."[8] Such feminists agree that one cannot dismantle the master's house with the master's tools (i.e., poststructuralist theory), as Audre Lorde put it.

The positions of these groups on the "subject" help clarify some of the dangers for feminists that have inhered in the academic rush to postmodernism. Indeed, one of the contributions of this group has been a questioning of postmodern trivialization of feminisms, and a clarification of the background of the antifeminist backlash often submerged in postmodern rhetoric.

The move to tame feminism is nowhere more obvious than in the use of the slippery and divisive term "postfeminism." Although it is never explicitly stated, Dan Cameron, in his article "Post-Feminism,"[9] assumes that a much more influential "post-feminist" art by women such as Barbara Kruger replaced 1970s feminism and art (characterized as "specialists' pursuits"). Cameron's argument suggests a level of progression from a now obsolete feminism to a more sophisticated "post"-feminism.[10] Feminism is reduced to a disposable and rhetorical strategy rather than perceived as a radical world view.[11] In contrast, art historian Amelia Jones considers the ideology of postfeminism to be part of a strategy to "remasculinize" culture by reducing the power of feminism.[12] As critic Maureen Sherlock says, " 'post-feminist' jargon . . . is usually only a disguise for an anti- or pre-feminist ideology."[13]

Cultural Critique and Resistance

Although recognizing the potential pitfalls for feminists in postmodern theory, a growing number of feminist art historians employ masculine-derived

contemporary critical theories in their practice as a tool to convey the patriarchal values of the founding myths of the discipline and to explain areas of resistance to them. Of the three strands discussed here, the reconstructive, dismantling politics of this group of feminists remain the most widespread in art history. Moreover, critical theory itself has been irrevocably transfigured by the conceptual contributions of such feminisms.[14]

Feminists have identified and established discourses now central to critical theorists, such as gender, sexuality, the body, and the gaze. They continue to forge strategies for the analysis of images situated not within normalized art-historical terms, methods, or power structures, but employing instead multiple factors drawn from many arenas, including attempts to reclaim the role and subjectivity of the artist/subject through relativized contextual studies of the "author/subject-effect."[15] Such multilayered interpretations offer the means to examine from the site of one's politics the varied textures of lives of women (in particular, women artists)[16] and the need for their masquerades,[17] as well as their resistances,[18] their histories,[19] their differences, and their complexity as individuals.[20] These interpretations also abet an examination of larger historicized cultural issues, such as gender difference,[21] the (mostly repressive) social systems, institutions, and ideologies under which women artists practiced,[22] the relation of the construction of masculinity to femininity,[23] the cultural impact of art-historical genres such as that of the female nude,[24] and the role of gender in cultural production.[25] The areas of research here outlined are by no means definitive. There are so many crossovers among them that I hesitate to discuss a single example of this type of work. Essays by Carol Duncan, Lisa Tickner, Marcia Pointon, Anne Wagner, Kathleen Adler, Linda Nochlin, Janet Wolff, Anne Higonnet, Thalia Gouma-Peterson, Tamar Garb, and Griselda Pollock, to name just a few, illustrate the range and breadth of the feminisms aligned with a politics of cultural critique and resistance.

This feminist critical practice of critiquing and reframing discursive formations and structures of power is in conflict with the feminist politics of recuperating individual experience discussed earlier. Feminist historian Joan Scott argues that experience cannot be the ultimate authority, because it, too, is never free from discursive pressure. The individual's experience is itself coded by her/his social position and context. Scott's approach does not "undercut politics by denying the existence of subjects, it instead interrogates the processes of their creation."[26] Rather than positing a stable identity for the artist to be revealed through the artist's experience as it is embedded in a work of art, a more fragmented and multiple subject is posited, one situated within historicized discursive and psychic formations.

Women's Cultural and Psychological Spaces

At the same time that some feminist art historians work to uncover women artists and their art while others critique and expose patriarchal structures of

viewing, thinking, producing, and stereotyping, a few have turned toward the increasingly useful and prolific feminist psychoanalytic theories in order to find a way back to the "subject effect" without resorting to masculinist modernist topoi of individual genius. These feminists work to reformulate the female subject, producing multidimensional and powerful alternatives to the erasure of women and the repression of the pre-oedipal relationship with the mother in the Lacanian Symbolic Order. Just as we saw with feminist cultural critics, post-structuralist theory in this case does not inhibit the study of the female subject, but facilitates it.

The desire to theorize a maternal site hitherto excluded from French psychoanalytic theorist Jacques Lacan's phallic Symbolic Order informs the work of French feminist psychoanalytic theorists such as Julia Kristeva, Luce Irigaray, and Hélène Cixous.[27] They have explored the possible influences on the child's psyche through experiencing the mother's body in the pre-oedipal period as well as after entry into the patriarchal Symbolic Order. Artist and psychoanalyst Bracha Lichtenberg Ettinger embraces these arguments and introduces her own psychoanalytic ideas into the discourse of art and art history in her discussion of the Matrix (her term).[28] She defines Matrix as the "feminine dimension of the symbolic order," the plural or fragmented subjectivity corresponding to the experience of the prenatal, and "what our phallic consciousness cannot reach."[29] She argues for "the concept of the Matrix not against but alongside a relativized concept of the Phallus in a universe which is plural/partial."[30] Significantly, Ettinger is concerned to inscribe this nonpatriarchal site into psychoanalytic theory not only for the traditional subject of psychoanalysis – the generic white, middle-class male – but for all those outside the power hierarchy of the Symbolic Order. "The Matrix deals with the possibility of recognizing the other in his/her otherness, difference, and unknown-ness. Matrixial acknowledgement of differences functions on both the psychological and the socio-political level" (p. 200).

Griselda Pollock employs Ettinger's notion of the Matrix in her search for "ways to acknowledge the continuing function in the Symbolic of the signification of the maternal as both generating body (life) and as intellect (knowledge)." She suggests that it is necessary, in order to provide access to "desires and fantasies" that challenge and transform phallic masculinity, to construct archives based on "feminist exploration of representations by women of women, especially of their mothers."[31]

DESPITE the range of feminisms operational in art history today, areas of investigation tend to concentrate in the modern field[32] and break down along discernible lines. Many of these thematic concerns originated in feminist studies from other disciplines. It is beyond the scope of this chapter to detail these areas, but I will briefly mention several topics currently of interest to feminist art historians.

Masculinity is one such area of intensive critical focus. Masculine privilege has been studied *ad nauseam*. Recent studies argue that the seemingly confident authority of masculine hegemony is actually riddled with insecurities, such as the need to affirm and maintain the continually constituting and reconstituting masculinities of a given period.[33]

Many feminist art historians continue to focus on canonic male artists, using diverse strategies to reframe them. Take, for example, the cases of Degas and Gauguin. Feminists debate the artists' intentions and the ideological effects of the many images of nude women by these artists. In the case of Degas's realist yet ambiguous bathers, the literature is split between affirming and denying the good intentions of the artist and/or the effect of his art.[34] Feminists have generally agreed that images by Gauguin often expose a very negatively charged masculinist ideology.[35]

Feminists have done groundbreaking work in reopening studies of Modernism to issues of race and class as well as gender. Feminists of color such as bell hooks have committed themselves to integrating issues of race and gender, arguing that the two are inextricably linked. Many feminists would agree that the subject is a product of the interaction of myriad discourses such as race and gender, and that one cannot examine one discourse independently from others without distorting its impact on the object of study. However, studies that integrate race and ethnicity (including whiteness) with gender (and/or class and so on) have remained largely absent from the work of white feminist art historians. Despite bell hooks's encouraging statement that white women have the responsibility to learn about and deal with women of color as long as they do not claim authority on the subject, few white practitioners have had the knowledge, interest, or courage to undertake such politically volatile studies.[36] In addition, there are still too few feminist art historians of color working in these areas.[37] On the other hand, more and more texts have begun at least to refer to race and class (among other marginalized discourses) along with gender, endorsing an interactive approach if not yet working entirely within one.

In contemporary art, however, there is a lively contingent of artists of color who focus on race and identity ("identity politics"), and a few critics who write about them.[38] Contemporary art institutions have enlisted scholars from other disciplines, such as African-Americans bell hooks and Henry Louis Gates, Jr., to write catalog essays or articles for major art magazines. The catalog of the recent exhibition at the Whitney Museum of American Art, *Black Male: Representations of Masculinity in Contemporary American Art*, Curator Thelma Golden (New York: the Museum, 1994), contains essays by both scholars as well as contributions by an impressive array of scholars and critics almost all of whom come from disciplines other than art or art history. The number of women artists in the Black Male exhibition critiquing black masculinity or its stereotypes also testifies to the inclusive nature of this particular effort.

Many other themes common to feminist art histories could be reviewed here, from essays on the female body[39] to studies of lesbian and gay art and artists.[40]

Additional areas of research continue to be opened up by feminist art historians, and from all accounts the field continues to expand in both numbers and influence.

FEMINIST politics, like any other form of politics, need not be tied to any one methodology, but may incorporate whatever strategies best allow entry into a particular issue. Since I believe that cultural and psychological conditions activate and direct the formation of the subject/artist, I maintain that interpretation of the multiple meanings in a work of art made by a subject demands the use of both cultural and psychoanalytic theories. The reductive modernist myth that meaning may be transferred directly from artist to viewer through the work of art produces an interpretive and hermetic closure that obscures the multiplicity and complexity of collaborators (artist/work/viewer) in the production of meanings in art. For example, feminist theories demonstrate that the enforcement of "separate spheres" institutionally, economically, and politically has not only generated a hierarchy of power but, more problematically, a different set of expectations, values, meanings, and experiences for those rarely granted access to the realms of power. Correspondingly, feminist interventions release psychoanalytic theory from the elitist closure of masculinist narcissism, accommodate the formation of subjects other than male, and explore areas insignificant for or unremarked by earlier theorists. Once the norms of a patriarchal culture have been exposed as exclusionary and constructed, whether in the work of cultural theorists or more conventional scholars, continued attachment to these restrictive norms yields work that is transparently limited. The return of the repressed in the form of other subjects, other values, changes the significance and the structure of all that it encounters.

My own feminist politics seeks to adjust historical narratives to describe a much more complex and diverse moment not bound by hierarchical categories. Based on a synchronic search for the conditions and terms of a cultural moment and for the acts of the individual artist within that moment as she/he transmits and transforms those conditions in works of art, this method demands intensive study of a historical moment rather than a diachronic tracing of a particular idea/ artist/style in a historical period. Although I realize that one can never completely recreate even a brief moment of the past, one can, by examining the prevailing systems and methods of dominant and minor or subversive political, economic, and psychological ideologies of a given moment, have insight into operative criteria for their social and individual inscription. Analysis of the artwork's participation in and negotiation of these ideologies makes visible the complexity and nuance of the work. Moreover, a variety of methodologies, from historical materialism to deconstruction and psychoanalysis, enlarges the scope of relevant interpretative material so that a more comprehensive view of the formation of the work of art may emerge.

I practice this multifaceted method grounded in my feminist politics to understand the work of French working-class artist Suzanne Valadon (1865–1938). Specifically, the aim of my work on Valadon is to reveal some of the complexity

and contradictions of the 1890s to 1930s in Paris through the study of an individual's participation in its social and artistic milieus. I ask how specific works of art produce cultural meanings, how they participate in and/or resist given values; I investigate resistance to the normative within specific cultural sites; and I examine how the complicity and/or resistance of images is received. Here I will focus on the interaction of class and gender in Valadon's representations of the female body to illustrate this approach.

The complex social position of Valadon and her attachment to the traditional genre of the nude led me to explore the necessary and vital negotiations that she, like all women artists, was expected to make between the various subcultures of class and gender to which she belonged and the dominant bourgeois culture and its artistic milieu, in which she also participated. By describing the way in which Valadon orchestrates and maneuvers between the various values, principles, and concerns of these discourses and groups, we may learn more about the way meaning is created in her art and in the art of her period, and more generally the various ways in which an individual might weave her own patterns out of the fabric of her culture.

Valadon lived in Montmartre during the formative years of the avant-garde, and produced an oeuvre dominated by images of the female nude body from adolescence to old age. She had been an artist's model before she took up art and was intimate with both Impressionists such as Renoir and Degas and Post-impressionists/Symbolists such as Toulouse-Lautrec and Puvis de Chavannes, but she painted works whose values and meanings differ dramatically from those of her male colleagues.

The strange lassitude of Valadon's nudes, their half-hearted coquetry (Fig. 15), or the ease with which they inhabit their bodies (Fig. 16), set up an unusual dynamic incongruous with the conventional portrayal of women as objectified bodies on display in the genre of the female nude. Conventional methods do not work here. Most useful for my study were the suggestions of multiple subject positions found in the discourse of the masquerade of femininity and Judith Butler's theory of performative gender.[41] I concluded that Valadon's nudes were in various stages of masquerade; they had let the mask fall away (Fig. 16), or had revealed its presence by their partial relaxation of it (Fig. 17), or were obviously posed or posing within it (see her many *Standing Nudes*).

Judith Butler's characterization of gender as a performance that gives the illusion of stability only because it is continually repeated in a "mode of belief" parallels the notion of femininity and female sexuality as a masquerade capable of being either worn or discarded. The masquerade of femininity is the expected and often dutifully performed gender act for women.[42] Valadon's nudes, in their conspicuous, inconstant, and frayed repetitions of engenderment, expose the performative nature of the more seamless and naturalized enactment of gender depicted in images of the conventional seductive female nude. Images of female nudes by artists from Titian to avant-garde contemporaries of Valadon such as Ludwig Kirchner and her friend Amadeo Modigliani (Fig. 18) represent first and foremost naturalized and therefore immutable masks of femininity.[43] The

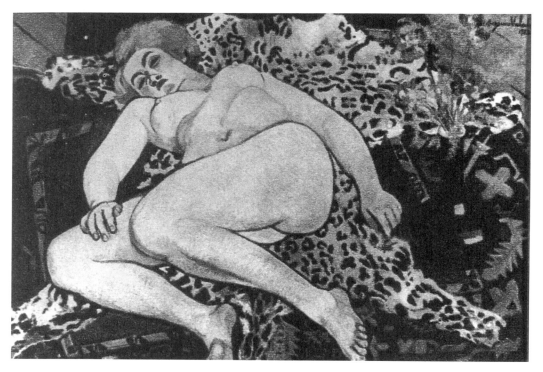

Figure 15. *Suzanne Valadon*, Catherine Nude Lying on a Panther Skin, *1923. Oil on canvas. Whereabouts unknown. Photo courtesy of P. Pétridès*, L'oeuvre complet de Suzanne Valadon *(Paris, 1971).*

coquettish or excessively sexualized nature of these images represents an emptied act, an act without a subject, an artifice that functions as a screen on which is projected the masculinist fantasies of power and control. These images reflect back values projected upon them rather than produce any meanings outside the circuit of conventional femininity. They expose the projective function of the objectifying gaze within the genre of the female nude. Valadon's nudes offer a fundamentally different relationship between artist and model (woman-to-woman versus man-to-woman) and viewer-to-work. They are present as subjects. One might conjecture that at the moment of visualization, when they are not being scrutinized through the masculinist gaze of power, they have no need to pitch themselves as feminine, no need to wear the masks of performative nudity; they are simply naked. Their gender masks have slipped or entirely fallen away, testifying to the performative and thus unstable nature of the act of engenderment.

Valadon's unmasked nudes are remarkably reserved. Traces of emotion flicker across bodies and faces, but none reflect overt desire or sexual pleasure to the onlooker. Faces are remasked by a sense of emotional distance and disinterest, not from the self – many of these figures are self-absorbed (Fig. 17) or self-content – but from the viewer. They possess subjectivity, and their subjectivity

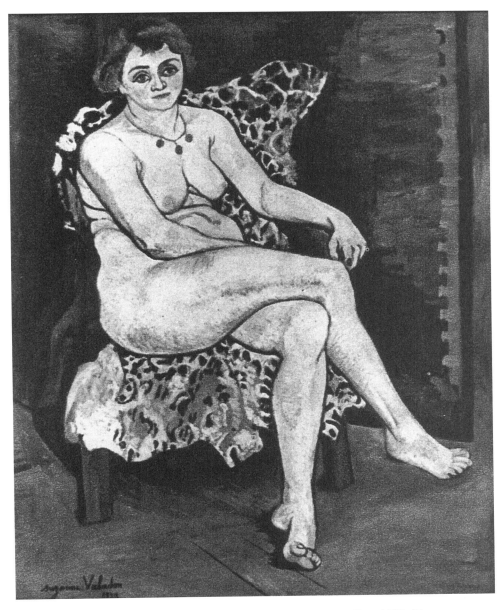

Figure 16. *Suzanne Valadon,* Catherine Nude Seated on a Panther Skin, *1923. Oil on canvas. Private collection. Photo courtesy of P. Pétridès,* L'oeuvre complet de Suzanne Valadon *(Paris, 1971).*

is not on display. Valadon seems rarely to have dramatized or narrativized these figures.[44] The sense of direct and unbiased representation of the mundane experience of modeling and the materiality and facticity of bodies are most prominent. Since no representation is actually neutral, since all paintings are made rather

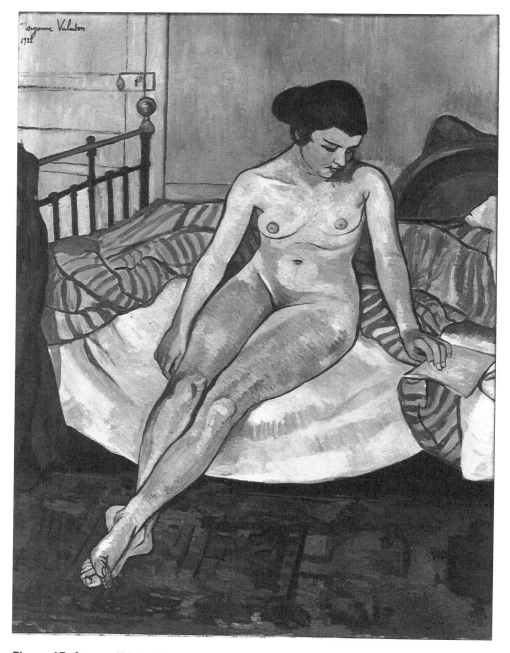

Figure 17. *Suzanne Valadon,* Nude with Striped Coverlet, *1922. Oil on canvas. Musée d'Art Moderne de la Ville de Paris, Paris. Photo courtesy of Giraudon.*

than spontaneously generated, since all representation is in some way projective, one might assume that forthright directness, sincerity, and bodiliness were important to Valadon's artistic strategy.

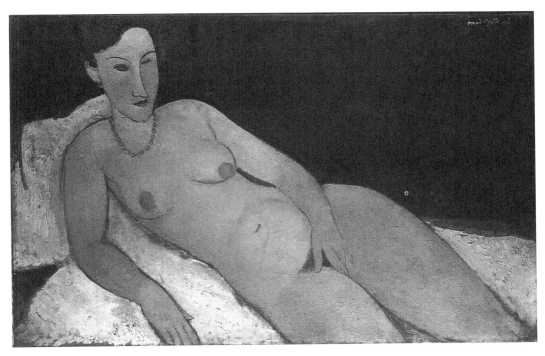

Figure 18. *Amadeo Modigliani,* Nude with Coral Necklace, *1917. Oil on canvas. Allen Memorial Art Museum, Oberlin College, Ohio; gift of Joseph and Enid Bissett, 1955. Photo courtesy of the Museum.*

Valadon paints the unmasked body at ease over and over again, obsessively,[45] suggesting a psychic impulse at work:

> The encounter between psychoanalysis and artistic practice draws its strength from . . . repetition, working like a memory trace of something we have been through before. It gives back to repetition its proper meaning and status: not lack of originality or something merely derived (the commonest reproach to the work of art), nor the more recent practice of appropriating artistic and photographic images in order to undermine their previous status; but repetition as insistence, that is, as the constant pressure of something hidden but not forgotten – something that can only come into focus now by blurring the field of representation where our normal forms of self-recognition take place.[46]

Valadon's obsessive repetition of unmasked nude models may represent the desire to efface her own experience as an artist's model. Forced to pose as the object of another's desire, as her self as others see her through the masquerade of femininity, she dropped the mask in her own work, and focused instead on the experience of the relaxed body outside the masquerade. Or perhaps she projects her

own experience of what it was like to actually sit motionless for hours on end, absorbed in her own thoughts. Whatever the case, the works seem to be informed by her own experience as a model. In works such as *Catherine Seated* (Fig. 16), Valadon reenacts bodily ease at the site of an undesiring body. Or perhaps her obsessive repetition of the body at ease was a response to the insistent regulation, dominance, and control of the female body through the very genre she was utilizing – that of the female nude.[47] Instead of the female body as marionette manipulated to express masculinist fears and desires, Valadon depicts nude women with agency, an even brash agency, as they read or dream or think while their bodies are observed.

The unconventional nature of Valadon's bodily presences has either remained unremarked, or critics have historically attempted to force it to fit uneasily into traditional art categories. Critics, mostly male, have seen Valadon's disinterested, nondeferential nudes as inept or consciously coarse and ugly (i.e., avant-garde), as woman-hating, or as sexualized. Predominating aestheticist discourses of class and femininity are largely responsible for the critical establishment's historically negative reactions to her nudes.

Despite their attention to titillating details of Valadon's bohemian lifestyle, critics were ill equipped to deal with the relation of her work to her class and to her life experience. They acknowledged neither her own class identity nor the representation of class in her works, except in veiled, dismissive attitudes toward her person and the bodies of her female nudes. Art historian Bernard Dorival indirectly responded to the class of Valadon's nudes by describing them in the terms used to stereotype working-class women: "These most vulgar creatures," "wasted by misery, pleasure or vice," were chosen, he suggested, for their heavy, thick bodies and their vulgar ("canaille") aspect to enhance Valadon's vigorous and harsh aesthetic.[48] Dorival subsumed her class into her avant-gardism by projecting Valadon's use of these classed bodies into the discourse of a disinterested aesthetic rather than relating it to her own class position. Jean Vertex, on the other hand, interpreted the lack of idealization in Valadon's nudes as outright ugliness and lack of feminine charm, and accused Valadon of hating women.[49] These critics' repugnance toward Valadon's representation of women is a classic example of the divisive practices of class difference here placed in opposition to the equally classed discourse of the ideal images of the female nude. The critics' inability to conceive of class difference in anything but pejorative terms reveals the formation of bourgeois identity to be founded in what it differentiates itself from and must therefore reject.[50]

In contrast, critics were entranced with Valadon's own appearance. She was fascinating to writers as an attractive and bohemian woman artist, and patronizingly praised for her "gamine" qualities and her passionate, robust sensuality. John Storm described the "ripened vigor of her spirit" that was "in her walk, in the long unfaltering stride so strangely incongruous to her size, in the lift of her breasts." He described her in terms reminiscent of the *femme fatale*: "She at once exuded fine sensuality and robust grandeur. She was far too subtle, too complicated, too dangerous to fire the desires of the callow."[51] Recognition of

her class underlay such comments; critics would be unlikely to speak of a bourgeois woman artist using such sexual innuendos. Her lifestyle, too, preoccupied critics. Her biographers spent much more time dramatizing her life than they did discussing her art.[52] A number of later critics and historians effaced her identity as an artist altogether. In Wilenski's book *Modern French Painters* (1940), Valadon was introduced as the mother of Utrillo, and identified as "friend and model of Renoir and Degas."[53] As late as 1985, Roy McMullen expressed surprise at Degas's interest in the work of this "Montmartre model."[54]

These various critical strategies that locate Valadon's art as well as her life within conventional categories illustrate the predominance of naturalized ideologies about women in structuring meaning from works of art by women artists. A feminist analysis of the historicized discourses of artistic genres, the classed female body, femininity, the artist's model, and the woman artist is essential to grasp these and other ideologies that locate Valadon's nudes as subjective conduits of cultural meanings. Such discourses suggested by the works themselves open interpretive realms otherwise unremarked by critics or art historians. Despite the lack of recognition in the past of the classed gender difference these images represent, we can now acknowledge the radical undermining of normalized categories of gender and class in these works. By indicating a site where women resisted their assigned positions, Valadon's nudes create a discourse counter to the construction of the stable ground of "woman" against which masculine identity could be affirmed. Projected masculine fantasies and desires do not easily find a place in these woks; indeed, they seem to be subverted in this realm of women's concerns. Valadon created, within the spaces of contradiction and disjunction, spaces which the dominant order did not publicly acknowledge in its search for a coherent homosocial fabric and for a Modernist universalizing truth. It is unlikely that she consciously chose or constructed these spaces, but rather existed in them; they were the spaces of her experience.

We can never know Valadon's intention, but the works themselves emanate alternative and subversive representations of women – working-class women who are asexual, educated, and self-absorbed, or bored, listless, and tired. My work on Valadon seeks to tease open and problematize representations within a convention. If space permitted, I would integrate certain cultural conditions into my narrative here.

The feminist methodology described here is critical of the status quo, examining its naturalized absences, its assumed privileges, its unremarked contradictions, and its institutionalized hierarchies, probing the lacunae and traces of difference in its controlled narratives and the ideological criteria of its interpretive modes, styles, and conventions, and evaluating the ideals it seeks to accomplish. This critique begins always with the work itself, observing the issues it excites – in the work of Valadon, the female nude, the working-class nude, the working-class woman, the woman artist, the working-class woman artist – and investigating them. This particular feminist approach is inherently reconstructive. It problematizes the conventions of art-historical inquiry – its institutionalized methods for dealing with such categories. It brings into question the

naturalized, canonic character of categories to reveal hidden agendas. Yet this method also has the ability to recognize the specifics of individual conformities and cultural participation.[55] The ideal result would convey an open-ended though not completely relativistic texture in which a work of art is immersed and through which meanings appear, shift, and defer, to each other and to the viewer.

Notes

Thanks to Professor Thalia Gouma-Peterson, of the College of Wooster, and to Stanley Mathews for their insights and encouragement, and to Paula Richman and Sandra Zagarell for their careful and helpful reading of this essay.

1 Criticisms of our original essay, with some of which I agree, will be addressed in my book, *Ways of Meaning: The Impact of Feminisms on Art History* (Twayne Publishers, div. of Macmillan), to be published in 1999. Several other essays on the state of feminist art history have been published since, including Lisa Tickner, "Feminism, Art History, and Sexual Difference," *Genders*, no. 3 (Fall 1988), 92–128; Griselda Pollock, "The Politics of Theory: Generations and Geographies. Feminist Theory and the Histories of Art Histories," *Genders*, no. 17 (Fall 1993), 97–120; Karen-Edis Barzman, "Beyond the Canon: Feminists, Postmodernism, and the History of Art," *Journal of Aesthetics and Art Criticism*, 52, 3 (Summer 1994), 327–39.

2 As Griselda Pollock refers to it in *Avant-Garde Gambits 1888–1893: Gender and the Color of Art History* (New York: Thames and Hudson, 1993). For an example of this notion of father and son, see Harold Bloom, *The Anxiety of Influence: A Theory of Poetry* (London: Oxford University Press, 1973).

3 Here I reveal my own investment in feminist politics.

4 See n. 33 for the controversy over male feminists.

5 See *Heresies*, 1989 (*Cunts/Quilts/Consciousness*), edited by artists Miriam Schapiro and Faith Wilding; some essays in the two volumes edited by Arlene Raven, Cassandra Langer, and Joanna Frueh: in 1988, *Feminist Art Criticism: An Anthology* (New York: HarperCollins), and, in 1994, *New Feminist Criticism: Art – Identity – Action* (New York: HarperCollins); certain essays in the *Art Journal* issue *Feminist Art Criticism* edited by Frueh and Raven (Summer 1991: vol. 50, 2); and especially the anthology *The Power of Feminist Art: The American Movement of the 1970s, History and Impact*, ed. Norma Broude and Mary D. Garrard (New York: Abrams, 1994). Amelia Jones, in her essay "Sexual Politics: Feminist Strategies, Feminist Conflicts, Feminist Histories," for the exh. cat. *Sexual Politics: Judy Chicago's "Dinner Party" in Feminist Art History*, ed. Amelia Jones (Berkeley and Los Angeles: UCLA at the Armand Hammer Museum of Art and Cultural Center in association with University of California Press, 1996), says of this volume (*The Power of Feminist Art*), "Broude and Garrard dismiss 'theory' (i.e. post-structuralism) in what I view to be an ill-informed way in their introduction to this volume; see esp. 28–29" (p. 38 n. 6). See also her review of this book, "Power and Feminist Art (History)," *Art History* 18 (September 1995), 435–43. This catalog repositions and complicates Judy Chicago's *Dinner Party* by asking contemporary feminist questions about its strategies, and by placing it in the context of other works of art from the 1960s to the present that examine the same issues but often in different ways.

6 *Art Journal*, 50, 2 (Summer 1991), 39–47.

7 Norma Broude and Mary D. Garrard, eds., *The Expanding Discourse: Feminism and Art History* (New York: HarperCollins, 1992), p. 4.

8 Mira Schor, "From Liberation to Lack," *Heresies*, no. 24 (1989), p. 19. Schor's argument against the repression of essentialism brings to mind recent feminist reformulations of it. See for example the *Feminism and the Body* issue of *Hypatia* (vol. 6, 3, Fall 1991), in which several women attempt to return to the body without recourse to essentialism through the philosophy of phenomenology and issues of materiality. Some assert that

essentialism is embedded even in arguments against it. However, unlike in these more speculative discussions of the nature of essentialism and of the return of the female body as a potentially different site of meaning from its social construction, Schor's reader is not instructed on the value of essentialism, but asked to retrench and "defy" any arguments against it.

9 Dan Cameron, "Post-Feminism," *Flash Art*, 132 (February–March 1987), 80–3.

10 Similarly, Randy Rosen's and Judith Stein's essays in the exh. cat. *Making Their Mark: Women Artists Move into the Mainstream, 1970–85* (compilers and curators Randy Rosen and Catherine C. Brawer [New York: Abbeville Press, 1989]) consider the aim of feminism – to give women artists their rightful place – to have been accomplished: "*Making Their Mark* . . . sharpens our awareness that even though excellence knows no sex, the fact of having been born a woman was no hindrance; indeed, as will be seen, the experience of growing up female has empowered a multitude of artists who have changed the shape of art and art history" (Stein, p. 51). Not all writers for the catalog agree with this opinion, however. Marcia Tucker, for example, argues that "not much has changed since those early days [1970s]. . . . Even in the arts, we haven't done as well as we think we have. The statistics still tell the same story. . . . While more women are visible now than in 1970, and while the rare woman artist (without exception – white) may even be highly visible, practice and theory – in the arts as elsewhere – have yet to meet in our century to provide the equity that might lead to real social change" (pp. 200–1).

11 Artist and writer Silvia Kolbowski, in her introduction to the *October* issue *Questions of Feminism*, argues against "the formulation of feminism(s) as a thing of the 'post'." "Introduction," *October*, 71 (Winter 1995), p. 4.

12 Amelia Jones, " 'Post-Feminism' – A Remasculinization of Culture?," *Meaning*, no. 7 (May 1990), 29–40.

13 Maureen P. Sherlock, "A Dangerous Age: The Mid-Life Crisis of Postmodern Feminism," *Arts Magazine*, 65 (September 1990), 70–4.

14 The recognition that feminisms have influenced critical theory has filtered down even to the *New Yorker*. Adam Gopnik's statement in his "Paris Journal: Basic Instinct. Why Are the French Importing Sex?" (December 4, 1995) remarks, "At some point in the early eighties in America, the abstract arguments of French post-structuralism were rekindled by the feminist revolution, which gave those arguments a fire they have achieved never [in Paris]" (p. 102).

15 For the subject effect, see Gayatri Spivak, "Subaltern Studies: Deconstructing Historiography," *In Other Worlds: Essays in Cultural Politics* (London: Routledge, 1988), pp. 197–221, esp. p. 204. See J. Christie and F. Orton, "Writing the Text of a Life," *Art History*, 11, 4 (1988), 545–64; and Griselda Pollock, "Agency and the Avant-Garde: Studies in Authorship and History by Way of van Gogh," *Block*, 15 (1989), 4–15, for approaches to rethinking biography.

16 For example, Griselda Pollock, "Modernity and the Spaces of Femininity," *Vision and Difference: Femininity, Feminism and the Histories of Art* (London: Routledge, 1988); Bridget Elliott and Jo-Ann Wallace, *Women Artists and Writers: Modernist (Im) positionings* (London: Routledge, 1994); Anne Higonnet, *Berthe Morisot* (New York: Harper & Row, 1990); T. J. Edelstein, ed. and intro., *Perspectives on Morisot* (New York: Hudson Hills, 1990); Deborah Cherry, *Painting Women: Victorian Women Artists* (London: Routledge, 1993); Barbara Buhler Lynes, *O'Keefe, Stieglitz and the Critics, 1916–1929* (Ann Arbor: UMI Research Press, 1989); Anne M. Wagner, "Lee Krasner as L. K.," *Representations*, 25 (Winter 1989), 42–57; Thalia Gouma-Peterson, "Collaboration and Personal Identity in Miriam Schapiro's Art," *Miriam Schapiro, Collaboration Series: Mother Russia* (New York: Steinbaum Kraus Gallery, 1994), pp. 3–9. Gouma-Peterson has also written other essays on Schapiro, as well as on Audrey Flack, Athena Tacha, Michelle Stuart, Ruth Weisberg, Joyce Kozloff, and a number of women artists of color (see n. 36).

The texts cited in this note and the next nine notes offer only a sampling of feminist writings in these areas. Many of those mentioned relate to more than one of the subject areas specified. In our 1987 article, Gouma-Peterson and I were able to create a fairly comprehensive bibliography, especially of the early period of feminist art and art history. The bibliography included here, however, is somewhat arbitrary. Feminist art historians have increased in number exponentially since then.

17 The masquerade of femininity is a prominent subject in feminist psychoanalytic film criticism since 1980. See for example Mary Ann Doane, *Femmes Fatales: Feminism, Film Theory, Psychoanalysis* (London: Routledge, 1991). The idea originated with Joan Riviere, "Womanliness as a Masquerade" (1929), in *Formations of Fantasy*, ed. Victor Burgin, James Donald, and Cora Kaplan (London: Routledge, 1989), pp. 35–44.

18 Lisa Tickner, *The Spectacle of Women: Imagery of the Suffrage Campaign 1907–14* (Chicago: University of Chicago Press, 1988); Tamar Garb, *Sisters of the Brush: Women's Artistic Culture in Late Nineteenth-Century Paris* (New Haven: Yale University Press, 1994); Lorraine Gamman and Margaret Marshment, eds., *The Female Gaze: Women as Viewers of Popular Culture* (Seattle: Real Comet Press, 1989); Tessa Boffin and Jean Fraser, eds., *Stolen Glances: Lesbians Take Photographs* (London: Pandora, 1991).

19 Whitney Chadwick, *Women, Art, and Society* (London: Thames & Hudson, 1990), and *Women Artists and the Surrealist Movement* (London: Thames & Hudson, 1985). Eunice Lipton's book *Alias Olympia: A Woman's Search for Manet's Notorious Model and Her Own Desire* (New York: Scribner, 1992; Meridian paperback, 1994), about her search for Victorine Meurent – Manet's model and an artist herself – admits of and even revels in the subjective nature of the engagement with another's biography.

20 See Chris Weedon, *Feminist Practice & Poststructuralist Theory* (Oxford: Blackwell, 1988); Griselda Pollock, "Feminism/Foucault – Surveillance/Sexuality," in *Visual Culture: Images and Interpretations*, ed. Norman Bryson, Michael Ann Holly, and Keith Moxey (Hanover, N. H.: Wesleyan University Press/University Press of New England, 1994), pp. 1–41; and Jana Sawicki, *Disciplining Foucault: Feminism, Power, and the Body* (London: Routledge, 1991), on the value of theory to feminism.

21 Kathleen Adler and Marcia Pointon, eds., *The Body Imaged: The Human Form and Visual Culture since the Renaissance* (Cambridge: Cambridge University Press, 1993); Norma Broude, *Impressionism: A Feminist Reading. The Gendering of Art, Science, and Nature in the Nineteenth Century* (New York: Rizzoli, 1991); Janet Wolff, *Feminine Sentences: Essays on Women & Culture* (Berkeley and Los Angeles: University of California Press, 1990). Numerous texts could be cited under this venue.

22 There is also a considerable literature in this area. See for example Adler and Pointon, *The Body Imaged*; Carol Duncan, *The Aesthetics of Power: Essays in Critical Art History* (Cambridge: Cambridge University Press, 1993); Kimberley Reynolds and Nicola Humble, *Victorian Heroines: Representations of Femininity in Nineteenth-Century Literature and Art* (New York: New York University Press, 1993); Richard Kendall and Griselda Pollock, eds., *Dealing with Degas: Representations of Women and the Politics of Vision* (New York: Universe, 1992); Hollis Clayson, *Painted Love: Prostitution in French Art of the Impressionist Era* (New Haven: Yale University Press, 1991); Linda Nochlin, *Women, Art, and Power and Other Essays* (New York: Harper & Row, 1988). Nochlin has continued to be an inspiration and a resource for feminist art historians. She manages to find as yet uninvestigated areas and to outline their complexities in witty and insightful texts.

23 Lisa Tickner, "Men's Work? Masculinity and Modernism," in *Visual Culture*, ed. Bryson, Holly, and Moxey, pp. 42–82; Kaja Silverman, *Male Subjectivity at the Margins* (London: Routledge, 1992).

24 Feminist studies of the female nude abound. See for example Marcia Pointon, *Naked Authority: The Body in Western Painting 1830–1908* (Cambridge: Cambridge University Press, 1990); Tamar Garb, "Renoir and the Natural Woman," *Oxford Art Journal*, 8,

2 (1985), 3–15; Patricia Mathews, "Returning the Gaze: The Nudes of Suzanne Valadon," *Art Bulletin*, 73, 3 (September 1991), 415–30.

25 Duncan, *The Aesthetics of Power*; Wolff, *Feminine Sentences*; Pollock, *Vision and Difference*.

26 Joan W. Scott, "Experience," in *Feminists Theorize the Political*, ed. Judith Butler and Joan W. Scott (London: Routledge, 1992), p. 38.

27 Influential feminist psychoanalytic theorists outside France include Kaja Silverman, Jacqueline Rose, Jane Gallop, and Bracha Lichtenberg Ettinger. Feminist revisions of Lacanian psychoanalytic theory were present much earlier in other disciplines, such as literary studies and film studies. They appeared in contemporary art and criticism in the mid 1970s and early 80s – see Mary Kelly, Sylvia Kolbowski, Barbara Kruger, Craig Owens, Victor Burgin – but feminist art historians have only recently begun to incorporate psychoanalytic theory into a historical study of women's cultural and psychic spaces.

28 Bracha Lichtenberg Ettinger, "Matrix and Metamorphosis," in Griselda Pollock, ed., *Trouble in the Archives*, *differences*, 4 (Fall 1992), 176–208. She cites art as one form through which the matrixial mode may be manifested.

29 Ibid., pp. 176, 200–3. This is a shorthand definition which does not do justice to the complexity of her concept.

30 Ibid., p. 206. "The borderlines between *I* and *not-I(s)* are surpassed and transformed to become thresholds" (p. 201).

31 Griselda Pollock, "The Case of the Missing Women," in *The Point of Theory: Practices of Cultural Analysis*, ed. Mieke Bal and Inge E. Boer (New York: Continuum, 1994), pp. 101, 95–6. Pollock also finds the work of Kristeva, Irigaray, and Silverman useful for her argument.

32 Although a range of feminist politics can now be found in every area of art history, Western modernism is one of the most populated and fruitful sites under reconstruction. Not only women's contributions but other unconventional modes of making and thinking recovered by feminists and others disrupt canonic modernism and necessitate a reconfiguration of that period.

33 For example, see Abigail Solomon-Godeau, "Male Trouble: A Crisis in Representation," *Art History*, 16, 2 (June 1993), 286–312; Kaja Silverman, *Male Subjectivity at the Margins* (London: Routledge, 1992); Andrew Perchuk and Helaine Posner, *The Masculine Masquerade: Masculinity and Representation* (Cambridge: MIT Press, 1995); and my book "Passionate Discontent: Creativity and Gender in Late Nineteenth-Century French Symbolism" (forthcoming from University of Chicago Press).
 Male feminism is another contentious issue in which important work has been done. The debate that raged over whether "feminist" men were really writing from a feminist position during the 1980s in literary studies (see Elaine Showalter, "Critical Cross-Dressing: Male Feminists and the Woman of the Year," *Raritan*, 3 [October 1983], 130–49, and her "Introduction: The Rise of Gender," in *Speaking of Gender*, ed. Showalter [London: Routledge, 1989], pp. 1–13) has now erupted in the field of visual arts. See the feminist film critic Tania Modleski's *Feminism without Women: Culture and Criticism in a "Post-feminist" Age* (London: Routledge, 1991), esp. "Part II: Masculinity and Male Feminism." She points out that the colonizing of feminism by certain male scholars, particularly on the subject of masculinity, exemplifies how easily feminisms are coopted and then absorbed into existing power structures.

34 See Eunice Lipton, *Looking into Degas: Uneasy Images of Women and Modern Life* (Berkeley and Los Angeles: University of California Press, 1986); Carol Armstrong, *Odd Man Out: Readings of the Work and Reputation of Edgar Degas* (Chicago: University of Chicago Press, 1991); Broude, *Impressionism*; Anthea Callen, *The Spectacular Body: Science, Sexuality and Difference in the Work of Degas* (New Haven: Yale University Press, 1997); and the following essays in *Dealing with Degas*, ed. Kendall and Pollock:

Griselda Pollock, "Degas/Images/Women: Women/Degas/Images: What Difference Does Feminism Make to Art History?," 22–39; Heather Dawkins, "Managing Degas," 133–45; Anthea Callen, "Degas' *Bathers*: Hygiene and Dirt – Gaze and Touch," 159–85. See also Amelia Jones, *Postmodernism and the En-gendering of Marcel Duchamp* (Cambridge: Cambridge University Press, 1994), esp. for her feminist analysis of Duchamp's *Etant Donnés*.

35 See Pollock's book *Avant-Garde Gambits 1888–1893: Gender and the Color of Art History* (New York: Thames & Hudson, 1993), which expands on Solomon-Godeau's pungent condemnation of Paul Gauguin's sexism and racism: Abigail Solomon-Godeau, "Going Native," *Art in America*, 77 (July 1989), 118–29. Pollock's book also deals with other French artists from the same period. Although both of these texts offer necessary criticisms concerning Gauguin's role in the discourse of primitivism, they also blithely criticize the artist's character based on his images and texts. Moreover, neither accounts for the continuing power of his images for those such as myself who recognize and abhor their racism and sexism. For a critique and rewriting of these Gauguin narratives, see my book (n. 33).

36 See bell hooks, "Feminist Scholarship: Ethical Issues," *Talking Back: Thinking Feminist, Thinking Black* (Boston: South End Press, 1989), pp. 42–8. A few white scholars deserve special mention in this regard. Lucy Lippard has for years devoted her art criticism to women artists and to artists of color. For one example, see *Mixed Blessings: New Art in a Multicultural America* (New York: Pantheon, 1990). Thalia Gouma-Peterson has organized/curated exhibitions and written essays since 1983 on women artists of color such as Elizabeth Catlett, Faith Ringgold, and Emma Amos; see "Elizabeth Catlett: The Power of Human Feeling and of Art," *Woman's Art Journal*, 4 (Spring/Summer 1983), 48–56; "Faith Ringgold's Journey: From Greek Busts to Jemima Blakey," *Faith Ringgold: Painting, Sculpture, Performance* (curator) (Wooster, Ohio: College of Wooster, 1985), pp. 5–7; "Faith Ringgold's Narrative Quilts," *Arts Magazine* (January 1987), 64–9; "Faith Ringgold's Story Quilts," *Faith Ringgold: A Twenty-Five Year Survey*, exh. cat. (Hempstead, N.Y.: Fine Arts Museum of Long Island, 1990), pp. 23–32; organizer, *We, the Human Beings/27 Contemporary Native American Artists* exh. cat. (Jaune Quick-to-See-Smith, guest curator) (Wooster, Ohio: College of Wooster, 1992); "Reclaiming Presence: The Art and Politics of Color in Emma Amos's Work," *Emma Amos: Paints and Prints 1982–92*, exh. cat. (curator and coauthor) (Wooster, Ohio: College of Wooster, 1993), pp. 5–14. Ann Gibson's work, including her book *Abstract Expressionism: Other Politics* (New Haven: Yale University Press, 1997), is a landmark study in art history, and hopefully will inspire others to explore such barely tapped areas of research. The same is true of Griselda Pollock's *Avant-Garde Gambits*. I am not suggesting that everyone focus research on color, class, or gender, although many will. Rather my hope is that the question of the impact of these discourses will become as essential to ask of artworks and artists as style and iconography are now.

37 See Samella Lewis, *African American Art and Artists* (Berkeley and Los Angeles: University of California Press, 1990), one among a number of publications by her; Judith Wilson, "Down to the Crossroads: The Art of Alison Saar," *Third Text*, 10 (Spring 1990), 25–44, and "Beauty Rites: Towards an Anatomy of Culture in African American Women's Art," *International Review of African American Art*, 11, 3 (1994), 11–18, 47–55 (among many others of Wilson's works); Lowery Sims, "African-American Artists' Passionate Visions: Generations Rediscovering Authenticity," *American Visions*, 9, 2 (April–May 1994), 20–6 (among many others of Sims's works).

38 Artists Carrie Mae Weems, Lorna Simpson, Clarissa Sligh, Pat Ward Williams, Song Yun Min, Judy Baca, Emma Amos, Lorraine O'Grady, etc., etc.; critics/art historians Lowery Sims, Thelma Golden, Judith Wilson, Moira Roth, Luis Camnitzer, Lucy Lippard, Samella Lewis, etc. etc.; and critics/artists Coco Fusco, Margo Machida, etc., etc. come to mind.

39 Feminist attempts of the early 1970s to reframe images of the female body return in the 1980s after a hiatus during which artists such as Mary Kelly refused to display the female body at all because of its associations with the male gaze. See the artwork of Kiki Smith in the 1980s, for example, and interdisciplinary texts published from an art context, such as the widely used Zone series, nos. 3–5, *Fragments for a History of the Human Body*, ed. Michel Feher with Ramona Naddaff and Nadia Tazi (New York: Zone, 1989). Such art-world luminaries as Jonathan Crary and Hal Foster served as editors for Zone. In both decades, interest in the female body stemmed from its oppressive institutional and discursive history saturated with masculinist meanings, as well as its materiality (particularly in light of the resurrection of phenomenology in a number of scholarly quarters), but the body rematerialized in the late 1980s and 90s as a more historicized, structured, and highly charged site of contestation.

40 Judith Butler's feminist work on gender performance and lesbianism from a psychoanalytic perspective, for example, has had a tremendous impact on disciplines in the humanities. See for example *Gender Trouble: Feminism and the Subversion of Identity* (London: Routledge, 1990). In art history, studies have slowly begun to appear. The recent rediscovery of and attention to French "surrealist" and lesbian artist Claude Cahun, for example, derives as much from her lesbian status as from the flood of new studies on Surrealism.

41 Riviere (see n. 17); Judith Butler, "Performative Acts and Gender Constitution: An Essay in Phenomenology and Feminist Theory," in *Performing Feminisms: Feminist Critical Theory and Theatre*, ed. Sue-Ellen Case (Baltimore: Johns Hopkins University Press, 1990), pp. 270–82.

42 Of course, this performance gives pleasure, sometimes but not always a masochistic pleasure, to the performer as well as to the observer. As Michel Foucault tells us, complicity with one's own subjugation may be contingent upon pleasure. See for example "The Subject and Power," *Art after Modernism: Rethinking Representation*, ed. Brian Wallis (New York: New Musuem of Contemporary Art in association with Govine, 1984), p. 427 and passim, and *The History of Sexuality, vol. 1, An Introduction*, trans. Robert Hurley (New York: Random Huse, 1980), pp. 45–9, 71–2, 92ff., and passim.

43 One of the reasons Manet's *Olympia* was so shocking to its contemporary audiences was the model's position as *subject* rather than object.

44 An exception is Valadon's series of allegories from 1910–11 related to her blooming romance with her future husband, André Utter.

45 Valadon does not express an obsessive nature as we think of it in terms of passion or anger or rage, but in the consistency and repetitiveness with which she returned to the body at ease – to an image absent from conventions of the nude – throughout her career as an artist.

46 Jacqueline Rose, *Sexuality in the Field of Vision* (London: Verso, 1986), p. 228.

47 For a critique of this genre, see Lynda Nead, *The Female Nude: Art, Obscenity and Sexuality* (London: Routledge, 1992).

48 Bernard Dorival, Preface, in Pierre Georgel, *Suzanne Valadon: Musée National d'Art Moderne*, exh. cat. (Paris: Réunion des Musées Nationaux, 1967), p. 6. These women, "ses créatures les plus vulgaires," are chosen for "leur anatomie épaisse, de leur aspect canaille." She paints as well "visages volontiers laids, usés par la misère, le plaisir ou le vice, à l'expression butée." Dorival speaks of "la . . . vérité charnelle" in all of her works.

49 "La sensualité avec cette femme fougueuse et implacable s'exprime au détriment de la sensibilité. . . . Elle déteste les femmes et se venge du charme qu'elles peuvent avoir en les condamnant par le trait, par la rassemblance d'autant plus fidèle que pas un détail n'en est négligé pour les idéaliser le moins possible." Jean Vertex, *Le village inspiré* (The Author, 1950), cited in Janine Warnod, *Suzanne Valadon* (Paris: Flammarion, 1981), p. 73.

50 Disgust for the "low" is typical of the bourgeois need to differentiate and create status within the social hierarchy. See Peter Stallybrass and Allon White, *The Politics and Poetics*

of Transgression (Ithaca: Cornell University Press, 1986), p. 191 and passim. Images by men such as the femme fatale have embodied a similar conflicted response of disgust and desire.

51 John Storm, *The Valadon Drama: The Life of Suzanne Valadon* (New York: Dutton, 1959), p. 154, in speaking of her encounter with Utter. Robert Rey, too, described Valadon in terms of her diminutive physique and her "court menton carré," and called her a "gamine" (*Suzanne Valadon*, Les Peintres Français Nouveaux, no. 14 [Paris, 1922], p. 4).

52 Storm (see n. 51); Robert Beachboard, *La trinité maudite: Valadon – Utrillo – Utter* (Paris: Amiot-Dumont, 1952); Nesto Jacometti, *Suzanne Valadon* (Geneva: Pierre Cailler, 1947).

53 R. H. Wilenski, *Modern French Painters* (1940) (London: Faber & Faber, 1947), p. 48. His only other mention of her cannot avoid recognizing her life work as an artist, but only in passing. She is noted among a large group of artists who painted portraits of Mme Maria Lani (p. 315).

54 Roy McMullen, *Degas: His Life, Times, and Work* (London, 1985), p. 434.

55 My book on the nudes of Valadon (in progress) examines the modes of conformity in her works more thoroughly.

6

"Homosexualism," Gay and Lesbian Studies, and Queer Theory in Art History

Whitney Davis

WHAT is often called "gay and lesbian studies in art history" (e.g., Davis ed. 1994) is not a method in the strict sense. In professional art history, it draws eclectically on well-established documentary and iconographic as well as more recently elaborated semiotic, psychoanalytic, and other methods, considered elsewhere in this volume. It can, however, invoke specific theories – for example, Sigmund Freud's concept of primary narcissism or Michel Foucault's "repressive hypothesis." These have been widely debated throughout the humanities and social sciences (see Abelove, Barale, and Halperin ed. 1993). Many projects influenced by gay and lesbian studies do not directly have to do with same-sex sexual attractions in history. Nonetheless they derive from and express broadly gay, lesbian, "queer," or nonhomophobic interests, in certain artists, for example, or artistic themes.

In this chapter, I introduce gay and lesbian studies in art history as a long-term development from *"homosexualism"* to *gay and lesbian studies* and *queer theory*. I first review these terms in their broad sense, commenting on their past and present interrelations. After this introductory orientation, I offer a historiography – necessarily brief, selective, and personal – specific to art history and cognate humanistic disciplines.[1] I conclude with an example.

Overview of the Intellectual Context, 1750–1996

By "homosexualism," I mean the Euro-American tradition of self-consciously – if obliquely – highlighting the homoerotic personal and aesthetic significance and historical meanings of works of art or other cultural forms. Homosexualism became visible in a recognizably modern way in the middle of the eighteenth century, chiefly in J. J. Winckelmann's concept of the *angeborenlich* or inborn nature of homoerotic aesthetic sensibility (as distinct from sodomical and pederastic interest) (see Davis 1996a). It was highly developed by the end

of the nineteenth century and partly institutionalized in certain artistic movements and critical schools. Homosexualist history and criticism was produced not only by scholars (though rarely as the overt content of their research). It was also pursued by nonspecialist essayists, collectors, amateurs, and laymen who constituted a diffuse community of devotees of the arts and of belles-lettres.

Homosexualism was a cultural and to some extent an erotic and political practice. Partly by way of it, many middle-class men and women in the nation states of Europe and America and the colonies achieved their complex self-understanding – a sense of their personal and social situation, aesthetic interests and creativity, and legal–political status and responsibility – as being what we now call "homosexual." Initially, and until the early 1870s, homosexualist criticism had no working discursive idea of "homosexuality" as such. This concept emerged organically in the recollection or discovery of homoerotic possibilities in the past or in imaginary worlds – for which works of art and literature were often the prime evidence – and in relation to contemporary legal, medical–psychiatric, anthropological, and literary investigations. (For the turning point, see especially Herzer 1985, Kennedy 1988.)

By the beginning of the twentieth century, homosexualism had largely become the self-conscious (if still often covert) acknowledgment of "homosexuality." This can be described as a strong personal belief – apparently achieved in the face of harsh social rejection – in the irreducibility and incorrigibility and often the sociocultural universality and psychobiological inevitability of (one's own) same-sex erotic attractions and sexual activities, often though not necessarily experienced and practiced as the exclusive form of personal sexuality.[2] Authored not only by "homosexuals," homosexualist scholarship in science, medicine, psychology, and history (see especially Bloch 1902, Freud 1905, Hirschfeld 1914) succeeded in suggesting – to the satisfaction, at least, of many academics and substantial portions of the general public – that this belief is very probably a *true* belief. It adequately discovers a real phenomenon irrespective of the admittedly partial and ill-informed (and indeed to some extent hostile or anxious) social and discursive lens of observation itself.

The plausibility of this homosexualism – like physics or Catholicism, it is committed to what it urges is a true belief – has declined among a small (but highly visible) number of academic scholars today. The general prestige of *all* truth claims, of course, has declined, in part because twentieth-century philosophy places great stress on how the "reality" of natural or social phenomena can be created through interest-driven observations and ideologically determined discourses. (See Foucault 1980, Halperin 1990 for the intersections between homosexuality as a truth claim and homosexuality as a discursive construction.) But homosexualism remains virtually uncontested by the vast majority of non-academic middle-class Euro-American "gay people." Indeed, it is, apparently, vitally necessary to them; in America, most of their principal contemporary spokespeople, whether on the right (Sullivan 1995), left (Vaid 1995), or center (Mohr 1988, 1994) of the political spectrum, accept it as the *sine qua non* of intellectual understanding and social decision. In the broadest forum, the homosexualist

view – that the homosexualist belief is a *true* belief – is the only one that has extremely wide evidentiary support and both public and scholarly credibility. In the simplest formula, homosexualism is the personal testimony of homosexuals that they exist.[3]

"Gay and lesbian studies" emerged in the second half of the twentieth century fully accepting the reality of "homosexuality" in the sense noted, whether or not previous generations would or could have done so. As an academic sub-discipline (or interdiscipline), gay and lesbian studies has now been established in most of the humanities and social sciences. It has transformed homosexualism by consolidating its deep but diffused learning and emancipatory ambition and by successfully professionalizing its factual basis and substantive argumentation. Retaining strong connections with homosexualist belles lettres and with civil-rights, feminist, and AIDS activism both inside and outside the academy, today it remains open to the empirical and theoretical frameworks of highly specialized disciplines in psychology, sociology, philosophy, literary criticism, history, and cultural studies. It is largely, though not exclusively, the institutional creation and arena of self-identified gay and lesbian – "homosexual" *and* "homosexualist" – teachers and students.

In turn, "queer theory" has attempted to "theorize," as some might put it, certain aspects of the personal, rhetorical, and analytic concerns of traditional homosexualism – for example, its stress on an aesthetics of marginality (and associated formations of appropriation and resistance), on the psychology of self-division, on the tropology of disguised or reserved meaning (for example, irony), and on the special stylization, inflection, and proliferation of texts and performances, verbal and visual. All of these can be the substantive concerns of criticism or history as well as the material of art itself, as they have been since the eighteenth century. But queer theory coordinates them in relation to high-level philosophies of consciousness or selfhood and of textuality or art – to the point of implicitly offering a *general* theory of *all* subjective identity and aesthetic creation, of all selves and texts and works of art, as "queer." In this way, it has revised nineteenth-century homosexualist perspectives on the peculiarity of certain selves and texts to create a late twentieth-century critique of the structural peculiarity of modernity or even mind itself. It presents itself as a systematic attempt to depathologize and demarginalize (or perhaps universalize) homosexualism and to purge its originally determining sense of its own unacceptability, abnormality, or impossibility. Although founded in the empirical and theoretical work of gay and lesbian studies and related disciplines, this approach can require a textual and historical – and possibly even the phenomenological or psychobiological – deconstruction of homosexuality itself.

This last direction is a move that gay and lesbian studies itself did not, and does not, always wish to take. On the one hand, queer theory tries to *dehomosexualize* homosexualism – to advance an ethics and critique of "queer" consciousness, selfhood, textuality, or art without centering it in the "gay" or "lesbian" belief in homosexuality. In this respect, the queer theorist can be close to her late eighteenth- or early nineteenth-century predecessors – for example,

in her stress on the mutabilities of gender and the transformative, transgressive aesthetics of sensibility. On the other hand, queer theory tries to *homosexualize* the nonhomosexual – to extend the gay/lesbian belief in homosexuality to other phenomena of eroticism, intersubjectivity, and social relations about which an overarching "queer" belief should be *equally* true. In this respect, the queer theorist can be close to her late twentieth-century colleagues in feminism, African-American studies, postcolonial and subaltern studies, and the like. Either way, in queer theory the true belief of homosexualism tends to become, if not actually less true, certainly less necessary or interesting.

Homosexualism in Art History

The apparent fact that disciplines such as art, architectural, design, theater, and music history have attracted many homosexual – if not always homosexual*ist* – scholars has often been remarked (e.g., Rosen 1994). The historical determinations of this phenomenon deserve further study. By the nineteenth century, some interests in fine-art artifacts, in design and decoration, and in the idealization (or aesthetic reorganization) of the erotic, social, and built environments were stereotyped as nonstandard and perhaps sexually deviant – notable, for example, in public perceptions of J. J. Winckelmann, Queen Christina of Sweden, William Beckford, Walter Pater, Oscar Wilde, Gertrude Stein, and others. Roughly speaking, their interests were seen as "fetishistic"; in 1927, Freud formalized the long-standing idea that "fetishism" replaces a primary homosexuality (see Davis 1992). In turn, some people were attracted to social or professional milieus in which such interests were projected and protected. Here we should notice the long tradition of homoerotic and homosexualist analysis and criticism of the visual arts, much of it produced outside art history. This tradition provided the groundwork for contemporary gay and lesbian studies – for example, by establishing the very terms by which scholars understand themselves as persons and especially as art lovers or at least aesthetically interested viewers and interpreters. As such it has become one of the main topics for art- and cultural-historical investigation itself (e.g., Dellamora 1990, Jenkyns 1992, Davis 1993, Dowling 1994, Schmidgall 1994).

In 1755, J. J. Winckelmann recommended that modern artists imitate the forms, especially the outline contours, of Classical Greek painting and sculpture. Although Winckelmann's preferred modern artists, such as Guido Reni, were supposedly doing this already, Winckelmann criticized artists such as Gianlorenzo Bernini, who worked, he believed, from nature. Winckelmann's regard for an artist like Guido – hence the critical standard applied throughout his critical writings, especially *Reflections on the Imitation of Greek Works in Painting and Sculpture* (1987; 1st ed. 1755) – was clearly motivated by eroticized interest in his painting of a youthfully beautiful Archangel Saint Michael and similar works. More important, Winckelmann imagined that the outline contour of the Classical Greek image had itself been secured homoerotically. The

ancient sculptor, Winckelmann implied, imitated the outline of the form of the young men he judged to be beautiful. In turn, these youths made themselves beautiful – for example, in gymnastic games – for the erotic and ethical appreciation of older male lovers. Indeed, Winckelmann imagined that the ancient artists actually copied the outline imprints of handsome youths wrestling in the sand. In imitating the contour of Greek sculpture, then, the modern artist would (at a kind of second remove) actually be restoring the homoerotic teleology of ancient art (see Davis 1993, 1996a; Potts 1994).

Winckelmann's neoclassicist prescription – embedding both his motivating homoerotic standards and his art-historical interpretation of ancient homoeroticism – had tremendous influence not only on modern art but also on the development of art history (modeled partly on his *History of Ancient Art* of 1764) in the decades after his death in 1768. To be sure, the actual visual evidence for Greek or other varieties of homoeroticism and related social formations concerned only a handful of specialists: For example, Richard Payne Knight (1786) and Jakob Anton Dulaure (1909) considered the artifacts used in "phallic," though not necessarily homoerotic, cults; Carl August Boettiger (1800: 62–6) studied the dedications of Greek painted vases made as love gifts between men; M. H. E. Meier (1837) and John Addington Symonds (1873, 1883) included visual evidence in their comparatively systematic histories of Greek pederasty; various editors presented the "Secret Cabinet" at Naples and similar collections, containing ancient phallic, hermaphroditic, and pederastic images (e.g., Millin 1814); and early homosexual-rights advocates like Otto de Joux (1897) and E. I. Prime-Stevenson (Mayne 1908) included the visual arts in their surveys of same-sex love. Moreover, the scholarly interests of many modern artist-intellectuals – Anne-Louis Girodet-Trioson, members of the Barbu movement, Gustave Moreau, Jean Cocteau, and others – encompassed an eroticized interest in homoerotic themes, such as the myth of Ganymede or the story of Sappho and the iconography of transcendent androgyny or of the mythically butch lower-class trick. Precisely because its social realization has been tentative and proscribed, modern homoeroticisms constructed both nostalgic antiquarianism and utopian connoisseurship in which certain images signified the imaginary possibility of a homoerotically fulfilling human order (see Aldrich 1993). In a more diffuse way, academic figure study of the male nude occasionally embedded a "Winckelmannian" acknowledgment of the homoerotic circuitry involved in a male artist's production of an image of a desirable male body for the visual admiration of a substantially male audience (and a complementary, if not identical, interest in such circuitries among women) (see Crow 1995). Finally, collecting and publishing (and an important industry of imitation) partly motivated by homoerotic interests – or even interests in the history of homosexuality – were partly responsible for the preservation of works of art, often sexually explicit and connected with otherwise inaccessible subcultures, that now form one of the empirical foundations of gay and lesbian scholarship in art history.[4]

Just as important as these isolated but direct engagements with the possible homoerotic significance of visual forms, however, was the broad, often

barely articulated, public awareness that a scholarly or artistic interest in Classical Greek art and certain other images could be carried to a pitch or to nuances of enthusiasm that could only be construed as sodomitical or pederastic. Euro-American society has always heavily penalized sodomy – nonprocreative sexual acts, including homosexual ones. Increasingly in the later part of the nineteenth century, modern society saw "homosexuality" – a homoeroticism supposedly intrinsic to a person's character or nature, regardless of sexual practice, and possibly inborn – as pathological. After a period of relative openness from the 1780s to the 1830s, homoerotic material in the visual arts was generally suppressed or driven underground into very restricted circulation; scholarly interests in homoeroticism (even among self-acknowledged "homosexuals") were frequently organized along homophobic lines. Thus Isidor Sadger, the Freudian writer most responsible for developing the psychoanalytic theory of homosexuality, regarded the homoerotic personal and cultural interests of his principal patient to be thoroughly neurotic. The man, a Scandinavian baron, conjoined his Winckelmannian profession as art historian (his supposed "infatuation with statues") with real-life homosexual relationships. Sadger (1910, 1921) took the baron's form of life to embody a fundamental "narcissism" – a self-love and inability to get beyond the value of his own sex and beloved images of its erotic desirability. Shortly thereafter, and extending Sadger's idea, Freud (1910) thought he could discover such "narcissism" in the character of Leonardo da Vinci, supposedly as the very psychological origin of his adult (if nonactualized) "homosexuality" (see further Davis 1995b).

In this hostile climate – we can roughly date it from the 1840s (see Kaan 1844) to the 1960s and a broad transformation of many attitudes to gender and sex – historians of homoeroticism worked cautiously or, more usually, in euphemistic or obscurantist terms. In his *Social Life in Greece* (1874), for example, J. P. Mahaffy felt obliged, in the second edition, to drop his pages on Greek pederasty. In his standard *History of Modern Painting*, Richard Muther (1896) explained Michelangelo's interest in young men by supposing that women spurned him because of his ugliness. (This was in spite of powerful reasons presented by John Addington Symonds [1877] to suppose that Michelangelo's poetry was in part homoerotic.) From the 1920s through the 70s, art history was dominated by enormous catalogs, descriptive and comparative compendia, and monographic studies. But systematic treatments of artists like Donatello or Géricault and of major modern and contemporary artists from Gustave Moreau to Andy Warhol avoided – or were ignorant of – the homoerotic or "homosexual" dimensions of the life and work in question. With the exception of certain feminist and semiotic analyses, the major modes of art-historical analysis and interpretation were developed without reference to the social reality of same-sex eroticisms, past and present.[5]

Nevertheless, in certain contexts, sometimes identified with specific subcultural homosexualisms and homosexual emancipation movements, historians did conduct research into homoeroticism and the visual arts. In fact, as gay and lesbian history has been refined in the past two decades, earlier engagements

with homoeroticism in visual culture can often be seen as having been quite innovative (or at least productively animated by critical tensions). For example, John Addington Symonds produced several studies that were fully conscious of, if not directly motivated by, homoerotic aesthetics, ethics, and politics – cobbled together from his own troubled personal experiences and his reading of Classical literature, Walt Whitman, current psychiatry, and other sources. His writing included not only a biography of Michelangelo (more realistic than Muther's) but also critical essays on the nexus of Greek literature, art, philosophy, and pederasty and on the erotics of Renaissance art. His correspondence and "memoirs" (published long after his death) document his homoerotic antiquarianism and art-critical attentiveness (see generally Grosskurth 1964). One might also consider the very different projects of Walter Pater (1980), beginning with his 1867 essay on Winckelmann, and of Oscar Wilde not only on their own complex terms (see Jenkyns 1992, Dowling 1994, Schmidgall 1994) but also in terms of their impact on later homosexualist culture, particularly in the Bloomsbury group (see Reed 1994). In his *Jahrbuch für sexuelle Zwischenstufen*, Magnus Hirschfeld published several important art-historical studies at the turn of the century, including L. S. A. M. von Roemer's (1904) study of hermaphroditism and androgyny in premodern and non-Western arts and religious traditions. In the 1930s and 40s, American and expatriate intellectuals in New York (largely Greenwich Village) circles published a varied, open, and sophisticated cultural history and criticism frequently engaged with homosexuality (see Ford and Neiman ed. 1991); Parker Tyler's *Screening the Sexes: Homosexuality in the Movies* (1973) is a fascinating late product of this tradition (cf. Tyler 1967). Lesbian feminists in the 1960s and 70s carried out research into the cross-cultural history of feminine erotic imagery, coupled with efforts to renew it (see Lippard 1983, Langer ed. 1993).

In part because of professional art history's involvement with the art market – it resists any threat to the exchange value of art objects – and accountability to influential collectors and museum publics, it was slow to respond to this homosexualist tradition in literary and art criticism and belles lettres broadly conceived (including many politically activist endeavors and texts). Indeed, the homosexualist tradition still tends to be seen as amateurish – naive, self-interested, or apologetic – even though it shaped the modern cultural identity and self-awareness of many "inverted," gay or lesbian, and queer men and women despite absorbing some of the homophobic stereotypes endemic in the society which produced it.

Gay and Lesbian Studies in Professional Art History

The chief impetus for a self-acknowledged gay and lesbian studies in professional art history was the gay liberation movement of the later 1960s and the 70s. This politically motivated scholarship was not necessarily more objective than the homosexualist criticism that it partly replaced. In keeping with its partly

introspective excavation of minority social formations and proscribed subjectivities, gay and lesbian studies and queer theory today remain highly personalized and subjective (see, e.g., Camille 1994, Rand 1994). Indeed, they often aim to criticize myths about historical objectivity and to invoke a more realistic sense of social and psychic intersubjectivities.[6] But the gay liberation movement did provide a new sense of intellectual authority and flexibility for the individual gay and lesbian scholars who participated in it, despite their relative professional ostracism. The movement publicly demanded social tolerance, equal rights under the law, and cultural visibility and political representation for gays and lesbians. This ambitious agenda was seen to require that a diffused homosexualism, however extensive and knowledgeable, must formalize its aspirations and knowledge and assert them publicly according to the most widely accepted canons of argument. In this crucible a professional gay and lesbian art history was fashioned.

As the last point implies, the methods employed in the first major professional treatments of homosexuality and the visual arts were traditional in the fullest and best sense of the term. Often appearing in the 1970s in gay-friendly galleries or gay periodicals, by the early 80s they began to appear in mainstream professional contexts. Here I cannot discuss individual scholarly works and the many forms of evidence, method, and theory they deployed: They are very different one from the next. But they are united by their common concern to establish gay and lesbian inquiry within the discipline in the discipline's own accepted and often most legitimate or prestigious terms and formats – the documentary exhibition, compendium, or history offering stylistic, thematic, and sociopolitical analysis (with at least a minimum and often a maximum of conventional scholarly apparatus).[7]

Given the small number of participants, their limited resources, and their precarious academic situation, the initial contributions to gay and lesbian studies in art history tended to analyze "homosexual" artists, major homoerotic motifs or themes in the visual arts, and gay and lesbian cultural networks and institutions or ancestral and comparable social formations (largely in the postmedieval West). Stylistic analysis was occasionally set to the task of identifying distinctively gay or lesbian modes of production or response – a project sometimes wedded, in turn, to homosexualist concepts of specifically homosexual nature or identity at a biopsychological level. Whatever the status of such claims, the research method was productive. Many cultural homoeroticisms and homosexualisms have had a minority social realization and often a fundamentally oppositional component, however continuous they might have been with dominant conventions in other ways. Thus they could be documented as specific – even socially unique or independent – traditions consolidated in the work of well-defined groups of historically identifiable, sometimes self-acknowledged, homosexual men and women.

One did not, however, simply assume that a preexisting "homosexuality" had created particular visual traditions – art history's business being merely to retrieve or reconstruct them. It was understood that cultural practices – such as certain

Classical iconographies, academic modes of teaching art, or various art criticisms – shaped possibilities for "homosexual" expression, response, or identity in the first place. Winckelmann had argued that young men in Greece fashioned themselves in relation to the model projected to them by Pindar's poetry and Phidias's sculpture. In the preferred term of early nineteenth-century German Hellenism after Goethe and Wilhelm von Humboldt, such homoeroticism (it could have modern forms) was "ethical" – *a complex product of highly personal, often troubled, partly unconscious, and socially circumscribed self-cultivation in the cultural field of aesthetic forms*. This theory remains the mainstay of modern gender and gay and lesbian studies in culturalist disciplines and of queer theory, often more indebted to nineteenth-century German philosophy than its overt or claimed relationships to poststructuralism might imply.[8]

Despite the underlying culturalist theory, as a point of *method* it was convenient and proper to begin with those arts tied – in seemingly one-to-one correlations – to homosexual biographies and social groups or to undeniably "homosexual" themes. For indeed there were artists, artworks, or arts to be seen, as this method both assumed and discovered, as homoerotic*ist* or homosexual*ist* – as having attempted aesthetically and ethically to *realize* same-sex eroticism as such, which otherwise subsists (it has been claimed) as a universal potentiality of all sexual, social, and cultural relations. Artistically *un*realized homoeroticism, of course, was not the concern of an art history conceived along traditional lines. As a formalization of previous traditions of belles-lettristic interpretation, this art history was the academic equivalent of the gay-liberationist project of achieving legal–political representation and cultural visibility. Representation obviously requires a preexisting constituency to be represented and visibility an entity to be recognized.

There were well-known limits, however, to the scope of the project. Obviously, the positive historical record of past social and cultural realizations of same-sex sex and eroticism might be extremely fragmentary. Substantial material has been lost or destroyed. Moreover, modern Western homoeroticisms had been *created* homophobically; they had partly accepted their impossibility, imaginariness, or unacceptability as the very condition of social and cultural expression. Thus the evidence for same-sex meanings or desires – or even practices or institutions – in the visual arts might be the very *absence* of evidence for such meanings or institutions.

At the level of method, historians are always uneasy about arguments from silence, whether or not theory expects that the silences must be necessary, indeed constitutive, features of historical experience and therefore of the historical record. The gaps can be filled through acts of imagination on the part of interpreters or they can be addressed in a hermeneutic procedure, a text-critical, psycho-biographical, or structural analysis of the causes of the gap. But activating such procedures – launching a codicology to show where variants can be presumed or a psychoanalysis to suggest where a "repression" occurred – requires that one be able to identify a gap *as* a gap in the first place, that is, to endorse a theory of representational transmission or replication in which gaps are

123

predicted. The *culturalist* theory of modern homoeroticism – for example, Winckelmann's, Symonds's, Sadger's, or Foucault's – has always offered such predictions, partly because modern homoeroticism has often imagined itself (especially when it has been socially labeled as deviant) as the lack or loss of certain ideal possibilities for social life, mourns for them, and aims to restore or creatively invent them. But this theory has not been congruent with popular biopsychological or sociological theories, which clearly have little place for an empirical account of homosexuality as a constitutive *lack* of homosexuality. And to the extent that gay and lesbian scholarship worked with these, rather than cultural–historical, theories, it was unable completely to fulfill its own inter-pretive aims: it avoided thoroughgoing hermeneutics in order to render homo-sexuality visible according to the canons of positivism, but it could not, for just that reason, recover the whole historical field of same-sex eroticism in its con-stitutive *in*visibilities. Gay and lesbian historians know perfectly well that their positive documentations and successful interpretations touch the tip of the ice-berg. But analytic techniques for diving below the surface remain uncertain, highly theoretical in both the positive and negative senses.

Recent Gay/Lesbian Studies and the Development of Queer Theory

In the later 1980s and early 90s, several developments led to an extension and refocusing of gay and lesbian studies.[9] Throughout, as in gay and lesbian social and intellectual life generally, the impact of the AIDS crisis has been enormous, engendering a second wave of political, artistic, and intellectual activism (see especially Crimp 1988, 1989; Owens 1992). This antihomophobia movement includes many straight scholars: Antihomophobia can be "theorized" as such and has renewed academic interest (having a long but often uncited ancestry in homosexualist belles lettres) in *all* nonstandard or "queer" sociosexual forma-tions, such as transvestism or fetishism (see Butters, Clum, and Moon ed. 1989, Garber 1992). In recent gay and lesbian studies, three intellectual developments stand out.

First, partly following the lead of feminism, Anglo-American scholars have absorbed Continental poststructuralist thought – especially deconstruction – and the discourse-deterministic sociocultural theory of Michel Foucault. In some ways, queer theory, most simply put, can be seen as the effect of deconstruc-tion on gay and lesbian studies. Some of the central theoretical ideas of queer theory derive from intensive engagement with and critique of the Hegelian, Heideggerian, and phenomenological traditions, influenced by other post-structuralist claims about consciousness, knowledge, and power (see especially Butler 1987). As such, it would have been impossible for late eighteenth- or nineteenth-century thinkers to be queer theorists, although homosexualism and queer theory have much in common. We will consider the matter in more detail momentarily.

The impact of Foucault's conceptualizations on gay and lesbian historical studies has been profound. The *Introduction* to Foucault's *History of Sexuality* (1980) stressed that whatever its empirical biopsychological correlates, "homosexuality" should be seen (as the background culturalism requires) as the historical product of a social process of cultivation – namely, the formation of subjects imprinted by, and identifying with, cognitive classifications the chief effect, if not the sole cause, of which is to secure the integrity, purity, intelligibility, and reproducibility of the social order. Foucault's deft blend of Freudian, Althusserian, and Lévi-Straussian insights offered a model for, if not quite a method of, diving below the surface – for a history positivism could not quite achieve. His investigations employed eclectic historical–critical methods and did not really engage the primary sources critically, let alone discover new ones. But they did set an agenda for many projects in the "history of sexuality" which have greatly enriched the base of evidence to which social, cultural, and art historians can turn.

Foucault asserted that "the homosexual" was "called into being" as an effect of "repressive" juridical, medical, and psychiatric "discourses" which represented his or her erotic desires, social practices, and cultural productions to be the result of a natural, that is, inborn or constitutional, character – in other words, as an effect of the new classification of (and for) "homosexuality," a term first used in 1869. Foucault's argument here is structurally very similar to Jean-Paul Sartre's notion in *Anti-Semite and Jew* (1948: 13) that anti-Semitism "invents" the "Jew." Sartre had a concrete sense of who the anti-Semite is and of his or her irrational psychology. Foucault, by contrast, rarely speaks of actual or concrete homophobes. If they too are the "effect" of discourse – as the general theory would seem to require – they must have been "invented" by the antionanism discourse (e.g., Kaan 1844) that substantially predated the discourse on homosexuality itself, for they are supposedly the *authors of* the discourse on homosexuality. Consistent with his earlier work, however, Foucault generally avoids attributing the authorship of texts or discourses to concrete persons or even to well-defined institutions. Thus he envisioned a much more abstract and diffuse "power" vested in the modern "pastoral" state and its systems of knowledge pitted against a kernel of "freedom" – here, the freedom *not* to be invented, homophobically, as a "homosexual" – possessed by every human being. But the problem of authorship – and thus of the complex sociopolitical authorizations and authenticities – of the concept or cultural discourse of homosexuality cannot be waved away quite so easily or by theoretical fiat.

Despite the dramatic force of Foucault's critique of modern society and its creation and regulation of "homosexuality," his specific historical proposals about this process were sometimes inaccurate and often incomplete. The medical–psychiatric concept of "homosexuality" was indeed connected with developments in law, psychiatry, and sexology. But Foucault did not study the discursive passage from established homoeroticist theory to legal reform, psychiatry, and sexology of the 1860s and 70s; he simply assumed that it was exclusively psychiatry which offered a discursive theory about, and for, "homosexuals." Thus

he failed adequately to recognize that the "inborn" (*angeborenlich*) character of homoeroticist taste had been one of the principal arguments of cultural homoeroticism since the mid eighteenth century (one of the rallying cries, for example, of a publicly debated "antiphysicalist" politics in the French Revolution). It was endorsed by nineteenth-century emancipationists – again, predating the emergence of the terminology of "homosexuality" – who fought strenuously against the psychiatrization of their autobiographical testimonies. Indeed, the discursive concept of homosexuality was as much homosexualism's resistance to psychiatry as it was psychiatry's repression of nonstandard sexuality. (In his later works, Foucault seems to have recognized this, but it was not initially included in his highly influential, but one-sided, "repressive hypothesis" about the construction of sexuality [Foucault 1980].) Moreover, Foucault simply ignored the fact that many major psychiatrists and sexologists of the 1870s through the 90s did not in any sense regard homosexuality as "congenital" or "constitutional," as a natural character, kind, or species, whether mundane or morbid. In the interests of their own therapeutic industry, they saw it as socially acquired in postnatal development, a construction *of* the homosexual social practices and cultural forms that Foucault claims were the result of the concept of indigenous or congenital "homosexuality."[10]

These and other historical blind spots do not vitiate Foucault's theoretical framework. They do, however, suggest that historians must approach it cautiously. Supplementing Foucault's studies of medicine and sexology with a more systematic appraisal of homosexualist art and literature, for example, is likely to yield a picture of nineteenth-century developments different from Foucault's. In addition, many queer theorists have moved away from discourse determinism of the Foucauldian variety toward renewed insistence on human agency, accountability, and responsibility – whether homophobic, homoeroticist, or otherwise. (Again, in his later work Foucault himself took this turn.)

The second intellectual development is that the Freudian legacy has been reassessed, owing to developments in psychoanalysis itself and, increasingly, the research of social and cultural historians (e.g., Sulloway 1979, McGrath 1986, Appignanesi and Forrester 1992, Gilman et al. ed. 1994, Davis 1995a). Many elements of Freud's general psychology have come to be seen as a powerful imagination – but also as an unwarranted generalization – of specific social relations, erotic practices and histories, and cultural representations in Freud's client pool and in the historical traditions he reviewed. This research has not completely refuted Freudian concepts of the unconscious, repression, sublimation, identification, anxiety, phobia, and the like – central to all accounts of homoeroticism, homosexuality, and homosociality from the belles-lettristic through the positivist to the poststructuralist. But whether the unconscious and so forth are natural kinds – real psychic and social processes requiring our *meta*psychological description and providing viable components of any general *theory* of eroticism in the social field – now seems highly questionable.

In particular, Freud's model of the earliest infantile eroticism or "sexuality" – what he called "bisexuality," a lack of gender differentiation in an infant's

erotic object choice – was an ideological, albeit innovative, effort metaphysically to describe sexual variations in order to constitute them as the apparent object of a hermeneutic archaeology (and therapy) of personal postnatal development. This metaphysics has been useful to antinaturalistic and constructionist or developmentalist theories of gender and sexuality. But it is largely inconsistent with contemporary nonpsychoanalytic thought. To the extent that non- or antipsychoanalytic psychologies have little currency in the humanities today, this debate has not yet been directly joined. At the moment, subpsychoanalytic theories of primordial undifferentiated sexuality and of a developmental history of complex, crosscutting, and always incomplete and anxious identifications remain a touchstone for some recent work in gay and lesbian studies and queer theory.

Some queer theorists, for example, continue to invoke a model of subjectivity, namely, the primal "undifferentiated sexuality" of the young infant, polymorphously perverse and narcissistic. For them, the continuing reproduction of this sexuality – despite Oedipal triangulation, pubescent maturation, and adult object choices – implies that no adolescent or adult eroticism could be completely stable. But according to its most general principles, noted below, queer theory probably does not really require (and actually hobbles itself with) this highly essentialist and deterministic Freudian legend about an early phase of (non)consciousness, of human instinct, sensation, and feeling. The instability of sexuality and gender can be derived from the partial noncoordination – or queer intersubjectivity – of persons (bodies and minds) in the social field without invoking an *essential* instability of sexuality or, at the same time, denying the existential truth of homosexuality by *reducing* it to a formation of originally undifferentiated eroticism. In general, although gay and lesbian studies and queer theory are compatible with homosexualism, Freudianism is almost certainly not. (This rift was dramatically clear at the very institutionalization of psychoanalysis itself, when, after a very short period of fellow-traveling, homosexualist theorists detached themselves from the psychoanalytic movement [see especially Herzer 1992: 92–119].) The implication of this feature of the conceptual landscape of homosexualism, gay and lesbian studies, and queer theory is not yet clear. Does it mean that queer theory will ultimately dispense with Freudianism? Or that Freudianism will (as its own theory of homosexuality intended) defeat homosexualism?

The third intellectual development is that the basic social and cultural history and anthropology of same-sex social formations and relations, on a worldwide and transhistorical scale, has been greatly enlarged. Earlier historians tended to rely on a few, often outdated, sources, however rich, in part because there had been little opportunity for primary research. Increasingly, however, archival materials have been published. Original ethnographies have been completed. New historical detective work has yielded its harvests; the premodern history of homoeroticism has received new attention reflecting contemporary text-critical and hermeneutic methods. Greek homosexuality itself – the point of reference for many modern Western homoeroticisms – has been subjected to

intensive new historical and critical evaluation. (For one selection of these developments, see Abelove, Barale, and Halperin ed. 1993.)

Indeed, for the first time *visual* evidence came to play a major role in historical and critical analysis of the origins, nature, or history of homoeroticisms and homosexualities themselves. Poststructuralist cultural studies does not limit itself to texts narrowly construed (e.g., Fuss ed. 1991). Post-Freudian interpretation and queer theory have both stressed the construction of fluid identities in the specifically imaginary (or imagistic) dimension (e.g., Rose 1986, Silverman 1992) and in the fields of gestural, sartorial, and interpersonal action and performance (e.g., Butler 1990, Garber 1992, Meyer ed. 1994). Most historians have accepted that visual productions must, by definition, index phenomena partly or wholly unknown through the printed word – circulating through distinct social spaces, such as private or even "clandestine" viewerships that did not require printers (a little-studied determinant of the history of homoerotic textual representations in the modern West) or attract censors.

Although gay and lesbian studies, in its full contemporary variety, does not have a single method or overarching theory, it addresses a coherent sociocultural possibility of meaning: Works of art regularly sustain same-sex eroticisms, regardless of the "homosexuality" of the artist and his or her viewers or of the homoerotic significance of particular visual motifs and themes, precisely because the management of same-sex sociality, always including an element of sexual desire and social attraction, is one of the fundamental functions of human social systems. Such management can be more or less "homosexual," directly permitting sexual activity between members of the same sex, or more or less "homophobic," prohibiting it; indeed, these possibilities tend to be reciprocally defining (Butters, Clum, and Moon ed. 1989, Sedgwick 1990). But the homoerotic, in this broad sense, is one of the unavoidable inflections of representation. It is a species of difference carried, by way of formal and thematic agreement, through entire systems of concord and coherence among representational elements – however concentrated or diffused the totality might seem to be according to some measure of actual "homosexuality," real or represented.

Queer Theory

Contemporary queer theory in the humanities (see, e.g., Fuss ed. 1991) urges that all modern human eroticisms and subjectivities are equally, but differently, peculiar in the strict sense of that term. Each arises in a highly specific interaction between an individual consciousness, person, or self (or closely related groups of such) and other people (or groups of people) to whom it can only be partly similar. To use a simple formula, every subjectivity exists in an obliquely overlapped or "queer" position in relation to every other subjectivity encountered, or realizable, in its wider society.

For example, from the vantage point of "heterosexuals" in modern Euro-American society, "homosexuals" – or homosexual forms of life – tend to be seen as it were obliquely or from the side. Thus they often appear to be largely (and for many people contemptibly) "queer," as the pejorative label of Anglo-American colloquial speech has long had it. But from the vantage point of "homosexuals" in the same society, their alleged "queerness" must be one of the central features of their experience, grounded in specific forms of life. Although homosexuals cannot avoid assimilating the majority view that being "queer" is unusual, unnatural, or immoral – peculiar in the pejorative sense – they can also occupy their position as a more or less self-consciously recognized species of difference, privately meaningful and sometimes publicly performed. And from this position, "heterosexuality" – or heterosexual forms of life – exists in a position overlapping with but lateral to it; from a homosexual vantage point, heterosexual forms of life appear equally "queer."[11]

By the most general terms of the underlying theory, the same possibility must be extended to *all* people and groups in the social field: queer-theoretical analysis describes subjective and intersubjective positionality and perspective, and the social practices and cultural forms engendered in and legitimated by them, across social spaces and through historical time. Thus a queer theory might well describe heterosexual forms of life as a difference from homosexual positions or potentialities. Here it often draws on neo-Freudian ideas about the formation of an unstable – if socially normative – heterosexual genital masculinity in relation to its attempts to forget, revise, and restore other possibilities for erotic pleasure and gender identity; for Freud, the emergence of normative heterosexual masculinity will be both an "overcoming" of desired homosexual positionalities and a "fixation" on – a neurotic quasi-fetishism of – a frightening femininity (see, e.g., Silverman 1992).[12]

In the end, we might conclude that such reciprocally defining formations of subjectivity cannot be captured by concepts of single or stable (more accurately, nonrecursive and uninflected) sexuality in the first place. Instead of identifying "homosexuality" or "heterosexuality," then, one simply observes continually varying psychic and social inflections of queerness. One way to cope with the analytic complexity entailed in this approach extends the fundamentally "grammatical" model of gender (i.e., the inflection of both the forms and the acts of speech) (see further Davis 1996b). A closely related terminology highlights the "performative" (or what might be called the pragmatic) dimension of sexuality (see further Butler 1990).

Queer theory, then, acknowledges the peculiarity – the specificity, distinctiveness, and originality – of every sexual and subjective position in relation to every other one *and* asserts that no such position could be a general model of *all* sexualities and subjectivities. As a point of both method and politics, it must insist that no single one of the overlapped but queerly situated positions should be privileged: None should be regarded a priori to be the *most* or the *least* peculiar in the history of the social realization of persons – even though each one

probably requires, and has often asserted, its peculiar reality, necessity, centrality, normality, ineradicability, exclusiveness, or independence.

Methodological and political questions arise not only from the premises of queer-theoretical analysis but also from its results. For some critics, queer theory tends to introduce a *relativism* potentially inconsistent with the standard liberal belief that society must protect individuals from the rights-denying interferences of others, a belief held by many queer emancipationists themselves when it comes to their own civil and constitutional rights. (Obviously such relativism must be incompatible with any philosophy of sexual normality and subjective normativity.) It might seem to such critics, for example, that queer theorists go too far in legitimating the subjectivity represented in, or relayed by, works of art or literature that could socially incite sadism or pedophilia – even though analysis might distinguish homoerotic sadomasochism or intergenerational pederasty from such formations. For others, by contrast, queer theory tends to guarantee the *perspectivalism* from which the very description of modes of sexuality and subjectivity must be conducted: What is the *difference* – real and represented – between pathological sadism and homosexual sadomasochism, or between pedophilia and pederasty, and what are their historical, intersubjective, and ethical coordinates? Painstaking care here ensures maximum recognition of different intersubjective erotic universes, even though we might ultimately resolve that certain ones cannot be freely tolerated.

Even within the academic and artistic community of feminists, gay/lesbian scholars, and queer theorists today, political tensions are increasingly visible. Most notably, queer-theoretical reasoning might not always be readily compatible with at least some of the political urgencies perceived by many self-identified gay and lesbian people. Thus David Halperin (1995: 222), responding to queer theory, writes: "Lesbians and gay men can now look forward to a new round of condescension and dismissal at the hands of the trendy and glamorously unspecified sexual outlaws who call themselves 'queer' and who can claim the radical chic attached to a sexually transgressive identity without, of course, having to do anything icky with their bodies in order to earn it." Others have complained that queer theory tends to validate the cultural production – more accurately, the commercial consumption – of malleable or disposable touristic psychosexualities exactly where actual communities grounded in specific historical experiences continue to fight for recognition.

Queer theory might retort, however, that any partly achieved erotic positions, such as the classic "homo" positions described with great acuity by Leo Bersani (1995), however transgressive in themselves, will tend to reject and resist their *further* mutation. Gays might resist and repress queers; at least, and by definition, for those who already occupy a sustainable eroticism – frequently due to the achieved privileges and institutionalization that others have yet to attain – little excitement lies elsewhere. If the "homos" must fight for recognition among the straights, must not the " 'homos' " – using the quotation marks advisedly – fight for recognition among the homos *and* the straights? And if their strategy (as well as their pleasure) is closer to a straight image of being

"homo" than to a "homo" image of being straight, is this proof of accommodation, commodification, or capitulation – or the expected aesthetic productivity of an emergent intersubjectivity?

Although it might be self-important, the construction or performance of "outlaw," queer identities does not necessarily delegitimate homosexual forms of life, normalize the sexually specific into the general commodity culture, or mainstream the "sexually transgressive" into domesticated chic. After all, viewed historically, the modern homosexual identities, positions, or forms of life – which Halperin and Bersani hope to rescue from vaporization, in present-day queer chic – have largely been the product of the transgressive imaginations and aesthetics, no doubt often ersatz and touristic, of earlier generations of queerly situated men and women, "homosexual" or not (see Davis 1993, Jackson 1995).

A Brief Example

In Edgar Degas's *Young Spartans*, ca. 1860, now in the Art Institute of Chicago (Fig. 19), the group of girls on the left is clearly distinguished from the group of boys on the right.[13] Each is a tight cluster of figures, separated by a pathway in the foreground continuing the vertical bisection created by the pavilion in the background. In the later (and much reworked) version of the painting, ca. 1860–80, now in the National Gallery in London (Fig. 20), Degas removed pathway and pavilion. But he juxtaposed the two groups more dramatically by organizing gestures and glances to suggest a relay of responses proceeding outward from the same-sex clusterings toward a future, but quite ambiguous, amalgamation of the groups. By repeating the shape of the houses in the town in the distance, the pavilion in the background of the Chicago painting represents the ideal form of Spartan society. In front of it, a stately lawgiver (presumably Lycurgus) converses quietly with two sturdy, dignified Spartan matrons. The group symbolizes the goal toward which the girls and boys should ideally develop – in the painting's projected history – along the path initiated by their interaction in the foreground. But the wide space between foreground and background (in the London canvas, Degas clarified it considerably) shows that they have some way to go. The girls are not matrons (although Degas, in an early study, did treat the gesturing girl as an older woman) and the boys are not Lycurgus. Thus there are two major orders of difference clearly marked in the composition – between Spartan girls and boys and between Spartan youth and adulthood. The visual prominence of these pictorial divisions suggests that the painting, whatever its specific theme, addresses the division of the sexes and their relations both because of and despite it – a narrative of gender difference relayed by the particular story of contest and courtship and, more important, of their psychic and social definition in a "Spartan" world known for its unique erotic and legal norms.

To explore this latter point, however, we must go beyond the differences marked in the division of left and right and foreground and background zones. In both

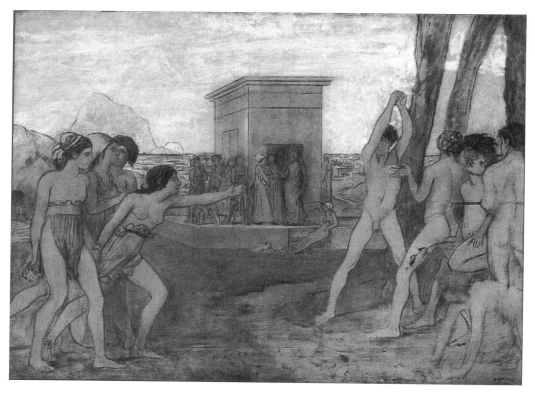

Figure 19. *Edgar Degas (1834–1917),* Young Spartans, *ca. 1860. Oil on canvas. 4'6⁹/₁₆″ × 3'2¹/₈″ (140 × 97.8 cm). Charles H. and Mary F. S. Worcester Collection, Art Institute of Chicago. Photo courtesy of Art Institute of Chicago.*

versions of the painting, subtle similarities obtain between the girls' and boys' poses, gestures, and glances. These do not simply reproduce the basic compositional distinction of gender. In fact, Degas partly aims to suggest *less* difference between the sexes than might have been assumed by viewers familiar with the conventions of neoclassical history painting. The athletic Spartan girls actively engage the boys from a position of comparative strength, unlike the modest, helpless women in paintings like J.-L. David's *Oath of the Horatii* (1785). Their half-nakedness and short hair differentiate them from mature, married, child-bearing Spartan women, in the background, and partly assimilate them *to* the boys. Indeed, Spartan girls – the painting implies – are virtually "boys" until they become "women" (granting that a Spartan matron was unlike her sequestered Athenian counterpart). At the same time, to assume Lycurgus's position the boys must control the girls. But Degas depicts several boys as virtually unsexed or partly "girls" – an approximation of the point – until they become "men." Distinct from the background domain of adulthood, both girls and boys are inflected by youth. This status permits same-sex eroticism, as the couplings

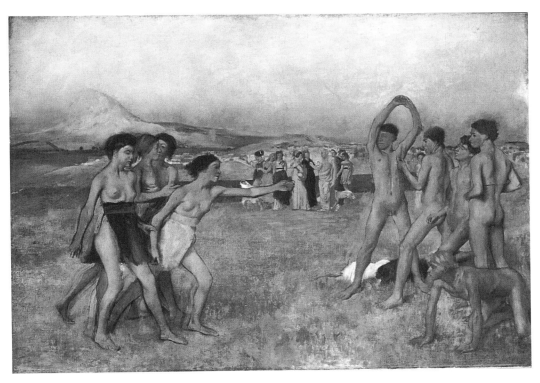

Figure 20. *Edgar Degas,* Young Spartans, *ca. 1880. Oil on canvas. National Gallery, London (L. 70). Photo courtesy of National Gallery.*

in the centers of the two clusters imply, and even a kind of animality, displays of desire, strength, or fear, suggested by the centermost girl and boy and by the recoiling girl and crouching boy in the corners of the composition.

In the Chicago canvas (Fig. 19), although Degas indicates the genitals of two boys and the breasts of three girls, the young people's hair, faces, and slim, long-legged bodies, equally important in the pictorial metaphorics, are very similar in both groups. Sex characteristics have been exchanged or wholly eliminated. The girl cupping another's breast seems to lack developed breasts herself; she has even been seen as a boy. Four boys have essentially unsexed forms, since Degas provides no direct sign of sex. But clearly we are not meant to see hermaphroditic bodies here. Instead, the notation inflects the designation of male sex – established by the agreements between the body of the boy frontally facing us, showing prominent if indistinct genitals, and the "unsexed" bodies of the others – with the signs of immaturity, variability, transformation, and uncertainty. The rightmost boy with back turned echoes familiar images of Classical male athletes. The boy with upturned face seems to echo images of St. Sebastian. A Classical athlete and a St. Sebastian have somewhat diverging traditional connotations – more or less masculine, more or less homoerotic –

that Degas enfolds in depicting the cluster of boys. It is formally and thematically somewhat "queer," although what this could imply historically about Degas's and his viewers' gender identity or erotic position, at least in relation to this painting and its depicted objects, would need extensive analysis.

As Degas's sources recounted, the boys belonged to the Spartan *syssitia*, a homosexually organized communal band that prepared them for war and leadership. The conventional male gender and erotic position of Degas's boys has been inflected, it seems, by this reimagined, sexualized gender; not quite a "homosexuality," it is clearly homoerotic in visual tone and thematic import in the Chicago canvas and has been recognized, for example, in Attila Richard Lukacs's 1988 replication and revision of the painting (Fig. 21) (see further Dompierre 1989). Apart from Degas's depiction of the slightly sadomasochistic eroticism of the boys' society, his early work for the painting included a study for a boys' footrace and (possibly) boxing match and an extraordinarily sexualized study for the boy on his hands and knees (losers in the Spartan boys' contests owed sexual gratification to the winners). In turn, these elements agree with the rest of the painting, spreading a *homoeroticized* masculinization to the girls. It is not incompatible to note, of course, that the girls' erotic bonding is transferred to the boys' group, which, however, suppresses its overt marking. In the longstanding conventions of Degas's culture, partial "feminization" of the youthful male form could designate its erotic desirability (see further Davis 1994) as long as sexual arousal was not depicted (indeed, the feminizing inflection or emasculation prevented it), for such marking of the object would identify an improper pederastic interest of the observing subject. It would seem, here, that Degas understood himself to be entering dangerous territory, like other artists in this period of the pathologization of homoeroticism; his images of homoerotic social relations – including the studies for and production of the Chicago canvas – tended to be organized, in the ongoing development of a final image, in anxious, defensive, even homophobic ways. In the London canvas, the homoerotic subinflections of male and female were *re*inflected more conventionally. Degas reorganized the gestures and glances of the boys and reduced their number to help establish *cross*-sex rather than *same*-sex interactions in the narrative. Moreover, the idealization of the faces – evoking the Classical referents and hence the specific norms of Dorian pederasty and male and female homoeroticism – was reduced; although this revision has been seen as an effort at greater contemporary "realism," it might also be seen as a retrospective attempt to moderate homoerotic fantasy.

Needless to say, although such observations are sensitive, as far as possible, to the full range of pictorial materials and historical evidence bearing on the production of Degas's paintings of the young Spartans, they are highly interpretive. The point, again, is not to determine whether Degas was a "homosexual" or himself experienced recognizably homoerotic sensations; it is, rather, to identify the ways in which same-sex desire and sociality operates as a determinate inflection in and of representation. In one sense, the theme of youthful Spartans necessarily entrained homoerotically charged connotations – for

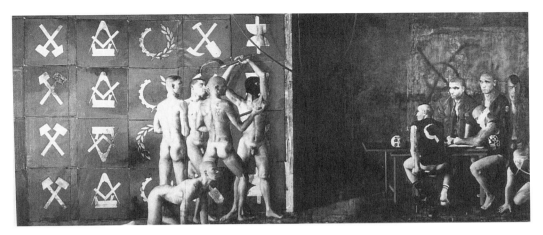

Figure 21. *Attila Richard Lukacs,* Junge Spartaner fordern Knaben zum Kampf heraus, *1988. Tar, oil, enamel, and varnish on canvas. 8′11¹¹/₁₆″ × 21′6⁷/₁₆″ (275 × 662.5 cm). London Regional Art and Historical Museum. Photo courtesy of Diane Farris Gallery, Vancouver.*

Sparta had long been interesting to modern observers precisely because of its distinctive political and erotic culture – and any representation of tightly bonded communities of young men or women necessarily confronted, whether or not it ultimately depicted, the possible eroticism of their interrelations. As an inflection in and of representation, the homoerotic may be homosexual or homophobic, barely visible or concentrated enough to offer, in itself, a complex representation *of* a particular homoeroticism rendered visible by a consciousness that clearly takes itself to be attentive to the subject as such.

Notes

1 For fundamental bibliographies, see Bullough et al. 1976; Herzer 1982; Dynes 1987, ed. 1990; Simons 1988; Langer ed. 1993; and Saslow and GLC ed. 1994.

2 To avoid anachronism, I use the term "sexuality" here in its early nineteenth-century sense – that is, to refer to the teleological organization (the direction and "aim") of human generative or sexual activity, even though in this context homoerotic sexuality often had to be seen as preposterous, excessive, distorted, incomplete, or vicious – as earlier canon doctrines of sodomy, generalizing across all nonreproductive sex acts, had it. Throughout the nineteenth century, emphasis increasingly shifted from the *action* of erotic attraction to its *feeling* or even its *instinct* (see further Davis 1995a: 115–40).

3 This matter is sometimes put as a supposed opposition between "essentialist" and "constructionist" accounts of homosexuality. But this polarity can (though need not) be misleading. Few deny that the "essentialist" homosexualist account of "homosexuality" is a *belief*, a socially determined cognitive and discursive construction based on highly specific and contingent observations or perspectives. So too are all beliefs or truth claims – for example, about gravitation, phlogiston, evolution by natural selection, the Trinity, or price fluctuations. The question is whether this belief is true – whether the "constructed" origins of the belief that homosexuality is some type of natural kind (or "essence") do, or do not, invalidate or discredit (for they clearly enabled) the belief. It is the belief of the present author that they do not. Nonetheless, it remains an open question *what* type

of natural kind (or "essence") homosexuality might be. It is, for example, probably in part a "socially constructed" natural kind (like a variety or species under natural selection), although not necessarily a culturally determined one (like a text or performance); even more probably, whatever *else* it might be, "homosexuality" is a partly culturally determined socially constructed natural kind of intersubjectivity (like a cognitive faculty or category, a human person, or even an attitude or aesthetic). Part of the confusion in this debate stems from the widespread fallacy that "essences" or "natural kinds" cannot be socially constructed and culturally determined – as if, for example, culture itself were not an essence or natural kind among human beings.

4 This crucial matter has yet to be treated systematically by art historians. Important collections (and/or publications of collections) included those assembled by Cardinal Albani from the 1720s to the 60s; P. F. Hugues d'Hancarville in the 1780s; William Beckford in the early 1800s; Henry Spencer Ashbee, Louis Constantin, and other collectors of erotica in the 1860s and 70s; Hans von Marees, Franz von Stück, and other German artist-intellectuals in the 1880s and 90s; Magnus Hirschfeld, Curt Moreck, Eduard Fuchs, and other scholars from the early 1900s into the 30s; Alfred C. Kinsey, Betty Parsons, Roger Peyrefitte, and other collectors and dealers in the 1940s and 50s. To date, both gay/lesbian studies and queer theory in the humanities have tended to study the composition and circulation of texts – or works of art treated as texts – rather than the manufacture and distribution of artifacts. But the specific artifactuality (or concrete archaeology) of texts is often the site of their homoerotic or "homosexual" constitution. A modest example: Many homosexually explicit illustrations were included in only some copies of some editions of well-known (if often quasi-clandestine) literary works, and are forgotten when the texts of these works are (re)printed. Or again: Patterns of mutilating classical statuary provide an important guide to changing modern standards for the erotically normative or comfortable.

5 However, these modes of analysis – especially iconography and iconology – did allow well-informed if somewhat muted treatments of historical homoeroticisms (e.g., Wind 1938–9, Panofsky 1939, Wittkower and Wittkower 1963). My point is that they were formulated independent of the demand motivating recent gay and lesbian studies and queer theory as such – namely, that they be specific accounts of, and more broadly accountable to, the histories and experiences of homoeroticisms.

6 A commitment to historical objectivity is not incompatible, of course, with identifying and interpreting the experiential realities of homoeroticism, and a more subjective or hermeneutic approach does not in itself guarantee that such realities will automatically be made visible. For example, Ernst van Alphen's (1993) study of Francis Bacon's work is a self-avowedly reflexive exploration in which the writer continually asserts his subjective position and deals at length with (his own sense of) Bacon's pictorial sense of "masculinity." But the book sidesteps Bacon's homosexuality and the homoeroticism of his images and of their potential reception. By contrast, in O. K. Werckmeister's (1991) analysis of how Bacon's work has been exhibited and interpreted – a treatment rooted in a commitment to realistic reportage and evaluation – such avoidance of gay significance, a politically symptomatic misunderstanding of Bacon's life and work, is identified as one of the principal objective characteristics of Bacon's reception.

7 See, e.g., Chadwick 1990; Champa 1974; Cooper 1994; Fairbrother 1981; Fernandez 1989; Hood 1987; Lambourne 1985; Langer 1981; Lloyd 1984; Saslow 1986, 1991; Sokolowski 1983. Extensive documentation is available in the bibliographies cited in n. 1.

8 Current variants of "social constructionism" in these fields, for instance, tend to be variants of this ethicist culturalism, revised in the light of Marxist, Freudian, and Saussurean concepts of ideology, desire, and language and filtered through twentieth-century critical sociologies. At the limit, however, ethicist culturalism must be incompatible with some versions of deconstructionist and Lacanian thinking (see Butler 1990, Benhabib 1992), a debate we can expect to be joined more fully in the next few years.

9 Again, I cannot be comprehensive; these studies are very differentiated. See, e.g., Abelove, Barale, and Halperin ed. 1993; Aldrich 1993; Barkan 1991; Bergman ed. 1993; Davis 1992, 1994, ed. 1994; Dellamora 1990; Fuss ed. 1991; Gilman 1988; Katz 1993; Meyer ed. 1994; Ockman 1993; Rand 1994; Saslow 1992; Silver 1992; Simons 1994; Watney 1990; Weinberg 1993.

10 As a small but typical and telling example of these slippages, Foucault (1976: 44) would use Carl Westphal's 1870 article (he gives the date and place of publication but not its title) to "stand for the date of birth" of the "psychological, psychiatric, medical concept of homosexuality" as "characterized . . . less by a type of sexual relations than by a certain quality of sexual sensibility, a certain way of inverting the masculine and feminine in oneself." Although this is broadly true in the long-term history or, better, retrospective political assessment of modern thought about homoeroticism that Foucault projects in his book, Foucault's historico-bibliographical comment elides some of the most difficult historical issues. For example, Westphal did not use the term "homosexuality" (*Homosexualität*) at all. This was the invention of Karl Maria Kertbeny, a maverick who was not part of the Central European medical establishment, unlike Westphal, a leading psychiatrist (Herzer 1985). And Kertbeny's concept was closely connected with homosexualist emancipationism: It was designed in part as an argument to absolve homosexual defendants of criminal responsibility in the farcical sodomy trials in which they were frequently embroiled. (It was, however, distinct from Karl Heinrich Ulrichs's embryological speculations, of the later 1860s, designed to *explain* the phenomenon as the appearance, in male homosexuality, of a "woman's soul in a man's body.") Westphal's (1870) own term, *conträre Sexualempfindung*, was distinguished from irresponsible instinct; *Empfindung* was a perversion of moral feeling (or even a vice or sin) for which a defendant could in principle be held responsible. Indeed, even setting aside the difference in Kertbeny's and Westphal's terminologies, it was not at all clear that Westphal's principal case of a man in *Frauenkleidern* matched Kertbeny's concept of a constitutional *Homosexualität* which is not necessarily marked by any particular erotic practice or overt behavior whatsoever. By 1900, the term *Homosexualität* covered both congenital *Instinkt* – Kertbeny's "homosexuality" – and casual or what Freud (1905) called "amphigenic" homosexual sexual activity (i.e., "a type of sexual relations"). Whether or not it denoted a pathology or morbidity, it was specifically distinguished, at this point, from a "sensibility" – denoted, in German, by such terms as *gleichgeschlechtliche Liebe* ("same-sex love") or *Lieblingsminne* ("chivalric love of comrades"), used by thinkers who wanted to see homoeroticism as an ethical–aesthetic taste (akin to Winckelmann's [1972] original *Empfindung*, the "ability to perceive the beautiful in art") instead of an instinctualized, organic, or involuntary state (see, e.g., Friedlaender 1904). Considering Foucault's own emphasis on the sociopolitical significance of discursive categories and conventions, it is worth noting that in the statement quoted he conflates at least three distinct, and partly opposed, concepts and attributes them to the wrong writer.

11 A similar conceptual framework has been used in recent anthropological work on "central" and "marginal" culture areas – for example, on the "centrality" of Greco-Roman civilizations and its traditions, in relation to which the provincial, hinterland or "barbarian" cultures appear to be ex-centric, or on the "centrality" of the Maya heartland in relation to which lower Central American prehistoric cultures appear as it were to be "queer." Of course, from the vantage point of the Danish or Costa Rican contemporaries of Roman imperial or classic Maya civilization, these "centers" probably appeared equally ex-centric. Much of the language of cultural history – with its intricate vocabularies for "primitive" and "civilized," "nonliterate" and "literate," "cosmopolitan" and "provincial," "high" and "low," "mainstream" and "marginal," "traditional" and "modern," etc. – can be approached queer-theoretically in the general sense.

12 Compare Davis 1995a: 221–5 for the Adlerian sources of this approach to "organ inferiority," now quite popular in art- and cultural-historical writing that blends Freudian,

feminist, and Adlerian concepts (for a typical example, see Bryson 1994). In some queer-theoretical work, the structural role and sociopsychic dynamics of "homophobia" – the psychologically internalized social bar against the realization of nonreproductive and specifically homoerotic sexualities – has been highlighted (e.g., Butters, Clum, and Moon ed. 1989, Sedgwick 1990).

13 This and the following four paragraphs are adapted from Davis 1996b, which presents a fuller discussion of gender and sexuality as phenomena of "agreement" – in the system of "difference" – in representation. For the paintings, see esp. Burnell 1969; Brettell and McCullagh 1984: 32–5; Salus 1986; Thomson 1987: 33–9, 1988: 40–8; Boggs et al. 1988: 98–100; Broude 1988. More generally, see Armstrong 1992, Kendall and Pollock ed. 1992.

References

Abelove, Henry, Michele Aina Barale, and David Halperin, eds. 1993. *The Lesbian and Gay Studies Reader.* London: Routledge.

Aldrich, Robert. 1993. *The Seduction of the Mediterranean: Writing, Art and Homosexual Fantasy.* London: Routledge.

Alphen, Ernst van. 1993. *Francis Bacon and the Loss of Self.* Cambridge: Harvard University Press.

Appignanesi, Lisa, and John Forrester. 1992. *Freud's Women.* New York: Basic/HarperCollins.

Armstrong, Carol. 1992. *Odd Man Out: Readings of the Work and Reputation of Edgar Degas.* Chicago: University of Chicago Press.

Barkan, Leonard. 1991. *Transuming Passion: Ganymede and the Erotics of Humanism.* Stanford: Stanford University Press.

Benhabib, Seyla. 1992. *Situating the Self: Gender, Community, and Postmodernism in Contemporary Ethics.* New York: Routledge.

Bergman, David, ed. 1993. *Camp Grounds: Style and Homosexuality.* Amherst: University of Massachusetts Press.

Bersani, Leo. 1995. *Homos.* Cambridge: Harvard University Press.

Bloch, Iwan. 1902. *Beiträge zur Aetiologie der Psychopathia sexualis*, part 1. Dresden: H. R. Dohrn.

Boettiger, Carl August. 1800. *Griechische Vasengemälde*, vol. 1, part 3. Magdeburg.

Boggs, Jean Sutherland, Douglas W. Druick, Henri Loyette, Michael Pantazzi, and Gary Tinterow. 1988. *Degas.* New York: Metropolitan Museum of Art.

Brettell, Richard R., and Suzanne Folds McCullagh. 1984. *Degas in the Art Institute of Chicago.* New York: Abrams.

Broude, Norma. 1988. Edgar Degas and French feminism, ca. 1880: "The Young Spartans," the brothel monotypes, and the bathers revisited. *Art Bulletin* 70: 64–79.

Bryson, Norman. 1994. Géricault and "masculinity." In *Visual Culture: Images and Interpretations*, ed. Bryson, Keith Moxey, and Michael Ann Holly, pp. 228–59. Hanover, N.H.: Wesleyan University Press/University Press of New England.

Bullough, Vernon L., W. Dorr Legg, Barrett W. Elcano, and James Kepner. 1976. *An Annotated Bibliography of Homosexuality.* 2 vols. New York: Garland.

Burnell, Devin. 1969. Degas and his "Young Spartans Exercising." *Art Institute of Chicago Museum Studies* 4: 49–65.

Butler, Judith. 1987. *Subjects of Desire: Hegelian Reflections in Twentieth-Century France.* New York: Columbia University Press.

1990. *Gender Trouble: Feminism and the Subversion of Identity.* New York: Routledge.

Butters, Ronald R., John M. Clum, and Michael Moon, eds. 1989. *Displacing Homophobia: Gay Male Perspectives in Literature and Culture.* Durham, N.C.: Duke University Press.

Camille, Michael. 1994. The abject gaze and the homosexual body: Flandrin's *Figure d'Etude.* In *Gay and Lesbian Studies in Art History*, ed. Whitney Davis, pp. 161–88. Binghamton, N.Y.: Haworth Press (= *Journal of Homosexuality* 27, nos. 1/2).

Chadwick, Whitney. 1990. *Women, Art and Society*. London: Thames and Hudson.

Champa, Kermit. 1974. Charlie was like that. *Artforum* 12 (March): 54–9.

Cooper, Emmanuel. 1994. *The Sexual Perspective: Homosexuality and Art in the Last 100 Years in the West*. 2nd ed. London: Routledge.

Crimp, Douglas, ed. 1988. *AIDS: Cultural Analysis, Cultural Activism*. Cambridge: MIT Press.

1989. Mourning and militancy. *October* 51: 3–18.

Crow, Thomas. 1995. *Emulation: Making Artists for Revolutionary France*. New Haven: Yale University Press.

Davis, Whitney. 1992. HomoVision: A reading of Freud's "Fetishism." *Genders* 15: 81–118.

1993. Homovisibility: Male Homosexual Desire in the Visual Field, 1750–1920. The Tomas Harris Lectures in the History of Art, University College London, May.

1994. The renunciation of reaction in Girodet's *Sleep of Endymion*. In *Visual Culture: Images and Interpretations*, ed. Norman Bryson, Michael Ann Holly, and Keith Moxey, pp. 168–201. Hanover, N.H.: Wesleyan University Press/University Press of New England.

ed. 1994. *Gay and Lesbian Studies in Art History*. Binghamton, N.Y.: Haworth Press (= *Journal of Homosexuality* 27, nos. 1/2).

1995a. *Drawing the Dream of the Wolves: Homosexuality, Interpretation, and Freud's "Wolf Man."* Bloomington: Indiana University Press.

1995b. Leonardo und die Kultur der Homosexualität. *Texte zur Kunst* 5, 17: 56–73.

1996a. Winckelmann's homosexual teleologies. In *Sexuality in Ancient Art*, ed. Natalie Boymel Kampen, pp. 262–76. Cambridge: Cambridge University Press.

1996b. Gender. In *Critical Terms for Art History*, ed. Robert Nelson and Richard Shiff, pp. 226–36. Chicago: University of Chicago Press.

Dellamora, Richard. 1990. *Masculine Desire: The Sexual Politics of Victorian Aestheticism*. Chapel Hill: University of North Carolina Press.

Dompierre, Louise. 1989. *Attila Richard Lukacs*. Toronto: Power Plant.

Dowling, Linda. 1994. *Hellenism and Homosexuality in Victorian Oxford*. Ithaca, N.Y.: Cornell University Press.

Dulaure, Jakob Anton. 1909. *Die Zeugung im Glauben* [*Les divinités generatrices*, 1st ed. 1805; 2nd ed. 1825], ed. and trans. Friedrich S. Krauss and Karl Rieskel. Berlin: Anthropophyteia.

Dynes, Wayne. 1987. *Homosexuality: A Research Guide*. New York: Garland.

ed. 1990. *Encyclopedia of Homosexuality*. 2 vols. New York: Garland.

Fairbrother, Trevor. 1981. A private album: John Singer Sargent's drawings of male nude models. *Arts Magazine* (December): 70–9.

Fernandez, Dominique. 1989. *Le rapt de Ganymède*. Paris: Grasset.

Ford, Charles Henri, and Catrina Neiman, eds. 1991. *View: Parade of the Avant-Garde: An Anthology of View Magazine (1940–1947)*. New York: Thunder's Mouth Press.

Foucault, Michel. 1980. *History of Sexuality*, vol. 1. *An Introduction*, trans. Robert Hurley. New York: Vintage Books. (Originally published 1976 in French.)

Freud, Sigmund. 1905. *Drei Abhandlungen zur Sexualtheorie*. 1st ed. (3rd ed. 1915). Vienna: Deuticke.

1910. *Eine Kindheitserinnerung des Leonardo da Vinci*. 1st ed. Vienna: Deuticke.

1927. Die Fetischismus. In *Gesammelte Werke*, vol. 14, pp. 311–17. Frankfurt: S. Fischer.

Friedlaender, Benedict. 1904. *Die Renaissance der Eros Uranios*. Berlin: Verlag "Renaissance." (Reprinted New York: Arno, 1975.)

Fuss, Diana, ed. 1991. *Inside/Out: Lesbian Theories, Gay Theories*. London: Routledge.

Garber, Marjorie. 1992. *Vested Interests: Cross-Dressing and Cultural Anxiety*. London: Routledge.

Gilman, Sander L. 1988. *Disease and Representation: Images of Illness from Madness to AIDS*. Ithaca, N.Y.: Cornell University Press.

Gilman, Sander L., Jutta Birmele, Jay Geller, and Valerie D. Greenberg, ed. 1994. *Reading Freud's Reading.* New York: New York University Press.

Grosskurth, Phyllis. 1964. *The Woeful Victorian: A Biography of John Addington Symonds.* New York: Holt, Rinehart and Winston.

Halperin, David. 1990. One hundred years of homosexuality. In *One Hundred Years of Homosexuality and Other Essays on Greek Love*, pp. 15–40. London: Routledge.

——— 1995. *Saint Foucault: Towards a Gay Hagiography.* New York: Oxford University Press.

Herzer, Manfred. 1982. *Bibliographie zur Homosexualität.* Berlin: Rosa Winkel.

——— 1985. Kertbeny and the nameless love. *Journal of Homosexuality* 12: 1–26.

——— 1992. *Magnus Hirschfeld: Leben und Werk eines jüdischen, schwulen, und sozialistischen Sexologen.* Frankfurt: Campus.

Hirschfeld, Magnus. 1914. *Die Homosexualität des Mannes und des Weibes.* Berlin: Louis Marcus.

Hood, William. 1987. The state of research in Italian Renaissance art. *Art Bulletin* 69: 174–86.

Jackson, Earl. 1995. *Strategies of Deviance.* Bloomington: Indiana University Press.

Jenkyns, Richard. 1992. *Dignity and Decadence: Victorian Art and the Classical Inheritance.* Cambridge: Harvard University Press.

Joux, Otto de. 1897. *Die hellenische Liebe in der Gegenwart.* Leipzig: Max Spohr.

Kaan, Heinrich. 1844. *Psychopathia sexualis.* Leipzig: Voss.

Katz, Jonathan D. 1993. The art of code: Jasper Johns and Robert Rauschenberg. In *Significant Others*, ed. Whitney Chadwick and Isabelle de Courtivron. London: Thames and Hudson.

Kendall, Richard, and Griselda Pollock, eds. 1992. *Dealing with Degas: Representations of Women and the Politics of Vision.* London: HarperCollins/Pandora.

Kennedy, Hubert. 1988. *Ulrichs: The Life and Works of Karl Heinrich Ulrichs, Pioneer of the Modern Gay Movement.* Boston: Alyson.

Knight, Richard Payne. 1786. *A Discourse on the Worship of Priapus and Its Connection with the Mystic Theology of the Ancients.* London. (Reprinted New York: Dorset Press, 1992.)

Lambourne, Lionel. 1985. *Solomon: A Family of Painters.* London: Geffrye Museum.

Langer, Sandra [Cassandra] L. 1981. Fashion, character and sexual politics in some Romaine Brooks lesbian portraits. *Art Criticism* 1, 3: 25–40.

——— ed. 1993. *A Selective Bibliography of Feminist Art Criticism.* New York: G. K. Hall.

Lippard, Lucy. 1983. *Overlay: Contemporary Art and the Art of Prehistory.* New York: Pantheon.

Lloyd, Phoebe. 1984. Washington Allston: American martyr? *Art in America* 72, 3 (March): 144–55.

Mahaffy, J. P. 1874. *Social Life in Greece from Homer to Menander.* 1st ed. London. (2nd ed. 1875, suppresses pp. 305–13 of 1st ed.)

Mayne, Xavier (pseud.). 1908. *The Intersexes: A History of Similisexualism as a Problem in Social Life.* Florence: Privately printed. (Reprinted New York: Arno, 1975.)

McGrath, William J. 1986. *Freud's Discovery of Psychoanalysis: The Politics of Hysteria.* Ithaca, N.Y.: Cornell University Press.

Meier, M. H. E. 1837. Paederastie. In *Allgemeine Encyclopaedie der Wissenschaften und Kunsten*, ed. J. S. Ersch and J. G. Gruber, sect. III, vol. 9, pp. 149–88. (Trans. and expanded L.-R. de Pogey-Castries as *Histoire de l'amour grec dans l'antiquité*. Paris, 1930.)

Meyer, Moe, ed. 1994. *The Politics and Poetics of Camp.* London: Routledge.

Millin, A. L. 1814. *Description d'un vase trouvé à Tarento.* Paris: C. Waserman.

Mohr, Richard D. 1988. *Gays/Justice: A Study of Ethics, Society, and Law.* New York: Columbia University Press.

——— 1994. *A More Perfect Union: Why America Must Stand Up for Gay Rights.* Boston: Beacon.

Muther, Richard. 1896. *History of Modern Painting.* 3 vols. New York: Macmillan.

Ockman, Carol. 1993. Profiling homoeroticism: Ingres's *Achilles Receiving the Ambassadors of Agamemnon. Art Bulletin* 75: 259–74.

Owens, Craig. 1992. *Beyond Recognition: Representation, Power, and Culture*, ed. Scott Bryson, Barbara Kruger, Lynne Tillman, and Jane Weinstock. Berkeley and Los Angeles: University of California Press.

Panofsky, Erwin. 1939. The Neoplatonic movement and Michelangelo. In *Studies in Iconology: Humanistic Themes in the Art of the Renaissance*, pp. 171–229. Oxford: Oxford University Press.

Pater, Walter. 1980. *The Renaissance: Studies in Art and Poetry (The 1893 Text)*, ed. Donald L. Hill. Berkeley and Los Angeles: University of California Press.

Potts, Alex. 1994. *Flesh and the Ideal: Winckelmann and the Origins of Art History*. New Haven: Yale University Press.

Rand, Erica. 1994. Lesbian sightings: Scoping for dykes in Boucher and *Cosmo*. In *Gay and Lesbian Studies in Art History*, ed. Whitney Davis, pp. 123–39. Binghamton, N.Y.: Haworth Press (= *Journal of Homosexuality* 27, nos. 1/2).

Reed, Christopher. 1994. Making history: The Bloomsbury group's construction of aesthetic and sexual identity. In *Gay and Lesbian Studies in Art History*, ed. Whitney Davis, pp. 189–224. Binghamton, N.Y.: Haworth Press (= *Journal of Homosexuality* 27, nos. 1/2).

Roemer, L. S. A. M. von. 1904. Ueber die androgynische Idee des Lebens. *Jahrbuch für sexuelle Zwischenstufen* 5: 707–940.

Rose, Jacqueline. 1986. *Sexuality in the Field of Vision*. London: Verso.

Rosen, Charles. 1994. Music à la mode. *New York Review of Books* 49, 12 (June 23): 55–62.

Sadger, Isidor. 1910. Ein Fall von multipler Perversion mit hysterischen Absenzen. *Jahrbuch für Psychoanalyse* 1: 59–87.

　　1921. *Die Lehre von den Geschlechtsverirrungen (Psychopathia sexualis) auf psychoanalytischer Grundlage*. Vienna: Deuticke.

Salus, Carol. 1986. Degas' *Young Spartans Exercising. Art Bulletin* 67: 501–6.

Sartre, J.-P. 1948. *Anti-Semite and Jew*, trans. Hazel E. Barnes. New York: Schocken.

Saslow, James. 1986. *Ganymede in the Renaissance: Homosexuality in Art and Society*. New Haven: Yale University Press.

　　1991. *The Poetry of Michelangelo: An Annotated Translation*. New Haven: Yale University Press.

　　1992. "Disagreeably hidden": Construction and constriction of the lesbian body in Rosa Bonheur's *Horse Fair*. In *The Expanding Discourse: Feminism and Art History*, ed. Norma Broude and Mary Garrard, pp. 187–205. New York: HarperCollins.

Saslow, James, and Gay and Lesbian Caucus, eds. 1994. *Bibliography of Gay and Lesbian Art*. New York: Gay and Lesbian Caucus, College Art Association. (Reprinted 1995.)

Schmidgall, Gary. 1994. *The Stranger Wilde: Interpreting Oscar*. New York: Dutton/Penguin.

Sedgwick, Eve Kosofsky. 1990. *Epistemology of the Closet*. Berkeley and Los Angeles: University of California Press.

Silver, Kenneth E. 1992. Modes of disclosure: The construction of gay identity and the rise of Pop art. In *Hand-Painted Pop: American Art in Transition, 1955–62*, ed. Russell Ferguson, pp. 179–204. Los Angeles: Museum of Contemporary Art/Rizzoli.

Silverman, Kaja. 1992. *Male Subjectivity at the Margins*. London: Routledge.

Simons, Patricia. 1988. *Gender and Sexuality in Renaissance and Baroque Italy: A Working Bibliography*. Power Institute Occasional Paper 7. Sydney: Power Institute of Fine Arts, University of Sydney.

　　1994. Lesbian (in)visibility in Italian Renaissance culture: Diana and other cases of *donna con donna*. In *Gay and Lesbian Studies in Art History*, ed. Whitney Davis, pp. 81–122. Binghamton, N.Y.: Haworth Press (= *Journal of Homosexuality* 27, nos. 1/2).

Sokolowski, Thomas. 1983. *The Sailor 1930–45: The Image of an American Demigod*. Norfolk, Va.: Chrysler Museum.

Sullivan, Andrew. 1995. *Virtually Normal*. New York: Knopf.

Sulloway, Frank J. 1979. *Freud, Biologist of the Mind: Beyond the Psychoanalytic Legend*. New York: Basic.

Symonds, John Addington. 1873. *Studies of the Greek Poets*, 1st ser. London: Smith, Elder.
 1877. *The Renaissance in Italy*, vol. 3. *The Fine Arts*. 1st ed. London: Smith, Elder.
 1883. *A Problem in Greek Ethics*. London: Privately printed.

Thomson, Richard. 1987. *The Private Degas*. London: Arts Council of Great Britain.
 1988. *Degas: The Nudes*. London: Thames and Hudson.

Tyler, Parker. 1967. *The Divine Comedy of Pavel Tchelitchew*. New York: Fleet.
 1973. *Screening the Sexes: Homosexuality in the Movies*. New York: Holt. (Reprinted with afterword by Charles Boltenhouse, New York: DaCapo, 1993.)

Vaid, Urvashi. 1995. *Virtual Equality: The Mainstreaming of Gay and Lesbian Liberation*. New York: Doubleday (Anchor Books).

Watney, Simon. 1990. *The Art of Duncan Grant*. London: John Murray.

Weinberg, Jonathan E. 1993. *Speaking for Vice: Homosexuality in the Art of Charles Demuth, Marsden Hartley, and the First American Avant-Garde*. New Haven: Yale University Press.

Werckmeister, Otto Karl. 1991. *Citadel Culture*. Chicago: University of Chicago Press.

Westphal, Carl. 1870. Die conträre Sexualempfindung. *Archiv für Psychiatrie* 2: 73–108.

Winckelmann, J. J. 1987. *Reflections on the Imitation of Greek Works in Painting and Sculpture*, trans. Elfriede Heyer and Roger C. Norton. LaSalle, Ill.: Open Court. (Originally published 1755.)
 1972. Essay on the beautiful in art [*Abhandlung von der Fähigkeit der Empfindung des Schönen in der Kunst, und dem Unterrichte in Derselben*]. In *Winckelmann: Writings on Art*, trans. and ed. David Irwin, pp. 89–103. London: Phaidon. (Originally published 1763.)
 1880. *History of Ancient Art*, trans. G. H. Lodge. 4 vols. Boston: Little, Brown. (Originally published 1764.)

Wind, Edgar, 1938–9. "Hercules" and "Orpheus": Two mock-heroic drawings by Dürer. *Journal of the Warburg and Courtauld Institutes* 2: 206–18.

Wittkower, Rudolf, and Margot Wittkower. 1963. *Born under Saturn: The Character and Conduct of Artists*. New York: Norton.

7

Phenomenology and the Limits of Hermeneutics

Stephen Melville

Phenomenology: From Description to Interpretation

MAURICE Merleau-Ponty's major early work *The Phenomenology of Perception* opens by laying out an understanding of the general enterprise to which the book's title subscribes him:

What is phenomenology? It may seem strange that this question has still be asked half a century after the first works of Husserl. The fact remains that it has by no means been answered. Phenomenology is the study of essences; and according to it, all problems amount to finding definitions of essences: the essence of perception, or the essence of consciousness, for example. But phenomenology is also a philosophy which puts essences back into existence, and does not expect to arrive at an understanding of man and world from any starting point other than that of their "facticity." It is a transcendental philosophy which places in abeyance the assertions arising out of the natural attitude, the better to understand them; but it is also a philosophy for which the world is always "already there" before reflection begins as an inalienable presence; and all its efforts are concentrated upon re-achieving a direct and primitive contact with the world, and endowing that contact with philosophical status. It is the search for a philosophy which shall be a "rigorous science," but it also offers an account of space, time, and the world as we "live" them. It tries to give a direct description of our experience as it is, without taking account of its psychological origin and the causal explanations which the scientist, the historian, or the sociologist may be able to provide.[1]

As the comment on the question with which this passage opens makes clear, Merleau-Ponty's description reflects a certain history of the phenomenological enterprise. It is in this respect very different from any number of similarly descriptive or definitional statements one might draw from the writings of Edmund Husserl, the philosopher who first coined the term "phenomenology" as the

name for a method designed to yield accurate descriptions of how things appear for us. Such Husserlian statements would not foreground the back-and-forth movement of possible paradoxes or contradictions that organizes Merleau-Ponty's description and would work actively to resolve or suppress such motion in favor of clear and rigorous statements of method or procedure. Indeed, the bulk of Husserl's writing consists in just such efforts at clarification and resolution (rather than in the actual production of the analyses those procedures aim to make possible).

In fact, each of Merleau-Ponty's contrasts – with the exception of the last one – is not to be found directly in Husserl but lies rather between Husserl and Martin Heidegger (to whom the quoted phrases "facticity," "already there," and "live" are to be attributed), so that Merleau-Ponty is actually giving an account of phenomenology both as a proposal and the reception of that proposal – an account of phenomenology as a movement rather than a fixed body of procedures or propositions either arising from or subtending them. As he puts it a page later, "*phenomenology can be practised and identified as a manner or style of thinking [which] existed as a movement before arriving at a complete awareness of itself as a philosophy.*" The particular strength of such an approach is precisely that it allows – and all but demands – that one begin by trying to understand the peculiar historical fruitfulness of a body of work that seems in many ways distinctly unpromising.

Husserl's general project, like that of his contemporary Gottlieb Frege, was to find a nonpsychological ground for philosophy. He imagined that such a ground could be found in the close description and analysis neither of objects in their independence nor of subjects in theirs but only of objects as they appear in the only place they do in fact appear – in consciousness. To this end, Husserl took over from his teacher Karl Brentano a central insistence on the intentional structure of consciousness. "Intentionality" here is meant to register that there is no consciousness that is not consciousness of . . . something, and that this "of something" is integral to its being consciousness at all. By the same token, there are no objects except insofar as they are objects of consciousness, and so the particular, essentially encyclopedic, project of phenomenological philosophy must be to describe the particular nexuses that constitute the things of the world before we abstract from those nexuses in order to imagine something like the encounter of an independent and preexisting consciousness with an equally independent and preexistent thing. The task assigned by Husserl is to understand what it is to grasp a cube as a cube rather than to be waylaid into wondering, for example, whether or how we can know that it is a cube or worry whether there are, beyond those aspects that currently face us, other aspects that do not. The latter questions are ones that arise only after the fact of our actual apprehension of the cube and that, if taken as primary, will render that apprehension mysterious and opaque. Husserl imagined – and his methodological reflections aimed to guarantee the terms of this imagination – that the way to such rigorous description of things (like cubes, but also like perception or the consciousness of time) lay through a series of suspensions (epochés, reductions,

or bracketings in Husserl's vocabulary) of our imposed attitudes toward and interests in things in favor of their simple appearance (hence the celebrated phenomenological slogan "To the things themselves!").

If Husserl, at least for most of his career, emphasized the dimensions of this thought that implied a cataloging of forms of objectivity understood to be transcendental with respect to our apparently more natural dealings with things, it was left to his distinctly wayward student Martin Heidegger to transform this essentially idealist project into an insistence on the ways in which no consciousness can be abstracted from its embeddedness in a particular world and tradition (and, Merleau-Ponty will add, body). On this account, Husserl's dream of a rigorous science of essences is empty; what remains of it is a work not of description but more nearly of interpretation of the appearing or showing of things as the things they are. Thus for Heidegger, phenomenological method opens immediately into ontology (the explication of the way things [more or less actively] are) and hermeneutics:

> Thus "phenomenology" means . . . to let that which shows itself be seen from itself in the very way in which it shows itself from itself. . . . Phenomenology is our way of access to what is to be the theme of ontology, and it is our way of giving it demonstrative precision. *Only as phenomenology, is ontology possible.* . . . Philosophy is universal phenomenological ontology, and takes its departure from the hermeneutic of Dasein, which, as an analytic of existence, has made fast the guiding-line for all philosophical inquiry at the point where it *arises* and to which it *returns.*[2]

"*Dasein*" is Heidegger's term for the kind of being we humans are – beings that have (or, as Heidegger will argue, essentially are) a question about Being as the very form of their inhabitation of the world. *Dasein*, sometimes rendered into English as "there-being," thus names human being both as a relation to what Heidegger calls Being (the central object of his philosophic work) and as a being who is always already extended into the world and its things, ex-sisting (another Heideggerianism) beyond himself or herself in the objects and concerns that are the shape of his or her consciousness. *Dasein* is thus a Heideggerian revision, radicalization, or interpretation of Husserlian "intentionality."

Merleau-Ponty's way of summarizing this drift in the context of his particular interest is as follows:

> Perception is not a science of the world, it is not even an act, a deliberate taking up of a position; it is the background from which all acts stand out, and is presupposed by them. The world is not an object such that I have in my possession the law of its making; it is the natural setting of, and field for, all my thoughts and all my explicit perceptions. Truth does not "inhabit" only "the inner man," or more accurately, there is no inner man, man is in the world, and only in the world does he know himself.[3]

Phenomenology so understood is less a method than a commitment to the careful description of things as they show themselves in our experience of them; such description unfolds toward interpretation on grounds significantly different from those of traditional art history, where interpretation seeks its justification through notions of objectivity of the kind Merleau-Ponty is explicitly concerned to reject.

Influences of Phenomenology

While the direct influence of phenomenology on art history has been quite limited, both phenomenology and phenomenological hermeneutics, conceived more nearly as a movement than a method, have played a considerable role in preparing the ground for many of the tendencies that are frequently loosely assimilated under the rubric of "new art history." Before turning to some explicitly art-historical instances, it may be useful to mention at least some of these developments.

Certainly, the first and most general is a growing tendency to take it that all description is interpretation and so that interpretation is essentially bottomless, resting on no deeper matter of fact. A number of diverse strains of thought have combined in recent years to force this issue, and among the most prominent are what Paul Ricoeur aptly called "the hermeneutics of suspicion" – the interpretive strategies put into play above all by Marx and Freud but also Nietzsche, and reinforced in the contemporary context by things as diverse as neopragmatism[4] and contemporary minoritarian politics. In themselves each of these (with the exception of pragmatism) is inclined to find its own, new and counterintentional, ground for interpretation; in tandem with the hermeneutic strains coming out of Heidegger through Gadamer, Ricoeur, and others[5] they have worked to cut interpretation free of dependence on notions of authorial intention, delimitable and stable context, and so on.

One might also note a general reorientation of questions of meaning around the act of reception, particularly but not exclusively in relation to literary study. Here again, there is a range of forces in play – the rhetorical orientation of the Chicago neo-Aristotelians, various psychoanalytic approaches, elements of Frankfurt School Marxism, and the reception theory of the Constanz School (Wolfgang Iser, Hans-Robert Jauss) with its explicit references to phenomenology – as well as the central emphasis placed on interpretation as an action exerting historical effects by such students of Heidegger as Hans-Georg Gadamer.

In addition to these very general matters of orientation and reorientation, there are some more specific strains of phenomenological influence that deserve remarking. One of these passes from Husserl through Alfred Schutz to the sociologists Thomas Luckmann and Peter Berger, ultimately giving rise to some influential formulations of the social constructedness of reality.[6] The latter part of Schutz's career was passed at the New School for Social Research, which served in the 1950s and 60s as something of a center for phenomenological interest in the United States; also there with Schutz were Dorion Cairns, a leading early

translator of and commentator on Husserl, and Aron Gurwitsch, whose massive work *The Field of Consciousness* importantly linked Gestalt psychology and phenomenology and did much to clarify the fundamental shape of the phenomenological interest in perception.[7]

Phenomenology also played an important role in the emergence in the late 1960s of revisionist views of the history of science. The explicit link is through the French historian of science Alexandre Koyré, whose work influenced both the French tradition that runs through Georges Canguilhem to Michel Foucault and the roughly parallel American developments associated above all with T. S. Kuhn. Although Gaston Bachelard's early visibility in the United States was more nearly as a theorist of symbolic meaning, he also belongs to this French tradition.[8] The phenomenology of the elements for which he is perhaps best known was in many ways a home-grown variety, but (like the phenomenology of religion begun by Gerardus van der Leeuw and carried further by Mircea Eliade)[9] it was rapidly assimilated to the more general phenomenological tradition, and did much to shape that tradition as especially interested in what one might describe as the deep background of meaning embedded in our grasp of things.

And one might finally mention the explicit impact of phenomenology on aesthetics. The most notable figures here include Roman Ingarden, Mikel Dufrenne in France, and Martin Heidegger.[10] Heidegger's work is potentially of interest to art historians because of its way of linking the work of art to the question of its (curatorial or historical) preservation, a linkage that turns back toward the questions of interpretation profiled in the previous section.

In the United States, all of these various threads are a significant part of the general theoretical and methodological flux that comes to characterize much of the worlds of art and the humanities in the mid to late 1960s and that seems to a high degree to have crystallized – at the possible cost of some historical amnesia – into the range of stances now called "theory."

The 1960s also saw the emergence within literary studies of a strong phenomenological school of literary criticism centered in Geneva. Such critics as Georges Poulet, Jean Starobinski, and Jean-Pierre Richard saw their task as one of making out the internal dynamics and lived logic of a writer's "imaginary universe" (Richard) or, in a distinctly less phenomenological formulation, the "interior distance" defining the writer's presence to himself (Poulet). The work of this school not only offered a variety of models for understanding the relevance of phenomenology to literary study but also exerted an important influence on the subsequent development of literary study in both France and the United States.[11] Clearly, some part of the attraction of the work of the Geneva School for North American literary scholars lay in the relative compatibility of its emphasis on intentionality as a dimension of the work with the similar emphasis in the New Criticism. While there is no equally strong parallel development within the practice of art history, it is probably important that the various examples I will discuss in the next section emerge in intimate relation to Clement Greenberg's formalist criticism, which bore marked affinities to the work of the literary New Critics.

Phenomenology, Art History, and Criticism

The mid 1960s were a moment of crisis for the dominant formalist criticism that accompanied the claims for American art after the World War II, and one version of that crisis centered on the emergence of minimalist art. While these things now come encumbered with various arguments about priority, independence, and so on, it is clear that by the mid 60s Annette Michelson (who had attended Merleau-Ponty's lectures in Paris and appears to have been the first to refer to him in print),[12] Rosalind Krauss, and Michael Fried had all come to a sense of the appropriateness and necessity of some reference to Merleau-Ponty's phenomenology in negotiating the claims of the new art. In the cases of Fried and Krauss, that reference has been a significant part of the foundation for their subsequent art-historical and theoretical work.

In the historical context, Krauss's position appeared as directly anti-Greenbergian, while Fried's differences from Greenberg were effectively masked by their shared judgment of particular tendencies; in retrospect it seems fair to say that both Krauss and Fried were at grips with an apparent difficulty in or exhaustion of Greenberg's valorization of "opticality" as the presumed criterion underlying modernist art, and that both found Merleau-Ponty's work of interest because of its holistic understanding of perception as the activity of a fully embodied subject that could not be reduced to an abstract eye. In this sense, Merleau-Ponty's phenomenology – and indeed the general phenomenological emphasis on grasping things as they are – appeared to offer a way of continuing an essentially formalist attention to the specificity of the work while considerably opening up the possible terms and scope of that attention.

Beyond this agreement, both the shapes of their reference to Merleau-Ponty and their understandings of its underlying interests diverge: In general, Fried's reference seems to be above all to Merleau-Ponty's aesthetic work, whereas Krauss's is to his more general account of embodiment. Put somewhat differently: For Krauss, Merleau-Ponty helps show a way out of the aesthetic and merely pictorial, while for Fried he offers a deeper or fuller way into just those things. Thus we find Krauss writing in the context of a review of Richard Serra's career (see Fig. 22):

By the time American readers encountered *Phenomenology of Perception* . . . their aesthetic horizons had been restructured by a belief in the necessity of abstraction. The Minimalist generation, becoming aware of abstraction against a background of the problematic inherited from Jackson Pollock, Barnett Newman, and Clyfford Still, did not read it as a call for figuration. For the Minimalists, the interest of phenomenology was located precisely in its assumption of a "preobjective experience" underlying all perception and guaranteeing that even in its abstractness it is always and already meaningful . . .

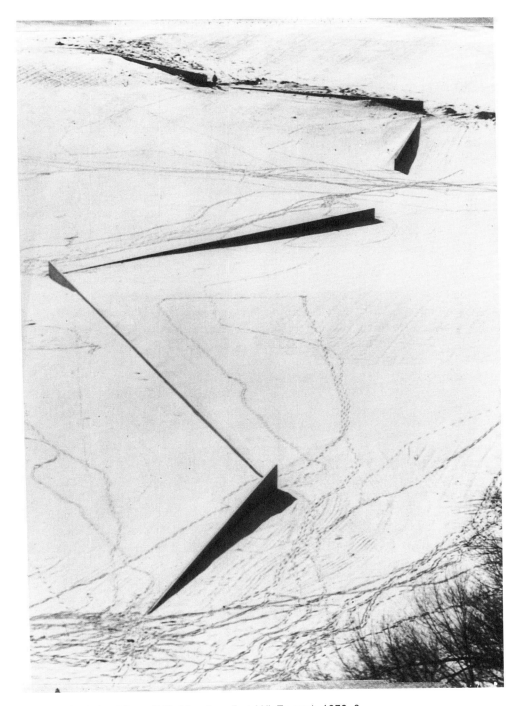

Figure 22. *Richard Serra,* Shift *(view from East Hill, Toronto), 1970–2. Concrete, six sections. 815′ overall (250.77 m). King City, Ontario.*

[Serra's] *Shift* does not, of course, relate to the *Phenomenology of Perception* as work to source. Rather, the ideas developed by Merleau-Ponty had been generally assimilated by a first generation of Minimalist artists, affecting the assumptions of Judd and Robert Morris that sculpture had better own up to what it had, in its former Idealism, attempted to hide. . . . In the play of perspectives in which Minimalism now grounded the object, abstract geometries were constantly submitted to the redefinition of a sited vision. And it is against this background that Serra arrived at the choreography of *Shift*, in which a work could be conceived as the mutually established "horizon" of two people at a distance.[13]

Shift, on this account, is a work made out of the phenomenological fact of embodiment rather than out of visual facts – or, more exactly, the visual facts underlying its construction (the facts of two people trying to keep each other in view as they move across hilly terrain) cannot be separated from the particularity of the bodies in motion and the terrain on which they move. The work cannot be grasped or coherently described apart from its deep responsiveness to phenomenological motifs – a responsiveness that is perhaps well caught by the crossing of Serra's direct interest, in *Shift*, in the horizonal limits of mutual vision with the more metaphorical role in phenomenology of the term "horizon" as a way of registering the embeddedness of any object within a more embracing context of experience and significance.

By contrast, Michael Fried takes up phenomenology initially as a way of determining what a given work is as an object of experience. Here are some of his remarks on Tony Smith's Minimalist cube *Die* (Fig. 23):

Here again the experience of being distanced by the work in question seems crucial: the beholder knows himself to stand in an indeterminant, open-ended – and unexacting – relation as subject to the impassive object on the wall or floor. In fact, being distanced by such objects is not, I suggest, entirely unlike being distanced, or crowded, by the silent presence of another person; the experience of coming upon [such] objects unexpectedly – for example, in somewhat darkened rooms – can be strongly, if momentarily, disquieting in just this way.[14]

What Fried is aiming at here is an account of the object as an object of experience; the larger claim of the essay is that if his account does indeed adequately render the experience of this object, it is transparently not the experience one has of a work of art – so the critical judgment is directly embedded in the experiential account. One aspect of Fried's description of this work perhaps deserves special mention – he takes it to be a leading feature of *Die* (and indeed much Minimalist work) that it is hollow. It is important in understanding Fried's procedures to recognize that this claim would not be falsified by the discovery that Smith's *Die* was, in actual empirical fact, not hollow but solid: What matters is that it presents itself in one's experience of it as hollow. By the same token,

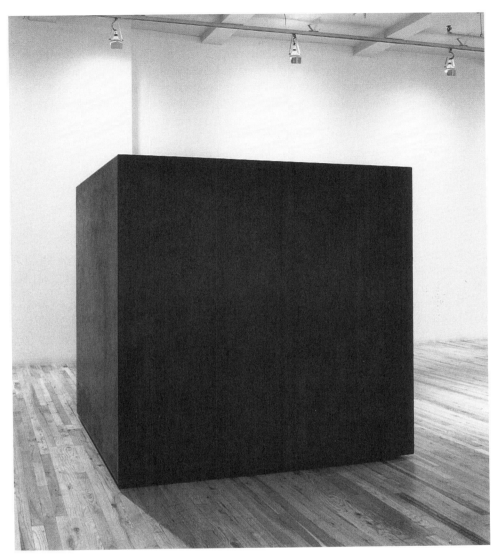

Figure 23. *Tony Smith, Die, 1962. Steel. 6′ × 6′ × 6′ (184.6 × 184.6 × 184.6 cm). Edition: 3. Private collection, New York.*

Fried's description of it as hollow does not follow from certain details of its construction that might be taken to indicate this fact; if anything, the experience of its hollowness is the ground on which certain features of it might become worth remarking.

This of course means that the work is taken as something that has no features fixed outside of experience and so also that its features may well change as the experience of it changes. Thus in another essay Fried makes the claim:

One might say that the relation between Pollock and Louis goes too deep for the notions of influence and style. Familiarity with Louis's work does not merely color one's experience of Pollock's art; it comes close to determining it. Louis's paintings do more than underline or point to aspects of Pollock's canvases which otherwise one might not have noticed; there is an important sense in which Louis's paintings create the aspects in question – in which they give significance to aspects of Pollock's art which otherwise could not be experienced as significant, or as having this particular significance. At the same time, the fact that Pollock's paintings, and not those of some other painter, are the ones which Louis's paintings invest with meaning in this way testifies to the fecundating power of Pollock's achievement and makes that investment seem, or be, a revelation of what was, in some sense, already there.[15]

It seems reasonable to say that in this passage Fried is offering an account of Louis's work insofar as it is itself the registration or rendering of an experience of Pollock's work, and, as with Fried's account of Tony Smith's *Die*, there is no access to the object independent of the experience of it; it has features only within that experience. For the historian, it is Louis's work that enables a certain experience of Pollock, engendering features in it that would not exist for that same painting in a different history.

This second example is obviously more complex than the first, and I have brought it in because it helps make clear three notable features of phenomenology as Fried understands it: first, that the boundary line between "description" and "interpretation" becomes much less clear once we take it that an object is always intentional in the phenomenological sense (that is, is always an object of consciousness and so of or in experience); second, that this emphasis on intentionality alters the relation between the critic or historian and what one might be tempted to call "the work itself" – when an object is understood as given only and always in experience, we can no longer separate subject (and so "the subjective") and object (and so "objectivity") in the way that a more "scientific" art history might prefer; and, third, that this means that the field in which the historian operates is itself thoroughly historical, and so the historian's activity cannot be imagined as the discovery, restoration, or delivery of the work from something that might be imagined as its historical corruption, forgetting, or transformation – rather, it is itself part of those processes.

Krauss and Fried do enter their appeals to phenomenology in significantly different ways and to significantly different ends, and these differences are clearly reflected in the different courses their more properly historical work has taken since the 1960s – Krauss increasingly focusing on the antiaesthetic positions of Duchamp and Surrealism as they appear to contest the terms of the Greenbergian narrative of emergent opticality, and Fried working to reconstrue central figures in the Greenbergian tradition (first Diderot, then Courbet, and now Manet) so as to reimagine its grounds.[16]

In both cases, the later work is accompanied by a considerable expansion of theoretical scope and a turn more particularly toward recent French theory (both Roland Barthes and Jacques Lacan have been perhaps particularly important for Krauss, as Jacques Derrida has been for Fried). Phenomenological appeals have come to play a relatively local role in the field of this later work: Fried's references to Merleau-Ponty tend to cluster around Courbet because Courbet's central problem, as Fried understands his work, is that of his own embodiment, and Krauss's recent references to Merleau-Ponty likewise tend now to refer to a specific historical moment, as in the retrospective passage I've cited, for roughly similar reasons.

In this sense, neither Krauss nor Fried takes up phenomenology as a method. Rather, it is the first step in both cases toward a significant shifting of the field in which they understand themselves to be acting. This is why it has been difficult in this chapter to treat phenomenology as if it were a method one might master and apply to a range of objects; it is more nearly a highly general and consequential way of understanding what kind of thing an object is, and its outcome, at this level of generality, is essentially antimethodological, if not antitheoretical.

If I have stressed the way in which phenomenological description has given way historically to a more open-ended interpretive enterprise, it is equally important that interpretation counts for this kind of thinking not as a way of getting at the meaning of something but as a way of showing what – or how – it is. In this sense, phenomenological interpretation returns to, and perhaps is only finally justified as, description; this is, in a sense, its continuing orientation to formalism, and this may suggest that such a reception of phenomenology understands it as having a relation to judgment rather than to method. That Krauss and Fried alike write always as both historian and critic suggests that in the end both see themselves called upon to give an account neither of what an object is apart from the experience of it nor of the meanings such an object might be supposed to have, but of something more nearly like the terms of their attachment to it. This, I would argue, is the level at which phenomenology – in the broad sense I have allowed it here – challenges the current practice of art history, resisting its standard ways of parsing "meaning" and "method."

Notes

1 Maurice Merleau-Ponty, *Phenomenology of Perception*, trans. Colin Smith (London: Routledge and Kegan Paul, 1962), p. vii. This text is also available in Joseph Kocklemans, ed., *Phenomenology* (Garden City, N.Y.: Doubleday, 1967), which provides a very useful collection of major texts in the phenomenological tradition.

2 Martin Heidegger, *Being and Time*, trans. John Macquarrie and Edward Robinson (New York: Harper & Row, 1962), pp. 58–62.

3 Merleau-Ponty, *Phenomenology of Perception*, pp. x–xi.

4 It's worth noting that C. S. Peirce, a figure central to the histories of both semiology and pragmatism, also worked for a time at a project closely paralleling Husserl's (but which he called "phaneroscopy"). On this – and for a comprehensive overview of phenomenology

and its various offspring – see Herbert Spiegelberg, *The Phenomenological Movement: A Historical Introduction* (The Hague: Nijhoff, 1960).

5 For a useful overview of main currents in hermeneutic theory, see Richard Palmer, *Hermeneutics: Interpretation in Schleiermacher, Dilthey, Heidegger and Gadamer* (Evanston: Northwestern University Press, 1969).

6 See Peter L. Berger and Thomas Luckmann, *The Social Construction of Reality: A Treatise in the Sociology of Knowledge* (Garden City, NY: Doubleday, 1966).

7 Aron Gurwitsch, *The Field of Consciousness* (Pittsburgh: Duquesne University Press, 1962).

8 For a critical exploration of this tradition, see Dominique Lecourt, *Marxism and Epistemology: Bachelard, Canguilhem, and Foucault*, trans. Ben Brewster (London: New Left Books, 1975). See also T. S. Kuhn, *The Structure of Scientific Revolutions* (Chicago: University of Chicago Press, 1962).

9 See Gerardus van der Leeuw, *Religion in Essence and Manifestation: A Study in Phenomenology*, trans. J. E. Turner (London: Allen & Unwin, 1938), Mircea Eliade, *Patterns in Comparative Religion*, trans. Rosemary Sheed (New York: Sheed & Ward, 1958), and Rudolph Otto, *The Idea of the Holy*, trans. John W. Harvey (New York: Oxford University Press, 1958). The notion of "myth" advanced by this tradition did much of the work now more frequently done by notions of "ideology."

10 For an account of contemporary theory interestingly attentive to Ingarden in particular, see William Ray, *Literary Meaning: From Phenomenology to Structuralism* (Oxford: Blackwell, 1984).

11 For a useful overview from the point of view of a critic who would himself soon become one of the major champions of deconstructive criticism in the USA, see J. Hillis Miller, "The Geneva School: The Criticism of Marcel Raymond, Albert Béguin, Georges Poulet, Jean Rousset, Jean-Pierre Richard, and Jean Starobinski," in *Modern French Criticism: From Proust and Valéry to Structuralism*, ed. John K. Simon (Chicago: University of Chicago Press, 1972).

12 So argued James Meyer in a paper presented at the 1994 meeting of the College Art Association.

13 Rosalind Krauss, *Richard Serra/Sculpture* (New York: Museum of Modern Art, 1986), pp. 29, 31.

14 Michael Fried, "Art and Objecthood," in G. Battcock, ed., *Minimal Art* (Berkeley and Los Angeles: University of California Press, 1995), p. 128 (first published in *Artforum*, June 1967).

15 Michael Fried, *Morris Louis* (New York: Abrams, n.d.), pp. 213–14.

16 See Michael Fried, *Courbet's Realism* (Chicago: University of Chicago Press, 1990), and *Manet's Modernism* (Chicago: University of Chicago Press, 1996).

8

Photo–Logos

Photography and Deconstruction

David Phillips

The philosopher should start by meditating on photography, that is to say the writing of light . . .

Jacques Derrida, in Steven Pyke, *Philosophers* (1993)

S INCE its invention, photography has been repeatedly promoted as a realism offering an immediate and transparent identity between image and refer-ent. Employing the language of deconstruction, we might say that photography's constitutive discourses have framed it within a "metaphysics of presence" in that, for these discourses, photography is a metaphysical project founded upon a desire for presence secured through an unmediated transcription of the real. Posited in this way as a mode of representation that most readily replicates an eidetic perception (as an identity of picture and *perceptum*), photography might be cited as a paradigmatic instance of logocentrism.

The claim that a photograph is a substitute for actual objects (once present to vision but now absent) is evident from the earliest accounts of photography. Such a belief in the photograph's literal re-presentation of a palpable presence, whereby objects or people effectively "drew" or imprinted themselves upon the paper (thereby effacing the distinction between original and copy), underwrites William Henry Fox Talbot's 1839 account of his own photography:

The object which would take the most skillful artist days or weeks of labour to trace or to copy, is effected by the boundless powers of natural chemis-try in the space of a few seconds . . . To give an idea of the accuracy with which some objects can be imitated by this process, I need only mention one instance. Upon one occasion, having made an image of a piece of lace of an elaborate pattern, I showed it to some persons at the distance of a few feet, with the inquiry, whether it was a good representation? when

the reply was, "That they were not to be so easily deceived, for that it was evidently no picture, but the piece of lace itself."[1] (Fig. 24)

The following year Edgar Allan Poe claimed that "if we imagine the distinctiveness with which an object is reflected in a positively perfect mirror, we come as near the reality as by any other means. For, in truth, the Daguerreotyped plate is infinitely (we use the term advisedly) is *infinitely* more accurate in its representation than any painting by human hands ... the closest scrutiny of the photogenic drawing discloses only a more absolute truth, a more perfect identity of aspect with the thing represented."[2] For Samuel Morse, daguerreotypes were "painted by Nature's self with a minuteness of detail, which the pencil of light in her hands alone can trace ... they cannot be called copies of nature, but portions of nature herself."[3] This line of thinking reached an apogee in Oliver Wendell Holmes's 1859 account of how the daguerreotype "has fixed the most fleeting of our illusions, that which the apostle and the philosopher and the poet have alike used as the type of instability and unreality. The photograph has completed the triumph, by making a sheet of paper reflect images like a mirror and hold them as a picture ... [this] invention of the *mirror with a memory*."[4]

What is at issue in these accounts is the indexical status of the photograph.[5] Such positivist assertions have been both persuasive and enduring, albeit more recent accounts lack quite the ambitious confidence of photography's early pioneers.[6] Nonetheless, references such as Ernst Gombrich's to the "perfect mimesis"[7] of photography and André Bazin's belief in its "essentially objective character"[8] are not untypical. For Bazin especially, both photography and cinema "are discoveries that satisfy, once and for all and in its very essence, our obsession with realism."[9] However, in Bazin's metapsychological account, photography oscillates between potentially opposing identities as it fulfills a subjective need (the desire for mimesis), yet is also free from subjectivity, since "only photography derives an advantage from ... [man's] absence."[10] Moreover, the photograph is not just an image (produced through the "transference of reality from the thing to its reproduction"), it is also the thing itself ("it *is* the model").[11] The dichotomous identity of photography, as both a vehicle of subjective affect and of mechanical objectivity, complements a yet more fundamental opposition between nature and culture in that, for Bazin, a photograph belongs to the realm of culture (as technology), but it is also "like a phenomenon in nature," owing to its beauty and its causal relation (as "fingerprint") with its object.

Such oscillations, or undecidables, between nature and culture, presence and absence, mechanical objectivity and expressive agency, the external world and the interior self, and the technical and the aesthetic, have persistently structured photo-discourse and have often been framed around a recurrent question as to whether photography's identity is essentially scientific or essentially artistic and whether it is an objective (mechanical) or subjective (expressive) medium. More often than not, however, it is seen as both. For example, asserting that "absolute unqualified objectivity ... is the very essence of photography,"[12] the

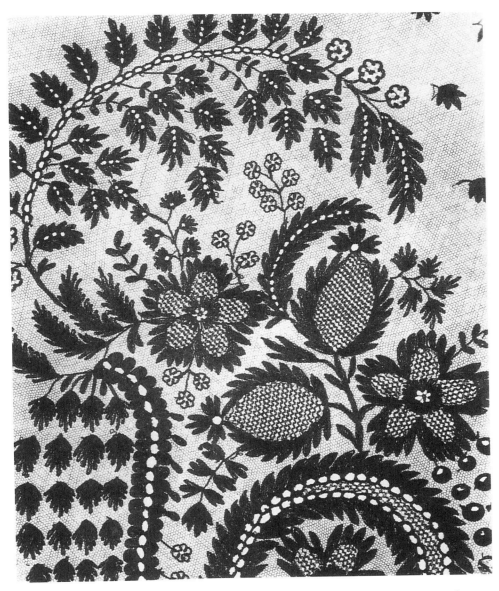

Figure 24. *William Henry Fox Talbot,* Lace, *mid 1840s. Salted paper print. Photo courtesy of Science & Picture Library, London.*

photographer Paul Strand also described photographs as the "untouched products of an intelligence and spirit channelling through a machine."[13] However, as the history of photography has gained institutional recognition, it has increasingly been contained within a paradigm of authorship that is most apparent in the search for the photographer's signature style.[14] Even more so than the history of art, photography is structured around narratives of origins and descent (the debates on who constituted the founding "fathers" of photography), often

complemented by a technicist determinism and predicated upon a belief in the inherently realist properties of the medium.[15] However, as argued perhaps most notably by John Tagg and Allan Sekula,[16] if photography does have an identity, it is one produced by the discourses and institutions that surround it. Yet even in recent social-historical accounts (for example, Marxist and Foucauldian), the evidential or mimetic status of photography remains largely unchallenged in that photography ultimately serves as an illustration of functionalist accounts of a hegemonic power.

Vision and/as Writing

Neither a philosophy nor a system, Derrida's project might best be understood as a technique of reading that entails a "putting into question the primacy of presence as consciousness"[17] and as a subversion of "the principle of identity, the founding expression of a philosophy of presence."[18] The structuring antinomies framing photography are particularly amenable to such a deconstructive reading. Indeed, for Derrida, "the metaphor of darkness and light (of self-revelation and self-concealment) [is] the founding metaphor of Western philosophy as metaphysics . . . in this respect the entire history of our philosophy is a photology, the name given to a history of, or treatise on, light."[19] If darkness and light are the founding metaphors of metaphysics, its fundamental claim is for being as presence. As Derrida notes (in a comment not without some pertinence to photography) of Husserl's attempt to ground self-presence:

> We have experienced the systematic interdependence of the concepts of sense, ideality, objectivity, truth, intuition, perception, and expression. Their common matrix is being as *presence*: the absolute proximity of self-identity, the being-in-front of the object available for repetition, the maintenance of the temporal present, whose ideal form is the self-presence of transcendental *life*, whose ideal entity allows *idealiter* of infinite repetition.[20]

Any attempt to summarize deconstruction, and to demonstrate its "application," will unavoidably be reductive,[21] but central to Derrida's project is his assertion that Western metaphysics entails an "ontotheological" privileging of presence whereby meaning and identity are secured by a "transcendental signified" which, while guaranteeing the coherence of any signifying system, necessarily exists beyond the play of textuality.[22] This logocentric desire for an origin and structuring center generates the hierarchical dualisms (e.g., essence/appearance, form/matter, nature/culture, interior/exterior, speech/writing) that structure metaphysical thought.[23] A recurrent instance of the "transcendental signified" in logocentrism is the sovereign and self-reflexive subject posited as the stable origin of meaning. For example, an author is seen as offering a fixed point of reference (whereby communication entails a transparent conduit to an intentional consciousness) that provides a closure to interpretation. Derrida argues, however, that there can be no such privileged point (the author, the real, etc.)

conferring significance and coherence upon a text. Instead, as meaning is both contextual and indeterminate, there is only the potentially infinite deferral of meaning: "Meaning . . . does not depend upon subjective identity but upon the field of different forces, the conflict of forces, which produce interpretations."[24]

An exposition of photography's logocentrism might begin with Derrida's description of "the phonocentric necessity: the privilege of the voice over writing":

> The priority of spoken language over written or silent language stems from the fact that when words are spoken the speaker and the listener are supposed to be simultaneously present to one another; they are supposed to be the same, pure unmediated presence. This ideal of perfect self-presence, of the immediate possession of meaning, is what is expressed by the phonocentric necessity. Writing, on the other hand, is considered subversive in so far as it creates a spatial and temporal distance between the author and the audience; writing presupposes the absence of the author and so we can never be sure exactly what is meant by a written text; it can have many different meanings as opposed to a single unifying one.[25]

Much of Derrida's account of the privileging of speech (due to its assumed proximity and authenticity to thought) is pertinent to photography in that it too is frequently posited as the site of an unmediated self-presence identical with the real and accessible through a transparent medium. Basic operative terms here are "presence" and "absence" in that, for Derrida, identity and meaning are defined through their constitutive (but suppressed) opposites or differences. In phonologocentrism, the supposedly unmediated plenitude of speech – "the unique experience of the signified producing itself spontaneously, from within the self"[26] – is always inhabited by the differential trace of writing (its nonpresent but preexistent substitutes) in that speech itself not only involves signification (and thus the spatiotemporal difference between signifiers), but its status as immediate and spontaneous self-presence (as the coincidence of intention and meaning) is contingent upon the viewing of writing as an unnatural, supplementary, or contaminating activity marked by the loss or denial of self-presence. In short, the conceptualizing of speech as self-presence depends upon an anterior, but excluded, writing (as the nonpresent and the nonoriginary), for "what opens meaning and language is writing as the disappearance of natural presence."[27]

Derrida's strategy, however, is not to reverse such hierarchical pairings by prioritizing the hitherto secondary term, as such a reversal would not only initiate a return to another binary logic of identity, structured upon mutually exclusive and hierarchized polarities (a logic of either/or), but it would also leave structurality itself intact. Instead, the focus of deconstruction is upon an undecidability or supplementary logic (one of both/and), the disruptive effects of which are indicative of a *différance* that "is no longer conceivable on the basis of the opposition presence/absence."[28] Signaling both difference and deferral, the specific spatiotemporal implications of Derrida's neologism *différance* preclude any finally securable and coherent "presentness" of signification (as an ultimate coincidence

of signifier and signified).[29] For although signification is achieved through relations of difference, the structures that would secure identity simultaneously threaten its stability. This constitutive dependence of the dominant term upon its subordinate is in part designated by the term "undecidable," which refers to a relation that not only subverts binary oppositions and classificatory systems but simultaneously initiates and occupies both terms. It is this generative logic of the supplement – as both a lack and a surplus – that deconstruction attends to in its "double gesture" of overturning and dislodging,[30] as it is this excess, or "undecidable oscillation," which denies textual stability, conceptual systematization, and the immediacy of presence. As Derrida observes of both philosophical and literary texts:

> It has been necessary to analyze, to set to work, *within* the text of the history of philosophy, as well as *within* the so-called literary text . . . certain marks . . . that *by analogy* . . . I have called undecidable, that . . . can no longer be included within philosophical (binary) opposition, but which, however, inhabit philosophical opposition, resisting and disorganizing it, *without ever* constituting a third term, without ever leaving room for a solution in the form of speculative dialectics . . . *the supplement* is neither a plus nor a minus, neither an outside nor the complement of an inside, neither accident nor essence etc. . . . Neither/nor, that is, *simultaneously either or.*[31]

An example of this supplementary logic is provided in Derrida's account of the unconscious and *différance*. Here Derrida does not ascribe a substantive identity to the unconscious but describes it as a play of "traces" that are not literal representations but are instead the material effects of *différance*:

> *Différance* maintains our relationship with that which we necessarily misconstrue, and which exceeds the alternative of presence and absence. A certain alterity – to which Freud gives the metaphysical name of the unconscious – is definitively exempt from every process of presentation by means of which we would call upon it to show itself in person. In this context, and beneath this guise, the unconscious is not, as we know, a hidden, virtual, or potential self-presence. It differs from, and defers, itself; which doubtless means that it is woven of differences, and also that it sends out delegates, representatives, proxies; but without any chance that the giver of proxies might "exist," might be present, be "itself" somewhere, and with even less chance that it might become conscious. In this sense, contrary to the terms of an old debate full of the metaphysical investments that it has always assumed, the "unconscious" is no more a "thing" than it is any other thing, is no more a thing than it is a virtual or masked consciousness. This radical alterity as concerns every possible mode of presence is marked by the irreducibility of the aftereffect, the delay. In order to describe traces, in order to read the traces of "unconscious" traces (there

are no "conscious" traces), the language of presence and absence, the meta-physical discourse of phenomenology, is inadequate.[32]

This description of the unconscious also demonstrates Derrida's aim to "recast the concept of text by generalizing it almost without limit, in any case without present or perceptible limit, without any limit that *is*. That's why there is nothing '*beyond* the text.'"[33] Yet while deconstruction is still most widely thought of with reference to this claim, for Derrida there can be no single definition of what constitutes a text. As he has frequently indicated, the text is not to be understood solely as "the book" (i.e., as a discrete authorial text or, indeed, as a literal object).[34] Rather the text, as "a field of forces: heterogeneous, differential, open and so on,"[35] can refer to any signification (necessarily) structured upon difference and, as such, is divorced from any ultimate guarantee of origin or presence. Moreover, as "text" can denote any signifying relation, all signification is predicated upon a much broader notion of "writing." Just as Derrida cites an *archi-écriture* that precedes the opposition between speech and writing, so too the existence of any text rests upon the operations of a generalized writing.[36] As he remarks of Jean-Jacques Rousseau's autobiography:

> In what one calls the real life of these existences of "flesh and bone," beyond and behind what one believes can be circumscribed as Rousseau's text, there has never been anything but a writing; there have never been anything but supplements, substitutive significations which could only come forth in a chain of differential references, the "real" supervening, and being added only while taking on meaning from a trace and from an invocation of the supplement, etc.[37]

If writing refers to any relation of difference (thereby allowing the possibility of a nonlinguistic text) or to any "spacing" (of signs detached from an authenticating origin),[38] then it is feasible to describe vision as textual, as it too is structured by a writing:

> If there were only perception, pure permeability to breaching, there would be no breaches. We would be written, but nothing would be recorded; no writing would be produced, retained, repeated as legibility. But pure perception does not exist: we are written only as we write, by the agency within us which already keeps watch over perception, be it internal or external.[39]

Elsewhere Derrida has also denied that "anything like perception exists" or "that there is any perception."[40] But while this assertion might appear to support the charge that Derrida cannot conceive (or, perhaps, cannot allow) anything to exist outside of language, his target here is the status of "perception" within those logocentric epistemologies that would privilege vision in that, for Derrida, "Perception is precisely a concept, a concept of an intuition or of a given originating from the thing itself, present itself in its meaning, independently from language,

from the system of reference . . . [and] is interdependent with the concept of origin and of center."[41]

The relation between perception and writing (as trace and supplement) is addressed in Derrida's discussion of memory in his reading of Plato's attack on the Sophists. Distinguishing "memory itself" from "monuments, inventories, archives, citations, copies, accounts, tales, lists, notes, duplicates, chronicles, genealogies, references. Not memory but memorials," Derrida argues:

> What Plato is attacking in sophistics, therefore, is not simply recourse to memory but, within such recourse, the substitution of the mnemonic device for live memory . . . the active reanimation of knowledge, for its reproduction in the present. The boundary (between inside and outside, living and nonliving) separates not only speech from writing but also memory as an unveiling (re-)producing a presence from re-memoration as the mere repetition of a monument; truth as distinct from its sign, being as distinct from types. The "outside" does not begin at the point where what we now call the psychic and the physical meet, but at the point where the *mnēmē*, instead of being present to itself in its life as a movement of truth, is supplanted by the archive, evicted by a sign of re-memoration or of commemoration. The space of writing, space *as* writing, is opened up in the violent movement of this surrogation, in the difference between *mnēmē* and *hypomnēsis* . . . A limitless memory would in any event be not memory but infinite self-presence. Memory always therefore already needs signs in order to recall the non-present, with which it is necessarily in relation . . . Memory is thus contaminated by its first substitute: *hypomnēsis*. But what Plato *dreams* of is a memory with no sign. That is, with no supplement.[42]

This description of writing and memory – in which perception is predicated upon an archive of mnemic traces – develops Derrida's earlier critique of what he describes as Husserl's assertion that "the identity of experience [is] instantaneously present to itself."[43] While Husserl sought to argue for the self-same identity of experience present to itself – as the indivisible instantaneity of mental acts that are "lived by us in the same instant" (*im selben Augenblick*) – Derrida claims that temporality and memory (the nonpresent) are in fact the very condition of any perception:

> The presence of the perceived present can only appear as such only inasmuch as it is *continuously* compounded with a nonpresence and nonperception, with primary memory and expectation (retention and protention) . . . As soon as we admit this continuity of the now and the not-now, perception and nonperception, in the zone of primordiality common to primordial impression and primordial retention, we admit the other into the self-identity of the *Augenblick*; nonpresence and nonevidence are admitted into the *blink of an instant*. There is a duration to the blink, and it closes the eye. This alterity is in fact the condition for presence,

presentation, and thus for *Vorstellung* in general; it precedes all the dis-associations that could be produced in presence, in *Vorstellung*.[44]

A similar argument is also initiated in Derrida's commentary on Freud's use of a child's toy, the Mystic Writing Pad, as a model for the unconscious in which Derrida claims that "consciousness for Freud is a surface exposed to the external world."[45] But while Freud's model of the unconscious is one of accreted and layered sedimentations produced as a consequence of its being written upon (even though the unconscious then retains these perceptions as permanent traces), Derrida's emphasis is on the active production of meanings in the unconscious due to its being "already a weave of pure traces, differences in which meaning and force are united."[46] The unconscious is thus not only a receptive surface (the wax slab) that retains impressions from an external source, but it is always reworking, deferring, and creating the traces that constitute it.

As distinct from Freud's model of a receptive surface, Derrida argues for the "possibility of a writing advanced as conscious and as acting in the world,"[47] and for an irreducible and "originary spacing, deferring, and erasure of the simple origin, and polemics on the very threshold of what we persist in calling perception."[48] This originary repetition, as a textuality or "psychical writing" (of substitutions), constitutes both memory and perception and undermines self-presence. However, although the psyche might be described as a textual productivity, Derrida comments, "It is not enough to speak of writing in order to be faithful to Freud, for it is then that we betray him more than ever."[49] For Derrida does not describe the unconscious as the transposing of (another) presence, which would be a return to "an ancient phonologism,"[50] but as a "nontranscriptive writing":

> The conscious text is thus not a transcription, because there is no text *present elsewhere* as an unconscious one to be transposed or transported . . . The text is not conceivable in an originary or modified form of presence. The unconscious text is already a weave of pure traces, differences in which meaning and force are united – a text nowhere present, consisting of archives which are *always already* transcriptions. Originary prints. Everything begins with a reproduction. Always already: repositories of a meaning which was never present, whose signified presence is always reconstituted by deferral, *nachträglich*, belatedly, *supplementarily*: for the *nachträglich* also means *supplementary*. The call of the supplement is primary, here, and it hollows out that which will be reconstituted by deferral as the present. The supplement which seems to be added as a plenitude to a plenitude, is equally that which compensates for a lack.[51]

It is this that also accounts for the threat of the supplement or substitute. Asking "Why is the surrogate or supplement dangerous?," Derrida replies:

> Its slidings slip it out of the simple alternative presence/absence. *That* is the danger. And that is what enables the type always to pass for the

original. As soon as the supplementary outside is opened, its structure implies that the supplement itself can be "typed," replaced by its double, and that a supplement to the supplement, a surrogate for the surrogate, is possible and necessary . . . writing appears to Plato . . . as that process of redoubling in which we are fatally (en)trained: the supplement of a supplement, the signifier, the representative of a representative.[52]

Derrida's claim that "writing supplements perception, before perception even appears to itself"[53] negates the "having been there"[54] phenomenological status and "proper-name effect"[55] of photography, as such claims for an analogical mimesis not only reaffirm a logocentric valuation of vision but also posit a metonymic identity between photography and the real, with the photograph as the being present of an absent referent. As Rosalind Coward and John Ellis argue:

Realism has as its basic philosophy of language not a production (signification being the production of a signified through the action of the signifying chain) but an identity: the signifier is treated as identical to a (pre-existent) signified. The signifier and signified are not seen as caught up together in a process of production, they are treated as equivalents: the signifier is merely the equivalent of its pre-established concept. It seems as though it is not the business of language to establish this concept, but merely to express or communicate it.[56]

As distinct from realism's model of a binary sign secured by a "transcendental signified," the photograph might be likened instead to a "trace" that, constituted through syntagmatic relations of difference, is the sum of all possible relations (of alterity) that inhabit it.[57] As "the signified must always already have been in the position of the signifier,"[58] its meaning is not secured through relations of identity or equivalence but is produced instead through an endless textual movement of difference from, and deferral to, other signs. In order to contain this *différance*, conventional accounts of photography initiate what Victor Burgin has described as

a metaphysics of interpretation through which an attempt is made to reconstitute the missing "presence" which is felt to be the source of a singular and true content of the empirically given form of the text. All too obviously such a metaphysics provides the framework of most photographic criticism with its preoccupation with intentions (the "committed photographer," etc.) . . . It is this logocentric longing which is expressed in the "window-on-the-world" realism of the great majority of writers on photography.[59]

However, while deconstruction undercuts the logocentrism of the claims made for photography, it provides more than just a critique of realism. For, attending

to the ways in which photography undermines the oppositions across which it operates, deconstruction foregrounds photography's necessary subversion of its own logocentric aspirations. Indeed, far from confirming a logocentric metaphysics, photography provides a powerful metaphorical model of the logic of the supplement. As Derrida observes, the "concept of the photograph *photographs* all conceptual oppositions, it traces a relationship of haunting which perhaps is constitutive of all logics."[60]

Stieglitz and the Quest for Presence

Thus far, my concern has been principally with the discourses of photography. To conclude, I shall focus upon a self-styled instance of "straight" photography – Alfred Stieglitz's *Equivalents* series – which can be viewed as an attempt to secure for photography a plenitude and purity of vision untainted by supplementarity, and as an example of "modernism's search for plenitude and unimpeachable self-presence."[61] For, despite a shift from documentary to abstraction in early twentieth-century photography (as exemplified by Stieglitz's own career), this shift did not signal a radical breach between the two but instead intensified a desire for presence in the image. Indeed, when photography was aligned with formalist modernism, this alignment entailed the search for a pure, absolute space of vision and subjectivity that marked an attempt not only to purge photography of the instabilities and opacities of signification but also signaled a retreat from modernity. This project of erasing modernity, as the precondition for the restoration of "a freshness of perception that results from a slate wiped clear,"[62] was perhaps most consistently exemplified by Stieglitz. For what emerges across Stieglitz's work is, first, the development of specific pictorial strategies for representing the city and, secondly, a complete withdrawal from the urban environment, a withdrawal that registered not only Stieglitz's own avoidance of difference but was indicative also of the incompatibility between the city (as a site of modernity) and the securing of presence through "straight photography."[63]

Frequently depicting the city (usually New York), Stieglitz's early photographs share the aestheticizing and Picturesque devices of contemporary Pictorialist and Photo-Secessionist photography (published principally in the journal *Camera Work*) such as the use of mid or distant points of view, the favoring of darkness and dusk and of rain and fog, weak or indirect lighting and silhouetting, a reluctance to use artificial lighting (so as not to undermine the supposed authenticity of the image), the denial of sharpness through soft focus and blurring, the avoidance of detail, and a lack of any direct engagement with people.[64] These techniques were not merely stylistic or technical issues but were means for keeping social relations to an abstraction. For in these photographs the city ceases to be a specific social environment but instead becomes a generic and subjective interior space. The blurring effects of steam in *The Terminal* or of snow in *Winter, Fifth Avenue*; the distanced fragmentation of the crowd into a play of reflective

surfaces in *Wet Day on the Boulevard, Paris* and a similar attention to the play of light in *Reflections, Night, New York*; and the depiction of the city as an arrangement of geometric patterns as in *From My Window* or within the tropes of the industrial sublime, as in *The City of Ambition*, all serve to aestheticize the city by denying (through abstraction) its constituent social relations. This Pictorialist "pastoralization of the cityscape"[65] by means of a precise gauging of distance and lighting (which then allowed for the assertion of subjective and symbolic affect) also perpetuated the *flâneur*'s mode of perception. As Walter Benjamin observed: "For the *flâneur* there is a veil over this picture . . . Because of it, horrors have an enchanting effect upon him. Only when this veil tears . . . does he, too, get an unobstructed view of the big city."[66]

The highly conventional, indeed clichéd, visual strategies of the Pictorialists can be discerned in *The Terminal* (Fig. 25), described by Stieglitz himself as an image representing his projected sense of alienation upon his return to America from Germany: "There seemed to be something closely related to my deepest feeling in what I saw, and I decided to photograph what was within me . . . What made me see the watering of the horses as I did was my own loneliness."[67] A similar relation between image and subjective affect is posited in another self-authoring narrative – this time referring to the genesis of *The Steerage* (Fig. 26). Recalling, once again, his sense of alienation (during a transatlantic voyage), Stieglitz relates:

> I saw a picture of shapes and underlying that the feeling I had about life. And as I was deciding, should I try to put down this seemingly new vision that held me – people, the common people, the feeling of ship and ocean and sky and the feeling of release that I was away from the mob called the rich – Rembrandt came into my mind and I wondered would he have felt as I was feeling . . . Would I get what I saw, what I felt? . . . I knew if I had, another milestone in photography would have been reached, related to the milestone of my "Car Horses" [*The Terminal*] made in 1892, which had opened up a new era of photography, of seeing. In a sense it would go beyond them, for here would be a picture based on related shapes and on the deepest human feeling, a step in my own evolution, a spontaneous discovery.[68]

In addition to Stieglitz's mythic identification of himself with, indeed as, the evolution of photography, this statement reiterates the well-established tenets of expression theory as Stieglitz, deploying a standard modernist privileging of inner depth over external appearance, moves swiftly from the empirical par-ticularities of the phenomenal to an assertion of the quasi-metaphysical truth of pure feeling. As Allan Sekula has observed of Stieglitz's narrative, "by a pro-cess of semantic diffusion we are left with the trivial and absurd assertion: shape = feelings."[69]

Despite his claims to innovation, Stieglitz's distinction between essence and appearance merely replicates the relation between form and meaning cited by

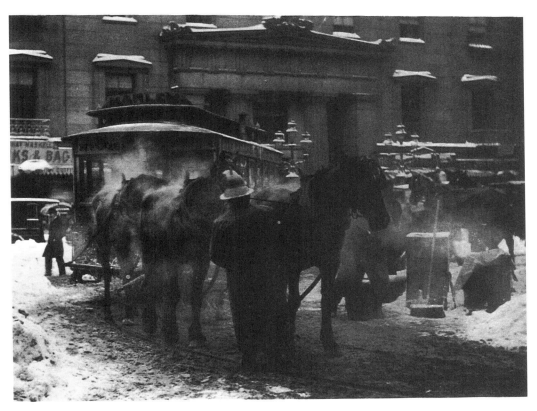

Figure 25. *Alfred Stieglitz,* The Terminal *(New York), 1892. From* Camera Work, *no. 36 (October 1911). Photogravure. 4¹³/₁₆″ × 6¹/₄″ (12.2 × 15.9 cm). Museum of Modern Art, New York. Photo courtesy of MOMA.*

Derrida as central to traditional aesthetics: "In order to think art in general, one thus accredits a series of oppositions (meaning/form, inside/outside, content/container, signified/signifier, represented/representer, etc.) which, precisely, structure the traditional interpretation of works of art. One makes of art in general an object in which one claims to distinguish an inner meaning, the invariant, and a multiplicity of external variations *through* which, as through so many veils, one would try to see or restore the true, full, originary meaning."[70] Stieglitz's claim for a semantic core or plenitude to both the visible world and to the self-sufficient photograph (as an inherent coincidence of form and meaning, signifier and signified) is, however, immediately undercut by his need to affirm this verbally. His commentary not only anchors our reading of the image (in part by referring it to an authorial intention) but functions as the very condition, as both supplement and frame (*parergon*), of its legibility. This claim for a directly communicable visual essence is thus predicated upon an attempt to banish from the photograph the *parergon* (the constitutive role of textual anchorage, and of determining contexts and pictorial conventions, etc.) which

is "neither work (*ergon*) nor outside the work (*hors d'oeuvre*), neither inside or outside . . . [but] *gives rise* to the work."[71] For, as Derrida notes:

> In the extent to which what is already called "meaning" (to be "expressed") is already, and thoroughly, constituted by a tissue of differences, in the extent to which there is already a *text*, a network of textual referrals to *other* texts, a textual transformation in which each allegedly "simple term" is marked by the trace of another term, the presumed interiority of meaning is already worked upon by its own exteriority . . . there is no signification unless there is synthesis, syntagm, *différance* and text.[72]

Although later repudiating Pictorialism's visual techniques, Stieglitz nonetheless maintained its aesthetic ideology through his privileging of abstraction and affect over mimesis. The solipsistic aestheticizing of the world in *The Steerage* and *The Terminal* (whereby the subject of Stieglitz's photography is always Stieglitz himself), and the concomitant quest for a transcendent subjectivity, culminated in the *Equivalents* sequence of cloud photographs that were produced mainly in the 1920s (Fig. 27). Referring to them as "Straight photographs," Stieglitz described these images as "*equivalents* of my most profound life experience, my basic philosophy of life . . . [they] are tiny photographs, direct revelations of a man's world in the sky – documents of eternal relationship – perhaps even a philosophy."[73] As in his account of *The Terminal*, Stieglitz proposes that an image (as equivalent) could embody an emotional correspondence between the photographer (as artist) and the scene depicted. What was implicit in the genesis of *The Steerage* is made explicit in the *Equivalents*, for, with all social reference and narrative effaced, Stieglitz now no longer identifies with the "common people" but with "the sky and the feeling of release."

Staging what Sekula describes as the desire for "a mystical identification with the Other," the equivalent maintained the Romantic quest for a fusion of self and object (as image), whereby form is only significant when subjectively invested. Thus for Stieglitz, "shapes, as such, do not interest me unless they happen to be an outer equivalent of something already taking form within me."[74] Moreover, he adds:

> The true meaning of the *Equivalents* comes through without any extraneous pictorial factors intervening between those who look at the pictures and the pictures themselves . . . [they] are a picture of the chaos in the world, and of my relationship to that chaos. My prints show the world's constant upsetting of man's equilibrium, and his eternal battle to reestablish it.[75]

Here Stieglitz's belief in the unmediated exteriorization of the interior self rests upon a claim for the transparency of the photograph as pure vision without limit or signification ("without any extraneous pictorial factors intervening"). Framing the photographs within a conflict between the loss and restoration of meaning, Stieglitz's aim is nothing less than access to a "transcendental

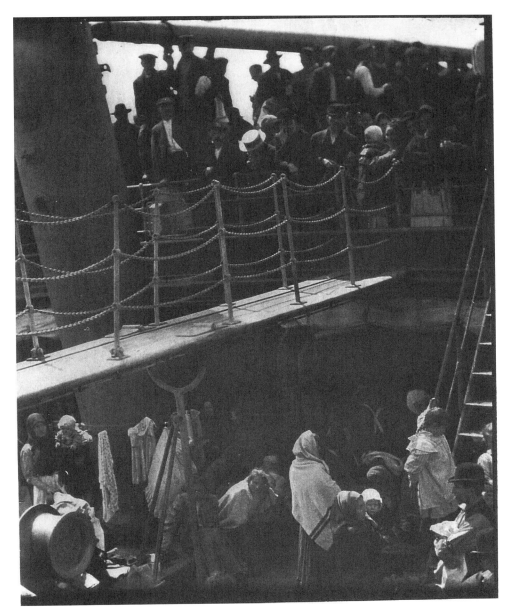

Figure 26. *Alfred Stieglitz, The Steerage, 1907. From Camera Work, no. 36 (October 1911). Photogravure. 7³/₄″ × 6¹/₂″ (19.7 × 16.5 cm). Museum of Modern Art, New York; gift of Alfred Stieglitz. Photo courtesy of MOMA.*

signified" beyond the undecidabilities of representation. As he commented to Hart Crane, "Several people feel I have photographed God. May be."[76]

Through their attempted suppression of "the indefinite process of supplementarity [which has] always already *infiltrated* presence,"[77] together with their

incitement of a solipsistic vision, the *Equivalents* share many of the character-istics of the Sublime as outlined by Thomas Weiskel:

> In the face of anxiety the stranded ego withdraws its attachment to objects in their irreducible otherness and thereby hopes to reproduce the primal state before otherness became the experience of frustration. This leads to regression as one major defence against the anxiety of depriva-tion. The regression intends the state of primary narcissism but neces-sarily results in the secondary narcissism we so often find in the egotistical sublime.[78]

Sharing the undifferentiated and circular perception of the egotistical sublime in which the meaning of objects is solely that conferred upon them by the sub-ject, the *Equivalents* suppress the distinction "between what the mind confers and what it receives."[79] Evacuated of reference,[80] these images function as blank screens or apertures framing a boundaryless space that "would subsume all other-ness, all possibility of negation . . . [and that] subverts the negativity which is the ground of the 'other'."[81] As an extreme instance of the belief in the trans-parency of the photograph (as an image without signs),[82] the *Equivalents* rep-resent a sustained denial of the "fact that nonpresence and otherness are internal to presence."[83] Ultimately, this quest for the unmediated presence of an absolute self-reflexivity is predicated upon an expulsion of not only the sign but the subject too. For, given the impossibility of a signifier of pure presence and the necessary recognition of alterity for the securing of any discrete iden-tity, the quest ultimately entails a dissolution of the subject itself. As Derrida comments, "without symbol or suppletory . . . pure presence itself, if such a thing were possible, would be only another name for death."[84]

However, not only is the effacement of reference the precondition here for a specific subjective investment in the image, it is also the precondition for the elevation of photography from mechanical medium to art. This promotion of art photography entailed a number of disavowals – not only an effacement of reference or figurality, but a transcendence also of the social and of history, including those precedents offered to Stieglitz himself by the history of photog-raphy. Complementing this is a denial of the institutional, and increasingly hier-archical, structures of photography (which, in fact, Stieglitz vigorously sought to reinforce) through a stress upon originality that served also to efface the Pictorialists' own reliance upon established aesthetic discourses and pictorial rhetorics (e.g., Impressionism and Symbolism). Underwriting these various denials was a disavowal of the industrial status of photography – its moder-nity – as both a method of image production and as commercial commodity.[85] What was promoted instead was a compensatory, indeed compulsive, fetishiza-tion of photographic technique (especially its potential for "artistic" or "crafted" manipulation) as sufficient in itself. Indeed, just as Stieglitz's modernity was profoundly antimodern, so too his photographic practice would appear to be

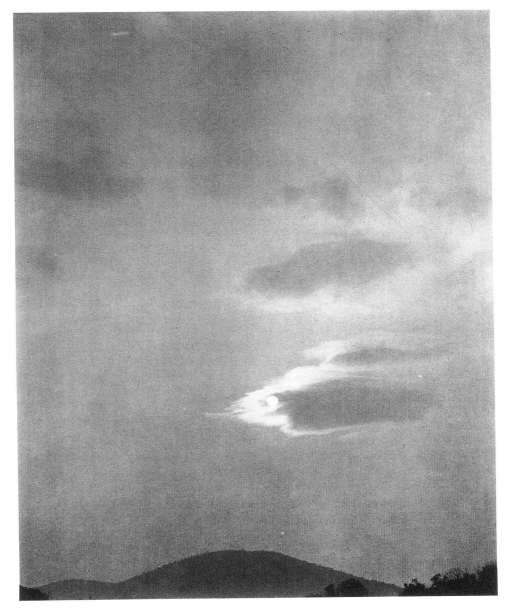

Figure 27. *Alfred Stieglitz, Music: A Sequence of Ten Cloud Photographs, #VIII, 1922.*
Gelatin silver print. National Gallery of Art, Washington, D.C. Photo courtesy of the Gallery.

animated by an antipathy to photography or, at least, by a sustained attempt to police its technical and semantic scope.

Stieglitz's stresses upon technique, upon an increasingly limited repertoire of subjects and visual effects, and upon the formal necessity of balance and harmony were not discrete technical questions (local only to photography) but

reflected his belief in photography as a transparent vehicle of visual presence. Situated within a dynamic of presence and absence – the role of photography in the "eternal battle" to restore order – the *Equivalents* represent an end point in the always deferred securing of presence. For although "the desire of presence is . . . born from the abyss (the indefinite multiplication) of representation,"[86] the photographic sign simultaneously denies this presence. As Derrida also remarks, "One cannot help wishing to master absence and yet we must always let go."[87]

Notes

1 "Some Account of the Art of Photogenic Drawing" (1839), in *Photography in Print: Writings from 1816 to the Present*, ed. Vicki Goldberg (New York: Simon and Schuster, 1981), p. 39. Talbot also recounts how his experimentation in photography was in part initiated by his speculation as to "whether it might not be possible to cause that image to impress itself upon the paper, and thus to let Nature substitute her own inimitable pencil, for the imperfect, tedious, and almost hopeless attempt of copying a subject so intricate" (p. 43), and he also remarks upon his making of "a great number of representations of my house in the country . . . [and that] this building [is] I believe the first that was ever known *to have drawn its own picture*" (p. 46).

2 "The Daguerreotype," in *Classic Essays on Photography*, ed. Alan Trachtenberg (New Haven, Conn.: Leete's Island Books, 1980), p. 38.

3 Cited in Richard Rudisill, *Mirror Image: The Influence of the Daguerreotype on American Society* (Albuquerque: University of New Mexico Press, 1971), p. 57.

4 "The Stereoscope and the Stereograph," in *Photography in Print*, pp. 101–2. Photography, Holmes argued, would eventually be able to supply a copy of everything, a universal "currency" of equivalence between the photographic sign and "objects of nature": "There is only one Coliseum or Pantheon; but how many millions of potential negatives have they shed – representatives of billions of pictures – since they were erected! . . . Every conceivable object of Nature and Art will soon scale off its surface for us. Men will hunt all curious, beautiful, grand objects . . . for their *skins* . . . The consequence of this will soon be such an enormous collection of forms, that they will have to be classified and arranged in vast libraries, as books are now. The time will come when a man who wishes to see any object, natural or artificial, will go the Imperial, National or City Stereographic Library and call for its skin or form, as he would for a book at any common library . . . where all men can find the special forms they particularly desire to see . . . And as a means of facilitating the formation of public and private stereographic collections, there must be arranged a comprehensive system of exchanges, so that there may grow up something like a universal currency of these bank-notes, or promises to pay in solid substance, which the sun has engraved for the great Bank of Nature" (pp. 112–13).

5 The term "indexical" is largely derived from the writings of the American logician C. S. Peirce. In Peirce's basic triadic model of the sign (as index, icon, and symbol), the index is directly connected to or affected by its object. This "dynamical" or causal relation between the sign and its object distinguishes the index from both the icon (which only shares, through resemblance, the characteristics of the object it denotes, e.g., a portrait) and the symbol (which is an entirely constructed, and hence conventional, sign). However, these three aspects of the sign are not mutually exclusive, and Peirce acknowledged, for example, that a photograph could be both indexical and iconic. Nonetheless, Peirce viewed the indexical and the iconic as natural properties of the sign, as distinct from the essentially conventional identity of the symbol. For an introduction to Peirce's extensive writings on semiotics, see his "Logic as Semiotic: The Theory of Signs," in *The Philosophy of Peirce: Selected Writings*, ed. Justus Buckler (London: Paul, Trench, Trubner & Co., 1940), pp. 98–119. See also *Collected Papers of Charles Sanders Peirce*, 8 vols., ed.

Charles Hartshorne and Paul Heiss (Cambridge: Harvard University Press, 1931–58), and *The Essential Peirce: Selected Philosophical Writings*, ed. Nathan Houser and Christian Kloesel (Bloomington: Indiana University Press, 1992).

6 Although, as Martin Jay has argued, the invention of photography was itself a catalyst in the "disillusionment with the realist paradigm": "Photo-Unrealism: The Contribution of the Camera to the Crisis of Ocularcentrism," in *Vision and Textuality*, ed. Stephen Melville and Bill Readings (Basingstoke: Macmillan, 1995), p. 347.

7 *Art and Illusion: A Study in the Psychology of Pictorial Representation* (Princeton: Princeton University Press, 1961).

8 "The Ontology of the Photographic Image," in *Classic Essays on Photography*, p. 241. See also Roland Barthes's account of how "the photograph (in its literal state), by virtue of its absolutely analogical nature, seems to constitute a message without a code" in "The Rhetoric of the Image," *Image–Music–Text*, trans. Stephen Heath (Glasgow: Fontana, 1979), pp. 42–3.

9 "The Ontology of the Photographic Image," p. 240.

10 Ibid., p. 241.

11 Ibid.

12 "Photography," in *Classic Essays on Photography*, pp. 141–2.

13 "Photography and the New God," in *Classic Essays on Photography*, p. 150. See also in this anthology Franz Roh, "Mechanism and Expression: The Essence and Value of Photography," pp. 154–63.

14 For a critique of the promotion of the author in the history of photography, see Rosalind Krauss, "Photography's Discursive Spaces," in *The Contest of Meaning*, ed. Richard Bolton (Cambridge: MIT Press, 1989), pp. 287–301; Abigail Solomon-Godeau, "Canon Fodder: Authoring Eugène Atget," *Photography at the Dock* (Minneapolis: University of Minnesota Press, 1991), pp. 28–51; Molly Nesbit, "The Use of History," *Art in America* 74 (February 1986): 72–83, and *Atget's Seven Albums* (New Haven: Yale University Press, 1992); and Max Kozloff, *The Privileged Eye: Essays on Photography* (Albuquerque: University of New Mexico Press, 1987), pp. 279–304. These critiques are largely directed at John Szarkowski's attempt to secure a coherent artistic agency for Atget in the catalog (coauthored with Maria Hambourg) *The Work of Atget*, 4 vols. (New York: Museum of Modern Art, 1981–5).

15 For example, John Szarkowski's claim that "more convincingly than any other picture, a photograph evokes the tangible presence of reality. Its most fundamental use and its broadest acceptance has been as a substitute for the subject itself – a simpler, more permanent, more clearly visible version of the plain fact": *The Photographer's Eye* (London: Secker and Warburg, 1980), p. 12. This book in particular demonstrates Szarkowski's typically modernist project of delineating the essential features of photography as a unique medium. These he lists as "the thing itself," "the detail," "the frame," "time," and the "vantage point."

16 See John Tagg, *The Burden of Representation: Essays on Photographies and Histories* (Basingstoke: Macmillan, 1988), *Grounds of Dispute: Art History, Cultural Politics and the Discursive Field* (Basingstoke: Macmillan, 1992), and "The Discontinuous City: Picturing and the Discursive Field," in *Visual Culture: Images and Interpretations*, ed. Norman Bryson, Michael Ann Holly, and Keith Moxey (Hanover, N.H.: Wesleyan University Press/ University Press of New England, 1994), pp. 83–103, and Allan Sekula, *Photography against the Grain: Essays and Photo Works* (Halifax: Nova Scotia College of Art and Design, 1984).

17 "Différance," *Margins of Philosophy*, trans. Alan Bass (Brighton: Harvester Press, 1982), p. 18.

18 "Freud and the Scene of Writing," *Writing and Difference*, trans. Alan Bass (London: Routledge and Kegan Paul, 1978), p. 207. In order to aid reference, published translations of Derrida are cited throughout.

19 "Force and Signification," *Writing and Difference*, p. 27. For Derrida's own texts on photography, see "The Deaths of Roland Barthes," in *Philosophy and Non-Philosophy since Merleau-Ponty*, ed. Hugh J. Silverman, trans. Pascale-Anne Brault and Michael Naas (New York: Routledge, 1988), and (with Marie-Françoise Plissart) "Right of Inspection," trans. David Wills, *Art and Text* 32 (Autumn 1989), pp. 10–97. Derrida's discussion of blindness as a constitutive condition of representation, in *Memoirs of the Blind: The Self-Portrait and Other Ruins*, trans. Pascale-Anne Brault and Michael Naas (Chicago: University of Chicago Press, 1993), is also pertinent to photography. For an account of the camera obscura as a metaphor for consciousness, knowledge, and ideology, see Sarah Kofman, *Camera obscura de l'idéologie* (Paris: Editions Galilée, 1973).

20 *Speech and Phenomena and Other Essays on Husserl's Theory of Signs*, trans. David Allison (Evanston, Ill.: Northwestern University Press, 1973), p. 99.

21 As Stephen Melville warns, "the risk is that the critic may see in Derrida the latest, best, or most powerful source of grounding principles for criticism and will thus use Derrida to re-epistemologize criticism": *Philosophy beside Itself* (Minneapolis: University of Minnesota Press, 1986), p. 118. Derrida's own extended commentary on the self-affirming interpretive strategies of a psychoanalysis which "finds itself/is found [*se trouve*] . . . in the text that it deciphers" is also pertinent here: "Le facteur de la vérité," *The Post Card: From Socrates to Freud and Beyond*, trans. Alan Bass (Chicago: University of Chicago Press, 1987), p. 419.

22 For the best introduction to Derrida's critique of logocentrism and the "transcendental signified," see "Structure, Sign, and Play in the Discourse of the Human Science," *Writing and Difference*, esp. pp. 278–82. As Derrida notes elsewhere, "There has to be a transcendental signified for the difference between the signifier and the signified to be somewhere absolute and irreducible": *Of Grammatology*, trans. Gayatri Chakravorty Spivak (Baltimore: Johns Hopkins University Press, 1976), p. 20.

23 "The notion of the sign . . . remains therefore within the heritage of that logocentrism which is also a phonocentrism: absolute proximity of voice and being, of voice and the meaning of being, of voice and the ideality of meaning . . . We already have a foreboding that phonocentrism merges with the historical determination of being in general as *presence*, with all the subdeterminations which depend on this general form and which organize within it their system and their historical sequence (presence of the thing to sight as *eidos*, presence as substance/essence/existence [*ousia*], temporal presence as point [*stigmè*] of the now or of the moment [*nun*], the self-presence of the cogito, consciousness, subjectivity, the co-presence of the other and of the self, intersubjectivity as the intentional phenomenon of the ego, and so forth). Logocentrism would thus support the determination of the being of the entity as presence": *Of Grammatology*, pp. 11–12.

24 "An Interview with Jacques Derrida," *Literary Review* 14 (April–May 1980), p. 21. So too: "The 'subject' of writing does not exist if we mean by that some sovereign solitude of the author. The subject of writing is a *system* of relations between strata . . . the psyche, society, the world. Within that scene, on that stage, the punctual simplicity of the sovereignty of the classical subject is not to be found": "Freud and the Scene of Writing," pp. 226–7.

25 "Deconstruction and Its Other," in *Dialogues with Contemporary Continental Thinkers: The Phenomenological Heritage*, ed. Richard Kearney (Manchester: Manchester University Press, 1984), pp. 115–16.

26 *Of Grammatology*, p. 20.

27 Ibid., p. 159.

28 Moreover, as Derrida has repeatedly stressed, it is impossible to operate outside logocentrism. Indeed, the very notion of being "outside" metaphysics is itself metaphysical. As Derrida notes of Heidegger, for example, "[he] recognizes that economically and strategically he had to borrow the syntactic and lexical resources of the language of metaphysics,

as one must always do at the very moment that one deconstructs this language": *Positions*, trans. Alan Bass (London: Athlone, 1981), p. 10.

29 Derrida's provides a brief account of *différance* in ibid., pp. 8–9, 45. See also *Speech and Phenomena and Other Essays on Husserl's Theory of Signs*, pp. 129–60.

30 *Positions*, pp. 41ff. However, as Derrida himself emphasizes, "despite appearances, the deconstruction of logocentrism is not a psychoanalysis of philosophy" ("Freud and the Scene of Writing," p. 196), nor is "logocentric repression . . . comprehensible on the basis of the Freudian concept of repression" (p. 197). So also, Derrida denies that "meditation on nonpresence . . . [is] necessarily . . . a theory of nonpresence *qua* unconsciousness" (*Speech and Phenomena and Other Essays on Husserl's Theory of Signs*, p. 63). More particularly, in *Of Grammatology*, Derrida states that "in spite of certain appearances, the locating of the word *supplement* is here not at all psychoanalytical," although he adds, "if by that we understand an interpretation that takes us outside writing toward a psychobiographical signified" (p. 159).

31 *Positions*, pp. 42–3.

32 "Différance," pp. 20–1.

33 "But, Beyond . . . (Open Letter to Anne McClintock and Rob Dixon)," trans. Peggy Kamuf, *Critical Inquiry* 13 (Autumn 1986), p. 167. See also *Of Grammatology*: "There is no outside text" [*il n'y a pas de hors texte*]" (p. 158). Elsewhere Derrida claims, "A text is henceforth no longer a finished corpus of writing, some content enclosed in a book or its margins, but a differential network, a fabric of traces referring endlessly to something other than itself, to other differential networks": cited in *Untying the Text: A Post-Structuralist Reader*, ed. Robert Young (London: Routledge and Kegan Paul, 1981), p. 29.

34 See *Of Grammatology*, esp. pp. 6–26, 158ff.

35 "But Beyond," p. 168.

36 This claim that writing is the condition of speech is illustrated by Derrida's term *différance*, which when spoken sounds identical to *différence* (spelled with an *e*) and thus can only signify (i.e., differ from *différence*) graphically and not acoustically.

37 *Of Grammatology*, p. 159.

38 "We have already defined elsewhere the fundamental property of writing, in a difficult sense of the word, as *spacing*: diastem and time becoming space; an unfolding as well, on an original site, of meanings which irreversible, linear consecution, moving from present point to present point, could only tend to repress, and (to a certain extent) could only fail to repress": "Freud and the Scene of Writing," p. 217. Elsewhere Derrida describes writing as the "textual spacing of differences . . . the chain of substitutions . . . (archi-trace, archi-writing, reserve, *brisure*, articulation, supplement, *différance*: there will be others)" (*Positions*, p. 14), and as "the impossibility of a chain arresting itself on a signified that would not relaunch this signified, in that the signified is already in the position of the signifying substitution" (p. 82).

39 "Freud and the Scene of Writing," p. 226.

40 Discussion after "Structure, Sign, and Play in the Discourse of the Human Sciences," in *The Structuralist Controversy*, ed. Richard Macksey and Eugenio Donato (Baltimore: Johns Hopkins University Press, 1972), p. 272. This exchange is not included in *Writing and Difference*. For a discussion of the status of vision for Derrida, see John McCumber, "Derrida and the Closure of Vision," in *Modernity and the Hegemony of Vision*, ed. David Michael Levin (Berkeley and Los Angeles: University of California Press, 1993).

41 Discussion after "Structure, Sign, and Play," p. 272.

42 "Plato's Pharmacy," in *Dissemination*, trans. Barbara Johnson (Chicago: University of Chicago Press, 1981), pp. 107–9.

43 *Speech and Phenomena and Other Essays on Husserl's Theory of Signs*, p. 60.

44 Ibid., pp. 64–5.

45 "Freud and the Scene of Writing," p. 212.

46 Ibid., p. 211.

47 Ibid., p. 212.

48 Ibid., p. 226.

49 Ibid., p. 211.

50 "It is with a graphematics still to come, rather than with a linguistics dominated by an ancient phonologism, that psychoanalysis sees itself as destined to collaborate" (ibid., p. 220). Although Freud's work is permeated by references to writing – "From a system of traces functioning according to a model which Freud would have preferred to be a natural one, and from which writing is entirely absent [in the *Project for a Scientific Psychology*, 1895], we proceed toward a configuration of traces which can no longer be represented except by the structure and functioning of writing," p. 200 – Derrida argues that Freud remains bound to a logocentric valuation of presence: "Freud, like Plato, thus continues to oppose hypomnemic writing to writing *en tei psychei*, itself woven of traces, empirical memories of a present truth outside of time. Henceforth, the Mystic Writing Pad, separated from psychical responsibility, a representation abandoned to itself, still participates in Cartesian space and mechanics: *natural* wax, exteriority of the *memory aid*" (p. 227). This juxtaposition of "natural" memory, as "the pure transparency of a perception without memory" (p. 201) and an auxiliary or external supplementation, is implied in Oliver Wendell Holmes's description of the photograph as "a mirror with a memory."

51 Ibid., pp. 211–12.

52 "Plato's Pharmacy," p. 109.

53 "Freud and the Scene of Writing," p. 228.

54 Roland Barthes, "The Rhetoric of the Image," *Image–Music–Text*, p. 44.

55 Derrida says of the proper name, "every signified whose signifier can neither vary nor be translated into another signifier without loss of significance, suggests a proper-name effect." "Coming into One's Own," *Psychoanalysis and the Question of the Text*, ed. Geoffrey Hartman (Baltimore: Johns Hopkins University Press, 1978), p. 127.

56 *Language and Materialism* (London: Routledge and Kegan Paul, 1977), p. 47. Referring to the "psychologism . . . inscribed and prescribed within the concept of the sign itself," Derrida also claims, with specific reference to Saussurean semiotics, that "the 'semiological' project itself and the organic totality of its concepts" assumes stable subjects and signifiers: "*communication* . . . implies a *transmission charged with making pass, from one subject to another, the identity* of a *signified* object, of a *meaning* or of a *concept* rightfully separable from the process of passage and from the signifying operation. Communication presupposes subjects (whose identity and presence are constituted before the signifying operation) and objects (signified concepts, a thought meaning that the passage of communication will have neither to constitute, nor, by all rights, transform). *A com-municates B to C.* Through the sign the emitter communicates something to a receptor, etc." *Positions*, pp. 23–4.

57 In "Différance" Derrida writes, "The trace is not a presence but the simulacrum of a presence that dislocates itself, displaces itself, refers itself, it properly has no site – erasure belongs to its structure" (p. 24).

58 *Of Grammatology*, p. 73.

59 "Photographic Practice and Art Theory," in *Thinking Photography*, ed. Burgin (Basingstoke: Macmillan, 1982), p. 55.

60 "The Deaths of Roland Barthes," p. 267. Much of Derrida's discussion of Barthes's text *Camera Lucida* devolves upon a distinction between the referent and reference: "He [Barthes] insists, and rightly so, upon the adherence of the 'photographic referent': it doesn't relate to a present or to a real but, in a different way, to the other, and each time differently according to the type of 'image' " (p. 275). As Derrida later observes, "Provided that we do not hold to some naive and 'realist' referentialism, the relation to some unique and irreplaceable referent *interests* us and animates our most sound and studied readings . . . The metonymic force divides the referential line [*trait*], suspends the referent and leaves

it to be desired" (p. 290). Derrida's notion of a "haunting . . . constitutive of all logics" might also be understood in terms of a destabilizing *mise en abyme*. As Alan Bass comments, "*En abyme* is Derrida's usual expression for the infinite regress of a reflection within a reflection, etc. The term originally comes from the heraldic notion of an escutcheon within an escutcheon; Derrida plays on *abyme* and *abîme*, abyss" (*The Post Card*, p. 511). For an application of this term within a discussion of mirroring and doubling in photographs, see Craig Owens, "Photography *en abyme*," *October 5* (Summer 1978).

61 Rosalind Krauss, "In the Name of Picasso," *The Originality of the Avant-Garde* (Cambridge: MIT Press, 1986), p. 38.

62 Paul de Man, "Literary History and Literary Modernity," *Blindness and Insight: Essays on the Rhetoric of Contemporary Criticism* (New York: Oxford University Press, 1971), p. 157.

63 My concern here is with the experience or perception of modernity – its cognitive conditions – as a set of imaginary responses, and not with an analysis of their possible causes. Any such account here must necessarily be very reductive, but what I wish to highlight is a tension or dynamic between opacity and clarity, chaos and order. For example, we might refer to a recurrent experience of modernity as an epistemological anxiety predicated upon ambiguity, an absence of legibility, and the insecurity or provisionality of meaning – see, for example, T. J. Clark, *The Painting of Modern Life: Paris in the Art of Manet and His Followers* (London: Thames and Hudson, 1985), and Marshall Berman, *All That Is Solid Melts into Air* (London: Verso, 1983). This experience of modernity, as the erosion of meaning, prompts what Zygmunt Bauman has recently described as "the struggle for order." This struggle, Bauman claims, "is a fight of determination against ambiguity, of semantic precision against ambivalence, of transparency against obscurity, clarity against fuzziness. Order as a concept, as a vision, as a purpose could not be conceived but for the insight into the total ambivalence, the randomness of chaos. Order is continuously engaged in the war of survival. The other of order is not another order: chaos is its only alternative. The other of order is the miasma of the indeterminate and unpredictable. The other is the uncertainty, that source and archetype of all fear. The tropes of the 'the other of order' are: undefinability, incoherence, incongruity, incompatibility, illogicality, irrationality, ambiguity, confusion, undecidability, ambivalence . . . The typically modern practice, the substance of modern politics, of modern intellect, of modern life, is the effort to exterminate ambivalence." *Modernity and Ambivalence* (Ithaca, N.Y.: Cornell University Press, 1991), p. 7. This identification of modernity with dislocation, confusion, ambivalence, and irrationality (for example, as social and spatial fragmentation; the dissolution of boundaries; the threats, imagined or otherwise, to the self) is contiguous with modernity itself. But what should be stressed here is that these effects of instability and flux coexist with powerful and sustained efforts to erase or transcend them through system, order, and purity.

64 Having rejected "manipulated, hybrid" images, Stieglitz claimed, "Personally, I like my photography straight, unmanipulated, devoid of all tricks; a print not looking like anything but a photograph, living through its own inherent qualities and revealing its own spirit." Cited in *Alfred Stieglitz*, Aperture History of Photography series (New York: Aperture, 1976), p. 18.

65 Ulrich F. Keller, "The Myth of Art Photography: An Iconographic Analysis," *History of Photography* 9, 1 (January–March 1985), p. 10. See also Keller, "The Myth of Art Photography: A Sociological Analysis," ibid. 8, 4 (October–December 1984): 249–75.

66 Cited in David Frisby, *Fragments of Modernity* (Cambridge: Polity Press, 1985), pp. 250–1. This privatization of perceptual experience by Stieglitz and other Pictorialists echoes Georg Simmel's contemporary description of modernity as the experience of an interior world (through the cultivation of extreme subjectivism) as well as Benjamin's later account of the elevation of inner existence (*Erlebnis*) over concrete historically specific experience (*Erfahrung*) in part as a defense against the shocks experienced in the city.

67 Cited in *Alfred Stieglitz*, p. 6.

68 Cited in Allan Sekula, "On the Invention of Photographic Meaning," *Photography against the Grain*, pp. 13–14. A slightly different version of this account is also cited in *Alfred Stieglitz*, pp. 9–10.

69 "On the Invention of Photographic Meaning," p. 15.

70 *The Truth in Painting*, trans. Geoff Bennington and Ian McLeod (Chicago: University of Chicago Press, 1987), p. 22.

71 Ibid., p. 9.

72 *Positions*, p. 33.

73 *Alfred Stieglitz*, p. 12.

74 Ibid., p. 14.

75 Ibid.

76 Letter to Hart Crane (10 December 1923), quoted in Sarah Greenough and Juan Hamilton, *Alfred Stieglitz: Photographs & Writings* (Washington, D.C.: National Gallery of Art, 1983), p. 208. See also in this volume "How I Came to Photograph Clouds," pp. 206–8. In addition, see Sarah Greenough, "How Stieglitz Came to Photograph Clouds," in *Perspectives on Photography: Essays in Honor of Beaumont Newhall*, ed. Pater Walch and Thomas F. Barrow (Albuquerque: University of New Mexico Press, 1986), pp. 151–65, and Graham Clarke, "Alfred Stieglitz and Lake George: The American Place," *History of Photography* 15, 2 (Summer 1991), pp. 78–83.

77 Derrida, *Of Grammatology*, p. 163.

78 *The Romantic Sublime: Studies in the Structure and Psychology of Transcendence* (Baltimore: Johns Hopkins University Press, 1976), p. 139. See also Neil Hertz, *The End of the Line: Essays on Psychoanalysis and the Sublime* (New York: Columbia University Press, 1985), esp. ch. 3, and Bryan Jay Wolf, *Romantic Re-Vision: Culture and Consciousness in Nineteenth-Century American Painting and Literature* (Chicago: University of Chicago Press, 1982).

79 Weiskel, *The Romantic Sublime*, p. 51.

80 As Rosalind Krauss observes, "In calling this series *Equivalents*, Stieglitz is obviously invoking the language of symbolism, with its notion of correspondence and hieroglyph. But what is intended here is symbolism in its deepest sense, symbolism as an understanding of language as a form of radical absence – the absence, that is, of the world and its objects, supplanted by the presence of the sign." "Stieglitz/*Equivalents*," *October* 11 (Winter 1979), p. 140.

81 Weiskel, *The Romantic Sublime*, pp. 49–50. In the early period in the production of the *Equivalents*, especially during his stays at Lake George, Stieglitz also produced a series of nude portraits of Georgia O'Keeffe (specifically, of her breasts and/or torso). This compulsive investigation of the signs of sexual difference provides an important context for the *Equivalents* in that both sequences of images occupy opposite but related positions with respect to the representation of difference: on the one hand (in the portraits), a fragmenting and fetishizing gaze, and on the other (in the *Equivalents*), an effacement of the signs of (sexual) difference.

82 "Self-presence must be produced in the undivided unity of a temporal present so as to have nothing to reveal to itself by the agency of signs. Such a perception or intuition of self by self in presence would not only be the case where 'signification' in general could not occur, but also would assure the general possibility of a primordial perception or intuition" (*Speech and Phenomena and Other Essays on Husserl's Theory of Signs*, p. 60). In this sense too the *Equivalents* suppress the gap of signification by effacing the *fort/da* (as absence, loss, and substitution) constitutive of all representation. As Derrida notes, "What we know is that every step (discursive or pictorial in particular) implies a *fort/da*. Every relation to a pictural text implies this double movement doubly interlaced to itself" (*The Truth in Painting*, p. 357). Freud's account of the *fort/da* game is in *Beyond the Pleasure Principle* (1920), *The Standard Edition of the Complete Psychological Works*, trans. and ed. James Strachey, 24 vols. (London: Hogarth Press, 1953–74), vol. XVIII.

See also Derrida's reading of the *fort/da* in "To Speculate – On Freud," *The Post Card: From Socrates to Freud and Beyond*, pp. 259–409.

83 Derrida, *Speech and Phenomena and Other Essays on Husserl's Theory of Signs*, p. 66.

84 *Of Grammatology*, p. 155.

85 As Paul Strand approvingly noted, "It is in the later work of Stieglitz . . . that we find a highly evolved crystallization of the photographic principle, the unqualified subjugation of a machine to the single purpose of expression . . . he has maintained in his own photographic work a unity of feeling uncontaminated by alien influences; in his own words, 'no mechanicalization [*sic*] but always photography'" ("Photography and the New God," in *Classic Essays on Photography*, p. 148).

86 *Of Grammatology*, p. 163.

87 Ibid., p. 142.

9

The Work of Art and Its Beholder

The Methodology of the Aesthetic of Reception

Wolfgang Kemp

CURIOUS to see what effect it would have, K. went up to a small side chapel near by, mounted a few steps to a low balustrade, and bending over it shone his torch on the altar-piece. The light from a permanent oil-lamp hovered over it like an intruder. The first thing K. perceived, partly by guess, was a huge armoured knight on the outermost verge of the picture. He was leaning on his sword, which was stuck into the bare ground, bare except for a stray blade of grass or two. He seemed to be watching attentively some event unfolding itself before his eyes. It was surprising that he should stand so still without approaching nearer to it. Perhaps he had been sent there to stand guard. K., who had not seen any pictures for a long time, studied this knight for a good while, although the greenish light of the oil-lamp made his eyes blink. When he played the torch over the rest of the altar-piece he discovered that it was a portrayal of Christ being laid in the tomb, conventional in style and a fairly recent painting. He pocketed the torch and returned again to his seat.[1]

In this passage from Franz Kafka's *The Trial*, everything has in fact been mentioned that comprises the aesthetics of reception, all of the elements, in other words, on which this theory is based and built. There is a work of art, a painting, which has a location, in a church, in a side chapel, and on an altar. There is a beholder who wants to see the painting and who takes appropriate steps in order to do so. He is disposed, not only because of the environment that he and the work of art share, but also because of his inner preconditions – as a beholder he has a specific gender, presence, and history. Yet the same conditions

also hold true for the work of art: From the few details supplied, we can conclude that the painting once had, and still also has, other functions than the straightforward desire to be observed in the manner described above. The suggestion of the painting's alternative raison d'être represented by the oil lamp, the "eternal light," is felt to be distinctly unsettling to its recipient. One could argue, then, that the work of art and the beholder come together under mutually imbricated spatial and temporal conditions. Apart, these conditions are not clinically pure and isolatable units. Although their coming together may be ill-starred, a mutual recognition of each other is assured. In the same way that the beholder approaches the work of art, the work of art approaches him, responding to and recognizing the activity of his perception. What he will find first is a contemplating figure on the other side of the divide. This recognition, in other words, is the most felicitous pointer to the most important premise of reception aesthetics: namely, that the function of beholding has already been incorporated into the work itself. The text suggests just how much time could be spent "illuminating" this fact, while an attention, say, to either the work's content or style can no longer retain a comparable attraction. Kafka's parable provides us with a clue to the allure of reception aesthetics: What his archetypal beholder really felt while contemplating the work remains eternally unspoken.

Whenever the consideration of reception has come to the fore in art-historical research, it has usually been in the form of studies devoted to the historical reception of works of art. Reception *history*, however, issues a methodology distinguishable from that employed in reception *aesthetics*. Let us first consider several approaches to the practice of reception history.

Reception Histories/Psychologies

(1) In the history of reception, there is a school of thought that pursues the migration and transformation of artistic formulas through different artistic contexts and historical periods. In its positivist applications, it procures data and establishes earlier influences. It researches the reasons that were decisive in the selection of certain motifs, and it analyzes the differences that inevitably come to exist between the "original" and its later "after-images." Derived from the recognition of how artists work every day, inheriting traditions that they then make their own, Harold Bloom (1973) in the arena of literary studies and, following him, Norman Bryson (1984) in the realm of visual arts each developed the idea of the drama of succeeding generations who labor under "an anxiety of influence." According to this branch of reception history, creative misunderstanding does not simply occur; given specific historical circumstances, it is both a deliberate and a necessary attitude.

(2) In contrast to this work-specific procedure, a different branch of reception history deals with the written (and, in a very restricted way, the oral) reactions of both beholders and users of works of art. Even if purely literary—

historical goals are not foremost (such as in the intellectual history of art criticism, of writings on art, etc.), one could still expect to find in these kinds of studies contributions to a history of taste and insights into the interaction between art production and art criticism in the broadest sense. Although such an approach has often been valued as highly promising (Bal and Bryson 1991: 184–8), it remains problematic because literary testimonials have only a limited value as sources with regard to the reception of visual art, since they are above all beholden to their literary mission and can only be expressed through that genre. Furthermore, there is the added problem that no one will ever be able to construct a comprehensive art-historical method for deciphering reception/historical statements, given that we possess such sources only for a minimal number of works of art, and also because whole art-historical eras remain silent in this respect.

(3) There is one trend in reception theory that would like to be considered as the authentic history of taste. This particular domain of research analyzes the factual reception of works of art by monitoring the art trade, the theft and destruction of art, and the enterprise of collecting. This approach must, however, be understood as only part of a more general program, which has as its main object the institutional forms of art reception. In this wider framework, the history of collecting art is accompanied by histories of collections, of museums, of exhibitions, of galleries, of the art trade, and of the presentation and placing of works of art, as well as by historical studies of the institutionalized behavior exhibited toward works of art.

(4) A further line of demarcation has to be drawn between the aesthetics of reception and the psychology of reception. The latter may study the spectator as its focus, yet it regards the process that occurs between the beholder and the work of art as a physiological or a perceptive one. Along with the aesthetics of reception, perception psychology shares the conviction that the work of art is based upon active completion by its beholder (see Gombrich's "beholder's share," for example) – that is to say that a dialogue occurs between the partners. Psychological studies place this dialogue, however, on the level of a construct created by an exchange between the organ of perception and the form of the work. As a consequence, this kind of approach necessarily entails an ahistorical way of proceeding. To put it more exactly, this approach removes the process of reception from the conditions of reception. It almost goes without saying that the work of art and the situation of reception make many more specific offers to the beholder than would arise through formal articulation. And the beholder, of course, brings more than his or her open eyes to the perception/reception of the work of art.

To be sure, reception aesthetics can benefit from the studies of these neighboring disciplines, and it certainly hopes to be able to contribute its share to them. Cooperation, however, cannot hide the fact that a very fundamental difference in principle exists. Neighboring schools of thought may claim the right to represent the last word in research on actual, individual beholders, not to mention the perceiving public in general. Their interests are aimed at people,

real beholders, be they the artists who appropriate the work of their predecessors, the critics who examine their productions, the collectors who purchase them, or simply the observers whose optical reactions are directed to the work of art. Moreover, the research on beholders is able to study the effect that art institutions have on the aesthetic behavior of the recipients.

Reception Aesthetics

As it is being used here, however, reception aesthetics enacts its interpretive power in a work-oriented fashion. It is on perpetual lookout for the *implicit beholder*, for the function of the beholder prescribed in the work of art. The fact that the work has been created "for somebody" is not a novel insight, proffered by a small branch of art history, but the revelation of a constitutive moment in its creation from its very inception. Each work of art is addressed to someone; it works to solicit its ideal beholder. And in doing so, it divulges two pieces of information, which, considered from a very high standpoint, are, perhaps, identical: In communicating with us, it speaks about its place and its potential effects in society, and it speaks about itself. Therefore the aesthetics of reception has (at least) three tasks: (1) it has to discern the signs and means by which the work establishes contact with us; and it has to read them with regard to (2) their sociohistorical and (3) their actual aesthetic statements. In this context, it is important to point out, as a specific characteristic of communication in the visual arts, that author and recipient do not deal with one another directly, as is the case in the daily occurrence of face-to-face communication. "Author and reader [and beholder] do not know one another, they have only to think of the respective other. In doing so, both carry out an abstraction from the real individuality, as it is present in the factual dialogue" (Link 1976: 12). It should be evident that this work of abstraction is permeated, on both sides, by projections, and that historical and societal ideals about the function and effect of art play a part in it. In this respect, reception aesthetics is prepared to read the appeals and signals that a work of art directs at its beholder.

Today, after a quarter-century of development and testing, reception aesthetics can be viewed as a fully valid apparatus for the study of literature (for general surveys, critical appreciations, and anthologies, see Warning 1975, Link 1976, Iser 1978, Suleiman and Crosman 1980, Reese 1980, Tompkins 1980, Jauss 1982, Holub 1984). Its application to the study of the visual arts, however, seems less assured, although art historians have done some interesting preliminary work in the field. For the most part, the historiography of reception aesthetics in art history will show its use to be erratic. No consistent tradition has been established, only a series of repeated efforts to apply its methodologies. Part of the problem is that reception aesthetics confronts some of the most basic tenets of the bourgeois appreciation of art: those that claim that the work can only be understood by or in itself, by the creative process, or by its producer.

Origins

Of essential historical importance, although not immediately consequential, was the step that Hegel took in his "Lectures on Aesthetics" (published as a book in 1835) by focusing on the relationship between work and beholder as an important factor in his general history of art forms. Whereas eighteenth-century aesthetics had called for the nonrecognition of the beholder as the prerequisite for the most intense effect on the beholder (Fried 1980), Hegel here identifies two modes of being for the work of art, which occur necessarily together, yet in different degrees: These are the existence of the work "for itself" and "for us." Hegel considers their relationships maintained through the historical process, which engenders a "development [of art] for others" in three phases (Hegel 1965, 2: 13ff.). Whereas the "austere style" of the early period remains closed both "to itself" and to its beholder, the "ideal style" of the classical period opens itself "to us" to such an extent that the recognition of our own presence seems like a gift in a moment of abundance, and not at all like an effort to draw us in and entrap us. In the following phase, during the "pleasing style," the "effect on the outer world" becomes purpose and matter in itself. Art no longer lives in and for itself but for its connections to the outer world.

Alois Riegl (1902) followed Hegel's developmental model in his last work on Dutch group portraiture. His large-scale analysis is dedicated not only to the relationship among the depicted subjects but also to the rapport established with the beholder. Riegl's essay must be regarded as the seminal study of reception aesthetics in the field of art history. With regard to architectural analysis, however, August Schmarsow had already led the way. As early as 1893, he had described architecture as a "creator of space" and its "spatial construct" as "living space," as a kind of space which refers to the elemental orientations of human beings and, above all, to their mobility.

After many decades in which stylistic analysis and iconographic studies were the reigning interpretive paradigms in art history, reception aesthetics finally resurfaced in the late sixties (for a methodology, see Kemp 1983). In the meantime, monographic studies have been published that examine the potential of the method for the interpretation of whole eras of art (see Fried 1980, 1990; Stoichita 1993; Shearman 1993; and for an anthology of relevant interpretations, see Kemp 1992).

Contemporary Conceptualizations

In the following section, I will attempt to present the scope of reception aesthetics as it is practiced today: in method, conceptualization, and stages of analysis.

It is not only in the power of works of art that an impression can be made on its beholder. Before the dialogue between work and beholder can even begin to transpire, both are already caught in prearranged interpretive spheres, as we saw in Kafka's parable. We have to distinguish between extrinsic conditions of

access and intrinsic points of reception already in place between the beholder in the church and the beholding knight in the painting. The aesthetic objects are only accessible to both the beholder and the scholar under conditions that are mostly safeguarded by institutions and that, in themselves, require certain patterns of behavior on the part of the recipient. Extrinsic conditions of access comprise, for example, the architectural surround and the corresponding ritual behavior expected by the religious cult, the court, or the bourgeois institutions of art. The task of restoring the work of art to its original environment and its context of comprehension is taken very seriously by reception aesthetics (for case studies, see Kemp 1986, 1994). And it is just as important to discover the processes that can provoke a change in context, that is, not to evaluate the work of art one-sidedly under the conditions of just its first and latest appearance, but to follow work and context throughout the history that they have mutually created. As part of this much more general movement in the humanities – what might be called contextualism – reception aesthetics seeks to revive a sensitivity for relationships among phenomena, to train, above all, other senses, especially the "sense for relationship" (Nietzsche).

The institutions, academic studies, and modern techniques of reproduction in modern art have often formed an unholy alliance, one whose intention is to present their objects as unrelated monads – ubiquitous, homeless, displaced – as aestheticians of the twenties and thirties (Valéry, Benjamin, Heidegger) already realized with some alarm (Wright 1984). The fact that many works of art in modern times were destined neither for a concrete location nor a specific addressee does not suggest, however, that analyses undertaken in the aesthetics of reception are without objects. The consideration of a more open reception situation can have as informative an effect on arriving at an interpretation as the information that derives from context-dependent studies. In a classic study, Brian O'Doherty, for example, has shown what tremendous power of definition is ascribed to the "white cube," the gallery space which supposedly recedes to the neutral background in order to let the works of art be effective "by themselves"; the same space which in reality has "created" modern art, which was the condition of its possibility, and which, unlike any other institution, has influenced the appearance and reception of modern art even down to its details (O'Doherty 1986). And as far as the works of art that have lost their original destination and appear in new contexts are concerned, it can be stated in a generalized way that the new availability will not succeed in severing completely the old relationships. Two hundred years of the history of art may have removed the work's ambience – may have severed it from its original forms of presentation and therefore may actually have established it as an art object, after all – yet it will in any case continue to show fossilized remnants of its context markers that position it and the beholder anew. As a historical method of investigation, reception aesthetics is obliged to reconstruct the original reception situation. In this way it can reverse the processes that had colluded to exclude this approach in general from the history of art appreciation and that also, in a parallel development, had isolated the works of art.

To return to the beginning: What we call *conditions of access* on the part of the beholder and institutions could be called *conditions of its appearance* on the part of the work of art. Both are conventional. The work reacts to its spatial and functional context through the means of its medium, through its size, its form, its shaping of the interface or the border between the "outside" and the "inside," its inner scale, the degree of its finish, and its spatial disposition (i.e., the manner in which it either continues or negates the outer space and positions its beholder). All these mechanisms of transmission and mediation are part of firmly established conventions or result from practical necessities and cannot, or only rarely, be understood as a particular achievement of either a work of art or an artist. Of course the case in which changes of communicative structures occur should be taken very seriously: It could indicate paradigmatic changes in the history of reception, for example. The particular task of interpreting a work of art according to reception aesthetics starts at the point of intersection between "context" and "text": at the point, that is, where the inner workings of the work of art initiate a dialogue both with its surroundings and its beholders.

I have already pointed out that the work of art, contrary to face-to-face communication, produces asymmetrical communication. This conclusion is a relative one, because the theory of communication does not recognize total asymmetry: It must always posit an opposite partner, must always take into account a common frame of reference. In the case of aesthetic communication, relative asymmetry proves to be the impetus for not only situating the beholder – by way of exterior arrangements as described above – but also for stimulating, for activating the beholder to take part in the construction of the work of art. This activation occurs by working through the way by which the beholder becomes part of the intrapainting communication; more precisely, through the way in which he or she takes part in the communication with which he or she can only be associated as a beholder, not as an actor. The *inner communication*, which we might call representation, composition, or action, consists of "people who give each other signs . . . , things which are signs . . . , events which, in themselves, already are communication or are at least accompanied by communication or which, on the other hand, are the object of communication that is created by the people in the painting" (Bitomsky 1972: 30). In contrast to most kinds of everyday communication, the essential characteristic of aesthetic communication is that its inner exchange takes place under the eyes of the beholders. "Within the medium certain forms have been inserted which organize the perception of the beholders, i.e., the way in which they look at inner communication. Inner communication is *presented* and, in fact, presented in such a way that it not only signifies that which it would signify for the participating actors of inner communication without any beholder, but that it has a supplementary meaning which results directly from the fact that beholders are present" (ibid., p. 105). The opening and presentation of inner communication are achieved by means of a structuring that, depending on whether they address the beholder directly or whether they are conceived for a broader reaction, can be called

precepts of reception or *offers of reception*. The term that is really appropriate in this case, however, is *implicit beholder*: the beholder who is intended by these *inner orientations* and becomes the addressee of the work of art.

Forms of Address

(1) First of all, one has to study the way in which things and persons of the intrapainting communication establish relations with one another while at the same time including or (seemingly) excluding the beholder. This process is called *diegesis* (from the Greek, meaning a wide-ranging discussion). Diegesis explains the distribution of the actors on the canvas and/or in the perspective space, the position that they take toward one another and toward the beholder, their gestures and visual contacts. In short the deictic arrangement of the work of art refers to its modes of manifesting communication and orienting its principal communicators.

(2) Many works contain figures who are, more or less, removed from the context of the internal action or communication and who have been thrown onto the side of the beholder (think of Kafka's knight, for example). They become vehicles of identification, figurations of the beholder in the painting, representatives of a *personal perspective*. In narratological terminology, they are the focalizers who can address the beholder directly, as figures that look at him or her, that point to him or her as well as to something else. But they can also proceed more cautiously and guide him or her toward an event, offer him or her their own view, admit him or her into their own ranks. As a third possibility, they can be taken out of the representational context and yet cannot be attributed directly to the beholder: As figures of reflection or diversion, they accomplish more than just pointing or guiding.

(3) The classic means of positioning the beholder is undoubtedly through the use of perspective in all of its manifestations. It is because of perspective – or the spatial composition of the painting in general – that the beholder is situated in relation to the painting, brought into position; a fact that could still be attributed to the demands of the exterior orientation. But perspective achieves more than connecting the space of the beholder with the space of the painting. In the end, it also regulates the position of the recipient with regard to the inner communication; that is to say, the presentation of the painting with its demands on how it should be viewed.

After Riegl's pioneering studies on the Dutch group portrait (1902), it was above all film analysis, without acknowledging Riegl's model, that developed a complex method based on the three aforementioned structural elements, in order to find out about the structure of the inner film world, about the position of the beholder in relation to it, and about the processes of the construction of subjectivity and gender roles (Heath 1981; Burgin 1982; Mulvey in Penley 1986: 57–68). The application of this methodological apparatus very quickly

reaches its limits in art history, because art (except for a relatively short time in the nineteenth century) prefers ideal positions of the beholder to positions of actual individuals and, unlike film, does not build its pictorial worlds from a tightly intermeshed succession of pictures of viewing and pictures of the viewed. This method bears fruit only if it establishes the historical forms of communication of a painting both as a view and as a staged view structure; that is, as both extra- and intradiegetic conditions of view.

(4) The behavior of the beholder is also decisively stimulated by the way in which the artistic scene or action is depicted, in its cropping, its details, its fragments. It is only since the fifteenth century that the painting conceived as a fragment has existed, and only since the seventeenth century has the intensification of this effect as a radical cutting into a presumed preexistent reality been the concern of painters. However, that which was practiced as a valid alternative before the fifteenth century, and, in fact, long after it – namely, the construction of the elements to form the painting – proves to be equally relevant in this context. One could take the view that the intended completeness of the constructed image does not ask for the supplementing of the nonvisible by its spectator. Though completing the incompleted might be one way of beholding a painting, it remains the case that every artistic activity entails drawing a border and defining itself by what it has excluded. If the selection of the painted "fragment" is recognized as an intersubjective strategy, then so too must be the classification of the realm of the visible according to categories such as exposition versus obstruction, accessibility versus inaccessibility. This process depends on whether objects are demonstrably revealed to or hidden from their beholder, whether they let themselves be observed or deliberately elude visibility, just like everything that exists outside the boundaries of the painting (Fontanille 1989).

(5) As the last item of this summary on forms of address, we need to identify the most difficult and, by definition, most intangible category, which can also interact in various ways with the previous four. Literary theory refers to the *blank* or the aesthetics of *indeterminacy*, both conceptualizations meaning that works of art are unfinished in themselves in order to be finished by the beholder (Ingarden 1965, Iser 1978, Kemp 1985). This state of unfinishedness or indeterminacy is constructed and intentional. But it does mean that as spectators we must complete the invisible reverse side of each represented figure, or that we mentally continue a path that is cut off by the frame. In this way, everyday perception is no different from aesthetic perception. The work of art lays a claim to coherence, though, and this impulse turns its "blanks" into important links or causes for constituting meaning. With regard to texts, but also in a process easily applicable to paintings, this means that the blanks "are the unseen joints of the text, and as they mark off schemata and textual perspectives from one another, they simultaneously trigger acts of ideation on the reader's part. Consequently, when the schemata and perspectives have been linked together, the blanks 'disappear.' " Blanks can be regarded as "an elementary matrix for the interaction between text and reader" (Iser 1978: 182–3).

An Analysis: Nicolaes Maes's *The Eavesdropper*

Consider a curious drawing that has been recognized for a long time as the work of Nicolaes Maes (1632–93)[2] (Fig. 28). The scene is sparse: a curtain, which takes up the entire right half, and, set in an interior, an apparently female figure who is oriented toward the right-hand side, toward what is hidden from view behind the curtain. It might be surprising that this drawing, with its minimal repertoire of motifs, served as a preliminary sketch for a painting. The painting itself (45.7 × 71.1 cm), which is signed and dated 1655, simplifies matters for the beholder (Fig. 29).[3] The female figure turns out to be the maid, who, coming up from the basement, is pausing, obscured by the newel post. She is obviously eavesdropping on the events which are unfolding in the background, in another room of the house. An extended excursion into iconography and social history could confirm this interpretation and elaborate on it. Maes produced a dozen paintings on the theme of the eavesdropper.[4] This was his most successful motif in the field of genre painting; in each case the composition was only slightly varied. In terms of both the composition and of reception aesthetics, the figure of the eavesdropper is crucial. Given that she is encoded in multiple ways, the woman clearly belongs to the category of the persona of the beholder, of the personal perspective. She becomes the focus of events by establishing direct eye contact with us from inside the painting. By smiling mischievously and using a gesture that imposes silence, she gives us to understand that we are supposed to behave likewise. Here, the construction of the beholder's presence brings about the extreme possibility of direct interaction. Whether the direct address to the beholder is achieved or not, however, is regulated by artistic conventions which (in a way that remains to be researched) are certainly connected with general norms of behavior.

Present as beholders, we are asked by the eavesdropper to become voyeurs. Such a transformation is suited to the medium. We see and do not hear what the eavesdropper hears but cannot see, and we are only seen by her, our accomplice, but not by the others in the painting. In this way the personified sender, that is, the eavesdropper, is supposed to trigger in the beholder two simultaneous reactions: a particular way of behaving and the shift to visuality. It thus becomes apparent what happens when part of the inner communication functions as a precept of reception. One might almost think that the woman would have to give up her eavesdropping because she is so preoccupied with us. This double role has its price, and here lies the critical point of forced relationships between the painting and its beholder.

It is the eavesdropper's task to make us participate in a communication of which neither she nor we are a part. That is what gives the painting such an exemplary character. If affirms the proposition that is true for the painting as such, and it stresses at the same time what matters with regard to the difference between the beheld painting (aesthetic perception) and the everyday event that was eavesdropped on or secretly observed (voyeuristic behavior). As already emphasized, the interior communication in the painting is "presented,

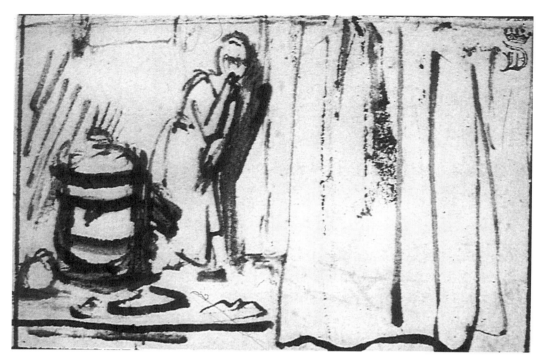

Figure 28. *Nicolaes Maes,* The Eavesdropper *(drawing). Pen and ink on paper. Fogg Art Museum, Harvard University. Photo from W. Sumowski,* Drawings of the Rembrandt School *(New York, 1984).*

and, in fact, presented in such a way that it not only signifies that which it would signify for the participating actors of inner communication without any beholder, but that it has a supplementary meaning which results directly from the fact that beholders are present" (Bitomsky 1972: 105). In the voyeuristic situation, the contrary holds true: Here the situation's supplementary meaning for the voyeur results from the fact that the participating actors are not aware of his or her presence. Therefore, the re-creation of the voyeuristic situation in the painting is not possible; it is only possible to represent it, and it is this very difference that gives Maes's painting its name. The eavesdropper is seen by us and, what is more, challenges our perception, a fact that in itself would basically change or diminish her status. In any event, her "supplementary meaning" results from the fact that she sees us and is seen by us: That is to say, there exists a perceptual aesthetic exchange. Furthermore, it is logically consistent that a painting of this kind is called *The Eavesdropper* and not "The Couple that Is Eavesdropped Upon" or something similar, because what is represented above all is the act of eavesdropping itself, and not the interaction which is both eavesdropped upon and observed. Among all the variants that Maes devoted to this topic, the two discussed here speak most plainly in this respect. What is it, after all, that is presented by the eavesdropper in a manner so pregnant with

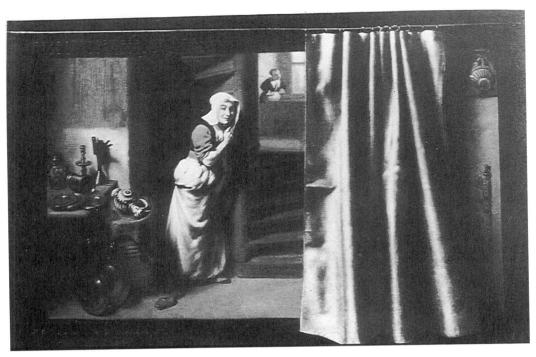

Figure 29. *Nicolaes Maes,* The Eavesdropper, *1655. 17¹³/₁₆″ × 15¹¹/₁₆″ (45.7 × 71.1 cm). Collection of Harold Samuel, London.*

significance? In the drawing, there is nothing – nothing that we can see. In the painting, there is little – in both cases the curtain hangs in front of the events.

The fact that this curtain, illusionistically drawn, hangs *in front of* the painting gives us an indication that we are, for the moment, supposed to ascribe it to the outer and not the inner apparatus of the work of art. Its treatment leads us to the conditions where we ought to have started, namely, the conditions of access and appearance. We are confronted with a panel whose function was to decorate the walls of a residence or of a collection. Representations of curtains (or, more generally speaking, veils) in works of art are as old as the tradition of painting itself.[5] Religious art draws its effect from the dialectic of unveiling and concealing; it deals in cult images hidden in the most holy places – behind curtains, or in shrines or folding altars whose interiors are opened only on high feast days. The first secular art collectors must simply have taken over the custom of veiling: Perhaps they also feared the dangerous luster of the new secular art. During the compilation of an inventory of many hundreds of paintings belonging to Margaret of Austria, who was one of the first art collectors in the North, few were found that were "without veil or cover" (*sans couverte ne feuillet*), as the register from approximately 1530 proclaimed.[6] When the secular use of paintings and collecting secular art became widespread, the only means of assuring a painting's survival was to cover it with a curtain. This practice was internationally customary: We find it as far afield as Rome and

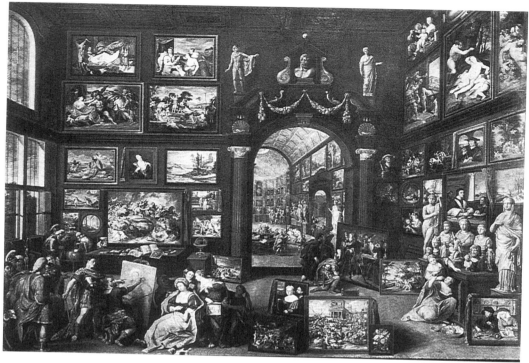

Figure 30. *Willem van Haecht,* The Studio of Apelles, *1628. Oil on canvas. Rubens House, Antwerp. Photo courtesy of the museum.*

Antwerp. Seventeenth-century paintings of collections show that there were always some painted works of art that were fitted with such curtains, for reasons of both protection and increasing their aesthetic allure[7] (Figs. 30, 31).

The first illusionistically painted picture curtain appears in 1644 in a small painting of the Holy Family by Rembrandt, a work of art that was copied several times by Maes.[8] From that date on, illusionistically painted picture curtains and frames became ever more numerous for the next two or three decades; both are found in Maes's oeuvre. Thus the painted picture curtain quotes a then-common requisite of art collecting: This alone, however, does not tell the whole story. Owing to the very fact that it is painted, the curtain multiplies, so to speak, the context markers of the work of art. It not only draws the painting into the collection, but also the collection into the painting. The painted curtain transforms the work into a piece of art, an act which represented, perhaps not in our eyes but undoubtedly in the eyes of its first owners and beholders, an enormous increase in value, and which really elevated the painting to its proper place and to the level of debate within the whole of the art collection. Deception, subterfuge, optical illusion, and surprise were essential qualities of items in a collection: artistic chairs that, once the unsuspecting user had sat down, did not release him or her; goblets that, once filled to the brim, let escape

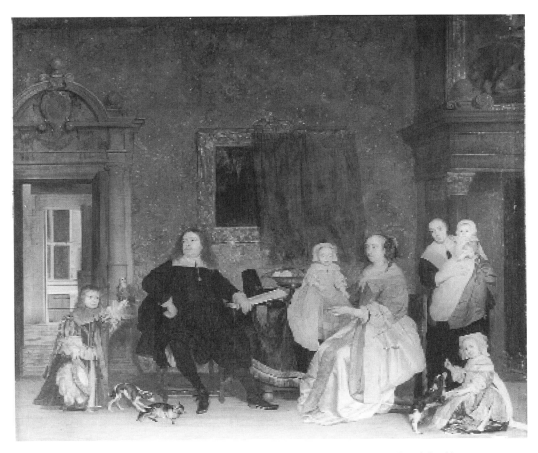

Figure 31. *Gabriel Metsu,* The Geelvinck Family, *ca. 1650. Oil on canvas. Staatliche Museen, Gemäldegalerie, Berlin. Photo courtesy of Bildarchiv Foto, Marburg.*

lewd substances or retained their contents in a strange way; paintings that conveyed the impression that they were drawn by human hands and were yet found in split rocks or felled trees; still lifes that made their objects palpable and yet were only painted. Their intended effect was not really the illusion but the disillusion, the disillusionment of the beholder. Such deceits brought about surprise, even laughter, but, above all, brought about discussion and argumentation about the numerous modes of reality between appearing and being.

I emphasize this kind of playfulness in order to characterize a historical type of beholder who was not conceived for contemplation, but for dialogue: a beholder conceived for a pleasant exchange between people of his or her own kind and the work of art, a beholder who could also be addressed by the painting in a direct manner. Just consider all of the multilayered aspects of the painted curtain: The painting produces its context as a marker (the work of art has to contribute to the creation of exterior provisions) and as a level of articulation and function (the painting as easel painting and therefore collectible); it

confirms the context by quoting it and thus attracting particular attention (competition among the many paintings on the walls of the collection); and it occupies and/or activates the beholder (illusion, disillusion).

Maes adds yet another function, and again, in doing so, he singles out that decisive point that marks the difference between aesthetic and nonaesthetic perception. He uses the external means of reception, that is, the curtain, in artistic recreation, in order to continue the argumentation (which is at least just as artistic) that has started between the beholder and the events in the painting. This means that he draws the external means to the inside. In terms of developmental history, this is not without importance: The context marker of the painted curtain is really only a shrunken version of the conditions of access, a small memory of all that once was part of the richness of the aesthetic "periphery." Now, demonstrably, this remnant is also made functional for the "center." In the drawing, the curtain blocks everything that would have been there to see or to hear – a great, bold blank. We must add (almost) everything. Not so in the painting. Here, in the sense of the above-mentioned terminology of Wolfgang Iser, the connectability of segments, of determinate and indeterminate elements, is prepared. Here the curtain has been drawn back to such an extent that half of the eavesdropped conversation becomes visible: A woman who stands behind a table and who, judging from the position of her ams, which she has on her hips, and her head, which she holds at an angle, reproaches a person opposite her. If now, as a result of the eavesdropper's invitation, we became active ourselves in the right half of the painting and lifted the curtain or tried to look behind it in our thoughts, the blank would close and we would really become the eavesdropper's accomplices. That this is not possible, or is possible "only in thought" – that by the art's grace we have "only" the painting – is made obvious by the curtain, which, as an everyday instrument of veiling and unveiling, yet belongs wholly and doubly to art by being part of the matter of the painting and, also as the painted curtain, its sign.

Notes

This chapter was translated by Astrid Heyer (University of Western Ontario) and Michael Ann Holly (University of Rochester).

1 Franz Kafka, *The Trial* (definitive ed.), trans. from the German by Willa and Edwin Muir, rev., with additional chapters and notes by Professor E. M. Butler (London: Secker and Warburg, 1963), p. 229.

2 See most recently W. Sumowski, *Drawings of the Rembrandt School* (New York, 1984), vol. 8, p. 3984.

3 Auctioned off on June 23, 1967, at Christie's, London, to Eduard Speelman Ltd., London. Now Collection of Harold Samuel, London.

4 Cf. *Beschreibendes und Kritisches Verzeichnis der Werke der hervorragendsten holländischen Maler des 17. Jahrhunderts*, ed. C. Hofstede de Groot, Esslingen, 1915, vol. 6, pp. 520ff. (incomplete list); Rijksmuseum, Amsterdam, *Tot lering en vermaak*, exhibition catalog (Amsterdam, 1976), pp. 145ff.; W. R. Robinson, "*The Eavesdroppers* and Related Paintings by Nicolaes Maes," in *Holländische Genremalerei des 17. Jahrhunderts* (Berlin: Staatliche Museen, 1987), pp. 283–313; Stoichita 1993: 76–8; Martha Hollander, "The Divided Household of Nicolaes Maes," *Word and Image* 10 (1994): 138–55.

5 For painted picture curtains, see P. Reutersward, "Tavelförhanget," *Kunsthistorisk Tidskrift* 25 (1956): 97ff.; Musée des Beaux-Arts, *La peinture dans la peinture*, exhibition catalogue (Dijon, 1983), pp. 271ff.; W. Kemp, *Rembrandt: Die heilige Familie oder die Kunst, einen Vorhang zu Lüften* (Frankfurt-on-Main: Fischer, 1986).

6 J. Veth and S. Müller, *Albrecht Dürers niederländische Reise* (Berlin, 1918), vol. 2, p. 83. Cf. the publication of the inventories in *Jahrbuch der Kunstsammlungen des Allerhöchsten Kaiserhauses* 3 (1885), pp. xciii ff.

7 Cf. the reproduction material in S. Speth-Holterhoff, *Les peintres flamands de cabinets d'amateurs au XVIIe siècle* (Brussels, 1957).

8 Kemp, *Rembrandt: Die heilige Familie oder die Kunst, einen Vorhang zu Lüften*.

References

Bal, Mieke, and Norman Bryson. 1991. "Semiotics and Art History," *Art Bulletin* 73: 174–208.

Bitomsky, Hartmut. 1972. *Die Röte des Rots von Technicolor, Kinorealität und Produktionswirklichkeit*. Neuwied-Darmstadt: Luchterhand.

Bloom, Harold. 1973. *The Anxiety of Influence: A Theory of Poetry*. New York: Oxford University Press.

Bryson, Norman. 1984. *Tradition and Desire: From David to Delacroix*. Cambridge: Cambridge University Press.

Burgin, Victor. 1982. *Thinking Photography*. Basingstoke: Macmillan.

Fontanille, Jacques. 1989. *Les espaces subjectifs: introduction à la sémiotique de l'observateur*. Paris: Hachette.

Fried, Michael. 1980. *Absorption and Theatricality: Painting and Beholder in the Age of Diderot*. Berkeley and Los Angeles: University of California Press.

1990. *Courbet's Realism*. Chicago: University of Chicago Press.

Gandelman, Claude. 1991. *Reading Pictures/Viewing Texts*. Bloomington: Indiana University Press.

Heath, Stephen. 1981. *Questions of Cinema*. Basingstoke: Macmillan.

Hegel, Georg Friedrich Wilhelm. 1965. *Aesthetik*, ed. Friedrich Bassenge. 2 vols. Berlin.

Holub, Robert C. 1984. *Reception Theory: A Critical Introduction*. London: Methuen.

Ingarden, Roman. 1965. *Das literarische Kunstwerk*. Tübingen: Niemeyer.

Iser, Wolfgang. 1978. *The Act of Reading: A Theory of Aesthetic Response*. Baltimore: Johns Hopkins University Press.

Jauss, Hans Robert. 1982. *Towards an Aesthetic of Reception*. Minneapolis: University of Minnesota Press.

Kemp, Wolfgang. 1983. *Der Anteil des Betrachters: Rezeptionsästhetische Studien zur Malerei des 19. Jahrhunderts*. Munich: Mäander.

1985. "Death at Work: On Constitutive Blanks in 19th Century Painting," *Representations* 10: 102–23.

1986. "Masaccios *Trinität* im Kontext," *Marburger Jahrbuch für Kunstwissenschaft* 21: 45–72.

1992. *Der Betrachter ist im Bild: Kunstwissenschaft und Rezeptionsästhetik*. 2nd ed. Berlin: Reimer.

1994. "The Theater of Revolution: A New Interpretation of Jacques-Louis David's *Tennis Court Oath*." In Norman Bryson, Michael Ann Holly, and Keith Moxey (eds.), *Visual Culture: Images and Interpretations*, pp. 202–27. Hanover, N. H.: Wesleyan University Press/New England University Press.

Link, Hannelore. 1976. *Rezeptionsforschung*. Stuttgart: Kohlhammer.

O'Doherty, Brian. 1986. *Inside the White Cube: The Ideology of the Gallery Space*. Santa Monica: Lapis.

Penley, Constance. (ed.). 1986. *Feminism and Film Theory*. New York and London: Routledge/BFI Publishing.

Reese, Walter. 1980. *Literarische Rezeption*. Stuttgart: Metzler.

Riegl, Alois. 1902. "Das holländische Gruppenporträt," *Jahrbuch der Kunstsammlungen des Allerhöchsten Kaiserhauses* 23: 71ff.

Schmarsow, August. 1893. "Das Wesen der architektonischen Schöpfung" (1893), in *Empathy, Form, and Space. Problems in German Aesthetics*, 1873–1893, Santa Monica 1994, pp. 281–98.

Shearman, John. 1993. *Only Connect . . . : Art and the Spectator in the Italian Renaissance*. The A. W. Mellon, Lectures in the Fine Arts, 1988; Bollingen Series XXXV, 37. Washington, D.C. and Princeton: National Gallery of Art/Princeton University Press.

Stoichita, Victor. 1993. *L'instauration du tableau*. Paris: Méridiens Klincksieck.

Suleiman, Susan R., and Inge Crosman (eds.). 1980. *The Reader in the Text*. Princeton: Princeton University Press.

Tompkins, Jane P. (ed.). 1980. *Reader-Response Criticism: From Formalism to Post-Structuralism*. Baltimore: Johns Hopkins University Press.

Warning, Rainer (ed.). 1975. *Rezeptionsästhetik*. Munich: Fink.

Wright, Kathleen. 1984. "The Place of the Work of Art in the Age of Technology," *Southern Journal of Philosophy* 22: 565–82.

Between Art History and Psychoanalysis

I/Eye-ing Monet with Freud and Lacan

Steven Z. Levine

I N *Five Lectures on Psychoanalysis* delivered on the occasion of the award-ing of an honorary degree at Clark University in Worcester, Massachusetts, in 1909, Freud summarized the lesson of his teaching for an educated American audience, the same sort of audience that I imagine to be reading my recontextualization of his words today. To Jung, at the time his close colleague and travel companion, Freud reportedly said that the Americans didn't realize that he was bringing them the plague.[1] Perhaps so; but if psychoanalysis is a plague it is increasingly apparent in our anxious millennial moment how deeply resistant to it American protocols of common sense and self-help have turned out to be. Hence this essay addressed to today's readers and writers of art his-tory on the still unacknowledged lesson of the indwelling disruptiveness of the unconscious that psychoanalysis would teach us were we willing to listen. Here, then, is Freud on art, suffering, and substitutive satisfaction in 1909:

> Ladies and Gentlemen, – . . . The deeper you penetrate into the pathogenesis of nervous illness, the more you will find revealed the connection between the neuroses and other productions of the human mind, including the most valuable. You will be taught that we humans, with the high standards of our civilization and under the pressure of our internal repressions, find reality unsatisfying quite generally, and for that reason entertain a life of phantasy in which we like to make up for the insufficiencies of reality by the production of wish-fulfilments. . . . The energetic and successful man [Freud never adds "or woman," though we must] is one who succeeds by his efforts in turning his wishful phantasies into reality. Where this fails, as a result of the resistances of the external world and of the subject's own weakness, he begins to turn away from reality and withdraws into his more satisfying world of phantasy, the content of which is transformed into symp-toms should he fall ill. . . . If a person who is at loggerheads with reality

possesses an *artistic gift* (a thing that is still a psychological mystery to us), he can transform his phantasies into artistic creations instead of into symptoms.

However mysterious it may be in its individual derivation, the work of art is not a neurotic symptom, not a regressive revival of unavowable or unrealizable infantile libidinal wishes, but, like the symptom, the work of art transforms the reality of dissatisfaction into a fantasy of satisfaction. Unlike the hysteric's or obsessional's private fantasy in which the transformational medium is the individual's mind and body, the artist's fantasy is materially embodied in a public medium: "In this manner he can escape the doom of neurosis and by this roundabout path regain his contact with reality."[2]

Freud's most extensive attempt to apply the model of compensatory fantasy to the work of art is found in *Leonardo da Vinci and a Memory of His Childhood* (1910), but given "the uncertainty and fragmentary nature of the material which tradition makes available," Freud acknowledges that he may "have merely written a psychoanalytic novel."[3] At the heart of Freud's controversial narrative reconstruction of Leonardo's career is the artist's recorded memory of a bird's tail being beaten about in his mouth when he was an infant.[4] Freud interprets this utterance not as an actual memory of the artist's but as an adult fantasy transposed to his childhood which at once conceals "a reminiscence of sucking – or being suckled – at his mother's breast" and also expresses an unconscious wish for "an act of *fellatio*, a sexual act in which the penis is put into the mouth of the person involved." For Freud the inferred link between the lost pleasure of nursing and Leonardo's unavowable passive homosexual desire is forged along the newly described path of narcissism: "The boy represses his love for his mother: he puts himself in her place, identifies himself with her, and takes his own person as a model in whose likeness he chooses the new objects of his love . . . boys whom he loves in the way in which his mother loved *him* when he was a child." For Freud, the results of these wishful transformations are there to be seen in the maternal and boyish smiles of the Mona Lisa, the Virgin Mary, John the Baptist, Bacchus, and Saint Anne: "It is possible that in these figures Leonardo has denied the unhappiness of his erotic life and has triumphed over it in his art, by representing the wishes of the boy, infatuated with his mother, as fulfilled in this blissful union of the male and female natures." As structures that substitute for unattainable desires, works of art mobilize the unconscious mechanisms of repression and sublimation whereby a private history of loss is turned into a public form of bliss. As for Leonardo's "quite special tendency towards instinctual repressions, and his extraordinary capacity for sublimating the primitive instincts," Freud acknowledges that "the nature of the artistic function is also inaccessible to us along psychoanalytic lines."[5]

In "Formulations on the Two Principles of Mental Functioning" (1911), Freud describes the situation of the artist as a "peculiar" sort of reconciliation between the unfettered pursuit of pleasure and the resigned acceptance of reality's constraints:

An artist is originally a man who turns away from reality because he cannot come to terms with the renunciation of instinctual satisfaction which it first demands, and who allows his erotic and ambitious wishes full play in the life of phantasy. He finds the way back to reality, however, from this world of phantasy by making use of special gifts to mould his phantasies into truths of a new kind, which are valued by men as precious reflections of reality. Thus in a certain fashion he actually becomes the hero, the king, the creator, or the favourite he desired to be, without following the long roundabout path of making real alterations in the external world. But he can only achieve this because other men feel the same dissatisfaction as he does with the renunciation demanded by reality, and because that dissatisfaction, which results from the replacement of the pleasure principle by the reality principle, is itself part of reality.[6]

According to the tragic terms of Freud's philosophical anthropology, we all live the same lifelong drama of renunciation and reconciliation, of dissatisfied ambition and deferred attainment, of unrequited desire and substitutive satisfaction, of turning away from reality and returning to it. As a result of this daily struggle, some of us, most of us, all of us will at times succumb to neurosis, but in *Totem and Taboo* (1912–13) the work of art is said to offer the artist a unique consolation: "Only in art does it still happen that a man who is consumed by desires performs something resembling the accomplishment of those desires and that what he does in play produces emotional effects – thanks to artistic illusion – just as though it were something real."[7]

Not only does the artist gain surcease in the work from the frustrations of desire, but so may we. In "The Claims of Psycho-Analysis to Scientific Interest" (1913), art is said to be "an activity intended to allay ungratified wishes – in the first place in the creative artist himself and subsequently in his audience or spectators." It may be that the artist "represents his most personal wishful phantasies as fulfilled," but, crucially, "they only become a work of art when they have undergone a transformation which softens what is offensive in them, conceals their personal origin and, by obeying the laws of beauty, bribes other people with a bonus of pleasure." The frustrated pleasure-seeking impulse of Freud's compensatory theory is now accompanied by a greater emphasis on the disciplined elaboration of the work. Art is now seen as "a conventionally accepted reality in which, thanks to artistic illusion, symbols and substitutes are able to provoke real emotions. Thus art constitutes a region halfway between a reality which frustrates wishes and the wish-fulfilling world of the imagination – a region in which, as it were, primitive man's strivings for omnipotence are still in full force."[8]

Freud's insistence on the semiotics of law, convention, and symbol marks an important difference from his earlier dialectic of frustration and fulfillment in the work of art. The constraints of reality are now seen not only as impediments to desire but as the necessary matrix for its realization, and the so-called weakness of the neurotic is replaced by the skill of the artist. Freud's most notable

analysis of just such a work of law, convention, and symbol is contained in "The Moses of Michelangelo," which he published anonymously in 1914.

In his essay on Leonardo, Freud endeavors to reconstruct – as though in a psychoanalytic novel – the inner fantasy that motivates the artist's work. This reconstruction of intention also plays a large part in the paper on the sculpture Michelangelo made for the tomb of Pope Julius II, but now Freud pays much more attention to what there is to be seen in the work, though not without a salutary expression of methodological doubt: "What if we have taken too serious and profound a view of details which were nothing to the artist, details which he had introduced quite arbitrarily or for some purely formal reasons with no hidden intention behind? What if we have shared the fate of so many interpreters who have thought to see quite clearly things which the artist did not intend either consciously or unconsciously? I cannot tell."[9]

In spite of these three momentous words, Freud does hazard an interpretation of the statue based on the relative positions of Moses' beard, his right hand, and the Tables of the Law. Unlike the art historians whom he extensively quotes, Freud does not see Moses as about to leap up and break the Tables of the Law in his rage at the idol-worshiping Israelites before him, nor does he see Moses as sitting there immutably as a timeless study in character: "What we see before us is not the inception of a violent action but the remains of a movement that has already taken place. In his first transport of fury, Moses desired to act, to spring up and take vengeance and forget the Tables; but he has overcome the temptation and he will now remain seated and still in his frozen wrath and in his pain mingled with contempt." Moving beyond the notion of art as a substitutive satisfaction for the frustrated erotic or ambitious wishes of the artist, Freud now insists on a new self-regulating motive in the work. Not only is this Moses "a concrete expression of the highest mental achievement that is possible in a man, that of struggling successfully against an inward passion for the sake of a cause to which he had devoted himself," this Moses is an unconscious expression of Michelangelo as well: "And so he carved his Moses on the Pope's tomb, not without a reproach against the dead pontiff, as a warning to himself, thus, in self-criticism, rising superior to his own nature."[10]

The constitutive role of self-directed and other-directed aggression in art is not much more than a hint in Freud at this time, but in 1920, in *Beyond the Pleasure Principle*, he recognizes in children's play and in "the artistic play and artistic imitation carried out by adults" a principle of repetition, even a compulsion to repeat, that joins to the pursuit of pleasure the instantiation of pain. Experienced inwardly as in mourning and melancholia, this principle beyond pleasure is the self-annihilation of the death drive; projected outward, it is manifest as aggression, as in works of art that "do not spare the spectators (for instance, in tragedy) the most painful experiences and can yet be felt by them as highly enjoyable."[11] The deliciously disruptive Schadenfreude of Surrealism and Postmodernism is not too far away.

In *Introductory Lectures on Psychoanalysis* (1917), Freud restates his theory of art as the work of nonneurotic, wish-fulfilling fantasy:

An artist is once more in rudiments an introvert [a term introduced by Jung], not far removed from neurosis. He is oppressed by excessively powerful instinctual needs. He desires to win honour, power, wealth, fame and the love of women; but he lacks the means for achieving these satisfactions. Consequently, like any unsatisfied man, he turns away from reality and transfers all his interest, and his libido too, to the wishful constructions of his life of phantasy, whence the path might lead to neurosis.

Like the analysand, the artist is said to engage in an act of transference whereby repressed wishes and affects are redirected from their lost and unavailing contexts of childhood and adulthood into the more amenable context of artistic construction. Freud calls this capacity of affectual redirection sublimation; and through its rather mysterious workings the artist, unlike the neurotic daydreamer, "finds a path back to reality":

A man who is a true artist has more at his disposal. In the first place, he understands how to work over his daydreams in such a way as to make them lose what is too personal about them and repels strangers, and to make it possible for others to share in the enjoyment of them. He understands, too, how to tone them down so that they do not easily betray their origin from proscribed sources. Furthermore, he possesses the mysterious power of shaping some particular material until it has become a faithful image of his phantasy; and he knows, moreover, how to link so large a yield of pleasure to his representation of his unconscious phantasy that, for the time being at least, repressions are outweighed and lifted by it.

Recalling his important clinical paper "Remembering, Repeating and Working-Through" (1914), Freud insists on the formal elaboration of the work that not only recontextualizes the repressed wishes of the artist but also gives aesthetic pleasure to the artist's spectators as well: "If he is able to accomplish all this, he makes it possible for other people once more to derive consolation and alleviation from their own sources of pleasure in their unconscious which have become inaccessible to them; he earns their gratitude and admiration and he has thus achieved *through* his phantasy what originally he had achieved only in his phantasy – honour, power and the love of women."[12] Freud's redundant reiteration of the male artist's narcissistic goals may suggest that it is also his own fantasy that is at stake in the production of psychoanalysis as a work of art; moreover, in this imaginary scenario of artistic and erotic power and adulation there may be more than a tinge of defensive denial of the very real and quite common eventuality of failing to secure the public's complicity in the disguised discharge of the private fantasy of the analyst/artist hero.

In *An Autobiographical Study* (1925), Freud acknowledges that the analysis of the work of art offered him an important occasion to extend the purview of psychoanalysis from the narrowly clinical to the broadly cultural field, but he insists on the differential deployment of the forces of repression and sublimation in neurotic production and artistic work:

The artist, like the neurotic, had withdrawn from an unsatisfying reality into this world of imagination; but unlike the neurotic, he knew how to find a way back from it and once more to get a firm foothold in reality. His creations, works of art, were the imaginary gratifications of unconscious wishes, just as dreams are; and like them they were in the nature of compromises, since they too were forced to avoid any open conflict with the forces of repression.[13]

Twenty-five years after *The Interpretation of Dreams* (1900) Freud now compares for the first time the formal processes of the artwork and the transformational processes of the dreamwork (principally, condensation and displacement) by means of which unconscious wishes are visually made manifest in the representational disguise of the dream.[14] Works of art are like dreams in this transformational respect, "but they differed from the asocial, narcissistic products of dreaming in that they were calculated to arouse interest in other people and were able to evoke and to gratify the same unconscious wishes in them too." In 1925 Freud remains insistent that psychoanalysis "can do nothing towards elucidating the nature of the artistic gift, nor can it explain the means by which the artist works," but he does offer the notion of "incitement-premium," first elaborated in his 1905 book on jokes, in order to explain how "the perceptual pleasure of formal beauty" anchors the spectator in front of what otherwise might appear as the expression of a socially unacceptable fantasy or wish.[15] Only in the 1914 essay on Michelangelo have we seen Freud invoke a motive of the critical regulation of self and others alongside that of substitutive instinctual satisfaction, but in *The Future of an Illusion* (1927) he extends this crucial regulating function to the artistic investment of the spectator as well:

As we discovered long since, art offers substitutive satisfactions for the oldest and still most deeply felt cultural renunciations, and for that reason it serves as nothing else does to reconcile a man to the sacrifices he has made on behalf of civilization. On the other hand, the creations of art heighten his feelings of identification . . . by providing an occasion for sharing highly valued emotional experiences.[16]

In partaking of aesthetic experience the spectator does not merely luxuriate in the open contemplation of formal beauty or hide in the covert discharge of libidinal and aggressive fantasy; these elements of art relate respectively to what by 1923 Freud had come to call the ego and id.[17] Identification with the ideals of the cultural group derives from the internalized agency of regulation known as the superego, "and when those creations picture the achievements of his particular culture and bring to his mind its ideals in an impressive manner, they also minister to his narcissistic satisfaction."[18] At best, however, this satisfaction is meager, as Freud concludes in his deeply pessimistic book *Civilization and Its Discontents* (1930): "People who are receptive to the influence of art cannot set too high a value on it as a source of pleasure and consolation in

life. Nevertheless the mild narcosis induced in us by art can do no more than bring about a transient withdrawal from the pressure of vital needs, and it is not strong enough to make us forget real misery."[19]

The Freudian triad of desire–dissatisfaction–fantasy may be filled in, psychoanalytically, with a variety of contents. In Freud's account of Leonardo, the classical Oedipal scenario is scripted as a three-act chamber drama for three, in which an erotic desire for the mother is followed by dissatisfaction with her unattainability as rooted in the intervention of the father, only to be followed after a prolonged delay by the retrospective fantasy of her possession embodied either in symptomatic neurotic conversion or sublimatory artistic construction. In the account of Moses and Michelangelo, on the other hand, an aggressive desire for retribution against both the wayward Israelites and the demanding pope is followed by a self-directed dissatisfaction with the aggressive impulse and a future-oriented fantasy of idealized self-control. The object of desire may vary from mother to father to self as well as any of those others who can stand as substitutes for these figures; and the mode of desire may shift from erotic to aggressive motives and may exhibit a blending of both. Melanie Klein, for one, puts artistic construction near the center of her metapsychological edifice in which contradictory fantasies of erotic possession or introjection of the maternal body (the "good breast") are seen to be constitutionally at war with fantasies of violent dismemberment and projection (the "bad breast"). In Klein's "Infantile Anxiety Situations Reflected in a Work of Art and in the Creative Impulse" (1929), the Freudian fantasy of substitutive satisfaction is represented in the register of not attainment but atonement, of reparation for the aggressive fantasies of hatred, envy, and destruction attendant upon the inevitable frustrations of desire. Writing about a painter named Ruth Kjär, Klein insists that "the desire to make reparation, to make good the injury psychologically done to the mother and also to re-store herself was at the bottom of the compelling urge to paint."[20] The Kleinian view of art as the reparation of damage to the adored-and-abhorred object of desire and the restoration of psychic wholeness to the divided subject of desire provides the pretext for the entry into the debate of Jacques Lacan.

In *The Ethics of Psychoanalysis* (1959–60), book seven in the twenty-seven-year series of transcriptions known as the Seminar (1953–80), Lacan acknowledges the interest of the Kleinian scenario of art as "an attempt at symbolic repair of the imaginary lesions that have occurred to the fundamental image of the maternal body," but, as a close reader of Freud, he insists on the incompleteness of this account: "Completely left out is something that must always be emphasized in artistic production and something that Freud paradoxically insisted on, to the surprise of many writers, namely, social recognition." Social recognition introduces private fantasy into the public arena of history and culture, and here Lacan's insistence is exemplary for the art historian: "Note that no correct evaluation of sublimation in art is possible if we overlook the fact that all artistic production, including especially that of the fine arts, is historically situated. You don't paint in Picasso's time as you painted in Velazquez's."[21]

You don't paint in the same way; but for Lacan you always paint the same thing – or, rather, the absence of the same thing.[22] Like sacred architecture from Altamira to Saint Mark's, "painting, too, is first of all something that is organized around emptiness."[23]

Lacan's question of art does not regard in the first instance the satisfaction of the artist: "What does society find there that is so satisfying? That's the question we need to answer." The answer: "All art is characterized by a certain mode of organization around this emptiness. . . . A work of art always involves encircling the Thing. . . . The object is established in a certain relationship to the Thing and is intended to encircle and to render both present and absent I am trying to show you how Freudian aesthetics . . . reveals that the Thing is inaccessible."[24] Art neither succeeds in representing the presence of the object of desire under the guise of imitation nor does it simply fail to represent it and thereby yield only its absence. The affirmation of a negation, art represents the Thing's presence (the loved-and-hated maternal body for Klein, the wished-for satisfaction and warned-against infraction for Freud, the *Ding-an-Sich* for Kant, the Idea for Plato) *in* the very phenomenality of its absence, *as* its absence. And from this aesthetic of the absent presence and present absence of the always lost and ever desired object from which we are perpetually suspended by a cut in being, an ethic of the subject's own primordial emptiness will follow. The object of art will help society bear this subjective void.[25]

Lacan initially follows Freud's formulations concerning the identificatory coimplication of artist and audience in the work of art:

> Freud points out that once the artist has carried out an operation on the level of sublimation, he finds himself to be the beneficiary of his operation insofar as it is acclaimed after the fact; it brings in its wake in the form of glory, honor, and even money, those fantasmic satisfactions that were at the origin of the instinct, with the result that the latter finds itself satisfied by means of sublimation.

Lacan curiously omits "the love of women" from Freud's litany of the male artist's fantasies of success, perhaps an index of the ambivalent break he initiates with Freud at this time. If Klein's account of artistic sublimation is too much weighted toward the private world of reparative fantasy, Freud's account of social recognition conversely errs in overly stressing the artist's secondary gains: "What needs to be justified is not simply the secondary benefits that individuals might derive from their works, but the originary possibility of a function like the poetic function in the form of a structure within a social consensus."[26] At the level of this social consensus we soon find a return of the repressed female object of desire, as Lacan indicates the ever deferred erotics of courtly love as the sort of transindividual structure of signification whereby the impossible satisfaction of human desire is given the material form of a lack, a gap, an interruption, a void.[27]

For Lacan, Freud's account of sublimation remains crucially unspecified at the level of the primary satisfaction afforded by art:

Freud was extremely prudent in this connection. On the nature of the creation that is manifested in the beautiful, the analyst has by his own admission nothing to say. . . . The definition he gives of sublimation at work in artistic creation only manages to show us the reaction or repercussions of the effects of what happens at the level of the sublimation of the drive, when the result or the work of the creator of the beautiful reenters the field of goods, that is to say, when they have become commodities. One must recognize that the summary Freud gives of the artist's career is practically grotesque. The artist, he says, gives a beautiful form to the forbidden object in order that everyone, by buying his little artistic product, rewards and sanctions his daring. That is a way of shortcircuiting the problem.

The problem, Lacan dares to add, is that Freud hasn't recognized that "the appearance of beauty intimidates and stops desire."[28]

The defensive nature of art, its intimidation of the relentless representatives of the ever lost Thing that cause our circling around the ceaseless dissatisfactions of desire, is at the center of Lacan's most famous Seminar, book eleven, *The Four Fundamental Concepts of Psychoanalysis* (1964). Once again Lacan approaches the question of art by way of an attentive rereading of Freud's texts:

Freud always stressed with infinite respect that he did not intend to settle the question of what it was in artistic creation that gave it its true value. . . . Nevertheless, when he studies Leonardo, let us say, roughly speaking, that he tries to find the function that the artist's original phantasy played in his creation. . . . Is it in this direction that we must look?

Still following Freud, Lacan rejects the reduction of the question of art to the artist's dreamlike fantasy, insisting on "the value [sublimation] assumes in a social field":

Freud declares that if a creation of desire, which is pure at the level of the painter, takes on commercial value – a gratification that may, all the same, be termed secondary – it is because its effect has something profitable for society, for that part of society that comes under its influence. Broadly speaking, one can say that the work calms people, comforts them, by showing them that at least some of them can live from the exploitation of their desire. But for this to satisfy them so much, there must also be that other effect, namely, that *their* desire to contemplate finds some satisfaction in it. It elevates the mind, as one says, that is to say, it encourages renunciation.

So far Lacan is true to the word of his celebrated "return to Freud." But then he adds his own twist: "Don't you see that there is something here that indicates the function I called *dompte-regard*?"[29]

Dompte-regard. The function of art is the taming of the gaze, and the gaze, one of the key manifestations of the "four fundamental concepts" (the unconscious, repetition, transference, and drive), is the Lacanian name for the intimately external ("extimite") object of desire and dread (the so-called *objet a*) whose internalized loving and loathing look at us is ever lost, ever repressed, ever pursued, ever found, and ever fended in the disparate miscellany of objects and signs that look at us and thereby give structure to our fantasies of self and other in the purview of the world: "It is to this register of the eye as made desperate by the gaze that we must go if we are able to grasp the taming, civilizing and fascinating power of the function of the picture." This gaze "is presented precisely, in the field of the mirage of the narcissistic function of desire, as the object that cannot be swallowed. . . . It is at this point of lack that the subject has to recognize himself."[30]

Lack in Lacan is not the adventitious product of unallayed wishes, as it may appear to be in Freud. Lack in Lacan is the constitutional mark of the divided subject, inevitably split from her or his putatively Real desire for the so-called Imaginary object of its fulfillment not simply by the subject's own weakness or the external world's resistances but by the Symbolic structures of art and language by way of which alone the subject must make her or his desire for the object kNOwn.[31] In the scopic field the blind face of that negation of the one who knows is the gaze.

"Painters, above all, have grasped this gaze as such in the mask,"[32] so let me end with a look at a mask, the 1917 self-portrait of the seventy-seven-year-old Claude Monet under whose lacking gaze I've continuously seen myself to be seen for the more than twenty years of my struggling to write and rewrite my dissertation, "Monet and His Critics" (1974), my articles "Monet, Fantasy, and Freud" (1985), "Monet's Series: Repetition, Obsession" (1986), "Monet, Madness, and Melancholy" (1987), and my book *Monet, Narcissus, and Self-Reflection: The Modernist Myth of the Self* (1994).[33] So, after reading Freud and Klein and Lacan for these twenty years, what do I say I see in Monet's self-portrait? (1) What I say I see in Monet's self-portrait is not only the unruly material trace of the subject's id-driven (or Real) desiring look, forever lost and found in the libidinized and aggressivized impressions of the painter's once vital but always wanting touch. (2) What I say I see in Monet's self-portrait is not only the jubilant yet alienated centralized image of the ego-constituting (or Imaginary) mirroring of the subject's mother's ever irretrievable loving and unloving look. (3) What I say I see in Monet's self-portrait is not only the conventional sign of the superego-positioning (or Symbolic) effect of the subject with respect to taking on, but not too soon and not too fully, the daunting personal and social legacy of the paternal name (*Nom-du-père = Non-du-père*): Monet, Manet, Courbet, et al. (4) So what I say I see in Monet's self-portrait is the knotting together of these nots, the empty embodiment of the matriphilic look and the patronymic mandate and taboo; in it Monet and I become one (or, rather, none) with the painting's gaze, the masklike materialization of desire, the *objet a*, the consoling suffering of the void. Id, ego, superego. Real, Imaginary,

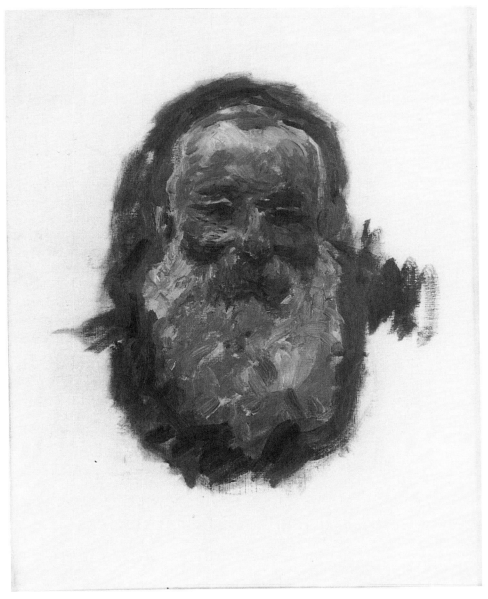

Figure 32. *Claude Monet,* Self-Portrait, *1917. Oil on canvas. 27$^{5}/_{16}$" × 21$^{7}/_{16}$" (70 × 55 cm). Musée d'Orsay, Paris. Photo RMN.*

Symbolic. Trace, image, sign. Something, nothing, no Thing. Who is the subject here? Monet or me or you?

Seen from the unseen angle of the paternal gaze of "père-spective,"[34] Monet's painting is "a self-portrait in which the subject will see himself as he cannot see himself, a vision of horror in which his own nullity appears to him."[35]

"This rapid painting, this portrait without gaze, . . . indifferent to all spirituality, even in a face,"[36] bodies forth the opaque pigmented screen "by means of which we confront the utter nullity of our narcissistic pretensions."[37] In the congealed gestural traces of his self-portrait, Monet "makes visible for us here something that is simply the subject as annihilated."[38] "This man was in reality . . . a daily tormented person, at the same time a solitary person with an *idée fixe*, racking his brains into exhaustion, forcing his will to the fixed and desired task, pursuing his dream of form and color almost unto the annihilation of his individuality in the eternal Nirvana of things at once changing and immutable."[39] Here Monet's biographer unknowingly repeats Freud's contemporaneous postulation of a Nirvana principle as the self-voiding impetus of narcissism, a Real principle of repetition and discharge whereby the self is obscurely driven "beyond the pleasure principle" to abdicate its Imaginary erotic teleology in favor of a concentration and, ultimately, an annihilation of all erotic investment within a Symbolic representation of itself. "We have unwittingly steered our course into the harbour of Schopenhauer's philosophy. For him death is the 'true result and to that extent the purpose of life.' "[40] This testament is from the Freud least amenable to the affirmations of American-style ego and self psychology and British-style object-relations theory and most resigned to the Gallic and Germanic negations of Lacan and, I believe, Monet as well.[41] Then again, I cannot tell. I may have merely written a psychoanalytic novel.[42]

But what does "merely" mean? Could it be the sign for the sort of rigorously self-reflexive writing about art that might matter most to us today?[43]

Notes

1 One source for this much-cited report is Jacques Lacan, as quoted in David Macey, "On the Subject in Lacan," in *Psychoanalysis in Contexts: Paths between Theory and Modern Culture*, ed. Anthony Elliott and Stephen Frosh (London: Routledge, 1995), p. 74.

2 Sigmund Freud, *Five Lectures on Psycho-Analysis* (1910), in *The Standard Edition of the Complete Psychological Works of Sigmund Freud*, ed. and trans. James Strachey and Anna Freud, with Alix Strachey and Alan Tyson, 24 vols. (London: Hogarth Press and the Institute of Psychoanalysis, 1953–74) [hereafter, *S.E.*], 11: 50. For an initial orientation to Freudian aesthetics and its art-historical implementation, see Jack Spector, *The Aesthetics of Freud: A Study in Psychoanalysis and Art* (New York: McGraw-Hill, 1974) and "The State of Psychoanalytic Research in Art History," *Art Bulletin* 70 (1988): 49–76. Essays by art historians and psychoanalysts have been collected and vigorous interdisciplinary dialogues staged by Mary Mathews Gedo, in *Psychoanalytic Perspectives on Art*, 3 vols. (Hillsdale, N.J.: Analytic Press, 1985–8). Fundamental essays include E. H. Gombrich, "Freud's Aesthetics" (1966), in *Literature and Psychoanalysis*, ed. Edith Kurzweil and William Phillips (New York: Columbia University Press, 1983), pp. 132–45; Richard Wollheim, "Freud and the Understanding of Art" (1970), in *The Cambridge Companion to Freud*, ed. Jerome Neu (Cambridge: Cambridge University Press, 1991), pp. 249–66; Michael Podro, "Art and Freud's Displacement of Aesthetics" (1972), in *Freud: The Man, His World, His Influence*, ed. Jonathan Miller (Boston: Little, Brown, 1972), pp. 125–35; Paul Ricoeur, "Psychoanalysis and the Work of Art" (1974), in *Psychiatry and the Humanities*, ed. Joseph H. Smith, vol. 1 (New Haven: Yale University Press, 1976), pp. 3–33; and Sarah Kofman, *The Childhood of Art: An Interpretation of Freud's Aesthetics* (1975), trans. Winifred Woodhull (New York: Columbia University Press, 1988).

3 Sigmund Freud, *Leonardo da Vinci and a Memory of His Childhood* (1910), in *S.E.*, 11: 134.

4 Freud mistakenly understood the bird referred to in Leonardo's memory as a vulture rather than a kite. Much of the voluminous criticism of Freud's account has flowed from this mistake, but Freud's psychodynamic scenario of repression and sublimation rises or falls independent of the gaffe. The most famous art-historical response is Meyer Schapiro, "Leonardo and Freud: An Art-Historical Study" (1956), *Theory and Philosophy of Art: Style, Artist, and Society* (New York: Braziller, 1994), pp. 153–99. On the controversy, see Brian Farrell, "Introduction," in Sigmund Freud, *Leonardo da Vinci and a Memory of His Childhood*, ed. James Strachey, trans. Alan Tyson (London: Penguin, 1963), pp. 11–88; Ellen Handler Spitz, *Art and Psyche: A Study in Psychoanalysis and Aesthetics* (New Haven: Yale University Press, 1985), pp. 55–65; Laurie Schneider Adams, *Art and Psychoanalysis* (New York: HarperCollins, 1993), pp. 14–41; and Bradley I. Collins, *Leonardo, Psychoanalysis, and Art History: A Critical Study of Psychobiographical Approaches to Leonardo da Vinci* (Evanston, Ill.: Northwestern University Press, 1997).

5 Freud, *Leonardo*, in *S.E.*, 11: 100, 117–18, 136.

6 Sigmund Freud, "Formulations on the Two Principles of Mental Functioning" (1911), in *S.E.*, 12: 224. This and other passages by Freud on art are conveniently quoted in Robert Waelder, *Psychoanalytic Avenues to Art* (New York: International Universities Press, 1965).

7 Sigmund Freud, *Totem and Taboo: Some Points of Agreement between the Mental Lives of Savages and Neurotics* (1912–13), in *S.E.*, 13: 90.

8 Sigmund Freud, "The Claims of Psycho-Analysis to Scientific Interest" (1913), in *S.E.*, 13: 187–8. For more on symbols and substitutes, see E. H. Gombrich, "Psycho-Analysis and the History of Art" (1954), *Meditations on a Hobby Horse and Other Essays on the Theory of Art* (London: Phaidon, 1963), pp. 30–44.

9 Sigmund Freud, "The Moses of Michelangelo" (1914), in *S.E.*, 13: 235–6.

10 Ibid., p. 234. For a recent essay, with bibliography, see Malcolm Bowie, "Freud and Art, or What Will Michelangelo's *Moses* Do Next?," *Psychoanalysis and the Future of Theory* (Oxford: Blackwell, 1993), pp. 55–85.

11 Sigmund Freud, *Beyond the Pleasure Principle* (1920), in *S.E.*, 18: 17. On the appropriation of the death drive in Surrealism and Postmodernism and its repression in Modernism, see Rosalind Krauss, *The Optical Unconscious* (Cambridge: MIT Press, 1993).

12 Sigmund Freud, *Introductory Lectures on Psycho-Analysis* (1916–17), in *S.E.*, 16: 376–7.

13 Sigmund Freud, *An Autobiographical Study*, in *S.E.*, 20: 64–5.

14 For useful definitions of these and other psychoanalytic terms, see Jean Laplanche and J. B. Pontalis, *The Language of Psycho-Analysis* (1967), trans. Donald Nicholson-Smith (New York: Norton, 1973); *Psychoanalytic Terms and Concepts*, ed. Burness E. Moore and Bernard D. Fine (New Haven: Yale University Press and the American Psychoanalytic Association, 1990); and Dylan Evans, *An Introductory Dictionary of Lacanian Psychoanalysis* (London: Routledge, 1996).

15 Freud, *Autobiographical Study*, in *S.E.*, 20: 65. Like a work of art, a joke is a formal representation of someone or something that is necessarily addressed to an audience; see Sigmund Freud, *Jokes and Their Relation to the Unconscious* (1905), in *S.E.*, 8: 137.

16 Sigmund Freud, *Future of an Illusion* (1927), in *S.E.*, 21: 13–14. On sharing as a basis for a theory of art as enactment, see Richard Kuhns, *Psychoanalytic Theory of Art: A Philosophy of Art on Developmental Principles* (New York: Columbia University Press, 1983).

17 Sigmund Freud, *The Ego and the Id* (1923), in *S.E.*, 19: 12–66. The classic formulation of a theory of art as a controlled regression in the service of the ego is by the art-historian-turned-psychoanalyst Ernst Kris, *Psychoanalytic Explorations in Art* (New

York: International Universities Press, 1952). For art-historical applications rooted in ego psychology (and its more recent variant, self psychology), in which a potentially conflict-free artistic expression is posited, see Peter Gay, *Art and Act: On Causes in History – Manet, Gropius, Mondrian* (New York: Harper & Row, 1976); Gilbert J. Rose, *The Power of Form: A Psychoanalytic Approach to Aesthetic Form* (New York: International Universities Press, 1980); John E. Gedo, *Portraits of the Artist: Psychoanalysis of Creativity and Its Vicissitudes* (New York: Guilford Press, 1983); Ellen Handler Spitz, *Image and Insight: Essays in Psychoanalysis and the Arts* (New York: Columbia University Press, 1991); Donald Kuspit, *Signs of Psyche in Modern and Postmodern Art* (Cambridge: Cambridge University Press, 1993); and Mary Mathews Gedo, *Looking at Art from the Inside Out: The Psychoiconographic Approach to Modern Art* (Cambridge: Cambridge University Press, 1994).

18 Freud, *Future of an Illusion*, in *S.E.*, 21: 14. On art and narcissism, see Mieke Bal, *Reading "Rembrandt": Beyond the Word–Image Opposition* (Cambridge: Cambridge University Press, 1991). Narcissism is thoughtfully resisted as an explanatory category in Michael Fried, *Courbet's Realism* (Chicago: University of Chicago Press, 1990).

19 Sigmund Freud, *Civilization and Its Discontents* (1930), in *S.E.*, 21: 81.

20 Melanie Klein, "Infantile Anxiety Situations Reflected in a Work of Art" (1929), in *The Selected Melanie Klein*, ed. Juliet Mitchell (New York: Free Press, 1987), p. 93. For essays on art in the tradition of British object-relations theory in which reparation of the object and restoration of the subject are emphasized, see W. R. D. Fairbairn, "Prolegomena to a Psychology of Art" and "The Ultimate Basis of Aesthetic Experience," *British Journal of Psychology* 28 (1937–8): 288–303 and 29 (1938–9): 167–81; Michael Balint, "Notes on the Dissolution of Object-Representation in Modern Art," *Journal of Aesthetics and Art Criticism* 10 (1951–2): 323–7; Hanna Segal, "A Psychoanalytic Approach to Aesthetics," *International Journal of Psycho-Analysis* 33 (1952): 196–207; Adrian Stokes, "Form in Art: A Psychoanalytic Interpretation," *Journal of Aesthetics and Art Criticism* 18 (1959–60): 193–203; Anton Ehrenzweig, *The Hidden Order of Art: A Study in the Psychology of Artistic Imagination* (Berkeley and Los Angeles: University of California Press, 1967); and Peter Fuller, *Art and Psychoanalysis* (London: Writers & Readers, 1980).

21 Jacques Lacan, *The Ethics of Psychoanalysis* (1959–60), in *The Seminar of Jacques Lacan Book VII*, ed. Jacques-Alain Miller, trans. Dennis Porter (New York: Norton, 1992), pp. 106–7.

22 "To point out references like these, is not to enter into the shifting, historical game of criticism, which tries to grasp what is the function of painting at a particular moment, for a particular author at a particular time. For me, it is at the radical principle of the function of this fine art that I am trying to place myself"; see Jacques Lacan, *The Four Fundamental Concepts of Psycho-Analysis* (1964), in *The Seminar of Jacques Lacan Book XI*, ed. Jacques-Alain Miller, trans. Alan Sheridan (New York: Norton, 1978), p. 110.

23 Lacan, *Ethics*, p. 136.

24 Ibid., pp. 107, 130, 141, 159. For an approach to the Freudo-Lacanian Thing in the visual realm of cinema and painting, see Slavoj Žižek, *Enjoy Your Symptom! Jacques Lacan in Hollywood and Out* (London: Routledge, 1992).

25 On the void that cultural production masks, see Slavoj Žižek, *The Sublime Object of Ideology* (London: Verso, 1989), and Stuart Schneiderman, "Art as Symptom: A Psychoanalytic Study of Art," in *Lacan and Criticism: Essays and Dialogue on Language, Structure, and the Unconscious*, ed. Patrick Colm Hogan and Lalita Pandit (Athens: University of Georgia Press, 1990), pp. 207–22.

26 Lacan, *Ethics*, pp. 144–5. On art and the social bond, see Slavoj Žižek, *Looking Awry: An Introduction to Jacques Lacan through Popular Culture* (Cambridge: MIT Press, 1991).

27 On the deferred pursuit of the desired object of courtly love as a paradigm of subjectivity, art, and the ethical attitude toward life and death, see the different readings of Slavoj Žižek, *The Metastases of Enjoyment: Six Essays on Woman and Causality* (London: Verso,

1994), pp. 89–112, and Henry Staten, *Eros in Mourning: Homer to Lacan* (Baltimore: Johns Hopkins University Press, 1995), pp. 73–97.

28 Lacan, *Ethics*, p. 238. "Lacking strength, Beauty hates the Understanding for asking of her what it cannot do. But the life of Spirit is not the life that shrinks from death and keeps itself untouched by devastation, but rather the life that endures it and maintains itself in it. It wins its truth only when, in utter dismemberment, it finds itself. This *tarrying with the negative* is the magical power that converts it into being": G. W. F. Hegel, "Preface," *Phenomenology of Spirit*, quoted in Slavoj Žižek, *Tarrying with the Negative: Kant, Hegel, and the Critique of Ideology* (Durham, N.C.: Duke University Press, 1993), p. ix.

29 Lacan, *Fundamental Concepts*, pp. 110–11. Also see Philippe Julien, *Jacques Lacan's Return to Freud: The Real, the Symbolic, and the Imaginary*, trans. Devra Beck Simiu (New York: New York University Press, 1994).

30 Lacan, *Fundamental Concepts*, pp. 116, 270. For the difficult notion of "extimacy," highlighted throughout Žižek's already cited writings, see Lacan, *Ethics*, p. 139. On the category of the gaze, crucial to both film theory and art history, see Jonathan Scott Lee, *Jacques Lacan* (Amherst: University of Massachusetts Press, 1990), pp. 154–61, as well as the essays by Antonio Quinet, Richard Feldstein, Hanjo Berressem, Robert Samuels, Ellie Ragland, and Slavoj Žižek in *Reading Seminar XI: Lacan's "Four Fundamental Concepts of Psychoanalysis,"* ed. Richard Feldstein, Bruce Fink, and Maire Jaanus (Albany: State University of New York Press, 1995), pp. 139–220. Two art-historical considerations are Norman Bryson, "The Gaze in the Expanded Field," in *Vision and Visuality*, ed. Hal Foster (Seattle: Bay Press, 1988), pp. 87–113, and Keith Moxey, *The Practice of Theory: Poststructuralism, Cultural Politics, and Art History* (Ithaca, N.Y.: Cornell University Press, 1994), pp. 51–5. Feminist authors have been in the forefront of the interrogation of the patriarchal manifestations of the gaze in film and painting; see Rozsika Parker and Griselda Pollock, *Old Mistresses: Women, Art, and Ideology* (New York: Pantheon, 1981); Mary Kelly, *Post-Partum Document* (London: Routledge & Kegan Paul, 1983); Jacqueline Rose, *Sexuality in the Field of Vision* (London: Verso, 1986); and Kaja Silverman, *Male Subjectivity at the Margins* (London: Routledge, 1992).

31 On the Lacanian categories of Real, Symbolic, and Imaginary (R.S.I. = "hérésie"), roughly homologous to the Freudian triad of id, superego, ego but with a crucial evacuation of the alleged autonomy of the third term, see Robert Samuels, *Between Philosophy and Psychoanalysis: Lacan's Reconstruction of Freud* (London: Routledge, 1993). My own fairly abject attempt at Lacanian punning in these final pages is meant to evoke the plural materiality of the signifier to whose effects we necessarily abandon ourselves, and thereby find ourselves outside of ourselves, in the shared public media of art and language. Amending the famous formula of classical autonomy of Buffon, "style is the man himself," Lacan instead insists in his *Ecrits* (Paris: Seuil, 1966), pp. 9–10, that "style is the man to whom one speaks" and "the object – the object *a* – responds to the question of style." See Judith Miller, "Style Is the Man Himself," in *Lacan and the Subject of Language*, ed. Ellie Ragland-Sullivan and Mark Bracher (London: Routledge, 1991), pp. 143–51.

32 Lacan, *Fundamental Concepts*, p. 84. Lacan refers to Goya in the context of his remarks on the painter's mask: "Only the subject – the human subject, the subject of the desire that is the essence of man – is not, unlike the animal, entirely caught in this imaginary capture. He maps himself in it. How? In so far as he isolates the function of the screen and plays with it. Man, in effect, knows how to play with the mask as that beyond which there is the gaze" (p. 107). Also see Slavoj Žižek, " 'In His Bold Gaze My Ruin Is Writ Large'," in *Everything You Always Wanted to Know about Lacan (But Were Afraid to Ask Hitchcock)*, ed. Slavoj Žižek (London: Verso, 1992), pp. 211–72.

33 Steven Z. Levine, *Monet and His Critics* (New York: Garland, 1976); "Monet, Fantasy, and Freud" and "Monet, Madness, and Melancholy," *Psychoanalytic Perspectives on Art* 1: 29–55 and 2: 111–32; "Monet's Series: Repetition, Obsession," *October* no. 37 (Summer

1986): 65–75; and *Monet, Narcissus, and Self-Reflection: The Modernist Myth of the Self* (Chicago: University of Chicago Press, 1994).

34 I have formed "père-spective" on the template of "père-version," Lacan's pun on the patri-archal point of view of rule-regulated enactments, or perversions, from which our Real encounters and Imaginary enticements are given encrypted Symbolic form. See Jacques Lacan, "Seminar of 21 January 1975," in *Feminine Sexuality*, ed. Juliet Mitchell and Jacqueline Rose, trans. Jacqueline Rose (New York: Norton, 1985), p. 167.

35 Mikkel Borch-Jacobsen, *Lacan: The Absolute Master*, trans. Douglas Brick (Stanford: Stanford University Press, 1991), p. 237.

36 Raymond Régamey, "Oeuvres de Claude Monet," *Beaux-Arts* 5 (15 March 1927): 89; quoted in Levine, *Monet, Narcissus, and Self-Reflection*, p. 283.

37 Žižek, *Looking Awry*, p. 64.

38 See Lacan, *Fundamental Concepts*, pp. 88–9, where his reference is to the enigmatic anamor-phic skull in Hans Holbein's *The Ambassadors* (1533; National Gallery, London). For a discussion, see Michael Payne, *Reading Theory: An Introduction to Lacan, Derrida, and Kristeva* (Oxford: Blackwell, 1993), pp. 214–17.

39 Gustave Geffroy, *Claude Monet: sa vie, son oeuvre* (Paris: G. Crès, 1922), p. 335; quoted in Levine, *Monet, Narcissus, and Self-Reflection*, p. 260.

40 Freud, *Beyond the Pleasure Principle*, in *S.E.*, 18: 49–50.

41 For a useful introduction to the competing psychoanalytic approaches to art mentioned here, see Elizabeth Wright, *Psychoanalytic Criticism: Theory in Practice* (London: Methuen, 1984). For compelling pleas on behalf of psychoanalysis as a critical, trans-formative practice, see Slavoj Žižek, *For They Know Not What They Do: Enjoyment as a Political Factor* (London: Verso, 1991), Anthony Elliott, *Psychoanalytic Theory: An Introduction* (Oxford: Blackwell, 1994), and Mark Bracher, *Lacan, Discourse, and Social Change: A Psychoanalytic Cultural Criticism* (Ithaca, N.Y.: Cornell University Press, 1993).

42 For a fuller version of the account of Monet I present here, see Steven Z. Levine, "Virtual Narcissus: On the Mirror Stage with Monet, Lacan, and Me," *American Imago* 53 (Spring 1996): 91–106. Also see id., "Manet's Man Meets the Gleam of Her Gaze: A Psycho-analytic Novel," in *12 Views of Manet's "Bar,"* ed. Bradford R. Collins (Princeton: Princeton University Press, 1996), pp. 250–77.

43 See Steven Z. Levine, "Mutual Facing: A Memoir of Friedom," in *The Writings of Michael Fried*, ed. Jill Beaulieu, Mary Roberts, and Toni Ross (Sydney: University of Sydney Press, forthcoming). Also see id., "Alter Egos – Close Encounters of the Paranoid Kind: W. R. D. Fairbairn, Salvador Dali, and Me," in *Fairbairn, Then and Now*, ed. Neil J. Skolnick and David E. Scharff (Hillsdale, N.J.: Analytic Press, 1998), pp. 179–96.

Passing between Art History and Postcolonial Theory

James D. Herbert

L EXICOLOGY alone dictates that a certain asymmetry will characterize the encounter between art history and postcolonial theory. The former phrase designates an academic discipline, its two nouns inflecting each other – the historical components of art, the artistic ingredients of history – to indicate the discipline's boundaries, or at least the territory upon which scholars will contest its frontiers. The latter phrase, while historiographically demarcating an analytic direction that emerged from the field of literary criticism and has since expanded outward, also denotes a process, even an advancement: The "post" in postcolonial theory promises to push beyond the ideas and beliefs of colonialism by challenging them, and perhaps setting them right. Practically by definition but owing also to a compelling political imperative, postcolonialism needs to distance itself, differentiate itself, from its colonial antecedent. Speaking tropologically, we could say that whereas art history consists of the exploration of metaphoric relations between its own two terms, postcolonialism appears to operate in the ironic mode by turning against that which, while preceding it, is also contained within its name. Accordingly, when the discipline of art history and the initiative of postcolonial theory interact, an obvious program of engagement suggests itself: Whereas art history left on its own might simply continue to attend to its own affairs, postcolonial theory would seem to have the capacity, indeed the responsibility, to identify and turn against aspects of colonialism rooted in art works and in the art-historical practices that study them.

Yet even prior to this envisioned analytic campaign into the realm of art history – a campaign, or rather its mandate, that I endeavor in this chapter to assess – postcolonialism's ironic turn against colonialism proves an elusive task to accomplish. The analytic turn would appear to depend on some functional stability of the concept being troped, and that stability – as the best of postcolonial writing itself recognizes – may not exist. Stephen Greenblatt has argued that divided belief has marked the colonial encounter from its beginnings: The first transatlantic explorers discovered in native Americans both exquisite beauty and satanic evil; the device of wonder held these two contradictory attitudes in suspense, if not – and this is the more intriguing possibility

– actually generating such antithetical perceptions.[1] Ever since, colonized peoples and spaces have, in the eyes of colonizers, manifested both virtues appreciable by Euro-Americans and vices demanding rectification at their hands, often at one and the same moment. The two types of perception in turn call forth different colonial responses: in the former instance, that which James Clifford has labeled the "salvage paradigm,"[2] and in the latter, the massive colonial project evoked by the phrase *la mission civilatrice*.

Homi K. Bhabha, in essays collected in the volume *The Location of Culture*, has provided the most perspicacious account of the ambivalence marking the object of colonial knowledge and action. A variety of figures – the mimic, the hybrid, the fetish – serve in Bhabha's essays to illustrate the doubled and contradictory attributes assigned by the colonial enterprise to the people and places falling within its purview. For instance, the mimicry of the Asian or African who emulates European behavior (or at least is perceived by the colonist as doing so) marks this colonial figure as "almost the same" as his European masters "but not quite." Consequently, Bhabha maintains, mimicry stands as

> the sign of a double articulation; a complex strategy of reform, regulation and discipline, which "appropriates" the Other as it visualizes power. Mimicry is also the sign of the inappropriate, however, a difference or recalcitrance which coheres the dominant strategic function of colonial power, intensifies surveillance, and poses an immanent threat to both "normalized" knowledges and disciplinary powers.[3]

The great insight of Bhabha's argument is to recognize that, far from constituting some epiphenomenal shortcoming in the practical realization of colonial ideals, this doubling of the colonized into both an "appropriate" likeness to and an "inappropriate" difference from the colonizer authorizes the colonial project itself. The failure to fix the colonized – a failure that is a product of the colonial episteme, certainly, not some inherent quality in the object of its knowledge – demands the further advances of colonial knowledge, precisely to address that gaping uncertainty. "It is as if the very emergence of the 'colonial' is dependent for its representation upon some strategic limitation or prohibition *within* the authoritative discourse itself," continues Bhabha. "The success of colonial appropriation depends on a proliferation of inappropriate objects that ensure its strategic failure, so that mimicry is at once resemblance and menace" (86).

Crucially, not only the colonized splits apart during this process; the colonizer does as well. Operating the machinery of similarity and difference against its uncertain object, colonial administration finds itself called upon both to extend the rights and benefits of European civilization to deserving human souls and to actuate more forceful means in the face of the exigent threat of perceived inhuman barbarism. As a result, colonialism, in Bhabha's words, drifts into a condition of being "civility's supplement and democracy's despotic double" (96), all in the name of civility and democracy. The individual colonizer likewise loses

any unambiguous sense of self, as "both colonizer and colonized are in a process of miscognition where each point of identification is always a partial and double repetition of the *otherness* of the self" (97). If the mimic divides its identity across the shifting and uncertain frontier between autochthone and European, the colonizer's self also vacillates as it both identifies with and differentiates itself from a colonized subject variably either evil or good.

We could label the rhetorical character of this constant process of simultaneous affirmation and negation of identities: Colonialism operates in the ironic mode, constantly measuring any given stance against that which it is perceived not to be.[4] Accordingly, postcolonialism cannot get past its colonial antecedent simply through the application of a new ironization: To negate the colonial when the colonial is already an uneasy alteration between opposites replicates its dynamic by inverting and thus perpetuating its antithetical terms. Rebuking the *mission civilatrice* and attempting instead to appreciate a different culture on its own terms reactivates the "salvage paradigm"; condemning the "salvage paradigm" for its epistemic hubris and cultural acquisitiveness risks casting the colonized culture into the realm of fundamental and unfathomable difference, an enabling precept of the *mission civilatrice*. At the very moment when we might like to imagine our own position of analysis at some Archimedean point outside colonialism from which we can turn the colonial world around the fulcrum of irony, the colonial world ironically turns on us as we repeat its own characteristic tropologies. That which Bhabha declares about the colonial subject – "What is denied the colonial subject, both as colonizer and colonized, is that form of negation which gives access to the recognition of difference" (75) – applies with equal validity to the postcolonial subject. Escape from the colonial may not be possible; to attempt to escape, paradoxically, may prove the most colonial gesture of all.

All this greatly complicates any postcolonial intervention into the discipline of art history, and does so for a couple of reasons. First, it should be clear that the asymmetrical exchange between academic fields that I laid out in the introduction may reproduce at the level of scholarship the dynamic of colonialism itself. We could rephrase the disciplinary relation in the following polemical terms, steaming with colonial connotations. Postcolonial theorists, traveling outward from their own scholarly domain, assume the analyst's burden of ameliorating scholarly conditions within the retrograde discipline of art history. Art historians, depending on their methodological stripe and political predilections, either chafe against the prospect of outside interference or greet with open arms the importation of an analytic technology from elsewhere that can realize the full potential of the discipline's principal natural resource: artistic artifacts. The very idea that a corrective theory should intervene from outside obviously reactivates the mechanism of impossible escape.

Second, to the extent that attempts to apply postcolonial theory to art history have tended to center on works of art produced in the modern period during the era of high European imperialism, analysis encounters in modernism an object that provides no more stability against which to trope than did colonialism.

Owing precisely to the many and various definitions that the concept of modernism has accumulated over time, no sooner does a writer fix some determinative meaning for it and forward some exemplary artists embodying its precepts than countless counterexamples, equally compelling, press for recognition. Within the modernist fold we find both the staid bourgeois Monet (or, if you prefer, the naively artisanal Renoir) and the wily well-bred Manet (or, if you prefer, the sardonic aristocrat Degas), both the eternal Frenchness of Matisse and the maddeningly mutable foreignness of Picasso, both the rigid and rational Mondrian and the playful Duchamp, both Breton writing manifestos and Bataille fretting over the monstrous, both the *echt* expressivity of Jackson Pollock and the deadpan artifice of Andy Warhol. Scholars probing the modern discover both a society of spectacle and the piercing of that facade of images, both the theory of modernism and a theory of the avant-garde, both opticality and its unconscious. Over and again artists who have been valorized for making significant contributions (roughly, the latter of each pairing in the list above) are imagined as doing so by turning against, by ironizing, the seemingly less sophisticated or radical efforts of their modernist colleagues (roughly, the former in each pairing). But even the modernists left behind are, more often than not, credited with the capacity to turn on their modernist predecessors. Pollock may have been Pop's patsy, but his flat abstracted surfaces also refuted the still visibly iconic canvases of the Impressionists and other painterly antecedents in the modernist canon. It may be that irony has been the master trope of modernism all along.[5]

Consequently, an ironization occurring within modernism may prove difficult to distinguish from a postcolonial ironization of it from outside, especially when the analyst attempts to elevate the modern artist to the analyst's own Archimedean point, from which artist and scholar alike can execute their turn against a purportedly stable antecedent. I would, by way of example, distinguish two general approaches to the frequently addressed issue of the modernist engagement of so-called primitive artifacts; the watershed between them, let us say for the sake of the argument, marked out by the exhibition *"Primitivism" in 20th Century Art: Affinity of the Tribal and the Modern* at the Museum of Modern Art in 1984 (the quotation marks in the title, like my own "so-called" are, of course, themselves attempts at ironic distance). An earlier interpretation posited that modern artists appropriated (or alternatively, allowed themselves to be influenced by) primitive art for the purpose of advancing the cause of modern art in the face of its detractors; any reference to the politics of colonialism would plainly be beside the point in such an account. The later scholarly trend recognizes that aspects of colonialism must inevitably impinge upon the circulation and display of primitive artifacts, but quite frequently imagines that the modern artist, full of tropological prowess, manages to turn against that force of historical determinism. Despite the obvious differences in method and results, in both cases the same basic analytical gambit has been ventured: The scholar identifies some morally suspect and historically grounded foundation – an inherited academic *poncif*, a colonial attitude in the *Zeitgeist* – and then demonstrates

how his or her artist of choice – in a moment of modernist intelligence, or of proto-postcolonial prescience – was doing just the opposite of that. But this simply reinitiates the self-ironizing dynamic of colonialism itself. One writer decries the characterization of non-Europeans as barbaric while praising modern artists who recognized the use value – aesthetic or political, depending on the method – of their artifacts. Another berates such valuations on European terms while insisting that such cultures are best appreciated by artists who truly recognize their vital and different authenticity. These positions are, of course, two sides of the same colonial coin.

These twinned approaches, moreover, return the ironizing subject to the heart of colonialism by perpetuating the impossible ideal of a coherent subject capable of grasping the colonial situation in its entirety, as if from outside. The fact that great modernists such as Picasso, Matisse, and the various Surrealists have garnered the largest share of art-historical approbation for their capacity to distance themselves from colonialism should, at the very least, raise a red flag of methodological caution: Perhaps the glorification of the clear-sighted autonomous artist for his proto-postcolonial critique differs little from the great modernist myth of the heroic individual, troping away from his inferior contemporaries.

Let us take as a case in point the recent analysis of Matisse's canvases evoking North Africa that appeared in the book *Fauve Painting: The Making of Cultural Politics*, by James D. Herbert. That author, my historiographic voice of today proclaims, avoided the most obvious form of the pitfall I describe above. In Herbert's account built from Bhabha's ideas, Matisse's paintings "were very much part of colonialism's epistemic project" as they "managed . . . to great profit" colonialism's operative contradiction between "aesthetics, the science of shared sensibilities [and] ethnography, the science of racial difference."[6] Playing the two sides of the contradiction off each other without offering any resolution between them, "the subject of Matisse's paintings," far from escaping the colonial dynamic through such ironizations, served as "an agent in the colonial quest – the interminable quest – for knowledge" (173). Yet by having the figure of the artist encompass both sides of the contradiction in this active process of management, Herbert's description risks reinventing the coherent subject: not Matisse the proto-postcolonial hero, but Matisse a complete embodiment of the full colonial project – unlike the ethnographers and lesser artists who in this reading each personify only part of it. Indeed, the personification of colonialism in the single figure of Matisse may unwittingly have attributed to a fractured and inconsistent political initiative the coherence usually associated with the modern autonomous individual.

More troubling still: If Herbert strove to reinsert Matisse back into the heart of colonialism, he implicitly claimed for himself an analytic position outside it, on the seemingly safe ground of postcolonialism. Using Bhabha's ideas to pry open a distance between himself and the painter – Matisse knew not what he did, whereas Herbert purports to grasp the true significance of Matisse's canvases – Herbert performs the ironic turn of pitting the stance of the scholar at the end of the twentieth century against that of the artist at its beginning.[7]

Whereas the artist became mired in the historically determinative force of a contradictory colonialism, the author seemingly breaks free from such force to speak with the consistent analytic voice of the disinterested scholar.[8] By now it should be clear that such an ironic move only replicates the modernist and colonial ideal of the coherent subject, capable of intervention at will. And within the context of an analysis of colonialism, that tactic constitutes much more than a personal claim to authority: Just as Matisse in Herbert's account embodied the complete colonial dynamic, Herbert himself personifies the capacity for postcolonial scholarship in the West to grasp colonialism fully.

Evaluating the recent methodological trend that shifts emphasis from subjects who have desires to desires that form subjects, Gayatri Chakravorty Spivak has leveled a similar attack, aimed at much bigger fish than the author of *Fauve Painting*, in her influential essay "Can the Subaltern Speak?":

> Some of the most radical criticism coming out of the West today is the result of an interested desire to conserve the subject of the West, or the West as Subject. The theory of pluralized "subject-effects" gives an illusion of undermining subjective sovereignty while often providing a cover for this subject of knowledge. . . .
>
> When the connection between desire and the subject is taken as irrelevant or merely reversed [as in the work of Deleuze and Guattari], the subject-effect that surreptitiously emerges is much like the generalized ideological subject of the theorist. . . .
>
> Th[e] parasubjective matrix [of Foucault], cross-hatched with heterogeneity, ushers in the unnamed Subject, at least for those intellectual workers influenced by the new hegemony of desire. . . .
>
> In the name of desire, they reintroduce the undivided subject into the discourse of power. . . . And that radiating point, animating an effectively heliocentric discourse, fills the empty place of the agent with the historical sun of theory, the Subject of Europe. . . .
>
> Neither Deleuze nor Foucault seems aware that the intellectual within socialized capital, brandishing concrete experience, can help consolidate the international division of labor.[9]

The disinterested scholarly analysis of the historical production of the subject ironically reestablishes the absolute Subject in the form of Western theory, or the Western theorist. And – this is Spivak's final irony – that absolute Subject of theory, rather than actually attaining a place outside history, relaunches the all-too-political process whereby the advanced intellectual technology developed in the metropole applies itself to the task of exploiting the raw materials of analysis offered up by the current set of postcolonial relations taking place between the former colonial powers and their erstwhile colonies.

A dismal state of affairs, it might seem, both politically and tropologically: The comforting ironic distance between colonialism and postcolonialism collapses into metaphoric similitude. Yet this grimness of prospect only appears

from a particular perspective, the perspective that imagines that the "post" in postcolonialism actually gets past its antecedent, that assumes that trenchant critique can only come from some Archimedean point outside.

We can instead abandon this fantasy of escape. What if, rather than collapsing hopelessly back into colonialism at the end of our argument, we concede from the start that scholarly discourse necessarily and productively operates from a base within the colonial? The ironic turn of postcolonialism then occurs *inside* the ideological space of the colonial. It thereby opens up the complexities and ambiguities of that ideology; it recognizes a multivocality that allows for the possibility of resistance and disruption from within – both in the past and in the present.[10] To reduce the colonial to a single-faceted program for the sake of providing higher moral ground for one's own ironizing position of articulation has the effect, ironically, of granting that regime a coherence that renders overwhelming its hegemonic powers. In contrast, to reposition one's own analytic voice, as well as ironizing gestures from the historical past, at the very heart of the colonial antecedent disturbs that coherence, denies that hegemony. The certainty of colonialism's program vanishes; its frontiers – absolutely necessary to fix in place for those striving to get outside – become ill defined. Cracks and fissures appear within the perfect system.

An effective postcolonialism might thus be imagined not only as the desire to get past colonialism, but also as the recognition of the paradoxical need to return to the heart of that antecedent to realize that desire. Postcolonialism, in other words, realizes its desire most when it acknowledges the impossibility of its realization. A postcolonialism that prides itself on being purely anticolonial, I have been arguing, actually generates a species of neocolonialism; a postcolonialism that recognizes its own role in the production of a certain type of neocolonialism may have the salubrious effect of inserting a note of anticolonial difference back within the colonial. Indeed, by relocating the irony of the postcolonial gesture – one's own, or that of a historical actor – at the center of colonialism, one may hope to confound the difference between neocolonialism and anticolonialism to a degree sufficient to blur the boundaries between the inside and the outside of colonialism, thereby enabling a decentering of the regime itself.

Let us then regard the "post" in postcolonialism not as a declaration of temporal posteriority or of spatial exteriority. Let us instead conceive of it along the lines of the role of the post in the game of basketball: positioned at the center of the floor, serving as a relay between players, assessing their motives and trajectories, facilitating without fully controlling the development of the contest; all the while remaining a part of the game.

Viewed from the perspective of the post, the play between postcolonial theory and art history offers a promisingly different configuration. Previously, a postcolonial critique of art history – or, conceivably but less likely, an art-historical assessment of postcolonial theory – threatened to situate itself on the sidelines (if not the press box) from where it could praise or reprove specific moves taken in a game in which it did not itself take part. The resulting list of

prescriptions and proscriptions could practically write itself: Art history should attend to the manner in which it imposes Western values on non-Western artifacts, postcolonial theory should respect the formal sophistication of visual artifacts that come under its scrutiny, and so on. The real product of such an analytic approach, I have been trying to suggest, would be less the resulting critique than the position of disengaged and objective knowledge thereby posited and claimed. Now, instead, all subjects – both historical and analytical – take up a position on the floor: They all become players, all of whose actions, including their assessments of each other, influence the future direction of the competition. No analytic move, however quick, actually lifts a player out of the action – though it may seem to do so for a moment, as part of the game. Crucially, no one yet knows the outcome (the objective observer on the sidelines had claimed to be able to discern that), since the course of the game shifts with every play – even for dead historical figures, with whom living analysts continue to interact.

What might such a contest look like? By way of illustration, allow me to trace the flow of one possible play. I choose my lineup not principally because of their skills – though they manifest those – but for the sake of providing a sampling, however abbreviated and incomplete, of the variety of players still active on the floor. The action will proceed from a historical figure poised between the disciplines of ethnography and art criticism, to a postcolonial theorist whom we have already encountered, to a contemporary art historian who has chosen to analyze the reception of ethnographic artifacts.

The pass goes to Georges-Henri Rivière, Paul Rivet's deputy director during the 1930s when the two men transformed the moribund Musée d'Ethnographie du Trocadéro in Paris into a refurbished Musée de l'Homme, and author in 1930 of an article entitled "An Object from a Museum of Ethnography Compared to One from a Museum of Fine Arts." Given the date of the article and Rivière's affiliation with the Muséum National d'Histoire Naturelle (stated on the credit line), one might imagine Rivière to be a fellow hopelessly mortgaged to the pseudoscientific vocabulary and principles of contemporary ethnography, a "reluctant imperialist" (to use Wendy James's memorable phrase)[11] cataloging the booty from the colonies for their documentary value while perhaps paying little heed to the aesthetic character of the objects collected and displayed with ethnographic intent. Rivière's opening lines, however, strive to place the author above the fray of competing sensibilities:

Ever since certain groups of ethnographic objects – in particular African and, later, Oceanic sculptures – were added to the realm of artistic curiosities some years before the war owing to prodding from artists of the School of Paris, a chasm has opened between the public converted to this taste and the curators of ethnographic museums.

This was, and still is, the result of nothing more than complaints levied against the barbarism and insensitivity of the scientists who fail to discriminate between the *artistic* and the *nonartistic* and brutally mix, in an

absurd bazaar, monuments of art equal or superior to those of Praxiteles and Verocchio with the most contemptible products of human industry.[12]

Rivière himself, these words proclaim, comprehends both of the contemporary attitudes taken toward objects from beyond the Occident, and can balance the one against the other.

Although now misplaced, the charge by the artistically inclined against ethnography had legitimate grounds, Rivière conceded later in the article: "The lamentable disgrace" of the old Musée du Trocadéro, an institution that failed to fulfill even its minimal mandate to preserve the collections from the destruction of parasites and the elements, had caused Paris to become "the place in the world – excepting its specialists – least informed about ethnography" (311). Advocates of the artistic appreciation of ethnographic objects, however, came under equally scathing ridicule from Rivière's pen. These viewers dreamed of a purely artistic presentation of the artifacts, a "Louvre for . . . all the beautiful works of primitive art" (310):

> On pedestals of mahogany, in a splendid isolation, basking coquettishly in the most refined lighting, carefully depilated, trimmed, stripped, and polished, the masterpieces of Fang, Polynesian, and Aztec art (to mention only those most in fashion) would present themselves. Guide-poets would break out in dithyrambs and teams of copyists would prepare to distribute to the four corners of world the aesthetic of savage regeneration. (311)

If the ethnographers of yore had failed to respect and appreciate the objects entrusted to their care, the artists of the Parisian avant-garde cared so much for the objects purely as objects that they ignored their significance as ethnographic documents and indulged instead in solipsistic, neoromantic poetic rapture.

A new generation of ethnographers – this is the central point of Rivière's essay – could avoid both of these flawed approaches. Able to appreciate the aesthetic character of the objects, such ethnographers nevertheless refused to abstract with finality the concept of artistic quality from the material function of the artifacts in their native context, for the compelling reason that

> in a primitive society of the past or the present, beliefs, customs, laws, and techniques are so closely conjoined that it is illusory to treat them separately. . . .
>
> As a result the aesthetic sentiment, which we tend to differentiate to an ever greater degree [a footnote adds at this point "art for art's sake"], in some sense to secularize, circulates in primitive societies, like blood in the body, closely linked to customs, to religion, and to material objects. (314)

The aesthetic as an abstract entity, in short, was a purely Occidental artifact, and thus the new breed of ethnographers found themselves torn between relevance

to their own culture and fidelity to the culture under study. Rivière devised the following ingenious two-step procedure by which he and his colleagues could finesse the difference: "From the abundance of legal, religious, and economic objects, and even from objects that appear to be of the most humble utility, we must extract aesthetic characteristics. It is up to the Musée d'Ethnographie to explicate these characteristics, to situate them, to restore them to their social setting" (314). Extract and abstract the aesthetic, by all means, Rivière insists; one would hardly wish to disown this refined European intellectual technology. But reinsert that abstracted value back in its source culture, where its signifi- cance compounds: One thereby admires both the aesthetic as such *and* a society in which that aesthetic has seemingly not been alienated into an autonomous and thus potentially isolated concept. Where the old-style ethnographer failed to appreciate artistic value and the artist behaved like a hoarder who to appreci- ate value removed it from circulation, the new ethnographer allows value to appreciate by reinvesting it in the market of intercultural exchange.[13]

There are several ways in which we might assess this set of moves by Rivière. We could celebrate his sophisticated evaluation and manipulation of the con- tradictions of colonialism. We could condemn him for proposing a false resolu- tion to those intractable contradictions and thus unconsciously both perpetuating the colonial stereotype of a fully integrated primitive community and reaffirm- ing the coherence of his own subjecthood. The first elevates both Rivière and ourselves to the standing of omniscient postcolonialist, the second elevates ourselves to such heights at the expense of Rivière; both settle the final score of colonialism.

Alternatively, we could explore how Rivière's formulations, as the initia- tion of a trajectory still active to this day, both extend and disrupt the precepts of an ongoing colonialism. Consider, for instance, the necessary counterpart to Rivière's analysis of aesthetic abstraction: the materiality of the ethnographic object. On the one hand, materiality as an attribute belongs in this essay fully to non-Western societies whose beliefs and values ostensibly impress themselves without mediation into the substance of their manufactured artifacts. Material- ity thus marks the possibility of a social existence for such societies independent of the West and its perceptions of them. Indeed the abstractions of the West – for that matter, scientific as well as aesthetic[14] – can never grasp that materiality precisely because they are always only representing it: Rivière concludes his article with the seemingly optimistic but in fact bittersweet claim that "the col- lections will thus draw a more living, touching, and faithful *picture* of primitive societies" (314; my emphasis).

On the other hand, without the investment of a Western aesthetic to value it, materiality in the field – from the perspective of the West, to be sure – hardly seemed to matter at all to the producers of the artifacts. Rivière's associate Michel Leiris, secretary to the Mission Dakar–Djibouti of 1931–3 led by Marcel Griaule and charged by Rivet and Rivière to gather artifacts for the newly reconceived ethnographic museum in Paris, exemplifies the conceit. Writing in the pages of a special issue of *Minotaure* devoted to the Mission, Leiris justified the

expedition's collection of religious artifacts in West Africa by forwarding the claim that the natives simply discarded the physical objects after their single ritual use: "The *Dégué* mask was found in a cave and the *Kâ* mask . . . in one of those rock holes where the Dogon customarily leave used-up masks to rot or disappear, eaten by termites."[15] In the same issue of *Minotaure* Griaule assured his readers when describing the Mission's removal of murals from a church in Abyssinia: "An old thing, has no value [to the Ethiopians] except that attributed to it by the incomprehensible Europeans."[16] Africans, it would seem, valued objects only for their practical use, after which they could be discarded. The material character of things as such merited attention only from traveling ethnographers intent on collecting, preserving (the ravages of the elements in the field outstripping even those in the old Trocadéro), and exporting to the metropole a representative sampling of African craftsmanship. By these lights, materiality was a European discovery: Only Europeans could see it, and care about it.

If aesthetic appreciation emerged in Rivière's article exclusively as a European activity, materiality thus stood in his work and that of his colleagues as a more ambiguous entity. The solid stuff into which the aesthetic need reinvest itself resisted clear ascription into either the European cultural realm or that of Africa. Rivière's rhetorical ploy of pitting art against science thus has the intriguing consequence of producing not only a version of the aesthetic that affirmed European cultural authority but also a type of materiality that rendered uncertain the compass of that authority: Materiality existed both inside and outside the grasp of Western knowledge. The problematic nature of the material substratum of non-Western existence, and whether Western analysts do or do not have meaningful access to it, persists, of course, beyond Rivière's day into our own era.

Pass forward in time (through the post, if you like) to Spivak's essay "Can the Subaltern Speak?" The essay opens, as we have seen, with a highly abstract theoretical discussion of the unintentional production of the absolute Subject in the work of Western theorists ostensibly committed to challenging the centrality of the subject in liberal-humanist thought. To rephrase the argument in a manner that reveals the parallel to our earlier discussion of the aesthetic in Rivière's article: From the materials of history and politics Foucault and Deleuze extract an abstracted absolute Subject that demarcates a certain colonial authority; the West has (or, rather, is) that absolute Subjectivity, the non-West does (is) not. Spivak herself replicates this move to the extent that she can be described as extracting from the materials of Foucault and Deleuze an abstract critique of the absolute Subject that marks her authority over them: The French theorists don't see the colonial component of their argument (the natives don't see the aesthetic of their artifacts, the avant-garde artists don't see the solipsism of their museological fantasy); Spivak does. Crucially, however, Spivak does not want her meta-analysis to be taken as a simple reversal of the poles of colonial epistemology; she does not want to play the role of the colonized now assessing the colonizer and thus claiming the position of absolute Subject for the non-West:

First, a few disclaimers: In the United States the third-worldism currently afloat in humanistic disciplines is often openly ethnic. I was born in India and received my primary, secondary, and university education there, including two years of graduate work. My Indian example could thus be seen as a nostalgic investigation of the lost roots of my own identity. Yet even as I know that one cannot freely enter the thickets of "motivations," I would maintain that my chief project is to point out the positivist-idealist variety of such nostalgia. (281)

Dividing her own subjecthood between an ethnic origin and an analytic voice that, since it derives many of its resources from the West, refuses ascription to such origins, Spivak will not speak for India: "The postcolonial intellectuals learn that their privilege is their loss. In this they are a paradigm of the intellectuals" (287).

Indeed, Spivak maintains, the very act of "speaking for" any dispossessed group, representing them in both the rhetorical and political senses of the word, constitutes a form of "epistemic violence" (280), since it asserts the speaking subject's authoritative access over the experience and interests of the group concerned. Spivak closes her essay with a lengthy examination of a figure who does not speak but also cannot be easily spoken for: the *sati*, the Hindu widow who immolates herself upon her husband's funeral pyre. Spivak traces a history *within colonialism* of conflicting attempts to speak for the *sati*: the British colonial administrator wishing to save native women from a heathen practice, the learned Brahman defending Hindu law and the doctrine of sanctioned sacred suicide, and so on. While from the comforting perspective of historical hindsight one can denounce such attempts as self-interested *mis*representations (Spivak explores some of the interests thereby realized), it would be a fundamental mistake to imagine that Spivak's act of analysis somehow correctly represents the *sati* in their stead. "Part of our 'unlearning' project," Spivak summarizes, referring to the need to unlearn the presumptuous Western claim to the position of the absolute Subject, "is to articulate th[e masculine-imperialist] ideological formation – by *measuring* silences, if necessary – into the *object* of investigation" (296). In the place of a new voice speaking for the speechless, Spivak offers an acknowledgment of the limits of Western colonial representational practice.

To pursue the parallel with Rivière, we could describe Spivak's move here as a reinvestment: The abstracted analytic position from which Spivak speaks – in order to realize its value, to circulate, to avoid becoming hoarded by the West until it solidifies into the absolute Subject – needs to reengage itself with mute material beyond the compass of Western analysis, material embodied in this essay by the figure of the *sati*, and, perhaps, by Spivak's rather empirical investigation of that figure. Moreover, if the absolute Subject of theoretical analysis in Spivak's essay emerges – like Rivière's aesthetic – as largely a Western artifact, the muteness of that material – like Rivière's materiality – holds its disruptive potential owing not to its speechlessness as such but rather to the impossibility of determining its placement on some conceptual map delimiting the

expanse of West and of non-West and thereby fixing the frontier between them. Muteness is both (and neither) an analytic figure of Spivak's own production and (nor) the real practice of Hindu widows that renders their subjectivity inaccessible to Western investigation. Spivak's essay, like Rivière's, generates both an authoritative position of analysis and an entity that renders impossible the determination of the effective epistemic reach of that position of analysis. Consequently the article, rather than lifting itself above the fray into the ethereal realm of objective postcolonial analysis, instead embroils itself productively in the ongoing enterprise – colonial in origin and arguably colonial still, with that term now freed of its pejorative connotations – of constantly reappraising the uncertain and mutable boundaries of Western knowledge.

Pass across disciplinary lines to Annie E. Coombes, author of *Reinventing Africa: Museums, Material Culture and Popular Imagination in Late Victorian and Edwardian England*. A refreshing respite within the art-historical literature from the glorification of certain prescient artists who heroically resisted the determinative force of colonial ideology, Coombes's book instead analyzes the competing initiatives undertaken by institutions ranging from museums, to temporary exhibitions, to popular books and newspapers, all directed toward making sense of Africa in Britain at the turn of the century. The Western category of the aesthetic stands within this account as one mechanism among many playing a part in the production of that knowledge: "[Much] can be gained from exploring the ways in which . . . discussions around aesthetic criteria and the artistic categories of art and design from the colonies contributed both to the definitions of 'race' and to the ideology of a national culture within Britain itself."[17] Coombes has assimilated a substantial body of postcolonial theory, and it shows in the adjectives she uses repeatedly to characterize the colonial understandings of Africa she investigates: "contradictory," "heterogeneous," "shifting," "variable"; above all, "ambiguous." Her introductory declaration of method, moreover, should by now strike a familiar note:

> I am . . . concerned to indicate some of the more ambiguous and strategic exchanges in the dialogue between coloniser and colonised. In recent years important work, much of it in the domain of literary studies, has theorized various aspects of the colonial encounter [the footnote at this point includes references to Bhabha and Spivak]. It is my hope that the reader of this account will recognize, in the materialist history which follows, the traces left by these insights. I have deliberately avoided expository passages laying out theoretical premises which are then "illustrated" by empirical data. The book has rather made use of critical and political theory to underpin such material and to lend it meaning. (5–6)

An abstracted theoretical machinery invests itself, in order to realize itself, in the empirical material provided by the history of the colonial encounter. The material acquires meaning – it receives it on loan, to be precise – from abstracted theory.

Coombes ventures her theoretical capital, it turns out, in quite certain securities. Taking to heart her own discoveries concerning the impossibility of acquiring unambiguous knowledge about Africa, she scrupulously avoids sustained declarative statements concerning the big continent. The object of her study is, instead, the British analytic means to understand the material of Africa, means now transmogrified into the material of Coombes's own speculations. And this material, Coombes's theoretical machinery discovers as it progresses, *can* be known. Coombes somewhat understates her case when she writes: "Representations of Africa . . . tell us more about the nexus of European interests in African affairs and about the coloniser, than they do about Africa and the African over this period" (3). If fact, this is more or less all they tell us about in the book, and tell us about thoroughly: Coombes uncovers not only the grand imperial strategies but also the local institutional motivations lying behind British formulations concerning Africa. If a Benin bronze plaque remains mute in Coombes's book, if it cannot be spoken for except through misrepresentation, European artifacts such as exhibition photographs, ethnographic treatises, and popular newspaper articles give forth with remarkable clarity, with virtual transparency, the truth of British imperial motivations. Thus the frontier here between what can be known – the ambiguities of British imperialist ideologies – and that which cannot – Africa and its artifacts – is sharply, even unambiguously, drawn.

It follows, of course, that at just this moment when Coombes's material attains certainty, her postcolonial position of analysis loses its ironic distance from its object. The strategy of dissimulating the uncertainties of one's own means of producing knowledge to attain a coherence and consistent voice akin to that of the absolute Subject, I have been arguing, replicates the hubris of colonialism itself: Coombes, in essence, colonizes late Victorian and Edwardian Britain across time with the same certainty and purportedly coherent subjectivity with which earlier British imperialists colonized Africa across space. My earlier analysis explicating the impossibility of escape through ironic distance foresees limited returns to this approach; but it is equally possible that I have misassessed the efficacy of Coombes's move. Perhaps this solid fixing of the material into which abstract theory must invest itself, and the resulting mimicry of colonialism's epistemic certainties, will ironically prove more productive – or will prove more productive of ironies – than a strategy that values the blurring of the boundary between the West and the non-West, between the knowable and the unknown.

I have just been gauging Coombes's approach against my own earlier analysis, and thus the pass has clearly returned to the post. Toward the beginning of this chapter, I abstracted an argument about the impossibility of using irony to abstract oneself out of colonialism into the comforting realm of objective postcolonialism. Toward its end, I have reinvested my abstractions into the material constituted by a set of texts arrayed across the floor upon which colonial and postcolonial players alike (it has been my contention that we can't really tell them apart) make their moves. Whether that set of texts thereby returns the investment or whether they fail to realize the value of my abstractions remains

uncertain: I hope I have left somewhat in question the degree to which these three texts are satisfactorily contained within my analytic compass. Whether I have managed to shift subjectivities frequently and artfully enough to disrupt an implied claim to the position of absolute Subject, or whether in the end I have settled a bit too comfortably into the authoritative position of the post should, in any case, lie beyond my determination: It will be my conceit that I cannot evaluate my success in this matter, just as Spivak maintains she cannot speak for the subaltern *sati*. The game is not over, in any case; the score is not settled. My moves will assume meaning – constantly changing meaning – only as new players assess my efforts and undertake moves of their own.

Which means, reader, that finally the pass is coming to you.

Notes

My thanks, as always, to Cécile Whiting for her careful reading of this essay. I am also indebted to Richard Caines for advice on technical matters.

1 Stephen Greenblatt, *Marvelous Possessions: The Wonder of the New World* (Oxford: Clarendon Press, 1991), 14–20.

2 James Clifford, "The Others: Beyond the 'Salvage' Paradigm," *Third Text* 6 (Spring 1989): 73–7. Clifford's general argument is undoubtedly better known through *The Predicament of Culture* (Cambridge: Harvard University Press, 1988), one of the books in the human sciences most frequently cited across disciplinary boundaries during the past two decades.

3 Homi K. Bhabha, *The Location of Culture* (London: Routledge, 1994), 86.

4 "Within that conflictual economy of colonial discourse which Edward Said describes as the tension between the synchronic panoptical vision of domination – the demand for identity, stasis – and the counterpressure of the diachrony of history – change, difference, mimicry represents an *ironic* compromise." Ibid., 85–6.

5 Fredric Jameson, in *Postmodernism; or, The Cultural Logic of Late Capitalism*, has described irony as "the supreme theoretical concept and value of traditional modernism and the very locus of the notion of self-consciousness and the reflexive," while pointing out that "one of the motifs in the present book has been the survival of just such residual modernist values into full postmodernism." (Durham: Duke University Press, 1991), 258–9, 427.

6 James D. Herbert, *Fauve Painting: The Making of Cultural Politics* (New Haven: Yale University Press, 1992), 167.

7 It might prove intriguing to attempt an entire reclassification of art-historical methodologies – cutting across the usual categories of connoisseurship, social history, semiotics, and the like – based on an assessment of the tropological relation established between scholar and object of analysis. The connoisseur, for instance, could be described as pursuing the synecdoche between the individual work and the oeuvre, which is personified by the connoisseur's own erudition. The social art historian claiming the advantage of historical hindsight over artists locked within history or the semiotician demonstrating the tropological naivety of some set of cultural producers are both ironizing. Yet the social art historian who champions artists credited with the capacity to ironize history and the semiotician who gleefully follows tropological masters, turn by intricate turn, both posit a metaphoric relation: The scholar is like the artist in attaining a certain insight.

8 To be fair, the author of *Fauve Painting* earlier situates the interests of the scholar by drawing a metaphor between the Fauves' relation to the Mediterranean shore and his own relation to Fauve landscapes, but that metaphor is not extended into the last chapter, dealing with the paintings of North Africa.

9 Gayatri Chakravorty Spivak, "Can the Subaltern Speak?" in *Marxism and the Interpretation of Culture*, ed. Cary Nelson and Lawrence Grossberg (Urbana: University of Illinois Press, 1988), 271, 273–5.

10 This, I take it, is one of Bhabha's points: "Resistance is not necessarily an oppositional act of political intention, nor is it the simple negation or exclusion of the 'content' of another culture, as a difference once perceived. It is the effect of an ambivalence produced within the rules or recognition of dominating discourse as they articulate the signs of cultural difference and reimplicate them within the deferential relations of colonial power." *The Location of Culture*, 110.

11 Wendy James, "The Anthropologist as Reluctant Imperialist," in *Anthropology & the Colonial Encounter*, ed. Talal Asad (Atlantic Highlands, N.J.: Humanities Press, 1973), 41–69.

12 Georges-Henri Rivière, "De l'objet d'un musée d'ethnographie comparé à celui d'un musée de beaux-arts," *Cahiers de Belgique* 2 (November 1930): 310.

13 I develop this economic metaphor for ethnographic activity in much greater detail in my article "Gods in the Machine at the Palais de Chaillot," *Museum Anthropology* 18 (June 1994): 16–36, which also appears as chap. 2 in my book *Paris 1937: Worlds on Exhibition* (Ithaca: Cornell University Press, 1998).

14 The abstracted character of ethnographic knowledge is, again, a theme developed in "Gods in the Machine at the Palais de Chaillot."

15 M[ichel] L[eiris], "Masques dogon," *Minotaure*, special issue no. 2 (1933): 51.

16 M[arcel] G[riaule], "Peintures abyssines," ibid., 85.

17 Annie E. Coombes, *Reinventing Africa: Museums, Material Culture and Popular Imagination in Late Victorian and Edwardian England* (New Haven: Yale University Press, 1994), 5.

Part Three

Places & Spaces for Visual Studies

12

Art History and Museums

Stephen Bann

THE popularity of museums is one of the most striking phenomena of the present period. Indeed, there is statistical evidence that attendance at museums has begun to overhaul the numbers of visitors to what are regarded as the distinctive places of resort for a mass society: the cinema and the sports stadium. Figures reported in the British press for the year 1994 record the astounding total of 110 million visits to museums and galleries, which certainly exceeds the total number of individual visits to films or football matches.[1] It seems odd, in retrospect, that scarcely more than half a century ago the French writer Léon-Paul Fargue could pour scorn on the crowds who piled into "sweaty cinemas" to witness the triumph of "the metaphysics of the mediocre," whereas he celebrated the lonely joys of the Natural History Museum: "Myself and a few others we remain there, before the *Diplodocus*, dreaming . . . of the quantity of fresh oxygen which pumped him up like a zeppelin."[2]

It would indeed be a curious reversal if the cinema had become, by the end of the twentieth century, a place for individual reverie, while the museum had come to define itself more and more as a purveyor of mass spectacle. Yet this is precisely the reversal which is urged upon us by cultural critics who have sought to explain the character of the museum experience. Umberto Eco, for example, sees the museum as a vehicle of "hyperreality": In the United States, at any rate, the "imagination demands" conditions in which "the boundaries between game and illusion are blurred, the art museum is contaminated by the freak show, and falsehood is enjoyed in a situation of 'fullness,' of *horror vacui*."[3]

This could easily appear to be the patronizing attitude of the Old World commentator on the New World experience. Yet New World critics return the accusation by asserting that the Old World, to an even greater degree, has succumbed to the dominance of the inauthentic view of history represented by the museum. When the Australian sociologist Donald Horne titles his book *The Great Museum*, he implies that Europe as a whole has succumbed to a view of history which is promoted by mass tourism but is essentially determined by the self-serving needs of the museum industry: "As tourism grows, attendances at museums soar. Museums respond to our need to rediscover a past. They fulfil this need by giving us a history: a history that reflects the priorities of those who keep and own the museums."[4] It would be pointless to try and argue out

this debate between a critic from the Old World fascinated by the factitious nature of history as spectacle, and the New World figure laying the same critique at Europe's door. But the question inevitably arises: If these institutions known as museums are like great Molochs which consume history and serve it up in appropriately processed form, then what about the history that has produced them? Can we disentangle a history of museums, in the strict sense, from the historical hyperreality allegedly fostered by the museum? Is art history, in particular, qualified by its traditions and its methods to approach this exceedingly delicate task?

The point of this chapter is to answer these questions in the affirmative. But first of all it is necessary to confront a specific historiographical issue which dominates all the others. This is the issue of art history's own vested interest in the form of organization which the museum, and particularly the museum of fine art, has come to embody. Wolfgang Ernst, when looking at the crucial period of transformation in which the Neoclassical collection became the modern museum, has commented effectively on the significance of this art-historical "blind spot":

> Art history more or less takes for granted that the display of historical works of art in public collections since the eighteenth century has changed from a traditional, rather miscellaneous cabinet type of exhibition, an atemporal "mixed school arrangement," to a more art-historical paradigm, placing the items within a conceptual frame of evolutionary, temporal, and stylistical development and thus reflecting a growing historical consciousness. But there is a blind spot in this art-historiographic narrative of an epistemological break between the Enlightenment ideal of universally categorizing information and a historical understanding and representation of art in the romantic/historicist epoch of the nineteenth century: its underlying paradigm – the assumption of art-historical development – itself already privileges, that is, assumes the kind of history it pretends simply to describe as a result of research.[5]

Here is indeed a point which requires to be taken very seriously from the outset. When we look back at the history of museums, it is inevitable that we should interpret that history *grosso modo* in terms of two conceptually distinct phases. The first, roughly speaking up to the end of the eighteenth century, qualifies as a "prehistory" in the sense that the collection and display of objects appears to answer to no clear principles of ordering by genre, school, and period. The second, which represents an almost irresistible movement toward conformity over the course of the last two centuries, is a history in which the museum has developed and perfected its own principles of ordering by giving spatial distribution to the concepts of school and period, in particular.

Is this a categorical distinction, or can exceptions be found? It hardly needs to be emphasized that the transition from one phase to the other was far from being a clean break. Alexandre Lenoir was no doubt the first museum director

to classify his groups of monumental sculpture in terms of a succession of "century" rooms, laid out in the former Convent of the Petits-Augustins, which had been placed at his disposal by the revolutionary Convention.[6] Yet Lenoir's museum has already been closed in 1816, by order of the new government of the Restoration, when Sir John Soane began to work seriously on the development of his own museum in Lincoln's Inn Fields, which Wolfgang Ernst correctly describes as being "ahistorically 'Neoclassical'."[7] The fact that Lenoir's chronologically arranged museum has disappeared, while Soane's wonderfully eccentric and "timeless" juxtaposition of heterogeneous elements has survived, is a potent reminder of the complex history of the museum in this transitional period. But it should not blind us to the fact that Lenoir's typology represented, in the long run, the winning side.

The extent to which this remains the case can be measured by the singularity of another exception. When the English painter Turner died in 1851, he left his personal collection to the nation under certain conditions, one of which was that two of what he conceived to be his best works – *Sun Rising through Vapour* and *Dido Building Carthage* – should be hung in perpetuity between two of the paintings by the French seventeenth-century painter Claude which were in the national collection. They were to go "between the Seaport and the Mill."[8] Although their place in the National Gallery has changed over the years, Turner's instructions have been respected, with the effect that, at present, the two seventeenth-century and two nineteenth-century works occupy a small polygonal gallery next door to a room of Claudes, but very far removed from the remaining Turners in the collection, which are placed in the company of Reynoldses, Gainsboroughs, Constables, and other examples of the "British School."

This remarkable, if minor, disruption of the order of the museum, to fulfill the wishes of a great painter, may well be an isolated instance. But it enables us to assess more precisely the degree to which the normative ordering of the museum in terms of chronologically arranged, usually national "schools," reflects and endorses the approach of the art historian. It is not, of course, that the juxtaposition of a Turner with one of his admired seventeenth-century models makes no art-historical sense. No art historian would dream of neglecting this crucial aspect of Turner's work. But the point is that art history offers a matrix which is, in the fundamental sense, historicist: That is, it proposes an overall distribution of works governed by the factor of period, with the succession of individual galleries being arranged so as to cause the least abrupt chronological transitions. It is assumed that the visitor will be disoriented, say, by the immediate proximity of Italian primitives and Dutch genre paintings.

Moreover, the art-historical approach superimposes on this chronological sequence a further normative classification, which is the distribution into schools. This means that a German painting from the early eighteenth century is more likely to hang with another German painting from the end of the century than with a French work closer to it in period. In the recent period, curators have indeed begun to question the validity of this norm, and to make appropriate changes. The new Sainsbury Wing of the National Gallery in London,

for example, systematically places within the same space representatives of the Northern "Netherlandish" schools and those of France and Italy. It will be clear that distribution by schools, which requires the massing together of national representatives from a period which can hardly be less than a century, over-rides to some necessary extent the principle of chronological hanging. But no one but a lunatic would propose a form of gallery organization which insisted on the strict chronological sequence of works of art, irrespective of their other properties.

In selecting the example of the museum of fine arts to demonstrate the museum's alliance with art history, I am of course taking the most salient possible case. Museums of natural history reflect, as will be clear, a wholly different scale of chronological ordering, which offers its own possibilities of aberrant or parallel classification (for example, the Oxford Museum, which arranges artifacts by type rather than showing all the artifacts from a particular area in an overall grouping).[9] But, as this chapter is specifically concerned with art history and its approach to museum studies, I shall continue to concentrate on the problem of the "blind spot": namely, that the art historian is in danger of registering as the definitive state of the museum precisely that form of order which has been determined by the growth of art history as a self-conscious discipline.

What is the alternative? Is it in fact impossible to escape from the conclusion that "aberrant" museological phenomena should be seen essentially as departures from a norm which was established in the nineteenth century, whether (like Soane's museum) they developed in the same culture or belong to the lengthy prehistory of modes of collecting and displaying artifacts? Instead of answering this question directly, I intend to list just a few of the ways in which the art historian can escape, with a little care and forethought, from the trap of relating all these diverse manifestations to the same ideal. If this requires the art historian to become, in a significant sense, a cultural historian, or indeed a practitioner of what has been called "cultural poetics," then this is a small price to pay for the increased clarity of focus.

The first point to be made concerns the vexed question of the "origins" of the museum. Although it has been assumed here (and will be further debated at a later stage) that the museum is a creation of the nineteenth century, there is no avoiding the point that the etymology of the word directs us (as is the case with all the major institutions of Western culture) to the ancient world. As with the history of the visual arts in general, the fragmentary state of our knowledge with regard to the classical period makes it impossible to speak with any certainty on the role of those institutions dedicated to the Muses to which the term "museum" was first applied. But we cannot doubt that an immense amount of contemporary historical interest has been generated precisely by the elusive nature of the evidence. Paradigmatic of this phenomenon might be the attempts to reconstruct, from the basis of the Elder Philostratus's famous *Imagines*, the Roman picture gallery of the third century A.D. to which his descriptions of individual paintings purportedly relate. Norman Bryson has convincingly shown that one of the most ambitious of these attempts at reconstruction, carried out

by the German émigré scholar Karl Lehmann in 1941, should be understood not as a disinterested historical enterprise, but as an attempt to defend "a beleaguered cultural subject."[10] That is to say, Lehmann's extraordinary ingenuity in working back from the ambiguous text to the solidity of "massively stable architecture" is an index of his own compelling need to find some ground of meaning for his own status as an art historian exiled in America while Europe went to war.

There is a genuine pathos in this example. Nonetheless, it should alert us to a problem endemic to the study of art history, and the history of museums in particular, which is that any pursuit of origins risks being overdetermined by the cultural needs of the contemporary subject. Art history, particularly in the hegemonic German variety represented by historians like Panofsky and Lehmann, has itself been formed by historical pressures which made such visions of the ideal all too necessary in the stark conditions of cultural production in the contemporary world.

A different type of problem is encountered if we look for the prehistory of museums in the medieval and early modern period. To a certain extent, the issue can be resolved by taking the approach implied by a recent essay title: "From Treasury to Museum: The Collections of the Austrian Habsburgs." As Thomas DaCosta Kaufmann convincingly argues, the amorphous notion of the "treasury," attached to a great ruler in the late medieval period, gradually yields to a more concrete manifestation, as the store of riches is no longer maintained in secrecy but opened up for purposes of conspicuous display.[11] The emperor Rudolf II's *Kunstkammer*, established at his palace in Prague from the 1580s onwards, represents the most elaborate and varied set of collections on view in the whole of Renaissance Europe. It has, moreover, a direct continuity with the final emergence of Vienna as a major museum center, with its Kunsthistorisches Museum, built in the 1870s. As early as the reign of Maria Theresa, in the mid eighteenth century, objects deriving from the Hapsburg collections had come "to be appreciated more for their historical than their numinous associations."[12]

However, the risk of construing the history of collections in terms of so broad a chronological sweep is that the specificity of each phase – treasury, *Kunstkammer*, educational collection, art-historical repertoire – becomes elided. Art history does indeed assert itself as the end of a teleology whose earlier stages are devalued by comparison. This fault is perhaps particularly apparent in relation to the distinctive phase in European cultural consciousness which bears the name of "curiosity."

Douglas Crimp has indeed specifically commented on the dangers of assuming (as was already done by Julius von Schlösser in his pioneering work *Kunst – und Wunderkammern*, published in 1908) that the Kunsthistorisches Museum of Vienna had its "prehistory" in the Hapsburg *Wunderkammer* of Schloss Ambras. He explains:

Anyone who has ever read a description of a *Wunderkammer*, or *cabinet des curiosités*, would recognize the folly of locating the origin of the museum

there, the utter incompatibility of the *Wunderkammer*'s selection of objects, its system of classification, with our own. This late Renaissance type of collection did not *evolve* into the modern museum. Rather it was *dispersed*; its sole relation to present-day collections is that certain of its "rarities" eventually found their way into our museums . . . of natural history, of ethnography, of decorative arts, of arms and armor, of history . . . even in some cases our museums of art.[13]

This is a salutary warning, and Crimp is quite right to point out the extremely diverse destinies of the objects and artifacts which originally found a common home in the "cabinets of curiosities." But of course it does not mean that these cabinets are inaccessible to study. On the contrary, it is much more rewarding for the historian of museums to encounter the cabinet of curiosities in terms of its irreducible difference, as a form of counterdiscourse to the nineteenth-century museum, than it would be to have something as improbable as the museum in an embryonic state, open to our inspection. Michel Foucault has pointed the way to an estimate of cultural history which takes account of its discontinuities, through giving prominence to the concept of the *épistémè*. Krzysztof Pomian has done the indispensable preliminary work of minutely examining the epistemology of "curiosity" in its Renaissance and early modern context. My own recently published work on the Cabinet of John Bargrave, benefiting greatly from these antecedent examples, has attempted to tease out the multiple symbolic meanings of just one of these collections, formed during the important transitional phase of the mid seventeenth century.[14]

If the "cabinet of curiosities" is best considered as a counterexample to the museum type, a different issue arises in relation to the more recent shift in periods and modes of thought, which is generally described as a transition from "Enlightenment" to "Romanticism." Here, quite obviously, we are on the threshold of the nineteenth century and hence close to the museum in its recognizably modern form. But this is no reason to reject the historiography of differences in favor of a crude evolutionary model. There is every reason to believe that, although the broadly educational and philosophical tone which collecting acquired in the eighteenth century continued to resound in the modern museum, the spatial and physical constitution of the museum was the result of a more radical shift in popular consciousness, conditioned by the historical rupture of the French revolutionary period.

Two examples may be cited here to clarify this point. By the mid eighteenth century, the venerable University of Bologna had accumulated numerous scientific and educational collections in an overall *Instituto delle Scienze*, which was housed in a vast *palazzo* in the Via Zamboni. Nowadays the university boasts no fewer than eighteen "Rectorate museums," loosely derived from the original institute but housed in laboratories and other buildings throughout the city: They include the Naval Museum, with model vessels dating back to the seventeenth century; the Obstetrical Museum Giovan Antonio Galli, with surgical instruments and clay models originally in the possession of an eighteenth-century

surgeon; the Museum of Human Anatomy, which comprises the oldest known anatomical relief models; and the Astronomical Museum, still housed in the original *palazzo* and still used as a working observatory.

How are we to judge the changes that have taken place? Clearly we have to acknowledge the point that, in the Enlightenment, it seemed appropriate to shower collections of demonstrable scientific value on a university like Bologna. It was indeed Pope Benedict XIV who provided both the anatomical collection and the stock in trade of the surgeon Galli for the benefit of the learned community. But nothing could have been farther from the intention of such a donor than to create a museum, or a group of museums. In the eighteenth century, collections of this kind were presumably not displayed or localized in a particular manner, except insofar as they needed to be available for consultation by teachers and students. At the present day, however, a quite different regime exists. The collections have not necessarily ceased to be of interest to students, but they are now made available in specific locations, where the element of phenomenal display inevitably determines our appreciation. The Astronomical Museum – where a succession of historically interesting quadrants for observing the heavens is still in place, not far from the humble contemporary devices for measuring wind velocity – is the epitome of this historicization of use in the interests of display.[15]

The situation at Bologna cannot of itself explain this "museum effect," which has gradually overtaken the university collections. But we can perhaps discover a clue to the significance of this change by looking at the privileged example of Alexandre Lenoir's Musée des Monuments Français, which existed in the old conventual buildings of the Petits-Augustins on the left bank of the Seine in Paris from around 1795 until it was disestablished by order of the Restoration government in 1816. On the one hand, Lenoir's commission from the revolutionary Convention was undoubtedly educational in nature: He was to salvage the numerous works of sculpture and architecture which had been damaged or placed in jeopardy by the iconoclastic acts of the revolutionary mob, and make them a vehicle for instruction. But this, of course, in no way determined the precise circumstances in which the objects were to be stored and made available; in this respect (as has already been noted here) Lenoir was an innovator. First of all, he took over an entire existing historical building in which to install his museum. Secondly, he arranged his collection in the form of a sequence of "century" rooms.[16]

My hypothesis is that the revolutionary period in France, whose effects also extended to the rest of Europe, contributed to the rise of the modern museum a distinctive and novel element, which could be described as the historical concretization of place. In France, both Alexandre Lenoir and his successor Alexandre du Sommerard, who opened the Musée de Cluny to visitors in 1834, took over existing buildings which they comprehensively reinvested with historical specificity: They simultaneously spatialized time – as in the succession of century rooms – and concretized milieu – as in the plethora of medieval and Renaissance objects which du Sommerard distributed throughout the rooms of

the medieval Hôtel de Cluny. Yet any attempt to make sense of the attraction which these novel forms of display held for the French and European public has to take account of a further and vitally important factor. For the historically concrete to make an impression, it was necessary for there to be a widespread and pervasive sense of historical loss; that is, the sense that the revolutionary break had caused a rupture in continuity with the past caused an exactly proportionate need for restitution. The genesis of the modern museum is inscribed in this unprecedented historiographical development.

Yet a final point to be made as a conclusion to this historiographic section is that the French experience can only be generalized to a certain degree. It was England's turn, as a country relatively unscathed by the French Revolution, to harbor aberrant museological examples such as the Soane museum, whose unique brand of atemporal Neoclassicism strikes a note of contemporaneity even today.[17] In Germany, by contrast, we can say that the special cultural circumstances of this amalgam of states, forced at differing paces into the modern world, favored an epiphany of the museum as the definitive repository of art and culture which was without precedent elsewhere. Carl Friedrich Schinkel's Altes Museum, constructed in Berlin between 1822 and 1830, is a classical temple dedicated to art which forms an amazing contrast to the makeshift endeavors of the contemporary French museologists, yet betokens at the same time an even more imperative desire for the restitution of an ideal past. It is not difficult to see in such a manifestation the matrix for an art history which would construe its procedures in accordance with the triumphant evolution of styles and schools, and at the same time perpetuate the desire for an ultimately irrecoverable classical past to which Lehmann's putative reconstruction of Philostratus's museum bears witness.

II

Just as the historiography of museums is irretrievably contaminated by art history's complicity with the museum as a form of display, so the critical study of museums has to reckon with a significant history of museum critiques. In effect, the modern museum has been a highly contested site from its very inception. As early as 1807, the classical archaeologist C. A. Böttiger, who was to become director of the Gallery of Antique Art at Dresden, had sketched out a historical scheme for the development of art and taste in which the museum epitomized the final stage of debasement. The Greeks had seen the function of art as being inseparable from religious and public functions. The Romans had begun the process of deterioration by making Greek art itself an object of aesthetic contemplation. The modern museum had completed the process by devising a new form of institutional display in which the works were by definition cut off from their original functions.[18]

Böttiger's comments seem mild, however, by the side of those provoked by his contemporary Lenoir's Musée des Monuments Français, which – true to its

revolutionary origins – provoked intense controversy at the opening of the post-Napoleonic era. As Francis Haskell has effectively outlined, the historically ordered museum which helped to educate a whole generation of French historians such as Barante, Thierry, and Michelet, was violently condemned at once by a Neo-classical theorist like Quatremère de Quincy and by a Romantic conservative like the poet Chateaubriand, who went so far as to assert: "These monuments have nothing any more to say to the imagination or the heart."[19] In both cases, it was precisely the displacement of objects from their original location that shocked these commentators, who appeared oblivious to the fact that Lenoir had in many cases saved sculptures and architectural features from likely destruction.

In the more recent past, the museum has again become the stake of ideological conflict in France, and the issues have not been neglected elsewhere. It is interesting to note that, in the early nineteenth century, Lenoir's museum was seen as an Enlightenment project, and consequently was condemned by those who wished to assert a more subjective, poetic valuation of the historical object, which was bound up with the desire to retrieve the prerevolutionary past in its integrity. In the current period. the museum has predominantly been attacked from the Left, not because it aspires to democratize and demystify art, but precisely because it has failed to fulfill that objective. In this context, it is worth looking carefully at the debate which arose in the 1960s around André Malraux's much-popularized concept of the "musée imaginaire," or museum-without-walls established by the widespread diffusion of images through photographic reproduction. The critic Georges Duthuit protested vehemently against this concept in his study *Le musée inimaginable*, while Maurice Blanchot summed up the issues of the debate in a searching essay, "Le mal de musée," where he acknowledged the many problems attaching to these "palaces of the bourgeoisie" and summed them up in the principle of almost metaphysical "lack" which the work of art suffers by its reluctance to find a home in the world. This is a very different ground of complaint from the one being developed at the same time by the sociologist Pierre Bourdieu, whose work *L'amour de l'art* certainly reinforced the evidence for the bourgeoisie's dominant place in the museum, without fully acknowledging the contradictions latent in its historical development.[20]

It cannot be denied that, at present, the burgeoning discipline of "museology," which takes Bourdieu's sociological study as one of its major paradigms, has a paradoxical effect insofar as it tries to load the museum with accusations of elitism and mystification. The fact that a rigorous critique of the museum as an institution should be conducted simultaneously with the museum's ineluctable rise to prominence and popularity is in itself unobjectionable. Indeed, it could be argued that this increasing popularity, as measured by the figures quoted at the beginning of this chapter, is at least in part the result of the fact that directors and curators are now taking more account of sensitively assessed visitor response. Certainly there is no special need for a celebratory spate of museological publications to counterbalance the pessimistic and politically pointed critiques of the last twenty-five years. Everything turns, however, in my

view, on the need to accept the internal contradictions which are built into the development of the modern museum. As it has been argued here, the museum as we know it is the result of an Enlightenment project. But it is a project which has been fulfilled precisely through its negation: that is to say, from the point at which the didactically assembled objects became also vehicles of feeling and testaments of loss. It is not possible for the museum to emancipate itself from this dual identity.

It is, however, possible for the art historian to work with this factor in mind. If I have insisted in this section on the historical basis of museum critiques, this is precisely in order to indicate the distance which the historical inquiry is obliged to adopt, for fear of endorsing one or other of the positions which those critiques have successively taken. It will be obvious from the way in which the argument has developed here that I advocate an approach to the museum which is, in the Nietzschean sense of the term, *genealogical*, paying close attention to the specific practices of collection and display existing at each particular epoch, rather than assuming false continuities which can only be made to seem plausible by fetishizing such terms as the "collection," the "display," or the "museum." It will also be obvious that my way of developing such an approach is greatly indebted to Foucault's concept of the *épistémè*, which, by drawing up formal oppositions between Renaissance, "classic," and "modern" mentalities and orders of discourse, makes it possible to see how, for example, the cabinet of curiosities and the modern museum participate in the distinct discursive formations appropriate to the total system of knowledge identified with a particular period.[21]

What does this imply in practice for the historical study of museums? I can only offer a few representative examples here before passing to a more specific recommendation. In the first place, it will be clear that this chapter has dealt predominantly with the museum of fine art as a privileged object for the art historian. Museums of natural history and ethnography – not to mention the forms of spectacle which find their apotheosis in the historical theme park – are unquestionably part of the same historical development, and they have attracted widespread interest in the recent past. But it can safely be asserted that the issues pertaining to them have arisen, and continue to arise, as a result of the necessary self-scrutiny of the social sciences, faced with such questions as: "What kind of knowledge do ethnographic museums transmit? What does it really mean *to see* a culture and to understand it by looking at objects?"[22]

In my view, it falls particularly to the art historian to look at those examples which refer back to a period antedating the functional separation of museum types, and hence to scrutinize varieties of display which promoted distinctive relationships between knowledge and visibility in the four centuries or so which elapsed between the Renaissance and the mid nineteenth century. To take one significant case, the Musée de Cluny, founded by the collector Alexandre du Sommerard in the early 1830s and subsequently adopted as a museum by the French state after his death, was before all else a historical museum, dedicated to the revival of the life of the late Middle Ages and the Renaissance, which were evoked in a series of densely packed period rooms.

Yet it was also in a real sense a precursor of the "folk museums" and "museums of everyday life" which are current today, insofar as it admitted innumerable objects of everyday use which had never been placed on display before. In this respect, it decisively changed the formula of Lenoir's Musée des Petits-Augustins, already mentioned here, which confined its own century rooms to the display of sculptural and architectural objects.[23]

In my own analysis of the Musée de Cluny compared with the Musée des Petits-Augustins, I attempted to show how general comments such as these could be tested and refined by the tools of structural and rhetorical analysis. These would show, for example, that the arrangement of objects in Lenoir's museum was exclusively metonymic in character, juxtaposing individual "specimens," while that of the Musée de Cluny was metaphoric and synecdochic, privileging the assimilation of individual objects into an overall image of resurrected "life." Although it cannot be denied that du Sommerard learned from, and to a certain extent imitated, his predecessor, it is surely more productive to insist on these crucial differences, which themselves relate quite evidently to the transition from an educational, "Enlightenment" project to one more comprehensively engaged with the revival of a vanished past, and hence appropriate to the "Romantic" epoch. Structural, rhetorical, and semiotic analysis of museum forms will not provide us with the overall historical concepts which are bound to dominate this (as indeed any other) mode of cultural analysis. But it will, arguably, provide the means for interpreting historical and cultural change in terms of specific differences, which are legible in the visual and literary records of the museums in question.

A further point about method must be made here. Bound up with the various methodologies which I have cited here is the overall thesis of the "Death of the Author," which in the early years of Structuralism seemed an indispensable preliminary to any task of exegesis. Yet no one was particularly preoccupied about the "authors" of museums and collections. Only in very rare cases had they acquired (as in the case of the Soane museum, perhaps) a mythic identity which to some extent dominated the way in which the collection was perceived. Hence there was no need for the "authors" of museums to die. Indeed, it could be argued that the genuinely creative move was in fact to bring back into debate the subjective agency of the collector, not to reinstate a naive notion of direct communication, but to emphasize the discursive element which was inevitably involved in any such sustained public role.

This shift of emphasis brings the history of museums more closely into phase with the widespread critical movement known as the "New Historicism," which gives emphasis precisely to the element of "self-fashioning" as a mode of socially negotiated cultural practice. Its effects can be detected especially in the early modern period. For example, my own recent study of the Cabinet of Curiosities created by John Bargrave takes for granted that the collection is a component of the overall project of "living symbolically," and is hence involved dynamically in the processes of display and communication, as well as in the vital function of providing a surrogate memory system for its author.[24] This approach

contrasts very sharply with the tendency to regard the Cabinet of Curiosities as an ideal model, more or less divorced from the social world and perceptible largely in terms of the complex array of types and categories of objects with which it peoples its miniature world.

Such an emphasis can also be brought to bear on the crucial transformations which took place in the nineteenth century and so initiated the regime of the museum as we know it today. It is beyond doubt that the great museums which dominate Western culture at the present time are the product of very diverse histories, in which many forms of subjective agency have been involved. They are, all of them, repositories of "micro-museums," or individual collections which have been assimilated at different stages and only retain a vestigial identity of their own. But this does not mean that the individual collection is irrecoverable. Still less does it mean that we should neglect the outstanding examples of collectors who were also novelists, poets, and pioneers of the imagination, and thus fostered the "historical-mindedness" to which the museum pays unending homage. From Sir Walter Scott to Pierre Loti, the past century is replete with examples of authors whose dialogue with former ages took the form of the establishment of a concrete milieu, made accessible to the public by stages and anticipating the battery of effects which the museum would subsequently press into service.[25]

III

There is perhaps little need to emphasize at this stage in the argument that I regard museums neither as the secular temples which their architecture often brings to mind nor as the Benthamite panopticons, compelling the visitor to ritualized degradation, which certain contemporary critiques conjure up. They are, in effect, institutions open to a plurality of experiences and interpretations, and, insofar as they concretize concepts of history and value in terms of visual display, they provide a privileged subject matter for art history and cultural studies alike. But how are they to be assessed? I have already ranged over a number of possibilities, the common factor of which is no doubt the method of genealogy; this implies the investigation of *difference* in the ostensibly monolithic museum, whether through the broad historical differentiations postulated by Foucault, or through the minuter features accessible to rhetorical analysis, or through the retrieval of subjective agencies in the form of the impersonal collection.

A further, related possibility remains to be looked at in more detail. This might be called comparative museology, since it draws its insights from the juxtaposition of museum types in a historical and contextual framework which is already given. It has been implicit throughout this chapter that the nation states of Western Europe – in particular Britain, Germany, and France – have engendered different museum types as a result of their differing experiences of modern history, however much the normalization of modes of classification and display

has tended to reduce this disparity in the last half-century or so.[26] But it would be an unwieldy project to compare, say, a great German and a great French museum, given that almost every museum is (as has been said before) a sum of different components. Yet the differences which exist between national cultures can also be found, on a more modest scale, in museums which exist in a single country, or indeed in a single town. At this level, they become specific enough to respond to close analysis, and they can be made to demonstrate features of more general importance.

France remains a country of inexhaustible interest from the point of view of museological study. At the top of the pyramid, the Grand Louvre actively and stridently proclaims its status as the largest museum in the world. At the same time, countless small museums distributed throughout provincial France demonstrate an infinite number of stages between gross neglect and hyperactive modernization. The state of neglect is, of course, more favorable to the interests of the historian. But the achievement of modernity can also be illuminating, from the comparatist point of view. The transformation of the nineteenth-century Musée Lapidaire installed in the ruined Eglise Toussaint at Angers into the prize-winning postmodern Galerie David d'Angers, filled with Neoclassical sculpture, is a case in point.[27]

This is a case of one site changing its function over a considerable period of time. But there are also many fascinating contrasts to be drawn between different types of museum existing within the same community which have evolved at differing paces, or indeed not at all. The only concession to the contemporary world offered by the turn-of-the-century installations at the natural history museums of Toulouse and Nîmes is a display warning the tourist that purchase of ivory objects is now illegal. (It is slightly offset, in the case of Toulouse, by the maintenance of a life-size display illustrating, in gruesome detail, the *gavage* of geese for *foie gras*.) On the other hand, Nîmes now boasts a double provision of museums of fine art, with the resplendent belle-époque Musée des Beaux-Arts separated by a few streets (and a Roman arena) from Norman Foster's high-tech Carré de l'Art. Toulouse is still struggling with the overrich legacy of the revolutionary period, but this position presents many advantages to the historian. It can claim to have, in its Musée des Augustins, the second museum to be founded in the whole of France after the Louvre; and the fact that its original installation in the church and cloisters of the Augustinian canons was not (as in the case of Lenoir's museum) revoked during the Restoration gives it a unique historical continuity. The completion of the exhibiting space by a massive posthumous gallery addition from the designs of Viollet-le-Duc gives it further interest as a composite of buildings connoting widely different modes of display which continues to offer creative possibilities to the curator.[28]

My primary example of the museum provision of a French town comes, however, from Chalon-sur-Saône, situated between Dijon and Lyon, at the southern limit of the Burgundy wine-growing district. Chalon's Musée Denon exhibits an extraordinarily complex series of historical functions and stages, whose effects are still perceptible in the institution as it exists today. The museum was

originally founded in 1820, as a result of a legacy by a prominent citizen who envisaged combining a school of drawing, such as had already existed in the town during the early days of the Revolution, and a museum of fine art. A collection of original drawings for the building by the architect Jacques-François Carbillet shows what is approximately the Neoclassical facade that still exists today, in a prominent location in the Place de l'Hôtel de Ville.[29] Chalon was one of the first towns in France to set up an institution combining the functions of a museum and an art school, and its initiative was favored by the links maintained with the renowned Egyptologist and supervisor of artistic life under the Empire, Dominique Vivant Denon, who had been born in the town in 1747. In 1866, the director of the establishment, Jules Chevrier, succeeded in divesting the museum of its art school, which was removed elsewhere, and developing the collections of what was henceforth exclusively the Musée Denon. Among the more unconventional additions which he made was a group of the original photographic apparatuses used by the pioneer of photography Nicéphore Niepce, himself also a native of Chalon.

The Musée Denon in its present form demonstrates the stages of this history like a palimpsest. Its highly public Neoclassical facade, though not provided with all the allegorical embellishments planned by Carbillet, indicates the town's commitment to the concept of artistic education, offered without cost; its large windows offer access to luminous studios, where studies from plaster casts of antique sculpture originally took place. These have been progressively taken over by collections of different kinds: French painting, represented by nationally important works such as a fine *Portrait d'un noir*, by Géricault, but also by achievements stimulating more local pride, such as the *Vue d'Alger* by the Chalon painter Etienne Raffort, which is proclaimed to be the oldest known manifestation of the Orientalist style; also French furniture, which is analyzed by the contemporary curators in a particularly sophisticated way, noting its use by different classes and its relevance to the concepts of provincial style. The obligatory Denon room has a more diffuse identity, being largely made up of work by contemporaries of the artist, and especially those whom he knew and assisted, though medals designed by Denon himself are also included. A minor difficulty of classification is made public in a note appended to the "Mosaïques de Florence" (French substitute products from a factory founded at Denon's instigation) exhibited in this section: They "ought not in principle to be on show among the paintings because they are mosaics" reads the note, surprisingly addressed to the visitor.

It is on the ground floor of the museum (accessible by a flight of steps) that the building's original use as a convent becomes evident, as we move from well-lit studios down to the stone-floored storerooms which contain the archaeological collections. It is an understandable strategy, followed by other French museums like the Musée Granet at Aix-en-Provence, for the multipurpose collection to devote its cellar, or its dimly lit and less accessible spaces, to the showing of stone sarcophagi and reconstructions of burial sites. As visitors only rarely percolate so far, the individual explorer is all the more conscious of a leap in time being concretized by a shift in space. Nevertheless, even the most

remote, the Gallo-Roman, recesses are from time to time invaded by hordes of school children, and it is partly for their benefit that a visitors' book has been provided. Current entries range from the purely phatic, signifying "I am here," to those which might be thought worthy of figuring in a sociologist's database:

Good exhibitions, neat museum.

[Signed] The Famous Five

Very fine museum – paintings badly lit – guards with the mentality of prison warders – not so smart for a museum. I would be in favour of more explanations in the room itself (putting everything back into the historical context now lost sight of . . .)

[Name and address withheld][30]

Jules Chevrier's foresight in preserving the apparatuses used by Niepce was finally rewarded when, in 1972, the town opened a second museum, the Musée Nicéphore Niepce, in a spacious converted building by the Saône. Denon's prestige is still to be revived.[31] That of Niepce, however, has grown enormously in the past quarter-century, and the new museum aspires to be a record not simply of this Burgundian pioneer's first experiments in the fixing of light rays on chemically prepared plates, but of the whole subsequent course of photography, from the 1820s to the present day. The vast exhibition rooms, still retaining the signs of their premodern construction, are filled with curious objects which relate to the age-old project of capturing the fugitive effects of light: not just the heliographic prints of Niepce and the daguerreotypes devised by his close colleague,[32] but also displays relating to initiatives like the optical research of the seventeenth-century Jesuit Athanasius Kircher, and to distinctive stages in photographic history, like Fox Talbot's editing of the *Pencil of Nature* and Ducos du Hauron's invention of the first color photography process.

In the difference which has opened up between the Musée Denon and its now much more favored offspring the Musée Niepce, it is possible to see a paradigm not merely of emerging museum types but also of the whole relationship between visibility and knowledge which might be of interest to art historians and cultural historians. In the Musée Niepce, it is noteworthy that only the earlier stages of the chronological display offer easy possibilities of participation by the visitor. Kircher's models can still be manipulated and recreated. The experiments of Niepce, and of Fox Talbot, are still placed under the sign of an individual quest which we can follow and, to a great extent, understand. But as the display progresses, it is very often the cameras themselves, isolated under great domes of perspex, which take over. They lie, like brilliant cult objects, against the black backgrounds of the display units, each more adept than its predecessor at capturing the functions of the eye.

I began this chapter by contrasting the popularity of the museum, by current estimates, with that of the cinema, and by suggesting that it would indeed be strange if the former were to become associated with mass spectacle and the

Figure 33. The Museum as Distopia *(from the entrance ticket to a major French provincial museum; tinted yellow in the original), 1994. Two schoolboys kneel before the instruments of the Passion in Lebrun's outsize Crucifixion while another cocks a snook in Meleager's direction.*

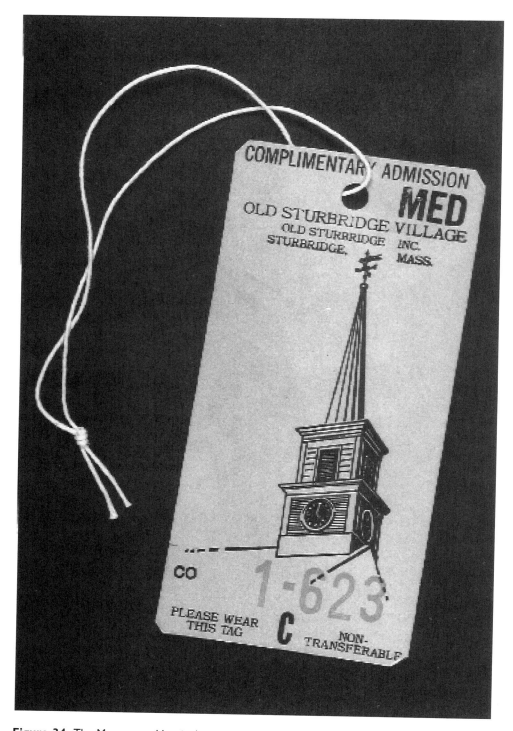

Figure 34. The Museum as Utopia *(entrance ticket to a historical theme park in the United States; tinted orange in the original), 1991. It is endless noonday in the revived colonial community.*

latter with individual reverie. My argument has no doubt shown that this opposition is not a valid one: that the phenomenon of the contemporary museum is still far too diverse for any such generalization to hold good; and that, in any event, the museum and the cinema have intertwined roots in that long-term historical evolution of the culture of visual display to which the Musée Niepce, however problematically, bears witness. Amongst the diverse types of spectator involvement postulated by museums at the present day, we can indeed discover the evidence of the most widely discrepant modes of engagement, ranging from blank alienation in the face of high culture to a virtual absorption of the visitor in the fictional spectacle whose goals are not very different from those of cinema itself (Figs. 33 and 34). Only a genealogical approach, as I have argued, can discern the threads in this bewildering tapestry.

Is the art historian specially qualified to undertake this type of work? The answer can only be that the area is not likely to be annexed by any other discipline. Despite the important contributions of specialists in history and the social sciences, the focus of museum studies must surely be on the nature and structures of visual display. This *sine qua non* is what justifies, and indeed necessitates, the work of the art historian. At the same time, it has to be recognized that art history can only advance effectively in this field if (as has been emphasized here) it is able to stand outside and criticize its own disciplinary paradigms.

Notes

1 Report in *The Independent* (London), January 2, 1995, p. 12.
2 "Moi et quelques autres nous restons là, devant le *Diplodocus*, à rêver . . . à la quantité d'oxygène tout frais dont il se gonflait comme un zeppelin." Léon-Paul Fargue, *Le piéton de Paris* (Paris: Gallimard, 1982), p. 119 (my translation).
3 Umberto Eco, *Travels in Hyper-Reality* (London: Picador, 1987), p. 8.
4 Donald Horne, *The Great Museum: The Re-Presentation of History* (London: Pluto, 1984), back cover. I discuss the thesis of this book, and contrast it with the approach of Patrick Wright's *On Living in an Old Country* (London: Verso, 1985) in my essay "On Living in a New Country," in Peter Vergo (ed.), *The New Museology* (London: Reaktion, 1989), pp. 99–118. Vergo's anthology offers a useful conspectus of different approaches to the study and critique of museums. It is broadly complemented by the recent and more historically based collection of texts edited by Marcia Pointon: *Art Apart: Art Institutions and Ideology across England and North America* (Manchester: Manchester University Press, 1994).
5 Wolfgang Ernst, "Frames at Work: Museological Imagination and Historical Discourse in Neoclassical Britain," *Art Bulletin* 75, 3 (1993): 481. For the most recent and relevant writing on the role of the great museums of Germany and France in forming the discourse of art history, see in particular Andrew McLellan, *Inventing the Louvre: Art, Politics, and the Origins of the Modern Museum in Eighteenth-Century Paris* (Cambridge: Cambridge University Press, 1994), and Alexis Joachimides, Sven Kuhrau, Viola Vahrson, and Nikolaus Bernau (eds.), *Museuminszenierungen: Zur Geschichte des Institution des Kunstmuseums Die Berliner Museumslandschaft 1830–1990* (Berlin: Kunst, 1995).
6 See Francis Haskell, *History and Its Images: Art and the Interpretation of the Past* (New Haven: Yale University Press, 1993), ch. 9, for a comprehensive recent account of this innovatory museum.
7 Ernst, "Frames at Work," p. 481.

8 Extract from Turner's will quoted in wall display panel, National Gallery, London (North Wing, Gallery 15). Although this has hardly been described as an iconoclastic gesture, it does undoubtedly have the effect of disrupting the otherwise inflexible grouping by period and school. Mark Cheetham has suggested to me that the effect is analogous to that of the photographs of Thomas Struth, which embed images of contemporary museum behavior in the context of the "historical" collection. One of Struth's photographs was chosen to accompany a collaborative essay in which I attempted to specify different kinds of incidental or aberrant experience in the context of museum visiting. (See William Allen and Stephen Bann, "Fragments of a Museum Discourse," *Kunst & Museumjournaal* 2, 6 [1991]: 1–6.)

9 On the significant distinction between "typological arrangement and the geographical system" in museums of ethnography, see Nelia Dias, "Looking at Objects: Memory, Knowledge in Nineteenth-century Ethnographic Display," in George Robertson, Melinda Mash, Lisa Tickner, Jon Bird, Barry Curtis, and Tim Putnam (eds.), *Travellers' Tales: Narratives of Home and Displacement* (London: Routledge, 1994), pp. 164–74.

10 Norman Bryson, "Philostratus and the Imaginary Museum," in Simon Goldhill and Robin Osborne (eds.), *Art and Text in Ancient Greek Culture* (Cambridge: Cambridge University Press, 1994), p. 278.

11 See Thomas DaCosta Kaufmann, "From Treasury to Museum: The Collections of the Austrian Habsburgs," in John Elsner and Roger Cardinal (eds.), *The Cultures of Collecting* (London: Reaktion, 1994), pp. 137–54. This anthology contains a number of useful essays bearing on museum studies, including Mieke Bal, "Telling Objects: A Narrative Perspective on Collecting" (pp. 97–115), which offers an incisive critique of Susan Pearce's *Museums, Objects and Collections: A Cultural Study* (Leicester: Leicester University Press, 1992).

12 DaCosta Kaufmann, "From Treasury to Museum," p. 150.

13 Douglas Crimp, *On the Museum's Ruins* (Cambridge: MIT Press, 1993), p. 225. A very pertinent example of the "dispersal" to which Crimp alludes can be found in the checkered history of the Amerbach Cabinet, which was originally formed in the course of the sixteenth century by the Basel patrician Basilius Amerbach and entrusted to the city in the subsequent century. The various remarkable collections attaching to it were indeed dispersed throughout the range of different museums which were founded from the early nineteenth century onwards. They were finally brought together again for a temporary exhibition in 1991. See Elisabeth Landolt and Felix Ackerman, *Das Amerbach-Kabinett: Die Objekte in Historischen Museum Basel* (Basel: Kunstmuseum Basel, 1991).

14 See Krzysztof Pomian, *Collectors and Curiosities* (Oxford: Blackwell, 1990), and Stephen Bann, *Under the Sign: John Bargrave as Collector, Traveler and Witness* (Ann Arbor: University of Michigan Press, 1994).

15 An invaluable document relating to the growth of the collections at Bologna is Giuseppe Gaetena Bolletti, *Dell'origine e de' progressi dell'Instituto delle Scienze di Bologna* (Bologna: Lelio dalla Volpe, 1751; repr. Bologna: Cooperativa Libraria Universitaria Editrice, 1987).

16 For my own comparative analysis of the signifying structures of Lenoir's museum, and the subsequent Musée de Cluny, founded by Alexandre du Sommerard, see Stephen Bann, *The Clothing of Clio: A Study of the Representation of History in Nineteenth-Century Britain and France* (Cambridge: Cambridge University Press, 1984), pp. 77–92. I return to further consideration of the Musée de Cluny in *Romanticism and the Rise of History* (New York: Twayne, 1995), pp. 144–50.

17 For a stimulating recent estimate, see John Elsner, "A Collector's Model of Desire," in Elsner and Cardinal, *Cultures of Collecting*, pp. 154–76.

18 See C. A. Böttiger, *Kleine Schriften*, vol. II (Dresden, 1838), pp. 5ff., and *Ueber die Dresdner Antikengalerie* (Dresden, 1815), pp. 7ff. I am grateful to Professor Alex Potts for indicating this source to me.

19 Haskell, *History and Its Images*, p. 247.

20 See Maurice Blanchot, "Le mal de musée," *L'amitié* (Paris: Gallimard, 1971), pp. 52–61, and Pierre Bourdieu and Alain Darbel, *The Love of Art: European Museums and Their Public*, trans. Caroline Beattie and Nick Merriman (Cambridge: Polity, 1990).

21 For Foucault's critical revision of Nietzsche's concept of "genealogy," see Alan Sheridan, *Michel Foucault: The Will to Truth* (London: Tavistock, 1980), pp. 116–20. The works by Foucault relevant in this connection are *The Order of Things* (New York: Pantheon, 1971) and *The Archaeology of Knowledge* (London: Tavistock, 1972).

22 Dias, "Looking at Objects," p. 164.

23 See Bann, *The Clothing of Clio*, pp. 82–91.

24 See Bann, *Under the Sign*, pp. 63–97. I examine some of the same issues across a wider time scale, returning to the later Middle Ages and the custom of pilgrimage in my "Shrines, Curiosities and the Rhetoric of Display," in Lynne Cooke and Peter Wollen (eds.), *Visual Display: Culture beyond Appearances* (Seattle: Bay Press, 1995), pp. 14–29.

25 For a further elaboration of what I am summarizing here as a "discursive" attitude to the past, see Bann, *Romanticism*, pp. 79–162 ("History as Discourse").

26 It is interesting to note that, following the inauguration of the Grand Louvre, with its subterranean systems of transit designed by I. M. Pei, Berlin devised a comparable project for the Museuminsel, and London was invited to contemplate the project of an "Albertopolis" extending from the museums on the Cromwell Road to the Albert Hall and Kensington Gardens. Both the latter schemes have, however, met with overwhelming opposition.

27 For an analysis of this exciting transformation in the context of historical epistemology, see Stephen Bann, "History as Competence and Performance: Notes on the Ironic Museum," in Frank Ankersmit and Hans Kellner (eds.), *A New Philosophy of History* (London: Reaktion, 1995), pp. 195–211.

28 For example, the impressive Gothic church of the Augustins, which was first used as an exhibition space under the Revolution and, from 1830 to 1835, boasted a classical "Temple des Arts" in its nave, is now primarily reserved for the display of the many outstanding religious paintings looted by Napoleon which have ended up in the collection (Rubens, Guercino, etc.).

29 These comments on the original plans for the museum are based on the information provided by André Laurencin and Didier Hardy, *Musée en plans* (Chalon-sur-Saône: Musée Denon, 1993).

30 "Bonnes expositions, chouette musée. [Signed] Le Club des Cinq." "Très beau musée – peintures mal eclairées – esprit gardien de prison des surveillants – pas très stylé pour un musée. Je souhaiterais plus d'explication dans la salle elle-même (replacer tout dans le contexte historique perdu de vue . . .). [Name and Address withheld]." (My translations.)

31 It is, however, rising steadily, no doubt as a result of the intensification of interest in the history of the Louvre, where he occupied the post of director from 1802 onwards. A best-selling biographical study by a notable contemporary man of letters has recently been published: See Philippe Sollers, *Le cavalier du Louvre* (Paris: Gallimard, 1995).

32 The remarkable story of Niepce's contacts with Daguerre is told, together with other equally enthralling incidents of his life, in Joseph Nicéphore Niepce, *Correspondances 1825–1829* (Rouen: Pavillon de la Photographie, 1974).

13

Museums and Galleries as Sites for Artistic Intervention

Gerald McMaster

The problem of where to practice is as pressing as how.

<div align="right">Tagg 1992: 46</div>

W HEN asked to write chapter for art historians, I said that one per-
spective on the problem of how to view objects should come from
an artist. For me, examining this question is a postcolonial activity
of reversing the gaze. In the jargon of identity politics, I am (un)fortunate enough
(depending on how one views it) to have multiple identities. Two of these iden-
tities are being a contemporary artist and a curator, a duality that will reveal
itself in the body of this text. I begin by establishing a theoretical perspective
on space and identity, then describe a project I undertook as an artist, and end
with a reflective look from a curatorial perspective. I see this not so much as
a shifting of roles as being able to see multiple sides (Fig. 35).

Space and Identity: *"Here's looking at you, kid!"*

Spaces, as social constructions, are where identities are produced and negoti-
ated. Understanding "spaces" here as the "field of forces" that constitutes con-
temporary art – and, by extension, museums of anthropology – I think of the
concept of "space" as a master metaphor in order to understand the social loca-
tions where institutional identities are constructed. I want also to suggest how
the artistic practice of intervention can transform spaces. Taking space in the
discursive sense as "discursive field," Michel Foucault posited that in order to
understand space one has to understand the relationship between power and
knowledge (Foucault 1980: 69). By this he meant that in the construction of
knowledge, a specific discourse establishes its domain or "field," regulated by
what he calls an "administration of knowledge." In effect, we can compare this

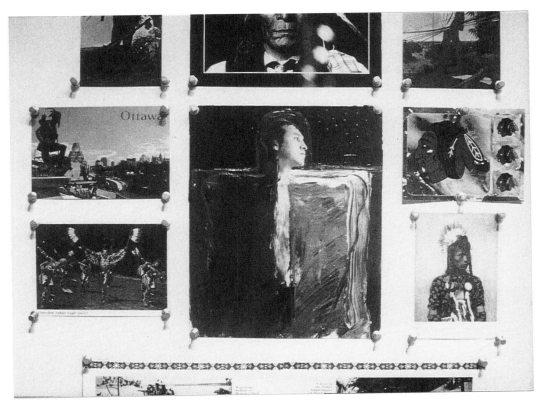

Figure 35. *Gerald McMaster,* Wall Collage Installation with Self-Portrait *(detail), July 1992. University of British Columbia Museum of Anthropology, Vancouver.*

to a gate-keeping ideology that maintains its boundaries by marginalizing the "Other" beyond its borders. This field becomes a discursive space where struggles are potentially waged. Within the "field of art," for example, the discursive field that marginalizes non-Western artists of color, or Native artists, holds the pejorative insinuation that their work is neither "art" nor of sufficient "quality" to be considered serious. Rather, it is deflected to another discursive formation called "ethnography." This anthropological (ethnographic) distraction has effectively cast these artists out of the discursive field of art. Yet it is the discursive space of art that is most sought after by contemporary Native artists (including artists of color, women, etc.), because it is here that they develop their practice.

Using Foucault's idea of knowledge as a form of power inscribed by an "administering power," I would like to argue that within the field of art a spatial (territorial) domination is constructed. The discursive field of art is in part a product of the linear narrative of "art history," which defines Europe as its narrative enclosure and in succession is linked to colonized countries like Canada and

the United States. I would argue that it is possible, then, using Foucault's ideas, to decipher art history's discourse by using spatial/strategic metaphors to enable us to grasp "the points at which discourses are transformed in, through and on the basis of relations of power" (1980: 70).

Continuing to work with Foucault's spatial metaphor, Pierre Bourdieu (1993: 30) similarly conceptualizes the "field" as a (socially) structured space within which a discursive formation, like art, can function. Bourdieu's "cultural field" situates artistic works in the social conditions of their production, circulation, and consumption, which exist within a kind of autonomous "cultural circuitry" consisting of various social agents (artists, dealers, curators, collectors, etc.) acting in complex social situations or contexts. Within this space, or field of cultural production, complex relations and struggles, or power relations, occur, which he calls a "field of forces." Because the field of cultural production consists of agents, it is their relative position that Bourdieu calls into question. His idea is that agents occupy spaces, from dominant to subordinate. The struggle or "position-taking" that occurs within this "field of forces" is a political act about gaining specific forms of symbolic capital, such as prestige.[1] The initiative to force change within the cultural field comes from those who have the least cultural capital; Bourdieu refers to younger artists who endeavor to "displace" their elders.[2] We can, of course, add women, Natives, and others, who also achieve "position" through the establishment of their differences. These young artists, he says, endeavor "to impose new modes of thought and expression, out of key with the prevailing modes of thought and the doxa, and therefore bound to disconcert the orthodox by their 'obscurity' and 'pointlessness' " (1993: 58). This is the logic by which the rules (discourses) are established.

I would argue that many articulate groups of artists exist who use political means ("direct action") to gain entry into the field above and beyond Bourdieu's analysis. The Society of Canadian Artists of Native Ancestry (SCANA) is a good example. The unfavorable side of a politics of direct confrontation is that the dominant discourse inevitably reverts to Bourdieu's point, which we know today as the "quality debate."[3] It has been an effective tool. Thus, the strategy is for marginalized artists to seek new and more sophisticated methods of intervention or inclusion in the field. I believe Bourdieu's assessment of displacement describes a strategy which "by the logic of action and reaction, . . . leads to all sorts of changes in the position-takings of the occupants of the other positions" (1993: 58).

Let us look at just one example. American artist Jimmie Durham writes:

Among artists, those efforts still today are usually made with constant reinforcement of the individual's identity and authenticity by employing parts of the stereotype. One's Indian community cannot authenticate or designate a position in the world of art because that world is of the colonizer. One must approach the colonizer for the space and license to make art. The colonizer, of course, will not grant such license, but will pretend to under certain circumstances. (1992: 434)

Durham says that aboriginal artists must make every effort to understand the territory before moving into it, because there exist very specific rules in any discursive space. Only when the rules (discourses) are deciphered is it possible to unlock the doors and subvert the rules. Durham's notion of the art world granting a "license" has a double meaning, at once signalling a permission to practice and an opportunity to transgress or deviate. The crucial point in making incursions into the discursive space is either the intention of "position-taking" or of constructing a spatial identity alongside others.

Dancing between the Same and the Very Different

The choice of presenting my work *Savage Graces* in an anthropology museum was not accidental; if fact, the University of British Columbia's Museum of Anthropology's (MOA) curator, Rosa Ho, played a large part. She understood that hanging works in the museum, quasi–art-gallery-style, would not effectively transform my ideas. Anthropology museums are not built to stage objects as works of art (Fig. 36). The MOA, however, has the distinction of presenting West Coast aboriginal cultural objects (such as totem poles, jewelry, and clothing) as art, albeit in a Modernist fashion, where the works stand on their own aesthetic and conceptual merit, usually with sparse labeling. The MOA also boasts of having an "open-storage" concept, which adds to the visual excitement of the space.[4] But despite these innovations, its institutional identity remains that of a place to view Others. Artists, both aboriginal and nonaboriginal,[5] present works almost exclusively in a Modernist gallerylike fashion.

There is something antithetical about aboriginal artists wanting to present their works in anthropological spaces, where they will not be judged as art. So where to practice? This has been a crucial dilemma for aboriginal artists for the past twenty or thirty years. They generally prefer their works to be presented and judged in art-gallery spaces on the basis of their aesthetic and conceptual merits. But the anthropology museum undermines this strategy or expectation. So why do they return? More important, why did I want to present my work in opposition to these conditions? Perpetuating such contradictions would have been easy if I had just handed over my works to the Museum. Or I could call attention to these issues by making an intervention in these debates, in the process hoping to change the perceptions of the Museum staff and their audiences. Rosa Ho was particularly interested in the latter strategy and was prepared to offer me not only status as artist, but the role of co-curator.

(Im)polite Gazes developed out of a conversation with a colleague (Fig. 37).[6] The full idea was not presented at the MOA installation; instead, it materialized only after being installed in an art gallery.[7] Initially, I began by amalgamating works from the MOA's collection with my displays. I used such "authentic" objects as moccasins, a tomahawk, and a feathered headdress, juxtaposed with the more offensive "Indian-alia" (as Rosa Ho described them). The idea was to see the kinds of observations and judgments visitors would make and register in the comment books.

It was in the art gallery that I began to be confronted by the notion that differing contexts evoke differing attitudes and ideas. In the anthropology museum, most if not all visitors were uncomfortable with the idea that my work was art and should be in an art gallery; conversely, the first reaction by an art curator in the gallery when I was installing this work was that, for him, the space was beginning to look more like a museum (Fig. 38). I realized then that I was frustrating audiences and their unacknowledged perspectives about institutional identity. And there was another thought that occurred to me about the "spatial politics of identity" and how as an aboriginal artist I was challenging accepted positions. In other words, I was metaphorically setting free the incarcerated "Indian"; I was *its* representation. I was confronted by an essentialist notion of place and identity, and I was being resisted for challenging the audience's assumptions and common sense.

The gallery installation of *(Im)polite Gazes* was fairly discrete from other areas, which allowed the visitor an opportunity to come to understand the differing perspectives (discourses) through which the "Indian" is presented. The three perspectival views – the commercial, the scientific, and the aesthetic – are not only distinct from each other, but each has its own discursive practice. Growing up on the prairies, my Saturday afternoons were spent listening to radio programs (no one on the Reserve had a television set). Listening with my cousins, our hearts would beat faster at the sound of the *William Tell* overture, followed by the words, "Hi-O, Silver!" Those, of course, if anyone remembers, were the music and words announcing the popular radio show *The Lone Ranger*. There were many programs and other visual media in this genre, but this one is particularly important because of the Lone Ranger's alter ego. Tonto was the Lone Ranger's trusty sidekick. Representing the Indian, he balanced out the Old West formula "cowboy and Indian." My heroes were the cowboys, never the Indians. I wasn't the least bit interested in Tonto. The cowboy hero was much more noble; the Indian – well, let us say they were the bad guys, which no one sided with. Such was the power of the media. I have since heard similar stories by other aboriginal peoples. When we look upon all the current commercial products that promote this stereotype (Fig. 39), it is easy to understand that history is indeed written by the victors. But here is the paradox that I tried to sum up in *Savage Graces*: The image of the Indian is contained in what Homi Bhabha calls a "productive ambivalence" of colonial discourse; that is, the Indian is at once the object of desire and derision (1994: 67). Upon surveying the cultural products, it seems the general belief was that the Indian was wild and savage; yet the Indian also had a gentle, if not innocent, side that could be romanticized as a preferred existence against a rapidly growing industrialized society. Neither of these views was ever evident in my early days growing up on the Reserve. As toys or in comic books, the Indian was the persistent bad guy; in food and adult-oriented products, the Indian lifestyle was romanticized; as a literary character, the characterization could be read as both good and bad. Surprisingly, the Indian continues to be as popular today as in the past, particularly as a commercial vehicle for multinational corporations or professional

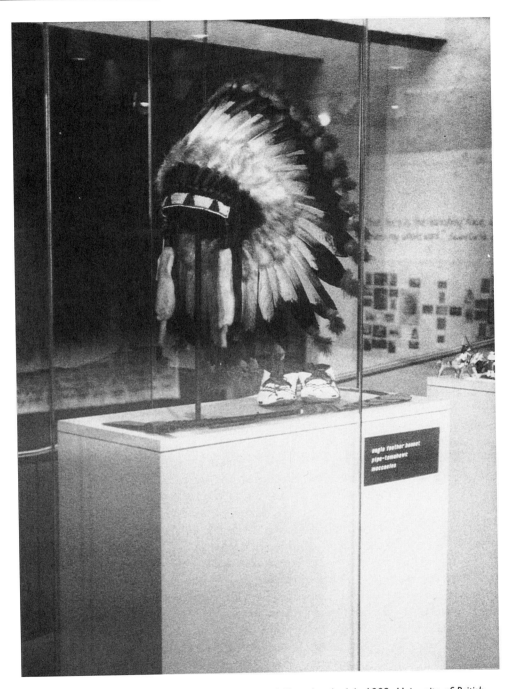

Figure 36. Plains Indian Headdress, Moccasins, and Tomahawk, July 1992. *University of British Columbia Museum of Anthropology. The titles of the objects were given in the language of Plains Cree so that audiences would have to come to understand that object titles are not as straightforward as we assume.*

sports teams.[8] A surprise twist, however, is that often products that picture the Indian as positive (read: romantic) are being marketed by aboriginal people themselves. Indeed, they have seen the economic advantages and see nothing wrong with creating their own market so long as there are willing buyers.

An even older tradition of trading in the representations of Indians is that of Western artists who painted a "West" that Goetzmann and Goetzmann call "the romantic horizon of the unknown." Indeed, they argue that since the mid-eighteenth century science and art have inevitably gone together, and that the beginnings of anthropology occurred when aboriginal specimens were brought back from the West into homes of white Americans. Early American and Canadian artists whose works reflected more ethnographic and scientific than aesthetic concerns were "so amazed by what they saw . . . that they became instant romantics" (1986: 42). In their eyes, the Indian was part of the landscape their society was in the process of "civilizing" through a doctrine called Manifest Destiny. To all intents and purposes, this doctrine proclaimed the inevitable disappearance of the Indian. In Canada, no equivalent belief about aboriginal peoples existed, except that Canadian artists did share visual impressions of the landscape and the aboriginal way of life. Paul Kane, the earliest Canadian painter to travel west, was inspired by the American painter George Catlin, whom he met in London in 1841. Along with John Mix Stanley, Kane and Catlin are referred to as the "Indian Gallery" painters by Goetzmann and Goetzmann. In my exhibition, I argued that they brought with them a socially constructed way of seeing, not only by colonizing the social space of the aboriginal, but also with their representational practices. Western artists have long been representing many aspects of everyday life, and traveling into and onto the prairies to paint the landscape was merely an extension of that practice. When we think of drawing, sketching, and painting, we tend to think of a fairly innocuous activity; and indeed, it is. When you begin to introduce human subjects into the picture, however, a relationship begins to take place. Often when an artist asks his or her subjects to pose, a relationship is created, leading to some sort of reciprocity.[9] But when an artist insists on representing his or her subjects without their consent, a breach, a transgression of social custom, occurs.

It was this last case that received the more critical attention in the exhibition. It was as though I was being iconoclastic. At each venue, I asked to borrow works from the collections, works by Western artists that depicted aboriginal peoples in some way. I then asked the preparators to install them without the usual markers (e.g., labels). What I was performing was not so much an iconoclastic move as something designed to focus attention on the practices that each group was inscribed by, and to insist that we have come to sanctify not only the objects but their creators as well. My placement of these artists, first as nameless and then as visual transgressors, was what annoyed the viewers, many of whom felt that I was being overly critical. But I asked them: How do you feel about someone's transgressing your social space without your awareness? Do you not object to passive colonization? I explained that this practice was unknown in many aboriginal cultures; that it was not so much a visual appropriation

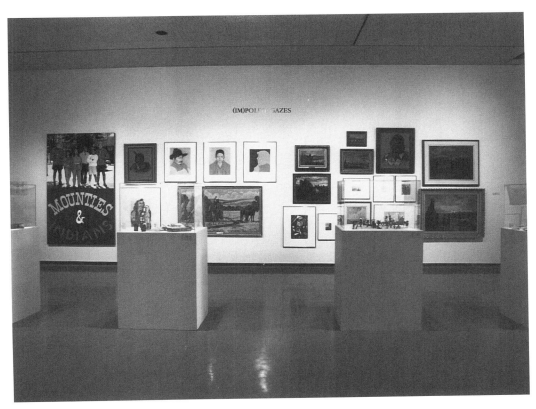

Figure 37. *Gerald McMaster, (Im)Polite Gazes Installation, January 1995. Winnipeg Art Gallery, Winnipeg, Manitoba. The curator, Shirley Madill of the Gallery, made the selection from its collection of works that represent aboriginal peoples. These works are all by nonaboriginals about aboriginal peoples. Photo courtesy of Sheila Spence, Winnipeg Art Gallery.*

such as we're all very familiar with today, but a transgression into the social space of the other, a stealing of a glance, as it were. Indeed, many of the works one sees in nineteenth-century Western art show the banality of everyday life. Only in later works are depictions more aggressive and emotionally charged. Frederic Remington's paintings come to mind. Many of these early works offer a type of touristic gaze that we employ even today when we travel to other countries and cultures.

In the third section of *(Im)polite Gazes*, I extended the idea of the gaze beyond the visual artists toward a practice that sought to see beneath surfaces. This was, of course, the gaze of science, which was now moving beyond empirical evidence, beyond what the eye could see. In medical science this meant opening up the body to see what was inside; no longer thinking in terms of symptoms, one might be able to analyze the inner workings of the body, perhaps see the disease. I began thinking of the impact the microscope had upon medicine, how it could see just past the surface. I used this metaphor for the

Figure 38. *Gerald McMaster, (Im)Polite Gazes Installation, January 1994. Ottawa Art Gallery, Ottawa, Ontario. These two display cases were probably made at the turn of the century for the old National Museum of Man in Ottawa. They are typical in style and quality of cases of that period.*

practice of anthropology, which was just at its nascent stage of development. It wanted to see more than artifacts: it wanted to see how culture operated. In my installation, I used the traditional museum display case as the metaphor for the microscope. At each venue, I managed to obtain some early twentieth-century display cases, ones that have real glass and were probably made by highly seasoned cabinetmakers. The idea was to show how the practice of museum gazing has become such a polite practice: We learn to behave "properly" when entering these institutional spaces, and once inside we often internalize our emotions. Placement of works behind glass comes to signify the distance between the cultures and between the self and the Other. The glass case protects and museumifies the culture of the Other – their objects scrutinized in medical fashion, as a sort of clinical gaze. It's a polite and aloof activity.

As institutions, museums and galleries have been around for well over two centuries, functioning as reflections of their societies' narratives. Consistently, their narratives are of themselves constructed through views of their Other. I recall one instance of an aboriginal artist asking a Dutch anthropologist about his view about repatriation: Would they ever consider returning some important

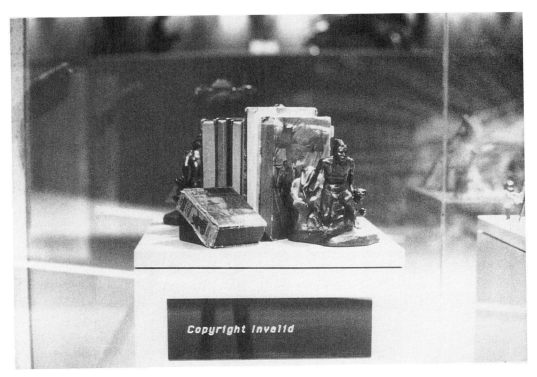

Figure 39. *Gerald McMaster, "Copyright Invalid": (Im)Polite Gazes Installation, July 1992. University of British Columbia Museum of Anthropology, Vancouver. The reverse of this small installation says "Captured by Indians," a title taken from one of the books on display. Pictured is a noble Indian with his equally noble dog. Five of these pedestal displays used double word play.*

cultural objects? The anthropologist gave an unequivocal no, because for him and his countrymen these objects represented a historical narrative of colonization. His position was that such objects were part of their identity as a nation and, furthermore, as an institution. Yet I could not help but realize that this was Europe and that it was further removed from issues specific to North America. This led me to ask: Are Canada and the United States different because they have a more pressing political responsibility? Indeed, there have been efforts on the part of major institutions in these two countries to work with aboriginal communities to resolve some long-standing issues. Europe, on the other hand, is not only far away, it has an extremely proud and unassailable history, never to be blemished by its colonized Other.

Despite their long and complicated histories, many institutional spaces, like the ones in Canada, are beginning to reexamine themselves in light of the rapidly changing cultural landscapes. There are the growing contributions to the contemporary debates in feminism, multiculturalism, and postcolonialism, by intellectuals, artists, and others. Indeed, our cultural institutions are finding they can no longer avoid representing the Other in colonialist terms: Our collective

histories are inextricably tangled. Together we make history. To some degree, this idea is antithetical to mainstream dogma that privileges its master narrative over others. Nevertheless, we all create boundaries between ourselves, to distinguish each other. Yet Jerry Saltz says that "all art shouldn't be blended together. That would be boring and entropic. We are all different – even in spite of our similarities" (1994: 301). Artists have been known to take the more radical route to border crossing; curators are generally slower to come to terms with these shifts, perhaps because of the potential political fallout. Institutions are even less willing because of their territorial constraints.

Often I've been asked how I manage to balance my two interests, to be an artist and a curator. Though it may seem rather self-centered to speak or practice from one's personal position, it is a position that non-Western peoples often start from. In the parlance of the Old West, it is from here that we first encounter the gates of the metaphoric fort. Having understood that position, it was from there that I could begin unlocking its doors. I say this because few academically trained individuals who happened to be aboriginal were in any position of influence or authority. Often these positions were assumed by artists. I continue to work from both perspectives, believing that each informs the other.

Notes

1 Bourdieu's concept of symbolic capital is based on the idea of symbolic power, a form of capital that is not based on economic capital. Symbolic capital could refer to a "cultural knowledge" which (for example) Native artists can bring to the field of art.

2 Bourdieu indicates that the site of struggle most often occurs between two principles of hierarchization: the *field of cultural production* and the *field of power*. The field of cultural production is based on the principle of autonomy, "(e.g. 'art for art's sake'), which those of its advocates who are least endowed with specific capital tend to identify with degree of independence from the economy, seeing temporal failure as a sign of election and success as a sign of compromise. . . . [The field of power, on the other hand, is based on the principle of heteronomy:] favourable to those who dominate the field economically and politically (e.g. 'bourgeois art')" (1993: 40).

3 See Howardina Pindell's excellent article on this and associated issues: "Breaking the Silence," *New Art Examiner*, October 1990: 18–27.

4 Open storage: This is the idea that nothing is hidden from public view, as some items would be in a "closed storage" system. The Windsor Art Gallery, in its new facility, has an area called by a similar term, although it is not as open as the MOA's. In the Winnipeg Art Gallery one sees only a storage room that one cannot enter or move around in.

5 For example, Vancouver artist Jack Shadbolt has extensively used the images of West Coast aboriginal cultures, on exhibition at the MOA, most certainly to show audiences this relationship.

6 I am indebted to Rob Shields for suggesting the title, thus helping me focus my attention on the discursive nature of the gaze.

7 The Ottawa Art Gallery was the site of the second venue. I am indebted to the staff for their willingness to bring about this idea, and for their assistance.

8 Professional sports teams continue to use the stereotype to full advantage. Names like the Atlanta Braves, Washington Redskins, Cleveland Indians, and Chicago Black Hawks continue this imaginary and mimetic form of playacting, only now tremendous profits are made. So who cares about strident groups of protesting aboriginals? No amount of protesting has been able to make a dent in the choices of professional teams; protest has been

somewhat more successful with nonprofessional ones. Cf. Ward Churchill, *Indians Are Us* (1994).

9 Say, Bodmer's relationship with Ma-to-tope.

Bibliography

Bhabha, Homi K. 1994. *The Location of Culture*. New York: Routledge.

Bourdieu, Pierre. 1993. *The Field of Cultural Production: Essays on Art and Literature*, trans. Richard Nice. New York: Columbia University Press.

Churchill, Ward. 1994. *Indians Are Us: Culture and Genocide in Native North America*. Toronto: Between the Lines Press.

Durham, Jimmie. 1991. "Free Tickets," *Marginal Recession: An Installation by Edward Poitras*. Exhibition catalog. Regina, Sask.: Dunlop Art Gallery.

 1992. "Cowboys and . . .: Notes on Art, Literature, and American Indians in the Modern American Mind." In *The State of Native America*, ed. M. Annette Jaimes, 423–38. Boston: South End Press.

Foucault, Michel. 1980. *Power/Knowledge: Selected Interviews 1972–1977*. New York: Pantheon.

Goetzmann, William H., and William N. Goetzmann. 1986. *The West of the Imagination*. New York: Norton.

Jameson, Frederic. 1991. *Postmodernism; or, The Cultural Logic of Late Capitalism*. Durham, N.C.: Duke University Press.

Keith, Michael, and Steve Pile. 1993. *Place and the Politics of Identity*. New York: Rutledge.

McEvilley, Thomas. 1992. *Art and Otherness: Crisis in Cultural Identity*. Kingston, N.Y.: McPherson (Documentext).

McMaster, Gerald. 1993. *niya nêhiyaw: Crossfires of Identity*. Exhibition catalog. Agnes Etherington Art Centre, Queen's University, Kingston, Ont.

 1994. "Savage Graces: 'after images.'" *HARBOUR Magazine of Art and Everyday Life* 3(1).

Pindell, Howardina. 1990. "Breaking the Silence." *New Art Examiner*, October: 18–27.

Saltz, Jerry. 1994. "More Than You Know." In *Cocido y crudo*, ed. Dan Cameron, 297–302. Madrid: Museo Nacional Centro de Arte Reina Sofía.

Tagg, John. 1992. *Grounds of Dispute: Art History, Cultural Politics and the Discursive Field*. Minneapolis: University of Minnesota Press.

Thomas, David, and Karin Ronnefeldt (eds.). 1976. *People of the First Man: Life among the Plains Indians in Their Final Days of Glory*. New York: Dutton.

14

Art History's Significant Other . . . Film Studies

Bruce Barber

The still is the major artifact of the projected film.

<div align="right">Barthes 1985: 61</div>

In a number of important respects, modern art history has been a supremely cinematic practice, concerned with the orchestration of historical narratives and the display of genealogy by filmic means. In short the modern discipline has been grounded in metaphors of cinematic practice to the extent that in nearly all of its facets, art history could be said to continually refer to and to implicate the discursive logic of realist cinema. The art history slide is always orchestrated as a still in a historical movie.

<div align="right">Preziosi 1989: 72–3</div>

N the introduction to their provocative anthology *The New Art History* (1986), A. L. Rees and Frances Borzello wrote that the next stage of art history "is anyone's guess." They suggested, however, that a possible direction could be supplied by film studies, a field which had influenced the direction of the so-called new art history. Nodding appreciatively in the direction of David Bordwell, Janet Staiger, and Kristin Thompson's exhaustive sociohistorical study *The Classical Hollywood Cinema* (1985), Rees and Borzello argued that the uniting of *Screen*-style theoretical explorations with traditional historical research could pave the way to a more progressive model of art history for the future (p. 9).

This chapter will reflect upon comments that construct art history as a "cinematic practice," born as they are of the putative crisis in art history established with the publication of several key texts in the 1970s[1] and early 1980s.[2] In the first section, I will trace aspects of the discursive relationship between the new art history and film studies explicitly acknowledged by a few art historians (Rees, Borzello, Preziosi, Clark, Tagg, Burgin, Wollen) and implicitly by many others

(Fried, Krauss, Pollock, Frascina, and Crow). Section I will be followed by a reading of several film examples that parody, satirize, and burlesque art and art history. I will argue that the relationship among cinema, film studies, and the institution art (Bürger 1984) has been far from innocent, and that as much as art history has provided a fertile ground for the germination of various discursive hybrids and tropes, such as Preziosi's above, it has also signified *difference*.

There is some legitimacy to Preziosi's cinematic paradigm for art history. Roland Barthes (1977) and Michael Fried (1980), both taking their cues from Diderot, have promoted similar conflations with regard to the "Organon of Representation" figured in the "perfect instants" (Barthes 1977) of canvas, cinema, and theater. However, when art history – a discipline within the institution art – is *actually* represented in film, it reveals less the discursive logic of realist cinema than instances of popular antagonism toward high culture and modernist art existing in classed society. In films such as *Suspicion* (1941), *Scarlet Street* (1945), *The Party* (1968), *Vertigo* (1958), *The Moderns* (1988), *I've Heard the Mermaids Singing* (1987), *Still Life* (1989), *Batman* (1989), and *Backbeat* (1994) (see Filmography), the institution art is subjected to the critical machinations of popular culture, becoming in the process a site for the symbolic contestation of meaning and a "nodal point" (Laclau and Mouffe 1985) in the continuing struggle for cultural power.

I

The postmodern era did not inaugurate the traffic in ideas, theories, and methodologies among disciplines, but it did in an important sense legitimize – some would say *legislate* – the overlaying of one discipline's discursive practices (or regimes) upon another. The traveling metaphors associated with this "littoralist" process – crossroads, intersections, boundaries; borders through which one, with intellectual baggage in hand, transports oneself; territory over which one crosses, hops, glides, and elides – in many ways affirm the correspondences between relatively homogeneous textual practices (discipline-grounded discourse) that have been in evidence since the inauguration of modernism. Many researchers have identified the postmodern theoretical "free market" as a battleground of competing theories, methodologies, ideologies – discursive practices[3] and names.[4] Others (Laclau and Mouffe 1985, Thompson 1990, Norris 1990) have explored these discursive regions of intertextuality and found them to be bounded/bonded territories which privilege specific theoretical (ideological) positions and interpretive strategies, which become, as Laclau and Mouffe argue, discursive "nodal points."

> Every nodal point is constituted with an intertextuality that overflows it.
> The practice of articulation, therefore consists in the construction of nodal
> points which partially fix meaning; and the partial character of this
> fixation proceeds from the openness of the social, a result, in its turn, of

the constant overflowing of every discourse by the infinitude of the field of discursivity. (1985: 113)

Viewed from within the subsets of historiographic discourse constituted as art history and film studies, these "nodal points" have had an interesting evolution, particularly since the early 1960s, a period identified by most film scholars as an origin point for the establishment of the film or cinema studies discipline area.[5] Sklar, for instance, underlines cinema studies' "coming of age" at a time "when its most closely aligned fields, such as philosophy, literary studies and art history, fell deeply under the thrall of European theories, Marxist and non-Marxist" (Sklar and Musser 1990: 11). While it could be stated, generously, that the study of cinema, like art history, traverses the time of its origins to the present – which for cinema is the last century[6] – cinema studies' actual existence as an independent study area has been very recent, spanning the post–World War II period – yet coinciding in a fascinating way with the development and critique of structuralism, the formations of poststructuralism, the introduction of feminism into cultural and sociopolitical debates, and the constitution of a new "non-generic" discursive territory, loosely titled cultural studies. It could be argued, in fact, that film studies is one of the few academic disciplines to owe its very existence to the challenging debates accompanying the paradigm shift from modernism to postmodernism.

Where the names of Saussure, Althusser, Benjamin, Jakobsen, Barthes, and Foucault figure prominently in the early film-studies texts, they are followed later by Lyotard, Eco, Todorov, Lacan, Derrida, Deleuze, Kristeva, and Said; but the names shadowing these European ones, for much of film studies' history, at least within the Anglo-North American context, are English: those of the labor historian E. P. Thompson and the literary historian, critic, and novelist Raymond Williams. Each of these intellectuals provided a rich mix of theoretical material and practical examples of sociocultural interpretation for the film-studies researchers of the 1970s and 1980s. Examining the film-studies texts of the period can provide a good vantage point from which to examine the shifting sediment of late modernist discourse. Such a purview reveals that the "overflowing of every discourse by the infinitude of . . . field(s) of discursivity" (Laclau and Mouffe 1985: 113) developed as a result of theoretical competition among several generic discourses associated with more firmly established academic disciplines: history, art history, philosophy, sociology, anthropology, political science, and English literature (literary studies). It is somewhat ironic that academics working in a number of these disciplines now acknowledge film studies as an influence on the rejuvenation of their own fields. Rees and Borzello note that Bordwell, Staiger, and Thompson (1985) cite the venerable art historian Ernst Gombrich as a major influence on their work, in company with E. P. Thompson, Raymond Williams, and the labor historian Harry Braverman.

A review of 1970s issues of the British film journal *Screen*[7] provides a window on the various shifts of attention in the theoretical discourse that have largely determined the shape of the English-language film-studies field[8] and

subsequently the new art history. While this is properly the scope of a much longer essay,[9] I will briefly trace some aspects of the intellectual provenance of *Screen* discourse over a five-year period, which has enabled art historians like Rees and Borzello to promote the appropriateness, indeed the *naturalness*, of the marriage of "*Screen*-like theoretical research with more conventional historical work," and to project this as a model for the future practice of art history.

During its early years *Screen* published formalist criticism and promotional pieces on various aspects of the revitalized British film and the developing television industries. With the editorship of Sam Rhodie in the spring of 1971, however, *Screen* began to turn its editorial policy away from this "homeground" practice and direct it more firmly toward contemporary theory and film in an international context. This shift led to a privileging of the semiotic analysis of ideology and the practical negotiation of an engaged politics in filmmaking and cultural criticism. The shift in attention begins with the translation and publication of work by writers associated with the influential French film journals *Cahiers du Cinéma* and *Cinéthique*, who were responding to the volatile political situation in France precipitated by the student and worker demonstrations in Nanterre and Paris of May/June 1968. *Screen*'s new identity was established with the introduction of the provocative ideas of the French writers Jean-Louis Comolli and Jean Narboni, and later Marcelin Pleynet and Pierre Braudy.[10] The importation of structuralist discourse encouraged the *Screen* writers to join their Continental cousins in producing semiotic analyses of the classical narrative forms of the bourgeois realist cinema; as well, they attempted to initiate a radical praxis through the formation of educational discussion groups, mandated in part by their association with the Society for Education in Film and Television. While less foregrounded than it was in the early years, this attention to praxis has remained an aspect of *Screen*'s "engaged politics." In keeping with their somewhat idealistic interest in political education – conscientization – the *Screen* constituency engaged in extensive discussions on the history of the modernist avant-garde cinema and forms of documentary practice. A few writers (Laura Mulvey and Peter Wollen, writers and directors of *Riddles of the Sphinx*, 1977) also attempted to put their newly adopted theories into practice by becoming filmmakers themselves. And unlike many of its sister film journals, *Screen* frequently accommodated writers and theorists from fields outside its domain, including individuals whose discipline bases were in literary theory, history, art history, sociology, and philosophy: for instance, Raymond Williams, Colin MacCabe, Terry Eagleton, T. J. Clark, and Griselda Pollock.

In part as a result of the influence of the French theorists, the contributors to *Screen* of the early 1970s endorsed and promoted the revision of traditional Marxist concepts in Althusser's influential books *Reading Capital* (1970), *Lenin, Philosophy and Other Essays* (1971), and later *For Marx* (1977).[11] Althusser's strategic revision of the conventional base/superstructure model, his privileging of ideology rather than economy in his critique of capitalism, and his introduction of the concept of state and institutional apparatuses was enormously influential in the film-studies literature of the early 70s and remained so to a

somewhat lesser degree throughout the decade.[12] Another key text *Screen* writers of this period responded to was from one of their own: Peter Wollen's *Signs and Meanings in the Cinema* (1972). Wollen reexamined the film aesthetics and politics of the revolutionary Soviet cinema and argued for a revision of conventional critical concepts based on semiotic analysis. While Christian Metz, translated somewhat later into English, based his work upon post-Saussurean semiotic methodologies and Lacanian psychoanalytic models – which remained the most influential branch of semiotic theory for *Screen* researchers – Wollen's semiological[13] model was based upon the American C. S. Peirce's theory of indexicality and referentiality, employing his triad of index, icon, and symbol.

John Ellis, a member of the *Screen* editorial board and editor of *Screen Reader I*, an important collection of *Screen* essays published in 1977, wrote that early on the *Screen* projects were quite varied and involved:

a critique of established critical concepts, such as auteurism, content analysis; an examination of the theory and practice of realism, seen as the dominant aesthetic of bourgeois cinema and television; work on the nature of the institution of cinema and on technological determinations; work on the theorisation of the articulation cinema/ideology/politics; the criticism and rewriting of the "history of the cinema"; the re-examination of the Russian cinema of the 1920s regarded as the major historical attempt to construct a revolutionary cinema; the examination of British cinema and television practices and histories. (Ellis 1977: ii)

It was this openness and attention to the institution of the cinema in *all* of its aspects – aesthetics, technology, the industry, marketing, spectatorship, cinema/ideology/politics – which proved to be so attractive to the new art historians of the 1980s, whose training had probably excluded most of the items listed by Ellis to focus on more conventional staples of art history such as iconography, style, attribution, dating, and the life of the artist.

Screen's critical work of the early to mid 1970s involved the total revision of stock-in-trade formalist methods, particularly psychologisms that aimed at disclosing the immanent meanings residing within the film through various Freudian reductions of the psychology of either the author or characters represented in the narrative. Many of the essays repudiated the authority of the author in favor of a shot-by-shot analysis (decoding) of the film's content in order to render ideology more visible. *Screen*'s Althussereanism remained relatively constant throughout the early 1970s; however, there were some major shifts in mid decade as a result of the introduction of feminist discourses and psychoanalytic theory, which resulted in a foregrounding of sexual politics (gendered power relations), textuality, subjectivity, and spectatorship. Under the sway of several key writings by Michel Foucault, Roland Barthes, Jacques Lacan, Julia Kristeva, and Christian Metz,[14] attention was now accorded subjectivity, processes of reading, language, and power.

While there was some free play between art history and film studies in *Screen* issues of the early 70s, which evidenced some extensive discussions of the aesthetico-political theories of Benjamin, Brecht, and Lukacs as well as the theories of the avant-garde and the Soviet art of the revolutionary period, it was not until 1975 that a firm opening for a fully fledged relationship between film studies and the new art history appeared. While many artists and art historians in the 1970s were subscribers to or regular readers of the journal, many felt excluded from the theoretical and technical debates about film itself. However, with the publication of some key feminist texts and a few others with specific art-historical content, this attitude began to change. Laura Mulvey's famous essay "Visual Pleasure and Narrative Cinema" (*Screen* 16, 2 [Summer 1975]), for instance, is often cited as an important influence on the course of discussions within the film studies, feminist, art, and art-history communities about the nature of spectatorship within patriarchal society.[15] Mulvey argued that the classical narrative cinema reinforces a specific kind of looking, a fetishistic form of spectatorship that she suggested was phallocentric, subjugating women to the sexual pleasure-seeking and controlling gaze of the male voyeur.[16]

As far as the development of the new art history is concerned, the crucial period of *Screen*'s influence occurred between the spring of 1975 and the winter of 1980.[17] In this period several influential articles appeared that began to shift the terms of discourse away from a mechanical structuralism, with its analytical emphasis upon the decoding of ideology, toward discussions about forms of spectatorship, film language, intertextuality, reading, interpretation, class politics, and power relations. The discussions revolved around the importance of context and the authority of the author versus that of the reader. The psychoanalytic theories of subjectivity initiated with the importation of Lacan and Kristeva were dominant at this time, but they began to be challenged around mid decade by the critical strategy of deconstruction conflated with a more conventional brand of historical materialism. The key debates at this time concerned realism, the "condition" of the real, reading, suture, and ideology, with labor process, class, culture, and society fighting for visibility.[18] A curb upon the prevailing influence of Althusserean theory and the entrance of deconstructive criticism occurred with the publication in the winter of 1978 (*Screen* 18, 4) of a debate on the topic of Marxism and culture, with a response by Rosalind Coward. The debate was among Stuart Hall, Ian Connell, Lidia Curti, Iain Chambers, Tony Jefferson, and John Clarke, members of an increasingly influential cultural-studies constituency associated with the Birmingham Centre for Contemporary Cultural Studies and subsequently the Open University. This issue of *Screen* also included a section (pp. 23–48) with three articles on the topic of suture – Jacques-Iain Miller's "Suture (Elements of the Logic of the Signifier)," Jean-Pierre Oudart's article "Cinema and Suture," and Stephen Heath's "Notes on Suture," revealing still a strong adherence to French contemporary theory.

A major sign of a shift in theoretical orientation,[19] which I would argue cemented the relationship between the film studies field and the developing new art history, occurred over the next three years, culminating with the Spring 1980

publication of T. J. Clark's article "Preliminaries to a Possible Treatment of 'Olympia' in 1865." Clark introduced his essay as a practical response to some theoretical questions posed with the publication of Colin MacCabe's "The Discursive and the Ideological in Film: Notes on the Conditions of Political Intervention" (*Screen* 19, 4 [1978]), which was itself a politically strategic response to several earlier articles that addressed the topic of spectatorship in a rather narrow, theory-bound, and depoliticized manner. Clark's essay focused on Paul Willemen's "Notes on Subjectivity" (*Screen* 19, 1), which was coincidentally a response to some earlier formalist essays engaging the topics of film signifying practices, POV (point of view), framing, the positioning of the subject, ideology, reading, and the practice of meaning production. Two of these articles were written by Edward Branigan – "Subjectivity under Siege – From Fellini's *8¹/₂* to Oshima's *The Story of a Man Who Left His Will on Film*" (which appeared in the same issue as Willemen's) and "Formal Permutations of the POV Shot" (*Screen* 16, 3 [1975]). The third article (somewhat ironic given Rees and Borzello's 1986 promotion of these authors' writing as a model for the antiformalist post–new art history) was written by Kristin Thompson and David Bordwell: "Space and Narration in the Films of Ozu" (*Screen* 17, 2 [1976]).

T. J. Clark wrote that his study of Manet was an attempt "to raise some theoretical questions which relate to *Screen*'s recent concerns" and to provide, with his examples (he quotes from MacCabe's article), "a materialist reading [specifying] articulations within the [picture] on determining grounds" (MacCabe 1978: 36). And not content with providing MacCabe merely with a practical (materialist) response to his theoretical questions, Clark's introduction shifts to Paul Willemen's "Notes on Subjectivity – On Reading 'Subjectivity under Seige'" (*Screen* 19, 1) and by extension to the aforementioned essays from the preceding three years. Clark writes of his concern about recent movements in *Screen*'s discourse: "There has been an impatience lately in the pages of *Screen* with the idea that texts construct spectators, and an awareness that" (he incorporates a quotation from Willemen's text)

> the activity of the text must be thought in terms of which set of discourses it encounters in any particular set of circumstances, and how this encounter may restructure both the productivity of the text and the discourses with which it combines to form an intertextual field which is *always in ideology, always in history* [my emphasis]. Some texts can be more or less recalcitrant if pulled into a particular field, while others can be fitted comfortably into it. (*Screen* 21 [Spring 1980], p. 22)

These essays, in the company of others outside the *Screen* context, provide an important indication of the shift in attention away from a formalist and ahistorical reading of a work of art – grounded in a programmatic communication system and a seamless semiotic – to one that foregrounds the instability of meaning. They also acknowledge the implicit power relations between texts and readers within a dynamic social, political, and historical context; in this

context, the location of the (classed) subject is *always* at issue. As Willemen announced in his provocative introduction, he wished to attend to the

> problem of enunciation and subjectivity, to mark a possible site of an exit from *formal semiotics and mechanical structuralism* [my emphasis], both of which tend to locate films as messages circulated between "inscribed" or abstractly conceived addressers and addressees, the a-historical "persons" put into place by conventional information theory. (Willemen 1978: 41)

And later he engages "the possibility of thinking discursive practices as constructing subjectivity in social formations, in/for ideology" (ibid., p. 43).

The key theoretical issues to which Clark responded in these essays, some of which he subordinated in his books on Courbet, involved the visual representation of ideology, the position of the author, and the status of the reader – both author's and reader's discursive relationships to the work – as well as the work's historical relationship to a labor process, a system of production, and a sociopolitical reality. These became, a few years later – almost by default – the bread-and-butter issues of the "new" art history. As Willemen wrote:

> . . . the process of meaning production can no longer be thought of as the effectivity of a system of representation, but rather as a production of and by subjects already in social practices; a production not dependent upon any single "system of representation," but determined by the relations of force, the conjunction of discursive, economic and political practices which produces subjects in history. (Ibid., p. 47)

Willemen's (Gramscian) gloss of the sociopolitical context and his emphasis upon history and power relations are key indicators of the shift in attitude away from coded representations which demand an exemplary reader/analyst (or historian) who seeks in the signifying practice some (Althusserean) vestige of state and/or institutional power, to one in which the political subject is predominant. Willemen assumed the reader to be a political subject (or agent) who is firmly planted – not simply *interpellated* as Althusser argued – in ideology, part of a social formation (class), and, as such, embedded in history. Willemen invokes the theoretical positions of Pierre Macherey, Tzvetan Todorov, and Umberto Eco on the stochastic nature of language, and the political projects with respect to language and power of Jacques Derrida and Antonio Gramsci. The rhetorical *accents* of Willemen's essay provide cues to his move away from theoretical positions that emphasize structure to those which privilege agency. However, his use of competing theoretical points of view forced him into the somewhat anomalous position of arguing that while "real readers are subjects in history" (classed subjects – Gramsci), "the real is never in its place," that "it is only grasped through discourse" (Lacan).

Willemen's essay is one of a small number of *Screen* essays that mark a major shift in the intellectual provenance of the journal, abridging or transgressing

some of the discursive nodal points evident previously in the work of other *Screen* writers, among them Wollen, Heath, and Mulvey.[20] In this particular essay his theoretical elisions and political "transgressions" encouraged editorial board members Ben Brewster and Elizabeth Cowie to make the uncharacteristic move of adding a critical addendum to the essay. In particular, they expressed some reservations regarding his Lacanian distinction between the real and reality. Willemen, they wrote,

> employs the psychoanalytic distinction between the "real" and "reality," which has been expounded in *Screen* by Stephen Heath in "Anata Mo" (vol. 17 no. 4), but links it to the question of the relations between discursive formations and the relations of production. The danger is that reality will be assigned to the former and the real to the latter, reproducing the now surely discredited notion of ideology as the misleading phenomenal form of the real movement of the relations of production. The problem is not just that this position is difficult to sustain theoretically, but also in so far as it answers a demand – for the reconciliation of two discourses: that of psychoanalysis and that of historical materialism – it does so in such a way that each reduces the effectivity of the other rather than the combination being productive of either. (Willemen 1978: 69)

These editorial interventions prevented Willemen's discursive shift from becoming mired in a form of postmodern relativism and reaffirmed the engaged politics and historical materialism long associated with the *Screen* project. MacCabe's essay reinforces the in-house critique of this implicit postmodern relativism by focusing the reader's attention upon *Screen*'s contradictory use of the term discourse. He persuasively presents a materialist point of view, arguing that "the appeal to the economic is necessary to anchor the ideological struggle in definite political terms. Without reference to the economic, ideological struggle would be given no political content" (1978–9: 35). He suggests that while theoretical considerations allow us to "appreciate the conditions for political intervention . . . they do not enable us to provide any immediate solution into any specific debate or struggle" (p. 42). Affirming that *Screen*'s success in transforming the critical discourse of cinema and television has been limited to the professional world and academia, MacCabe promotes the useful political work of film critics and other writers working for the popular London magazine *Time Out*, cautioning however that while *Time Out*'s work regularly reaches a larger audience, it is still too journalistic, impressionistic, and reactionary to provide a model for resisting the hegemonic power of the ideologically dominant culture.

Clark's response to both Willemen and MacCabe underwrites the reemergent Marxism of some members of the *Screen* editorial board while implicitly endorsing the postmodern concerns with the relativity of meaning. The bulk of his *Olympia* essay is based on his reading of sixty popular reviews published in Paris journals and newspapers during and after the Salon exhibition of 1865.

He considers this to be a practical response to Willemen's theoretical point that "the activity of the text must be thought in terms of which set of discourses it encounters in any particular set of circumstances." Clark questions which discourses *Olympia* encountered in 1865 and concludes that there were two: "a discourse in which the relations and disjunctions of the terms Woman/Nude/Prostitute were obsessively rehearsed (which I shall call, clumsily, the discourse on woman in the 1860's), and the complex but deeply repetitive discourse of aesthetic judgement in the second empire" (1980: 23). Any new art historian would now add other discourses – editorial policies of the media, the politics of humor (irony, satire, parody, burlesque), race, gender, sexuality, the roles of the artist and the critic – all of which would now have to be appended to Clark's two. However, the clarity of Clark's argument in this essay, his exemplary interpretation of his examples, a rich extended corpus – beyond the painted artifact – provided an *ex cathedra* example of the *concentration* he sought in the social-historical project. Clark's intervention reveals that while Rees and Bordello can claim a conjugal relationship with film studies, film studies can certainly claim the same of art history, and cultural studies can with both.

II

Many film-history texts argue the close formal relationships among theater, literature, visual arts, and film. Without I hope, belaboring the point, we should acknowledge that there is much interchange, appropriation, quoting, and borrowing, both formally and theoretically, from the discursive fields of art history, film and literary studies and among the rival arts of theater, literature, visual arts, and film. The formal innovations presented by modernist art have been very productive for the development of cinema as an art form. Similarly, the theoretical and methodological innovations in the history of art have been conducive to the development of the discourse of film and film historiography, participating in the construction of historical (periodization) and stylistic registers and genre typology and for demonstrating the importance (or lack thereof) of national identities in the production of culture. The selection of exemplary authors – canon building – as well as the sharing of technological language have all presented opportunities for shared discourses, some productive and useful, some not.

Film historians and theorists – Kracauer, Bazin, Sadoul, Mast, Rhode, and Bordwell – have all acknowledged in various ways the important influences on the development of cinema of modernist avant-garde strategies in theater, literature, and visual art. Film history has recently admitted other texts that examine the close theoretical relationships between film and the other arts. Timothy Murray's *Like a Film: Ideological Fantasy on Screen, Camera and Canvas* (1993) and Brigitte Peucker's *Incorporating Images: Film and the Rival Arts* (1995) provide some useful examples of the cooptation and conflation of theories and forms. And inspired by Lacan's psychoanalytic models, Barthes's *Camera Lucida:*

Reflections on Photography (1980), and Derrida's extended essay *The Truth in Painting* (Peucker 1995: 162), the relationship between visual art and film has also been a site of discussion in the work of Jacqueline Rose, Noel Carroll, Kaja Silverman, Angela Della Vacche, John Walker, Emen Spitz, Raymond Bellour, Constance Penley, Pascal Bonitzer, and Jacques Aumont, continuing the important work of *Cahiers du Cinéma*, *Cinéthique*, *Screen*, and other film-studies journals.

The connection between the history of visual art and that of cinema does not require rewriting here. But what of the representation of art and art history – the institution art – in film? This has been a very different relationship, one marked less by discourse conflation, utility, hybridity, similarity, consonance than of *dissonance* and *difference*. For all of those films that reproduce modernist technical innovations, or faithfully represent the vanguard projects of modernist art, there are as many that repudiate, reject, and disavow art, playing out familiar popular rejection and negation strategies (satire, parody, burlesque) in a manner reminiscent of cartoons, comics, and other forms of popular culture.[21]

In an article published in *Screen* Stephen Heath discusses the relationship between modernist art and narrative. He cites the example of the film *Suspicion* (1941), directed by Alfred Hitchcock, in which a character, Lina Aysgarth, played by Joan Fontaine in an Oscar-winning performance, is questioned by police detectives about her husband Johnnie. Before and after their interrogation of Aysgarth, one of the detectives, Benson, pauses on his way into the living room of the Aysgarth residence to inspect a Picassoesque Cubist painting. Heath argues that this gesture provides a rupture in the film's diegesis, thus presenting "a problem of point of view, different framing, disturbance of the law and its inspectoring eye, interruption of homogeneity of the political economy." He continues with "it is somewhere else again, another scene, another story, another space."[22] I would argue that the insertion of this gesture also represents an interruption of homogeneity in the film's *political* economy by reinforcing the popular hostility between the 1940s public and the project(s) of modernist art. The insertion of this scene may also reveal Hitchcock's own somewhat ambivalent opinions – not unusual among film directors of the time – about modernist art.[23] This view is reinforced in *Suspicion* by the introduction early on in the film of another painting, a conventional three-quarter-length military-style realist portrait of Lina's father, the imperious General Mackinlaw. This gilt-framed painting conveniently falls down from its pride of place above a mantel when the rakish suitor Johnnie (Cary Grant) asks it in jest for Lina's hand in marriage. This situation is prefigured in an earlier paternalistic comment from the general that is overheard by Lina standing outside the living-room window of her parents' home – "Lina will never marry, she's not the marrying sort. . . . Lina has intellect and a fine solid character." The painting appears in other significant sequences in the film, usually animated by the framing eye of the camera or the points of view of the protagonists. In a crucial sense, Hitchcock anthropomorphizes the painting, using it to simulate the presence of the absent father. After the somewhat hasty marriage of Lina and Johnnie, it begins to cast the general's disapproving eye upon their increasingly tense relationship. In the scene

that contains the police questioning Lina, Benson's rapt yet distracted attention to the modernist painting is contrasted to the *very* alive realist portrait of the general. This tension between the vital realist representation and the modernist abstract appears in many Hitchcock films. In fact, Hitchcock's films are riddled with subtle references to art, less a result of the scripts he worked on than of his own conservative introduction to art at London University[24] and his typically sardonic sense of humor. In many of his films, most of which conform to conventional Hollywood genres, art and art history become vehicles for providing suspense-filled dramas with some light relief, or more often some dark necromantic significance; yet the underlying discursive motif, I would contend, is resistance and, perhaps, accommodation to modernist art.

Brigitte Peucker (1995) has discussed the shock of contrast between these discursive fields in Hitchcock's *Vertigo* (1958). She describes the scene that contains a painting by Midge, the fashion designer/artist character in the film, a copy of the image of the Judy Barton (Kim Novak) character who throughout the film is the object of desire of Scottie Ferguson (James Stewart). In order to convince him that she is an available substitute, Midge has imbricated her own image with Judy's portrait body, creating a kind of palimpsest of Scottie's obsession. Peucker suggests that the shock value of Midge's painting (Fig. 40) is difficult to assess, particularly for contemporary audiences used to modernist art. However, located back to its time of reception – 1941, the third year of World War II – Midge's artist's studio is full of examples of contemporary and abstract art which would have been recognized by the audience as shockingly avant-garde. Midge's entry into Hitchcock's sardonic discourse on the relationship between art and death is signaled in a conversation between her and Scottie. When she tells him that she "has gone back to her first love, painting," he asks whether it is a "still life." "Not exactly," she replies, which Peucker interprets as a further indication of the "unnaturalness" of her portrait palimpsest, which is "not even *like* nature and hence doubly lifeless" (p. 66). She goes on to suggest that this scene,

> with its flaunting of fragmented and modernist works of art[,] figures the hesitation created in the film by its multiplicity of perspectives, the splitting of point of view that finds its visual analogue in the fragmentation of the female body, displayed not only in the doubled portrait, but in the freestanding sculpture of the breast. (Ibid.)

Diane Waldman argues that the 1940s woman's gothic film conventionally casts suspicion on the husband's sanity by associating him with the distorted style of modern art.[25] Peucker's examples reveal that this is not necessarily specific to the husband, and I would suggest that this "critical use" for modernism may have as much to do with the public [mis]perception of the modernist project as with the exigencies of the film's diegesis. In the hundreds of films through the history of the cinema that critically represent the institution art, the political economy of such representations is always at issue. In many films the work

of modernist art, like Manet's *Olympia* discussed earlier, is situated at the confluence of several (competing) discourses: the body/the idea of woman, art, technical competency, the role of the artist, the psychology of the artist, architecture, art history, criticism, the museum, capital/the art market, crime, and genius. The film frame becomes a site for questioning and contesting the meanings and value of modern art.

Pierre Bourdieu (1984; Bourdieu and Passeron 1977) has demonstrated that the aesthetic tastes of members of various classes and class fractions are strongly tied to the accumulation of cultural capital provided by an individual's education and class background. Bourdieu's research reveals that a high level of "cultural competency" is required in order to consume (understand, appreciate) the products of high culture, including the discursive fields in which they are located. The representation of modernist art in film often confirms the lack of such competency on the part of the viewing public as well as the producers of the film. As much as the classical Hollywood cinema confirms popular expectations and attitudes – "a system of norms operating at different levels of generality" (Bordwell et al. 1985: 7) – the art framed within this system provides an affirmation of conservative ideologies generally understood and upheld by the culture-consuming *and* -producing public.

The institution of art figures prominently in *Scarlet Street* (1945), an important early example of film noir directed by Fritz Lang. Edward G. Robinson plays the part of Christopher Cross, an honest, quiet, and sensitive financial office clerk with a domineering wife who spends his leisure hours painting naive modernist works (Figs. 41–4). On a typically "noirish" rainy night after a work celebration for his boss, J. J., he intervenes in a struggle between a beautiful vamp, Scarlet Street, and her rakish beau Johnnie. Not realizing the relationship between them, he falls helplessly in love with Scarlet and over the course of a few days is drawn unwittingly into a sugar-daddy relationship, providing her with money for a studio apartment, clothes, cosmetics, and food. In order to accede to her (and Johnnie's) escalating demands, he steals money from his employer. And in order to placate his philistine wife, who abhors his art, he removes his "dreadful paintings" to the studio apartment. Grasping for more money to satisfy his hyper-consumption, Johnnie decides to try selling one of Chris's paintings. He finds an interested shop-front secondhand dealer, who buys the painting and shows it among his other wares. The painting commands the attention of a famous art critic, who is excited by what he perceives to be a rare talent. He demands to know who painted the pictures and requests a meeting. Johnnie passes Scarlet off as the "master," and, with some positive attention from the critic, her first show is a sellout and her success in the art world assured. Meanwhile Chris's wife has discovered that a painting "similar" to one of her husband's paintings is showing in an uptown gallery and accuses her husband of copying this famous artist's work. This results in Chris's discovery of the relationship between Scarlet and Johnnie and the revelation that both he and his art have "been taken for a ride." In a blind rage – about Scarlet's relationship with Johnnie, not about her success with his art – he kills her. The

Figure 40. Vertigo: *Barbara Bel Geddes and James Stewart. Photo courtesy of Photofest N.Y.*

crime is pinned on the protesting Johnnie, who is sent to the chair. At the conclusion of the film it appears that Chris may have gotten away with it, an ending that was considered a breach of the Production Code Administration rules of the day. This was overruled in the end because Chris was finally driven mad by his acute remorse, punished effectively by a higher power.

The film's narrative and the characters of Chris and Scarlet, Johnnie and Chris's wife represent several negative stereotypes about the artist's role and the

Figure 41. *Bathroom genius...Edward G. Robinson doesn't know it, but his paintings in Universal's Scarlet Street are the crux of a plot that will have audiences hanging onto their seats. Robinson and Joan Bennett are costarred with Dan Duryea in the melodrama which Fritz Lang is bringing to the screen. Photo courtesy of Photofest N.Y.*

conditions of creativity.[26] Chris's wife is the domineering philistine who, lacking cultural competence, openly detests modernist art. Her counterparts appear in hundreds of cartoons in the pages of the *New Yorker* from the 1930s through to the 1960s, often reinforcing the opinions of their sexist and equally conservative male companions. The film's narrative also underlines the popular perception that the art world is fickle, that reputations are made on very little evidence of talent, and that the value of art can be easily inflated by the system. Another position for audience consideration is that artists are fakes, fools, or misunderstood geniuses and that critics make arbitrary and quite often wrong judgments. *Scarlet Street* provides a context for the contestation of several discourses and a site for questioning the terms and conditions of modernist art's entry into popular culture. It encounters resistance all the way and finally falls into the abyss of cultural disenfranchisement, alienation, criminality, and death.

With its extraordinary Gotham City scenes inspired by Fritz Lang's *Metropolis*

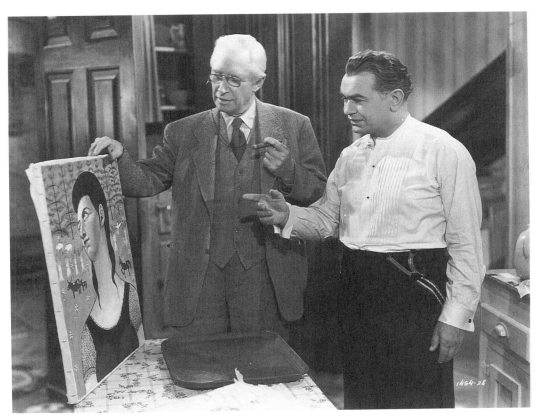

Figure 42. *"... Sure I painted it..." Samuel S. Hinds is skeptical of Edward G. Robinson's ability as an artist, but obtains first-hand information when he visits his home. They are appearing in Universal's Scarlet Street, which costars Robinson and Joan Bennett with Dan Duryea. Fritz Lang produces and directs. Photo courtesy of Photofest N.Y.*

(1926), director Tim Burton's *Batman* (1989) fully deserved its Academy Award for best art direction. However, art and art history figure in a very different way from the Academy's expectations in a crucial scene from the film. In company with the Hitchcock and Lang films discussed above, discourses of death, crime, and art are conflated to provide an engaging and educative burlesque on the value and meaning of art in society.

When Bruce Wayne (Batman) does his research on Jack Napier a.k.a. the Joker – surely one of the most lovable, if diabolical, characters in any film of the past few decades – he finds that his high-school aptitudes were listed as "Science, Chemistry and Art" – indicating the makings of a stereotypical Renaissance man. His hideout features a huge mural of his ideal woman, a huge *Playboy* Varga-type image of a 1930s vamp. The Joker's status as a contemporary artist is confirmed when we see him working on a huge montage of magazine and newspaper photograph cutouts. Attracted to an image of photographer/

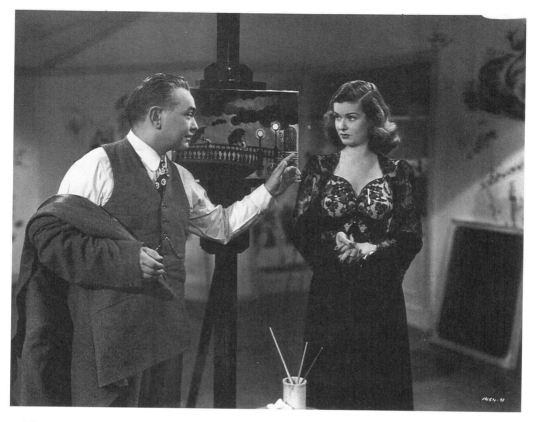

Figure 43. *Putting her on canvas... Edward G. Robinson paints a portrait of Joan Bennett in Universal's* Scarlet Street, *which also headlines Dan Duryea. Fritz Lang is producer and director. Photo courtesy of Photofest N.Y.*

reporter Vicky Vale (Kim Basinger) that he finds, he decides to interview her for a potential "job" with his organization. He sets up a meeting with Vale in the Gotham City Museum, a composite of New York's Frick, Metropolitan, Guggenheim, Whitney, and MOMA. Using his superior chemistry skills, he fills the museum space with a purple gas that anesthetizes everybody in sight with the exception of Miss Vale, to whom he has sent a protective facemask. After the gas has filled the space, and to the accompaniment of a bouncy Joker rap song, Jack invokes his pack with "Gentlemen . . . Let's broaden our minds," as they proceed to move quickly through the museum, altering, painting, spraying, tearing, cutting, hacking, destroying famous artwork after famous artwork. The desecration of culture is accompanied throughout by a bizarre rap from Jack, directing his band with a choreographed point here, a point there; at least ten major works from the canon are "creatively altered" Shafrazi-style, including a Rembrandt self-portrait, two Degas dancers, a Vermeer, a Joshua Reynolds, and a Monet, until he stops one of his men from defacing a Francis Bacon "butcher series" painting with "Hold it! I rather like that one."

Figure 44. *Portrait of Joan Bennett from* Scarlet Street. *Photo courtesy of Photofest N.Y.*

At the conclusion of his destructive tour of the museum he alights next to the astounded Vicki Vale sitting in the museum restaurant. He demands to see her portfolio and quickly flicks through the pages of glossy colored advertising photographs with "crap," "crap," "crap," "crap," until he arrives at some black-and-white documentary photographs – social commentary – images of victims of war and famine. "Ah, now that's good work . . . the body . . . skulls

279

... you give it so much of a glow," he says, followed by the kicker – "I don't know whether it's art, but I like it!" He then proudly announces to Vale that he, Jack Napier, is also an artist – "I make art, 'til someone dies. . . . I'm the world's first fully functioning homicidal artist!" – and that she will "join him in his avant-garde – a new aesthetic." Ordering Alicia, one of his companions, to unmask, the Joker reveals one of his masterpieces, a once beautiful model with an acid-scarred face. "I'm no Picasso," he says, "but do you like it?" He then presses a pocket bulb to propel some acid from a joke flower in his lapel, as Batman, crashing predictably through a skylight, arrives on the scene to rescue this damsel in distress. High drama, comic book style, but the political messages are similar to those discussed earlier. The Joker's burlesquing of the art institution encourage the audience to do the same. The conflation of the separate discourses of art, crime, death would be humorous if it were not for the fact that these represent ideological positions which are commonly voiced in other contexts.

These few film examples, among many others, reveal the symbolic contest of power as this is representative of the struggle between various groups and constituencies over the social relevance and use (or lack thereof) of art and art history. They confirm that art's otherness is indeed significant; and moreover, as Pierre Bourdieu has argued, that "different classes (and social fractions) are engaged in a specifically symbolic struggle to impose the definition of the social world most in conformity with their interests. The field of ideological positions reproduces in transfigured form the field of social positions" (Bourdieu and Passeron 1977: 112).

One of the benefits, perhaps albatrosses, which the so-called new art history has conferred upon students of art history is the freedom to explore art (and art history) *inter alia* – from the outside, the underside – occasionally the dark side – to acknowledge the complexity of social relations which an artist, and indeed an art historian or critic, enters into when he or she produces or writes about a work of art. An art historian can no longer follow the "protocols of the Western canon" (Crow 1996: vii), isolating a work of art from its social and political contexts, privileging its formal elements, the psychology of the artist, or the aesthetic school to which he or she belongs. As Crow remarks:

> a postmodern outlook can afford no exclusion of the Hollywood films, television productions, glossy advertisements, computer graphics, and all the enticing products of the age. Likewise, the ancestors of these artefacts in the emerging popular media of previous centuries must be given equal standing to any received curriculum of masterworks. (p. vii)

In this chapter I have attempted to reveal some of the complexities of an interdisciplinary approach to art history, in terms of theory, identified in this chapter as the imbrication of one discursive regime upon another; and in terms of practice, the meanings attached to the representation of modernist art in popular culture.

Notes

1 The indications of a crisis can be traced to T. J. Clark's famous *Times Literary Supplement* essay of May 24, 1974, in which he stated, "It ought to be clear by now that I'm not interested in the social history of art as part of a cheerful diversification of the subject, taking its place alongside the other varieties – formalist, modernist, sub-Freudian, filmic, feminist, radical. For diversification read disintegration. And what we need is the opposite: concentration, the possibility of argument instead of this deadly co-existence, a means to the old debates. This is what the social history of art has to offer: it is the place where the questions have to be asked, but where they cannot be asked in the old way." Rees and Borzello (1986) cite the importance for the development of the new art history of the publication in 1973 of T. J. Clark's books *The Absolute Bourgeois: Artists and Politics in France 1848–51* and *The Image of the People: Gustave Courbet and the 1848 Revolution*, as well as the institution in 1975 of the MA course in the social history of art at Leeds University.

2 The Winter 1982 issue of *Art Journal* (42, 4) was partially responsible for introducing the crisis into the North American context. Guest-edited by H. Zerner, the issue included contributions by O. Grabar, O. K. Werkmeister, J. Hart, D. Summers, R. Krauss, and D. Preziosi. In Britain the Middlesex Polytechnic and *Block*, a magazine devoted to the publication of progressive art history, held a conference called "The New Art History?" Preziosi suggests that there "both is and is not a crisis in art history at the present time" (1989: 2) and distinguishes between "a crisis *in* the discipline" and a "crisis *of* the discipline" – the latter a constituent and ongoing feature "that antedate[s] the institutionalization of the discipline and has been built into it from its academic beginnings" (p. 19), and the former (crisis *in* the discipline) a feature that questions the accommodation of theories and methodologies that disavow the foundational historicism of art history, which Preziosi suggests has more serious implications.

3 Formalism, connoisseurship, feminism, Marxism, neo-Marxism, social history, structuralism, poststructuralism, phenomenology, discourse analysis, reception aesthetics, deconstruction.

4 Althusser, Bakhtin, Barthes, Bataille, Baudrillard, Coward, Cixoux, Derrida, Deleuze, Eco, Foucault, Greimas, Jameson, Kristeva, Lacan, Lévi-Strauss, Marx, Said, Spivak, Thompson, and Williams – to list a few of the more prominent ones.

5 Many texts in the film-studies bibliography appeared well before this time; e.g., Hugo Munsterberg's *The Film: A Psychological Study* (1916) and Siegfried Kracauer's classic *From Caligari to Hitler: A Psychological Study of the German Film* (1947). However, the introduction of film studies to the academic curriculum did not occur until the early 1960s. See Robert Sklar, "Oh! Althusser!: Historiography and the Rise of Cinema Studies," in *Resisting Images: Essays on Cinema and History*, ed. Robert Sklar and Charles Musser (Philadelphia: Temple University Press, 1990).

6 Roland Barthes (1977) identified the eighteenth century as the beginning of this discourse, and Diderot as the exemplary proto-cinematic theorist.

7 John Tagg argues that *Screen*'s sister journal *Screen Education*, which later merged with *Screen*, "had an idea of cultural history and cultural theory that was, by then [1980] much broader than the journal *Screen*'s idea of finding a methodology and a text to apply it to – a can-opener to open the text. The board of *Screen Education* had tried to develop a notion of cultural politics that carried over into the journal's specific involvement with teaching and pedagogy" (Tagg 1992: 78–9). Tagg's view can be considered somewhat biased, given his place on the editorial board of *Screen Education* at this time.

8 A similar process could be undertaken with a large number of journals (*October, Parachute, New Literary History, Jumpcut, Social Text, Yale French Studies, Camera Obscura*, etc.), each of which would emphasize different aspects of the structuralist, post-structural, and postmodern debates.

9 *Screen* has been the subject of a number of essays, and it figures prominently in several recent texts examining film theory of the 1970s and 1980s. See Anthony Easthope, "The

Trajectory of *Screen*," in *The Politics of Theory*, ed. Francis Barker (Colchester: University of Essex Press, 1983); and Robert Lapsely and Michael Westlake (eds.), *Film Theory: An Introduction* (Manchester: Manchester University Press, 1988).

10 The late 1960s and early 70s saw the translation and publication of several influential books on film theory and criticism, among them Andre Bazin's *What Is Cinema*, trans. and ed. Hugh Gray, 2 vols. Berkeley and Los Angeles: University of California Press, 1967–71; Noel Burch, *Theory of Film Practice*, trans. Helen R. Lane (New York: Praeger, 1973); and J.-P. Lebel, *Cinéma et idéologie* (Paris: Editions Sociales, 1971).

11 All translated by Ben Brewster, subsequently an important member of *Screen*'s editorial board. Brewster's translations, along with those of Stephen Heath (Roland Barthes's *Image – Music – Text* (1977), helped facilitate the smooth entry of French theory into the English intellectual milieu.

12 In contrast to *Screen*'s appropriation of French theory, other journals were attempting to revisit some of the implications of Marxist discourse in the Western European context. Throughout the 1970s the *New Left Review* remained an important forum for discussions among Williams, Thompson, Perry Anderson, et al. about the changing relationships among theory, politics and social and cultural practice. Anderson's book *Considerations on Western Marxism* appeared in 1974 as a result of some of the important debates which had occurred in the *NLR* in the preceding three years.

13 Ferdinand de Saussure's *semiotics* is now the preferred term over Charles Sanders Peirce's *semiology*. According to its supporters, "semiotics connotes a discipline less static and taxonomic than semiology" (Stam, Burgoyne and Flitterman-Lewis 1992: 4).

14 Christian Metz, *Film Language* (New York: Oxford University Press, 1974), and *Language and Cinema*, trans. D. Umikerseboek (The Hague: Mouton, 1974); Julia Kristeva, "The System and the Speaking Subject," *Times Literary Supplement*, October 12, 1973; as well as R. Coward and J. Ellis, *Language and Materialism: Developments in Semiology and the Theory of the Signifier* (London: Routledge & Kegan Paul, 1975).

15 Many other essays assisted in determining the confluence of the twin discourses – film studies and the new art history, e.g., "Diderot, Brecht, Eisenstein" (1973), which was selected by Stephen Heath for translation in Roland Barthes's *Image – Music – Text* (New York: Hill & Wang, 1977), and Jean-Louis Baudry's "Ideological Effects of the Basic Cinematographic Apparatus," *Film Quarterly*, Winter 1974–5. Barthes's essay discusses the importance of recognizing the individual tableau – "the instant" (or still) as the primary unit of meaning in a film, painting, or play. Baudry's article is an early attempt to construct a paradigm for viewing film by comparing this to the Renaissance perspective system for painting which privileges the spectator as the – fixed or centered, yet active – producer of meaning.

16 This model was present in John Berger's famous book *Ways of Seeing* (1973) from the television series of the same name.

17 I do not wish to totally isolate *Screen* in this development. Many other journals were active participants in the revisionist process, among them *October, Parachute, New German Critique, Telos, Art Journal, Art History, Camera Obscura, Art Forum, Yale French Studies, Semiotica, Critical Enquiry, Representations, Social Text, Semiotext(e)*.

18 The year 1980 witnessed the publication of a very influential group of essays under the title *The Cinematic Apparatus*, ed. Teresa de Lauretis and Stephen Heath (London: St. Martin's Press, 1980).

19 A number of writers (Tagg 1992: 104) have identified the coincidence of a more politicized orientation in the late 1970s and early 1980s with the first election victory of Margaret Thatcher in 1979.

20 From 1973 to 1983, the list of *Screen*'s contributors reads like a "who's who" of the developing film, literary, and cultural studies fields: Terry Eagleton, Stuart Hall, Rosalind Coward, Ian Chambers, Stephen Heath, Laura Mulvey, Colin MacCabe, Geoffrey Nowell-Smith,

Peter Wollen, T. J. Clark, Edward Branigan, Ben Brewster, Constance Penley, Kristin Thompson, David Bordwell, Paul Willemen, and, last but not least, Raymond Williams.

21 I have previously explored the negotiation of meaning and the symbolic contest of power with respect to the representation of modernist art in cartoons and comics. See B. Barber, *Popular Modernisms: Art, Cartoons, Comics and Cultural In/Subordination* (Jackson: University of Mississippi Press, forthcoming).

22 Stephen Heath, "Narrative Space," *Screen* 17, 3 (Autumn 1976): 71.

23 Donald Spoto, *The Art of Alfred Hitchcock: Fifty Years of His Motion Pictures* (New York: Hokinson & Blake, 1976), pp. 155–6.

24 Hitchcock was trained as an engineer at a school of engineering and navigation, where he studied mechanics, electricity, acoustics, and navigation. After graduating, he took employment with Henleys Telegraph and studied art part-time at the University of London. As a result of his art training, Henleys transferred him to the advertising department, where he worked on promotions for electric cables.

25 Diane Waldman, "Horror and Domesticity: The Modern Gothic Romance Film of the 1940's," unpub. Ph.D. thesis, University of Wisconsin, 1981, pp. 164–93, cited in Bordwell, Staiger and Thompson 1985.

26 See G. Pelles, *Art, Artists and Society: Origins of a Modern Dilemma. Painting in France and England 1750–1850* (Englewood Cliffs, N.J.: Prentice-Hall, 1963), and Rudolf Wittkower and Margot Wittkower, *Born under Saturn. The Character and Conduct of Artists: A Documented History from Antiquity to the French Revolution* (New York: Norton/Random House, 1963).

Bibliography

Andrew, D. *Concepts in Film Theory*. Oxford: Oxford University Press, 1984.

Barthes, R. *Image – Music – Text*, trans. Stephen Heath. New York: Hill and Wang, 1977.
 Camera Lucida. New York: Hill and Wang, 1982.
 The Grain of Voice: Interviews 1962–1980, trans. L. Coverdale. New York: Hill and Wang, 1985.

Bordwell, D., Staiger, J., and Thompson, K. *The Classical Hollywood Cinema: Film Style and Mode of Production to 1960*. New York: Columbia University Press, 1985.

Bourdieu, P. *Distinction: A Social Critique of the Judgement of Taste*, trans. Richard Nice. Cambridge: Harvard University Press, 1984.

Bourdieu, P., and Passeron J. C. *Reproduction in Education, Society and Culture*, trans. Richard Nice. Beverly Hills, Calif.: Sage, 1977.

Bürger, P. *The Theory of the Avant-Garde*. Minneapolis: University of Minnesota Press, 1984.

Clark, T. J. "Preliminaries to a possible treatment of *Olympia* in 1865." *Screen* 21, 1 (Spring 1980): 18–41.

Crow, T. *Modern Art in the Common Culture*. New Haven: Yale University Press, 1996.

Della Vacche, A. *Cinema and Painting: How Art Is Used in Film*. Austin: University of Texas Press, 1996.

Denzin, N. K. *The Cinematic Society: The Voyeur's Gaze*. London: Sage, 1995.

Ellis, J. (ed.). *Screen Reader I: Cinema/Ideology/Politics*. London: Society for Education in Film and Television, 1977.

Fried, M. *Absorption and Theatricality: Painting and Beholder in the Age of Diderot*. Berkeley and Los Angeles: University of California Press, 1980.
 Realism, Writing, Disfiguration: On Thomas Eakins and Stephen Crane. Chicago: University of Chicago Press, 1987.

Kracauer, S. *Theory of Film: The Redemption of Physical Reality*. New York: Oxford University Press, 1965.

Laclau, E., and Mouffe, C. *Hegemony and Socialist Strategy*. London: Verso, 1985.

MacCabe, C. "The discursive and the ideological in film – Notes on the conditions of political intervention." *Screen* 19, 4 (Winter 1978–9): 29–43.

 Theory/Low Culture: Analysing Popular Television and High Film. Manchester: Manchester University Press, 1986.

Murray, T. *Like a Film: Ideological Fantasy on Screen, Camera and Canvas*. London: Routledge, 1993.

Norris, C. *What's Wrong with Postmodernism: Critical Theory and the Ends of Philosophy*. Baltimore: Johns Hopkins University Press, 1990.

Peucker, B. *Incorporating Images: Film and the Rival Arts*. Princeton: Princeton University Press, 1995.

Preziosi, D. *Rethinking Art History*. New Haven: Yale University Press, 1989.

Rees, A. L., and Borzello, F. *The New Art History*. London: Camden Press, 1986.

Sklar, R., and Musser, C. (eds.). *Resisting Images: Essays on Cinema and History*. Philadelphia: Temple University Press, 1990.

Stam, R., Burgoyne, R., and Flitterman-Lewis, S. *New Vocabularies in Film Semiotics: Structuralism, Post-Structuralism and Beyond*. London: Routledge, 1992.

Tagg, J. *Grounds of Dispute: Art History, Cultural Politics and the Discursive Field*. Minneapolis: University of Minnesota Press, 1992.

Thompson, J. B. *Ideology and Modern Culture*. Stanford: Stanford University Press, 1990.

Walker, J. *Art and Artists on Screen*. Manchester: University of Manchester Press, 1993.

Willemen, P. "Notes on subjectivity" – On reading "Subjectivity under Siege." *Screen* 19, 1 (Spring 1978): 41–69.

A Selected Filmography: Art Representations, Parodies, Satires, and Burlesques in Film

Edited and augmented from "Hollywood at the Museum: A Filmography," by Patrick Butler, William Howze, Sally Shelton, and David Spaulding, presented at the "Museums and Popular Culture" session of the American Museums Association annual meeting, Philadelphia, 1995. I am indebted to colleagues Harold Pearse and Virginia Stephen for providing me with a copy of this list.

The Agony and the Ecstasy (1965), dir. Carol Reed. Michelangelo contests papal authority as he paints the ceiling of the Sistine Chapel.

All the Vermeers in New York (1990), dir. Jon Jost. Drama about New York art world set in the Metropolitan Museum which explores parallels between the art world and big business.

An American in Paris (1951), dir. Vincente Minnelli. Musical in context of Paris art world.

Animal Crackers (1930), dir. Victor Heerman. Marx Brothers and stolen art.

Annie Hall (1977), dir. Woody Allen. In this romantic and somewhat autobiographical comedy Allen gently satirizes high and low New York culture.

Appointment with Murder (1948), dir. Jack Bernard. The Falcon and international art thieves.

Artists and Models (1955), dir. Frank Tashlin. Dean Martin plays a cartoonist who gets his ideas from Jerry Lewis's dreams. Wild and surreal.

The Art of Love (1965), dir. Norman Jewison. Art forgery and art fraud in Paris.

Backbeat (1994), dir. Ian Softley. Beatles' early art-school days in Liverpool and Hamburg.

Backtrack (1990), dir. Dennis Hopper. Electronic artist Jodie Foster (ref. to New York artist Jenny Holzer) is being tracked by a killer.

Batman (1989), dir. Tim Burton. Jack Nicholson as the Joker trashes the Gotham City art museum containing modernist paintings.

Bell, Book and Candle (1958), dir. Richard Quine. Kim Novak as a dealer in African art.

The Bird with Crystal Plumage (1969), dir. Dario Argento. Murder attempt in a gallery.

Blackmail (1929), dir. Alfred Hitchcock. An artist is killed by a young girl he asks to his studio to see his paintings and whom he attempts to seduce.

A *Bucket of Blood* (1959 and 1996) two versions, dir. Roger Corman. A sculptor murders people and then casts them in cement.

Burglar (1987), dir. Hugh Wilson. Includes an art theft. Whoopi Goldberg as thief.

Camille Claudel (1988), dir. Bruno Nuytten. Claudel's unhappy love affair with Auguste Rodin.

Caravaggio (1986), dir. Derek Jarman. Famous Renaissance artist and homosexual murderer.

Carrington (1996), dir. Christopher Hampton. An inside look at two members of the Bloomsbury group. Lytton Strachey and the painter Dora Carrington, played by Emma Thompson, explore their sexuality and creative desires.

Confessions of Boston Blackie (1941), dir. Edward Dmytryk. Blackie solves an art forgery.

Cop and a Half (1992), dir. Henry Winkler. Several art/crime references.

Corridor of Mirrors (1948), dir. Terence Young. Artist as collector of Renaissance artifacts.

Crime Doctor's Gamble (1947), dir. William Castle. Doctor's vacation in Paris interrupted by murder and art theft.

Crime Doctor's Warning (1945), dir. William Castle. Doctor is involved in case where a mad artist is suspected of murdering people during blackouts.

The Dangerous (1994), dir. Robert Davi and Michael Pare. Ninjas in New Orleans. Climax in galleries and outside Museum of Art.

Demolition Man (1993), dir. Marco Brambila. Stallone and Wesley Snipes shootout in Museum of the Future.

Dodsworth (1936), dir. William Wyler. Adaptation of Sinclair Lewis novel. Man's struggle with high culture in Europe.

Dressed to Kill (1980), dir. Brian de Palma. Has opening sequence of a female victim being followed in a museum.

Eddie and the Cruisers II: Eddie Lives (1989), dir. Jean-Claude Lord. Eddie saves his artist girlfriend from being ripped off by an agent at her first art-show opening.

The Eiger Sanction (1975), dir. Clint Eastwood. Clint Eastwood plays Hemlock, a college professor (art historian, collector, and critic) who proves that one can combine criticism with assassination. Based on a Trevanian novel.

Father Brown (also called *The Detective*) (1954), dir. Robert Hamer. Father Brown is in pursuit of stolen art.

The Freshman (1990), dir. Andrew Bergman. Offbeat comedy starring Marlon Brando, who parodies his *Godfather* role. High cult cuisine, art theft, and traffic in endangered species.

Gaslight (1944), dir. George Cukor. Psychological thriller. Charles Boyer tries to persuade his wife, played by Ingrid Bergman, that she is going insane. Art helps.

Gentleman at Heart (1942), dir. Ray McCarey. Bookie discovers more money in art forgery.

Ghost Busters II (1989), dir. Ivan Reitman. Art conservator becomes inhabited by his painting.

Gothic (1986), dir. Ken Russell. Byron, Percy Shelley, and Mary Shelley in this Russellian portrait of the tortured artist as creative magus stereotype.

The Happy Thieves (1962), dir. George Marshall. Art museum theft in Spain.

Horrors of the Black Museum (1959), dir. Arthur Crabtree. Unfriendly curator.

The Horse's Mouth (1958), dir. Ronald Neame. Gully Jimson paintings done by British kitchen-sink painter John Bratby.

How to Steal a Million (1966), dir. William Wyler. Forgery and museum theft.

I've Heard the Mermaids Singing (1987), dir. Patricia Rozema. Art-world satire starring Sheila McCarthey.

Just Cause (1955), dir. Arne Glimcher. A prisoner in jail paints his cell in an obsessive–compulsive parody of the creative magus/mad genius archetype.

L.A. Story (1991), dir. Mick Jackson. Steve Martin skates through L.A. art museum.

Lady Ice (1973), dir. Tom Gries. Art thieves and the insurance business.

Legal Eagles (1986), dir. Ivan Reitman. Murder and art fraud. Darryl Hannah as artist's daughter and Winger and Redford attempt to recover stolen art.

Lust for Life (1956), dir. Vincente Minnelli. Kirk Douglas as van Gogh struggles obsessively with his life and art.

Manhattan (1979), dir. Woody Allen. Life in New York, including the art world.

Minnie and Moskowitz (1971), dir. John Cassavetes. Romance between museum curator and parking-lot attendant.

The Moderns (1988), dir. Alan Rudolph. Ironic look at the Paris art scene of the 1920s.

Modern Times (1936), dir. Charlie Chaplin. Culture is contrasted with alienating features of Fordism.

Moulin Rouge (1952), dir. John Huston. The desires and frustrations of painter Henri de Toulouse-Lautrec.

The Mystery of Picasso (1956), dir. Henri Georges Clouzot. Documentary about Picasso works subsequently destroyed.

New York Stories (1989), dir. Woody Allen, Francis Ford Coppola, and Martin Scorsese. Scorsese's "Life Lessons" examines in intricate detail the obsessive love of a celebrated abstract expressionist painter (Nick Nolte) for his young model protégée (Rosanna Arquette).

Night Gallery (1969), dir. Boris Saegal, Steven Spielberg, and Barry Shear. Anthology of lessons learned from paintings led to TV series.

Nothing Lasts Forever (1984), dir. Tom Schiller. Comedy about an aspiring artist.

The Party (1968), dir. Blake Edwards. Peter Sellers satire of Hollywood film society and Californian hard-edged abstraction.

Pee-Wee's Big Adventure (1985), dir. Tim Burton. Pee-Wee stops in a museum in search of stolen bicycle.

The Picture of Dorian Gray (1945), dir. Albert Lewin. Adaptation of Oscar Wilde's novel about art, life, love, and death. A young man visibly ages while his portrait becomes more youthful.

Pink Panther (1964), dir. Blake Edwards. Art and jewel thieves.

Play It Again Sam (1972), dir. Herbert Ross. Museum visits and world of high art as part of setting.

Rembrandt (1936), dir. Alexander Korda. Rembrandt's love life and personal tragedies.

The Rothko Conspiracy (1983), dir. Paul Watson. Drama of legal battle over abstract painter Mark Rothko's estate.

St. Ives (1976), dir. J. Lee Thompson. Art theft.

Scarlet Street (1945), dir. Fritz Lang. Starring Joan Bennett. A quiet cashier and Sunday modernist artist falls in love with a femme fatale who ruins his life.

Scrooged (1988), dir. Richard Donner. Two short satires of the art of Pablo Picasso and Yves Klein.

Secret of the Whistler (1946), dir. George Sherman. A wife suspects artist husband of killing her predecessor. She's next.

Six Degrees of Separation (1993), dir. Fred Schepisi. Donald Sutherland as sophisticated Upper West Side (New York City) art buff whose dinner party is invaded by a subject from the margins of society.

Sleeper (1973), dir. Woody Allen. Vision of a museum's future.

Some Kind of Wonderful (1987), dir. Howard Deutch. Love story in museum settings.

Still Life (1992), dir. Graeme Campbell. Slasher movie. Satire of expressionist painting and performance. Art as crime.

Suspicion (1941), dir. Alfred Hitchcock. Joan Fontaine and Cary Grant star in this murder mystery. Includes a short satirical reference to Cubist painting.

Take the Money and Run (1969), dir. Woody Allen. Life history of a thief includes art and museum thefts.

Topkapi (1964), dir. Jules Dassin. Museum theft.

The Train (1965), dir. John Frankenheimer. Question of art versus life.

Vertigo (1958), dir. Alfred Hitchcock. Mystery. Art figures prominently in this film starring James Stewart and Kim Novak.

The Wheeler Dealers (1963), dir. Arthur Hiller. Art deals in French Impressionists by crazy Texans.

The Wolf at the Door (1986), dir. Henning Carlsen. Two years of Gauguin's life story dramatized.

15

Interpreting the Void

Architecture and Spatial Anxiety

Anthony Vidler

**Space – does it belong to the primal phenomenon
(*Urphänomenen*) at the awareness of which men are
overcome, as Goethe says, by an awe to the point of anxiety?**
Martin Heidegger, "Art and Space," in Neil Leach, ed.,
Rethinking Architecture (London: Routledge, 1997), p. 122.

O F all the characteristics that have been identified as specific to
architectural form, that of "space" is perhaps the most elusive. "Style,"
"structure," "function," and "composition" are, if not tangible, at least
knowable through one representational means or another – physical descrip-
tion, analytical drawing, three-dimensional model. "Space" however is essen-
tially intangible; it escapes representation. The "space" of a building or urban
area is neither physically evident nor subject to easy depiction. Its qualities, indeed,
can only be characterized through a study of what is not represented – the white
ground of a plan, the implied sense of visual and bodily projection in perspective
views – or at best through its transformation into something which it is not –
a figure–ground reversal, a solid model of the voids in a building. Space, as
Proust discovered, eludes verbal precision. The effects of a single space might
shift in nature according to subjective and individual states of mind, take on
differing social, gender, and sexual roles, alternate between claustrophobia and
agoraphobia, inspire dread with what Pascal termed its "eternal silence," and
at the same time create the image of comfort through associations with "place"
and "home."

And yet "space," however variously defined and ambiguously formalized, has
been a consistent preoccupation of architects and historians throughout the mod-
ern period, considered as the very leitmotif of modernity, and held out as the
solution for all the paradoxes and problems of historicism. For many theorists
of architecture and urbanism, indeed, the very idea of space and its realization
in three dimensions is in itself a mark of progress; to a large extent the debates

among the avant-gardes and between them and their conservative critics have turned around conflicting notions of space and their attached associations with differing social and political ways of life.

This chapter will examine only one aspect of the complex history of modern space, but one that has formed a constant refrain throughout the century: the essential ambiguity, if not the indefinability, of space as a category of analysis and synthesis, and the corresponding interpretative anxiety it has aroused. It will be my argument that this very ambiguity, boundary-breaking and limit-crossing, continues to make the idea of space especially useful in confronting contemporary questions of site, situation, and place, as well as opening up the possibility of interpreting a range of new architectural positions regarding the *informe*, or "nonform," that have so far resisted traditional concepts of formal analysis.

From Style to Space

The historical and critical interpretation of architecture in the eighteenth and nineteenth centuries was largely dominated by concepts of "style" and "genre" similar to those operative in the domain of painting. Marked by nineteenth-century debates over the relative merits of historical revivals – "Gothic" versus "Classic" – and by the emergence of new functional demands in industrial society, architectural history was generally cast in the form of a narrative tracing the succession of major or minor stylistic periods, more or less tied to a quasi-evolutionary history of society and culture. From James Ferguson in the early nineteenth century to Nikolaus Pevsner in the mid twentieth, some version of this narrative of the styles has remained constant.

This basis in narrative, generally a narrative of progress, has seemed to offer a reassuring authority – the precedent and law of historical development – and one that gained even more significance when joined to the emerging science of evolution. A work might thus be constituted as representative of another era, bringing that era's principles, morals, ethics, and social and cultural values into play in the present. The medievalizing theories and designs of August Welby Pugin, John Ruskin, and William Morris were based on this premise. Alternatively, according to the historicist principle that each epoch in the past seemed to have its own manner of speaking, its own language, authentic to its society and no other, an architectural theory might call for a language appropriate to modern times, one that future historians could single out as being distinctively modern: The Viennese architect Otto Wagner set out this position comprehensively in his *Moderne Architektur* of 1895. In each case the architectural work was seen as deeply founded on and in history, with a sense of its place, however precarious, with respect to past, present, and future.

Formed in this way under the aegis of nationalist romantic ideals that sought a unity between aesthetic character and architectural style, stressing the moral virtue of a "natural" language expressing the culture of an entire

"people," this version of architectural history, elaborated by Hegelian and Rankean historians alike, was equally easily adopted by formalists like Heinrich Wölfflin as a way of endowing pictorial attributes with historicity; following Wölfflin, while scholars have attempted to complicate periodization, disturb previous "crude" stylistic divisions, and substitute new styles, from "late Roman" to "Mannerism" to "Rococo," they have done little to subvert these fundamental outlines. The application to contemporary practice of such terms as "postmodern," "late modern," "deconstructivist," and the like has demonstrated the staying power of this approach, which seeks to identify a nucleus of specific stylistic attributes in order to measure normalization, deformation, and transformation in relation to temporal "periods."

And yet, as early as the end of the nineteenth century, and gaining ground in the first years of the twentieth, this sense of temporal authority was potentially challenged, first in philosophy and psychology, and then in the interpretation of the three-dimensional arts of sculpture and architecture, by a new preoccupation with space. Founded on the understanding that the relationship between a viewer and a work of art was based on a shifting "point of view" determined by a moving body – a theory worked out in popular art criticism by Adolf Hildebrand – the spatial dimension rapidly became a central preoccupation for those interested in understanding the special conditions of architecture, an art that, while perceived visually, was experienced in space.

In architectural history, similarly, the notion of architectural space as having a historical specificity was used to give new life to the historicist paradigm: The history of styles was gradually dissolved into, or replaced by, the history of spaces.[1] Given historical specificity as a product of culturally determined vision by pioneers of formal analysis like Aloïs Riegl, "space" became central to the architectural histories of August Schmarsow and Paul Frankl. In his thesis of 1913–14, *Die Entwicklungsphasen der neueren Baukunst*, translated as *Principles of Architectural History*, Frankl grafted a spatial history of architecture since the Renaissance on the time-honored perdiodization of historicism. His four categories, spatial form, corporeal form, visible form, and purposive intention, were explored in the context of four periods or phases, with the intent of reformulating the question of style according to spatioformal criteria that acted together to form a total building: "The visual impression, the *image* produced by differences of light and color, is primary in our perception of a building. We empirically reinterpret this image into a conception of *corporeality*, and this defines the form of the *space within*, whether we read it from outside or stand in the interior. But optical appearances, corporeality, and space, do not alone make a building. . . . Once we have interpreted the optical image into a conception of space, enclosed by mass, we read its *purpose* from the spatial form."[2]

This type of developmental history of space was to be canonized, so to speak, in the modernist tradition by the publication of Sigfried Giedion's *Space, Time and Architecture* in 1941.[3] For Giedion, as for most modernist architects, the invention of a "new" space conception was the leitmotif of modernity itself,

supported by the modernist avant-garde call for an escape from history, that affirmed the importance of space both for architectural planning and form and for modern life as a whole. The idea of space held the double promise of dissolving rigid stylistic characterization into fundamental three-dimensional organizations and of providing the essential material, so to speak, for the development of a truly modern architecture.

For these reasons, spatial ideas were particularly attractive to modernist architects, first as a way of escaping the historicist trap of stylistic revivalism and incorporating time, movement, and social life into the conceptualization of abstract form in general, then as a way of defining the terms of this new life, its relationship to nature and the body. The history of modernism, indeed, might be and has often been written as a history of competing ideas of space. At the turn of the century, Hendrick Berlage wrote on "Raumkunst und Architektur" (1907); August Endell, who had followed the lectures of Theodor Lipps in Munich, joined spatial theory to empathy theory in his *Die Schönheit des grossen Stadt* of 1908; both authors have been seen as influential on the spatial ideas of Mies van der Rohe.[4] The Dutch architects and painters in the de Stijl group, including Theo van Doesburg and Piet Mondrian, advanced their revolutionary concepts of "neo-plastic" space in their own journal. In the United States, Frank Lloyd Wright took on the entire space of the continent in his vision of a "prairie" space, fit for democratic individualists. His Viennese assistant Rudolf Schindler dubbed this "space architecture" in a brief homage to what he called this "new medium" published in 1934. In France, the reflections of Henri Bergson on time, movement, and space were quickly picked up by architects and artists, and incorporated into the popular writings of Elie Faure, and were taken up by the painter Ozenfant and the architect Le Corbusier, later to be elaborated into the latter's poetic evocation of a modernist *espace indicible*, or "ineffable space." It was hardly concidental, then, that historians of the Modern Movement like Sigfried Giedion and Bruno Zevi, armed with the same spatial concepts in their own discipline, were able to find a neat correspondence between "space" and the "modernity" of the century.

Initially construed in this way as a substitute for and amplification of the stylistic and genre classifications of nineteenth-century art history, spatial history emerged in the 1930s and 40s as the counterpart to avant-garde abstraction and the authorization for spatial experimentation. This theme was taken up after World War II by, among many others, historians like Bruno Zevi, Rex Martienssen, and Renato de Fusco.[5] The political and social characteristics of space, theorized in political geography and sociology since Theodor Herzl, Georg Simmel, and Maurice Halbwachs, were also increasingly seen as keys to the understanding of architecture and urbanism, informing studies as diverse as Chombart de Lauwe on Paris and the Situationists' critiques of urbanism in *Internationale Situationniste* (1958–69).

Psychological and existential theories of space based on the theories of Eugène Minkowski, Jean Piaget, and of course Heidegger and Sartre were equally

influential in the interpretation of architecture's "poetics" (Gaston Bachelard's *La poétique de l'espace* was first published in 1957). Architectural "functionalists" were comforted by the empirical experiments of Edward T. Hall (*The Hidden Dimension*, Prentice-Hall, 1969) and Robert Sommer (*Personal Space: The Behavioral Basis of Design*, Prentice-Hall, 1969) at the same time as being helped in different ways by the manuals of spatial organization by Christopher Alexander and Kevin Lynch. In the late 1960s, Marxist (Henri Lefebvre) and poststructuralist (Michel Foucault) analysis reinvigorated the idea of space by relating it to power and institutionalized systems of order: Prisons, asylums, and schools, as well as the ideology of functionalism, became the privileged objects of study for historians concerned to locate and resist the sources of power within the professional discourse of architecture itself. Postmodernism has, similarly, been characterized as a reaction to modernism – whether in its spatial complexities or its return to traditional values. Critics like Fredric Jameson, in his seminal essay on the Hotel Bonaventure in Los Angeles, have even postulated a generalized "postmodern space."

More recently, and building on 1950s and 60s Marxist concepts of the production, consumption, and spectacular representation of space, theories of identity, gender, postcolonialism, and regionalism have sought to appropriate spatial analysis for their own interests. The spatial interpretation of architecture and urbanism has followed these tendencies, and redefined its ideas of space and its analytical approaches at each juncture.

In this context of continuous reinterpretation, we might be tempted to assert, paraphrasing Heinrich Wölfflin on vision, that space "has a history," or rather, considering its multiple definitions in different academic and professional domains, "has many histories."[6] Indeed, far from the innocent and self-evident entity imagined by many art historians and architects – as exemplified in the common idea that one might readily determine the characteristics of, say, "Greek space" as opposed to "Baroque" or "Modern" space – space can now be seen in the light of these histories as a complex cultural and intellectual construct, continually shifting in its formulation, application, and instrumentality. In historical-cultural terms, space (much like the "body" or "sexuality") should be considered not so much a constant as a continuously changing concept that shifts over time and according to the conceiver.

To assert this, of course, does not mean that what a Marxist philosopher of space like Henri Lefebvre calls *material* space does not exist. Certainly the physical enclosure and occupation of space, together with the instrumental expansion, consumption, and reproduction of territories and boundaries, assisted by technologies of mapping and viewing, is a constant factor in our lives. Space is, in this sense, "produced" like any other material object, with corresponding social, political, and economic effects. But the interpretation of this space, however measurable, is not, as Kant and his followers opined, an unchanging and universal a priori, precisely because its perception and inhabitation are the products of individual and social experience.

Baroque Space

Appropriated on behalf of multiple identities, whether of individual subjects, peoples, or buildings, the idea of "space" in the modern period has ever been marked by instability and an elusive negativity, opposing itself to the apparent securities involved in the notion of "place." Thus the attempt of phenomenological thinkers from Rousseau to Bachelard to arrest the fluidity of space and to domesticate it for the body and society in place has ever been thwarted by the anxiety attached to space and its tendency to invade even the most defended of places.[7] The theory of the uncanny, outlined by Schelling and redefined in psychoanalytical terms by Freud, stresses this capacity of invisible space to unsettle place, the *unheimlich* erupting in the *heimlich*.

Modern space, after all, took its initial definition from the sublime, where infinite extension, whether of distance, height, depth, or light and dark, approximates the terror of the naturally infinite. Space in the sublime of Burke and Schiller is precisely that incommensurable, unknowable, invisible nothingness that represents, if it represents anything, the very extent of our incapacities. Space and boundary, space and limit, and, more important for architecture, space and monumentality have therefore been opposed to each other from the beginning.

In this context, it is symptomatic that the initial art-historical interpretation of architectural space was first worked out precisely in response to an uncertainty about limits: that uncertainty which arose in the face of the difficulty of comprehending the nature of architectural "space" after the Renaissance – the so-called baroque space that seemed altogether to break the bounds of architectural stability and three-dimensional harmony. Whether it was the need to understand the Rococo (in France) or later the Baroque (in Germany), the terms of spatial analysis were conceived in the face of what to many historians were the distasteful signs of dissolution and fragmentation, illusion, and indefinability.

Thus, for Wölfflin, the Baroque (which he dated from the Council of Trent) pushed the limits of (classical, Renaissance) architecture to their potential destruction. An architecture of depth and obscurity had, in his view, replaced an architecture of surface and clarity. The Baroque, according to Wölfflin, introduced "an entirely new feeling of space, tending toward infinity." "Space," he wrote, "that in the Renaissance was regularly lit and which can be represented only as tectonically closed, here [in the Baroque] seems to be lost in the unlimited and undefined." No longer faced with a clear external form, "the gaze is led towards infinity."[8] Such a dissolution of space into incommensurability verged on the pathological, only to be explained from a psychological point of view that understood every object to be judged according to its relation to the body – a view that Wölfflin had already espoused in his thesis, *Prolegomena zu einer Psychologie der Architectur*, two years before. In the Baroque, the capacity of the human body to empathize with the building was stretched to deformity. Such a psychological interpretation was to influence that of Jacques Lacan, whose summation of the "baroque" seems to extend Wölfflin's critique: "The

baroque," wrote Lacan, "is the regulation of the soul by the scopic regulation of the body."[9]

Equally, what August Schmarsow called the *Raumwille* or *Raumgestaltung* of the Baroque was more a psychological force than an aesthetic code, setting the tone for Walter Benjamin's melancholic Baroque of allegory, ruins, and fragments. Echoing Wölfflin's characterization of the Baroque as representing the decline and decadence of the Renaissance ("die Auflösung," "die Symptome des Verfalls," "die Renaissance entartet"), Benjamin wrote of the period of Baroque tragic drama as one of decadence.[10] Against the "exact mean between excess and deficiency" achieved by Renaissance harmony, the Baroque signaled "dissolution" of all forms and boundaries; the call for "unlimited space and the elusive magic of light" led to the transgression of all architecture's "natural limits."

Unstable Modernism

But this critique of the Baroque, however historically and formally derived, was ultimately pointed toward the larger problem of modern art, itself seen as a direct extension of, if not a pathological development from, the Baroque. Wölfflin's celebrated remark of 1888, "One can hardly fail to recognize the affinity that our own age in particular bears to the Italian Baroque,"[11] underlines the extent to which these ascriptions of decline and dissolution were deliberately aimed at the modern. Wölfflin cited Carl Justi's characterization of Piranesi as having "a nature entirely modern in its passion" embodied in "the mystery of the sublime – of space and of power," and compared this to the "same emotions which a Richard Wagner evokes to act on us."[12] For Benjamin, writing in the 1920s, the analogy was more poignant still, joining two periods of decadence by means of a symptomatic analysis of forms in tumult, disrupted forms that were emblematic of the conflicted forces of their respective epochs. He spoke of the "striking analogies with the present state of German literature," and noted the common themes between Baroque tragic drama and Expressionist drama, beginning with the presentation of Franz Werfel's *Trojan Women* in 1915.[13] As with many myths surrounding the emergence of modernism, the Baroque effect was seen in terms of light and dark, rather as modernity itself was construed as poised between reason and the abyss of Expressionist exaggeration.

But if Wölfflin and Walter Benjamin saw the Baroque as representing an end to an architecture of stability and perfection, others, like Paul Frankl and Sigfried Giedion, celebrated just these qualities as proto-modernist exhibitions of the will to overcome all structural and spatial limitations in the service of a new architecture. Giedion formulated a Baroque that was both triumphant and prospective. For him, the Baroque, and its complex questioning of Renaissance perspective stability and realist representation, its combination of perspectival multiplicity and illusion, found in its most developed form in the work of Borromini and Guarini, seemed, in retrospect, to prefigure Cubism. When joined to the spatial interpenetration exhibited in the engineering structures of the late

nineteenth century, the potential of the Baroque was turned into constructive possibility. In this model of spatial history, the role played by structure became pivotal; Giedion's pairing of Borromini's lantern of Sant'Ivo and Tatlin's project for a Monument to the Third International has itself become a commonplace, as has his analysis of Guarini's cupola of San Lorenzo, where "the impression of unlimited space has been achieved not through the employment of perspective illusions or of a painted sky but through exclusively architectural means" that go "to the very end of constructional resources."[14] It remained only for modern construction methods to overcome these limits, and for modern architects to imagine modern space, and the equation *spatial imagination + structural invention = progress* would be confirmed.

The dynamics of Baroque spatial interpenetration were further pressed to their modernist fulfillment, so to speak, by the return of temporality, but this time in an antihistoricist guise. Long before the popularization of Einstein, the calibration of space to time preoccupied philosophers and aestheticians, writers, painters, and architects to the extent that "space-time" became a dominant leitmotif of modernism.[15] The visual experiments of Marey and Muybridge, followed by their instrumentalization in the service of time-and-motion studies and Taylorization, provided images of movement in space that were ratified and exploited not just in moving pictures, but in the overlapping and multiple exposures of Futurism and Cubism. In architecture, the moving subject in space was given the role of form giver, accommodated mechanically and phenomenally through all the techniques and representational devices of speed and transparency. And, as the subject was not only moving in its physical dimensions, the new space was called on to reflect its shifting moods and psychological states. The resulting call for a spatial representation of such double movement, physical and psychical, found diverse responses in modernism, from Expressionist distortion to Purist "promenades" in "infinite space" to the psychological flânerie of Surrealism.

Phobic Space

In this sense, the utopian modernist dream of "bathing in space," a dream suited to the Uebermensch of Le Corbusier's aerobic imagination, was, from the outset, countered by the troubling realization that space as such was posited on the basis of an aesthetics of uncertainty and movement and a psychology of anxiety, whether nostalgically melancholic or progressively anticipatory. With its roots in the empirical psychology and neo-Kantian formalism of the late nineteenth century – Robert Vischer's theories of optical perception, Theodor Lipps's concepts of empathy and "Raumästhetik," and Conrad Fiedler's mentalism – the psychology of space was one that was devoted to calibrating the endlessly shifting sensations and moods of a perceiving subject whose perceptions moreover had less to do with what was objectively "there" than with what was projected as seen.[16] The social psychology of space, as elaborated by Georg

Simmel, was established on equally insecure grounds. Space itself, Simmel argued, was the result, rather than the container, of social relations.[17]

In these terms we might characterize the space of modernism as from the outset as "psychological space." This kind of spatial construction was developed, so to speak, along with and as a product of the modern subject, and entered the vocabulary of urbanists and doctors around the 1870s. It was a space invented initially to respond to what were seen to be the pathological conditions of life endemic to the metropolis – conditions that were to be described in Simmel's own "Metropolis and Mental Life" of 1901; it follows that psychological space as first formulated was "negative" space or "psychopathological space." Construed as the milieu in which flourished a gamut of newly identified spatiomental diseases – George Miller Beard's neuresthenia, Charcot's hysteria, Westphal's agoraphobia, Ball's claustrophobia, among many – metropolitan space seemed both essentially modern and essentially estranging. Simmel wrote often of the "fear of contact" or *Beruhrungsangst*, a "pathological symptom . . . spread endemically" in turn-of-the-century Berlin, constructing it as a spatial fear, one that stemmed from the too rapid oscillation between closeness and distance in modern life.[18]

Beyond this (perhaps overliteral) understanding of spatial pathology, considered simply as a matter of proximity and distance in a generalized field, there gradually emerged what for Freud (and perhaps for Bergson), and a little later for psychoanalytical phenomenologists like Eugène Minkowski, was a conception of space that adhered to none of the dimensions (literal or phenomenal) of perspective or quantity. Beginning with the space of the dream, and continuing with the space of drives, psychic space was seen to be a simultaneous container of everything that in "real" space had to be separate and temporally discrete.

Warped Space

The most radical of the attempts to join time, space, and psyche was assayed by Expressionism. In architecture, as represented by Paul Scheerbart's manifestos and Bruno Taut's drawings of 1914–18, space was deliberately constructed to reflect the tormented psychological states of modern alienation. As Ernst Bloch noted, this resulted in the desire to construct an entirely new, "non-Euclidian," kind of space, what El Lissitsky termed "pan-geometrical." Whether or not such a space was ever attainable, the formal results were clear: "Expressionism experimented with it by generating stereometric figures through rotating or swinging bodies, which at least have nothing in common with the perspective visual space (*Sehraum*); an architecture of the abstract, which wants to be quasi-meta-cubic, sometimes seeks structures appearing to be similarly remote, not organic any more, nor even meso-cosmical."[19] Such a space, as we know it from the drawings, was dynamic, crystalline, and potentially infinite.

The very notion of a "non-Euclidian space," one that might escape the bounds of limited perspectival vision, and thence, like Alice's mirror, act as a means of

stepping into the new world, was, however, tantamount to an admission of utopian "impossibility." For, in the event, as Bloch recognized, the old Euclidian world was entirely necessary for any non-Euclidian hypothesis to have any effect: "Of course the space of these bodies of rotation remains as Euclidian as any other, and the so-called un-Euclidian pan-geometry provides positive ways for architecture also in the symbolic illusions." Panofsky, to whom Bloch refers as his authority, was equally skeptical in his discussion of El Lissitsky's idea of "pan-geometry." "In fact," he noted, "the space of [Lissitsky's] 'imaginary' rotating bodies is no less 'Euclidian' than any other empirical space."[20]

This is no doubt why the Expressionist spatial medium par excellence, and precisely the medium in which Expressionist architecture found its fullest development, was, in fact, not architecture, but film. Which was to say that no matter how Expressionist space tried to construct its material analogues, it was inevitably bound, precisely because of its counter-Euclidian aspirations, to the realm of the imaginary. Expressionist space in its most authentic form, was, for all intents and purposes, unrepresentable. This would be to say that Expressionist space was truly in the domain of the sublime.

But the Expressionist sublime, while on the surface subscribing to all the "alpine" commonplaces of the Romantic period – witness Bruno Taut's transcendentalist utopia of an "Alpine Architecture" carved out of the snows and ice of the mountain ranges – was marked less by the sense of absolute terror described by Burke than it was by the lurking anxiety characterized by Freud as "uncanny." A postpsychological era found its frisson not so much in the extremes of light and dark as in the ambiguities of obscurity. For the Expressionists, the world was pervaded by a sense of loss, a sense of unexpected and frightening return, a sense of something homely (*heimlich*) turning without warning into something unhomely (*unheimlich*). The space of the uncanny was not a space of clear boundaries or satisfying emotions; it destroyed, indeed, any such clarities in favor of psychological suspension, insecurity, estrangement effects; it was, as Freud himself recognized on his visit to the Acropolis, a space that might be experienced anywhere, even on the highest hill of civilized aspirations; on the site where he expected the sublime, he found instead what he called "de-realization," letdown, disappointment, and also strange sentiments of loss and betrayal. The ur-home of Western culture had been found less than homely even as the experience of the war, as Freud noted in his "Thoughts on War and Death," had transformed the "happy museum" of Europe into a bloody battlefield.

At the moment when Expressionism, heir to this battlefield, attempted to assert a world of purity in glass, the real foundation of such crystalline utopias was revealed, in the sets of *Caligari* as much in the wastelands of Alfred Kubin's *Die andere Seite*, to lie in the uncanny eruption of the uneasy psyche. The destiny of Taut's "Alpine Architecture" was in the end to reside in Ernst Junger's *Auf den Marmorklippen*. Standing between a nostalgic dreamland of fairytale happiness and the broad and ever expanding domain of the terrifying Chief Ranger, Junger's marble cliffs transformed the alpine landscape of Taut's dreams into the sinister lookout that pointed toward, and was in some way

complicit with, Fascism, in what George Steiner has characterized as its alien-ated coldness.

Such a perception of the unease behind the crystal might lead us to recharacterize Expressionist space in a way that escapes the easy platitudes of geometrical deconstruction, and in its combination of psychological anxiety and geometrical instability see it as a fundamentally *warped space*. Warped space would be essentially psychological and defined not so much by the clear prismatic nature of its geological or post-Cubist representation as by its lurking opacity, obscurity. Alice's mirror, yes, but in this context a mirror that takes on the role of a reflector of the psyche – something like that mirror evoked by Jacques Lacan in 1937 as the instrument and harbinger of schizophrenia. The space of such a mirror is not a Cartesian, nor yet a Euclidian, space; by projection it is transformed into a space that turns on itself – a bent or warped space; the kind of space that Nietzsche, not yet cognizant of Freud, tried to imagine when he noted that "we can't see around our own corner." Warped space would then be what Panofsky in his seminal essay "Perspective as Symbolic Form" called psychophysiological space – geometry transformed by psychic projection. It would not, perhaps, be overstating the case to say that warped space has been a condition of modernist anxiety and alienation throughout this century, a hallmark of architecture and its filmic, video, and recently digital representations that go further than mere positive construction of reality to reveal the unstable conditions of modernity.

Formless Space

Countering the fractured images of a twisted and distorted psychic space in Expressionist dystopias, the Surrealists envisaged the space of introjection and projection in more conventionally Freudian terms, which nevertheless led to equally radical formal experiments. Salvador Dali's excursuses on the space of hysteria, paranoia, and ecstasy, no doubt influenced by his contacts with Jacques Lacan; André Breton's and Louis Aragon's dream narratives; and Max Ernst's explorations of hallucinatory interiors were only the most notable of such results of the intersection of psychoanalysis and spatial representation. But perhaps the most fundamental critique of rationalist space, and one that had reverberations throughout the second half of the century, was that of Georges Bataille. At once simple in its reversal or refusal of conventional and defined spatial distinctions (divisions, boundaries, enclosures, and so on) and complex in its attempt to assert the characteristics of "formlessness" engendered by the collapse of such distinctions, his critique exploded both the traditional vision of classical – monumental – space and its modernist – universalist – replacement.

In his brief review of the photographic album *X Marks the Spot* (Chicago: Spot Publishing Company, 1930) published in *Documents* in 1930, Bataille remarked on the custom of publishing photos of criminal cadavers "qui semble également se faire jour en Europe, représente certainement une transformation

morale considérable touchant l'attitude du public à l'égard de la mort violente."[21] To illustrate the point, Bataille selected a photograph from this "first photographic history of Chicago gangland slayings" depicting the corpse of an assassinated gangster found in the ice of Lake Michigan, the figure face up as if frozen while floating, a literal monument to its own death. In one sense, of course, this image has no relation to the concept of "*x* marks the spot" announced in the title of the album and referring to the custom of marking the position of the victim after the removal of the body; there was in this case no mark to be left on the ice following the excavation of the frozen corpse, and its place of discovery was destined to be effaced forever with the subsequent thaw. For an instant, however, the corpse acted as its own mark, one only to be rendered permanent in the police photo. And this photograph, as Georges Didi-Huberman has recently pointed out, was itself an enigmatic record: "On n'y voit d'abord pas grand-chose, tant l'image évoque un pur et simple lieu – mais chaotique –, un magma blanc et noir. Puis on reconnaît l'homme noyé (et préablement assassiné) *pris dans les glaces* du lac Michigan."[22] Transformed into an anamorphic vision by virtue of the flattening surface of the ice and the angle of the photo, the dead gangster has been doubly recomposed, first as a marker of the site of his own death and secondly as a visually encoded "hieroglyphic" image of that mark. Further, whatever place was marked by the position of the body, it was not the site of the assassination itself, but rather of the place where the gangster had ended up, propelled by the currents of the lake and frozen by chance on rising to the surface. A mark therefore of the ever exilic, ever transitory place of death in modern urban life, but at the same time of the consistent popular fascination with the nature and signs of that place.

This signal of Bataille's interest in the position and role of *x* in marking the spot of death in the city anticipated by eight years his more developed reflection on Nietzsche's proclamation of the "Death of God" in an essay in which the role of the mark is now played by a monument – the Obelisk of Luxor erected in the Place de la Concorde in 1836 – and the "spot" is that of the erection of the guillotine for the execution of Louis XVI. In this process of transformation in which a police inquiry into a murdered gangster is enlarged to encompass the "Death of God," the mystery – who was the victim and who the murderer? – is similarly deepened, both by the historical age and mysterious origins of *x* in Egypt and by its subsequent deracination and transposition to modern Paris. The circumstances of its reutilization, and the subsequent history of its interpretation and reception in the *place* or Place de la Concorde, when joined to the monumental history of this Place itself, establish for Bataille the appropriate *mise-en-scène* in which to stage Nietzsche's fool, running into the public square with lantern lit in broad daylight, crying: "I'm looking for God!"

The obelisk held a special place in Bataille's symbolic topography. For by virtue of its origin in history and its monumental role in space, it at once potentially reconciled time *in* space, effacing the one in favor of the latter, at the same time as opening the way, through a process of desymbolization, and by its insistent presence, to a negation of all historical meaning. X, then, marks

the "spot" not only of the proclamation of the "death of God" and of the actual murder, but also of the threshold of all ensuing consequences and potentialities, or rather the place from which it would be possible to imagine any such future. The conjuncture of the Place de la Concorde and the obelisk was thus an entirely appropriate "place" for a Nietzschean inquiry. The place itself had indeed been the object of almost as many redefinitions and imposed identities as the obelisk – as a *place*, that is, its place was singularly unstable in both political and architectural terms.

Bataille's observations on this place, while set in the context of his reading of Nietzsche in the 1930s, were also informed by his inquiry into architectural monumentality and the space of the public realm in modern culture, an investigation begun in the articles "Architecture," "Espace," and "Musée" in *Documents*, and continued, as Denis Hollier has demonstrated, throughout his writings.[23] Here Bataille began to explore that profound destabilization of the realm of the monumental operated by the force of space itself, and, more precisely, the psychological power of space considered as a fluid, boundary-effacing, always displaced and displacing medium. Characteristically, his brief article "Space," published in the first issue of *Documents* in 1930, was "illustrated" by Bataille by four apparently unrelated, but in fact carefully selected, photographs, placed in pairs on facing pages. The first depicted the demolished or collapsed wall of a prison revealing the bars of the cells within; the second, immediately below, showed a monkey dressed up like a chambermaid and carrying a picnic basket; the third, across from the destroyed prison, was an image of a Nandi initiation ceremony, photographed in Tanganyika in 1929; the fourth, the scene of a giant fish about to swallow a smaller variety. Each of these images was provided with a "title" drawn from the text of Bataille's essay. These read, respectively: "The day when the walls collapse in front of the bars of their cell," "That a monkey dressed as a woman should be only one of the divisions of space," "An ignoble initiation rite practiced by some negroes," and, finally, "Space can become one fish who eats another." A clue as to Bataille's meaning may be gleaned from his first qualification of the word *espace* as "Question des convenances." *Convenance*, or suitability, had always been, in architecture especially, a loaded term referring to the classical codes of appropriateness of a genre or an Order to a particular program – at its simplest regulating the application of the Orders and constraining decoration to a rigid social hierarchy. But evidently the *convenances* of which Bataille speaks are very different from those of the classical canon, or rather, even as they rely on former canons, are conceived in order to establish entirely new mixed genres and canons, not of social hierarchy but of its dissolution; not of social propriety, but its withering away; new genres and canons, that is, of power and eroticism represented in space, precisely through the abilities of space itself to dissolve boundaries. Bataille's examples, reinforced by carefully chosen photographs, refer not to the power invested in the controlled spaces of aristocratic taste or bourgeois function, nor to the ritual spaces of traditional political or erotic practice, but to the more

fundamental eroticism of spatial transmutation in itself. Thus, for Bataille, "space can become one fish who eats another," or, equally, "a monkey dressed as a woman should be only one of the divisions of space." Traditionally conventional space, such as that of a prison, for example, is, indeed, only perceptible in its full force when caught in the act of passing from one space to another, as in the moment of collapse; Bataille, didactic to the last, speculates that "evidently, no one has thought of throwing the professors into prison *to teach them what space is* (for example, the day when the walls collapse in front of the bars of their cell)." This imagined collapse of the Sadean universe, which was, after all, anticipated by Sade himself, was, for Bataille, an opening onto a world of unmitigated eroticism in unimaginable freedom from traditional *convenances*.

That this imaginary freedom took place, in Bataille's terms, in space pointed to the special place of the idea and practice of space in modernism; his recent "revival" as the eponymous theorist of the *"informe"* art of the last quarter of a century, represented by the exhibition and catalog curated and written by Yve Alain Bois and Rosalind Krauss for the Centre Pompidou (1996), points equally to the persistent modernist desire to use space precisely to consume and erode any fixed formal or constructed stability, to produce an art out of and with materials and processes that have no recognizable form. And while the shock value of the formless, certainly a part of the Surrealist project, has long since lost its cultural effects, the forced struggle to interpret the object without form *as form* has paralleled, if not represented, the need to redefine subject identities in the complex new world of sexuality, gender, and ethnicity.

Space and Identity

In this context, the notion of space has recently shown signs of another revival, this time on two fronts. Supporters of minority discourses based on gender, sexuality, and ethnicity have explored the potentiality of spatial analysis for the assertion of specific values and sites that might confirm and sustain subjects and societies more differentiated in nature and construction than the imaginary "universal subject" of modernism and traditional Marxism. Sociologists and urban geographers have rewritten Marxism to include the spatial and the territorial in their considerations of class and ethnic struggle; gender theorists have interrogated the "space of sexuality," attempting to identify what might be the dimensions of feminist, gay, lesbian, or "queer" space; postcolonial thinkers have stressed the "liminal" conditions of exilic subjects in space.

In its unsettling ability to join the infinite to the tangible, the sublime to the real, modern space has thus retained the double dimensions of utopia and melancholy present in its initial theorization. Both these dimensions have been, indeed, fully exploited by contemporary identity theorists; in, for example, the double condition of "liminality" and the "uncanny" experienced by the postcolonial subject characterized by Homi Bhabha, or the space of affirmation and

mourning affirmed by theorists of "queer space," or again the elusive space of lesbian and bisexual theory as outlined by, among others, Judith Butler and Elisabeth Grosz.

The capacities of the spatial metaphor both to confirm and undermine the places and sites of gender difference have been most significantly mustered on behalf of gender theory by the feminist philosopher Luce Irigaray in her radical rereading of the Heideggerian "space of being." In *L'oubli de l'air* (1983) and *Ethique de la différence sexuelle* (1984), Irigaray sought to formulate a theory of space that would deconstruct the very notions of space and time as they had become fixed in modernist phenomenology. "In order for difference to be thought and lived," she wrote, "we have to reconsider the whole problematic of *space* and *time*. . . . A change of epoch requires a mutation in the perception and conception of *space-time*, the *inhabitation of place* and of the *envelopes of identity*."[24] Irigaray recognized the difficulties of using such categories, already defined within, and the product of, masculine parameters: "The maternal feminine . . . necessarily exists, but as *a priori* condition (as Kant would put it) of the space-time, of the male subject . . . the maternal-feminine does not necessarily exist as woman."[25] Woman was not only in the male "imaginary," but also of it. As Irigaray pointed out, it was man who traditionally "places her within the home," provides that "shelter." And "that home, which is usually paid for by man's labor . . . encloses her, places her in *internal exile*."[26] In this sense, woman "traditionally . . . represents *place* for man," which in turn creates limits that transform woman into a *thing*. As "thing" woman herself becomes a readily "collectible" place to be placed in the home, itself the place assigned by man to the maternal-feminine. And as maternal-feminine, woman is endowed with the qualities of *envelope*, of *container*, the very point of reference from which man defines limits that form his relationship to other things. From this condition derives the notion of woman as "threat," as "castrating" in Freudian terms; for if man creates his identity precisely with woman as starting point, as envelope and thing, it is with the result that, without a truly subjective life of her own, and with only a place defined for her, she "becomes threatening because she lacks a 'proper' place." Hence Irigaray posed the need for a quasi-utopian redefinition of spatial being that responded to the question, as Margaret Whitford has summarized it, " 'Where and how to dwell?' How are women to live (in both senses – to dwell and to remain alive) in the edifices built by the male imaginary?"[27] Woman's topology – her space-time, her dwelling, her *espacement* – would demand an entirely new language that stands outside all previous terms. Perhaps unconsciously echoing William Blake's aphoristic assertion of woman as space, man as time, Irigaray envisaged a "place" for woman not already given her by man. "Space," she asserted, against Heidegger, "is given first by her."[28] The task of redefining "*space-time*, the *inhabitation of place* and of the *envelopes of identity*" was thus defined as a kind of "re-envelopment" of the woman within the woman, both as woman and as mother. Which would, Irigaray noted, "presuppose a change in the whole economy of space-time."

In this way, the theorization of modern space has been brought back to its starting point, so to speak, but with an entirely new instrumentality and on behalf of a new politics of identity and gender. First formulated as a way of understanding the pathological states of bodies and minds when confronted by objects, at the end of a century of interpretative experience, psychoanalytical, political, and philosophical, the concept of space seems to maintain its critical force as a measure of the place of differentiated subjects and their desires in the world, even as it provides a link between the abstract contemplation of architectural objects and the act of their construction. In this role, it would seem to be entirely appropriate that the practice of spatial analysis continues to be construed as the study of spatial anxiety.

IN conclusion, I want to look briefly at the persistence of these themes in the present fin-de-siècle, a period that has not been without its own anxieties of dwelling. The persistence of spatial warping as a contemporary signal of modernist aspirations has been marked in the work of Coop Himmelblau since the late 1960s, work in which the uncanny visions of Expressionism have found a peculiarly appropriate "home" in a space of canted planes, intersecting angles, pyramids of light, shifting floors, and tilted walls. With evident reference to the vocabulary of the original Expressionists, Himmelblau formulated an environment that went beyond imitation to construct an entirely contemporary world of disquiet and unease, estrangement and distance, from the insistent world of the modern "real." As Himmelblau wrote as early as 1968: "Our architecture has no physical plan, but a psychic plan." It was especially appropriate, then, that Himmelblau was called on to install the exhibit Expressionist Utopias, for the Los Angeles County Museum of Art in 1994. In this installation, this "psychic plan" was doubled in a tantalizing way. It was at once an archaeological reference to an imaginary scene long buried – that of Expressionist utopia before World War I – and a contemporary scene of deliberate distortion and displacement. Freud once remarked that it would be impossible to conceive of the same space containing two different contents at the same time – he was speaking of the series of monumental constructions over the centuries built one on top of the other in Rome. Only in the mind, he argued, was the retention of two "places" in the same space possible. But it is a peculiar property of some architecture to resonate with double meaning in such a way as to approximate the imaginary of Freud, and in this after-image of Expressionism such a double exposure was evident.

Nowhere was this more apparent than in the most dramatic event of the installation, in a thick "slice" of light, so to speak, cut at an angle from one side to the other. Captured between sheets of Plexiglas, this slice had an obviously material dimension; but, as light, it was as if a negative fault line had cracked open the solid fabric of the interior, displaying its inner substance. Earlier projects of Himmelblau had played with the metaphor of skin, peeled back to

reveal the flayed flesh of building beneath; now the building overcame its organic attachment to the human body and was revealed as pure desire. In a kind of Rosicrucian metaphor of "light from within," this crack of luminosity lured at the same time as it closed itself off from accessibility.

For the light was in a real sense captured, sliced as if between the two glass slides of a microscopic specimen. Light that no longer served its function of lighting, as for example in Bruno Taut's Glass pavilion of 1914, but was now deprived of all function, simply to be looked at as an exhibit in a museum. Fetishized light then, cut uncomfortably close to our own bodies as we moved carefully through these uncertain spaces. Where previously Himmelblau's images of desire were figured in the many semiangelic wings that hovered, soared, and blazed through the space of their projects, in this slice of light any material reference to structure was abandoned. The "angel" was dissolved, as if in the navel of the dream, into an umbilicum of searing nothingness that hurt our eyes.

Commentary on Expressionist dreams and fabrication of our own, this installation fittingly ended up displaying them in the museum as if to offer a cabinet of curiosities dedicated to the exploration of our own spatial warpings. No longer can we be satisfied with the comforting distance that separates us, as spectators, from the implications of Dr. Caligari's cabinet; we are literally entered into a scene populated by our doubles and constructed like our psyche. And, inevitably, the moment we feel we are arriving at the center of this strangely comforting experience, we are suddenly and cruelly cut off from any access to what we want most: trapped light. As if to imply that the essential characteristic of modernism's psychic "utopia" was not so much the happy and transparent dream of wish fulfillment as the anxious dream of blocked desire.

Considered from the purely psychological level, of course, such architectural fomulations of "warped space" are merely caricatural illustrations of states of mind that are for all intents and purposes entirely independent of actual spatial conditions, more the result of introjection and projection than of any "warped" stimuli in the world itself. In this understanding lay the roots of the already strong critique of *Caligari*'s sets in the early 1920s, from Kracauer and others, to the effect that in the movies, at least, the camera itself was the mobile instrument, taking the place of the moving eye, and thus the *mise-en-scène* itself was no longer to imitate the effects of movement in its own forms. The shadowy and sinister movements of the camera, from high to low, distance to close-up, in, for example, a film like Lang's *M* were, for Kracauer and his contemporaries, far more successful at evoking the anxiety and terror latent in space – the street as hunter with M as prey of the street itself as registered through rapidly shifting the lens.

For us, at the end of the century, it is perhaps even more important to insist on this separation between the anxiety of space and its all-too-easy representation in architectural terms, whether Piranesian, postmodern, or deconstructive. Considered from the vantage point of the end of the century, and in the light of the history of modernist space – whether that of Le Corbusier's "infinite" kind or of Expressionism's "warpings" – Bataille's evocation of the Nietzschean

critique of classical "space" and its boundaries becomes, I think, all the more pertinent for the interpretation of late twentieth-century urbanism. Certainly they may be read, as they were intended, as fundamental destabilizations of the normal in favor of the pathological; certainly, as Rosalind Krauss and Georges Didi-Huberman have indicated, they presage contemporary interest in the *informe* in their direct critique of the traditional idea of monumentalization. But if we think back to the uneasy spatiality of Bataille's frozen water – the Seine in winter, the body in Lake Michigan – we might also be reminded of the vast and frigid emptiness of the Corbusian heritage, today so proudly recalled in the search for a strong link with a supposed modernity. At the heart of this apparently universalist vision of a space for all, in which each individual in mass society might find his (one has to admit, rarely her) home, as if only the ineffable could shelter the Uebermensch, there is, as I have noted before, a special kind of anxiety. From the point of view of the architect, this would seem to be an anxiety of the small, the particular, the banal, the everyday, in short a claustrophobia in the face of the crowded metropolis; a claustrophobia that hides its misogyny, its racial preferences, its anticommunitarian and antisocial prejudices beneath a veil of the universally transparent. From the point of view of the subject, the anxiety aroused by modern space has been commonly translated into terms approximating agoraphobia (a disease, interestingly enough, still referred to in medical literature as the "housewife's complaint" and earlier in the century unhesitatingly attributed to the so-called decadent and weak members of society – the homosexual, the woman). But, following Bataille, we might be more inclined to see the anxiety of space as residing in the notion of space as an endlessly fluid psychopathological condition – a kind of spatial transvestism that anticipates the often heralded potentialities of virtual reality – and that in and of itself provokes an instability of identity. This would be, so to speak, a positive, critical reading of the kind attempted by Walter Benjamin in the 1930s and Homi Bhabha today.

Notes

This essay forms part of a larger study in progress entitled "The Anxiety of Space." It has been presented in different versions to audiences at the Architectural Association School of Architecture, London; Princeton University School of Architecture; and the University of Zurich. I am grateful to Michael Holly, Mark Cousins, Stanislas von Moos, and Emily Apter for their helpful comments.

1 See Paul Zucker, "The Paradox of Architectural Theory at the Beginning of the 'Modern Movement'," *Journal of the Society of Architectural Historians* 10, 3 (October 1951): 8–14.

2 Paul Frankl, *Principles of Architectural History: The Four Phases of Architectural Style, 1420–1900*, trans. and ed. James F. O'Gorman (Cambridge: MIT Press, 1968), p. i.

3 Sigfried Giedion, *Space, Time and Architecture: The Growth of a New Tradition* (Cambridge: Harvard University Press, 1941).

4 See the excellent discussion of Mies's spatial antecedents in Fritz Neumeyer, *The Artless Word: Mies van der Rohe on the Building Art* (Cambridge: MIT Press, 1991), pp. 171–93.

5 Bruno Zevi, *Saper vedere l'architettura: saggi sull'interpretazione spaziale dell'architettura* (Turin: Einaudi, 1948), trans. as *Architecture as Space: How to Look at Architecture* (New York: Horizon Press, 1974); Rex Distin Martienssen, *The Idea of Space*

in Greek Architecture, with Special Reference to the Doric Temple and Its Setting
(Johannesburg: Witwatersrand University Press, 1956); Renato de Fusco, *Segni, storia e projetto dell'architettura* (Rome: Laterza, 1973). See Cornelius van de Ven, *Space in Architecture: The Evolution of a New Idea in the Theory of the Modern Movement* (Assen/Maastricht: Van Gorum, 1987).

6 This sentiment is also echoed by Victor Burgin, "Geometry and Abjection," in *Psychoanalysis and Cultural Theory: Thresholds*, ed. James Donald (London: Macmillan, 1991), p. 12.

7 A vulgarized version of romantic phenomenology, stressing "roots," "home," "security," and "being-in-place," has, however, been a continuous influence on conservative theories of architectural space in the twentieth century. Epitomized in the attempts of anti-modernists in the 1920s and 30s to determine the appropriate (traditional) style for *heimat*, and most recently offered as a postmodern antidote to modernism and deconstructivism, this discourse has drawn on a variety of philosophical and sociological sources for its authorization to "return" to the essentials of "place-making" and "shelter," including the partisans of *Gemeinschaft* after Tonnies and Sombart, the philosophers of *posthistoire* after Hendrick de Man and Arnold Gehlen, architectural theorists from Heinrich Tessenow in the 1920s to Leon Krier in the 1980s, and, after the 1950s, Heidegger and Bachelard. As evoked in the writings of Christian Norberg-Schultz, what might be called the "architectural phenomenology of dwelling" took its cue from Heidegger's staged retreat to a rustic hut in the forest, read more or less in parallel with the essay "The Origin of the Work of Art" and his meditations on Hölderlin's fragment in "Poetically Man Dwells." This despite the evident destabilization of space by time in Heidegger's own uneasy theorization of space in *Sein und Zeit*.

8 Heinrich Wölfflin, *Renaissance und Barock: Eine Untersuchung über Wesen und Entstehung des Barockstils in Italien* [1888] (Leipzig: Kochler und Amelang, 1986), p. 71.

9 Jacques Lacan, *Le Séminaire de Jacques Lacan*, XX, "Encore," ed. Jacques-Alain Miller (Paris: Editions du Seuil, 1975), p. 105.

10 Walter Benjamin, *Ursprung des deutschen Trauerspiels*, in Walter Benjamin, *Gesammelte Schriften*, vol. 1, 1, ed. Rolf Tiedemann and Hermann Schweppenhäuser (Frankfurt: Suhrkamp, 1974), p. 235.

11 Wölfflin, *Renaissance und Barock*, p. 105. This sentiment was echoed in turn by Riegl, Frankl, Giedion, and Walter Benjamin in the first half of the century, and more recently by Bruno Zevi, Paolo Portoghesi, Robert Venturi, and, among other critics, Gilles Deleuze and Jacques Lacan.

12 Ibid.

13 Benjamin, *Ursprung des deutschen Trauerspiels*, pp. 234–5.

14 Giedion, *Space, Time and Architecture*, p. 58.

15 See Linda Dalrymple Henderson, *The Fourth Dimension and Non-Euclidian Geometry in Modern Art* (Princeton: Princeton University Press, 1983).

16 For a brief but incisive summary of this movement, see Mitchell W. Schwarzer, "The Emergence of Architectural Space: August Schmarsow's Theory of *Raumgestaltung*," *Assemblage* 15 (August 1991): 50–61.

17 See Anthony Vidler, "Agoraphobia: Spatial Estrangement in Simmel and Kracauer," *New German Critique* 54 (Fall 1991): 31–45.

18 See Anthony Vidler, "Psychopathologies of Modern Space: Metropolitan Fear from Agoraphobia to Estrangement," in *Rediscovering History: Culture, Politics, and the Psyche*, ed. Michael S. Roth (Stanford: Stanford University Press, 1994), pp. 11–29.

19 Ernst Bloch, "Building in Empty Spaces" ["Die Bebauung des Hohlraums," in *Das Prinzip Hoffnung* (Frankfurt am Main: Suhrkamp, 1959)], in *The Utopian Function of Art and Literature: Selected Essays*, trans. Jack Zipes and Frank Mecklenburg (Cambridge: MIT Press, 1988), p. 196.

20 Ibid.

21 Georges Bataille, *Oeuvres complètes*, vol. 1, *Premiers écrits 1922–1940*, Introduction by Michel Foucault (Paris: Gallimard, 1973), p. 256. This article was first published in *Documents*, no. 7 (1930): 437–8.

22 Georges Didi-Huberman, *La ressemblance informe ou le gai savoir visuel selon Georges Bataille* (Paris: Macula, 1995), p. 154.

23 See Denis Hollier, *La Prise de la Concorde: essais sur Georges Bataille* (Paris: Gallimard, 1974).

24 Luce Irigaray, *An Ethics of Sexual Difference*, trans. Carolyn Burke and Gillian C. Gill (Ithaca: Cornell University Press, 1993), p. 15. This is a translation of *Ethique de la différence sexuelle* (Paris: Editions de Minuit, 1984).

25 Ibid., p. 86.

26 Ibid., p. 65.

27 Margaret Whitford, *Luce Irigaray: Philosophy in the Feminine* (London: Routledge & Kegan Paul, 1991), p. 157.

28 Irigaray, *L'oubli de l'air* (Paris: Editions de Minuit, 1983), p. 90.

16

Computer Applications for Art History

William Vaughan

Historical Background

WHEN considering the use of computers in the study of the history of art, one is not addressing a discrete area of theory. Rather one is looking at a rapidly developing set of practices that are throwing up a range of methodological issues. These issues are diverse, and since they arise in connection with different kinds of pragmatic encounters, it is probably best to start by considering the history of the situation itself before attempting any kind of synthesis or overview.

Like every other group of scholars, art historians have found themselves making increasing use of computers in recent years. The use has grown exponentially, particularly since the arrival of the latest generation of internet facilities provided via the World Wide Web. But it remains highly questionable what the implications of this situation are. Are we seeing simply the application of a new tool, a useful aid for gathering and processing information which enhances existing potential but does not basically change the nature of the subject or the conceptual patterns of its practitioners? Or are we seeing a fundamental reordering of a discipline, in which interests and modes of interpretation will become irrevocably changed?

Perhaps one of the most potent forces at work at present is the fear of what might happen. It is no exaggeration to say that, by and large, the response to computerization in the history of art – as in other humanities subjects – has been defensive. At its crudest level, it is seen as the invasion of raw technology into the refined sanctum of the arts – yet another stage in the ongoing struggle between the opposing practices of the sciences and the arts. Ever since computers first began to emerge outside the confines of pure scientific research in the 1950s, there have been stories told of their destructive effects – sometimes comic, sometimes horrific. Yet despite this, more and more humanities scholars use computers. Their application is as inevitable as that of any other modern technological advance. Like these other advances, too, the pressure for their use has been primarily economic. The academic community does not like to be

reminded of how dependent it is upon the broader demands of the economies in which it is situated. But the bare truth of the matter is that the new technology is part of the contemporary world, and academic scholars have to adapt their practices to accommodate it. The question is not "Should this happen?" but "In what ways will it happen?"

It is here that the debate is at its most extreme. Those who have been involved most closely in the application of the new technology in the humanities have pointed out frequently how much is to be lost by a failure to engage in the issue in a positive manner. At the economic level this comes down to the lack of adequate resources being made available and a failure to develop appropriate techniques. There are many computer scientists who stress how much innovative work there is to be done in devising new processes to aid humanities research. There are places, indeed, where such work does take place in an exemplary manner – as for example in the new methods for text analysis and image research that have been pioneered by the Humanities Computing Centre at the University of Oxford.[1] But important though these are, they touch only a small part of the problem. In an age of increasing networking of systems and enhancement of multimedia potential, there needs to be a more global response to ensure that humanities research in general gains access to appropriate resources and uses these fruitfully.

These are pragmatic reasons for the engagement – and probably the ones that will be the most powerful agents for change. But we should also remember that there is an intellectual basis as well. The view of computers as a philistine intrusion into the sanctum of the humanities is somewhat misleading from this point of view. For although a confrontation between arts and sciences practices might always be present, this is in fact more of a dialogue than a disagreement. For more than a generation now, it has been understood that modes of scientific inquiry are as engaged with the conditions of a given society as are those of "artistic" culture. These areas are never wholly divorced from each other. Indeed, they share fundamental perceptions far more often than is commonly imagined. This is certainly true in the case of the computer, which is very much a product of the prevailing intellectual practices of Western societies. Whereas the potential for automated calculation was first explored in the nineteenth century,[2] it was only in the mid twentieth century that this was developed extensively. True, this was partly owing to the fact that, in a pre-electronic age, the computer was technically unbuildable in any but its simplest form. But it was also because the potential of the computer's flexibility was not perceived (or perhaps even perceivable) before the development of the relativistic methods of modern linguistics. It was, after all, a twentieth-century scientist, Turing, who turned what had been a nineteenth-century calculating machine into a "universal transformation" machine operating by means of the manipulation of symbolic structures. It is this principle of rule-based transformation, the "playing" with possibilities by means of reference and association, that makes the very structure of computerization so relevant – as Lyotard has pointed out – to our "postmodern" condition.[3]

It is, of course, perfectly possible to make use of computers without engaging with these issues. We do not need to know how they work, or what they are doing with our material, to profit from their services. This is, in effect, how most of us use them. But we should also recognize that when we do this, we are working at second hand. We are making use of processes devised by others, usually for other purposes. All too often in the humanities, scholars accept what is on offer without thinking about whether they could in fact be doing something quite different with the machine, something that might in fact be much more relevant to their inherent modes of inquiry.

Computers and Research in the Humanities

It is the recognition of this fact that has led to such interesting developments in the applications of computers to humanities research – including of course the history of art. Reviewing developments over the three decades since these applications began to emerge, one can, I think, see three distinct stages. The first was one in which the computer was still essentially a calculating machine. This was the situation in the 1950s, when it was beginning to be used more and more for "number crunching" in the sciences. The enhancement of proof that this brought – or seemed to bring – began to impress those students in the humanities whose work came closest to the scientific practice of using a large quantity of material to explore a specific problem. This was the time when, for example, statistical surveys of historical population groups became a possibility. An early example of this potential came with the exploration of the extensive demographic material provided by the British nineteenth-century population censuses.[4] Such practices also began to invade more sensitive areas, such as textual studies. The number-crunching approach became the means of identifying an author's hand and even – in work that has come to fruition recently – in analyzing character formation in novels. The latter has been demonstrated recently in Burrows's study of Jane Austen.[5]

The second phase was really one of divergence. Having realized something of the power of computers, certain humanities scholars began to think of ways in which its practices might be adapted more clearly to their own traditions. The first stage had been one in which computers were "mainframe," managed by people in white coats and fed by punched cards which were tricky to process and were immensely time-consuming. But commercial pressures had led in the 1970s to the development of the small personal computer – essentially for office use. Concurrently with this development there had emerged a more anarchic, "D.I.Y.," side of computer technology. As computers became easier to use, the nonprofessional moved in, even participating in the hallowed field of programming. For a few heady years it seemed as though humanities scholars might actually gain a hold on the beast and perhaps even tame it. This was the period in which the distinguished French historian Emanuel Leroy Ladurie made the prediction that "within a decade" every historian would have to learn FORTRAN

in order to write his or her own programs. I was one of the unfortunates who followed his advice. Wiser heads, however, realized that this was but a transitional state of affairs, and sat back and waited.

Nevertheless, it must be admitted that this anarchic moment – with self-styled programmers and "friendly" personal computers proliferating in all directions, as they did around 1980 – did precipitate some valuable contributions. It led to a new generation of didactic programs – often generated by gifted teachers – which brought computers into the classrooms and addressed areas of problems that professional computer scientists had not considered. Perhaps most important of all was the way in which it demonstrated to the commercial producers of machines and software that a whole new range of demands and possibilities had emerged. The computing community regained control over the disruptive situation by making concessions. They accepted that there would now be a more individual usage of computers, and a concomitant growth in the variety of demands. They provided friendlier interfaces and a larger variety of tools for developing personalized applications. At the same time they effectively removed knowledge of the actual architecture of the machines and of programming from the public sphere. I do not mean to imply by this that there was an actual conspiracy. It was probably the natural consequence of the growing complexity of the new consumables that were produced.

This is the period in which we now exist. Programming has been reclaimed by the experts, but in its place we have been left with a new generation of flexible tools and "authoring." At the same time, the huge advances in storage, multimedia, and networked facilities have provided a seemingly endless series of possibilities. So much so that many must feel lost.

But at least we can say now that there is the right situation for productive development – and one that has been used by certain scholars with great skill. Unfortunately, the number of art historians who have been doing this is still small. But in the humanities at large there is much that has been achieved.[6]

Numerical and Textual Applications in Humanities Studies

We are now in a period where certain clear gains for the humanities have been achieved. Before going on to the specific situation of the history of art, I will move into a consideration of these. Since history of art is a relatively late arrival in this field, it will be necessary for me to include some reference to applications developed in the humanities at large, as well as to those that have taken place in the discipline itself.

Quantitative Methods

The new technology has not only made large-scale statistical surveys and analyses a possibility. It has also brought these techniques within the range of those

who are not adept in the mathematical sciences. People who could not begin to calculate a standard deviation or run a chi test can nevertheless understand what such procedures do, and can make use of the existing tools for performing such tests in standard packages such as SPSS (Statistical Package for the Social Sciences).

Such processes have been used for phenomena that have a "population," ranging from groups of people to texts with their "population" of words.

One noticeable opportunity opened up by such processes has been the conduct of detailed surveys of artistic communities. This certainly offers a new and powerful tool to the study of the social history of art, where intuitive and anecdotal methods have tended to prevail. In recent years, a number of studies of artistic communities using quantitative methods have been conducted. A recent study of architects at work in Palestine during the British Mandate in the 1920s and 30s gives perhaps a fuller example of what can be achieved.[7] Using a database of 595 persons, this study was able to make precise observations of architectural practice in relation to the origins and training of individuals working in a highly complex situation. Through these means it was also able to throw new light on why there was such a striking predilection for modernist styles among architects working in Palestine at the time.

Although it is dangerous to overgeneralize here, it would seem that the main gain has been to provide quantifiable assessments in areas that have traditionally been left in the humanities to more haphazard processes. There are those, of course, who would argue that such practices blur the insights gained from intuition. But this does not have to be the case. It is up to the individual researcher to be aware of what quantitative methods can and cannot deliver, and to use the evidence provided alongside other forms of inquiry.

Databasing

The construction of databases – in which a body of information is ordered in a manner that makes it accessible to a wide variety of types of inquiry and analysis – is perhaps one of the most challenging areas for the humanities scholar. Whereas the statistical methods provide answers to given questions, the database is typically conceived as an ongoing information system which will be consulted on an indefinite number of occasions.

We are probably most aware of databases as they occur in the indexing and ordering of archival and library material. Undoubtedly this has provided humanities scholars with new potentials for conducting certain types of searches. An example known to all is the ability to search with great rapidity for bibliography on a certain topic in a library. But there is also a vast range of more sophisticated uses, particularly in indexes relating to specialist areas. In the field of the history of art one can mention the large number of database projects supported by the Getty Art History Information Program (AHIP). There are as well the database indexes for specific visual archives such as the Princeton Index[8] and the Witt Library, University of London.[9] Naturally, all these databases are

only as good as the data that is put into them and the structure that is used for organizing them. It is here that one comes up against one of the frequent problems in constructing computerized databases for archives, libraries, and collections. There are rarely if ever enough resources available to implement an ideal solution. Usually institutions have to make a choice between entering information about their complete holdings at a relatively simple level and effecting the program at a high level of detail but at a very slow pace. Extreme examples of both tendencies can be found in London. Faced with the problem of indexing its collection of 6 million items, the Victoria and Albert Museum decided to restrict information about each item to no more than four "fields" of data (museum number, an object type, a classification, and the location of the object). It was able to complete the inventory in a couple of years – but ended up with information that was valuable for its registrar but of little use for any kind of detailed investigation.[10] At the other end of the scale, the Witt Library of reproductions of works of art adopted a highly probing and elaborate standard for entering information about its 1.5 million items. The result is a database that is a model of scholarly endeavor. The only problem is that, given the rate at which the library can find resources to carry out its project, it will not be able to complete the process until at least the middle of the next century.

These might seem to be local problems. But in fact they affect all scholars in the field, once again emphasizing how much computerization of information systems is dependent upon a much higher level of funding being available than is commonly set aside for humanities subjects. Without it, humanities scholars are inevitably bound to become second-class citizens in the new technological age. There are some rays of hope on the horizon, however. Many of the providers of facilities for humanities scholars have recognized this situation and have taken steps to procure appropriate funding, often through specific project work. In the field of the visual arts, a number of visual archives have been developing a scheme for digitizing and databasing their holdings with funding from the European Commission. A notable example of this is the VAN EYCK project, which involved the Witt Library in the University of London.[11]

Before leaving the question of databasing, I want to raise a specific issue of relevance for the art historian. One of the main areas brought into question by the process of databasing is the classification of forms and subject matter. Without decisions having been made about terms for describing images and their meanings, much of the power of the database is lost. This has inevitably led to disputes about how "standards" can be achieved, with a wide variety of solutions being proposed. An attempt has been made to provide a standard for verbal descriptions via the *Art and Architecture Thesaurus* that has been produced by the Getty Art History Information Program.[12] In the area of subject matter, many solutions have been proposed. But it would seem that the most fruitful is ICON-CLASS. This is a system that was devised by H. van de Waal in Holland before the computer era to provide a hierarchical way of ordering subject matter. It has proved particularly appropriate for computerization and is now widely accepted as a standard – even by those institutions who supplement it with their own

local systems.[13] One particularly interesting methodological issue that is raised by this issue of iconography is the relationship of subject to object. ICONCLASS is an "abstract" system that classifies subjects irrespective of particular examples. Images are therefore fitted into a preexisting type. However, as the curators of collections will rapidly point out, pictures can also be seen as entities that each have a unique performance of a subject. There are, for example, an infinite number of ways of representing the Crucifixion, each with its own nuances of meaning. And frequently there is more than one subject in a picture. A representation of the suicide of Cleopatra may also be the portrait of a courtesan, the execution of Charles I may also be a view of Whitehall, and so on. The managers of the Princeton index, for example, take the view that subject classification should begin with the object rather than that the object should be designated an exemplar of a preexisting type. In practice they use ICONCLASS definitions as an adjunct to their own personalized system.

Databasing was discussed above largely in terms of large-scale projects. But it should be remembered that databases can also be valuable tools for individual research. One striking example of this is the use of a database that has been made by Marilyn Lavin in her analysis of narrative structures in medieval Italian narrative cycles.[14] In the case of the individual researcher there remains the question of the relationship of time spent designing the structure and inputting data as against the gains achieved.

By and large, art historians have profited from the construction of databases in the work done in other humanities disciplines. However, one large problem is still unresolved. This is the question of the use of images in databases. With the latest generation of computers and the introduction of image-storing and -retrieval devices such as CD-ROM there is little problem about the provision of images themselves. The questions are really ones concerned with the quality of the images and the extent to which the analysis of images (as opposed to their mere employment as illustrative add-ons) can be introduced into the database.

Computers and the Image

Imaging Techniques; Storage and Analysis

The sections above have suggested that there are significant advantages for art-historical studies in numerical and textual techniques forged for other purposes. But there is still a central area where there is a problem for the art historian – in the treatment of the image. At first sight the situation might not seem to be so different. After all, visual information is used in a wide number of other disciplines. In the sciences, of course, highly sophisticated image-recognition and -management techniques have been developed in areas like geography and medicine. In the arts, the image is used as a matter of fact in archaeology and increasingly by the historian. But while admitting all this, the art historian has had two problems with the image up to now.

The first is the question of quality. This is a difficult one to put across, as it smacks of connoisseurship. But the central point is that the image is the *text* of the art historian. Other scholars use images by way of illustration – to reveal evidence about a specific point. But the art historian explores the image as a phenomenon. There is, ultimately, no substitute for exploring the image directly. This has led to art historians treating the reproduction in a certain way. They see its function as being analogical, and require it to simulate as closely as possible the experience of confronting the work of art directly. Early computer imagery came a poor second to conventional photography for this point of view, a circumstance that has led to a prejudice against the medium that is only now beginning to dissolve.

The second problem is more of an intellectual one. One of the most stimulating aspects of computer technology is the way in which it employs a process of codification that, while being mechanical and therefore in some sense limited, is nevertheless capable of translating the codes of traditional forms of communication. In the first instance the computer was used to simulate the codes of mathematics – to such an extent that some people still believe that computers work fundamentally by calculation (which they don't). Then it became adapted to handle the conventions of the alphabet as a means of accessing the structures of writing. Since music – like writing – used a codified form of notation, it was not long before this, too, became a field for computerized analysis. But what of the image? While theorists might interpret images as forms of codified communication, they manifestly do not depend upon a discrete set of conventions for their transcription. In the jargon of the age, the traditional image, however made, is "analog." It is constructed by a process of simulation without the use of invariant coded subunits. There is no equivalent of the letter, the number, or the note in the traditional image. This situation has seemed to make the possibility of "automated" pictorial analysis comparable to that used in linguistic, literary, and musical studies unattainable. There would always have to be a phase of human intervention, of interpretive codification before the analysis could proceed.

The Digital Image

This is what seems to be the case. Yet in fact the computer does offer a fascinating possibility which, to my mind, has only recently begun to be explored. This is the fact that the very process whereby the computer stores and produces images does provide a type of codification. Computers, as we all know, can only work by means of the manipulation of symbols, coded assemblages of digits. To manipulate an image, it has to transform the image into such a set of codes. This is what takes place in the process of digitization. Essentially what digitization does is to break down any pictorial phenomenon into a set of discrete units. Each of these units will have a coded value (typically relating to hue and/or luminosity in the case of a picture) and an "address" – that is, a set of coordinates that give the precise location of the unit (or "pixel," as it

is called). By subdividing an image into a series of pixels each with an address and a value (or set of values), the digitization process does, in effect, create a "text" out of an image.

This might seem to be a purely formal point, but in fact it is much more. Three fundamental effects emerge as a result of this process that have implications for the subsequent usage of the image.

(i) The first is stability of record. Once the visual impression has been codified, it is unchanging in the same way that letters and numbers are unchanging. No longer is the record of an image dependent upon its actual effect – as it is in, say, a conventional photograph of an image. As long as the code is expressed in symbols (for example those of letter or number), then the physical changes to those symbols have no effect on their meaning. Once captured digitally, the image can be relayed to another medium – it could even be printed out as a text – without the information deteriorating in any way. This stability does of course have one practical problem – namely, that to be made visible the code has to be "reinterpreted" by another machine. But this is a practical problem that does not affect the integrity of the record. This stability has been one of the reasons why so much interest has been expressed in the digital image by restorers and conservationists. But it has implications beyond. All art-history departments, for example, have the constant problem of obsolescence in their slides. The digital image is one that does not deteriorate.

(ii) The second important feature of the digital image is its transferability. It can be disseminated in a way that no conventional photographic image can.

(iii) The third important feature is manipulability. In other words, it is possible to perform analysis on images through digitization. This is interesting both for identity and analysis.

Digital Applications

The power of the digital image to perform specific calculations makes it a power tool in reconstruction. It has become a powerful tool, for example, in the reconstruction of partially preserved three-dimensional objects. One recent example of this is the use of computer modeling to reconstruct the original appearance of Inigo Jones's facade of the Whitehall palace.[15] Similarly, computer modeling can be used to construct structures that were planned but never built, such as Serlio's temporary theater, as described in his *Architettura* (1545) (Fig. 45).[16]

There have, as well, been extremely impressive uses of the computer image to aid the infilling of lost parts of paintings – such as that used to help reconstruct the Cimabue *Madonna* damaged in the Florence flood of 1967, and to penetrate beneath the surface of pictures in a far more accurate way than is provided by the conventional use of X-rays or infrared photography.[17]

Yet the problem remains as to how much such work can be made available to scholars outside the specialized laboratory. Here the problem seems to hang on the accessibility of the digital image itself. Very gradually museums and other custodians of pictures are beginning to address this problem, with a view to

Figure 45. *Vaughan Hart and Alan Day, computer model of Serlio's theater. Photo courtesy of Vaughan Hart.*

making such imagery available either on-line or in CD-ROM form. There are, as well, "Rolls Royce" solutions – notably that of the pioneering VASARI project, digitized works in the Louvre, the Neue Pinakothek in Munich, and the National Gallery in London to the level of 30 lines per millimeter – a standard that would meet the most exacting standards of reading. At the same time, many commercial companies are offering to produce digitized images of works in museum collections of a lower quality, but one that would still be useful for general purposes.

As yet, the pool of good-quality digital images is limited. I suspect it will remain so until a large demand is evident.

Digitized Reproductions and Pictorial Analysis

This is an area of immense promise. As has already been mentioned, the digital image offers the possibility of picture recognition and picture analysis by automated means. It will be necessary to develop some form of picture recognition by motif and visual form (as opposed to recognition by textual description) if the true potential of visual databases is to be exploited.

Many schemes are being planned. To a large extent they are dependent upon experiments conducted by psychologists into pictorial recognition.[18] But there are also more pragmatic approaches available which might in the end be of more practical use.

Attempts have been made to use this potential to create "expert systems" that will simulate the formal elements used by certain connoisseurs to identify various artistic schools and individuals. In the University of Bergen, as has already been mentioned, Britt Kroepelien has developed the means for making an expert system out of the criteria used by Edward B. Garrison for the identification of medieval Italian wall paintings (Fig. 46).[19] Such systems are important, not just for testing the ability of the machine to simulate the expertise of a connoisseur, but also for testing the degree of consistency that might exist with a particular method. This is not just to test the reliability of a particular scholar. It is also a test of the assumption that formal features are sufficient to characterize a style. Either style is a formal quality that possesses certain constant objectively observable features or it is not. In the case of Garrison, Kroepelien had to construct a set of principles from the scattered observations made over a wide range of articles. In fact, the attempt proved remarkably successful. Not only did she succeed in finding a series of clearly designated style determinators which seemed to support the notion that style could (at least in the case of early Italian murals) be described in terms of formal constants – such the line shapes used to describe drapery, hair, and other such features – but she was also able to develop the means by which these could be read unequivocally by the machine. The problem behind her experiment was that the process proved enormously time-consuming. If her expert system could be adapted easily to fit other situations, then it might be practical to adopt it – much the way expert systems have been adopted to help doctors in the diagnoses of certain diseases (in fact it was a medical expert system that formed the model for her own). But the criteria that Garrison used for his style analysis were peculiar to the particular type of painting that he was investigating. In themselves these would not be appropriate for art forms dependent upon different formal and thematic criteria.

Kroepelien's study is important for opening up a set of problems and suggesting solutions to them. One can only hope that more investigations of this kind will take place. If they are successful, they could revolutionize current thinking about the notion of style and return us once again to the "scientific" connoisseurship that was proposed at the end of the nineteenth century. But while this process is taking place there is still the possibility of using simpler means to achieve some less ambitious forms of picture recognition. Whereas Kroepelien's approach is "top-down," working from a developed concept toward implementation, such an approach would be "bottom-up," working from the simple practical tools available toward increasingly more complex achievements.

This is essentially the principle behind MORELLI, the picture-recognizing system that I have developed at Birkbeck College. It works on the principle of deriving a unique identifier of the smallest and simplest possible kind for

Figure 46. *Britt Kroepelien, analysis of style features of early Italian mural. Photo courtesy of Britt Kroepelien.*

each picture. This identifier is linked to a more sophisticated digitized version, which allows the possibility of searching for further characteristics. Whereas Kroepelien's system is built upon a highly specialized knowledge of the works of art being investigated, MORELLI works in a completely arbitrary way, deriving similar sets of data from any image presented to it by entirely automated means.

MORELLI has proved effective in being able to get a machine to recognize other reproductions of the same work of art by a simple matching process. It has further been able to range these with close variants of the pictures being explored (Fig. 47). Although this might seem to be of limited use in the area of style analysis, it has proved to be of practical use as a visual tool for exploring picture archives that have been digitized. Since the unique identifiers created for each image are remarkably small – using no more than 67 bytes per image – it is practical to have the identifiers stored in fields in parallel with textual information in the database managing a visual archive. This also raises the fruitful possibility of making combined text and image searches.

Essentially, MORELLI[20] functions in a manner similar to the program that manages a text database. In a text database management program, you enter a key word which is used as the basis for a search of the database. In MORELLI, you

use an image to search through a visual archive. The image can be a repro-
duction scanned in from outside the system, a sketch image drawn by the user,
or an image that has been drawn out of the database itself. If, for example,
you had come across an unidentified picture and wanted to see if anything sim-
ilar was already recorded in a picture archive, you could scan in the image and
use this to search the visual archives for the nearest related works they had
stored in them. Alternatively, you could "block out" a design and see whether
the database had anything of a similar kind in it. Or it would be possible to
select an image already in the database and see if there were anything similar
that had been done by some other artist.

The MORELLI system has been tested on a group of two thousand images,
and results have been encouraging.[21] However, its full value would only be real-
ized if it were applied to a large archive of digitized images. To date, this has
not happened. At the moment, MORELLI is being integrated into the system devised
under the E.C.-sponsored VAN EYCK project to provide a standard for databases
for visual archives. This system is being developed in collaboration with the Witt
Library in London and the Rijksbureau voor Kunsthistorische Documentatie in
The Hague.[22]

The MORELLI system differs in a number of ways from other picture-matching
systems currently available commercially.[23] First, it works with the overall con-
figuration of a picture, rather than by searching for motifs within it. This is
useful when one is looking at works of art, which have a fixed appearance and
(usually) a determined edge. It is not so useful when you are using images prin-
cipally as a description of objects rather than as important in their own right.
A journalist wishing to survey a collection of photographs for an image of the
pope would not find this system useful. An art historian searching an archive
to spot a particular religious painting would. It is because MORELLI measures
at its basic level only the characteristics of the total picture that it is able to
make accurate matches with so little information. This makes it practical for
it to scan very large archives – archives literally of several million images – in
a way that other searching techniques – dependent as they are on large bodies
of data and highly complex algorithms – cannot. The second major difference
is that it focuses exclusively on shape and tone, and ignores color. The reasons
for this are purely pragmatic. First, most existing photographic archives of works
of art are predominantly of images in black and white. It would therefore be
useless to use color matching to scan them. The second point is that color
reproduction is so notoriously varied that it would be impractical to use color
matching as a way of linking different reproductions of the same objects. Most
commercially available systems use color as a matching criteria. But, then, they
are dealing typically with color photographs of a particular type, where color
matching may be effective. User trials, however, have suggested that even in
these cases color matching appears to be of limited effectiveness.

It may be that the two different approaches represented by Kroepelien's research
and the MORELLI system could be brought together. The low-level data of MORELLI
can be linked, as has already been said, to higher-level digital reproductions in

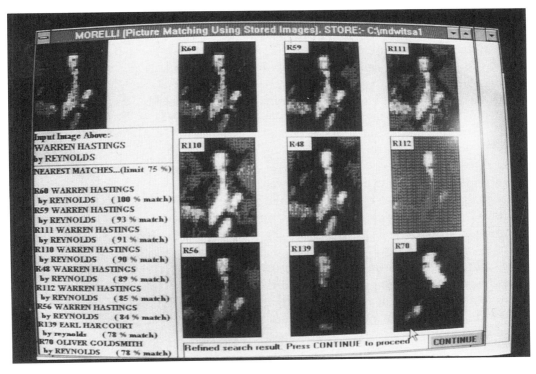

Figure 47. *William Vaughan,* MORELLI *picture search.*

which more sophisticated formal features could be explored. But such an experiment is in the future. As yet, developments in this area are restricted, but the potential is immense.

Bringing It All Together: Hypertext, Multimedia, and Networking

Hypertext and Multimedia

The procedures discussed above are all individual techniques, to be used for specific purposes. But the arrival of multimedia systems – in which text, image, film, and sound can all be brought together and managed on a personal computer – has stimulated interest in providing systems in which all these operations can be managed as a single process.

This concept is epitomized in the notion of "hypertext," a term that has become highly suggestive since it was coined by Theodore H. Nelson in the 1960s. Hypertext is a text that is read in a nonlinear manner and that can be accessed by many different routes. This possibility has entranced a number of people working in the art-historical field, among them George P. Landow at Brown University and Kim Veltman at the Marshall McLuhan Institute, Toronto. Landow

has published a series of studies on the impact of hypertext on critical studies – or rather the relevance of hypertext for critical studies.[24] He has, too, addressed the issue more specifically in relation to the potential of uniting the new hypertext with the new generation of digital imagery and with networking. "Computer hypermedia, which produces texts in ways that differ fundamentally from those created by printing, therefore offers the promise or threat of thus changing the conception and practice of art history."[25]

One implication of the new flexibility that such methods provides in the employment of images has been noted by E. de Benedictis, who has used multimedia in undergraduate teaching.[26] It removes the pressure to teach the subject using the dialectical process established by Wölfflin and others in the late nineteenth century, namely, the comparative method of lecturing using two-screen projection. In multimedia applications one can move from using one to any number of images simultaneously, thus allowing for a far richer range of types of analysis and association.

In his publications, George Landow has given convincing and impressive accounts of how the hypermedia can be used to gather and collate a plethora of data. This certainly turns the computer into a powerful tool for the exploration of data and for making new types of connections.

Landow's work is based on a practical example at Brown University, where he uses a hypertext system developed on the Apple Macintosh personal computer. In his article "Connected Images: Hypermedia and the Future of Art Historical Studies," he gives an account of how his system will enable scholars to bring to bear a seemingly endless body of information about their investigations. For example, he talks of a case where an art historian might wish to link a motif in one picture with that in another. The picture in question here is Holman Hunt's *Lady of Shalott*.

> Looking at William Holman Hunt's large version of the subject, which is now in Hartford, Connecticut, our art historian wishes to determine how closely the lady's discarded clogs resemble those in paintings by van Eyck and Memlinc, so she searches through folders until she finds reproductions of the relevant works. Then, using Intermedia's recently developed capacity to permit full-text searches, she uses the computer mouse to begin one. When a dialogue box appears, she types "Hunt van Eyck Memlinc Composition" and after waiting twenty to thirty seconds, she receives a hierarchically arranged list of all documents on intermedia . . . in which these terms appear.[27]

All of this is very impressive, and lends substance to Landow's conclusion:

> Clearly, working in a hypertext environment permits the scholar to obtain information far more rapidly than has been otherwise possible (assuming, of course, that the textual or visual information appears on the system), and it also permits the scholar to make annotations, comments, and working

notes. Most important, a hypermedia environment allows art historians far more easily to do what a recent study suggests is their primary scholarly act – perceiving, recording, and analysing relations among large amounts of data.[28]

All this may be very true, but there are a series of problems as well. No one would deny the uses that hypermedia can be put to. Landow's global approach is one that has been adopted by others. Veltman, as has already been mentioned, has a similar ambition for his sums system (System for Universal Media Searching) at Toronto. In other fields, classical studies have greatly benefited from Harvard University's Project Perseus, which includes an impressive textual and visual database for Classical Greek art, as well as for other aspects of ancient Greek civilization. Historians are developing similar types of hypermedia workbenches, such as the hides project at the University of Southampton, or the cleio database devised by Manfred Thaller at Göttingen.[29] But there are still some problems.

First is that phrase of Landow's: "assuming, of course, that the textual or visual information appears on the system." This is an obvious limitation, but it begs the question – who is going to put such information on? The problem might not be so acute in a teaching situation – where one is seeing an extension of the concept of preparing material. But in the context of research there is an obvious limitation. Most researchers are involved in one way or another in "primary" material which, by definition, lives somewhere outside the system. It may be a document in an undeciphered hand in some distant archive. It may be some previously unobserved part of an ancient building in an out-of-the-way place. However good the system is at offering us an unheard-of number of new possibilities and connections with the data that we already have, it cannot give us what no one has gathered.

Networking and the World Wide Web

It may well be that this situation will change through the possibilities offered by networking. As has already been discussed, there are an impressive number of collections and archives that are now entering material about their holdings into computer systems of one sort or another. Through the process of networking, it is possible for one individual user in theory to gain access to any of these from his or her personal machine. Even now it is possible to see breathtaking examples of the transfer of such information, such as the summoning up in London in a matter of seconds of a high-definition reproduction of an image stored in New York. There are, it is true, a host of logistical problems that still have to be resolved. There is, for a start, the sheer cost of the venture. At the moment billions are being poured in by governments and other agencies keen for these processes to develop. But this cannot go on forever, and some day individual users will have to start paying the cost. Then there are problems to do with the compatibility of the different systems in which data is stored. There

is no standard at the moment – though standards are being hotly debated.[30] It may be that standards will be firmly established in the end. But it will be a difficult business, and there will always be the nagging feeling that, whatever standard has been adopted, some kinds of data will have had to be distorted to accommodate it. Finally, for objects, at least, there are horrendous problems of copyright. It may be that in the end principal holders of images and reproductions will be persuaded that it is in their interest to allow images to move through the ether with the speed and multiplicity that will make true networked investigation a possibility. But most of them at the moment are unwilling to sign away rights to what seems to them to be a potential goldmine. Without such agreements, the cost of any but the simplest searching will be prohibitive for the average user.

Undoubtedly, the development of the World Wide Web over the past few years has had a great effect both on freeing up information in general and on making images more generally available for usage. With the emergence of the Web, it is possible for every user to set up a graphics environment on a "page." Anyone who can use a scanner can thereby communicate images throughout the world. Already vast banks of images have been made available in this form, for example by Michael Greenhalgh at the National University of Australia. While copyright problems still exist, the technical difficulties involved in monitoring them have become so large as to make copyright virtually uncontrollable. For the private user, at least, it has never been so easy to become a pirate. Naturally, quality is equally hard to monitor, in all senses of the word. But a number of helpful indexing systems have been set up to help guide users toward useful resources. In the area of the history of art, several have been set up, for example the Art History Research Centre. Such resources can easily be found by browsing through the World Wide Web. It remains to be seen whether this monitoring process will eventually be brought together into a centralized system.

However, even if all these problems are resolved, it will remain the case that multimedia and the internet will have little to offer in the acquisition of primary archival research material, however helpful it is for subsequent investigation.

This does not mean that we should not make use of such resources. Apart from anything else, the World Wide Web offers unrivaled new powers for sharing information among scholars and for the development worldwide of special-interest groups, who can hold online conferences and seminars and can comment on each other's research prior to its appearance in more conventional published form. All this is admirable, and will undoubtedly help to facilitate both teaching and research.

But none of this obviates the continued need to conduct primary research at the traditional archival level. I would argue that we should use multimedia and internet facilities as we do all other computer applications, like a tool, and not as a total environment that subsumes our whole working practice. I also feel that the sheer ability of multimedia to present multiple choices should not blind us to the analytical processes that the computer is capable of, some of which I outlined when discussing the image.

It is one of the ironies of the subject that digitization does bring within the art historian's grasp the possibility of formal and structural analyses like the ones that have been carried out by literary scholars and musicologists. But to carry out such analyses, it would be necessary for art historians to return to consideration of the significance of form. In modern studies – under the heavy influence of linguistics – the tendency has been to see images purely iconically, as though the formal basic unit of a picture were the interpretable sign, rather than existing at a more primitive level of signification, that driven by the interpretation of form. This is ironic, since the whole structure of the history of art as an independent discipline with its own particular contribution to knowledge was based initially on the scientific analysis of form of the generation of Morelli and Wölfflin. It remains to be seen whether any art historian will now be tempted to return to this more primal area of pictorial analysis with the aid of the new process of picture analysis that the computer is offering.

Notes

1 For an overview of work done by the Oxford University Computing Centre and other centers in the U.K., see *Information Technology in Humanities Scholarship*, British Library Research and Development Report 6097, London, 1993, pp. 4ff.
2 A useful general introduction to the principles behind the structure of computers can be found in J. Weizenberg, *Computer Power and Human Reason*, 2nd ed., Penguin Books, 1984. See especially ch. 3, "How Computers Work."
3 J. F. Lyotard, *The Post-Modern Condition*, London, 1987, p. 14.
4 E. A. Wrigley (ed.), *Nineteenth Century Society: Essays in the Use of Quantitative Methods for the Study of Social Data*, Cambridge: Cambridge University Press, 1972.
5 J. F. Burrows, *Computation into Criticism: A Study of Jane Austen's Novels and an Experiment in Method*, Oxford: Clarendon Press, 1987.
6 For a recent survey of such work, see M. Katzen (ed.), *Scholarship and Technology in the Humanities*, London: Bowker-Saur for British Library Research, 1991.
7 Gilbert Herbert and Ita Heintze-Greenberg, "The Anatomy of a Profession: Architects in Palestine during the British Mandate," *Computers and the History of Art*, 4, 1 (1993), 75–86.
8 Brendan Cassidy, "Computers and Medieval Art: The Case of the Princeton Index," *Computers and the History of Art*, 4, 1 (1993), 3–16.
9 Catherine Gordon, "Dealing with Variable Truth: The Witt Computer Index," *Computers and the History of Art*, 2, 1 (1991), 21–7.
10 K. O'Sullivan, "Planning the Computerisation of Collections Management at the Victoria and Albert Museum," *CHArt Newsletter*, 2 (Spring 1989), Birkbeck College, London, pp. 23–9.
11 Colum Hourihane and John Sunderland, "The van Eyck Project: Information Exchange in Art Libraries," *Computers and the History of Art*, 5, 1 (1995), 25–40.
12 *Art and Architecture Thesaurus*, 3 vols., Santa Monica, Calif.: Getty Art Historical Information Program, 1992.
13 H. van de Waal, *ICONCLASS: An Iconographical Classification System*, completed and ed. L. D. Couprie with E. Tholen and G. Vellekoop, Amsterdam, 1972–85. The computerization of ICONCLASS has been undertaken by Jurgen van den Berg at the University of Utrecht. A recent account of the computerized version of ICONCLASS, with a consideration of its functionality, can be found in Hans Brandhorst and Peter van Huisstede, "The Iconclass Connection: ICONCLASS and Pictorial Information Systems," *Computers and the History of Art*, 2, 1 (1991), 1–20.

14 Marilyn Aronberg Lavin, *The Place of Narrative: Mural Decoration in Italian Churches, 431–1600*, Chicago: University of Chicago Press, 1990.

15 Vaughan Hart, Alan Day, and David Cook, "Conservation and Computers: A Reconstruction of Inigo Jones's Original Whitehall Banqueting House, London, c. 1620," *Computers and the History of Art*, 4, 1 (1993), 65–9.

16 Vaughan Hart and Alan Day, "A Computer Model of the Theatre of Sebastiano Serlio, 1545," *Computers and the History of Art*, 5, 1 (1995), 41–52.

17 See "Riflettoscopia all'infrarosso computerizzato," in *Quaderni della Soprintendenza ai Beni e Storici di Venezia*, vol. 12, Venice: the Soprintendenza, 1984, pp. 48–53.

18 A useful general account of the problems can be found in A. R. Anderson (ed.), *The Mechanical Concept of Mind*, Englewood Cliffs, N.J.: Prentice-Hall, 1964. For introductory accounts of neural networking, see P. K. Simpson, *Artificial Neural Systems*, New York: Pergamon, 1990, and T. Kohonen, "An Introduction to Neural Computing," *Neural Network Magazine*, 1, 1 (1988).

19 "Fra still till algoritme," unpub. doctoral thesis, University of Bergen, 1994.

20 The name, apart from its tribute to the great Italian "scientific" connoisseur, can stand for "Matching of relatable library images."

21 William Vaughan, "Automated Picture Referencing: A Further Look at Morelli," *Computers and the History of Art*, 2, 2 (1992), 7–18.

22 Hourihane and Sunderland, "The van Eyck Project."

23 For a comparative review of systems, see Catherine Grout, "From 'Virtual Librarian' to 'Virtual Curator'," paper delivered at the conference "Electronic Imaging and the Visual Arts: EVA '96," National Gallery, London, July 24–6, 1996. To be published by Vasari Ltd., Aldershot.

24 G. P. Landow, *Hypertext: The Convergence of Contemporary Critical Theory and Technology*, Baltimore: Johns Hopkins University Press, 1991.

25 Landow, "Connected Images: Hypermedia and the Future of Art Historical Studies," in *Scholarship and Technology in the Humanities*, ed. May Katzen, London: British Library, 1991, p. 77.

26 E. de Benedictis, "Teaching with Multimedia in the Art History Undergraduate Classroom," *Computers and the History of Art*, 5, 1 (1994), 53–64.

27 Landow, "Connected Images," p. 89.

28 See note 27 above. The study Landow is referring to is E. Bakewell, W. O. Beeman, C. M. Reese, and M. Schmidt, *Object Image Inquiry: The Art Historian at Work: Report on a Collaborative Study by the Getty Art History Information Program (AHIP) and the Institute for Research in Information and Scholarship (IRIS), Brown University*, Santa Monica, Calif.: Getty Art History Information Program, 1988.

29 Manfred Thaller (ed.), *Images and Manuscripts in Historical Computing*, St. Katharinen: Scripta Mercaturae for the Max-Planck Institut für Geschichte, 1992.

30 See, for example, D. A. Roberts, *Collections Management for Museums*, Cambridge: Museum Documentation Association, 1988.

Bibliography

Andrews, D., and M. Greenhalgh. *Computing for Non-Scientific Applications*. Leicester: Leicester University Press, 1987.

Bakewell, E., W. O. Beeman, C. M. Reese, and M. Schmidt. *Object Image Inquiry: The Art Historian at Work: Report on a Collaborative Study by the Getty Art History Information Program (AHIP) and the Institute for Research in Information and Scholarship (IRIS), Brown University*. Santa Monica, Calif.: Getty Art History Information Program, 1988.

Corti, L. (ed.). *Automatic Processing of Art Historical Data and Documents*. Pisa: 1. *Census of Projects*. 2. *Proceedings of Conference* (2 vols.). Scuola Normale, 1984.

Denley, P., and D. Hopkins (eds.). *History and Computing*. Manchester: Manchester University Press, 1987.

Greenhalgh, M. "Databases for Art Historians: Problems and Possibilities." In Denley & Hopkins 1987: 156–67.

Hamber, A., J. Miles, and W. Vaughan (eds.). *Computers and the History of Art*. London: Mansell, 1989.

Landow, G. P. *Hypertext: The Convergence of Contemporary Critical Theory and Technology*. Baltimore: Johns Hopkins University Press, 1991.

Roberts, D. A. *Collections Management for Museums*. Cambridge: Museum Documentation Association, 1988.

Sarasan, L. "Why Museum Computer Projects Fail." *Museum News*, January–February 1981, pp. 40–9.

Thaller, Manfred (ed.). *Images and Manuscripts in Historical Computing*, St. Katharinen: Scripta Mercaturae for the Max-Planck-Institut für Geschichte, 1992.

Vaughan, W. (ed. in chief). *Computers and the History of Art* (periodical). Harwood Academic Publishers. Vol. 1 (1990); vol. 2 (1991). It is worth reading articles here to gain an idea of the coverage of the subject.

Index

perception
 aesthetic and nonaesthetic, 194
 as concept (Derrida), 161–2
 relation to writing, temporality and
 memory as condition of (Derrida),
 162–3
 writing as supplement to (Derrida), 164
perspective
 to position beholder, 187
phenomenology
 defined, 143
 impact on aesthetics, 147
 influences of, 146–7
 of literary criticism, 147
 Merleau-Ponty's account of, 143–4,
 148
 as philosophy, 143
 in revisionist history of science, 147
Philippot, Paul, 45–6
phonologocentrism, 159
photograph
 concept of (Derrida), 165
 indexical status of, 156
photography
 aligned with formalist modernism,
 165
 as art form, 3
 conventional accounts of, 164
 history of, 157
phrenology, 16–18
physiognomy theories (Lavater), 16–18
Pictorialism
 Stieglitz's use of, 168
 strategies in Stieglitz photographs of,
 166
pointer
 in use of index concept, 77
politics, feminist, 95–7, 100–8
postcolonial theory
 of Coombes, 225–6
 encounter with art history, 213
 turn against colonialism, 213
poststructuralism
 attitudes toward historiography
 influenced by, 26
 history in theory of, 26
Princeton Index database, 312, 314
Project Perseus, 323
prorairetic code, 78, 83

queer theory
 attempts of, 117–18
 development of, 124–8

in the humanities, 128
 interpretation of art using, 131–5
 sexualities and subjectivities
 acknowledged by, 129

race
 topic of interest to feminist art
 historians, 99
Raphael, Max, 27
Realism, nineteenth-century European,
 31–2
reception
 factual, 182
 offers of, 186–7
reception aesthetics
 Maes's The *Eavesdropper*, 189–94
 as practised currently, 184–7
 in study of literature, 183
 in study of visual arts, 183
 tasks of, 183
reception history
 aesthetics and psychology of reception,
 182–3
 analysis of factual reception of works
 of art, 182
 approaches to practice of, 181–3
 written and oral reactions of beholders
 and users of art, 181–2
referential code, 78
Reinhold, Karl Leonhard, 10
Ricoeur, Paul, 146
Ridderbos, Bernhard, 45
Riegl, Alois
 as art historian, 27, 55–6, 64, 67
 reception aesthetics of, 184
Rijksbureau voor Kunsthistorische
 Documentatie, 320
Ringbom, Sixten, 45
Rivière, Georges Henri, 220–5

Sadger, Isidore, 120
Scheerbart, Paul, 296
Schindler, Rudolf, 291
Schinkel, Carl Friedrich, 237
Schlegel, Friedrich, 29
Schlosser, Julius von, 56
Schmarsow, August, 184
Schorske, Carl, 59, 61
Schutz, Alfred, 146
Screen
 influence on art history, 267
 influence on film studies, 264–6
 intellectual provenance of, 264–70